MW00583249

THE WORLD OF

HUMAN

SEXUALITY

To the memory of

ALFRED C KINSEY

**still the most spectacular light
in the history of
the study of human sexuality**

and to the late

ANTHONY S MERCATANTE

**whose suggestion
made this book possible**

EDGAR GREGERSEN

THE WORLD OF HUMAN
SEXUALITY

BEHAVIORS, CUSTOMS AND BELIEFS

IRVINGTON PUBLISHERS, INC.
NEW YORK

Copyright © 1996 by Irvington Publishers, Inc.
Copyright © 1994 by Irvington Publishers, Inc.
All rights reserved. No part of this book may be reproduced in any manner whatever, including information storage, or retrieval, in whole or in part (except for brief quotations in critical articles or reviews), without written permission from the publisher.

Please address permission, editorial and marketing requests to
Irvington Publishers, Inc.
Box 286, Cooper Station P.O., New York, N.Y. 10276-0286
Fax (212) 861-0998

Customer service and warehouse in care of:
Irvington Publishers Warehouse
Lower Mill Road, N. Stratford, N.H. 03590
603-922-5105
Fax (603) 922-3348

Picture layout and production by:
Octal Publishing, Inc., Atkinson, N.H.

Library of Congress Cataloging-in-Publication Data

Gregersen, Edgar.
 The world of human sexuality : behaviors, customs, and
beliefs / Edgar Gregersen.
 p. 464 cm. 15 x 23
 Rev. ed. of: Sexual practices. 1983, c1982
 Includes bibliographical references (p. 383) and index.
 ISBN 0-8290-2633-9
 1. Sex customs—Cross-cultural studies. I. Gregersen,
Edgar. Sexual practices. II. Title.

HQ12.G75 1994 94-31339
 306.7—dc20 CIP

Printed in the United States of America

∞

The paper used in this publication meets the requirements of American National Standard for Information Sciences — Permanence of Paper for Printed Library Materials, ANSI Z39.48-1984.

CONTENTS

PREFACE

In the latter part of the 19th century and early 20th century a number of scholars attempted encyclopedic works covering many human societies. Names such as Karsch-Haack, Mantegazza, Marcuse and Westermarck come to mind. None of these were anthropologists in our modern sense of the word. Anthropology, born in the Victorian era, has always been sex shy. There were a few brave souls such as Malinowski, but they dealt only with the cultures they had studied. There followed a great gap in time and the next global approach to sex was in the middle of the century with Murdock and Ford & Beach, but they worked within the limits of the Human Relations Area Files and wisely eschewed illustrations.

It was not until almost forty years later that a *bona fide* anthropologist, Edgar Gregersen, met the need for a world-wide view of sex with his work now entitled *The world of human sexuality*. Gregersen paints with a broad brush and has the courage to include numerous illustrations. This volume is a "must" for sex researchers, anthropologists, and indeed anyone who is concerned with this basic aspect of life.

Paul H Gebhard, Ph.D. former Director
The Institute for Sex Research
("The Kinsey Institute")

AUTHOR'S NOTE ON SPELLING AND PRONUNCIATION

The spelling of foreign words adopted here avoids unusual letters but still tries to show pronunciation accurately. For example, no special symbol is used for the *ng* sound as in *singer*, but where the *g* is "hard," as in *finger*, the spelling *ngg* has been used. Thus the well-known Indian erotic manual, elsewhere written *Ananga ranga* (*ṅ* pronounced *ng*), is here written **Anangga rangga**.

Long vowels are shown by doubling the relevant character, so that a long a with the same quality as in the a in *father* is written *aa*. Thus we write **Kaama suutra**, elsewhere written as *Kāma sūtra*. This method is followed for Arabic as well as ancient Greek, but vowel length is ignored for Latin, following Church Latin conventions, and for Hebrew, following modern Hebrew usage.

To help the reader with the pronunciation of the names of the societies mentioned here, a stress mark (´) is written over the stressed vowel except where the next to the last vowel is stressed; thus:

Kágaba Múria Wógeo Bororó Samoyéd Yóruba Wálbiri Árapesh Sirionó

But no stress mark is written on:

Sarakatsani Murngin Malekula Tikopia Nambikwara Ifugao Miao

or in names that have a special English form (e.g., Blackfoot, Burmese). Chinese words are written in accordance with the official Pin-yin romanization, where *x* = a kind of *sh* sound, and *q* = a kind of *ch* sound. Indonesian words are written in accordance with the latest official spelling, thus **Toraja** (not the older *Toradja*).

The names of many societies have a number of variant spellings, e.g., **Návaho** *vs.* Navajo, **Chaga** *vs.* Chagga, **Maasai** *vs.* Masai, **Nambikwara** *vs.* Nambicuara, **Karajá** vs. Carajá. I have used the first spelling for each of these. In every case I have tried to use a form where the spelling corresponds most nearly to the conventions of World Orthography, in which, for example, a *k* sound is written with *k* (not *c* or *ch* or *qu*), an *h* sound with *h*, etc. In some instances, the variants reflect something other than spelling conventions, e.g., **Zande** *vs.* Azande, **Yãnomamö** *vs.* Yanoama or Yanomami, **Timbira** *vs.* Canella. I have used the name that is either most common or else is preferable for some other reason.

In the general spelling of English, American conventions are usually followed (e.g., *color, center, catalog, connection, canonize*), but spellings with *ae* and *oe* are generally kept because they are better than ones with *e: anaemic* (with a long *ee*) does not rime with *academic* (with a short *e*) in my pronunciation. Hence, I write *paedophilia* but *pederastry* because for me the vowels are different.

SUMMARY OF SPECIAL VALUES FOR LETTERS

Vowels

 a as in f*a*ther, or (in Indian words) as *u* in b*u*t
 e as in m*e*n, or v*e*il
 i as in sk*i*, or p*i*n
 o as in g*o*, or *o*r
 u as in r*u*le, or p*u*t

Consonants

 c or č as in cello, *ch*urch
 š (or x in Chinese, Portuguese, Spanish, and names of American Indian groups)
 as sh in *sh*ip
 x or kh as in *Kh*omeini (or ch in Ba*ch*, lo*ch*, *ch*utzpah)
 ngg as in fi*ng*er not si*ng*er

Other

 ´ stress (in Chinese and some other languages, high tone) as in **Bororó**
 ~ nasalized vowel as in **Yãnomamö**.

Part One

SEXUAL THEMES

There is no reason why
sexual customs cannot be examined
as are other customs, to find out
when and where they originated,
how they spread,
and why they are maintained.

ONE SEX: THE ANTHROPOLOGICAL PERSPECTIVE

**Sex began as a biological adaptation, but in all
human cultures it has become a focal point for social
and moral codes, as well as generating themes that
permeate religion and art.**

Sex began more than 2,000,000,000 years ago. It has survived as the
most spectacularly successful adaptation in the evolution of life.
Profound changes have taken place since the first primordial pooling of
matter between bacteria, or blue-green algae, or whatever the earliest
sexual beings actually were. The hundreds of millions of years between
then and now have seen the unfolding of an incredible diversity. Among
human beings this diversity shows up not only in behavior but in ideals:
societies that insist on a very limited range of erotic acts versus those
that revel in erotic riches; cultures dominated by prudes versus those
governed by lechers; and all sorts of gradations.

Our own society has recently been exposed to tremendous ideological
changes with regard to sex. In large part this has to do with two
developments: the widespread use of contraception, and the breakdown
of the traditional division of labor whereby men and women performed
different but complementary tasks, and marriage was seen as a financial
arrangement. This view of marriage now has less reality than ever before.
More and more, sex has become the fragile basis of getting and staying
married, or of living in some less ritually defined relationship.

Among human beings, nowhere has sex remained merely a physical
act to relieve certain bodily tensions. It has been transformed within all
human societies to become a basic area for morality and the organization
of society. At an even greater remove from biology, it has generated
themes that permeate religion and so participates in enormously complex
symbolic systems.

This mingling of biology and symbolization in human sexuality can, I
think, best be dealt with from the anthropological viewpoint — the
fundamental assumption of and justification for this book.

Sex is clearly one of the important aspects of human life, but in the
four million or so years that human (or humanlike) beings have existed,
only within the past few hundred years have people started to study it

objectively. Even some of the most fundamental and seemingly obvious facts of biology have been misunderstood. And as examples of misconceptions, we need not dwell on such oddities as the belief that some people are male one month and female the following month — a belief that has been reported from such divergent groups as the Tarascan Indians of North America and the Burmese (who say these individuals are being punished for illicit seductions in a previous life).

Consider instead such commonplace matters as menstruation and paternity. At least 12 societies in the world hold that menstruation is caused by having sexual intercourse. This belief can probably be explained by the fact that most girls in these societies marry or are allowed to have sex before puberty. But surely some girls do not. Among the peasants of Tepoztlán, Mexico, this belief broke down when later marriages became the fashion, but even so is still held by older people. A man who accidentally discovered that his 15-year-old unmarried niece was menstruating denounced her for not being a virgin and held her mother responsible for not guarding her.

Theories about how babies are made have great variety. Some societies, such as the Áranda of Australia, the Trobriand Islanders off the coast of New Guinea, and the Yapese on an island in Micronesia in the Pacific, reportedly deny that men are necessary for procreation. Some anthropologists discount these reports, but there are other beliefs that are equally astonishing. The Buka of the Solomon Islands in the Pacific believe that a child is formed only out of its mother's blood — semen playing no role in procreation. But sticking a penis inside the woman is necessary: it somehow triggers the whole business of conception. As proof of the correctness of this belief, people told about a man in a neighboring village who developed an ulcer on his penis, which rotted away. Undaunted, the man made an artificial one of wood and continued to copulate with his wife, who gave birth to a number of children. Clearly, penetration, not ejaculation, was all that was required!

In a great many societies throughout the world it is believed that conception requires more than one act of sexual intercourse. The Wógeo of Papua New Guinea, for example, say that a foetus is made up of a combination of menstrual blood and semen. Copulation has to be repeated often so that the passage leading from the womb will be blocked up with semen to prevent the blood from escaping. The Yãnomamö of Venezuela and Brazil believe that for a child to grow strong, many men should copulate with the mother frequently during her pregnancy. This has its problems, since if she is discovered with a lover, her husband will almost invariably challenge him to a duel and will abuse her. But

mothers apparently know their obligations and risk even the wrath of their husbands for the sake of their children.

The Ngonde of Malawi take the belief in the need for many acts of coïtus one step further: if a woman should become pregnant after having had sexual intercourse only once with her husband, she would be accused of adultery — without further evidence. On the other hand, the Mam of Guatemala may accuse a woman of adultery if she has copulated with her husband regularly for two or three years and does not become pregnant: they believe that having sex with more than one man prevents conception.

A society that recognizes that men are necessary for procreation and that one act of intercourse is enough to cause pregnancy may hold to other inaccuracies. The Kubeo of Brazil insist that a pregnant woman stop having sex altogether, because continued intercourse will pile up the number of foetuses within her and she may explode. Somewhat less dramatic is the conviction in a number of societies that twins are a sign of adultery.

All of these examples tend to be amusing to us in part because they are culturally remote. It is more upsetting to know that Westerners have held equally wrong ideas. In contemporary urban England, in many parts of Jamaica, Puerto Rico and rural America, an earlier European belief that a woman must experience orgasm if coïtus is to lead to conception is still held. The fact is that women need not enjoy sex at all to get pregnant — as prim Victorian women who lay back, shut their eyes, spread their legs, and thought of England could readily attest.

A more serious matter is the belief held throughout most of western history (which has been discounted by educated people only within the last 200 years) that a woman is simply the greenhouse in which a man's seed grows to become a child. Of course, this myth was not restricted to the West: the Trukese of the Pacific and the Tupinambá of South America still believe it. Without scientific technology people will create such explanations not only to account for biology but probably also to justify some aspects of their society. For example, those societies that play down paternity tend to play up the woman's role in the culture and trace descent, inheritance and succession through women. The opposite is true when maternity is played down.

For the most part, ignorance about basic aspects of sex and the reproductive cycle can be blamed on the lack of microscopes and other such equipment. But ideology has also been a deterrent.

On the one hand, specific religious groups have tended to put down such study as immoral. On the other hand, there is even more persistent

folk morality based on philosophically crude notions of what is natural (I am not referring to natural law, which is, however, related). Every culture has developed such ideas with regard to sex. Reference is made to the "order of things" or "nature" when such ideas are challenged. Now the interesting thing is that cultures do not always agree on what is natural. For example, we in the western world frown on polygamy, whereas it is the ideal in most societies: not only is it thought natural for a man to have more than one wife, it is expected of him if he can possibly afford it.

Consider the views of the Kágaba Indians of Colombia on what is natural. Unlike many peoples in the world they do not believe that incest will produce deformed or insane children. But if a man's rhythm during sexual intercourse is thrown off, this may cause harm to his children — and to himself and his partner. Furthermore, if the woman should even move, she might cause the whole world to tremble and fall from the shoulders of the four giants believed to hold it up.

The Kágaba have other apparently unique beliefs. One is that people have copulated on every square centimeter of the earth and that semen has seeped through the ground everywhere. For more semen to penetrate the earth would in some way open up the gates of sickness and possibly destroy the world. Masturbation, therefore, is regarded as monstrous and even during sexual relations in marriage special magical stones must be placed beneath the sex organs to catch any seminal flow. Semen has a special importance in another way: if a forbidden sexual act has been performed, a semen sacrifice must be made to the spirit Heiséi, the master of sexuality and its aberrations. What this means is that the forbidden act has to be done all over again. To expiate incest, the guilty couple — whether brother-sister, father-daughter, or even mother-son — must repeat the offense so that the semen and vaginal secretions can be collected on a piece of cotton cloth and handed over to a priest to sacrifice. (There is said to be much incest among the Kágaba.) I know of no other society in the world in which expiation for a crime demands its repetition.

Certainly of all human behavior, sexual conduct on the face of it should be closest to the instinctual, with relatively little variation. The facts are different: even the way people copulate differs from one group to another. The missionary position (as it is informally referred to, with the partners lying down and facing each other, the man on top) is generally taken for granted in the western world as the most natural in the repertory. When the Bororo Indians of southern Brazil first heard about it, they were deeply offended. "What an insult against the one who is

underneath!" exclaimed one Bororo man; another said in astonishment, "But what weight!" The Trobriand Islanders are almost as uncompromising as traditional Westerners: they recognize two natural copulatory positions — neither of these is the missionary position, which they regard as impractical and improper. As one Trobriander reported of this position (to use the stilted translation given by the anthropologist): "The man overlies heavily the woman; he presses her heavily downwards, she cannot respond." The Zulu of South Africa judge it to be vulgar and unbecoming in a human being because they claim — quite inaccurately — that it follows "the manner of the animals."

The earliest representations of human sexual intercourse tend never to be the missionary position. The commonest may be with the woman on top and this is found in one of the oldest representations known (about 3200 BC) from Ur in Mesopotamia. The same position is found in ancient Greek, Roman, Peruvian, Indian, Chinese and Japanese art. Rear-entry intercourse is also frequently shown.

Sex and class
Within the same society there may be striking differences in sexual behavior and ideology. In the United States, Kinsey and his associates found that Americans in the 1930's and 1940's showed a very clear social class difference, and the differences even included instances of involuntary nocturnal emissions. Specifically, American men who had gone to college or who belonged to one of the professions started having nocturnal emissions earlier in life than blue-collar workers. Among the more educated males emissions continued longer and occurred 10 to 12 times more frequently. In general, less educated men tended to think of anything but the missionary position as perverse. They avoided and condemned as unnatural: masturbation, oral-genital sex, petting, deep kissing, mouth-breast contacts and the use of pornography as an erotic stimulus. When they had sex, they did so with a minimum of foreplay and nearly always wearing some clothing. On the other hand, promiscuous premarital intercourse with someone other than their future wife was regarded as normal and natural. The young man from a less educated background who had not had intercourse by the age of 16 or 17 could be characterized succinctly: he was either physically incapacitated, mentally deficient, homosexual, or earmarked for leaving his social class by going to college.

Better educated men showed a strikingly different pattern, stemming partly from the fact that they were willing to delay sexual intercourse (or experienced so many social pressures that they had to delay it) until

fairly late in life. They made do with masturbation, petting and pornography. When they did begin intercourse, it was generally performed in the nude, with a great deal of foreplay and experimentation with regard to position. Premarital sexual intercourse occurred most frequently with their fiancées. In general, men of this class tended to react to a greater variety of erotic stimuli.

Since Kinsey's 1948 study, these class differences seem to have changed considerably. What is particularly interesting, however, is that these distinctions seem to represent long-established patterns going back at least to colonial times and probably earlier. Aretino, an Italian living in the sixteenth century, describes how a lower-class woman taught her daughter to become a prostitute — this meant in part accepting the "perverted" behavior of her rich upper-class clients. In much the same way there is evidence that the exotic sexual techniques recorded in the Kaama suutra were known only to the social elite of India; these were mysteries that ordinary people did not know or even hear about, although devotees of the book regarded it as a religious revelation. Even the relatively simple and homogeneous society of the Marquesans in the Pacific shows subcultural differences with regard to sexual behavior. And everywhere, the sexual behavior of the upper classes and ordinary people seems to show marked differences.

What seems obvious is that sex is to a very large extent learned and not totally biological. Sexual tastes are similar to food likes and dislikes, which are also acquired and vary from culture to culture. These tastes need not even be spelled out in strong tabus or admonitions. It does no good for most Westerners to discover that insects are a perfectly adequate source of protein. They simply will not rush out to catch a grasshopper or start breeding cockroaches to supplement the family diet. For both sex and food, elaborate rationalizations are constructed, sometimes of considerable symbolic intricacy.

As an example of the variation of symbolic values attached to a sexual act — as well as a tie-in with food — consider the sucking of a woman's breast. In many societies breasts are not considered especially erotic and they are thought of primarily as the source of a baby's milk. Among the Návaho Indians an adult man may sometimes suck on a nursing woman's breasts to relieve her of the pain caused by excess milk when there is no baby around to empty them. Orthodox Jews, on the other hand, specifically prohibit an adult from drinking the milk from a woman's breast. The Marquesans and the Kgatla-Tswana of southern Africa recognize sucking and kissing of breasts as standard foreplay —

among the former to excite the woman; among the latter, apparently the man.

Various patterns joining eating and sexual behavior are found throughout the world and cannot be accidental. It is useful to keep this in mind because sexual rules, behavior and expectations are for the most part less easy to deal with objectively than food and eating. But there is no reason why we should not at least try to deal with sex objectively, and no reason why sexual customs cannot be examined as are other customs, to find out when and where they originated, how they spread, and why they are maintained.

In part, that is what I have tried to do. In a more general way, I have attempted to document the culture of sexuality. In doing so I have hugged the facts pretty closely and avoided large-scale theorizing. Not that I am against such theorizing: it is merely that a lower level, less grandiose approach has its own merits and an indisputable fascination.

Of all the sciences, only anthropology studies man cross-culturally as well as biologically. Every culture is taken as an experiment in survival and a realization of the human potential. This book assumes an anthropological perspective in exploring the richness and diversity of human sexuality in spite of its biological underpinnings. On the pages that follow I have tried to map that variety within its cultural contexts.

TWO THE WESTERN CULTURAL BACKGROUND

Almost all anthropologists are products of the sexually repressive Judaeo-Christian tradition, and this has colored their perception of the sexual customs of other cultures.

Sex and anthropology seem to go together in most in people's minds. Bizarre erotic customs investigated by licentious Ph.D.'s in pith helmets, reveling in the honored field methods of observation as well as participation — this is a popular myth about the anthropological profession. It is not accurate.

Anthropologists may develop a certain objectivity about their own customs and it seems to be the case that they are sometimes even misfits in their own culture (maybe that inability to fit in is what pushes them into the study of other cultures). But the great majority are probably as embarrassed and guilty about sex as anyone else brought up in the Judaeo-Christian tradition. Initially, therefore, it is necessary for us to investigate that tradition in some detail in order to get a more dispassionate view of sex. Otherwise, we may be reduced to uttering moralistic judgments that will tell more about ourselves than the cultures we are studying.

I remember well my first field trip to Africa and my encounter with a Christian missionary who had lived for 20 years with a group I wanted to study. Within the first five minutes of our conversation, he blurted out with astonishment and horror: "These people marry more than one wife!" Twenty years had not lessened his moral outrage.

The Judaeo-Christian tradition encompasses quite a varied collection of beliefs about sexuality. For the most part, only conservative, orthodox views will be examined here, rather than those associated with the folk reality or with various liberalizing tendencies (these are examined in Chapter 11). For a generation that has experienced the "sexual revolution," the pill, Women's Lib and Gay Lib, some of the beliefs summarized here may sound quaint. However, these doctrines still hold enormous influence over a very large segment of the western world.

In the Judaeo-Christian tradition the ultimate justification for sexual intercourse is procreation. The only appropriate setting for sex is

marriage, which is held to be divinely sanctioned. More specifically, the fundamental notion of Judaeo-Christian sexual morality is that a man should ejaculate only within his wife's vagina. All other forms of sexual expression causing a man to ejaculate are tabu.

Many groups forbid the insertion of a penis into any bodily opening except the vagina, whether or not ejaculation occurs, but others permit such behavior if ejaculation does not occur. Thus, some Roman Catholic and Jewish moralists hold that a woman may legitimately perform fellation on her husband as foreplay, but that it becomes a mortal sin if he has an orgasm in the process.

The sexual response of men is the obvious focus for the moral code. What women do in the absence of men has not usually been considered of much consequence. For example, in the Old Testament there is no discussion of lesbian activity at all (although most groups in the tradition disapprove of it and St Paul in the New Testament, Romans 1:26-32, apparently condemns such behavior). But female sexual contact with animals is condemned — perhaps because it is presumably with a male animal. Female masturbation is virtually never considered, and at one point in the Middle Ages was tolerated if, during intercourse, the woman did not achieve an orgasm, which was believed to be necessary for procreation.

In contemporary western Judaeo-Christian practise, marriage is almost always monogamous except for a very few aberrant groups such as dissident Mormons (about 20,000 to 30,000 Mormons in the western United States are involved in polygamous marriages at the present day). Virtually all groups permit divorce (and remarriage) for one or another reason — almost always for a wife's adultery. The Roman Catholic Church insists on the indissolubility of marriage, but permits remarriage on the death of a spouse.

Premarital virginity is highly prized and generally expected of women and desirable for men, although a double standard permitting male experimentation has generally been tolerated and even fostered by western society if not by the religions themselves. Lifelong virginity is advocated as a possible sexual career — and conceded to be spiritually higher than married life — primarily among the Eastern Orthodox and Roman Catholics, but even among them marriage is the overwhelmingly common life-style. In a very few sects such as the Shakers, an American offshoot of radical Quakers, total sexual abstinence is required. New members are recruited from non-Shaker families through conversion. Theirs is an exceedingly uncommon life-style, both in the Judaeo-

Christian tradition and cross-culturally. Fewer than ten Shakers existed in 1990. Formerly, the Rappites (a German Protestant group) and the Filiponi (a faction of the Russian Orthodox Old Believers) also insisted on universal celibacy. However, the Rappites disbanded in 1906 and the Filiponi dropped this rule early in the 19th century.

Different social roles for men and women are believed to be divinely sanctioned and to reflect the biological order of things. A unisex society is regarded as undesirable. In particular, transvestism is condemned as a blurring of categories. Interestingly enough, however, although there are no overt male transvestite saints in the Christian tradition, a few transvestite women, such as Joan of Arc, have been elevated to sainthood.

Until quite recently, nearly all groups within the tradition have considered contraception to be the equivalent of murder. Abortion and infanticide are also condemned. The reality, however, has not always been in keeping with the ideal.

One of the fundamental themes found in western thought, to make sense of the sexual moral code, is the notion of "nature" — a basic assumption in Roman Catholic teaching and also greatly influential throughout the rest of Christendom and even Judaïsm. According to this doctrine (originally derived from pagan Greek philosophy, especially Aristotelian notions) all actions have an essential purpose — or nature, in the technical jargon. The essential purpose of eating, for example, is to sustain life. The essential purpose of sexual activity is taken to be procreation. To perform an act so that its essential purpose — its nature — cannot be met, is to perform an unnatural act. The notion of "nature" in this use is not really the same as the romantic notion of nature involving animals and plants (or, more familiarly, the birds and the bees) — though it is not completely alien to it. But even if animals performed sexual acts without reproductive relevance, this would not alter the situation since the moral laws exist only for human beings.

Consider masturbation. Clearly it cannot meet the criterion of legitimacy for sexual acts and so is both a mortal sin and an unnatural act. It follows that all other acts that qualify as the equivalent of masturbation — fellation, anal intercourse, vaginal intercourse using some sort of contraceptive — are sinful and unnatural. Masturbation, homosexual acts and birth control are, therefore, basically equated. To change positions on one of these would have far-reaching implications for the system as a whole.

Modifications through time
Changes have, however, occurred in the sexual morality of the Judaeo-Christian tradition. One of the most fundamental occurred relatively recently. In the 1930 Lambeth Conference of the Anglican Communion, previous condemnation of birth control was modified. The 1958 Conference proclaimed the Christian obligation of limiting births and sanctioned the use of artificial contraception. This ruling applied to the Church of England, the Episcopal Church in the United States, and various related groups. Apart from a few Talmudic dispensations permitting women (but never men) to practise contraception, this was the first time in a more than 3,000-year tradition that sex was deemed to be moral even if procreation had deliberately been made impossible to achieve.

The consequences of making artificial contraception respectable in such an influential group have undoubtedly been tremendous. It may even have helped to bring about the acceptance of birth control in something like 70 percent of Roman Catholic households in the United States, in spite of papal denunciations. What implications the change will have on other aspects of the sexual code is not altogether clear, although some within the Anglican Communion have already taken a conciliatory attitude toward the activities of practising homosexuals.

An examination of the history of Judaeo-Christian traditions shows a number of other important changes.

The Christian breakaway from the Jewish community in the first century also signaled a shift from the notion of ritual contamination to personal sin. A practical consequence of this has been the abandonment by all Christians of the ritual bath house *(mikvah)* where menstruating women and women who have given birth must bathe to remove their "polluting status."

Among Christians (except for the Eastern Orthodox), menstruating women have no special status, nor is it usually considered sinful for a man to have sexual intercourse with his wife during her period, but under Orthodox Jewish law sexual intercourse with a menstruating woman is strictly tabued.

The view about nocturnal emissions is comparable. The Orthodox Jewish position is that any depositing of semen outside of a vagina is unclean: semen, like menstrual blood, is polluting.

Because Christians have given up the notion of ritual pollution, nocturnal emissions are not generally considered to have any moral significance whatever. But this position was not entirely clear until

Thomas Aquinas argued that sin involves a conscious wilful act. Thus, nocturnal emissions cannot in themselves be considered sinful but masturbation must be and is regarded as a mortal sin. (The Orthodox Jewish position on masturbation comes from the view that it is a conscious waste of nature, in effect the murder of potential progeny. Consequently, some Jewish commentators have wanted it to be punishable by death.)

An even more dramatic change with the independence of Christianity from Judaïsm was the adoption of monogamy. What seems to have happened is this: throughout the Graeco-Roman world (with a few exceptions such as the Jews) monogamy was the prevailing form of marriage at the beginning of the Christian era. Christianity did not introduce monogamy to the pagans; rather, it embraced a pagan social institution and abandoned Judaïc custom.

The adoption of monogamy by Christians in turn affected the Jews living in Christian Europe. They accepted monogamy as obligatory following a ban on polygamy in AD 1030 by the eminent rabbi Gershom ben Judah. But this ban merely reflected social reality: Jews in Europe no longer practised polygamy by that time but followed the Christian pattern. Jews living in the Muslim world, where polygamy was accepted, have preserved their own old custom, although they follow the Muslim (and talmudic, but not biblical) ban on having more than four wives at a time.

The changes discussed so far are obvious ones. Examination of both ritual and scripture suggest a number of other significant and somewhat unexpected changes. They are not accepted by all scholars and the orthodox will reject them outright.

Consider for example a detail in the Orthodox Jewish ritual of circumcision: the *metsitsah*. This is the custom of sucking the wound of the newly circumcised penis by the mohel (circumciser). In the Mishna recorded in the Babylonian Talmud, for example, the *metsitsah* is assumed to be an essential part of the circumcision procedure, to be performed even on the Sabbath: "We perform all the requirements of circumcision on the Sabbath. We circumcise, uncover [the corona], suck [the wound], and place a compress...on it" (Seder moʻed, Sabbath 133b). The accompanying commentary or Gemara adds: "If a surgeon does not suck [the circumcision wound], it is dangerous and he is dismissed." Kinsey and a number of other scholars believed that the *metsitsah* is a survival of an ancient phallic cult that required ritual fellation. Although this explanation may seem farfetched, some scholars see it

bolstered by the fact that sacred prostitutes (that is, prostitutes used in religious rites) were known to the ancient Hebrews from their association with the Canaanites. Several biblical condemnations of male sacred prostitutes (for example, Deuteronomy 23:17-18, where they are referred to as "dogs"; and II Kings 23:7, where they are linked to the temple in Jerusalem) prove that they existed among the Hebrews from probably before the tenth century to the Babylonian Exile in 586 BC, if not later. Although officially condemned, they seem to have been accepted in practise. Sacred prostitution has now entirely disappeared from the Judaeo-Christian repertoire. But that it once existed has been used (probably erroneously, however) to link up the *metsitsah* to a phallic cult. Very likely, however, the *metsitsah* developed quite late, possibly even as late as the Middle Ages.

Differences and developments

Today there are different rules about incest in the various groups within the Judaeo-Christian tradition. An examination of the Bible shows that the rules changed even during the formation of the Scriptures.

As an example of the differences, Orthodox Jews permit marriage between uncle and niece but forbid it between aunt and nephew. They also permit marriage between full stepbrothers and sisters as well as between first cousins. Most of these marriages are totally forbidden by Christians. First-cousin marriage is tabu for Eastern Orthodox Christians but is occasionally allowed in most other groups. Furthermore, traditional Jewish law has permitted marriage between a man and his deceased wife's sister and even encouraged it with his deceased brother's widow.

Christians, however, were eventually associated with a larger international community in which marriage ties with relatives or in-laws were not profitable and there was everything to be gained from alliances farther afield; so the list of forbidden marriages increased. The rules have fluctuated considerably, so that at the present time it is possible for Roman Catholics to marry their first cousins (but only with a dispensation).

The Judaeo-Christian tradition also underwent changes in emphasis or philosophy. For example, Jews have traditionally tended to regard marriage as a moral necessity. But at the beginning of the Christian era there were a number of ascetic Jewish sects such as the Essenes who were in part associated with monasticism or played up celibacy. For Christians, the example of Jesus' own life elevated the unmarried state.

This notion was encouraged by St Paul, who thought that marriage was good but celibacy was better: for those who could not exercise self-control, it was "better to marry than to burn" with passion (I Corinthians 7:8-9). According to St Augustine a few centuries later, sex even within marriage was suspect and he doubted that in Paradise before the Fall Adam would even have had erections, since lust — concupiscence — had not yet entered the world. His doctrine is not the official view of the Church, which holds that sexual passion in itself is morally neutral.

The emphasis on celibacy in the Church was attacked by Luther and various other reformers, who tended to elevate the status of marriage; at the same time they denied that it was a sacrament and permitted divorce.

Three developments since the Reformation have been particularly repressive with regard to sex. The first of these was by the rise of the Puritans in England in the seventeenth century. Although not opposed to sex within marriage, the Puritans were intolerant of adultery and fornication in a practical sense that was virtually unparalleled in the history of Christianity. It was they who developed (particularly in the American offshoot) an extraordinary paranoia about satanic sexual orgies, which led to a methodical and widespread persecution of people accused of witchcraft.

A second development, also in the seventeenth century, was the revival of Augustinian doctrines in the Roman Catholic Church under the label of Jansenism. This movement stressed the damage caused to human nature by original sin and the evils of lust. Although Jansenism was declared a heresy, much of its moral preoccupation with the dangers of sex lingered in Holland even after it had been officially disapproved, and it has particularly survived in Ireland, where fear and repression of sexuality is said to be astonishingly high, unparalleled elsewhere in the Roman Catholic world or perhaps anywhere.

The third development is more recent and only partially religious in nature: Victorianism. The extreme prudery of the movement was accompanied by a belief in the dangers of the loss of semen — not in the Orthodox Jewish sense of pollution, but in the pseudoscientific belief that all ejaculation was debilitating and that sexual intercourse even within marriage was to be avoided as much as possible for the higher good of society. In other words, it espoused with a vengeance a doctrine of sublimation. This doctrine was to have profound results. In spite of its concomitant cult of the sexless woman, England developed an enormous cadre of prostitutes (some estimates go as high as 40,000 in

London during the heyday of Victorianism). This discrepancy between the ideal and the real created the cultural climate of the beginnings of scientific sexology and the in-depth probings of Freud.

In some of Freud's writings Judaeo-Christian notions survive. The traditional idea of reproductive relevance was adopted by him (at least occasionally) as a measure by which to judge the normalcy of sexual acts. It is a common criticism of psychiatry and psychology that Judaeo-Christian conceptions of sin have been translated wholesale to "pseudoscientific" notions of mental illness.

But in spite of the awesomeness of the Judaeo-Christian tradition, it is clearly not an unchanging monolithic structure. It has made numerous responses to a number of outside forces, and is continuing to do so.

Western legal notions on sexuality

Throughout the history of the West, sexual infractions have not only been sins but very often crimes as well. The punishments for these crimes have been fines, imprisonment, torture or death. Regulations concerning marriage, divorce and incest (but not always other areas of sexual behavior) have been incorporated into all the western legal systems from Roman law — the earliest legal code considered here — through to English common law, the Napoleonic code, the Soviet socialist penal code, and the Model penal code proposed by the American Law Institute.

In Roman law, a small number of sexual offenses were, at least theoretically, punishable by death. The regulations varied over the years, but at one time or another the following were treated as capital crimes:

Adultery committed by the wife. A husband's adultery did not count as a crime at all. At times banishment or some lesser punishment was substituted.

Incest. Originally the death sentence was carried out by throwing the culprits from the Tarpeian rock near Rome. Later, banishment was the appropriate punishment.

Intercourse between a free woman and a male slave. Under the emperor Constantine, both were to be killed (the slave by burning). A free man had legal sexual access to his own slaves.

Traditional historians tend to assert that the Romans dealt with homosexual acts as a form of fornication, which in some instances was punishable by seizure of half of each guilty party's property. (Under

some emperors the penalties could be considerably more severe. But the Roman legal attitude to homosexuality is not clear.) The historian John Boswell maintains that no laws against homosexual acts existed among the Romans at all and that even homosexual marriage was permitted. Not all scholars are convinced that he is right, however.

During the reign of Valentinian I, the fourth-century Christian emperor, men found guilty of sodomy are said to have been burned alive. By the time of the emperor Justinian (sixth century), the death sentence for homosexual acts was certainly on the books — although Justinian had offenders castrated rather than killed — and was officially retained throughout Byzantine history. In the Middle Ages in western Europe, the charge of sodomy seems to have been heaped on heretics and others who were going to be killed anyway, so the reality of the law here is not clear.

In Constantine's time (fourth century) rape was a serious offense: even the victims were liable to be punished for not preventing the rape by screaming for help. Thus a virgin who was raped might well be burned to death.

Virtually all these extreme punishments were paralleled in the Mosaïc code. Both the Mosaïc code and the Roman law permitted divorce. According to Plutarch, the earliest laws of the Romans (traditionally ascribed to Romulus) permitted only the husband to initiate a divorce and the sole grounds were that his wife had committed adultery, poisoned his children, or counterfeited his keys, presumably to get at the wine cellar. Drinking was thought to lead almost inevitably to adultery and in early Rome a wife accused of either drinking or adultery could be killed.

The divorce laws changed and other reasons for divorce were permitted. During the Empire, women were allowed to initiate divorce but apparently never on the grounds of a husband's adultery.

Fornication was an offense only if it involved upper-class women. A man might frequent prostitutes without being guilty of fornication, but no upper-class women were allowed sexual relationships outside marriage. The emperor Augustus exiled both his daughter and granddaughter for criminal fornication and forbade their burial in his tomb. Some upper-class women dared oppose this double standard by officially registering as prostitutes, who were not subject to such laws. The emperor Tiberius, who succeeded Augustus, closed this loophole by making it illegal for a woman to register as a prostitute if her father, grandfather or husband was a Roman knight or senator.

Roman law also punished celibacy and childlessness by giving substantial privileges to people with many children; the unmarried and childless thereby suffered economic and social disadvantages.

The establishment of Christianity as the official religion of the Empire tended, at least in the West, to make sexual offenses and marital disputes a matter for ecclesiastical rather than civil courts. There were, of course, exceptions and local variants. In Spain under the Visigoths, for example, homosexual acts were punished with castration and death following secular court decisions, whereas in the British Isles penance was prescribed. According to one Welsh penitential, sodomy requires a four-year penance as opposed to a three-year pilgrimage for incest with one's mother. The sixth-century Irish penitential attributed to St Columban insists on a 10-year penance for sodomy committed by a clergyman or monk, but only a seven-year penance for a layman. In both instances, the only food the penitent is allowed to eat is bread and water, salt and dry vegetables.

In another penitential, the sixth-century *Book of David*, nocturnal emissions are regarded as sins; as a penance the sinner is required to sing seven psalms on rising and live on on bread and water for a day. The book also stipulates that sexual contact with animals or fornication with a nun requires as much as a lifetime of penance.

The Reformation saw the secularization of many of the traditional religious sexual prohibitions. In England, ecclesiastical law on sex was converted in large part to common civil law. During the reign of Henry VIII, the notion of sin against nature was transformed into that of crime against nature so that in 1533 sodomy ("buggery") was made a crime for the first time, although this law was repealed by the first parliament of Edward VI, his successor. In 1548 sodomy was again made a crime, but this law was abolished once more in 1553 under Queen Mary. In 1563 the law was re-established under Queen Elizabeth and remained (with some modification) until its repeal in 1967. The punishment varied but from time to time included death or life imprisonment.

The domination of the English parliament by the Puritans led, in 1650, to the Act of May 1, according to which adultery and sodomy were punishable by death, and fornication by three months' imprisonment and the posting of a bond to guarantee good behavior. The Restoration of Charles II in 1660 saw the repeal of all sex laws except those dealing with the practise of sodomy.

The French Revolution provided the first major break with western tradition. The early revolutionaries removed the death penalty for sex

crimes soon after taking control of the country and in 1792 made divorce legal and dependent on mutual consent of the parties. (The latter rule was eventually changed and divorce was abolished altogether in 1816 after the restoration of the monarchy.) In 1810, an important revision of the laws appeared: the Napoleonic code. The most significant feature of this, from the point of view of sex crimes, was that sexual behavior in private between consenting adults was decriminalized and sexual contacts with animals were no longer considered crimes. Certain acts continued to be punishable but only if they involved an outage of public decency, violence, or happened to be committed with a minor or an incompetent.

Many western countries (with the notable exception of England and other common-law countries such as the United States) followed suit, at least in the abolition of the death penalty, which was generally on the books for animal contacts and homosexual acts but was seldom actually meted out. The dropping of these harsh penalties had the effect in some areas of creating a greater willingness to prosecute such crimes. But there has been a movement toward the decriminalization of consensual sexual acts between adults in private since the enactment of the Napoleonic code.

In 1917, the Soviet Union started what has been called a sexual revolution. Incest, bigamy (and polygamy), adultery, homosexual acts and animal contacts were expunged from the penal code. Abortion was legalized in 1920, and so was divorce by consent. Only civil marriages were recognized and the distinctions between concubinage and marriage, as well as legitimacy and illegitimacy, were legally dropped. Social changes within the Soviet Union, however, resulted in the re-emergence of what had previously been attacked as bourgeois mentality. In 1934, new laws against homosexual behavior were passed. In 1935-36, abortion was made illegal and divorce laws were made more severe: substantial fees were introduced and each divorce was registered on internal passports. By 1944, the only recognized ground for divorce was political disloyalty of the spouse. Some of these changes are directly attributable to the losses accompanying collectivization (a minimum 10 million) and the enormous number of casualties in World War II (30 to 40 million). Nevertheless, legal abortions and birth control were re-established in 1955-56.

The only form of marriage allowed in the Soviet Union was monogamy and incest was considered to be a crime.

Although the general trend in the West has been to decriminalize adult consensual private acts, in some areas the laws against at least some of them are still severe. The most consistent opponents of liberalization in the twentieth century include some of the modern Communist governments. Earlier in the century the Fascists and Nazis also both took an anti-liberalizing position. The dramatic changes in the politics of eastern Europe at the end of the 1980's, involving the virtual collapse of Communist régimes, do not necessarily point to greater liberalization. Time will tell.

The goals of the sex law reform are still championed by a number of small groups. In large part, liberalized views put forward in the recommendations offered by the Bellagio conference of 1963 have been adopted in the Model penal code for the American Law Institute and essentially accepted by the Association Internationale de Droit Pénal during the Ninth International Congress on Criminal Law held at The Hague in 1964.

Western folk notions on sexuality
Folk wisdom in the western world has often been practically as misleading as religion and the law have been repressive. Superstitions recorded by Pliny in ancient times are still believed by some people. The astonishing thing is that superstitions and misinformation are not restricted to the uneducated. Studies of medical students' knowledge about sex, for example, show that they seem to be no better informed than their nonmedical contemporaries. A report by Greenbank revealed that half of the 1959 graduates of a Philadelphia medical school believed that mental illness is frequently caused by masturbation. A more extraordinary finding is the fact that one out of every five faculty members of that school believed the same thing. One hopes that the situation has changed in the decades since this study.

Members of the medical profession have even manufactured their own kinds of sexual myths. A notable example is Dr David Reuben in his enormously popular book *Everything you always wanted to know about sex (but were afraid to ask)*. It is a sort of hip catechism of sex — but without the benefits of revelation, or sometimes even the most basic information.

The most striking error in the book may unfortunately be the one best remembered. He puts in a plug for Coca-Cola as a contraceptive: all you have to do is shake up a bottle and fizz the liquid into the vagina after intercourse and you are safe. He forgets to add that such a

procedure is believed by some in the medical profession to lead to salpingitis, peritonitis, or even gas embolism, causing death. All things do not go better with Coke!

A thoroughgoing study of sex myths and superstitions has not yet appeared. Some involve quite fundamental errors. A case in point is the whole notion of biological relationships as blood relationships. This is scientifically false: what is involved is genes, not blood. Nevertheless, it is a dominant theme in the western folk idea of conception.

A number of less farfetched myths or folk tales have appeared in the West and survive in various places. A few are given below, arranged according to topic.

Menstruation is associated with an enormous number of superstitions. The general belief of the Graeco-Roman world (as described by Pliny) included some of the following notions: contact with a menstruating woman will turn new wine sour, blunt the blade of an iron knife, rust bronze and iron, cause ivory to lose its luster and trees and plants to become unfruitful. Should a menstruating woman look in a mirror its brilliance will be blurred. If such a woman sits under a tree its fruit will fall off. A dog that laps up menstrual blood goes mad and its bite becomes incurably poisonous.

All of these notions are false with the possible exception of some adverse consequences on plants. There is some evidence, though this is controversial, that menstrual blood contains a toxin that has an injurious or at least an inhibiting effect on flowers, sprouting seeds and plants in general.

Many of these ideas or similar ones have survived in various parts of Europe and the New World. Thus, Eastern European Jews believe that the touch of a menstruating woman can stop the process of pickling (a folk idea with no biblical support at all). According to a belief reported from North Carolina, if a woman bakes a cake while menstruating, it will not turn out well. In some parts of the English-speaking world, girls are advised not to wash their hair while menstruating or to pick fruit (which would go bad).

Menstrual blood has not always been avoided. In the Middle Ages in Europe it was sometimes used as a medicine for sufferers of leprosy, and it has occasionally been assumed to be a powerful aphrodisiac. Louis XIV of France apparently believed in its aphrodisiac powers; he reportedly was introduced to this idea by his mistress the Marquise de Montespan.

Avoiding intercourse during menstruation may be due to a superstition about the dire consequences of such an act. Although some risk of infection is admitted by a few scientists, there are no clear dire consequences at all. From the point of view of birth control, intercourse during menstruation is safest because it is unlikely to lead to conception.

Genitals and other body parts
The size of a penis or vagina is frequently believed to be correlated with other anatomical characteristics. For example, a frequent correlation is made between the size of a man's penis and that of his nose, feet or hands. It is also generally believed that tall men have larger penes. No scientific information exists confirming these correlations. A similar unverified statement, but one less frequently made, is that a woman with a large mouth has a large vagina.

Other related notions involving anatomy include the following. A woman whose vagina is dry during intercourse has been unfaithful. The genitals of Oriental women lie farther back than those of European women and therefore Oriental positions for copulating are different from the European ones. A very widespread notion found in cultures throughout the world is that the bigger the man's penis, the more effectively he will sexually satisfy a woman. The researches of Masters and Johnson suggest that this simply is not the case. Sexual adequacy seems to be unrelated to the size of a man's penis since a vagina can generally adjust to the size of any penis inserted. Their researches further indicate that the size of the vagina is also of no special consequence in arousing men.

Sexual activity, particularly when it is believed to be excessive, has been said to cause a number of disorders, including elephantiasis, blindness, swollen gums, bad breath, weak legs, whitening of the hair and baldness (particularly if one picks an old partner). All coïtal positions except the missionary or other standard positions are thought to be harmful. This is quite a common notion. Rabbinical commentators, for example, have held that coïtus performed while standing leads to convulsions and prevents impregnation; while sitting, to delirium; on the bare floor, to sickly children; and in other unacceptable positions, to diarrhoea.

The commonly held view that athletes should abstain from sex before competitions seems to be more a continuation of ancient tabus than the result of medical insight. The work of Masters and Johnson —

as well as occasional admissions from champion athletes themselves —
suggests that orgasm has little if any effect on athletic performance.

On the other hand, sexual intercourse is sometimes credited with
various beneficial effects, and has been seen as good therapy for certain
types of epileptics, depressives and various other mental patients. It is
said to restore skin texture. One unfortunate but widely held view is that
intercourse with a virgin is a cure for syphilis.

The most extraordinarily elaborate notions about the harmful effects
of masturbation have been perpetuated, in part, as a pseudoscientific
legacy from the eighteenth century. The practise of male masturbation
was associated with all of the following: insanity, infantile paralysis,
rheumatism, epileptic fits, bedwetting, round shoulders, blindness,
melancholy, impotence, hair growing on the palms of the hands, idiocy,
hypochondriasis, tuberculosis, various skin diseases, asthma and suicide.
Female masturbation was said to cause rickets, hysteria,
hermaphroditism, painful menstruation, jaundice, stomach cramps,
falling of the womb, painful childbirth and sterility (among other
calamities).

Masturbation is now known to cause none of these maladies and to be
totally harmless from a psychological and physiological point of view.

THREE HISTORY OF THE STUDY OF SEX

**Sexual repression and prudery have both hampered
and stimulated the development of sexology.
The scientific study of sex may have begun
as a reaction to Victorian hypocrisy.**

The history of the study of sex is characterized by two major ironies: first, scientific sexology began in the Victorian era, when the mere mention of sex was strictly tabu; second, professional anthropologists for the most part have been too embarrassed to add much to such a study.

Prior to the Victorian era there were very few sexologists. Paul Gebhard has described the centuries following Aristotle's groundbreaking work as a period of "unrelieved ignorance and silence."

Perhaps the peculiar prudishness and sexual repression associated with the Victorian period helped escalate serious thinking on the subject: the discrepancy between the ideal and the real was too great to go unnoticed. But there was also the emergence of empirical science, the growth of medicine and psychology, a weakening of belief in traditional religions and moral codes in general.

Sexologists of this period were persecuted in a number of ways. Their professional status was nearly always in jeopardy and personal attacks centering on speculations about their own sexual problems were common. Books and articles of even the highest scientific respectability were often banned if published, and actually getting published was a serious problem. Havelock Ellis's work is an example. Edward M Brecher has characterized Ellis's erudition as breathtaking, but Ellis's books were banned in his native England and had to be published in Germany. On the other hand, Richard von Krafft-Ebing was accepted in spite of the highly detailed accounts of sexual behavior and fantasy he presented. But then, as Brecher has said, Krafft-Ebing was more respectable simply because he characterized sex as "a loathsome disease"; he deplored pathology and perversion (and wrote the juicier portions of his books in Latin).

I shall discuss aspects of the second irony in more detail later. The only thing I want to stress at this point is that both before and after the

Victorian period, very few people have studied sex at all and many see fit
to condemn any such study, whatever shape it might take.

Ancient and mediaeval approaches

The ancient Greeks are a case in point. They speculated about certain
aspects of sexuality and used religious myths to explain the origins of
certain sexual practises. For example, there were at least four myths
accounting for the origin of pederasty, which they considered an
essentially Greek institution. According to one, pederasty began with the
abduction of Ganymede by Zeus, who carried him off to Mt Olympus to
be cupbearer for the gods. According to another myth, Orpheus turned
to the love of boys because of his grief over the loss of his wife,
Eurydice. Another explains pederasty as the invention of Thamyris, the
son of Philammon and the nymph Argiope, who was captivated by the
beautiful youth Hyacinthus. A fourth myth identifies the founder of
pederasty as Laius (father of Oedipus) who seduced the youth
Chrysippus.

But there are no down-to-earth accounts of Greek sexual behavior or
studies of sexual practises comparing Greek with Persian behavior, or
even one Greek group with another. Herodotus, the fifth-century Greek
historian often called the father of history (and geography and
anthropology), is a partial exception. Furthermore, he suggested a theory
of sexual behavior that is perhaps the first anthropological theory of any
kind recorded in human history. He set up the hypothesis that peoples
living in warmer climates tend to be sexually more active and less
restrained than peoples living in colder areas. In 1980, G P Murdock
tested this hypothesis with a sample of 126 societies and found,
amusingly enough, that it was confirmed — this after 2,400 years!
(Actually, what Murdock confirms is that the rules for behavior differ
according to climatic zones, rather than actual behavior, which is not the
same thing.)

Until the Renaissance most travelers' accounts included fictitious
stories of monsters with ears so big they could be used as umbrellas, or
people with misplaced eyes or genitals. Traditions of this kind existed
even in Columbus's day, so that his writings may sometimes be
unreliable.

A general exception to this is Marco Polo's account of his travels in
the early fourteenth century where he occasionally writes about sexual
customs. For example, he talks of virgin deflowering in Tibet; sex
hospitality among the Kaindu (perhaps the Ningyuen in modern Sichuan)

and the Kamul or Hami (who lived north of the Gobi desert); and various sexual superstitions, such as the belief found in some parts of Cathay (modern northern China) that a stain made by the blood of a virgin cannot be removed from cloth by any amount of washing.

This is the western tradition, if one may call it that, of ethnographic sexology. In India, a much more sophisticated and informative tradition developed, which culminated in the *Kaama suutra (The precepts of pleasure)* by Vaatsyaayana. This dates from about AD 200-400, but probably represents a continuation of much earlier traditions.

A number of other similar manuals were derived from or inspired by the *Kaama suutra* and continued its format. These include the *Koka shastra* by Koda Pandita, which possibly dates from the twelfth century, and the *Anangga rangga (Theater of the love god)* by Kalyaanamalla from the fifteenth century. The important thing is that these books were respectable in Indian society and the Kaama suutra in particular was considered a revelation of the gods.

This tradition moved from India to the Islamic world, where it produced a number of treatises, the most famous of which is known in English as *The perfumed garden*, written by an Arab, Nafzaawii, possibly in the sixteenth century. One of the interesting ethnographic aspects of this work is the recognition of 25 coïtal positions as peculiarly Indian (11 others described are within the Arab tradition).

There was really nothing approaching such sophistication in the West until the translation and publication of the *Kaama suutra* and *The perfumed garden* in the 1880's. The closest thing to a sex manual of coïtal positions about which we have reasonably accurate information is a series of drawings by Giulio Romano from the 1524. They depicted 16 different sexual positions. Romano was a famous artist in his day, the principal assistant of Raphael, commissioned by the Vatican, and even referred to by Shakespeare (in *The winter's tale*, act V, scene 2). In 1524, Marcantonio Raimondi engraved the entire series (referred to as *I mòdi*) and tried to distribute them in Rome. The next year they were used as illustrations for a collection of sonnets by Aretino. Pope Clement VII found out and was outraged that an artist who had been employed by the Church should have been involved in such a scandal. The engraver was actually arrested, Raimondi threatened with arrest and the pictures confiscated. In 1559, the *Index of prohibited books* was established, and whatever sexology or pornography existed was driven underground.

Even sex in plants was a suspect topic. Some 100 years later, in 1676, Sir Thomas Millington first proposed that plants had sex. When Carl Linnaeus published an essay on it in 1759, there was a scandal and some clergymen wanted his books to be banned.

An astonishing source of information about the sexual repertoire of the Middle Ages comes, however, not from sex manuals but from the penitentials, the handbooks that stipulated how much penance should be meted out for particular sins. In a sense, they represented the *Kaama suutra* in reverse, or *The perfumed garden* for sexual negativists.

The ancient Greeks were more interested in theories about the mechanism of reproduction and the origin of sex as a phenomenon than in sexological ethnography. Some of their ideas on these matters were current until recently. The most influential thinker was undoubtedly Aristotle (384 BC - 322 BC), whose views were adapted hundreds of years later by Avicenna and St Thomas Aquinas (c 1224-1274). Aristotle has been considered the father of western sexology. Unfortunately, in spite of his concern with fundamental problems, he proposed some erroneous answers that have become entrenched in western thought. For example, in *Generation of animals* he proposes that the contribution of a woman to the development of an embryo is merely the substance needed for its growth, and he identifies it with menstrual blood. This was, however, only one view held by the Greeks. A theory referred to as the doctrine of the two seeds was held by Hippokrates as well as a later (second-century) writer, Galen. This doctrine proposes that a woman contributes to the formation of the embryo through her vaginal secretions, thought to be the female equivalent of semen. Aristotle's view seems to have prevailed because it coincided with biblical views and supported the outlook of a patriarchal society.

The Bible does not specifically state that a man is the main contributor to the foetus and that a woman serves merely as a sort of greenhouse for the man's seed to grow in (this is a variant of what has been called the spermatist view). But this position is implied in biblical imagery: only men speak of their children and descendants as seeds of their loins, women never do.

In the Koran, a spermatist doctrine is explicitly stated, in about a dozen passages. Here is one, from Suura 23, Al-Mu'minuun, where the process of foetal development is described (lines 13-15): "Verily, We created man from an extract of clay; then We placed him as a drop of sperm in a safe depository; then We fashioned the sperm into a clot; then We fashioned the clot into a shapeless lump; then We fashioned

bones out of this shapeless lump; then We clothed the bones with flesh...."

Mediaeval Western thinkers often assumed that a tiny but essentially complete human being or homunculus (plural, homunculi) constituted the male seed. In fact, some theologians speculated that when the first man, Adam, was created, so too were all future generations of human beings because the homunculi in Adam's semen themselves contained homunculi in their own semen, and so on. This means that every man is like a walking matryóshka doll: open one up and you find a smaller copy, which can also be opened to reveal a still smaller version, and so on. God, in this view of creation, emerges as the divine miniaturist. This belief in homunculi within homunculi now regarded as an intellectual curiosity is referred to as emboîtement or encasement.

A number of contributions to the knowledge of sexual physiology were made over the centuries, and even Leonardo da Vinci was concerned with such questions, as his anatomical drawings show. Important names in the study of sexual anatomy include Andreas Vesalius (1514-1564), a sixteenth-century Belgian, and a contemporary of his, Gabriel Fallopius (1523-1562), who is famous for his description of the fallopian tubes and the clitoris.

In spite of this increase in knowledge, radical changes in thinking about sexuality only became possible with the invention of the microscope in the seventeenth century. With its aid, Antonie van Leeuwenhoek (1632-1723) discovered spermatozoa in semen in 1677. However, he misinterpreted them as homunculi. The mammalian egg was discovered in 1827, and the human egg in 1829 by Karl Ernst von Baer (1792-1876). In 1875, Oskar Hertwig (1849-1922) became the first scientist to observe the moment of fertilization, in sea urchins.

The laws of genetics were discovered in the 1860's by an Austrian monk, Abbé Gregor Mendel (1822-1884). Curiously, his findings remained unknown to, or ignored by, the scientific community until after 1900, when they were independently rediscovered by three other researchers: de Vries from the Netherlands, Correns from Germany, and Tschermak from Austria. Even more recent investigations into hormonal secretions and chromosome patterns have led researchers to a study of maleness and femaleness more profound than could have been imagined in the previous centuries. The development of surgical techniques made transsexual operations reasonably successful. Although some sort of sex reassignment may have been attempted in the nineteenth century, the most famous instance gained international notoriety in 1952: an

American ex-soldier, George Jorgensen, became Christine Jorgensen (1926-1989) after treatment in Denmark. Since that time hundreds of sex-change operations have been performed and attempts at producing functioning genitalia have had practical as well as theoretical results.

Concern in the scientific community about sexual behavior started out for medical reasons. At a time when syphilis and gonorrhoea were ravaging Europe, sex was seen not only as sinful but dangerous. Masturbation was not exempt but regarded as a particularly vicious habit. One of the most influential writers about the dangers of masturbation was the French physician Simon André Tissot (1728-1797), who in 1758 published a book called *Onanism: dissertation on the sicknesses produced by masturbation.* It went through several editions and remained available for over a century. His thesis was that masturbation was directly responsible for a host of disorders and this view became popular at a time when beliefs in demon possession as causing illness had largely been given up by the educated but the germ theory of disease had not yet been developed. Much of the theorizing about the supposed dangers of masturbation either entered western folklore or helped to perpetuate already existing notions.

Some of the famous non-physicians who took up Tissot's position included the Rev. Mr Sylvester Graham (1794-1851), who developed the Graham cracker, and John Harvey Kellogg (1852-1943), founder of the cornflakes company — cornflakes in fact were developed as an antimasturbatory remedy. Graham in turn profoundly influenced Anthony Comstock (1844-1915), who dedicated himself to the elimination of all sorts of vice including prostitution and obscenity, as well as contraception.

Early German sexology

Sexology as a discipline distinct from medical preoccupations with pathology was the result of the work of several European, particularly German-speaking scholars. Iwan Bloch (1872-1922) was one of these. He has in fact been called the father of modern sexology in part because he coined the earliest term for it: *Sexualwissenschaft* "sexual science". Although he had a medical background himself (he was a dermatologist), he believed sexology had to rely heavily on historical and anthropological research. One of his significant books was *Das Sexualleben unserer Zeit (The sexual life of our time)*, published in 1907. Krafft-Ebing (1840-1902) has also been named the father of sexology because of the

importance of his publications, most notably his *Psychopathia sexualis (Sexual pathology)* first published in 1886.

Other important early sexologists include Paolo Mantegazza, Auguste Forel, Albert Moll, Max Marcuse, Ferdinand Karsch-Haack, Albert Eulenburg and most importantly Magnus Hirschfeld (1868-1935). In 1908, Hirschfeld founded the first journal devoted to sexual matters exclusively, *Zeitschrift für Sexualwissenschaft (Journal of sexual science)*. In 1913, Hirschfeld and Bloch along with several other physicians founded the first sexological society, The Medical Society for Sexology and Eugenics. (Interestingly, this organization was dismissed by Freud.) A few months later, Albert Moll started a rival society, The International Society for Sex Research.

Sexology was not only an intellectual enterprise but also developed out of a number of social reform movements in the nineteenth century, including attempts to repeal or change sex laws in the western world, particularly with regard to birth control and homosexuality. The most important pre-World War II organization involved in the study of sex developed in conjunction with the first homosexual emancipation lobby: the *Wissenschaftlich-humanitäres Komitee* (Scientific Humanitarian Committee) founded by Magnus Hirschfeld in 1897. In 1919, Hirschfeld founded the *Institut für Sexualwissenschaft* (Institute of Sexual Science, or Institute of Sexology) in Berlin. Although it had a close association with the Committee they were both housed together the Institute concentrated on the whole range of sexual behavior and offered counseling for all sorts of sexual problems.

In the field of sexology, the Institute made important contributions, not the least of which was the model of what such an institute could be like. It accumulated impressive archives of ethnographic and biological material and amassed an enormous library open to scholars from all over the world. It also collected the sex histories of more than 10,000 people who made use of its facilities. By 1923, the importance of the Institute was officially recognized by the Prussian government and was renamed the *Magnus Hirschfeld Stiftung* (Foundation). Hirschfeld himself was an indefatigable worker and wrote several enormous volumes on sex, which remain classics in the field. (However, people who knew him frequently found him difficult, and an ugly rumor persists — the truth of which I have been unable to verify — that he even occasionally blackmailed people who had contributed their highly detailed sex histories.)

The Committee, on the other hand, was not only involved in lobbying for the reform of antihomosexual legislation, notably Statute

175 of the German criminal code, it also attempted to gather reliable information about the incidence of homosexuality and bisexuality in Germany.

In 1904, questionnaires were sent to 5,721 Berlin metal workers. Unlike a previous attempt with students the year before, there were no lawsuits this time and about 49 percent of the total sample answered. On the basis of these replies, Hirschfeld concluded that 94.3 percent of the males were exclusively heterosexual, 2.3 percent were homosexual and the rest bisexual. Although the percentages for non-heterosexuals seem small, they suggested that more than 1,000,000 Germans were homosexual — a finding that was astonishing at the time and politically of some importance.

In 1921, Hirschfeld convened the first International Congress for Sexual Reform, held in Berlin. Out of this developed the World League for Sexual Reform, which at one point had a membership of 130,000 (counting membership in organizations affiliated with the League). Other conferences of the League were held in Copenhagen (1928), London (1929), Vienna (1930) and Brno in Czechoslovakia (1932). Some very eminent sexologists were members of the League, including Havelock Ellis and Wilhelm Reich. George Bernard Shaw and Bertrand Russell participated in some of its meetings. The disbanding of the League was in large part the outcome of the destruction of the Institute by the Nazis by 1933. Its incomparable library of more than 10,000 volumes was publicly burned, its anthropological and biological material destroyed and at least some of its workers sent to concentration camps. The justification for this destruction by the Hitler regime was that the Institute was *undeutsch* "un-German".

Although Hirschfeld's institute was destroyed, another institute founded some two years later in 1921 survives to this day. This is The Sexological Institute of the Faculty of Medicine in Charles University in Prague, Czechoslovakia. Its first director was Ferdinand Pečírka, who like Iwan Bloch was also a dermatologist.

Kinsey

In the United States, which was eventually to become the major center of sex research, the attempts to establish a comparable institute met with serious resistance. In 1921, the distinguished biologist-psychologist Robert Yerkes tried to establish a Committee for Research in Problems of Sex within the National Research Council. Although this proposal was eventually accepted by the Division of Medical Sciences (after having

been refused by the Division of Anthropology and Psychology!), most of the research findings of projects sponsored or approved by the Committee were never published owing to a lack of funds. If they did appear, they did so without sponsors. A precedent for the scientific study of sex within the United States had been set, however, and was to culminate in the official establishment of the Institute for Sex Research at Indiana University in Bloomington in April 1947 (in November 1981 it was renamed the Alfred C Kinsey Institute). In fact, Kinsey and his co-workers had been doing research on sex since 1938.

Alfred Kinsey (1894-1956) was himself a zoölogist with his D.Sc. from Harvard. Before his investigation of human sexual behavior, he had become a world expert on the gall wasp. In 1938, he was chosen by Indiana University to be the co-ordinator of a course on marriage. He soon realized that the literature on human sexuality relevant for the course was non-existent or a disappointment. He began to supplement this information by taking the sexual histories of his students, who apparently were quite free about doing so. This was the start for his epoch-making research in which he was aided by his associates Wardell B Pomeroy, Clyde E Martin and Paul H Gebhard (who later succeeded Kinsey as director of the Institute).

The findings of the Kinsey Reports and of other research projects carried out by the Institute are referred to constantly throughout this book, but two of the most important conclusions, from an anthropological point of view, were that sexual morality and the sex laws of society do not necessarily correspond with how people behave, and that the behavior of individuals varies enormously within a society.

In spite of the flood of criticism that nearly overwhelmed the first two volumes published by the Institute, *Sexual behavior in the human male* (1948) and *Sexual behavior in the human female* (1953), they remain the standard references on the subject. Kinsey thought that a sample of 100,000 would be adequate, but when he died only 18,000 interviews had been completed. The major criticism launched against Kinsey concerned the sampling and statistics. However, his findings tend to be confirmed by more recent surveys. One reason for this is Kinsey's attempt to avoid the exclusive use of volunteers, who might present some sort of bias, and to obtain 100 percent group interviews — that is, interviews with all the people in a certain group, for example a law school, fraternity, rooming house or Sunday school.

In reviewing the literature, Kinsey deplored the lack of reliable reporting by anthropologists. There still remains virtually nothing even

remotely approaching a Kinsey Report for any non-western society. Anthropologists, however, tended to be quite free with their criticism of the work of the Kinsey team.

Margaret Mead, for example, was extremely critical of the second volume, and described the first as "puritanical." But whatever that might mean, it is nothing compared to what Pomeroy calls her "shocking" proclamation that the sale of *Sexual behavior in the human female* should be restricted because "the sudden removal of a previously guaranteed reticence has left many young people singularly defenseless in just those areas where their desire to conform was protected by a lack of knowledge about the extent of nonconformity." She was joined in this view by a virtually international group of Christian clergymen of various denominations, as well as a few rabbis. The critics did not dispute the factualness of the report, but for the most part attacked its moral message.

The attack was so virulent that the Rockefeller Foundation under Dean Rusk withdrew its financial support from the Institute. The United States Customs began seizing material addressed to the Institute, and a member of the United States House of Representatives urged that Kinsey's books should be barred from the mails. (Opposition to Kinsey's work and findings continues, usually by politically conservative people.)

Fortunately, in spite of all this opposition, the National Institute of Mental Health (N.I.M.H.) took up the funding of sex research on an unprecedented scale and the Institute itself was maintained for many years. In 1978, the N.I.M.H. funding for the Institute's important information services was dropped — ostensibly the money was to be used to support new ventures rather than those that were well established. As a result, the Institute has been forced to curtail many services.

Masters and Johnson
During the whole history of sexology, information has been acquired by questioning rather than by observation. One exception was the nineteenth-century traveler Sir Richard Burton, who probably based his reports of sexual practises on first-hand experiences — including his accounts of Middle Eastern boy brothels (the vividness of his descriptions so horrified his widow that she burned all his unpublished manuscripts).

In 1966, however, Dr William H Masters and Mrs Virginia E Johnson published an epoch-making book, *Human sexual response,* which was based on direct laboratory observation of sexual activity performed by

694 persons (382 women and 312 men) between the ages of 18 and 89. This meant observation of more than 10,000 male and female orgasms.

The book was the result of work done over a 12-year period, largely at the Reproductive Biology Research Institute (later renamed the Masters and Johnson Institute) in St Louis, Missouri. The goal of the research was primarily therapeutic: to find the simplest cures for impotence, frigidity and other sexual dysfunctions that apparently plague an enormous number of men and women in the western world. But in carrying out the research, basic information about sexual response in general was collected. For example, Masters and Johnson confirmed Kinsey's earlier assertion that the existence of a clitoral as opposed to a vaginal orgasm is a myth. This distinction — which may go back to Aristotle — was proposed by Freud in 1913 in his *Die Disposition zur Zwangsneurose* (Collected Works, vol. 8). The distinction has been retained as orthodox psychoanalytic theory.

Reaction to Masters and Johnson's work was mixed. Some found it morally deplorable — in part because of the use of "marital surrogates" (prostitutes) at various stages of the research. Others hailed it as a giant step toward the solution of serious marital problems. Still others found it weak on theory. Anthropologists have tended or pretended to be uninvolved. Mariam Slater recalls that the response of her anthropologist colleagues to Masters and Johnson at an annual meeting of the American Anthropological Association, before the publication of their book in 1966, seemed to be for the most part either embarrassment or (feigned?) indifference. And at a showing of some of their extraordinary slides and films, only five women anthropologists dared to appear and the men made adolescent jokes. This unfortunate reception of their work apparently so offended Masters and Johnson that they decided never again to return to anthropological conventions — a decision, if true, one hopes will be abandoned.

There are, of course, problems with their study that they themselves concede. All the people they observed were American, none was Oriental, most were Caucasoid. Clearly what anthropologists could do is to try to improve the sample by studying non-white, non-western subjects. So far this has not even been considered.

Masters and Johnson have been attacked in a similar vein but in a different key by the prominent women's liberationist Germaine Greer. She describes their research as producing "dull sex for dull people" *(The female eunuch)*.

Social constructionism and sociobiology

A specifically anthropological approach to sexology has been uneven in
the making. Generally speaking, anthropologists have tended to play up
cultural aspects of sexuality as opposed to emphasizing biological
constraints or programing. In part this is a continuation of the view
associated with Franz Boas and his students (such as Margaret Mead),
which dominated American anthropology, that human beings are
extraordinarily malleable and influenced by their cultures profoundly.
Their view directly opposed the eugenics movement and the general
racism of the day. Here we see the classic nature/nurture controversy.

Since about the 1970's, more modern versions of this controversy
have come on the scene, in large part from outside anthropology proper.
At the nature end of this controversy is sociobiology, a general attempt by
biologists to correct flaws in the classic Darwinian model of evolution. A
considerable number of physical anthropologists find sociobiology
attractive despite the fact that it seems to invoke theories of instinct and
to reintroduce biological explanations long considered suspect in
mainstream cultural anthropology. This theory will be considered in
greater detail in the next chapter.

At the nurture end of the controversy is social constructionism. In
many ways it seems to be merely an elaboration on long-established
anthropological ideas such as those proposed by Margaret Mead in her
famous but controversial book *Sex and temperament in three primitive
societies* (1935), which questioned traditional western stereotypes linking
sex (maleness–femaleness) with gender (masculinity–femininity). Some
anthropologists take social constructionism to mean little more than such
a position. More strictly, however, the real ancestors of social
construction theorists are to be found among historians, French
philosophers — especially Michel Foucault (1926-1984) — and
feminists (which makes sense because feminists have to believe, for the
most part, that on some level biology is not destiny). From sociology, it
has incorporated much of what is known as labeling theory and the
sociology of knowledge.

In extreme social constructionism, biology is virtually ignored.
Sexuality is not something generated by biology, but is defined in
personal and relational terms. In fact, all views making some sort of
accommodation to biology are lumped together and dismissed as varieties
of "essentialism." "Essentialism" includes not only such obvious
candidates as sociobiology, but in this extreme sense, even the work of

Margaret Mead herself because she assumed a biological core that cultures could mould.

Sex, gender, reproduction, even "desire" — in short, all aspects of sexuality are not assumed to be givens in all cultures at all times. Rather, they exist in terms of subjective meanings created ("constructed") by specific societies.

Since contexts and meanings are almost never the same, the social constructionist has to reject attempts at formulating cross-cultural, trans-historical regularities and instead concentrate on descriptions of unique cultural configurations something on the order of Ruth Benedict's aesthetic approach in *Patterns of culture* (1935), in which cultures are compared to poems, losing much in translation. However, since the time of the Neanderthals, between 50,000 and 100,000 cultures have existed (about 5,000 exist today). To avoid making any generalizations about them would seem odd. It is not clear how far social constructionists would go in keeping up such an avoidance.

Using anthropological jargon, one can say that social constructionists are concerned primarily with *eemics* (usually written *emics*) — native folk views and categories — as opposed to *etics* — an objective, outsider, scientific view. In fact they tend to deny the possibility of a true etics, which they put down as simply modern western eemics. Medical models dealing with sexuality specifically come in for a barrage of criticism. Needless to say, the leading anthropological approach, which tries for the most part to be a comparative science grounded in empiricism, is rejected by social constructionists (and some others) as futile and even arrogant.

In the same vein, notions of sexual deviance are seen as cultural judgments and political weapons rather than as objectively valid or cross-culturally true. The label "deviant" derives from the view of the group in power (the group that displays "hegemony"); e.g., men may brand women working in certain jobs as immoral, or the legal/medical establishment may define homosexual acts as criminal and/or pathological.

As a matter of fact, sexual orientation has become one of the hot topics in the social constructionist debate. As is to be expected, social constructionists argue that categories of sexual orientation are culture-bound at best (something like "hippy" or "archbishop") rather than cross-culturally valid (like "brown-eyed" or "six-fingered"). In particular, they have tried to prove that conceptualizations of sexual orientation have changed dramatically in the course of western history. For a more

detailed discussion of this specific topic, see the section "Western concepts of sexual orientation" in Chapter 18.

In some quarters, social construction theory has become intellectually chic and "politically correct," generating an excitement that even its severest critics have to acknowledge. However, it has yet to dominate anthropological thinking or even, for the most part, to enter into the more restricted world of sexology proper.

Cross-cultural investigations

The nineteenth century saw the development of encyclopaedic inventories of sexual behavior, unfortunately at times uncritical and sometimes even approaching a Ripleyesque "believe-it-or-not" point of view. One of the earliest of these was by Friedrich Carl Forberg, who ransacked Greek and Roman literature and art for every scrap of erotica. His main publication appeared in 1824: *Manual of classical erotology (De figuris Veneris)*. On the basis of his research, he concluded that the ancients knew of at least 90 erotic postures (48 referred to heterosexual coïtus; the others included coïtus with animals, group sex activities and various noncoïtal acts). A comparable study for all periods of the western world was made fewer than 100 years later by Edward Fuchs.

For cultures outside the West, a number of sexual compendia were made early in the twentieth century by Edward Westermarck, E Crawley and some others. The most important early work in cross-cultural studies was that of Havelock Ellis (1859-1939), who admitted that at the age of 16 he resolved that the main business of his life was to spare the youth of future generations the trouble and perplexity which ignorance of the true facts of sex had caused him.

The essential theme of Ellis's work is that people differ sexually and that diverse cultures at various times have capitalized on these differences. Sex is clearly a physiological imperative, but society can dominate its expression in incredibly powerful ways.

At the same time that Ellis was collecting data to document diversity, Freud (another Victorian who defied convention to study sexuality, but on different terms) tried to set up a universal model of the steps of sexual maturation. Freud believed that culture could only have a superficial effect on what was basically a matter of biology. Relatively few anthropologists have taken an orthodox Freudian view, which social constructionists tend to reject as a variant of essentialism.

Ellis's work remains unparalleled except for a cross-cultural study by Clellan S Ford and Frank A Beach: Patterns of sexual behavior (1951).

This study had the benefit of the Human Relations Area Files, a compilation of anthropological data for nearly 200 societies. In this book I have tried to update their account by going through the most recent, expanded form of the Files.

Unfortunately, the Files are only as good as the information provided by field workers, government officials, missionaries and travelers. More information has been provided by officials, travelers such as Sir Richard Burton and even missionaries such as Henri Junod, than by professional anthropologists. The most detailed sex information has been acquired about Oceania and Africa, and most of the field workers were either trained or stimulated by Bronislaw Malinowski (1884-1942). His best known work has the racy title *The sexual life of savages* (which the book does not live up to although he provides a good deal more information on copulating positions and practises than many of his colleagues). Kinsey regarded Malinowski as a prude and thought that he was afraid of sexuality — which seems to be an accurate judgment. But Malinowski deserves praise for making the study of sex respectable in anthropology.

The other major anthropological figure associated with the study of sex is Margaret Mead (1901-1978). Actually, she provides relatively little information about sex itself and is more concerned with such matters as sex temperament and sex roles. A common view of her work by professional anthropologists is that she seems to have found in a society what she herself wanted — or needed. As we have already seen, she was opposed to much of Kinsey's work and in particular was against the use of statistics in studying primitive societies. In a sense, she felt the aim of anthropology was to get at the ideal pattern of a culture, such as the natives themselves perceive it. She believed that the natives would strive toward accommodating that ideal, which could be thought of as the grammar of that culture: cultural slips of the tongue — realized in deviant behavior — were of less interest to her.

Unfortunately here we have the dilemma that Kinsey confronted: the ideal versus the real. The anthropologist must ultimately know about both. But he sometimes fools himself into thinking that the ideal will correspond in some direct way with the real.

A striking case is found in the studies of the Highlands of New Guinea, where the ideal is often said to be that menstruating women are contaminating and dangerous and that men will do all they can to avoid contact with them, much less have intercourse with them. The fieldwork of Gillian and David Gillison demonstrated that the reality is much more

complicated. In fact, the huts to which menstruating women are confined are sometimes sought out by men as places of assignation.

Donald Tuzin gives an even more graphic example of the conflict between reality and ideal models. Tuzin did fieldwork with another New Guinea group, the Ilahita Árapesh, who also have a belief that menstrual blood is polluting. He discovered that several men admitted that they practised and enjoyed cunnilingus (mouth-vagina contacts) — which most anthropologists familiar with such cultures would probably hold to be unthinkable given the beliefs of the people. Furthermore, Tuzin found variation in the actual behavior of men in this regard — which strongly suggests that Kinsey-report projects make sense in small homogeneous "primitive" societies (something Margaret Mead, for one, denied).

In more recent years, a number of anthropologists have become increasingly interested in sex research. For example, sessions at the American Anthropological Association annual meetings have occasionally been devoted to the subject. The first such meeting of major importance took place in 1961 in Philadelphia, when human sexual behavior was the exclusive topic of a plenary session. Furthermore, significant fieldwork with important theoretical ramifications has recently been done by Gilbert Herdt (1981) on pederastic initiation rites among the Sámbia of New Guinea, and by Thomas Gregor (1985) on the broad spectrum of sexuality of the Mehinakú of Brazil. More specialized but closer to home is Jack McIver Weatherford's study of a porn shop in Washington, D C (1986).

It must be conceded, however, as Dona Davis and Richard Whitten do, that "human sexuality is not yet a coherent subspecialty of anthropology." One can only hope that it soon will be.

FOUR EVOLUTION OF HUMAN SEXUALITY

**Human sexuality is the result of millions
of years of evolution. But although based on an
ancient heritage traced through mammals, it has
become a unique human phenomenon.**

In the beginning, people copulated through the nose or in the armpit,
women had breasts on their foreheads, and men menstruated.

These are of course not the serious speculations of modern biologists
or anthropologists, but folk beliefs scattered through a variety of
cultures. Modern scientific speculations no longer support such
fantasies. Rather, given the theory of evolution, the scientist must say
that human sexuality and certainly human sexual anatomy are part of
man's ancient biological heritage. In short, sex did not begin with man
nor was it re-invented independently by him.

For example, if we try to figure out why a woman has breasts on her
chest, rather than near the groin like cows, we cannot restrict our
theorizing to human females alone: having two milk glands on the chest
is the pattern for chimpanzees, gorillas and monkeys — in fact all
primates (as well as bats and hyaenas). Why should this be, since this
pattern does not hold for all mammals? With four-legged mammals there
are three patterns: a dozen or so milk glands arranged in pairs running
down the whole length of the trunk of the body (as in pigs, rats, dogs,
cats); four or so milk glands at the hind-leg end of the trunk (as in cows
and horses); two to four milk glands near the forelegs, corresponding to
the human chest area (as in elephants).

There are two separate questions involved here. Why should there
be different numbers of teats or nipples? And why should there be
different locations for them? For the first question there is a reasonably
simple and convincing explanation: the number of milk glands reflects
the number of offspring normally born at one time. Pigs and dogs give
birth to litters and have many milk glands; horses, elephants, and human
beings give birth to few offspring (usually only one) and have few glands.

There are less convincing explanations for the position of the
nipples. The human and general primate pattern of having them on the
chest has been most often explained by reference to the fact that the

ancestral primates probably lived in trees and held their young by a forearm pressed against the chest while climbing on a branch. Nipples on the chest might therefore have made nursing easier. In any case, modern biologists frame their explanation in terms of natural selection, the principle of Darwinian evolution that explains survival and perpetuation of desirable traits as a function of how well members of a species adjust to conditions in which they live. The idea of natural selection is usually attributed to Charles Darwin and Alfred Russel Wallace, working independently in the middle of the 19th century to explain the origin of species. Darwin himself admits that an even earlier theorist came up with the notion in 1831, Patrick Matthew. And a Dr W C Wells writing in 1813 may have had a similar explanation.

Referring to another aspect of human sexuality: just as human breasts could be dealt with for the most part in terms of the larger problem of primate breasts, there is no need to think up ingenious explanations for the basic fact of human copulation — inserting the male penis into the female vagina. It is simply the general pattern for all mammals and has to be understood as part of man's mammalian heritage.

To be sure, other ways of bring sperm and egg together have been evolved — though never through the nose or the navel, in spite of folkloristic fantasies. For example, in a certain kind of fish, the African mouthbrooder, the female deposits her unfertilized eggs in the water and then catches them up in her mouth. The male waits nearby. He has red spots on his anal fin that look like eggs. The female tries to take these into her mouth, but when she opens her mouth, she takes in sperm ejaculated by the male instead. Fertilization takes place in her mouth rather than in her sexual organs.

The origins of sexual reproduction

Sexual reproduction involves a transfer of genetic material from one organism to another of the same species. Distinct sexes may not even be involved in sexual reproduction at all. Consider the paramoecium, a one-celled animal that normally reproduces merely by splitting itself in half — a nonsexual form of reproduction called binary fission. It multiplies rapidly because it splits in half about every eight hours. Occasionally, however, one paramoecium joins with another and they lie side by side: the cell membranes break down in the area of joining and the paramoecia exchange genetic material. Eventually the fused pair will divide into a number of daughter cells, each of which is now distinct from the ancestral couple. This process of fusion, called conjugation, is

sexual reproduction without anything that even remotely approaches a traditional male/female distinction.

Many forms of nonsexual reproduction occur (fission is simply one of them). It is generally assumed that at least some of them are older than sexual reproduction. But even in the simplest organisms we now realize that an exchange of genetic material is basic to their survival.

Some organisms are not known by direct observation to reproduce sexually. For example, ever since it was first discovered, the amoeba, a one-celled animal, has been observed under the microscope by literally thousands of scientists for about 200 years and has never been seen to reproduce in any way other than by splitting in two. At one point the amoeba was believed to be the prototype of the ancestor of all animal life so that it more or less followed that nonsexual reproduction preceded sexual reproduction. But even though amoebas have never been observed conjugating, they probably do so because otherwise it is extremely difficult to explain why the descendants of an original amoeba sometimes contain different genetic material not found in the ancestor.

The evolutionary significance of sexual reproduction and sexuality
Why should sex have developed at all? And why should it have become the dominant mode of reproduction among all higher plant and animal forms?

The usual explanation is that it has a tremendous advantage in ensuring the survival of a species in a changing environment. Fission, on the other hand, guarantees the production of forms that are identical to the parent form: in a sense, an original amoeba does not die but is continued in identical copies when it reproduces by fission only. But if an original form cannot survive when the environment changes, identical copies will fare no better. The payoff is extinction.

In sexual reproduction, differences are emphasized. The new forms are not identical with a single parent but have inherited unique combinations of traits from both. It is more likely then that at least some of the offspring produced sexually will be able to survive. The great advantage to sexual reproduction is genetic variation.

In spite of the tremendous evolutionary success of sexual reproduction some of its drawbacks are obvious (others are more obscure). Consider an obvious one: there is a relatively long period of helplessness in the life history of an animal produced by sexual reproduction; for example, the larval stage in insects and the embryo/foetus/newborn stages

of mammals and particularly of human beings, where such helplessness lasts many years.

Another drawback is the time, energy and frustration brought about in seeking and securing a new mate. Perhaps human beings can appreciate this disadvantage most clearly of all living beings because of the romantic and social trappings that have been added on to their sexuality. Inability to find a mate spells reproductive failure. It may also ensure psychological chaos.

This drawback to sexual reproduction has been called by a recent school of biologists, the sociobiologists, "the cost of mating." One of the things sociobiologists try to do is to calculate, like an accountant going over the books of a business, what the "costs" are of the various strategies of reproduction.

Sociobiology

Sociobiology as a distinct model began in the 1950's but it is frequently identified with the work of Edward O Wilson of Harvard University, whose important book *Sociobiology: the new synthesis* first appeared in 1975. One estimate suggests that 70 per cent of biologists have taken up sociobiology. Even its critics admit that it presents plausible explanations for mating behavior and reproduction in lower animals dominated by instinct, such as insects and birds. However, most anthropologists tend to dismiss sociobiology as inadequate to explain human behavior. But the approach raises many interesting questions. We shall soon see where this model of sexuality leads.

Before we do so, let us consider yet another cost of sexual reproduction which is also obvious: if the original form is a success, the departure from it may not be. The genetic reshuffling that goes on because of sexual reproduction may in fact be dangerous and even lethal: the offspring of the healthiest stud bull may be sickly or die because the bull has passed on some hidden deleterious gene. The same is true for all animals that reproduce sexually, including man. This drawback is known as the "cost of recombination."

Sociobiologists argue that sexual reproduction will have the most value and provide the most benefits if millions of offspring are produced and scattered or dispersed into new environments. Among these many offspring there may be some that will be able to fit into the changed ecology. Sex, then, is adaptive for oysters, whose young are carried along indiscriminately by sea currents, and for elm trees, whose seeds are scattered by the winds.

But human beings are neither oysters nor elm trees. Sex may not be as much of a benefit as is usually assumed either for human beings or for the less prolific organisms in general.

There is at least one more cost that has been recognized by sociobiologists; and with it the investment model or accountant metaphor is most clearly pointed up. The technical expression for this is "the cost of meiosis." It refers to the fact that in sexual reproduction both parents pass on only half of their genes to an offspring. This may not seem to be much of a loss, but it is crucial to sociobiological thinking and the reason for its rejection by most anthropologists — at least when applied to human beings.

The point is that genes, not individuals, are played up in this model. The Darwinian notion of the survival of the fittest has been somewhat re-interpreted. It is no longer seen in terms of a specific *individual* reproducing himself but rather in terms of a *gene* perpetuating itself. The gene, rather than the individual, is taken as the locus of evolution and the gene is classically described as "selfish," at that. In fact, sociobiologists tend to look at people (or snails, worms, lizards, ostriches, giraffes — you name it) as tools used by genes to replicate themselves. This may not be the most exalted way of viewing mankind, but there are certain advantages to it.

With this in mind, one can argue that it might even prove to be good reproductive strategy for a given individual not to reproduce — if by so doing his genes are more likely to be successfully passed on through his kinsmen.

One of the big virtues of this re-interpretation is that it can make sense of something that Darwin could not: why some animals have developed castes of nonreproducing individuals, such as the sterile workers among bees, ants and termites. What traditional Darwinians had to think of as dysfunctional can be shown to have a very real function in the sociobiological scheme of things. In the same way, it also makes evolutionary sense of those human beings who do not normally reproduce, whether for social or for other reasons: celibate priests, monks, nuns and exclusive homosexuals. All these individuals by not reproducing but by otherwise playing useful roles in society may be helping to ensure that their genes found in the offspring of relatives (nephews, nieces, etc.) will survive. Therefore, real evolutionary fitness cannot be equated with the successful reproduction of a single individual — as in the traditional Darwinian view — but with his success combined with that of his relatives: "inclusive fitness." In fact, the underlying

thrust of evolution has been summarized in the phrase "the maximization of inclusive fitness".

There is, however, a problem here for sociobiologists since inclusive fitness strictly refers only to immediate kinsmen (brothers, nieces, etc.) and fitness would probably not include even second, let alone third, cousins. For human beings, we would probably have to invoke some wider notion of group affiliation — which sociobiologists do not want to do and which they apparently need not do with nonhuman animals.

There are other problems with sociobiology as well. Current attempts to expand the model may attempt more than it makes sense to do.

The most recent sociobiological thinking has tended to include a life history approach considerably removed from a classical kind of biological determinism. For example, Patricia Draper and Henry Harpending explain styles of male-female relationships that seem only remotely biological. Although they talk about a "learning bias" brought about in human children by natural selection for the acquisition of reproductive style, they concede that "we do not know nor have we theoretical reasons for predicting *what precisely is the mechanism* which triggers the learning track 'chosen' by the child". They then go on to describe two kinds of situations where adult personality is largely determined by the presence or absence of a father figure in childhood — a very common model of explanation used by psychological anthropologists and in fact associated with much of the thinking of the school of Culture and Personality (a famous proponent of which was Margaret Mead, hardly an advocate of biological explanations).

Draper and Harpending set up two ideal mating strategies: (1) the "dad" strategy in which fathers tend to be present, investing a lot of time and energy in the rearing of their children, and generally having stable and intimate relationships with their wives; (2) the "cad" strategy where men have as little to do with their children as possible, and try to inseminate as many women as possible, while at the same time denigrating women. The "cad" strategy is linked very closely by Draper and Harpending to the "male supremicist complex" proposed by the anti-sociobiologists William Divale and Marvin Harris. Here relationships between men and women tend to be hostile (husbands and wives may not even sleep or eat together), men are big on violence and public bombast, warfare often is done for the sake of capturing women.

These are indeed two different mating and parental strategies. But the settings they occur in cannot easily be specified by biological

triggering factors, but rather by sociocultural differences. Draper and Harpending admit as much when they associate the "dad" strategy with hunting and gathering groups in harsh environments, as well as densely packed agricultural peoples and industrialized societies (in short, settings where resources are scarce). The "cad" strategy they find in middle-range societies such as those that practise agriculture at a low level of intensity, with a low-density population (in short, where resources are relatively abundant and where women can easily raise their children without the help of men).

Whatever the truth or adequacy of this particular analysis, it is by no means clear that a peculiarly sociobiological explanation is either needed or desirable.

No matter what the ultimate merits of sociobiology, it seems likely that a considerable amount of human behavior involving sex and reproduction can make sense in terms of a model developed for the animal kingdom as a whole. But whether this necessarily involves some sort of genetic wiring as opposed to a conservatism that preserves instinctual patterns even though the instincts are lost, remains controversial.

Internal fertilization and the anatomy of sex organs
Animals as different as woodlice, periwinkles, octopuses, scorpions, spiders, sharks, turtles, kangaroos, dogs, lions and human beings have evolved different and in some cases totally dissimilar ways of placing sperm inside the female so that eggs can be fertilized internally.

A very common form of internal fertilization requires the male to deposit his sperm directly into the female's body by putting part of himself into her genital opening. This is of course the human way, and the way associated with all mammals and many reptiles. Various parts of the body other than the penis have been used to deposit sperm inside the female. For example, lobsters, crabs and shrimp have a modified leg serving the same function. Squids and octopuses use a specialized arm; in a few species this arm snaps off in the process of fertilization.

The penis of most mammals has a single channel running through the urethra, and a single opening for depositing sperm. Lizards and snakes, on the other hand, have paired organs that are like pockets (often with spines like thorns). During copulation they are pressed together like claspers turned inside-out and used separately. When not in use, they retract into the tail. When erect they stand out to either side: which one is used depends on which side of the female the male finds himself.

The development of internal fertilization had dramatic consequences for the evolution of animals: it led to life on land. Both egg and sperm need a moist or liquid environment; without this, they would dry up and perish. Internal fertilization provides an appropriate environment which is also usually safer than water. Other aspects of internal fertilization, however, could count as drawbacks. For example, it requires finding a specific mate. Although courtship practises exist among some spawning animals, courtship increases in importance as a necessary consequence of internal fertilization. The cost of mating mentioned earlier becomes even greater. This is obvious particularly in species where a male will try to mate with many females. In such a species it is believed that only something like 25 percent of the males reproduce at all and only one percent of males sire the great majority of offspring.

Furthermore, with internal fertilization, females cannot possibly produce very many eggs: few offspring are produced and parents (particularly the mother) make a considerable investment in their survival. As a matter of fact, the total offspring produced as well as the number of times an individual reproduces in a lifetime are further components of the reproductive strategy of a species. As an instance of the second aspect, consider the Pacific salmon, which reproduces only once in a lifetime and then dies. This is referred to as the "big-bang" (or, less dramatically, as semelparity). Another possibility is of course repeated reproduction (iteroparity), familiar to us from cats, dogs, and human beings themselves.

With regard to number of offspring, two strategy types have been recognized: one in which a great number are produced and very little parental investment occurs, r-strategy or r-selection; the other, where only a few offspring are produced but each offspring tends to receive a great deal of parental investment, K-strategy or K-selection. The term r is, roughly, a measure of rate of increase of a population, and K stands for the carrying capacity of a particular habitat (which refers, again roughly, to the resources available to sustain a species in a particular place).

The r-strategists include smaller, short-lived animals such as insects and fish. In extreme cases they may produce thousands, even hundreds of thousands, of offspring but in most situations only a few of these survive to reproduce in turn. This is fortunate for human beings because otherwise, mosquitos and cockroaches would tend to fill every inch of the earth's surface.

The K-strategists include such extremes as whales, elephants, and human beings — and human beings by using birth control have intensified their own K-selection. Interestingly, closely related species can display different strategies: beavers are almost classic K-strategists but their close relatives the voles are r-strategists.

Generally speaking, for r-selected species, the population varies sharply whereas for K-selected species, the population is relatively stable.

To return to the phenomenon of internal fertilization. In some widely differing species there seems to be an attempt by the male to justify his own investment and to secure what has been called "paternity certainty". Some sociobiologists have even suggested that differences in female faithfulness will trigger differences in the investment a man will make in his mate's offspring. If his paternity certainty is high, his energies (his "parental investment") will be directed towards his mate's offspring, which presumably are also his own. If his certainty is low, his investment will go to his nearest undoubted blood relative — particularly to his sister's children who will inevitably share some of his genes (but not to his brother's presumed children because, as Strindberg says in his play *The father*, "only the mother knows for sure"). It is generally believed that in societies tracing descent through women, paternity certainty is low; hence (say sociobiologists) inheritance tends to go from a man to his sister's children. The Trobriand Islanders are an oft-quoted example of this. But some societies tracing descent through men, such as the Muslim Nupe of West Africa, seem to offer no greater assurance of paternity certainty. Furthermore, in the absence of Kinsey-type reports for the societies in question, we really have no data to support this particular sociobiological assertion, other than impressions and anecdotal accounts. One exception is Thomas Gregor's account of the Mehinakú of Brazil, described as "patriarchal." Among them, women are as promiscuous as men, and some women even more so: at least one woman had had 11 affairs in 1972, another as many as 14 — but no man had had more than 10. (Recent "paternity tests" given to parents and offspring in various bird species traditionally thought to be strictly monogamous even demonstrate that unfaithful females seem almost the rule rather than the exception.)

As a matter of fact, to help insure high levels of paternal certainty, human beings have had to improvise with various cultural innovations such as secluding women (purdah), or requiring chaperones, or actually sewing up the vagina (infibulation), or locking it with a chastity belt. But some animals such as cockroaches, garter snakes, rats, wombats and

rhesus monkeys have evolved a kind of internal chastity belt. After copulation, the male deposits a secretion to plug up the genital opening of the female. This "mating plug" has been described by David Barash as a male calling card, indicating that the female is already taken.

In dogs, foxes and wolves another development has taken place that has also been suggested as ensuring paternity certainty: the penis swells inside the vagina during copulation so that the male is locked to the female, sometimes for as long as half an hour. This genital locking makes sociobiological sense for dogs because they are promiscuous, but not for monogamous foxes. Some other animals such as kangaroos copulate for hours at a time without genital locking. But this sort of behavior all too clearly has its dangerous side too. It is lucky that wolves get locked up this way and not sheep.

Rumors about less functional kinds of genital locking pop up every once in a while concerning human beings. Such locking is then referred to as *penis captivus*, "the captured penis." I well remember a vivid account told me several years ago of the peculiar circumstances associated with the death of François Félix Faure (1841-1899), president of France. Even the most sober historians admit he died in the presence of a woman not his wife. But the version I heard added that he actually died in a *maison de tolérance* while copulating and the prostitute he was with got so hysterical that her vaginal muscles contracted round the dead man's penis. She had to suffer the further ignominity of surgical separation. This is almost certainly mythical: many people have died in comparable circumstances without requiring nekro-amputation.

The *penis captivus* theme is not limited to the western world. The Marshallese of the Pacific believe that incest between brother and sister (less commonly between parent and child) brings about a disease called *rue*, in which the woman develops muscle spasms that trap her partner's penis inside her. Among the Yao of Africa, a husband who must leave home for a while will put a knife into a sheath and hang it in his hut. If his wife commits adultery in his absence, she and her lover will be locked together until someone draws the knife from the sheath.

Although this theme is widespread, no factual basis for it exists among human beings.

The sex organs of human beings are similar to those of other mammals and of primates in particular. All primates have a penis that hangs free and is not attached to the belly, as it is in other mammals. The human penis is virtually unique among primates in lacking a small bone, the os penis, or bacculum (penile bone). The few other primates

that lack it are the tarsiers and some New World monkeys (we have no evidence at all as to whether ancestral forms of man such as *Homo erectus* or *Australopithecus* types had it or not). In gorillas this bone is about three-quarters of an inch (2 cm) in length, and one inch (2.5 cm) in diameter. It is widely found among mammals in general, including shrews, hedgehogs, rodents, whales and bats.

There are a few other differences in the male sex organs among primates. For example, among some of the prosimians, the testes are withdrawn seasonally into the body; in all other primates, they lie permanently in the scrotum. The scrotum itself is variously colored, making it easy to differentiate between species.

The female sex organs differ in several ways. In New World monkeys, for example, the clitoris is quite large; the spider monkey in particular has such a long clitoris that it resembles a penis and (at least to the human observer) makes it difficult to tell the difference between the males and the females. The pigmy chimpanzee or bonobo has the largest clitoris of all the primates, which doubles in length during sexual excitement. These anatomical details have been linked by some scholars with a frequent form of lesbian behavior among these pigmy chimps involving rubbing genitals during a face-to-face embrace.

Of all primates, only human beings have a real hymen. Its exact function or evolutionary advantage is unclear. Among many societies an intact hymen has significance far out of proportion to its biological usefulness because it is assumed to prove virginity.

In general, the vaginal opening in nonhuman primates is farther to the rear than in human females. The human position seems clearly to be associated with changes in the body because of walking on two legs, and this has encouraged frontal entry coïtus.

The sexual anatomy of human beings and other primates is so similar that the same basic repertoire of sexual techniques is shared by them, with one notable exception: human males are rarely capable of bending over far enough to perform fellation on themselves. It has been estimated that fewer than four percent of men are able to do so. But among male chimpanzees autofellation is reportedly commonplace and all are apparently able to perform it.

Sexual differences
Biologically it is not absolutely necessary that differences (besides those of genitalia) should actually exist between males and females. In the simplest animals living in water, males and females are identical except

for the sex cells. Fertilization takes place externally. Sex cells are simply ejected into the surrounding water: no need to find a particular mate, no pressure to fight off rivals or to attract a partner. In some species that live in colonies, such as sea urchins, one individual will give off a chemical message (technically known as a pheromone) that triggers the other members of the colony to eject their sex cells simultaneously, in what in referred to as a spawning crisis.

Even in higher animals, there is sometimes no noticeable difference between males and females and even the genitalia are fairly ambiguous, as among hyaenas. But for the most part the development of internal fertilization (which requires attracting a mate) has led to an elaborate evolution of secondary sex characteristics. These characteristics usually involve size, body shape, or color — sometimes all three.

Darwin assumed that these characteristics had a significant value: they either aided the individuals to mate more frequently or to choose more fertile mates. This is the essence of his theory of sexual selection. For example, he explained the brighter plumage of male birds as an attraction for females. In general, it is the male in the animal kingdom that is the more prepossessing of the sexes with regards to both decoration and size. An example of this is the bull sea lion, which may weigh as much as seven times the average cow in his harem.

Sometimes, however, the differences are dramatically reversed, as in the case of the deep-sea angler fish: the male becomes permanently attached to the female's body and shrivels up so that he is virtually reduced to a glorified sex organ his only biological function being to produce sperm. It is a sobering thought that the hulkiest football player or the most muscle-bound weight-lifter is reproductively no better biologically than the wizened male deep sea angler fish. Within an evolutionary framework, males can be thought of as merely devices for impregnating females.

Recent sociobiological theorizing has tried to make the Darwinian notion of sexual selection clearer. In particular, attempts have been made to explain why females tend to be shy and coy and less striking in appearance than males. The major explanation for these tendencies is in terms of what we have already referred to: "parental investment strategy". Females tend to invest more in their offspring than males. For one thing, sperm are cheap. And even with regard to size of sex cell, eggs are bigger than sperm. Generally it is the female who takes care of the young (if any care is shown to them at all).

Consequently, according to the theory of parental investment strategy, females will tend to be choosier than males when it comes to finding mates. That implies that males may have to develop all sorts of displays to catch the coy female's attention and at the same time be bigger and stronger to fight off other males. Among human beings, all things being equal, this should mean that bigger muscles and possibly bushier beards would pay off in gaining feminine favors. But being a good hunter or owning a Rolls-Royce or a yacht would seem to be an even more effective display than having the body of a Greek god — depending on what culture you live in. Culture will out.

Females as a rule, then, do not develop display tactics or surpass males in size of strength. But sometimes they do. In those species where this occurs, it is the male that takes care of the young. Among sea horses, for example, it is the male who carries the fertilized eggs until they hatch. True to the theory, it is the female sea horse that is bigger and more brightly colored and it is the male that is coy and reluctant and must be courted.

When males mate with several females and set up harems (as is true of sea lions, antelopes and hamadryas baboons), the differences between the sexes tend to increase. Most typically, the males become even larger and more aggressive — presumably because there is even greater competition for females. But this increase in the difference between the sexes may have serious consequences: sometimes the males become so different that they cannot live with the females and juveniles. The reason is that a larger individual usually has need of a different diet and requires a different kind of area to live in.

One of the most extraordinary examples of this is a close relative of man: the orangutan. An adult male orangutan normally weighs twice as much as an adult female and there is very little interaction between them. Even sexual encounters between males and females are infrequent and have been described as rape by some observers, perhaps because extreme sexual differences have forced them to live apart and they have to seize sexual opportunities as they present themselves.

Parenthetically, it may be added that despite the great total body size of the male orangutan — and also of the gorilla — testicle size is relatively small. This in contrast to what is found among chimpanzees. One correlation that has been pointed out is that chimpanzees show a pattern of almost frenzied promiscuity with much competition for mates, a pattern very different from the larger apes. Testicle size among human

beings is nearer the orangutan side of the scale than the chimpanzee. But what this correlation means (if anything) is unclear.

Distinctively human aspects of sexuality

Nearly 4,000,000 years ago, the earliest ancestors of mankind were walking upright on two legs. Doing so is generally believed to have changed sex in profound ways for their descendants. Other developments have also modified human sexuality. Here we shall consider some of the distinct aspects of this sexuality.

One of the more dramatic changes linked to the development of upright posture and walking on two legs is frontal entry intercourse. Human beings are almost the only higher animals who regularly use frontal entry: rear entry is practically universal among other mammals (including primates), as well as among reptiles and birds.

Primates other than man sometimes practise frontal entry, but it is exceedingly rare and never the commonly observed position. Pigmy chimpanzees use such a face-to-face position more than any other nonhuman primates, and for this as well as a few other reasons are sometimes believed to be the most likely promate model for human sexuality. For some primates a number of positions have been noted — among orangutans, called by some the "sexual athletes of the primate world," copulation may even be performed while hanging from a tree and last an hour or more. Among gorillas, too, which according to Desmond Morris are the "least sexy primate" (he considers man to the be "most sexy"), a wide range of positions have been observed, though seldom in the wild.

Virtually all of these positions are used by human beings as well.

The development of frontal entry as associated with the change in posture makes sense because of changes in the relative placement of the vagina along with other aspects of pelvic geography. A number of other distinctively human sexual traits have also been linked to upright posture. Some of these may fall into the category of the farfetched, but let us consider a few that have gained a certain popularity.

Women are the only female primate to have permanently large breasts. According to Desmond Morris in *The naked ape* (elaborating on a somewhat different theory proposed by Wolfgang Wickler), breasts are buttock substitutes.

In most primates, a female who is in heat presents herself sexually to a male by exposing her buttocks to him. In some primate species such as baboons, macaques and chimpanzees, the skin around the anus and

between the anus and vagina swells and changes color. For example, among baboons the "sexual skin" is usually black, but in heat changes to pink. In other words, the area around the buttocks is a sexual key to female receptivity and presumably also acts as an attractant to the male, although sexual odors (pheromones) seem to play a greater role. With upright posture and frontal entry, this area no longer plays a crucial role. Human beings have no sexual skin at all (although there may be premenstrual swelling of hands, feet, belly and breasts all at the same time) and have no effective pheromone system.

Morris maintains that the shape of breasts has therefore evolved as a kind of sexual mimicry: to evoke memories of buttocks — hence their erotic appeal to men. Marvin Harris argues that large breasts do not attract because they are locked into some sort of "racial memory"; rather, they simply imply that a woman is healthy. However, breasts are not considered especially erotic in all human cultures. Therefore, the alleged motivations for their "emergence" are poor.

Ronald S Immerman has presented a much more comprehensive model to account for not only permanent female breasts but other distinctively human characteristics such as reduction in size of canine teeth as well as in amount of body hair, loss of pheromones — not to speak of the development of monogamy and language.

On the face of it, the model is too broad: monogamy, for one thing, is hardly a pan-human trait, and language may have occurred much later than these other traits. But his reconstruction is interesting because it plays up the fact that at least the physical characteristics mentioned would all be undesirable in a sex partner among other primates. Enlarged breasts would normally indicate that a female was breast-feeding a child — a time when female primates are usually neither receptive nor sought out by males. Loss of body hair would be a sign of sickness not sexiness among nearly all mammals (imagine a cat without body hair). Why should all this have happened? Immerman assumes that prehistoric peoples were confronted with the ravages of sexually transmitted diseases. Those individuals who would have been sexually successful before the onslaught of such venereal epidemics because they were physically attractive in a traditional primate way perished, along with the genes for the traits that produced their attractiveness. Individuals survived precisely because they were unattractive, not particularly sought out as sex partners, and therefore less likely to be exposed to such diseases. Eventually, initially unattractive traits could even become eroticized — as did enlarged breasts in some groups.

It is perhaps impossible to verify Immerman's reconstruction in any archeological sense. But certainly a more plausible explanation for the loss of body hair relates not to sickness but to the distinctively human mechanism for controlling body heat through sweating — a good thing for our hunter ancestors who often had to run down game. Moreover, experience with modern sexually-transmitted diseases including AIDS suggests, however, that not only the attractive fall victim to such diseases. Could it have been much different in prehistoric times?

Other theories have been presented for a few of these changes. For example, the reduction in size of canine teeth has been interpreted by some as an indication of a lessening in competition among males for mates. Darwin, on the other hand, believed that tools came to replace teeth in combat. Nancy Tanner has invoked the mechanism of sexual selection: the ancestors of modern women (or proto-women) may have preferred proto-men who kissed rather than growled.

Female orgasm has also been linked to upright posture, walking on two feet and frontal entry intercourse. It is generally (but not universally) believed that among all nonhuman primates female orgasms simply do not occur. (Suzanne Chevalier-Skolnikoff, however, maintains she found evidence of female orgasms in captive macaques resulting from both heterosexual and homosexual mounting. She believes that they probably occur in all female mammals.) But if such orgasms are distinctively human, why should they have evolved at all? One line of argument goes as follows: for primates who do not walk upright and who practise rear-entry intercourse, there is little danger that semen will drip out of the vagina after being ejaculated into it, even if the female should walk away immediately. But if a woman stands up and walks away right after intercourse, it is quite likely that the semen will simply ooze out. Loss of semen in this way might be considerable and even maladaptive. It is argued, again by Desmond Morris, that orgasm produces a sort of fatigue that ensures that the woman will probably not jump up before the sperm has traveled a sufficient distance inside her.

The argument may have a certain appeal until one realizes that frigid women — that is, women who do not get orgasms — can produce and have produced many children. Nevertheless, some scholars still believe that female orgasms have an evolutionary advantage: they probably ensure that the male will ejaculate because of the vaginal contractions that may be sexually stimulating for the male. Other scholars see no advantage at all.

Some women are capable of multiple orgasms. Mary Jane Sherfy sees this as evidence that women are sexually insatiable and links it somehow to a past stage of human development characterized by matriarchy (believed by most anthropologists to be a mythical stage, however). Sarah Blaffer Hrdy, on the other hand, argues from a sociobiological perspective that seeming nymphomania is a strategy to confuse males about paternity certainty.

Erect posture has played a large part in discussions of the sexuality of women, but hardly any in those about the sexuality of men. Even Desmond Morris has refrained from doing so in spite of the fact that, as we have already seen, he has called man (in the nongeneric sense) the sexiest of the apes because he has the largest penis among all the primates. The male gorilla, which can weigh up to nearly 400 pounds (about 180 kg) in the wild, has a penis perhaps two inches (5 cm) long at most. It is so small that it is hidden in the surrounding fur. Unlike human or chimpanzee counterparts, it does not just hang normally but projects stiffly. The human penis generally measures about four inches (10 cm) and considerably longer ones occur the maximum reliably recorded so far is 14 inches (35 cm). Nancy Tanner, following a hint by Freud, proposes that male bipedalism may have been associated with a more visible penis, presumed to be attractive to women. But if this is true, how account for female bipedalism?

The only theories suggesting a function for a larger (especially thicker rather than longer) penis have to do with an apparently wider vagina. I have been unable to find detailed reliable information about vaginal openings in the various primates, but it seems clear that there must be something larger or at least more accommodating about the human vagina because of the larger skulls of human infants. Increased size of the penis might also in some way be linked to the loss of a penis bone, or the nonexistence of genital locking (increased length might be a compensation, associated with paternity certainty).

Upright posture and walking on two rather than four feet (or two feet and two knuckles, as gorillas and chimps do) have been tied up with two profound changes in human sexuality: the development of long-term sexual bonds rather than general promiscuity, which tends to be true of primates, and the development of year-long sexuality rather than the normal mammalian pattern of breeding seasons, or copulating only when the female is in oestrus (heat).

Long-term bonds are fairly rare among mammals. Monogamy is even rarer. Among primates, only gibbons and a few New World monkeys are

monogamous. Marmosets were formerly thought to be monogamous also, but are now known to have a different and relatively uncommon arrangement: a single female will be associated with several males and mate with all of them. For mammals in general, the list of monogamous species is not much longer: beavers, foxes, badgers, mongooses, hooded seals (but not fur seals), possibly also rhinos, roe deer (but usually not other deer), and hyraxes (small animals closely related to elephants, which are not monogamous). Socially, monogamy has the drawback of not expanding networks of various kinds. It is not immediately obvious what the evolutionary advantages of monogamy are.

With regard to seasonal sex, it should be realized that most animals engage in no sexual behavior at all during most of the year: about 90 percent of all mammals and animals mate seasonally. Mice are a common exception to this, and the same thing is generally true of species that live in the tropics and most domesticated animals such as dogs, cats, cows and pigs (but not sheep). Possibly human sexuality could be interpreted as a consequence of domestication.

Some primates have breeding seasons. Japanese macaques mate nearly always during winter months, and macaques in a monkey colony off the coast of Puerto Rico restrict mating to the period between July and January. Male chimpanzees, on the other hand, seem to mate throughout the year. Pigmy chimpanzees seem to show nearly continuous sexual receptivity. Rhesus monkeys kept indoors under constant conditions do not show any mating seasons, which must be triggered in part by diet and light differences.

It has sometimes been suggested that human mating has seasonal aspects — at least in some groups — but this is unlikely. Among mammals, the seasonality in breeding tends to be timed so as to ensure the best period for birth. Spring is in many ways an optimal period for many mammals and autumn matings are the rule, for example among deer and sheep. With animals that have a longer period of gestation, such as horses, the mating occurs before autumn. Bats mate in the fall but store the sperm for several months before fertilization; once fertilization occurs, gestation is short and birth occurs in the spring. Among human beings births occur throughout the year, though there is seasonal variation. This variation may be cultural, however, since Europe and North America have peak periods for births at different times of the year.

One theory relating upright posture and walking on two feet to significant aspects of human sexuality stresses the human trait of food

sharing. The remarkable thing is that of all the primates, it is only the ones traditionally labeled as monogamous that regularly share food: marmosets, gibbons and human beings. Furthermore, human infants go through a very long period of helplessness. It is much longer than that of chimpanzees; and even chimp babies have to be looked after for the first four or five years of their lives. Chimps, who do not share food except in mother-child pairs, can raise only a single infant at a time.

Owen Lovejoy has proposed that if a proto-human mother had had to raise a child unaided by food sharing with her mate, there would have been tremendous problems in reproducing fast enough for human groups to thrive, particularly since fossil evidence suggests that early human beings died young, generally by about the age of 30. To reproduce successfully and in sufficient numbers, a female could not space her children 8 to 10 years apart, but would have to reduce that period considerably. Lovejoy thinks this was possible only because of food sharing. Food sharing in turn was possible only because human beings began to walk on two feet, thus freeing their hands to carry food back home to a home base. Lovejoy's model is that the mother basically stayed put with the kids, and the father "brought home the bacon." He was willing to do so because human sexuality somewhere along the way must have stopped being bound up with female oestrus and he could be sexually rewarded throughout the year. Even the great variability of appearance among human beings — much greater than among chimps and gorillas — plays a part here, since it probably adds to the tightness of pair bonding among mates.

This model accounts for a great many things: for example, long-term heterosexual bonding, monogamy, the nuclear family, and the sexual division of labor. Lovejoy first proposed the model because of theoretical difficulties associated with the discovery of an apparent ancestor of man known as *Australopithecus afarensis*, who lived between 3,000,000 and 4,000,000 years ago in East Africa. The usual explanation for upright posture and bipedalism — enlargement in the size of the brain and increased intelligence — could not apply to this new find because its head was perfectly apelike and showed no brain increase. Consequently, there must be some other explanation. Hence, Lovejoy's own model.

Unfortunately, there are a number of problems with his reconstruction. For one thing, Lovejoy rejects the classic model of "man the hunter" (proposed by Darwin and championed in the work of Sherwood L Washburn) for another model favored by many recent archeologists: "the gathering hypothesis" (derived largely from the work

of Adrienne Zihlman and Nancy Tanner). This hypothesis plays down hunting altogether, an activity almost always associated with males. It plays up a unisex model of gathering fruits, nuts and other plant products that probably constituted the great bulk of the early proto-human diet, as it still does in the simplest hunting and gathering societies. Consequently, we have to change our characterization of Lovejoy's prehistoric father/mate to someone who "brought home the vegetables," not the bacon.

But the gathering hypothesis produces a huge explanatory hole in any reconstruction that tries to account for what is special in human sexuality and social organization. In hunting and gathering societies, women gather and contribute most of the food for their families. From the point of view of food sharing, males either would not be particularly important or else would even be parasites unless they contributed something special. The most likely special something would have been meat — which is highly prized universally in hunting and gathering societies. But not so, vegetables.

John Tooby and Irven DeVore, in an impressive article appearing in 1987, discuss very serious problems with Lovejoy's view, including the basic issue that in hunting and gathering societies, men do in fact hunt and women gather. If gathering made the most economic sense, as he suggests, why don't the men gather to the same extent as the women?

In addition, Tooby and DeVore point out that the fossil record does not go along with Lovejoy's assumption of monogamy. We have noted before that in species that are monogamous, little or no difference occurs in the size of males and females. Where males are larger, however, this trait goes along with a competition for mates and the reality that one male may have several. The earliest of proto-human beings, the australopithecines, showed such a male-female divergence in size. Presumably monogamy as a regular feature came about much later (some see it as associated with certain forms of economy, in particular plow agriculture).

Throughout the reconstructions of the evolution of human sexuality, much is made of the disappearance of oestrus: the periods of sexual excitability and receptivity of the female. In Helen Fisher's reconstruction, for example, those females who had the longest periods of sexual receptivity had a great advantage: males catered to them by sharing meat and offering defense in return for sexual favors. This led to what Fisher has called "the sex contract," which she sees as the basis for human society, including long-term pair bonding and the division of

labor. Eventually, the periods of female sexual receptivity became year long but in the process, a distinct oestrus cycle disappeared.

Curiously, few theorists have even asked whether the loss of oestrus in females had any corresponding change in males. The one anthropologist to my knowledge who has done so is Mariam Slater, in a seminal but virtually ignored paper delivered in 1978 at the annual meeting of the American Anthropological Association, held in Los Angeles, and later in an expanded version at the New York Academy of Science in 1990.

Slater maintains that among other primates and presumably also proto-human beings, males don't pursue females unless the females are in heat. Apparently males become sexually "turned on" by certain very specific cues given off by the female, such as swelling and color change in their sexual skin or possibly special odors (pheronomes) indicating sexual receptivity. The classic primate (and mammalian) pattern shows the females generating sexual triggers and males responding to these triggers. In a phrase, to borrow sociological expressions, the pre-human female is sexually inner-directed and the pre-human male is other-directed. Support for Slater's theory includes the fact that males in the wild are almost never observed masturbating, they do not rape non-oestrous females, and apparently do not have nocturnal emissions.

After the loss of oestrus, male sexuality changes dramatically. She maintains that it is not anchored firmly in some sort of heterosexual instinct but subject to a variety of conditioning factors. Hence, the possibility of specialized interests such as fetishes and sadomasochism (which are usually described as primarily male interests) and also of extensive homosexual outlets, which would be impossible in the classic primate scheme of things.

As a matter of fact, the question becomes: why do so many males become heterosexual? Slater's answer is that they are not biologically programed to but are following the models of previous generations going back to pre-human society: the heterosexual pattern associated with the instinctual set-up continues in a cultural setting because of modeling of traits. In short, human beings have preserved an ancient pattern not because of biology but because of cultural conservatism — in this case, rewarded by the division of labor. For Slater, the loss of oestrus must have occurred after the development of the classic division of labor.

Salvatore Cucchiari takes a totally different line of approach, which is ultimately an offshoot of the gathering hypothesis. In his model (though this is nowhere said), the division of labor must probably follow

the loss of oestrus. In any event, he speaks of the proto-human social groups as bisexual hordes where the main groups of people are children, people who tend children, and foragers (people who gather food) — and these may be either females or males but neither sex can be identified with any particular group exclusively. He asserts that kinship, incest prohibitions, marriage, and the family are all predicated on a subsequent development: what Cucchiari calls the gender system, the conceptualization of male and female into the categories of man and woman. He maintains that these categories could not have existed in the original proto-human set-up and consequently proto-human sexuality was indiscriminate and bisexual.

Eventually, a gender revolution occurs linking women to the reproductive power of giving birth (the role of men in siring children is not yet understood). The consequence of this gender revolution — which he calls "a revolution in meaning, not perception" — ultimately involves controlling sexuality. The first step is the prohibition on homosexual acts. Later come prohibitions on heterosexual incest, along with the development of kinship and the family.

Cucchiari's model is exceedingly interesting, if counter-intuitive. Its correctness is tied up with the validity of the gathering hypothesis — which is in doubt, given the trenchant critique by Tooby and DeVore mentioned earlier. Even the avowed feminist Donna Haraway in her acclaimed book *Primate visions* (1989) concedes that their work cannot lightly be dismissed but is "sophisticated and cogently argued."

One last thing with regard to homosexual behavior and evolution. It is true that homosexual acts involving both males and females are fairly common in nonhuman animals. But most of these incidents have been reported from zoos; accounts from the wild vary.

The general view of many anthropologists, biologists and sexologists is that human homosexual response represents merely a continuation of a mammalian heritage. In at least one aspect, however, this cannot be entirely correct. In most mammals, there would seem to be a virtually automatic mounting response to an individual who "presents" himself; that is, crouches and assumes the female position to show sexual availability. In many instances the "presenting" behavior is only minimally sexual and apparently expresses submissiveness rather than passion. Similarly, mounting is an automatic response to a behavior rather than to a sex. The whole dimension of homosexual behavior as an automatic response seems to be lost among human beings perhaps because of the loss of the presentation position with the general switch

to frontal entry intercourse. On the other hand, much sexuality has retained dimensions of submission, dominance and status.

It has been argued that rape, the most clear-cut instance of domination, is a purely human phenomenon — again because of the loss of female oestrus and the switch to frontal entry. But this is less obvious, and the facts suggest that rape occurs in other species as well. Among mallard ducks, for example, gang rapes of a female occur, often resulting in the female's death since she may have her head held under water until she drowns.

FIVE SEX TECHNIQUES

**The sexual acts have been classified
by several societies before the growth of
modern sexology,
notably in the *Kaama suutra*.**

There are exactly 529 possible positions for sexual intercourse, according to the Indian sexologist Yasodhara, commentator on Vaatsyaayana's *Kaama suutra*. Vaatsyaayana inflates the number considerably by including different arm and leg positions and sometimes other relatively inconsequential details. Take, for example, his description of the *dhenuka* position ("congress of a cow," as it is translated). The main characteristic of this position is that the woman stands on her hands and feet in imitation of a cow and that the man penetrates her from the rear like a bull. Vaatsyaayana adds: "In the same way can be carried out the congress of a dog, the congress of a goat, the congress of a deer, the forcible mounting of an ass, the congress of a cat, the jump of a tiger, the pressing of an elephant, the rubbing of a bear, the mounting of a horse. And in all these cases the characteristics of these different animals should be manifested by acting or producing sounds like them."

Multiplication of sexual positions in this way has been called the *Kaama suutra* fallacy. I shall not perpetuate it here.

A more basic problem is to find out what people do sexually. For the most part we can only ask because human beings, unlike other mammals, seldom copulate in public. This means that they have to be told what to do. In several societies, verbal instruction is aided by sexual apprenticeship. A man may take his son to a brothel to be initiated into the heterosexual adult world — a pattern reported for much of Latin America. In Polynesia, teenage boys were traditionally assigned to older married women who were charged with their sexual training. To my knowledge no anthropologist has undergone such an apprenticeship — and recorded it.

The terms used to describe sexual acts have not been completely standardized, and the traditional terms are neither adequate nor satisfactory on all points. The term "sodomy," for example, has been used with so many different meanings that it is not clear what a particular writer may be referring to. It has referred to sex with animals

or sex involving anal penetration or even other sexual arts (often unspecified). The term should be avoided as much as possible, and preferably altogether.

The term "coïtus" also presents a problem. Specifically it refers to the act of inserting a penis into a vagina (as does the less precise term "intercourse"). It is also commonly used to describe the insertion of the penis into any bodily opening or fold, so that we find expressions such as anal coïtus (placing the penis into the rectum), interfemoral coïtus (placing the penis between the partner's thighs), intermammary coïtus (holding the penis between a woman's breasts). Most of these activities could more accurately be classified as techniques of petting: as preliminaries to vaginal penetration, or substitutions for it. I have therefore coined another term, to *forate*, and suggested to the Kinsey Institute their adoption of it. I define it technically as follows: to insert the penis into some nonvaginal opening or other body fold. The term is derived from the Latin *forum* "open space."

In some instances, only obscene words exist for specific acts and these are hardly suitable for scientific discourse. For example, quite recently in the United States among a few sadomasochistic homosexuals (more rarely heterosexuals) the practise has developed of inserting a hand or arm — sometimes as far up as the elbow — into the rectum or vagina of a willing partner. Very seldom do people try to insert feet, though this also happens. This may be the only sexual practise invented in the twentieth century and was not noted in any of the Kinsey reports. Paul Gebhard, the former director of the Kinsey Institute, has told me that statistically its incidence in the 1940's and before was negligible. It is totally unreported from other cultures, ancient or modern. The earliest written reference to it I know of is in James Joyce's *Ulysses* (1914), in what is almost a stage direction: "Bello bares his arm and plunges it elbow deep into Bloom's vulva." From the sixteenth century comes a curious scene in Michelangelo's *Last judgment* in the Sistine chapel: one of the damned has begun his punishment by apparently having a demon's hand thrust up his anus. Whether this is a sexual joke desecrating the sanctuary where popes are traditionally chosen or merely Michelangelo's imagination without any reference to secret sexual obsessions is unknown. Some Japanese erotic drawings occasionally show unlikely combinations of feet (or toes or heels) and vulvas. Again, their relation to reality remains unclear. Since the 1960's, however, there seems to have been a tremendous increase in this practise. Subsequently a club called TAIL (Total Anal Involvement League) was formed; it had a

membership of about 1,500 men in the 1970's. When the act is discussed it is almost invariably referred to by an obscene expression, or more recently simply as *fisting* (despite the fact that the inserted hand is apparently never clenched in a fist). The term is unsatisfactory on several accounts.

To remedy the linguistic situation, I have suggested to the Institute that they adopt the verb *gantize*, which I define technically as follows: to insert a nonpenile extremity (such as an arm or leg or part thereof) into the anus, less commonly the vagina. The term is derived from the French *gant* "glove" and the idea is to suggest that a hand is inserted into the anus much as into a glove. (Since the appearance of the term *gantizing*, a number of other, more specific expressions have been coined: *brachioproctic* or *brachiorectal eroticism*; *brachioproctic insertion*; *brachiovaginal eroticism*, etc. By being so specific, they fail to capture a significant generalization.)

The pages that follow present a classification of coïtal and some foratal positions that are known to occur in different cultures of the world. Only three dimensions are used in this classification: general posture — lying, sitting, squatting, standing; position vis-à-vis partner — face to face, rear entry; dominance — man on top, woman on top, side by side. Of the many combinations that even these few dimensions could create, only a few are singled out in the anthropological record as culturally recognized positions.

Both partners lying, face to face, man on top
This is the so-called "missionary position," one of several positions technically described as ventro-ventral (belly [to] belly). According to Montegazza, the natives of Tuscany refer to it as the "angelic position" (*la posizione angèlica*); a metaphor at the other extreme is reported from some Arabic-speaking groups who call it "the manner of serpents." The sixteenth-century Tunisian sexologist Nafzaawii lists it first in his catalog of coïtal positions in *The perfumed garden*. He notes that it is a particularly good position for a man with a long penis. Although by no means found or approved of in all societies, the missionary position is nevertheless the most common in reports from other cultures. It occurs among such diverse societies outside Europe as the Japanese, Tibetans (Asia); Chaga, Kanuri (Africa); Crow, Návaho (North America); Kágaba, Yahgan (South America); Sámbia (New Guinea). Among traditional Christian groups, moralists have defined it as the only appropriate or natural position for sexual intercourse because, according to St Paul,

women should be subject to their husbands; the husband must, therefore, assume the dominant position in copulation. It is not for nothing that it is called the missionary position: Christian missionaries have sometimes felt it incumbent upon them to spread its use to societies where other positions predominated. The major advantage of the position is that it is good for ensuring impregnation, since sperm will not readily escape from the woman's vagina. The major drawback is that it may not be as satisfying to the woman as other positions.

A number of variants of this position occur, mostly affecting where the woman places her legs. She may keep her legs apart and flat or wrap them around the man's waist or she may place her ankles on his shoulders. For the most part, anthropologists have not provided enough detailed information on these points to enable us to draw such fine distinctions. Often it is pointless to do so, since these variants may be assumed within the same copulatory act.

Man lying, woman squatting, face to face, woman on top
In the western world this has sometimes been considered an "unnatural" position and the man who prefers it has been suspected of being a latent homosexual. No convenient label exists, but one possibility is to call it the Ur position, because the earliest representation of it was found in Ur in Mesopotamia. Although this position figures prominently in ancient art, at present it is nowhere the preferred or most common one. As a secondary position it seems to be fairly commonly reported, but in one sample of nearly 200 societies, fewer than five percent are stated as practising it. Among these are the Murngin (Australia); Crow, Hopi (North America); Marquesans, Ponapeans, Pukapukans, Trobrianders, Trukese, Wógeo (Pacific). The main advantage of this position — generally recognized by the peoples who use it — is that it gives the woman greater satisfaction possibly than any other. The main disadvantages are that it is poor for impregnation and the man's penis may keep slipping out of the vagina during the up-and-down movements performed by the woman.

Both partners lying, face to face, side by side
The Marquesans call this position "the gecko-lizard manner." No convenient label for it exists, but since it is reported from quite a few African societies, it might well be called the African position. It is the preferred (or only recognized) position in the following African societies: Bambara, Basongye, Dogon, Maasai, Nyoro, Tswana, Turu and Zulu. In

several societies it occurs as a secondary variant thought to be particularly suitable when the woman is pregnant. This is the case, for example, among the Zande (Africa), Crow (North America), Trobrianders (Pacific), Murngin (Australia), Lepcha (Asia), and Goajiro (South America). According to Noël Berckmann, it is the preferred position among the Vietnamese for a very practical reason: their beds are made of bamboo slats. To use the missionary position (which he calls *la position de l'amour classique*) would probably result in the skin being scraped off the man's knees. Unfortunately Berckmann's account comes across as so unscholarly that it is hard to know what to believe.

The advantages of this position include the fact that both partners usually find it restful; it is particularly pleasant when one (or both) of the partners is tired, sick or old. It can also be used during the last months of pregnancy. Its major disadvantage seems to be that some men find it difficult to achieve entry at all. According to Nafzaawii, continued use of this position leads to rheumatic pains and sciatica. No reliable data support his assertion.

Rear entry
Reliable accounts of all positions in this category are so rare that further specifications as to squatting, standing, etc., turn out to be superfluous for our purposes. In Marquesan, rear entry of any kind is referred to as "horse intercourse," or "stick the bottom"; in Arabic it is known as "after the fashion of a bull." Nafzaawii lists a number of Indian positions requiring rear entry; animal names again predominate: one is "after the fashion of a ram," another is "coïtus of the sheep," a third — described as the easiest of all methods — is simply "coïtus from the back."

Rear-entry coïtus seems to be used most commonly for brief encounters in the woods — illicit interludes that may require a quick getaway. In this situation the man usually stands behind the woman while she bends over or rests on her hands and knees. Such is reported for the Crow, Hopi (North America); Buka, Dobuans, Kwoma, Marshallese, Marquesans, Wógeo (Pacific); Lepcha (Asia). According to Berckmann, this is a common alternative to the major position among the Vietnamese and is actually performed on a bed rather than standing.

Early travelers' reports frequently included graphic accounts of rear-entry intercourse among the most technologically primitive peoples, for example the Tasmanians and the Bushman of South Africa — suggesting that they are so primitive that they retain the basic mammalian position. It turns out that modesty, not bestiality, explains the prevalence of this

form among most groups where it is the primary position: to copulate in this way (lying side by side under a covering) in the presence of others round a campfire permits the couple to entertain the fiction that no one else will know they are copulating. Rear entry is most frequently mentioned for some South American Indian groups, including the Apinayé, Chiriguano, Nambikwara, Ona and Timbira. It is also reported, probably inaccurately, as extremely common among contemporary Russians, who consider it highly erotic and refer to it as *rákom* "(in the manner of) the crayfish." In spite of the stigma of bestiality that often accompanies this position, there are advantages to it, most notably the fact that it can be performed during the last stages of pregnancy. It can also be good for impregnation. Disadvantages include difficulty some men experience in entry as well as in keeping the penis in the vagina.

Man squatting, woman lying, face to face, man on top
This is frequently known as the "Oceanic position" because it predominantly occurs in the Pacific. Nafzaawii describes a position that seems to be a variant of the Oceanic position, called "with the toes cramped."

The man usually squats or kneels between the spread legs of the woman, who is lying on her back. He draws her toward him so that they embrace each other while squatting. Variants of this position are reported from the Balinese, Buka, Kusaians, Lesu, Trobrianders, Trukese (Pacific); Santal, Cencu (or Chenchu), Lepcha (Asia); Sirionó, Karajá, Mehinakú (South America); and Tallensi (Africa).

This position achieved a certain notoriety in western intellectual circles because it figured prominently in Malinowski's much quoted description of the Trobriand Islanders in *The sexual life of savages*. Although Malinowski was quite the gentleman (he was actually a Polish aristocrat as well as being a university professor), he is said to have entertained his colleagues at staid academic parties by demonstrating this position. One benefit of the Oceanic position is that it can be carried out with a minimum of bodily contact which encourages young people to have sex with ugly or older partners. On the other hand, as Malinowski has expressed it: "...where love exists, the man can bend over the woman or the woman can raise herself to meet him and contact can be as full and intimate as is desired."

The Tallensi list another possible advantage or disadvantage. They point out that the position the woman is in, vis-à-vis the man, enables her to push him over with a kick.

Man sitting, woman squatting, face to face, woman on top
This position is the preferred one in only a handful of cultures, including the Yap and Palau in the Pacific; it also occurs as a variant among the Trukese and the Marquesans. Nafzaawii discusses a similar one he identifies as Indian and calls "pounding on the spot." Usually the man sits with his legs stretched out. Among the Pukapukans (Pacific), the man folds his legs under him and the woman faces him with her legs on his thighs. Sitting in a chair figures prominently in Chinese erotic art but seldom occurs in other cultures. In fact the oldest known Chinese erotic painting depicts coïtus in a seated position. An advantage of this position is that it is restful and the man can delay ejaculation because motions do not involve sharp pelvic thrusts. Disadvantages include the fact that it may not prove to be vigorous enough.

Standing
Among most cultures of the world any kind of standing position for coïtus seems to be associated if mentioned at all with brief and often illicit encounters. The Fijians, for example, use it exclusively for premarital or extramarital affairs. Standing positions are common in Chinese erotic paintings perhaps because they frequently depict illicit interludes. Nafzaawii mentions several Indian positions where at least the man has to stand: "belly to belly" and "driving the peg home" (in which the woman wraps her legs round the man's waist and her arms around his neck; she steadies herself by leaning against a wall). This second position is similar to what is called *avalambitaka*, "suspended congress," in the *Kaama suutra* but here it is the man who leans against a wall while the woman sits on his clasped hands. She throws her arms around his neck and hugs his waist with her thighs. She is the one who moves, by shifting her feet, which are touching the wall the man is leaning against.

Anthropological accounts of standing coïtus seldom include such gymnastics. Among the Trukese, for example, people occasionally stand during a quick daytime encounter, with one leg of each partner supported by a tree stump. They are also said to practise a variant where the woman rests her foot on the man's shoulder. The description is not clear and leaves a great deal to the imagination. Standing while partially submerged in water (as in a lake or stream) is occasionally reported, e.g., from the Mehinakú (South America).

Occasionally other coïtal positions are mentioned for a particular society. A truly exotic example is the "flying fox" position, in which the

copulating couple hang from a beam with their legs free. There is a
single reference to it in the sexological literature. It is recorded for Fiji
but seems likely to be restricted to folk fantasy. But even sexual fantasy
is cultural and will be mentioned when relevant.

Other variants and idiosyncratic techniques are mentioned in the
chapters dealing with specific cultures.

Other techniques
Few noncoïtal erotic techniques have been mentioned in anthropological
studies. What is known can be briefly summarized here: interfemoral
foration and genital apposition — that is, placing the penis between the
partner's thighs or against the vagina without penetration — are reported
from various cultures such as the Tuareg of the Sahara and the
Pukapukans of the Pacific, but are traits mainly associated with east
Africans.

Anal foration (frequently referred to as sodomy) is rarely mentioned
as a heterosexual technique, though it does occur, for example, among
the Mangaians during menstrual periods. On the other hand, it seems to
be the most common homosexual act among primitive peoples. In many
New Guinea societies anal foration is absolutely obligatory for young men
as part of the puberty rites: it is generally believed that boys will not
grow properly unless they have received the semen of older men.
Various positions occur involving both face-to-face and rear entry, but
they are seldom discussed in any of the anthropological accounts. Only
a few recent western sex manuals for male homosexuals explore the
possibilities.

Other kinds of foration are even less frequently discussed. An
exception is again provided by the Mangaians, who practise a number of
different kinds of foration including placing the penis between the
woman's breasts or in an armpit. These variants occur primarily when
the woman is menstruating because menstrual blood is thought to cause
venereal diseases.

Oral-genital acts are reported most from high civilizations and from
parts of the Pacific and Africa. From the scanty information that exists,
it appears that mouth-penis contacts are more common than mouth-vulva
contacts. In the United States both are more frequent with those who
have been to college than with the less well educated. In particular,
American male homosexuals are said to be orally, rather than anally,
oriented; but fellation even among American heterosexuals is believed to
have become quite common since the 1950's. The French call this

preoccupation *le vice americain*. Mouth-penis contacts are sometimes
distinguished as fellation (or fellatio), in which the person applying the
mouth is the active partner and sucks, licks, moves up and down on, and
even bites the penis; or irrumation, in which the person whose penis is
being stimulated makes coïtal thrusts in and out of the partner's mouth,
which is literally a vagina substitute.

Soixante-neuf or sixty-nine is in a heterosexual context simply
simultaneous fellation and cunnilingus; in a homosexual one, it is either
mutual fellation or cunnilingus. Reports of it are scattered and few, but it
is depicted on ancient Peruvian pottery and in art from other erotic
high cultures. Soixante-neuf figures as part of the normal erotic training
program of Mangaian youth.

Information on animal contacts, masturbation, deep kissing and
various other sexual acts is seldom adequate. They are discussed in the
chapters on specific cultures.

SIX PHYSICAL TYPES

Variations attributed to race, geography, temperament and even sex itself indicate the complexity of human sex roles as well as the anatomical differences.

The folklore of my youth was filled with stories of women whose vaginas opened sideways or else were so cavernous that a man could fall in while copulating. And with jokes about men with penes so long they could be carried under the arm. And with tales of how the tropics inflamed sexual passions to match the heat. And with detailed accounts of what a "real man" was like and vivid narrations of what "bad women" did.

Comparable stories are found in the adult world. In this chapter we shall look at the hard and fast data available for many of these and similar topics.

In spite of the enormous casual interest in such matters as racial differences in sexual anatomy — particularly the length of penes and the size and location of the vaginal opening — very little serious work has been devoted to the matter. From the information available it seems that actual physical variation in sex organs in human beings is of little physiological consequence and may occur within the same group to the same extent. The only truly unique characteristic I can think of is reported from the Bushmen of southern Africa. Among them the flaccid penis often looks as though it is in semi-erection, but no known physiological consequences follow from this.

The greatest amount of information available about variation in sex organs deals with the size of the penis. The studies are unsatisfactory in many ways and are not consistent. In the findings of a Dr Robert Chartham reported in *Simon's book of world sexual records* (1975), the consistently greatest size of the erect penis is found among Englishmen with a length of $10\frac{1}{2}$ inches (26.7 cm); Negroes — not otherwise defined — are attributed $7\frac{1}{2}$ inches (19 cm); Frenchmen, $7\frac{3}{4}$ inches (19.7 cm). I gather that Dr Chartham is himself English. His findings are not in accord with the assertion of an early twentieth-century sexologist, writing under the pen name of Dr Jacobus, that the largest penes of any human population are found among Arabicized Sudanese Negroes, with recorded

dimensions of 12 inches (30 cm). He describes such an organ as a
"terrific machine — more like that of a donkey than of a man."

The most extensive data on penile size was gathered by the Kinsey
team for over 6,000 men, both white and black. Unfortunately, the data
refer merely to penis size and give no indication of other body
dimensions, such as height (although it does specify whether the
individual is college educated or not). It would have been interesting to
find out if folkloristic fantasies correlating nose length or size of hand
to penis length had any basis in fact. The subjects measure themselves,
so that there may be some inaccuracy in the figures. Length is given to
the nearest quarter inch and the nearest centimeter: the smallest penis
was 1½ inches (3.8), found among whites — the smallest among blacks
being 2¼ inches (5.7 cm). The largest, 6½ inches (16.5 cm) was also found
among whites — the largest among blacks being 5½ inches (13.97 cm).
The most frequent penile size for blacks, 4½ inches (11.4 cm) was a little
bigger than that for whites, 4 inches (10.2 cm).

These figures do not include absolute extremes. For example, men
with a flaccid penis 14 inches (35.6 cm) and possibly more in length
exist among both white and black, although they would seem to be quite
rare. Some porno magazines have reported the existence of a man ("Long
Dong" Silver) with a 19-inch (48.3 cm) penis. To my knowledge the
measurement is unconfirmed by any reputable researcher.

Variations in female genitals have also been reported but no reliable
statistics exist. Measurements are hard to make. One variation is the so-
called "Hóttentot apron," found among Hóttentots in southern Africa.
It is often not clear whether the condition, which involves very long
labia minora, is really natural and not induced by stretching, as in many
societies throughout the world.

The older anthropological literature differentiated a number of
breast shapes in human populations, such as conical versus hemispheric,
and noted variations in the formation of the nipple and the areola (the
colored area round the nipple), but precise measurement is hard because
no natural boundaries are readily found. Very little comparative
information is available.

Variation in age of maturation and duration of active sexuality
With regard to female sexual maturation, it is clear that populations
vary, but for the most part there would seem to be as much if not more
individual variation as there is ethnic or racial variation. Some scholars
believe that in the past 100 years the onset of menstruation has

decreased by about four years. In 1860, menstruation began at about 16 to 17. In 1960, the age had gone down to 12 to 13. This pattern is found in Great Britain, the United States, Norway, Denmark, Sweden, Finland and Germany. However, statements from the ancient Romans as well as from mediaeval Arabs show that girls generally became mature between 12 and 14. Among Orthodox Jews, girls traditionally were married shortly after puberty, at about 13.

At the present time Cuban girls and Chinese girls in Hong Kong have the earliest recorded average age of onset of menstruation: a little more than 12 years. In some parts of the world, the average age is over 15 — as among Greenland Éskimo and South African Bantu, not to speak of the Bundi of New Guinea, where the average age has been reported as 18.8 years. It has been suggested that we are not dealing with racial or ethnic variables; rather with diet and sociocultural considerations that were fairly close to those of nineteenth-century England.

It is generally asserted that girls in warmer climates menstruate earlier than those in cooler climates and that climate has other effects on the menstrual cycle. Alan S Parkes mentions a study of 192 American army nurses transferred from the United States to New Guinea, where the tropical jungle heat was said to have had the effect of shortening their average menstrual cycles from 27.7 days to 26.9. But here there are problems with the way in which the data were collected so that this particular study can hardly be thought crucial (if even significant). Ashley Montagu maintains that higher temperatures and humidities delay the onset of menstruation and in general retard development of reproductive functions. He cites data on American girls born and brought up in the Panama Canal zone who also began to menstruate later than girls in the United States. The variables are many, the studies few.

The onset of menstruation is usually taken to mean the onset of fertility, but this seems to be undue and a case is generally made for what is called adolescent sterility. This means that there is a period after menstruation begins (perhaps as long as four years) during which conception is not possible for many girls. The reason for such a period has been attributed to the delayed secretion of a hormone produced by the pituitary gland called the luteinizing hormone.

But this does not mean that no girls can get pregnant during this period. In Great Britain in 1971, about 4,000 girls under 16 were known to become pregnant. A girl of 12 had an abortion (her lover was 13). The youngest mother ever recorded was a five-and-a-half-year-old

Peruvian girl, Lina Medina, whose child was delivered by caesarean section. This girl began to menstruate at five months. (Her child was raised as her sister.)

The variability of the age at which menopause occurs is even greater than that for the onset of menstruation, although 50 is generally taken as the maximum age. However, an American woman is said to have given birth at 57.

The data for the sexual maturation of boys are not as clear as for girls. There really is no event in a male's life that is truly comparable to menstruation. Information available about first ejaculations (however produced, including nocturnal emissions) suggests that there is an enormous variation even within a single population. Kinsey found a range from the age of 8 to 21, but noted that 50 percent of his sample had their first ejaculation at about 13 years and 10 months. He also found that there was no significant difference between whites and blacks in this matter. Information about other groups is simply lacking.

Even the age of the first appearance of pubic hair or onset of change of voice does not seem to vary considerably, though there is said to be a difference of almost two years in the development of pubic hair in Israeli boys of Middle Eastern and European backgrounds. In the United States it has been reported that virtually no difference exists between white and black boys on this score.

Intensity of sexual interest and even the duration of sexual activity may differ from one group to another, but when it does, it seems likely to be cultural rather than biological or racial. As to the period of sexual activity, for the most part we must rely on anecdotal accounts. One of the fullest of these is given by Sula Benet for the Abkhasians, a people living in the Caucasus in the south of the Soviet Union. They are among a number of other Caucasian groups famous for their remarkable longevity. According to the official census for 1954, there were 100,000 ethnic Abkhasians living in the Soviet Union and 2,144 of them were 90 or older. Several were more than 100. Benet has indicated cultural factors that may account for this longevity and among other things points out that only 79 of the people over 90 lived in urban, nontraditional areas.

The Abkhasians have no notion of "dirty old man" — or "dirty old woman," for that matter. They believe that regular sexual relations should start late in life. Abstinence in youth is held to prolong sexual potency and promote general physical and psychological well-being. Many men are said to retain sexual potency far above the age of 70, and

at least one man is known to have sired a child at the age of 100: doctors obtained sperm from him when he was 119 and he still maintained his sexual interest and potency. Unfortunately, no hard and fast figures are available for these assertions of vigorous old Abkhasian men. It is interesting to compare Kinsey's findings for American men: 75 percent of his sample were potent at 70 but only 20 percent at 80. Alan S Parkes notes that a certain American farmer almost came up to Abkhasian standards: he produced 16 children during his first marriage, and a seventeenth by a second wife in his ninety-fourth year. It is perhaps the fact of longevity rather than sexuality in old age that is so extraordinary among the Abkhasians.

One of the assertions of early travelers (including Marco Polo) was that primitive men differed from the civilized in that some groups had a rutting season. The closest thing to this that has been reliably reported for any human group involves variations in seasonal birth rates. Mammals tend to give birth in an optimal time for ensuring the survival of the offspring, and there might be tendencies of this sort among human beings as well. For example, Ethel Nurge found that in rural Germany more babies were born in that period of the year when there is less work to be done — presumably this would be of survival value because the infant would be better tended. The highest birth rate occurred in March; however, although November has virtually the same workload as March it has a significantly lower birth rate, so deterring factors must be more complicated than mere workload. A number of other factors come to mind: intercourse may be most frequent during times of greatest leisure, for example, in summer vacations in western cultures.

Obviously, temperature and climate enter into the picture as well, since copulating at 50°C (122°F) awash in a pool of sweat or at minus 10°C (14°F) when one is freezing to death, does not present a very enticing situation. But things are never quite that straightforward. Even fairly plausible suggestions must be checked carefully. For example, the lower conception rate in wintertime in Europe is sometimes explained partially in terms of hot, heavy underwear worn by men, which presumably reduces their fertility, in much the way that this is done for some domestic animals by enclosing the scrotum in an insulating bag. But Parkes relates the following incident that indicates that human testes may become desensitized to heat. While he and a fellow biologist were in India, they went to a restaurant in Delhi where the cooks, wearing only loin cloths, squat on top of special cauldron-shaped ovens, *tenduurs*, with the top open at floor level, half-full of red-hot charcoal. This

situation was clearly more drastic than heavy underwear. Parkes's companion, curious about the reproductive consequences of working in such conditions, asked one of the cooks whether he had any children. "Oh yes," was the reply, "a large family." The man had been working at the job nearly all his life: "like my father before me, and his father before him." Another problem with the underwear theory is that the conception rate is reversed in the United States.

For one society where there has been extraordinarily high concentration of births in the spring, a cultural explanation rather than a climatic or biological one would seem to make at least partial sense. The group is the Yurok of California. Alfred L Kroeber suggested that the concentration of births in the spring among them should be attributed to a preoccupation with shell money and the tabus associated with it. The curious factor is the belief that if sexual intercourse is performed in the house where the shells are kept, the shells will leave that house. A man never sleeps in such a house with his wife; rather, he sleeps in a separate "sweat-house." It is only during the summer months when the couple can sleep together outdoors in comfort that they normally copulate. And so births tend to occur in the spring. Although there are elements of the implausible in this explanation — most notably in the fact that year-long sexual receptivity goes unrequited for an extraordinarily long period of time — nevertheless it helps to explain an otherwise unlikely occurrence.

Among the Éskimo, a comparable seasonality for copulation has received much attention, but the pattern is practically the reverse of the Yurok situation: there is a very low conception rate during the summer.

Again, positing a rutting season seems unwarranted, but some sort of climatic explanation is possible. There is some evidence that the reproductive cycle is seriously affected by the six months' daylight and six months' darkness alternation of the Arctic. Dr Cook, the ethnographer accompanying the first Peary North Greenland expedition, reported that menstruation was generally suppressed during the winter period of day-long darkness. This is not, however, confirmed by other reports: a Dane living in Greenland who married an Éskimo woman found she had no apparent change in her menstrual cycle throughout the year.

In any event, it is clear that the sexuality and reproductive abilities of human beings are affected by climate and geography, although precisely how is not clear. One of the most famous instances of such effects concerns altitude. In 1545, the city of Potosí was founded in

Bolivia. It is one of the world's highest cities, its altitude being 13,045 feet (3,976 m) above sea level. No child was born to Spanish settlers until 53 years after the foundation of the city. But native Indians had made high-altitude adaptations (comparable in some sense to their barrel-chestedness to facilitate breathing) and did not suffer from sterility.

In spite of occasional examples of this sort, for the most part evidence suggests that human sexuality varies more within a group than across groups and that the variation across groups can by and large be ascribed to cultural rather than biological differences.

Sex, physique and temperament

The ancient Hindu sexologists attempted classifications of human beings according to physical type and temperament and tried to suggest which combinations were the most desirable. For example, in the *Kaama suutra*, men are classified as to size of penis, and women as to depth of vagina; both are further classified as to degree of passion and also by the amount of time they take in coïtus. No attempt seems to have been made to correlate these various components but best-partner combinations were suggested.

In a later Hindu erotic manual, the *Anangga rangga*, a correlation between temperament and penis size and vagina depth is made. For example, a man with a large penis (described as one that in erection is 12 finger-breadths long) is called a Horse-man in both books. But in the *Anangga rangga*, both his physique and temperament are predicted from this one feature.

The classification of women is more complicated because vagina depth is the basis for one typology but this is superimposed on another dealing with total appearance and character. The genital typology talks of the Deer-woman, with a depth of six fingers; the Mare-woman, nine fingers; and the Elephant-woman, 12 fingers. The last of these is decidedly the worst, being unclean, noisy, gluttonous in the extreme, wicked and utterly shameless. The other classification sets up four types of women. Of these, the most desirable is the Lotus-woman, who is beautiful, courteous and pious. Her neck is so delicate that the saliva can be seen through it. Her vagina represents an opening lotus-bud and her vaginal secretions are "perfumed like the lily which has newly burst." The other types are the Art-woman, the Conch-woman and yet another kind of Elephant-woman — again the worst of the lot with her coarse body, choked voice, slouching walk and insatiable sexuality.

This kind of classification is interesting in itself but hardly contributes to a scientific understanding of a relationship between physique, temperament and sexuality.

The scientific classification of physique dates back to Hippokrates (c 400 BC). The most important recent work in trying to create an adequate typology is surely that of William H Sheldon in the 1940's. He isolated three components of extremes in general body type: endomorphy (round, soft, fat); mesomorphy (square, hard, massively muscled); ectomorphy (thin, fragile, delicate).

These components show up in the genitalia as well. (Unfortunately, nearly all typologies of physique deal primarily with males; Sheldon's work is no exception and a comparable study for females is not available. Hence the bias of the following discussion.) An endomorph has a penis that is short and small and sometimes almost completely hidden within the pubic hair; it seems to be practically undeveloped. The foreskin is frequently "too long" — which is undefined. Undescended testes are common. A mesomorph is described as nearly always having genitalia that are compact and "well developed" — again, undefined. The scrotum is said to be relatively thick and firm. An ectomorph has genitalia that seem overdeveloped in comparison with the rest of the body. The penis is characteristically quite long. The scrotum is also typically long and permits the testicles to hang loosely. The left testicle is usually lower than the right. We must take Sheldon's word for all these assertions since the photographs he provides block out the genitals altogether.

With regard to his observation on the relative heights of the testes, it has more recently been shown that in right-handed men the right testis tends to be higher whatever the physical type. The opposite holds true for left-handed men. This has nothing to do with actual weight of the testis, since the right testis is heavier and of greater volume.

Concerning differences in the degree of sexual interest, ectomorphs are described as being intermittently overcome by an overwhelming sexual drive and to experience the most intense sexual ecstasy. Although people who are endomorphic tend to need companionship most strongly, sex is not their most pressing need. Mesomorphs tend to be matter-of-fact about sex and fairly unimaginative.

Sheldon also sets up three main components of temperament: viscerotonia (love of eating, indiscriminate amiability, need of people when troubled); somatotonia (love of exercise and physical adventure and lust for power, competitive aggressiveness, need of action when troubled);

cerebrotonia (inhibited social behavior, emotional restraint, need of solitude when troubled).

His correlation between physique and temperament is the crucial and most controversial aspect of Sheldon's approach. For one thing, it takes no account of cultural influence. Consider, for example, the case of Boris, who is written up in some detail as a subject showing extreme somatotonia as well as mesomorphy. For us the crucial parts of his history are the sexual aspects. He seems to have become fully mature physically at 14, and in fact was sexually experienced at that age. He is described as sexually well endowed, with large testes and "fairly massive penis of moderate length and well-developed corona." Since the age of 16 (he was 21 at the time of interviewing), he has not had a nocturnal emission. Sexual intercourse is described as a matter-of-fact business for Boris and he is not sexually stimulated by pornography of any kind or by the thought of a girl. Intercourse is an exercise lasting from 10 minutes to half an hour. Although Sheldon's description does not include this information specifically, Boris seems not concerned with foreplay or sexual experimentation.

The sexual picture Sheldon draws of Boris is totally consistent with the definition of somatotonia, apparently generated from Boris's basic mesomorphy. But this picture of Boris's sexuality rings a cultural bell that Sheldon could not have been aware of at the time of writing (1942). Everything about Boris's sexuality, from rarity of nocturnal emissions to nonstimulation by pornography and early coïtal experience is essentially what Kinsey found to be the pattern associated with noncollege-educated, working-class people (which actually was Boris's background) — Kinsey's "lower level." Culture rather than physical constitution may be the key element here.

This sort of thing is one of the main problems of Sheldon's work: lack of a cultural perspective. Very little work has been done to revise his scheme using cross-cultural testing and data. But Sheldon, in spite of this perspective, has created a typology that is flexible enough to be used in a considerable number of different situations — such as the study of sexual behavior.

How many sexes?
"... There are more than five sexes, and only the Demotic Greek distinguishes among them." So wrote Lawrence Durrell in his haunting novel *Justine*. Recent work in genetics suggests that in at least some ways Durrell may not be far wrong.

Since the 1960's especially it has become clear that the genetic combinations are more complicated than was assumed earlier. In human beings, there are usually but not invariably 46 chromosomes (not 48 as was previously believed). These chromosomes are arranged in 23 pairs. Determination of the sex of an individual depends on the presence of chromosomes labeled X and Y. Like all mammals (but unlike birds, which reverse the pattern) the presence of two of the same chromosomes (XX) produces a female, two different chromosomes (XY) a male. A YY pattern does not occur. Whatever the physical appearance of an individual, these patterns are now taken to define the sexes so that, for example, in sports competitions, unusually robust "women" have sometimes been given chromosomal tests (to prevent men from posing as women to gain an unfair advantage).

But other chromosomal patterns occur, such as X, XXX, and XYY. The last pattern (known as XYY-trisomy) has gained much publicity because a high incidence of this pattern has been found among persons — all apparently males — convicted of crimes of violence or sex. In France and Australia, courts have taken XYY-trisomy as grounds for lessening punishment or even acquittal in criminal cases, but there is no positive evidence that there is a causal connection between this condition and any criminal acts at all. People with the XYY pattern have been described as having a kind of "supermaleness," being tall and aggressive.

"Superfemaleness" has sometimes been attributed to people with XXX (X-trisomy or triple-X syndrome), but these appear to look and act like ordinary women. They experience puberty and are usually fertile.

A single chromosome (X) condition — symbolized as XO — is known as Turner's syndrome and is thought to be quite rare. An individual with such a syndrome looks like a physically immature female. Ovaries are absent or rudimentary. Unless treated with female sex hormones the person does not undergo puberty or experience a sex drive. Individuals with a single Y chromosome have not been found. Turner's syndrome is the only known condition in which a single chromosome pattern is not lethal.

The XXY pattern is known as Klinefelter's syndrome. Persons with such a syndrome appear to be men. They are tall and thin with small genitals; some develop breasts. Such men are sterile and usually sexually inactive. A number of variants are generally included under Klinefelter's syndrome: XXXY, XXXXY, XXYY, XXXYY.

In a sense, these 10 or so chromosomal patterns could be defined as separate sexes. However, they never are and instead are treated as pathological conditions. Despite the enormous complexity of the nature of sex assignment, modern westerners have resisted dealing with more than two sexes (except in very few cases). Other societies have occasionally been less rigid in their folk classification — particularly with regard to individuals who seem to combine features of both sexes in some way.

Hermaphrodites
It must be stated at once (despite numerous sensational accounts to the contrary) that there are no real hermaphrodites among human beings in the sense that both male and female reproductive capacities exist in the same person at the same time or even at different times during the individual's life span. This is also true of all primates and indeed of all mammals. It is only in lower forms that we find both types of hermaphroditism. For, example, simultaneous hermaphroditism exists among earthworms. To copulate, an earthworm only needs to find another mature earthworm. They lie in close contact next to each other and simply exchange sperm through grooves in their bodies.

A different system is followed by a large shell-less snail called the seahare. Seahares do not exchange sperm, but while one seahare mounts another, a third may mount the top one. The number of seahares involved in such copulations may be seven or eight and sometimes the one at one end swings round to mount the one at the other end, forming a true hermaphrodite daisy-chain.

Sometimes with this sort of hermaphroditism, self-fertilization takes place and no partner is needed. The tapeworm is an example of this and for it self-fertilization is almost a necessity because quite frequently only one tapeworm exists in the host animal's body. Self-fertilization is exceedingly rare in the animal kingdom (though fairly common among plants).

Some animals change their sex at different times of the life cycle as a natural process of maturation. Such sequential hermaphroditism is found among oysters and a number of other marine animals such as the hagfish (which has many sex changes during its life) and the cleaner fish, whose sex changes are triggered by social conditions: when the one male fish in a group dies, the largest female assumes his role and actually changes sex.

Among human beings, the term hermaphrodite has been used to refer to an individual whose sexual anatomy is ambiguous and who is in a sense sexually "unfinished" rather than containing equally functioning sets of sexual organs. In different societies, the reaction to such individuals varied considerably — from awe to disgust. Among the ancient Greeks and Romans, babies born with ambiguous sex organs were usually killed, even though hermaphrodites were a common subject in Greek art. Among the Pokot (Suk) of East Africa, boys with sex organs considered too small (even if unambiguously male) are not allowed to participate in male initiation rites, may not marry, and lead generally pitiful lives. The Návaho of the southwestern United States and the Gilyak of Siberia take quite a different view and hold such individuals in high esteem.

Human "hermaphrodites" have traditionally been differentiated as "true hermaphrodites" or "pseudo-hermaphrodites," and virtually all general sexology textbooks have preserved this distinction. Traditionally, true hermaphrodites have some traces of both ovaries and testes. Usually, the external appearance shows masculine sex organs but feminine breasts. Some hermaphrodites of this sort menstruate.

Pseudo-hermaphrodites have only ovaries or testes but not both, but because of hormonal factors the individual may have the appearance of the opposite sex. For example, an individual with female sex organs may have a clitoris so enlarged that it is taken to be a penis; and the folds of the labia may be fused to such an extent that they are taken to be a scrotum.

Experts such as John Money, however, maintain that this distinction between true and pseudo-hermaphroditism is unjustified and that it is based on "the mistaken belief that only the gonads revealed the truth." He further points out that the traditional medical typology of hermaphroditism is quite inadequate and has himself tried to remedy the situation with a much more elaborate scheme.

A situation that has occasioned a good deal of research and speculation involves a number of cases reported primarily from the Dominican Republic, which seem similar to a kind of sequential hermaphroditism but really involve mislabeling males as girls at birth. At puberty these genetic males raised as girls become biologically obvious boys: their voices change, they become muscular, and their penis grows so that it can no longer be mistaken for a clitoris. The situation has in fact become so well known among the three rural villages in the area of Santo Domingo where this has been reported that a special term has

become current for individuals who make these apparent female-to-male sex changes at puberty: *guevedoces*, literally penis-at-twelve-[boy]s. In short, an expectation exists that a certain number of girls will become males after puberty. As a matter of fact, some 38 from 23 families have been documented. At birth, they are at best sexually ambiguous with an absent or clitoris-like penis, undescended testes, and a scrotum that resembles labia. These traits are brought on by a hormone condition known technically as steroid 5-alpha reductase deficiency.

The extraordinary thing is that many of the individuals involved also make a social change from female to male roles after puberty. At least 13 individuals were actually observed to make such a change (still others have been alleged to do so). Some of the crucial questions involved bring in the perennial nature-nurture controversy as well as the way in which natives conceptualize the sexes in the first place.

With regard to the first question, social constructionists (who are on the nurture end of the nature-nurture continuum) would play up the apparent lack of adaptability in changing sexual identity after a childhood of being reared as one sex rather than another. John Money, J G Hampson and V L Hampson have taken a position that sex assignment (i.e., being labeled a boy or girl in infancy) and rearing, rather than biology, determines gender identity. A case of some notoriety tending to support their view comes from the United States. A boy (one of a set of twins) had his penis badly damaged during circumcision and the decision was made when he was seventeen months old to rear him as a girl. The initial reports suggested that he made an impressive adaptation to his sex reassignment. Some saw this as a triumph of nurture over nature.

But critics such as Richard Green have maintained that as the individual grew older, unambiguous masculinization took place and that nature could not be denied. The case seems to some to be very like that of the myth about the ancient Greek hero Achilles who was brought up as a girl to protect him from the prophecy that he would die fighting at Troy. Achilles was discovered to be a boy because he chose masculine toys (play weapons) rather than dolls despite his upbringing. In other words, nature will out.

In point of fact, the American's later life history is unclear because his family has decided to shield him from further psychological probing.

Gilbert Herdt, reporting on a situation similar to the Santo Domingo one but found in a New Guinea group he refers to as the Sámbia, adds an important dimension to the problem: the way in which the natives

themselves conceptualize the situation — in technical terms, the *eemics* *(emics)* — as opposed to the objective reality as it appears to outsiders — the *etics*. He notes that the Sámbia have three sex categories: male, female and *kwolu-aatmwol* "hermaphrodite" (which he translates as "male thing-transforming-into-female thing"). Although infants with ambiguous sex organs might be killed at birth, if the *kwolu-aatmwol* were thought originally to be females, they would almost certainly survive. However, later on in adulthood they might take on some male roles, but apparently only if they were exposed to humiliation after marriage when their true condition was discovered. Unlike the Dominican *guevedoces*, they do not seek out such a role even though the position of men would seem to be considerably more attractive from the point of view of power and prestige.

Such situations seem clearly more than a simple nurture or nature model can handle. Herdt advises: "We do not have to alienate biology from culture, and gender identity is not merely an illusion of culture. But an illusion it would be to imagine that the answer to the problem of mistaken gender could be solved without the work of culture and the study of whole lives."

The situation is further complicated by the existence of a number of people of unambiguous gonadal, chromosomal, hormonal and anatomical sex who nevertheless feel that they are genuinely members of the opposite sex. They consider themselves women trapped in the bodies of men, or vice versa. Such people have been reported from a number cultures, but until recently had to assume the role of transvestites or else be castrated, as is the case with many individuals among the *hijraa* of India. They are now called transsexuals, a term coined by D 0 Cauldwell in 1949, and have received a flood of publicity because of sophisticated operations that have recently been developed which change the anatomy quite successfully, though reproductive functioning has not yet been achieved.

Jan Morris (née James Morris), a postoperative transsexual who was famous for his masculine exploits when he was still socially a man, has described transsexualism as "not a sexual mode of preference. It is not an act of sex at all. It is a passionate, lifelong, ineradicable conviction, and no true transsexual has ever been disabused of it."

The earliest reference to transsexuals in any sense may be in classical mythology — Venus Castina is said to be the goddess who is concerned with and sympathetic to the yearnings of feminine souls locked up in male bodies.

The Emperor Nero is said to have ordered one of his ex-slaves, a young man called Sporus, to undergo a sex-change operation. Nero had previously kicked his pregnant wife, Poppaea, to death. Filled with remorse, he sought someone who looked like her to take her place. Sporus was the closest look-alike. After his operation, the two were married with all traditional trappings, including a bridal veil and a dowry. Sporus lived as a woman from that time on.

In the West, surgical technology to effect a reasonable facsimile of the opposite sex was reported by the end of the nineteenth century. One of the first known postoperative transsexuals started out as a woman, Sophia Hedwig, whose operation and treatment in 1882 brought her a penis of sorts, a beard, and the name Herman Karl. The most famous instance is that of George Jorgensen, who in 1952 became Christine Jorgensen. Since that time several thousand transsexual operations have been performed and greater surgical finesse has been developed. There were between 3,000 to 6,000 transsexuals (mostly men wanting to be changed to women) in the United States in the 1980's. Anne Bolin suggests that as many as 60,000 may exist throughout the world.

Some societies recognize intermediate "sexes." One group that has recently been written up is found in Oman (controversy exists as to how best to describe the situation). This culture observes the custom of purdah, prohibiting women from socializing with men who are not related or married to them. The curious thing is, however, that there is a group of men known as *xaniith*, who may intermingle freely with women as though they themselves were female. Unni Wikan regards them as transsexuals, but none has gone through any transsexual operations or been castrated. Some eventually return to a masculine role and are then forbidden to mingle freely with women; most of these maintain their masculine role till death, while others drift back and forth between sex statuses. It is unknown for women to assume a comparable role.

The *xaniith* dress neither as women nor as men, but as some intermediate category. Whereas both men and women cover their heads, the *xaniith* go bare-headed. They eat with women in public but unlike them do not wear a mask. Wikan suggests the *xaniith* does not become fully assimilated to the woman's role precisely for the sociological reason that he is what no Omani woman should be — a prostitute — and for a *xaniith* to dress like a woman would be to disgrace womanhood. In a sense, the *xaniith* functions to mark off more clearly the roles of men and women by being what they should not be. Wikan found them fairly

numerous; in a town of about 3,000 adult men, there are about 60 *xaniith* — one in every 50. Although it is regarded as shameful to be a passive homosexual, xaniith are tolerated. And it is said that they are the best singers.

Clearly *xaniith* constitute a range of people who may be transsexual, impotent, homosexual or transvestite from a western point of view, but who are conceptualized in a way different from any of these western categories. However, it must be added that apparently the term *xaniith* is a term of abuse and literally means "weak" so that it may be that Wikan may have underplayed their deviant position within the society.

In dealing with homosexuals in western cultures, it has sometimes been argued that they constitute a third sex. Not many people share this view at present. Karl Heinrich Ulrichs, a self-proclaimed homosexual and one of the first leaders of the German homosexual emancipation movement, produced a theory (between 1865 and 1875) that homosexuals indeed constituted a third sex and that to persecute them was therefore unjust, cruel and pointless. The belief that homosexuality is at least congenital (if not associated with a third sex) seems to be a dogma encouraged by the Metropolitan Community Church, a gay Christian denomination that has arisen in the United States as an offshoot of the Gay Liberation movement.

Hindu culture is also described as recognizing a third sex. This is a hodgepodge, including hermaphrodites as well as eunuchs of various kinds. The *hijraa* mentioned earlier are of course included. They often identify themselves with the god Shiva, who is both male and female, but they are specially devoted to the Mother Goddess — specifically Bahucaraa Maataa (here as elsewhere in Indian words, *c* is pronounced like the *ch* in *church*). Professionally they tend to be entertainers but commonly function as prostitutes as well.

Sexual superiority

"Everywhere, in every known culture, women are considered, in some degree, inferior to men." This is a statement by an anthropologist who happens also to be a woman, Sherry Ortner. Her view is challenged by some profeminist anthropologists, but seems to be generally true in a number of ways including actual denial of authority and power to women and symbolically viewing women as polluting. For example, menstrual blood is frequently thought to cause sickness, but semen is regarded as giving health and vigor.

Another way in which women are seen as subordinate to men has to do with the fact that female sexuality is frequently controlled by men but not the other way round. A woman's adultery is almost always a serious offense: this is seldom true of a man's. Furthermore, in all societies the traditional tasks performed by women tend to have less prestige than those performed by men.

An astonishing theory proposed by the famous French sociologist Émile Durkheim suggests that the increasing complexity of society has been accompanied by a decline in women themselves: they have become weaker and their brains smaller, leading to a greater dependence on men. Although the earliest men and women were basically equal in physical and mental capacities, civilization and its need for a tight interdependent family unit created the passive, inferior woman subject to her husband. In a sense, Durkheim's view is the opposite of a more recent one by Ashley Montagu.

Montagu argues that women are superior to men in most ways. He carries this position even to the point of downgrading the Y chromosomes, whose presence is necessary in production of a male. He calls the Y chromosome "really a sad affair; in fact, it isn't really a sex chromosome at all." Hence, the male can be considered "a sort of crippled female, a creature who by virtue of the fact that he has only one X chromosome is not so well equipped biologically as the female."

Men are subject to a number of unfortunate or undesirable conditions simply because they are male. Genetically, at least two different things are at work. First, the Y chromosome carries genes for at least four undesirable conditions that never occur in women at all since they have no Y chromosomes. Fortunately, the drawbacks to these conditions are more aesthetic than anything else: barklike skin, dense hairy growth on the ears; nonpainful hard lesions of the hands and feet; and a form of webbing of the toes (fusion of the skin between the second and third toes).

Second, men suffer biologically because they have only one X chromosome, which may carry harmful genes that are not blocked by the Y chromosome. Women are sometime subject to these conditions, but the chances that they will suffer are far fewer because both their X chromosomes would have to have the same deleterious gene. Some of these sex-linked conditions are of no particular consequence, for example, a lock of white hair on the back of the head, double eyelashes, red-green colorblindness and various forms of baldness — including congenital baldness. But others can be quite serious indeed, including

haemophilia, a kind of glaucoma, mitral stenosis (a head deformity), wasting of the eye (optic atrophy), wasting of the muscles of the legs (peroneal atrophy), retinal detachment and thromboasthenia (a blood defect). Over 30 conditions of this sort are known.

Even statistics of life *in utero* make a case against male superiority. Montagu estimates that at the moment of fertilization for every 100 female embryos there are about 120 to 150 males. The reason for the considerably greater numbs of males at this time seems to reflect the advantages of the smaller size of the Y chromosome as compared to the X: the Y has greater mobility and speed, enabling it to arrive at the egg consistently earlier. But in spite of the enormous difference in sex ratio at fertilization, at birth the proportion is about 106 males to 100 females. Throughout life women survive better than men. In the first year of life, the death of one girl is matched by the deaths of three boys. By 21, the ratio is one to two. The life expectancy of women is always greater than that of men.

Montagu not only argues that femaleness is biologically sounder than maleness but that femininity (nurturing, sensitivity and lack of aggressiveness among other things) is normally preferable.

Such is not the cross-cultural consensus, however. The view in most societies would be more in accordance with the sentiments of the Orthodox Jewish male, who thanks God daily for not having been born a woman. What most societies emphasize as valuable is the greater size and strength of men generally, in comparison with women. This is reflected in the fact that men throughout the world more readily beat their wives than the other way round. Most important of all, throughout the world, whatever the social organization of a particular culture, overt institutionalized power is in the hands of men. Women, of course, can always tap informal sources of power, and a domineering wife can no doubt exert considerable influence over a milksop husband. Even in cultures where the organizing principles of social structure focus on women, as among the Íroquois Indians, power is still vested in men. The Íroquois trace descent through women, men move in with their wives (rather than the other way around), and succession to political of office goes through women. Nevertheless, real power is in the hands of men.

In the present-day society with widespread contraception and the development of a technology that reduces the need for physical strength, hard and fast boundaries between men's and women's roles make less sense than at any other time in human history. It is no wonder, therefore, that women's liberation movements should have developed at

such a time. The main thrust of the ideology of Women's Liberation — that the options and rewards open to men should be available to women — came in a society where women had long been competing for jobs in the economic marketplace traditionally monopolized by men. The social reality had changed and significant numbers of middle-class women were already going out to work before the rhetoric of Women's Liberation proclaimed that this should be so. In this instance we see a basic principle at work: values follow social reality — though they may in turn loop back and influence society, at least to make it more consistent.

Another point to be considered here is an aspect sometimes related to notions of male dominance: the widespread custom of killing more girl babies than boy babies in societies where infanticide is customary. In a sense, female infanticide offsets the biological advantages of natural female hardiness. But from a reproductive point of view, very few males are really necessary to ensure the production of a new generation since a single male can mate with large numbers of females and sire hundreds of offspring.

In some nonhuman species it is believed that only a few of all the males actually do reproduce. Hence, from a reproductive point of view male rather than female infanticide might make sense since most males are reproductively superfluous. But there are military considerations.

The fact is that males are always in control of weapons and are regularly involved in warfare. Therefore in the maintenance and defense of a society men are indispensable. According to an argument proposed by William Divale and Marvin Harris, women's very fertility may pose a threat to a group: overpopulation. The most efficient way of providing for the survival of a group at a particular stage of development may very well be to cut down on the number of women, while preserving as many men as possible. Harris has in fact called the development of preferential female infanticide "a remarkable triumph of culture over nature."

The position of men and women in society has been compared by Claude Lévi-Strauss to the basic dichotomy he recognizes between nature and culture. Men as hunters, for example, provide the raw meat (nature) which women must cook (culture). In a sense, women in all cultures could be said to try to tame the rawness of men's natures. In fact, much of Ashley Montagu's argument for the superiority of women can be seen in Lévi-Straussian terms: woman — as civilizing agent, as ennobler, as tamer — is of necessity superior to man.

I think it is interesting that Lévi-Strauss's very comparison has been challenged by Sherry Ortner, following Simone de Beauvoir. She believes that the analysis should be the other way round. Women are closer to nature physically. Being tied to a menstrual cycle (natural time rather than cultural time) they are controlled by nature and more intimate with it. The English idiom "Mother Nature" is indicative of this sort of tacit conceptualization; "Father Nature," or some comparable male image, simply does not exist in any language as far as I know. Men, on the other hand, try to control nature and even bend it; they are the products of, as well as the contributors to, culture.

This analysis would help in part to explain the widespread use of male puberty rites that make boys into men — frequently by genital or other mutilations sometimes thought of as breaking ties with mother, and/or the learning of special cultural information such as ritual secrets. In a sense, too, it points out that male dominance, though real, has to be propped up, suggesting that it is essentially quite frail.

These polar interpretations (Lévi-Strauss's and Ortner's) point to the complexity and importance of the role of the sexes over and above actual anatomical differences.

Figure 1 The Fall: Adam and Eve about to commit the Original Sin, with all its sexual implications, from a 16th-century woodcut.

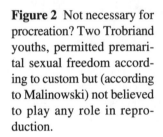

Figure 2 Not necessary for procreation? Two Trobriand youths, permitted premarital sexual freedom according to custom but (according to Malinowski) not believed to play any role in reproduction.

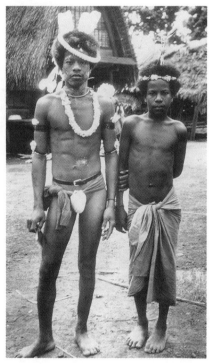

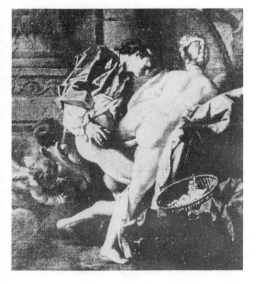

Figure 3 An erotic painting by Boucher, commissioned by Louis XV for the boudoir of his mistress, Madame de Pompadour.

Figure 4 Coïtus with woman on top. Scene from an ancient wall painting in the House of the Vettii, Pompeii.

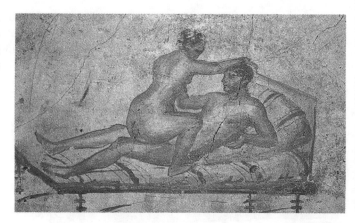

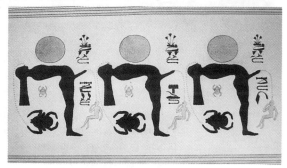

Figure 6 The ancient Egyptians believed that semen unaided could generate new life. Perhaps such a spermatist view is shown in this enigmatic detail from the tomb of Ramses IX.

Figure 5 In many societies across the world, kissing is regarded as unnatural and disgusting. This Makonde woodcarving may have been made for tourists.

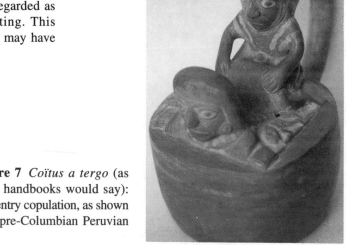

Figure 7 *Coïtus a tergo* (as older handbooks would say): rear-entry copulation, as shown on a pre-Columbian Peruvian pot.

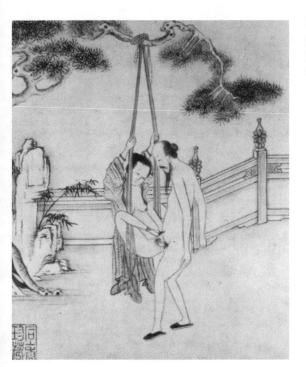

Figure 8 Hardly the missionary position: sex on a swing, from a painted album on paper, late Ming or early Ching dynasty.

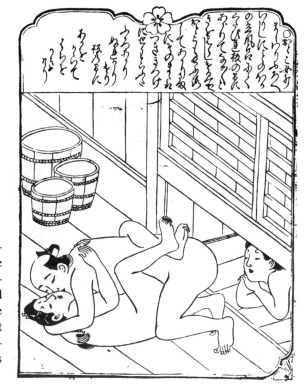

Figure 9 The missionary position, with or without the influence of Christian missionaries, is cross-culturally the most widely used copulatory position. A Japanese woodblock *shun-ga* (erotic) print by Hishikawa Moronobu (1618-1703), popularly known as Kichibee.

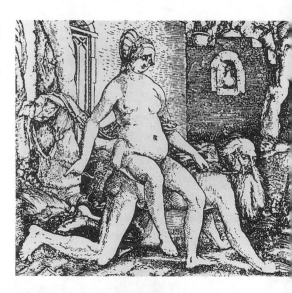

Figure 10 Aristotle (384–322 BC), considered by some the father of western sexology, here being taught a lesson by the hetaera Phyllis, in a woodcut by Hans Baldung Grien, 1513.

Figure 11 "Aristoteli[an] law CANNOT ru[le] Russellian reality[,]" philosophically-mind[ed] demonstrators in a G[ay] Pride march challeng[e]ing the notion of n[at]ural law.

Figure 12 Material culture versus natural law: a button used in the war against AIDS (and, some would say, Christian morality).

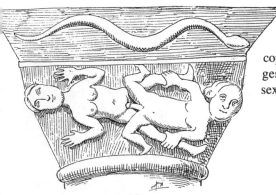

Figure 13 Scene from a 13th-century church in France, apparently showing Adam and Eve copulating (note the serpent) and suggesting that the Fall was somehow sexual.

Figure 14 A woodcut dated 1578 illustrates the contemporary burning to death of monks accused of sodomy.

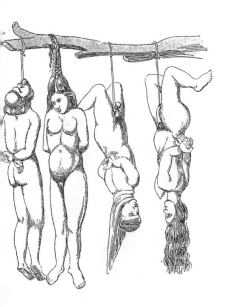

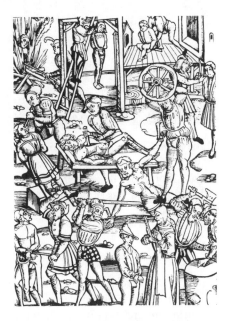

gure 15 The torments of fornicators in Hell, envisaged by Giotto (1266?-1337).

Figure 16 The principal earthly punishments for sexual violations in western tradition.

Figure 17 Masturbation or "onanism" led to "failure of intelligence, nocturnal hallucinations, and suicidal and homicidal propensities," according to a leading 19th-century psychiatrist. An illustration from *The silent friend* (1853) purports to show the practise's deleterious effects.

Figure 18 Fresco in Pompeiian house showing the fertility god Priapus weighing himself. Formerly, this picture was under lock and key and was shown only to "gentlemen" tourists.

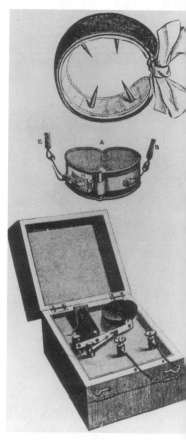

Figure 19 Anti-erection appliances of the 19th century reveal the obsessive concern in the West with masturbation and "spermatorrhoea." The four-pointed ring was fitted round the penis, and the erection detector (bottom) rang a bell in an adjoining room if an erection occurred.

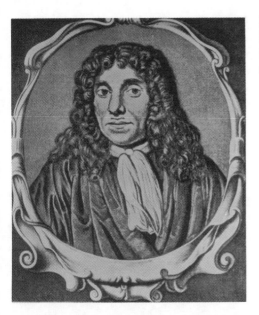

Figure 20 Antonie van Leeuwenhoek (1632-1723), the first to observe spermatozoa in semen (1677).

Figure 21 Human sperm shown as homunculi in this drawing by Leeuwenhoek in 1703.

Figure 22 Leeuwenhoek depicted in the process of discovering sperm.

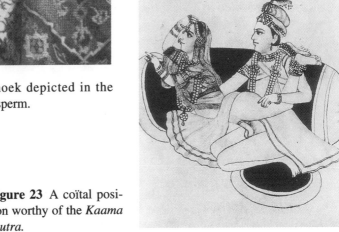

Figure 23 A coïtal position worthy of the *Kaama suutra*.

Figure 24 Iwan Bloch (1872-1922) (German)

Both Block (left) and Krafft-Ebing (below) have been called "the father of modern sexology."

Figure 25 Richard von Krafft-Ebing (1840-1902) (Austrian)

Figure 26 Auguste Henri Forel (1948-1931) (Swiss)

Figure 27 Karl Ernst von Baer (1792-1876) (German)

Figure 28 Paolo Mantegazza (1831-1910) (Italian)

Figure 29 Magnus Hirschfeld (1868-1935), a tireless scholar and advocate of sex law reforms, founded in Berlin in 1919 the *Institut für Sexualwissenschaft*, the most important scientific center for the study of sex before the Kinsey Institute.

Figure 30 Alfred C Kinsey (1894-1956), whose work—although severely criticized by many of his contemporaries—is undoubtedly the most important so far done on human sexual behavior.

Figure 31 The Kinsey team, from left to right: Paul H Gebhard, Wardell B Pomeroy, Kinsey, and Clyde E Martin.

Figure 32 Dr William Masters and Mrs Virginia Johnson, sex therapists whose groundbreaking work on sexual dysfunction has led to a more profound understanding of sexual function, as well.

Figure 33
Meeting of the first International Congress for Sexual Reform in the Langenbeck-Virchow House in Berlin (1921 Sept. 15-20).

Figure 34 The "secret collection" of the National Museum of Naples, Italy, remains closed to the public over a decade after the decision to open it up. Here, one wall of the room housing the ancient erotica.

Figure 35 Margaret Mead (1901-1978). Although Mead is internationally linked with the study of sex in non-western and western cultures alike, she really worked with problems of sex roles and gender, rather than sex. She was highly critical of Kinsey's work and was perhaps his severest critic among anthropologists.

Figure 36 Havelock Ellis (1859-1939), a scholar of vast erudition who tried to put sexology in a firm cross-cultural perspective. His own interest in the study of sex he quite consciously explained in terms of personal problems arising from his own highly repressive background.

Figure 37 Cross-section of human and chimpanzee (left) penis, showing the presence of a penis bone (*os penis* or *bacculum*) in the chimpanzee and its absence in the human.

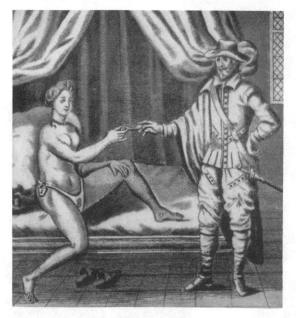

Figure 38 A chastity belt is t[] cultural equivalent of a mating pl[] in various animals. In this engra[] ing from 1706, a woman is givi[] her husband the key to the chasti[] belt she is wearing.

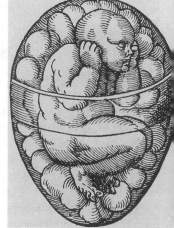

Figure 39 Jakob Rueff's *De conceptu et generatione hominis* (1554) assumed production of an embryo from the father's semen and the mother's blood.

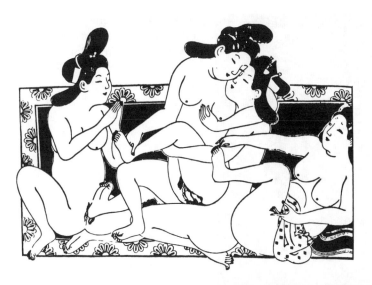

Figure 40
Japanese wood-block print from about 1680, showing gantizing with a foot. The man, a young samurai, is the second figure from the right.

Figure 41
Coïtus with woman on top. A Japanese rendering, from a painted album.

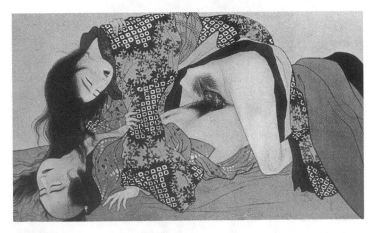

Figure 42 (left)
Coïtus in seated position, as depicted in a Chinese painted album.

Figure 43 (below)
Cunnilingus as shown on a Japanese painted scroll from about 1930.

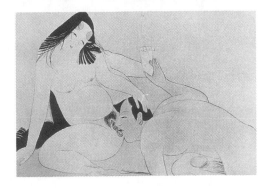

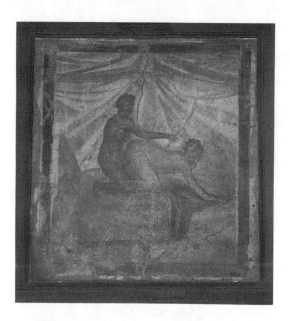

Figure 44 Rear-entry intercourse is often shown in ancient art, as here in a wall painting from Pompeii.

Figure 45 Fellation as shown on a South American Indian clay pot. (A variety of sexual acts are depicted in about 200 known "erotic" ceramics from pre-Columbian Perú.)

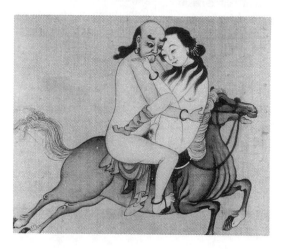

Figure 46 Sexual fantasies are also grist for the sexologist's mill. Copulation on horseback was the subject of a series of 12 paintings on silk about the amorous adventures of equestrian Mongols.

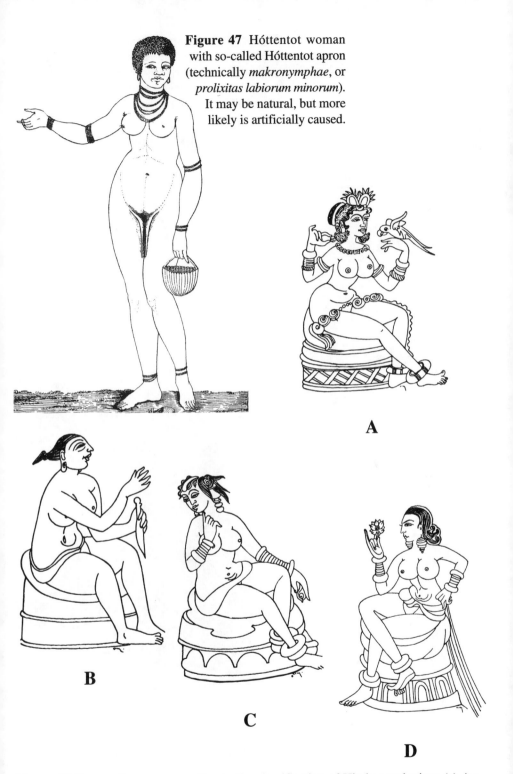

Figure 47 Hóttentot woman with so-called Hóttentot apron (technically *makronymphae*, or *prolixitas labiorum minorum*). It may be natural, but more likely is artificially caused.

A

B

C

D

Figure 48 Types of women according to the classification of Hindu sexologists: (a) Art-woman, (b) Elephant-woman, (c) Conch-woman, (d) Lotus-woman.

Figure 49 Human sperm as seen under the microscope. The X-bearing sperm has the larger, oval-shaped head; the Y-bearing sperm has the smaller head and larger tail.

Figure 50 Breast shapes: an early 20th-century typology.

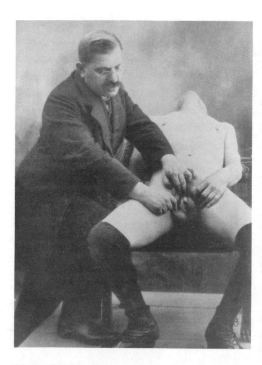

Figure 51 Ambiguous sex organs being examined by Magnus Hirschfeld to decide a case of possibly erroneous sex assignment.

Figure 52 In Oman, men and women normally cover their heads; the *xaniith* goes bareheaded.

Figure 53 Chukchi transvestite shaaman who was married to his cousin, a non-transvestite man (Siberia).

Figure 54 Two *hijraa* blessing a baby.

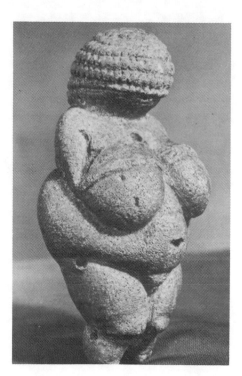

Figure 55 Paleolithic pin-up girl, ferti[l]
symbol, or the self-portrait of a pregn[ant]
woman? Many interpretations have been m[ade]
of the "Venus" figurines of prehistoric Euro[pe.]
Here, the Venus of Willendorf.

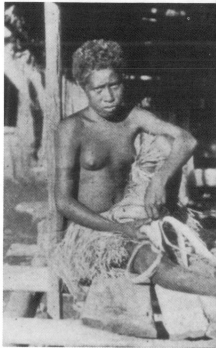

Figure 56 A Trobriand Island beau[ty]
according to local standards.

These photos, published by Malinowski [in]
1929, are the only photographic studies [of]
native standards of beauty made by a[n]
anthropologist.

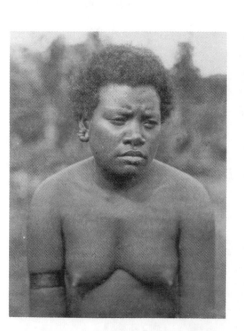

Figure 57 A Trobriand Island woman not
considered attractive by local standards.

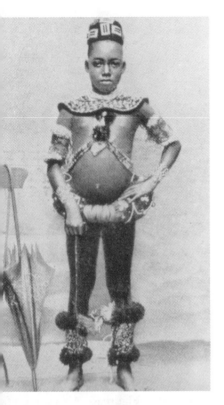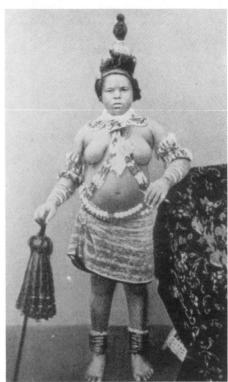

Figure 58 Before and after pictures of a girl from Calabar, Nigeria, who has undergone a fattening process and skin-bleaching to make her more desirable as a bride.

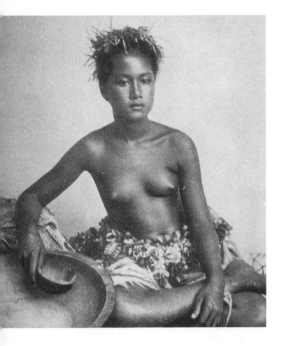

Figure 59 Polynesian beauty: a western view. The natives were not asked whether they thought her particularly good-looking.

Figure 60 Woman with parasol.

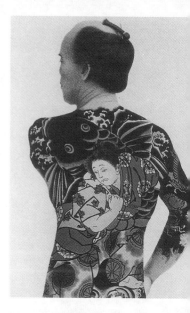

Figure 61 Tatooing is so popula▪ some Japanese groups that both n▪ and women have virtually their wh▪ bodies decorated.

Figure 62 Ainu women fr▪ northern Japan, with lip ▪ face tatooing resemblin▪ moustache.

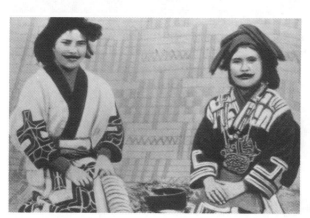

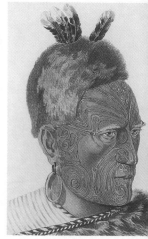

Figure 63 The Maori men of New Zealand sometimes had their whole faces tatooed, as in this picture of Tauhi'ao, a 19th-century chief.

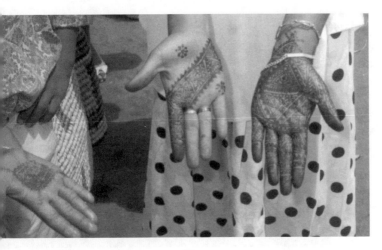

ure 64 Palm decorations among Middle Eastern women have a religious well as an aesthetic aspect. Little boys (as left) sometimes have a palm nted for good luck.

ure 65 Cleanliness was not always t to godliness. Or so this 16th engrav- s of goings-on in the public bath se was meant to suggest. Mediaeval ristianity found bathing a questionable ivity.

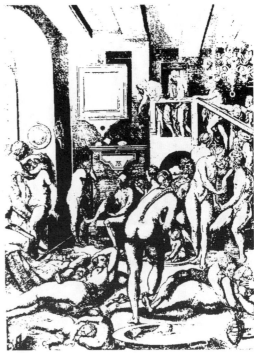

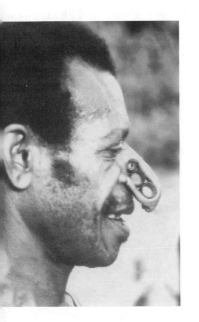

Figure 66 Multiple bamboo nose plugs worn by a New Guinea man of the Awyu group (Irian Jaya)—a style confined to men and going out of fashion.

Figure 67
Scarification of the back, formerly done in secret among these New Guinea natives on Chambri Lake, now is witnessed even by tourists.

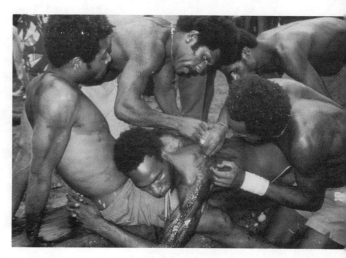

Figure 69 German students with dueling sca (*Schmisse*), at one time thought to be virtually in sistible to women.

Figure 68 Maasai woman with multiple ear-piercings and elaborate ear decorations.

Figure 70 One style of filed teeth formerly popular among Central Bantu peoples in Angola, Africa.

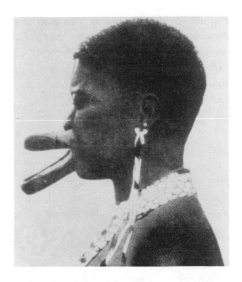

Figure 71 The filed teeth of a Bogobo man from Mindanao, the Philippines— fashion now generally defunct.

Figure 72 Woman with huge lip plates (labrets) from the Sara peoples of Central Africa.

Figure 73 Bound foot of a Chinese woman. Bound feet became the national fetish (more technically, "paraphilia") of China and remained so for several centuries.

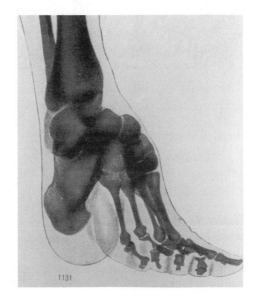

Figure 74 X-ray of bound foot of a Chinese woman.

Figure 75 Headflattening was considered attractive by groups in several parts of the world. Here a drawing from the 19th century shows a chinook (Northwest Coast Indian) woman with a flattened head herself, flattening the head of her child.

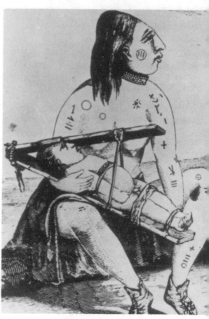

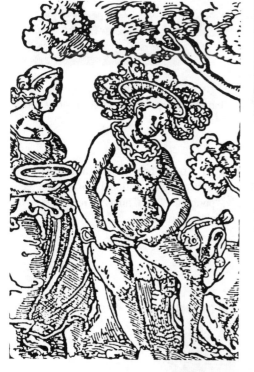

Figure 76 16th-century European woo cut showing a woman removing pu hair—apparently a fashion of the time.

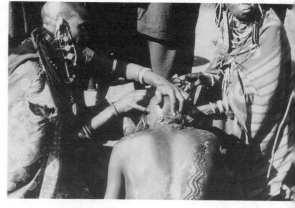

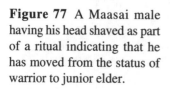

Figure 77 A Maasai male having his head shaved as part of a ritual indicating that he has moved from the status of warrior to junior elder.

SEVEN PHYSICAL ATTRACTIVENESS

Beauty may be in the eyes of the beholder,
but the beholder is culturally conditioned
to begin with, so that variations
will always exist in ideal types.

...Ask a Northern [American] Indian what is beauty [in a woman] and he will answer, a broad flat face, small eyes, high cheekbones, three or four broad black lines across each cheek, a low forehead, a large, broad chin, a clumsy hook nose, a tawny hide, and breasts hanging down....

So wrote Hearne in 1796 after many years of encounters with American Indians still living in traditional cultures. His account was quoted by Darwin in 1871 in a detailed examination of what people look for in sexual partners. In all the years since Darwin's work, anthropological investigations into ideas of physical attractiveness have tended to stagnate on the anecdotal level provided by Hearne. The general lack of interest in the topic by anthropologists is unfortunately symptomatic of the way they deal with anything having to do with sex. Only here, prudery cannot account for failure to deal with the matter. Even collecting photographs of people considered attractive (and unattractive as well), in terms of their own standards, has seldom been attempted, though Malinowski did so as early as 1929, in his famous book about the Trobriand Islanders called *The sexual life of savages*.

In anthropological studies of physical attractiveness, anything at variance with contemporary western tastes invariably gets played up. A cross-cultural survey of notions of beauty is sure to include such "oddities" as a preference for cross-eyes (Mayans), flattened heads (Kwakiútl), black gums and tongue (Maasai), black teeth (Yapese), joined eyebrows (Syrians), absence of eyebrows and eyelashes (Mongo), enormously protruding navels (Ila), pendulous breasts (Ganda), gigantic buttocks (Hóttentot), fat calves (Tiv), bound, crippled feet (Chinese), oily skin (Kubeo) and so on. Because of the nature of the information we have, we can do very little else. Such differences are in themselves astonishing and certainly interesting. It is possible that in every culture (as suggested earlier, there have been perhaps 100,000 different cultures since the time of the Neanderthals) some detail or other has been singled

out as particularly entrancing in its standardized fantasies of beauty. The facts of variation are intriguing enough.

But it seems almost inconceivable that people are not born programed to find some things more attractive than others. A healthy appearance almost certainly is one of them. The only counterexample I know of is the claim by Tessman writing in 1913, that women among the Fang of Africa prefer men with leprosy for adulterous love affairs. I'm afraid I can hardly take this claim seriously: there is no evidence from anywhere else in the world that lepers or others with comparable diseases like ringworm, yaws, or tertiary syphilis rate high in attractiveness. On the contrary they are almost inevitably shunned or even tabued, as among the Balinese.

The whole question of physical attractiveness is very complicated. Perhaps all societies play up some notions of attractiveness that have significance in choosing a sex partner. But since in most societies nearly everyone marries and reproduces, the evolutionary importance of these criteria for good looks (which is what Darwin was after) is not clear.

In western society, the criteria of attractiveness have often been so specific that very fine rankings based on physical beauty can be achieved — the basis on which all beauty contests rest.

In other cultures even talking about physical attractiveness may be tabu. I know of only one culture where this seems to be true absolutely: that of the Hasidic Jews.

In yet other cultures, specific detailed criteria may be lacking. I remember talking to certain northern Nigerians, several years ago, trying to find out what they thought a beautiful woman should be like. Although I did not do so systematically, the few answers I received astonished me at the time. A truly beautiful woman must walk in a sort of languorous way, they said. She must be deferential to a man (in their society, good wives would kneel when greeting their husbands in the morning). But I noticed that they were hard pressed to specify anatomical details such as being slender, having big breasts or special facial characteristics. After some prompting they were willing to say she should have a fairly long neck. When I asked about facial features and virtually insisted on some sort of reply, one man said in exasperation: "Well, she certainly shouldn't have a nose like yours!" (which is a relatively nondescript Caucasoid type).

This experience brought vividly to mind one of Darwin's conclusions about physical attractiveness: people generally admire (and even try to exaggerate sometimes) the physical characteristics they are used to. In

fact he saw this tendency as a major cause of social differences. One of the more striking generalizations he makes along these lines is that in populations where the men have little facial hair, whatever hair exists is disliked and often removed; whereas beards are greatly admired in hairier groups. Darwin's generalization has its problems however. Ever since Alexander the Great ordered his soldiers to shave their faces so that the enemy would not grab their beards in hand-to-hand combat, the western world, although hairy, has had its glabrous centuries.

More recently, Dale Guthrie has suggested that beards have a symbolic value and that they tend to be found in societies where social inequality is stressed. A clean-shaven chin, on the other hand, would be more appropriate in democracy. The facts don't bear this out in any compelling way. But I'm sure beards can have very symbolic connotations. And I am equally sure that the present widespread fashion for beards and/or moustaches in the West is in some part a male reaction to the Women's Liberation movement — if only because it defines boundaries in an otherwise unisex world.

In many instances, the anthropological reports suggest that in various cultures, the total gestalt of a person is considered, not just some isolated criterion — at least for a marriage partner. It is not only a beautiful face (whatever that means) that is considered in a wife, but more importantly whether the woman looks able to bear many children or is known to be a good worker.

It is almost impossible to specify any cross-culturally valid notions of physical attractiveness, though a few do exist. Donald Symons suggests that good teeth, clear eyes, and firm gait almost certainly are universally attractive if only because they indicate health. He does not believe, however, that any particular body build could by the same token be universally desirable. In some situations, depending on diet and the possibility of food shortages, fat may indicate both health and high social status; in other situations, exactly the opposite may hold true. The individual picks up what fatness means in his particular social group and acts accordingly. In some societies, for example, fat women are prized and (as in some West African groups) women are even placed in a "fattening hut" before marriage, where they are made to gorge themselves in order to gain as much weight as possible. In Nagiib Mahfuuz's wonderful novel of the Cairo of a few generations ago, *Palace of desire*, one man describes the object of his passion, an enormously fat woman, "...as massively beautiful as the ceremonial camel when it set off for Mekka with the pilgrims." Also in the same novel, a woman (herself

marvelously fat) declares "Slenderness is in vogue among women who can't gain weight." In other societies, fat is anathema. In the 1990's in the western world, this would seem to be the case. The dictum attributed to the Duchess of Windsor that "one can never be too rich nor too thin" summarized the economic and aesthetic philosophies of a great many people in our society. Nevertheless, there is considerable personal variation and some people are attracted only to the fat.

One generalization that can be made is that men are usually aroused more than women by physical appearance. This would seem to be true whatever sexual orientation is involved. For women the world over, male attractiveness is bound up with social status, or skills, strength, bravery, prowess and similar qualities. Whether this is biological or a consequence of male domination is arguable.

But this male concern with good looks in the ideal partner does not mean that even women defined as ugly cannot find male partners in the real world. In an anthropological study of a brothel in Perú (the only large-scale study of this sort) George Primov and Carolynne Kieffer found that physical appearance was seldom of importance in determining the popularity of a particular prostitute, even though the men were paying and could be choosy. The prostitutes themselves were unanimous that the most important professional asset was the ability to get along well with the customers and to be a good and sympathetic listener.

Outside the brothel, men the world over seem to accept "any port in a storm" — which is how Holmberg characterized the behavior of Sirionó men, who have fairly clear-cut standards for female beauty. Such willingness to put up with less than the ideal relates to what sociobiologists see as the major male reproductive strategy found throughout the animal kingdom. Sperm are cheap. Copulation, therefore, will be attempted as long as there is some potential mate.

Although specific universals of physical attractiveness are hard to discover, it is fairly easy to list traits regarded as disgusting and sexually repulsive (they can perhaps all be related to the criterion of health mentioned before). Poor complexion and excessive acne and pimples, for example, are almost always considered negative qualities.

Bodily filth, bad breath and body odor are also almost universally mentioned as repulsive. Odors associated with the genitals are sometimes especially singled out as disgusting. For example, among the Marquesans very scrupulous attention is paid by males to cleaning beneath their foreskins. Girls are started on treatments a few weeks after birth to

ensure that vaginal odors will be suppressed and that the vagina itself will be kept tight and free from vaginal secretions.

The generally adverse reaction to genital odors found cross-culturally is of considerable interest because in many mammals odors are part of sexual communication, and function as what are known as pheromones. For example, among some primates, vaginal odors indicate whether the female is sexually receptive. It is known that many chemical substances given off in sexual secretions have odors detectable to human beings; the question is, do they function like the sex attractants of moths or are they without any aphrodisiac properties whatever? The answer is not clear. But one experiment which required participants to smell tampons taken from women at different points in their ovulatory cycle found the participants unable to tell when the women were most fertile. Some commentators on western culture have decried the widespread use of deodorants because they may destroy biological attractants of various kinds. But in very few cultures do we find evidence that genital odors are natural attractants. And the effects of unambiguous pheromones in other species are not at all subtle.

Individuals may be conditioned, however, to finding body odors of various kinds sexually arousing. Morris Opler reports that an Apache said that he would stick a finger into a woman's vagina and smell it as a method of combating temporary impotence. In our own society, certain people are into sniffing soiled underwear, and various homosexual publications occasionally include advertisements for filthy, smelly jockstraps. This is interesting because the odor is clearly unrelated to ovulatory cycles and suggests that other conditioning factors are at work.

Yet another generalization about sexual attractiveness can be made in relation to grooming. In virtually every society some form of grooming prevails and the individual who does not follow the convention is considered unattractive — all other things being equal. There are exceptions to this generalization. Prophets, for example, are often shaggy, disheveled and otherwise unkempt, but because of a personal magnetism they may exert a profound sexual attraction on their followers.

In this connection it should be noted that the early Christians were highly suspicious of the grooming habits of the ancient Greeks and Romans. In particular, the Christians were opposed to the institution of public baths largely because they were assumed to be a hotbed of illicit sexual activity. The noted anthropologist Alfred Kroeber has traced the history of cleanliness in the western world and found that for much of

the Christian period a feeling developed that being scrupulously clean was not being too good a Christian — especially for a man — and smacked of the sensuousness of paganism. The current cliché that cleanliness is next to godliness would have been rejected as dangerous nonsense.

This view persisted for about 1,000 years, through the Middle Ages until the 1400's, when people once more began to enjoy washing and public baths were opened. There was less piety than in previous centuries, perhaps because of greater contact with foreign cultures.

In the 1500's Protestants and Catholics alike called for a return to an ascetic ideal and demanded the suppression of the baths. Kroeber suggests that "if we of today had personally met sovereigns like Elizabeth or Louis XIV, we should probably have been aware of their body odor."

In the seventeenth and eighteenth centuries, the revival of cleanliness occurred with the rise of the middle classes. Europe and America are still in this cycle in which hygiene is venerated.

A custom associated with the baths of the ancient Mediterranean and continued in the modern baths of Turkey and other areas in the Middle East was the removal of body hair by special attendants. Various methods of depilation were and are used, including shaving, plucking, hair removal creams, waxing and a method still in use in the Middle East involving the unlikely sounding combination of sugar and lemon juice heated until they caramelize. Women in these societies depilate their entire bodies, removing even pubic hair. Men normally remove hair only from their armpits, though sometimes more extensive depilation is practised. These conventions were dropped by Christians, perhaps with the abandonment of the classical bath system.

When some of the returning crusaders tried to revive female depilation, they were quite unsuccessful. Female pubic hair is almost universally regarded as erotic in the West, although, strangely enough, in western art idealized bodies, both male and female, have nearly always been glabrous. This convention probably represents petrified Graeco-Roman tastes and has as little reality now as the Greek profile found on classical statues had even among ancient Greeks (the archeologist Schliemann was dismayed to uncover graves of Greeks whose profiles were "less than Greek"). But this too has implications: we cannot derive knowledge of reality directly from artistic conventions.

In classical statues body hair is shown only in such subhuman forms as satyrs or comical bacchantes. In idealized human forms, men are hairless except for pubic hair (always represented in the typical feminine pattern) and woman are totally hairless — as well as vulvaless. By the

Renaissance, even men lose their pubic hair in art, though probably not in reality.

Presumably as a looping back to these artistic conventions, some men in the West are sexually aroused only by women with hairless pudenda. A famous example is John Ruskin (1819-1900), who had led such a sheltered life that he was shocked to discover his wife had pubic hair and refused to consummate his marriage.

The custom of removing hair from various parts of the body can be found on every continent. In particular, there is a vast expanse in the Old World where both men and women remove pubic hair as well as hair from the armpits. This ranges from the Zulu in southern Africa to Muslim groups in India and Pakistan, and includes many Bantu-speaking peoples as well as the Amhara of Ethiopia. Among Jews, only women are allowed to remove body hair; men are specifically forbidden to do so.

The Bantu Ila have the unusual custom that a bride must pluck out all of her husband's pubic hair the morning after the consummation of the marriage. She must start at the crack of dawn and remove all hair from her husband's chin as well. Later that morning, an old woman comes to inspect the job and fingers the naked man's genitals and chin to see that everything is smooth.

Throughout the world, if there is a custom of depilation it will almost always apply to women — though it may also apply to men. In virtually no society that has so far been reported do men, for example, remove pubic hair if the women do not. The only exceptions to this generalization that I know of are the contemporary Bororo of South America and apparently also the ancient Egyptians (who drew in pubic hair in paintings of women but not of men).

This tendency to depilate women more readily than men could be interpreted symbolically in at least two ways. It could be a way of making women more like children and hence not threatening to men. Or else it could be an attempt to make women less like beasts — an interpretation that would support Lévi-Strauss's view that women are closer to "culture" than to "nature."

At present, the Anglo-American style of female depilation of the whole body except for pubic hair is spreading throughout the western world. Resistance to it has been championed by some women's liberationists but is apparently ineffectual.

Male body depilation has not caught on in the West. A study by Veneris and Roll (1970) found that in a group of American college students of both sexes from two schools in Illinois, male body hair was

not considered attractive to either men or women, but it was associated with being more masculine and virile. A hairy arm was seen, for example, as "more masculine, harder, larger, more virile and stronger" than an otherwise identical hairless arm. And all these features are of more consequence than good looks in assessing male attractiveness.

The last general category to be discussed here is skin color. An occasional fantasy that white people have is that a light-colored skin is universally more highly prized than a dark skin. The cross-cultural evidence makes it clear that such is not the case. An American Indian group, the Pima, dislike light-skinned people. Among the dark-skinned Wógeo the light coloring of Europeans — especially blondness — is regarded as almost shameful and reminiscent of albinos, who are considered unattractive. They think that the skin coloring of Europeans is more than enough justification for wearing many clothes to hide it. The Trobriand Islanders also regard albinos with distaste; on the other hand, a very dark brown complexion is considered a decided disadvantage — a truly attractive skin may be compared to "white flowers, moonlight, and the morning star." In some Polynesian groups, however, both men and women attempt to bleach their skins.

The attractiveness of a light skin coloring sometimes has obvious sociological reasons — often it is associated with social prestige for one reason or another. For example, in many of the Islamic emirates of West Africa, such as those of the Hausa and Nupe of northern Nigeria, men tend to marry "light"; the taste in light-skinned women must at least partially be the result of contacts with Arabs and also with the often light-colored Fulani groups who conquered many of these emirates before the middle of the nineteenth century.

That notions of attractiveness can be rooted in other social situations is well illustrated by color preferences in the western tradition. Until recently paeans to the beauty of women played up the whiteness of skin and compared it glowingly to snow, ivory or some other appropriate white object.

Until a generation or two ago, ladies of quality in the western world carried parasols to avoid a suntan, which was identified with farm workers toiling in the fields. But the status significance of a suntan (first sanctioned by Coco Chanel in the 1920's) has been reversed: parasols are now out and a sun-tanned body is considered sexy. What has happened? Laborers have mostly moved out of the fields and into factories. But the rich can fly to Acapulco, Mykonos or wherever is fashionable and sport

suntans throughout the year. More recently, fear of skin cancer has undermined this craze for tanning.

The attractive woman (cross-culturally)

A greater concern for good looks in women rather than in men is a characteristic of all societies, but what constitutes good looks varies considerably.

Take, for example, general body shape. From the point of view of one of the main functions of women — the bearing of children — wide hips to permit easy delivery should be desirable. In the great majority of societies for which there is adequate information, this is true. Ford and Beach, in their classic cross-cultural survey, found only a few societies that prefer slim women, notably the Dobuans (who consider fatness in either sex to be disgusting) and the Tongans (whose women actually diet to avoid getting fat bellies). But even these societies seem to go along with the dictum that women should have a broad pelvis and wide hips. The Yakút of northern Siberia are the only society mentioned by Ford and Beach who dislike such women — to which we can of course add modern western and Japanese society. It has been suggested that the modern western taste has serious biological consequences since the ideal type of woman may have problems in the delivery of her babies, and this type is being selected for reproduction.

The Mangaians are an example of a society where wide hips are seen as exceedingly desirable. Donald S Marshall reports that Mangaian men are almost fixated on hips and genitalia. Breasts, ankles and legs are not considered especially erotic. What the Mangaian fantasizes about is a fairly plump girl with big hips who can rotate and swing in hula-like dancing as well as during copulation. Such a girl is spoken of approvingly as a "bed with a mattress."

In many societies, outright fat is considered desirable in a woman. Among the Marquesans, a truly flattering description of a girl is simply *tau tau!* (fat), and the male admirer who makes such a comment may flex the biceps of both arms to indicate the voluptuous chunkiness of the girl in question — not to indicate his own muscularity. Girls with heavy shoulders, hips, buttocks and legs are believed to have the most endurance and vitality during sex.

Among Hóttentots and related African groups, women have developed a unique accumulation of fat in the buttocks called steatopygia. One explanation offered for this peculiarity is that it is an adaptation to a

desert environment, not unlike a camel's hump. In *The descent of man* Darwin cites Sir Andrew Smith as asserting that steatopygia was at least formerly highly prized among these people. Smith once saw a woman who was considered a beauty and who was so immensely developed behind that when seated on level ground she could not rise, and had to push herself along until she came to a slope.

In many societies, breasts are not necessarily thought of as erotic but what constitutes beautiful breasts is clear enough. Among the Marquesans, for example, large breasts are considered an asset but are rarely mentioned along with the other idealized traits. For the most part, long pendulous breasts generally associated with old women are not considered to be very attractive, although at least two groups, the Zande and Ganda, idealize such breasts.

The American preoccupation with what has jocosely been called "pneumatic" breasts has been linked by Geoffrey Gorer in his book The *American people* with an unsuccessful attempt at finding a nourishing mother. This somewhat Freudian interpretation is mentioned here only because Whiting and Child, in their classic cross-cultural study of child-bearing practises *(Child training and personality)*, reveal that in their entire cross-cultural sample, American society proved to be the most strict and unrewarding orally toward children; so Gorer's interpretation gains a certain credence.

In some societies there are specific criteria for beauty associated with the female genitals — thus belying Freud's dictum that sex organs are not at all beautiful. Among the Mangaians, men are very much concerned with the size, shape and consistency of the mons veneris and of the degree of sharpness or bluntness of the clitoris. Among the Marquesans a flat symphysis pubis is desired. A fat vulva is highly prized among the Sirionó. A large clitoris is reportedly preferred by Easter Islanders, and elongated labia minora are of great interest to Dahomeans, Kusaians, Marquesans, Ponapeans, Thonga, Trukese and Venda. In all these groups attempts to lengthen the labia are made, usually by simply stretching them.

Among the Kgatla-Tswana long labia minora seem to have extraordinary erotic value, and are sometimes referred to as "the exciter of the bull." With the onset of puberty Kgatla girls start pulling their labia and sometimes will ask a girlfriend to help. If the labia do not get longer as quickly as desired, the girls resort to magic. They kill a bat and cut off its wings, which they then burn. The ashes are ground up and mixed with fat. Each girl makes little cuts around her labia and

smears the bat-ash ointment into the cuts. This is done so that the labia will become as big as the wings of a bat.

Such a remarkable preoccupation with a physical detail is matched by the opposite side of the coin: surgical removal of the labia as a precondition for marriage found in other cultures.

The attractive man (cross-culturally)
Darwin in his discussion of the development of the differences of appearance between the sexes, suggests that males who put on the most spectacular displays are preferred by females. The most brightly colored male birds have an advantage and are the most likely to be chosen as mates by relatively drab looking females, thereby reproducing themselves. Similarly with mankind. Darwin suggests in *The descent of man* that beards were developed "as an ornament to charm or excite the opposite sex," and that in effect facial and bodily hairiness were assets. In reply to this, the physical anthropologist Ernest A Hooton has pointed out a probably ethnocentric bias on Darwin's part here. Many of the features that Darwin singled out as part of human masculine display recall the fact that he boasted a bushy beard, tufted eyebrows "and a somewhat Neanderthaloid physiognomy." Hooton fantasized that the protohuman female (in Darwin's reconstruction of the earliest human groups), instead of waiting around while hairy-chested males fought over her, might well "sneak off into the bush with some sinuous and smooth-cheeked precursor of the modern gigolo."

The notion of physical "display" as a major element in masculine attractiveness can be doubted, if only because it seems quite likely that nonphysical characteristics, primarily social status and wealth, or possibly even some personality trait such as valor or dependability, are ultimately more attractive to women than good looks. Among the Toda of India, for example, women reportedly find men especially attractive who are good at catching buffalo at funerals (a prestigious ritual act). A recent survey of English women's tastes revealed that they preferred men who had a slight paunch to those with a trim athletic body — presumably the aesthetic ideal. The reason why may be that a paunch suggests a certain social position, being able to afford to eat luxurious foods and not having to do manual labor. A paunch goes well with a Rolls-Royce.

According to G Charles-Picard the ancient Oriental high cultures even held the body-beautiful goal of their Greek contemporaries to be an abomination. Dignity and wealth were preferred to strength and athletic prowess. Men, therefore, chose to cultivate a portly figure and to cover

themselves in ample robes rather than follow the Greek ideals of muscular symmetry and heroic nudity. Similarly the pre-World War ll shtetl Jews of Eastern Europe idealized the pale, emaciated, etherealized man whose pallor was to be taken as a sign of studiousness and spiritual vigor. But babies and women were primarily considered beautiful only if round and rosy.

One of the common ideals for masculine good looks in the contemporary western world is the combination of broad shoulders and narrow hips. Alice Brues has suggested that this aesthetic standard may reflect a holdover from an age of archery because a man with broad shoulders has an advantage in drawing back a bow. In general, she believes that a case can be made for assuming that a dominant tool or weapon (such as the bow) in a culture may give a selective advantage to individuals having a physique best adapted to its use.

For many societies, there are criteria for male genitalia. Almost invariably a big penis is much admired. Among the Sirionó, for example, it is thought that a man's penis should be as large as possible. Among the Hausa, men boast in their praise songs (a kind of personal advertisement) that they are "breakers of vaginas," both because of sexual prowess and penile size. Curiously enough, contrary to most other societies, the ancient Greeks seem to have idealized a small penis and identified large ones with passive homosexuals. Even more curious is the following assertion from the *Anangga rangga*, the mediaeval Indian sex manual: "The man whose *lingga* (penis) is very long, will be wretchedly poor. The man whose *lingga* is very thick, will ever be very lucky; and the man whose *lingga* is short, will be a *raajaa* (king)."

In the United States, fear of inadequate penis size is one of the most frequent sources of sexual anxiety for men (as reported by an analysis of letters to *Sexology magazine*), and several devices have been offered for sale — usually a type of suction pump — to increase the size. At least some of these devices are dangerous because they can rupture blood vessels and may cause fatal blood clots. Plastic surgery is sometimes used to correct penile imperfections and occasionally to achieve a kind of de-circumcision in males who oppose foreskin amputation. A urologist from Florida has reportedly even developed an operation to lengthen a penis by as much as one inch.

The *Kaama suutra* suggests another method for enlarging the penis that is both painful and dangerous. The man is advised to rub it with bristles from certain insects that live in trees, and then rub it with oil for 10 nights. After that he should again apply the bristles. The whole

procedure should be repeated until a swelling is produced. He should then lie down with his penis hanging through a hole in the cot. This is said to produce lifelong effects and is attributed to certain Dravidian people.

Physical alterations
The human body has been altered in several ways to make it conform to aesthetic, social or erotic ideals. Methods used include: cutting; burning; insertion of foreign objects (lip plugs and penis bars); staining (as in tatooing or body painting); compressing; distending and enlarging. These may all sound quite alien and possibly primitive. However, they pale in degree of drasticness when compared to many modern cosmetic surgery techniques such as face-lifts, liposuction to remove fat, or various implants — mostly for increasing breast size in women and modifying pectoral and calf shape in men.

The cultural motives for such alterations may have little to do with physical attractiveness. For example, in various societies ranging from the Plains Indians to the highlanders of New Guinea, a finger, or less commonly a toe (as in Fiji), is hacked off after the death of a near kinsman as a sign of grief. In large areas of Africa, tribal or other local allegiance is indicated by facial scars varying in design. Religious motivations are sometimes involved, as among the Skoptsý (a nineteenth-century Russian Christian sect), who cut off women's nipples. It has been said that Germans joined fencing clubs primarily to get scars on their faces from wounds acquired in duels: these scars had a tremendous prestige value in some circles and possibly had erotic connotations.

The variability of alterations from culture to culture (as well as from time to time in the history of particular cultures) seem to be largely unpredictable — although certain patterns emerge. Kroeber, who was skeptical about notions of evolution in human culture, nevertheless believed that one could talk about cultural progress in some instances, including the decline of physical mutilations.

Yet although the more severe and dysfunctional alterations have in fact been given up, the resurgence from time to time of various alterations as part of the general fashion makes it seem implausible that such alterations will be abandoned altogether. At present, for example, in the United States there has been an upsurge in ear piercing among women — sometimes with multiple piercings of each ear; a fashion also adopted by some men. Nose piercing, unheard of only a few years ago,

has a certain limited vogue — presumably in imitation of Indian or African models.

A number of alterations involving the head are reported in the cross-cultural literature. Attempts at moulding the shape of the head in infancy, either by flattening with a board or lengthening by tying bands around the back of the head, occurred in many parts of the world, including parts of France as late as the early part of the twentieth century.

Piercing of cheeks occurs but is fairly rare, but the piercing of ears, nose and lips is quite common. One of the most extraordinary examples is the use of lip plates by women in the Ubangui-Chari region of Africa, notably among the Sara. It is sometimes suggested that the Sara started the lip plate fashion in order to make their women so unattractive that slave raiders would not be interested in capturing them. Nevertheless, the fashion caught on and tastes among the Sara themselves changed. At present, the fashion has changed once again and it seems that the use of lip plates is dying out.

Teeth have been blackened, reddened, knocked out, dug out, filed, chipped and drilled (and filled with decorative objects). Many of these customs are clearly dysfunctional but nevertheless they have a wide distribution and a considerable history. Among the Nilotes of East Africa, two or more (up to six!) of the lower front incisors are removed, usually at puberty. In some groups an instrument resembling an icepick is used to dig out the teeth, without benefit of anaesthesia. Other groups knock the teeth out. Some evidence exists that the custom of tooth excision goes back to the Mesolithic: a skull found on the Blue Nile, referred to as the Singa skull, is also missing its lower front incisors and is sometimes taken to be an ancient relative of modern Nilotes. Because of western influence, the custom has begun to disappear.

One of the best known nongenital alterations is the foot-binding practised by upper-class Chinese women from the eleventh century AD until the twentieth century. It probably originated as a symbol of a woman who has no need to work and so became a form of conspicuous waste to indicate wealth. But very early the ideal bound foot took on highly erotic connotations, and was referred to approvingly as the "golden lily" foot. Traditional Chinese erotic drawings usually show women completely naked except for socks covering tiny deformed feet. The effect on someone outside that sensibility might be that such drawings are vaguely comical rather than erotic; but the passion for bound feet in Chinese culture reached the proportions of a national fetish. Although

enormous numbers of traits from Chinese culture spread to Japan, the fashion for foot-binding did not.

Common methods of decorating the skin include tatooing, painting, cutting and less frequently burning. Cicatrization is generally found among dark-skinned perhaps because tatooing does not show up so well. In Japan, tatooing is the only physical mutilation of any importance. Japanese tatooing clubs have existed for some time and both men and women often tatoo their entire bodies. Tatoos are also associated with the criminal underworld. Perhaps for this reason they play a conspicuous role in certain domestic Japanese sadomasochistic pornography. In several Polynesian groups, such as the Maori, tatooing can also be quite extensive and elaborate.

In some societies the designs are erotic, but occasionally the mere fact of tatooing or cicatrization on the body is regarded as erotic. Among Bala women of Zaïre, the cicatrices extend from the chest above the breasts down to the groin. Cicatrices are erotically important to Bala men, who avoid intercourse with a woman who lacks them.

Other kinds of alterations are relatively rare. Neck stretching is practised by Padaung women of Burma with the aid of coiled brass neck rings. A length of 15 inches (38 cm) can be attained. The Ndebele of southern Africa have a similar custom. Bands are sometimes tied round arms and legs so tightly that they may become pronouncedly enlarged. Practises of this kind are found in various parts of Africa, South America and Melanesia.

Beauty contests
The earliest known beauty contests occurred among the ancient Greeks, and both men and women were honored for their looks. According to Athenaeus, a chatty writer from the third century, contests for masculine good looks were the most common and usually had religious connotations.

The Romans did not hold beauty contests of any sort, and the coming of Christianity — which abhorred glorification of the body — saw the end of any contests that still existed.

Beauty contests were revived as a totally secular institution in the twentieth century and the emphasis shifted towards preoccupation with contests for women. Male beauty contests have not caught on in modern times, perhaps because there is some sort of traditional stigma associated with a man overly concerned with his appearance. Physique contests are not thought of as beauty contests by their promotors but as a kind of sports event.

The whole idea of beauty contests came under attack by women's liberationists in the 1960's as relegating women to the status of sex objects. This view did not make much impact on large portions of the U.S. population, and these events are regularly televised.

To my knowledge, no real female beauty contests have been developed independently in any nonwestern culture. But some developments come close. Each year, for example, Havasupai Indian men are said to agree informally on the one or two most attractive girls of the season. These unofficial "Miss Havasupai" become prize catches and are put under more than usual sexual pressure from the men.

Only one non-western culture has developed male beauty contests independently: the Bororó Fulani of the Sahel in Africa. These contests are part of yearly ritual dances known as *gerewol* and seem to approach the ancient Greek contests in their symbolic function. The standards used in judging are totally different from those in western physique contests. From a western point of view, they reward effeminacy. The faces of the contestants are frozen in a tight-lipped smile, with eyes almost popping to expose the whites as prominently as possible. The contestants are concerned that their make-up and ornaments should be just right.

Genital mutilations

"They practise circumcision for the sake of cleanliness, considering it better to be clean than good-looking." This remark, revealing a Greek bias against circumcision, was made by Herodotus in the fifth century BC to explain why the ancient Egyptians circumcised. It represents the beginning of scientific speculation about why circumcision — or, for that matter, any surgical modification of the sex organs — occurs. Controversy continues today as to the origin and benefits of such customs.

Whatever the reason, people in many different societies have felt and still feel that the genitals should be altered in one way or another by cutting, piercing, hacking, or slicing, or by inserting objects into them.

Some alterations have become relatively well known because of the flood of handbooks about erotic miscellanea. A Burmese custom of inserting tiny bronze bells under the penis was made famous by David Reuben in *Everything you always wanted to know about sex (but were afraid to ask)*. At one point details such as this would have been buried in learned treatises, but in this instance a bit of arcane anthropological knowledge swept the United States and apparently became the basis for

the phrase "Come ring my chimes," popularized on television in the late 1960's.

Among the Trukese of the Pacific, it was the women who exploited sounds erotically. Until recently, some Trukese women made holes in their labia and inserted objects that tinkled when they walked with their legs a little apart. The anthropologists who studied Truk were unable to determine exactly what these objects were, but they were said to have been retained during coïtus.

A comparable genital modification, only noiseless, is reported from the Dayak of Borneo. They insert a metal rod, called an *ampalang*, into the penis. The rod has balls or brushes fixed to the ends and is worn transversely through a perforation in the end of the penis. It is like a built-in "french tickler," a device sometimes used in the West for the same purpose but which is simply fitted onto the penis and is removable.

Mutilation of the male genitals is both more frequent and more varied than that of the female.

The most common mutilation is, of course, male circumcision, whereby the foreskin is totally removed. It is estimated that about half of all the men alive in the world today are circumcised. Egyptian representations of circumcised men (and even of the act of circumcision) date back beyond 2000 BC. Because in most areas where circumcision is performed a stone rather than a metal knife is used in the actual surgery, some theorists posit a Stone Age origin. In any event it is a very ancient custom. Among the Nandi of Kenya, the foreskin is burnt off with a hot coal, a procedure known as circumbustion.

Circumcision is religiously required of all Jewish males, and it is customary among Muslims (although not enjoined in the Koran). Slight differences in the manner of circumcision occur between these groups. It is common throughout most of the Middle East and Africa, but there are several areas where it does not occur, notably in many groups in Central Africa, among the southern Bantu such as the Zulu, and among Nilotic groups of East Africa. Hunting and gathering groups such as the Bushmen do not practise it either, though Pigmies do in imitation of their taller neighbors. There is doubt as to whether circumcision was ever developed by American Indians, but it may have been found among the Totonác of Mexico and the Moche of Perú (the facts are not clear). It is not found among Orientals or traditionally among Christian Europeans or Americans. Egyptian and Ethiopian Koptic Christians practise it, in imitation of their Muslim neighbors.

Circumcising babies is normal among Jews and in the West, but in most societies, including traditional Islamic ones, circumcision and the other genital mutilations to be discussed later are performed after the age of six, often at or around puberty. A striking exception is presented by the Konso of Ethiopia, who use circumcision not to mark the beginning of sexual maturity but the end of sexual life: men may be in their 60's or older when the surgery is performed and they often become transvestites, being as it were in a sexual limbo.

In at least two societies, much more than the foreskin is removed so that one could literally speak of penis flaying. Among the Dowayo of Cameroon in West Africa, the entire shaft of the penis is peeled. Among certain groups in Arabia, the traditional form of mutilation flayed not only the penis itself but also the scrotum, the inner legs, and the belly below the navel. The brides-to-be of the young men are all present at the ordeal (which is undergone without an anesthetic); they may refuse to marry a man if he so much as flinches.

In many societies in the Pacific, the foreskin is not totally removed, it is merely slit lengthwise. Making such a slit is known as superincision (or supercision or supracision). Among the Marquesans the operation is performed without an anesthetic (as is also the case with all traditional genital mutilations) by stretching the foreskin tightly over a piece of bamboo.

Superincision is almost entirely restricted to Polynesian groups such as the Samoans, Marquesans and Tahitians. The major cultural explanation for the custom is that it promotes cleanliness and reduces the odor from smegma, considered altogether disgusting and the cause of insults of a very serious nature. Among the Mangaians, if the superincision is not well done and the foreskin hangs the wrong way, below the shaft of the penis, it is also considered a very serious matter.

Subincision (sometimes also called ariltha) is a mutilation of the penis not involving the foreskin. A single cut is made on the ventral side of the organ from one end to the other, through to the urethra. As a result, the penis can be flattened out. One of the consequences of this mutilation is that a man cannot direct his flow of urine and usually squats while urinating. In a similar way, it has been speculated that semen will not flow and will therefore not be effective. The evidence suggests otherwise, however, because in all the societies in which subincision occurs, it takes place before marriage and legitimate children are produced. One of the curious things about subincision is that with a single exception, the Samburu (a group in Africa), it occurs only in

areas where there are kangaroos or closely related animals. This fact has been used with some success to explain the existence of the custom. I shall discuss this in more detail later on in the chapter.

Bleeding the penis without altering its shape is rare but has been reported from the Maya of Mexico and is still performed regularly by the Wógeo, who live on an island just north of New Guinea. The Wógeo bleed themselves in this way because they believe that contact with women leads to infection and diseases that can only be prevented by bloodletting. One might imagine that this custom would drive men en masse into homosexuality. The remarkable thing is that although it is not condemned, homosexual behavior reportedly almost never occurs.

Only four societies in the world are believed to practise (or have practised) the removal of one testicle: hemicastration, also called semicastration or monorchy. Two of these societies are in Africa, one in Ethiopia: the Janjero, a subgroup of the Sidamo; the other in southern Africa: the Hóttentot, who are said formerly to have cut out one testicle to prevent the birth of twins (thought to be especially bad luck). The other two are in Micronesia in the Pacific. The best documented account comes from the Ponapeans, who live on an island in the Caroline group in Micronesia. The operation used to be performed between the ages of 14 and 16. More recently, with the decline of the custom, it was performed at a later age. At present, the custom has practically died out. To perform the operation on oneself seems to have been considered especially brave. The last instance of a reported attempt at self-castration occurred during the Japanese occupation of World War II and was not successful; the operation had to be completed by a Japanese surgeon. Traditionally it was also considered a good thing to remove the remaining testicle fairly late in life as a demonstration of loyalty to a chief, particularly in time of war. It is said that the chief and and other nobles often managed to avoid the removal of even one testicle. We cannot be sure about this because it was forbidden for a commoner to remark about the omission.

Total castration has been inflicted on various people for various reasons. The Roman priests of the goddess Cybele were eunuchs dressed as women. Although the Koran forbids castration, Islamic societies have made use of eunuchs castrated by Christians: the keepers of harems have almost invariably been castrated slaves. In Byzantium, China, and a number of African despotic kingdoms, eunuchs were occasionally elevated to important positions such as that of vizir or general to avoid dynastic rivalries. The biblical injunction, now widely challenged, that

women should keep silent in churches (I Corinthians 14:35) was observed so strictly in the Roman Catholic Church at one point that women were not even allowed to sing in them and this led, especially in Italy, to the employment of the *castrati* (castrated male singers). Papal decree abolished the custom in 1878.

Nipple excision — cutting off the nipples of adolescent boys (to my knowledge, never off girls except occasionally among the Skoptsý, a Russian religious sect) — has been reported from at least one society, the Janjero. In addition to hemicastration, they also circumcise and take male genitals rather than scalps as war trophies. The custom of taking genitals as trophies is more widespread than might be imagined. Even in the Bible we hear that David was required to collect the foreskins of 100 Philistines killed in battle (I Samuel 18:25).

Female mutilations have recently become the subject of considerable political concern because they are seen as techniques to rob women of practically all sexual fulfillment. Only two are normally mentioned, clitoridectomy and infibulation (terms used very loosely), but there is at least a third: vaginal introcision (cutting of the perinaeum). This is found exclusively among certain Australian aborigines. In western culture, a similar operation, called an episiotomy, is often performed to facilitate childbirth (this practise has come under much criticism in recent times).

Clitoridectomy refers to the removal of the clitoris and sometimes other parts of the female genitalia. It is sometimes called female circumcision. The expression sunna circumcision refers to the removal not of the entire clitoris but only of the prepuce. Among the Nandi of Kenya, the clitoris is burnt off with a hot coal; this procedure is known as circumbustion.

Clitoridectomy occurs much less frequently than male circumcision. It is fairly common throughout Africa, but seems to be the custom only where male circumcision occurs. Estimates of the number of women in the world today who have undergone clitoridectomy range from 30 to 80 million. The Falasha, the black Jews of Ethiopia, observe clitoridectomy, unlike other Jews, presumably in imitation of neighboring groups. This practise has been reported from various other groups, particularly from certain Islamic peoples, who generally use sunna circumcision. A single group of American Indians has been reported as practising it, the Pano of Ecuador, but the report may be dubious. Clitoridectomy has been used sporadically in the West both as a therapy to overcome frigidity, nymphomania and lesbianism as well as a punishment for "excessive"

masturbation. Success on all these counts seems to have been nil. It is sometimes maintained that clitoridectomy reduces sexual pleasure in women and that it most probably started as a custom to accomplish just that. Very little clinical information is available, but the one study that is at all scientific (by Marie Bonaparte) found that removal of the clitoris did not lower sexual excitement and that masturbation was as effective a means of sexual stimulation as before surgery. However, informal accounts by men who have copulated with women who have not been declitorized as well as with those who have, suggest that clitoridectomy has a drastic effect and lowers female response considerably.

The various procedures known as infibulation are even more restricted geographically. Eastern Africa is the main center of infibulation, particularly among the Kushitic-speaking people of the Horn such as the Somali and the Galla. It has also been reported from various other Islamic groups. The term pharaonic circumcision is sometimes used for infibulation, suggesting that it was practised by the ancient Egyptians, but this seems to be untrue. One variety of infibulation, the commonest, involves sewing the labia majora together with only a very small opening to allow for urination. In all forms of infibulation, parts of the clitoris and labia minora are also removed.

The Conibo of Perú seem to be the only American Indian group to have developed a kind of infibulation — and this quite independently of northeast African groups. The Conibo variety had the unique feature that a clay dildoe — apparently an exact replica of her fiancé's penis — was inserted into the girl's mutilated vaginal opening so that the vagina would provide a custom fit for the fiancé.

A kind of infibulation was practised on men by the ancient Greeks and Romans. The Greeks tied the foreskins of athletes over the glans. Among the Romans, musicians, actors and similar people actually made a hole in the foreskin and a fibula (a ring or clasp) was inserted.

There are many theories to account for these various practises, and some have already been mentioned. The rationale for infibulation seems fairly straightforward: the prevention of intercourse by a sort of built-in chastity belt. Sporadic examples crop up even in modern Europe. In Portugal in the twentieth century, a jealous woman was reported as having infibulated her lover with two gold clasps. After five years, the man was reduced to seeking medical aid.

Why the other mutilations are carried out is less obvious. The usual explanations for circumcising in the West (apart from religious rules) have been hygienic or other medical reasons. But these reasons have

varied from time to time. Formerly, what was played up was the incidence of cancer of the penis, which accounts for fewer than two percent of all the cancers of men in the United States, but in China for about 18.3 percent. Circumcised men almost never develop cancer of the penis. Only one case has ever been reported in a Jew. Indian Muslims, who practise circumcision, rarely if ever develop such cancers, whereas the non-circumcising Hindus have an incidence of about 10 percent. In addition, the wives of uncircumcised men have a significantly higher incidence of cancer of the cervix.

However, with the realization that the penile cancer is exceedingly rare among the non-circumcising Skandinavians and Amish, this justification has been largely abandoned. In 1975 the American Academy of Pediatrics stated as policy that it should not be routinely practised. But in the 1980's, evidence was found that infections of the urinary tract of male infants are eleven times higher among the uncircumcised. And the assertion has been made that circumcised males are less vulnerable to AIDS than the uncircumcised (the evidence for this is at present hardly compelling seeing that the great majority of American men with AIDS are probably circumcised). On the other side, it should be noted that deaths have sometimes occurred because of hemorrhaging after the operation, and sometimes the circumcision itself is bungled, leaving the penis severely damaged. One instance of this has become quite famous because it was decided that the little boy would be raised as a girl and become a transsexual. What must not be forgotten is that circumcision is an operation: it seems hardly prudent to undergo any operation unless it is specifically required.

The orthodox Jewish explanation for circumcision is merely that it shows a bond between God and Abraham and his descendants (Genesis 17:10-11, 14). No other scriptural reason can be cited.

Two outrageous but possibly true explanations for subincision exist. According to one, it reflects vagina envy in boys (comparable to the Freudian notion of penis envy in girls and usually referred to as menstruation envy since blood figures prominently in subincision rituals and old wounds may be reopened later). This explanation has been proposed by the psychoanalyst Bruno Bettelheim.

The menstruation-envy theory of subincision has been challenged by a competing kangaroo-penis envy theory. According to the kangaroo version, subincision attempts to imitate the kangaroo penis, which is distinctive because it is two-headed (in technical jargon, bifid). A number of arguments support this theory, hilarious as it has seemed to

some who accept with a straight face the notion of menstruation envy. Subincision is found only in areas where kangaroos or other marsupials with bifid penes live. And the anatomical similarities between subincised men and kangaroos are impressive: the urinary stream emerges at about the same place; the urethra is exposed; urination requires squatting; the penis is widened, and resembles quite closely the two-headed kangaroo penis. Perhaps most important is the fact that the Australians practising the mutilation say that they do so in imitation of kangaroos and other marsupials. An additional factor seems to be envy of the sexual prowess of kangaroos, who can copulate for up to two hours at a time. It is interesting that this theory was proposed by two different groups of anthropologists apparently independently.

Other scholars have argued that genital mutilations are not associated with any specifically sexual motivation but are arbitrary social rituals serving the same function in a puberty ritual as, say, the pulling of teeth, a custom having fairly wide distribution. In aboriginal Australian initiation rites, for example, various physical operations are practised that differ from one part to another, but are in some way functionally equivalent. Thus we find circumcision (and sometimes subincision) especially prominent in central and northwestern Australia, pulling teeth in New South Wales, yanking out body hair south of the Murray River, and cutting elaborate scars on the body in South Australia and eastern Queenland. Occasionally, a group may have more than one kind of operation involving the imposition of a foreign type of mutilation upon a culture already practising another kind. The Nilotes of East Africa literally dig out two to six lower front teeth and their Kushitic neighbors practise circumcision and clitoridectomy. The Maasai, a Nilotic group heavily Kushitized, have the best of both worlds by requiring all three operations.

Yet other scholars have tried to find correlations between specific genital mutilations and the way children are brought up. It has been suggested, for example, that noninfant circumcision is an attempt to separate a boy from his mother's influence and to help create a strong masculine identity. Elaborate male coming of age ceremonies involving circumcision are often found in societies where the child is closer to his mother than his father, or where the father is away a good deal of the time. In societies where circumcision occurs boys and girls tend to be treated differently and their differences are maximized or at least stressed. This can be seen even in the puberty rituals for girls which

often involve clitoridectomy. But their ceremonies tend to be informal, private and matter of fact.

Superincision, on the other hand, is associated with a different upbringing pattern: boys and girls tend to be treated alike and their differences minimized. A menstruation-envy theory seems to hold here, at least in the imagery of the superincising cultures themselves. The same term, for example, may be used for menstrual bleeding as for bleeding from the superincision opening, and the tabus associated with the menstrual period may also apply to men while they bleed from their wounds.

But it must be admitted that the motivations for these mutilations remain obscure and require considerably more investigation. What is not obscure is the very great symbolic value often attached to them. This is perfectly illustrated by Colin Turnbull in his book *The lonely African*. He tells of an English missionary working in what was then the Belgian Congo (Zaïre), who at one point abducts a boy about to undergo ritual circumcision as part of an initiation rite. The missionary, fearful of both the unhygienic and pagan aspects of the rite, has the boy circumcised in a western-type hospital. The boy's relatives — even though they are Christians — are furious, and the missionary attempts to explain to his congregation that circumcision is not required of Christians and that he himself is not circumcised. Dumbstruck, the congregation abandons him (only their enemy neighbors are known to be uncircumcised). He is alone except for his most trusted convert, who asks him if it is true:

> "When I answered yes, he spat at me, his filthy spittle clinging to my clothes as I stood numb with shock, and said, 'That is what we think of the uncircumcised.'"
>
> The convert went back to his own village and completely renounced Christianity."

EIGHT CLOTHING AND MODESTY

Clothing may imply modesty —
and also sexuality. Nudity is associated
with lust in some cultures, and
with purity in others.

Nudity and unbridled lust go hand in glove — at least this has been the view of orthodox Jews, Christians and Muslims. It is not necessarily the personal experience of Westerners who saw "streaking" as a welcome comic relief to Vietnam War protests or health addicts promoting therapeutic nudity. In other societies, nudity has other, sometimes totally different meanings.

For the traditional Zulu of South Africa, for example, willingness to expose the body is sometimes taken as a proof of sexual morality. They believe that sexual looseness produces flabby bodies. In certain rituals, unmarried girls are supposed to dance naked (more precisely, dressed only in beads with breasts bare). Because of European influence, many girls have taken to covering their breasts in these rituals to the great consternation of older non-Christian Zulu, who see it not as an expression of modesty but as a way to cover up evidence of sexual misconduct.

The Tonga of the South Pacific similarly had a ritual dance in which a high-born virgin had to dance naked. This was not viewed as licentious but rather as a symbolic way of proclaiming her chastity.

A very few groups have forbidden total nudity in all situations, even when a person is alone. The Mormons require the faithful to wear a sacred garment at all times, even when copulating. This piece of clothing (called the "temple garment" by Mormons, but commonly "jet suit" by unsympathetic non-Mormons) is something like a decorated white longjohn. It is first worn by women when they marry, and by men when they are "sealed" in the temple (a rite preparing them for missionary activity). The motivation for wearing the garment seems not to be prudery but the belief that it is a form of supernatural protection — something like a body-covering religious medal.

It is sometimes alleged that certain ultra-orthodox Jews are so prudish that they copulate through a cloth with a hole in it. At least 100 Jewish informants have told me that they have heard of this custom. As far as I can discover, this assertion is pure myth and totally untrue.

There is at least one society, however, that actually required sex to be performed in a similar way: the Menómini Indians, who made use of a soft deerskin blanket with a hole in the middle.

Occasionally, Christian groups have sprung up that championed or tolerated nudity. As a matter of fact, in the early church all people — adults as well as children — were baptized totally naked. This was insisted on by Pope St Hippolytus in his *The apostolic tradition* (written about 215). The custom is reflected in mosaïcs in the ancient baptistries of Ravenna in Italy, where Christ himself is shown as naked during his own baptism.

Several groups appeared in the second century that preached that the perfection and sinless condition of Adam before the Fall had been achieved through baptism so that nakedness was the preferred state. They were persecuted wholesale and by the end of the fourth century all the groups had died out. A similar group of nudist Christians sprang up after the Middle Ages in Germany and Holland: the Adamites. They too were short lived. Occasionally Christian ascetics might include nudity in their self-denial, as with the early desert eremites or the early Franciscans, but these are relatively idiosyncratic. The use of nudity as religious nonviolent protest has been developed by the Dukhobors, a Russian Christian sect founded in the eighteenth century. Most of the present-day members (about 20,000) live in Canada, where an extremist subgroup (the Sons of Freedom) occasionally protests against taxation and compulsory education by burning down government buildings as well as their own houses and also by parading in the nude.

In other religions and cultures, nudity plays quite a different role. It is frequently regarded with reverence and is considered the appropriate state for confronting the divine. The fear of ritual pollution associated with dirt on clothes prompted pre-Islamic Arabs to offer sacrifices naked. In the Hindu-Jain-Buddhist-Sikh traditions, nudity often has overtones of the highest piety. Vardhamaanaa Mahaaviira, who died about 468 BC and was one of the founders of Jainism, preached not only nonviolence and vegetarianism but instructed all his ascetic

followers to walk about totally naked as an act of the utmost religiosity (laymen, however, were permitted to wear clothes).

A particularly interesting Hindu ritual is the Sinhasta or Lion festival held every 12 years at the holy city of Naasik. One of the high points of the festival is catching sight of the naked saadhus (holy men) who have congregated in the city to bathe in the sacred Godaavari river. Other pilgrims clamor forward to touch the saadhus' fingers as "they march past...in their naked majesty and glory," as Masani puts it. The origin of this naked procession is somewhat surprising and reminiscent of the Dukhobor protests. According to the saadhus themselves, the cult of nudity started in the seventeenth century when some Hindu holy men in Junaagadh were molested by fakirs (Muslim holy men). The ruler of Junaagadh refused to interfere and so the saadhus took matters into their own hands. One night they stripped stark naked, smeared themselves with soot and charged the fakirs, who were frightened out of their wits by the sight.

Going to battle naked (by otherwise clothed people) is a scare tactic reported from a number of diverse areas. Marco Polo in the thirteenth century reported that the people of Malabar "go to battle all naked with only a lance and shield." The same practise was apparently a standard strategy of the Gauls in pre-Roman France and of the Picts in Scotland, who either painted their naked bodies blue or were elaborately tatooed. At least some ancient Greek warriors are believed to have gone forth in battle naked except for helmets, shields and sandals.

Nudity is sometimes an essential ingredient in initiation rites. One of the more extraordinary examples of this comes from a description of the ritual swearing of the "Batuni" oath, which bound a Kikuyu man to the Mau Mau rebellion against British rule in Kenya. Josiah Kariuki, writing of his initiation, said that when called he took off all his clothes and squatted facing his initiator. He was given the thorax of a skinned goat and was told "to put my penis through a hole that had been made in it and to hold the rest of it in my left hand in front of me." The oath to the death was then sworn. Clearly the function of nudity here was to create an atmosphere of appropriately chilling awe.

Obviously, then, nudity in itself cannot be equated with concupiscence in any simple-minded way. The modern nudist movement,

which began in Germany at the end of the nineteenth century, always
tries to underplay the sexual connotations of nudity.

Nudism was also popularized by the Wandervogel movement in
Germany, a romantic youth group not unlike the boy scouts, which was
frequently beset by charges of immorality and in particular homosexual
licence. To counter such charges, later organized nudism has played
down all aspects of overt sexuality both in its propaganda and in practise
at nudist camps. Family nudism is encouraged and single men have
usually had a hard time gaining admittance to the camps. The result, in
the words of Albert Ellis, the prominent sexologist (who is not a nudist):
"Nudist communities are much more in danger of being distilleries of
antisexualism than factories of rampant sexuality..."

It has been conceded by various apologists for nudism that the
movement attracted some peculiar types. But however peculiar these
converts to nudism are, they are not the key to answering questions
about the relationship of nudity or clothing to sexual behavior simply
because they were not brought up in a nudist culture.

The question remains: what happens to the sexuality of people
raised in societies where all the people normally expose their sex organs
all the time?

A fairly detailed account of modesty training among a traditionally
naked people is given by John W M Whiting for the Kwoma, who live
just north of the Sepik river in Papua New Guinea. Modesty is stressed
from childhood. Boys are scolded and even beaten for looking at female
genitals. The same tabu continues throughout life except with respect
to the genitals of a lover or wife. When he reaches puberty, if a boy
stares a girl's body he is suspected of having made a sexual advance:
to stare at her genitals may invoke insults and threats from the girl's
relatives. The proper behavior for a boy or man in the presence of a
woman is to fix his eyes on the ground or to sit or stand with his back
to her whenever he is in her presence. Furthermore, if he meets a woman
walking, they may not speak until they have passed each other.

A girl for her part is trained not to assume "immodest" postures.
Even little girls are scolded for doing so, but in adolescence the criticism
may become severe. A proper girl should not sit with her legs apart or
knees drawn up, but should stretch her legs out close together with knees
unbent. She should never bend over when men are present unless she

is wearing a net bag (which function, as an article of clothing as well as a receptacle for carrying objects). This bag hangs from the forehead down the back and may reach almost to the knees. If a girl does not observe these rules she is branded as a loose woman and her chances for getting married are greatly reduced.

Such rules of modesty persist throughout life, to be broken only by the old. The old may even embrace someone of the opposite sex — an act totally forbidden to others except among spouses, lovers and with infants.

A matter of particular embarrassment among the Kwoma is getting an erection in public. Even in boyhood, an erection is a cause of considerable humiliation and any female who sees a boy with an erection is expected to hit his penis with a stick. Whiting noted that the training must have been very effective because he never saw a man with an erection and only once observed a little boy with an erect penis.

In his important early survey of modesty in different cultures, *The evolution of modesty* (1899), Havelock Ellis concluded that modesty was far more entrenched among primitive peoples than among those who were more highly developed, and furthermore that modesty continued to be more intense among lower-class people than among "the more cultivated classes." The second observation has in part been confirmed by the later researches of Alfred Kinsey and his colleagues in the United States. They found that in the 1940's older working-class people tended to wear some clothes when copulating, and that the men did not even go bare-chested before their wives; modesty required that they should at least wear undershirts.

Among the cross-cultural evidence that Havelock Ellis gives are the following: Tocantins reported that although the Munducurú women of Brazil are completely naked, they are so skillful at avoiding any indecorous postures that it is impossible to tell when they are menstruating. As for the Dinka, among whom the men go naked and the women wear only a pubic covering, Lombroso and Carrara in the 1890's wrote of how astonishing the intensity of modesty was among these people: no Dinka man would permit examination of his genitals; no Dinka woman, of her breasts. One woman who permitted examination of tatoos on her chest was clearly upset by it for two days.

Writing some 50 years later, Franz Kiener compared the "high" sexual morality of the Luo of Kenya, among whom the men lived in total

nudity, with the "loose" neighboring Baganda, who were traditionally covered to the neck.

A study by William N Stephens tries to relate degrees of modesty to stages of human social evolution. The most intensely modest peoples turn out to be peasants who also attach great importance to premarital chastity in women. Virtually only peasant societies require that women cover their breasts, although there are a few exceptions such as the Balinese, Dahomey, Naayar, Mohave and Ojibwa. Stephens attributes the peasant obsession to a particular kind of authoritarian, patriarchal family structure, which is the rule among such societies. He associates this family structure with the rigid class structure of feudal kingdoms. The political democracies of industrialized societies seem to be associated with more democratic family structures and these, in turn, he correlates with more relaxed attitudes to sex restrictions.

Although Stephens's causal model has attractive features, it cannot be said that modesty invariably goes along with chastity. For example, among societies where even women's breasts are covered (his highest criterion for modesty in this scheme), the Tepoztecans and Yadaw are said to have ineffectual rules against premarital intercourse for girls, whereas the Shavante, who rank very low in the modesty scale (the women go naked), have very strict rules against both premarital and adulterous relations for women.

A subsequent study by Gwen J Broude and Sarah J Greene has summarized the evidence on behavior and ideology among traditionally nude societies in comparison with others: there would seem to be as much variation as among clothed groups. The number of naked groups considered, however, was small. Of a sample of 186 societies, only six practised adult male nudity. Of these only four were said to have comparable female nudity. This small sample shows that the concerted effort by Christian missionaries and others to stamp out nudity throughout the world has been quite successful. Even 100 years ago, a considerably larger number of people practising nudity could be found. Be that as it may, in both behavior and belief, the existing naked societies show almost as wide a range as do clothed groups.

So far nudity has been equated with exposure of the genitals. Some people, however, do not hide their sex organs, but may wear headdresses, arm bands or strings around the waist. In a number of societies, skins

or cloaks may be thrown over the shoulders as a sign of rank or for protection while the genitals remain uncovered. This is true of the Nuer leopardskin chiefs, California Indians, and other Indians from the Great Basin. Exposure of the shoulders, however, was not considered immodest. In all societies, modesty is almost always associated with the genitals, although it may be extended to other body parts, so that intense feelings can be aroused by having nose plugs removed (as among some Brazilian groups) or lip plugs (Alaskan Indians) or socks (Chinese). But it does not happen the other way around. Thus, we do not expect, nor do we find, societies in which normal women are intensely modest, for example, about their hands but not about their vaginas.

The Naaga, a head-hunting group from India, are a frequently mentioned counterexample. This exception was first reported by Ibn Muhammad Wali in his history of the conquest of Assam (1662 to 1663), retold by Havelock Ellis and repeated verbatim in virtually every subsequent book on fashion and clothing. According to this account, Naaga women covered only their breasts because "it was absurd to cover those parts of the body which everyone has been able to see from their births, but that it is different with the breasts, which appeared later, and are, therefore, to be covered" (Ellis). But Masani, writing in 1934, puts the situation in a more readily believable light, saying that Naaga women wear necklaces and an apron — and sometimes not the apron. But necklaces are merely decorations, and decorations of even the most elaborate sort are sometimes found among naked people to indicate ritual or social status. An even more thoroughgoing description of the present-day Naaga by von Fürer-Haimendorf, along with photographs he has taken, suggest that although the necklaces are elaborate, they hardly hide the breasts. In fact, totally naked women can sometimes be seen among the Naaga and they apparently feel no embarrassment even if menstrual blood appears on their thighs. Usually, however, they wear narrow skirts that just cover the genitals.

An almost identical and equally unlikely story is told about a group in Thailand in the vicinity of the Mekhong. There, too, the women are said to go around bottomless but not topless, and for the same reason: that breasts were the one part of their body they did not have since childhood. A few other somewhat unexpected fashions have been reported, notably an early Egyptian male kilt that covered the buttocks

but exposed the genitals, a style for working men in the Old Kingdom recorded in art. A similar anomaly occurs in the representation of ancient Greek hoplites (a kind of foot soldier), who are often shown with helmet, breastplate and greaves (leg coverings) but with genitals exposed. No obvious military advantage comes to mind for this outfit. In both the Egyptian and Greek situations we are probably dealing with an accepted nudity, although the styles in question are cross-culturally rare.

Greek nudity was proverbial in the ancient world. The Etruscans and Romans found it distasteful but copied Greek styles in their art: it did not correspond with the reality of dress any more than modern nudes in painting and sculpture correspond to how people look in New York or London. The Greeks themselves were conscious of the uniqueness of their custom of "heroic nudity," at the Olympic games and elsewhere. Initially, they wore a *perízooma* (something like a bathing suit) in athletic competitions. But traditionally the change came when Orsippus of Megara won the footrace by allowing his *perízooma* to fall off along the way.

A cross-cultural tendency with regard to nudity is that men either equal women in bodily concealment or wear less, seldom the opposite. The ancient Greeks, for example, did not generally tolerate nudity in women (except in Sparta); the statues of young women were originally always draped in long garments. The same tendency can be observed on so-called nudist beaches in America: the men are totally naked but their women are usually only topless. A number of reasons have been suggested for such a phenomenon. Perhaps the most striking is a psychoanalytic one: it is that women prefer to remain covered in order to hide what they lack — a penis.

In countries where part of the population has traditionally gone naked changes are sometimes difficult to enforce. The elite in these groups have usually been trained in the West or are very westernized and may want to end nudity because it is "primitive" or "immoral." Such has been the case with the Turkana of Kenya since the 1960's; they have resisted attempts by the central government to get them to wear clothes. Nudity became a symbol of Turkanahood and so not something to be given up lightly.

Tanzania launched the same sort of harassment against the seminaked Maasai in 1968 (Maasai men cover their bodies with red ochre

and wear a loosely draped blanket, which does not always hide the genitals). Maasai men were forbidden to enter the town of Arusha unless they wore trousers. An enormous debate was thereby unleashed. Maasai in neighboring Kenya were outraged by the cultural pogrom the Tanzanians had attempted. Interestingly, at the same time, Tanzania forbade the wearing of miniskirts. The move against the Maasai was taken in the name of modernization and national integration; the move against miniskirts as a rejection of western decadence.

Nudity is clearly a complex matter and may become a symbol having little to do with concupiscence.

Clothing and sexuality

Clothing frequently does not diminish sexuality but enhances it, and is often deliberately designed to entice. In saying this, I am not even considering the psychoanalytic view that clothes can function as sexual symbols (for example, the modern tie is frequently cited as a phallic symbol).

In those areas of the world where women go topless, breasts are not singled out as particularly attractive, whereas in the West and particularly the United States, breasts form the focus of much sexual fantasizing and attraction. A female researcher of my acquaintance went to a certain island in the Pacific in the late 1950's, wearing conservative western clothes at the time. The women of the island customarily go about topless but with wraparound skirts reaching to the ground. My friend noticed that although native men paid no attention to the bare breasts that were everywhere to be seen, they ogled her ankles. Her social position was in doubt because exposing her legs was considered reprehensible. She went native in dress and had no more problems on that score.

A somewhat similar account (which has become quite famous in the sexologist literature) also suggests that hiding the body is itself erotic. It was mentioned by Havelock Ellis and drawn from the autobiography of the celebrated philanderer Casanova (1725-1798). When he was in Rome, Casanova went to a public bath in which he was bathed by a naked girl attendant. After the bath, the girl expected Casanova to have sex with her, but to his own surprise he found he was not attracted to

her. He concluded that his nonsexual comportment with her while she was naked had reduced her attractiveness.

Other accounts also support this view, at least in part. Young men I interviewed in Síssano on the north coast of New Guinea told me that they found the breasts of young girls very erotic; older men did not. But it was only within the past two generations that young girls (but not older women) covered their breasts at the insistence of the Catholic missionaries. Clearly one can find anecdotal accounts that support the idea that the wearing of clothes promotes concupiscence rather than reduces it. Along these same lines, clothing fetishes (sexual interest in articles of clothing) are fairly common in prudish, highly clothed, advanced societies but are almost nonexistent elsewhere.

One of the obvious functions of clothing is to exaggerate the distinction between the sexes. A true unisex style of dress and adornment is rare in the world's cultures. The use of codpieces, penis sheaths, epaulettes or padding to broaden the shoulders, play up certain aspects of male anatomy; the use of crinoline hoopskirts and décolleté have emphasized feminine characteristics. An especially explicit fashion for women has been called the erotic style. It is characterized by such features as transparent materials (gauze, tulle), tight-fitting clothes and garments that only partially cover the body (décolleté, cutouts, side vents). Strangely, in mediaeval Europe, the Virgin Mary is occasionally represented in one version of the erotic style — with cutouts for her breasts (a fashion never worn by contemporary women). Another style, but one that has been identified as essentially masculine, is the so-called aggressive style, characterized in part by noisy materials such as creaking leather or clanking metal.

The various recent changes in the status of women in the western world, bringing them closer to men both economically and socially, have led to the widescale use of trousers for women and the emergence of a fairly general unisex style. Mario Bick, in an unpublished paper "What's on, what's coming off," has suggested that an erotic style is not essentially a feminine style but one associated with a certain position in what he calls the "sexual marketplace." For Bick, the sexual marketplace has little to do with marriage but is essentially "the arena in which premarital and adulterine sexual relationships are contracted."

In his analysis of European peasant society, he says that women are on display before marriage and tend to wear colorful clothing and expose their hair. After marriage, their dress tends to become drab and their hair is generally hidden under some sort of kerchief, indicating that they are not technically available for adultery. But married men, Bick finds, are more decoratively dressed after marriage in peasant society: they then become the "objects" in the sexual marketplace, displaying themselves so that "consumers" will be attracted. In the royal courts of Europe, the sexual marketplace was open to everyone and men and women were equally on display.

With the breakdown of arranged marriages in the western world, women become virtually always the objects, in competition for men who until recently represented economic security as well as sex partners. Hence it is the women who have consistently been more flamboyant (except for a few periods such as the 1920's and today, when women have become more economically independent).

In most societies, says Bick, it is men who are nearly always more gaudy. But recently in the West their clothing has been uniformly drab and regimented. This drab masculine style has been called the "great renunciation" by J C Flugel, the psychoanalyst of clothing. If Bick is right, this label seems to be quite accurate. Fashion for men is changing and Bick suggests that the sources for the new fashions are lower-class black ghettos and the gay world, where men are competing in a special sexual marketplace. Among blacks, it is frequently women who are economically the more stable and so, in a sense, able to be the consumers. Among homosexuals in anonymous settings such as gay bars, appearance is virtually the only criterion of attractiveness.

Bick's analysis, which is meant to account for a vast array of details of style, has several attractive features but seems not to be totally true cross-culturally or even within western society. And it certainly goes against what sociobiologists would predict.

Drab versus gaudy clothing in the West can, for example, be associated with the development of local forms of cloth manufacture and dyeing. Jane Schneider has set up a contrast between the sartorial "penguins" and "peacocks." The Italian Renaissance was a heyday for peacocks: fashionable men wore brightly colored clothes as varied as those of women. But the dyes were expensive and had to be imported

from the Orient. Eventually a superior black dye was developed in Europe and this became the preferred color not only for economic reasons but also as an expression of nationalism. Black even ousted white as the traditional European color of mourning. Black became at once a symbol of piety, frugality and elegance. It also developed erotic overtones: black stockings and underwear, for example, were identified with prostitutes. One the one hand, the ideal nun wears black garb; on the other, so does the ideal sadomasochistic dominatrix (both sadomasochists and leather fetishists tend to opt for black leather clothing or accessories, particularly boots). Although the nun and dominatrix may share a number of characteristics — notably an image of strictness and discipline — they are clearly at opposite ends of an erotic reality. Probably we are dealing with some sort of symbolic reversal.

Homosexual clothing conventions tend to vary considerably. There is no inherent "homosexual style" of dress, and what would be identifiable as such a style in one society at any given time may be interpreted differently in others. In the 1970's in the United States, the use of a single earring or ear stud by men (especially in the right ear) was thought of as a "gay" style. But it was also worn by many black heterosexual men. The style was later adopted by many white heterosexuals. In Great Britain, this more general fashion seems to have developed earlier.

In some cultures, homosexuals are identified with transvestites and there is no terminological difference between them. But homosexuals are seldom transvestites in the western world. According to the evidence we now have, western transvestites tend to be more often heterosexual than homosexual.

The kinds of clothing conventions homosexuals have used in the western world vary. Green cravats were an ingroup sign among Parisian homosexuals during the nineteenth century. I have been told that in some sections of New York in the 1950's or 1960's, the wearing of a green tie on Thursdays was taken as a sure sign that the person wearing it was homosexual. In *Sexual inversion,* Havelock Ellis seems to suggest some sort of psychological or even instinctual basis for preferring green, but this can hardly be taken seriously if only because he reports that at the end of the nineteenth century, male prostitutes in New York and Philadelphia almost invariably wore red ties, and it was assumed that

any men wearing such ties were homosexual. Bullough notes that the Chicago Vice Commission in 1909 found that the numerous male homosexuals there (estimated at 10,000 or more) also made use of the red tie convention to identify each other. Bullough comments: "This leads to a question of whether homosexuals had adopted red as a color in Chicago or whether they wore red because Havelock Ellis told them it was the thing to do." In the 1960's another set of conventions was developed among a subgroup of male homosexuals: the sadomasochists. These conventions distinguish sadists from masochists by having the former wear keys, chains, earrings, occasionally also handcuffs on the left; and the latter wear the same items on the right. What is curious is that even masochists have started wearing "hardware" on their left because it is felt to be chic or at least more "manly" to be sadistic. The symbolism used is exceedingly interesting since it almost certainly represents a reversal of what is nearly a cultural universal. In most societies it is the right side that is regarded as the more masculine or prestigious and in many languages the right hand is called the "male hand."

Clothing, then, can obviously be an integral part of various expressions of sexuality. It has probably exerted an influence on sexuality from its very inception at least 400,000 years ago. By 100,000 years ago, clothing of various sorts and a knowledge of sewing and tailoring existed among several peoples in different parts of the world. But the use of clothes must have been abandoned at least once (and possibly more than once). Ancestors of the American Indians migrated across the Bering Straits at least 20,000 years ago undoubtedly with clothing for protection against the cold. But they may have used clothing as the Éskimo and other contemporary Arctic peoples do, for warmth outdoors unaccompanied by a sense of shame at its absence indoors. When the Indians reached farther south, the indoor/outdoor distinction was dropped and with it clothes. The most southerly group of Indians, the Yahgan of Tierra del Fuego, did not reinvent this distinction. Although they lived in a severely cold climate, they went about naked. Darwin saw snow melt on the skins of Fuegians. He offered a large piece of cloth to one of the natives for protection, but instead of using it to cover his body the Fuegian tore it into strips and gave each of his fellow tribesmen a piece for decoration.

The veil

The earliest references to the veil occur in the ancient Mesopotamian Epic of Gilgamesh, parts of which date from as early as 2000 BC. In it a goddess is described as "covered with a veil"; and night is metaphorically referred to as a "veiled bride" suggesting the custom found in many societies and still in use in the Judaeo-Christian tradition.

In modern times, the habitual wearing of a veil is primarily associated with the conservative Islamic world. In traditional Muslim society, veils are worn by girls after the onset of menstruation and up to old age. Women may uncover their faces only before other women, children, husbands or close male relatives. Not only the head and usually the lower part of the face but also most of the body should be covered. Some veils are so extensive that the whole body is hidden.

The Islamic custom developed out of pre-Islamic fashions in Arabia, when the use of veils was optional. The ancient Hebrews also used veils: covering the head with a large shawl such as is usually shown in traditional Christian representations of the Virgin Mary. St Paul's injunction to women to cover their heads when they pray or prophesy (I Corinthians 11:5-15) presumably refers to the use of such veils. The general Roman Catholic practise of requiring women to cover their heads in church (at least during Communion), was made optional only in the mid-1960's.

The use of veils for women was borrowed by upper-class north Indian Hindus in the period of Muslim domination. Occasionally groups on the fringe of Islamic cultures have adopted the veil and reinterpreted it in a totally non-Islamic way. A striking example of this comes from the African country of Chad, where some non-Muslim women have adopted veils though they still go bare-breasted.

A number of attempts have been made to get Muslim women to abandon the veil. Kemal Atatürk made use of the veil optional in Turkey after he took over the government in a coup following defeat in World War I. He discouraged the wearing of veils but realized that total abolition would be too scandalous for most Turks. On the other hand, in November 1923 the wearing of the traditional Turkish head covering for men, the fez, was totally forbidden as part of a general westernization policy.

In 1935, Riza Shah outlawed the veil in Iran. A little more than 10 years later, when he was forced into exile, the veil reappeared overnight. In 1978 to 1979, during demonstrations against the Shah, even profoundly westernized women readopted the veil as a symbolic rejection of the regime. On the other hand, when the postrevolutionary government insisted on the use of the veil, there was a massive protest demonstration by these same women.

In France in 1989, an uproar was created when three Muslim students wore veils to a public school in a suburb of Paris. At one point, the principal demanded that they remove the veils or leave school. The French Minister of Education, however, decided that despite the fact that the public school system is secular, schools had no right to ban any clothing or other insignias of religious affiliation. This decision was denounced by feminists, who saw veils as a form of oppression against women. Politicians on either end of the political spectrum attacked the decision for a number of reasons.

The general Islamic justification for veiling women is that it shields men from their dangerous sexuality rather than because of some extraordinary sense of modesty. It has been noted by travelers that women brought up with a tradition of veiling when caught unawares by strange men tend to cover their faces even if otherwise naked.

In a very few societies do men normally wear veils, the best example being the Tuareg of the Sahara. The Tuareg probably originated in Tripolitania and were at one time Christian. They converted to Islam after the eleventh-century invasion of North Africa by Beduin Arabs, who displaced them and forced them into the desert. The remarkable thing is that unlike other Muslim groups, women do not go veiled. It is not clear why the men do so instead. In any event, the male veil (or mouth muffler, *tagilmust*) has become symbolic of social distance between men and is not even removed while eating: special spoons with long curved handles that can go under the veils are used. The greater the social distance, the higher up his nose a man's veil will go.

Men sometimes wear veils for special reasons, very often religious or magical in nature. In the Bible, Moses and Elias are both described as veiling their faces in the presence of God (Exodus 3:6; I Kings 19:13), and Moses was also believed to have covered himself with a veil when he came down from Mount Sinai bearing the Ten Commandments. This is

surely similar to customs found in certain traditional kingdoms of black
Africa whereby the king, regarded as divine, is virtually isolated and
concealed by curtains because his glance is considered dangerous.
According to Westermarck, in Arabia handsome men used to veil their
faces against the evil eye, especially in large gatherings of people. Male
transvestites have frequently adopted the use of the veil in Muslim
countries.

The wearing of masks is similar although a different part of the face
may be covered. In western Europe, the custom is said to have been
introduced by Venetian courtesans and is recorded as early as 1295.
Samuel Pepys notes that in the England of his day (1664) "ladies hide
their whole faces."

The penis sheath, the codpiece and foreskin tying
In some societies, men wear no clothing other than penis sheaths or other
kinds of coverings for the penis variously called phallocrypts or penis
wrappers. These seem almost never to be used for contraception and are
generally removed both for urinating and during copulation.

Phallocrypts are of particular interest because on the one hand their
users almost always identify modesty with covering the head, or glans,
of the penis, but on the other hand, these devices are often so large and
so elaborate that they must surely draw attention to the genitals rather
than hide them as the term phallocrypt (penis-hider) suggests. In
Vanuatu (the former New Hebrides), for example, the custom was for a
man to go naked except for wrapping his penis in many yards of calico,
winding and folding it until a bundle 18 to 24 inches (45-60 cm) long
and two inches (5 cm) or more in diameter was formed; it was then
decorated with flowers. The testicles were left naked. Gourd penis
sheaths up to two feet (60 cm) in length are reported from a number of
areas; they were sometimes decorated with bird feathers, beaks, animal
fur or tails and attached to the body at an angle suggesting a gigantic
erection.

A number of theories accounting for the various fashions of penis
confinement have been given: for example, they might indicate that men
are sexually available in those societies where women are the sexual
"consumers," as in some places in New Guinea where fears of menstrual

pollution inhibit male sexuality (in accordance with Bick's theory mentioned earlier); they might involve aggressive display much like that found among baboons and other primates who are sitting guard over the group territory (a theory proposed by Wickler in 1966); they might be concerned with "status sex" and the greater the angle of the pseudo-erection displayed the more dominant and aggressive are the people in question (a theory proposed by Desmond Morris in 1969 and derived from Wickler's views); or there might be some sort of positive correlation between circumcision or other genital mutilations and the use of penis sheaths.

None of these theories receives total support from the cross-cultural data. Native explanations tend to be practical and neither sexual nor aggressive (although the real reasons for the fashion may be repressed). Explanations given are, for example, that penis sheaths are protection against insects or thorny bushes or that they prevent fish from biting off the penis while a person is wading. But these explanations are not particularly compelling if only because an equally vulnerable area of the body — the testicles — is exposed and in many instances the construction of the penis sheath offers very little protection.

The essence of the function of the penis sheath is covering the glans, and for this reason it has been likened to foreskin tying found in such diverse cultures as those of the Amazonian Indians, Marquesans and ancient Greeks. In some areas of Japan, foreskin tying is still practised by fishermen but only apparently for some sort of magical protection.

Another fashion penis sheaths have been compared with is the European codpiece, the origins of which are obscure, but which was first invented in the late fourteenth century. This fashion continued until the late sixteenth century, when it fell out of style and was considered indecent. It survived in some rural areas until the seventeenth century. Codpieces started out as a means of ensuring decorum when jerkin and doublet became shorter and hose tighter. Later on they became a matter of display and approached the spectacular qualities of some penis sheaths, being stiffened, padded, decorated with embroidery or bows and so large that they were used as pockets or purses (it has been said that men could hide oranges or spoons in them). In design they often resembled an erect penis, but there was considerable local variation.

Penis sheaths have been made in a variety of materials, even in the same community. In Vanuatu, for example, the penis might be wrapped in grass, tapa (bark cloth) or cotton cloth; or placed in a horn or within a bamboo sheath. Leaves, grass, shells, gourds, wool, ivory, nuts, horns, leather and basketry have been common materials. A recent Zulu style found in South Africa makes use of aluminum for glans cups. In various parts of New Guinea the following recent materials have been utilized in addition to traditional ones: toothpaste containers, Kodak film containers, opened sardine cans.

With the onslaught of western styles, penis sheaths and foreskin tying are no longer obvious in many areas because of the adoption of trousers. But it seems that many peoples still wear them under their western clothes.

MALE GENITAL MUTILATIONS

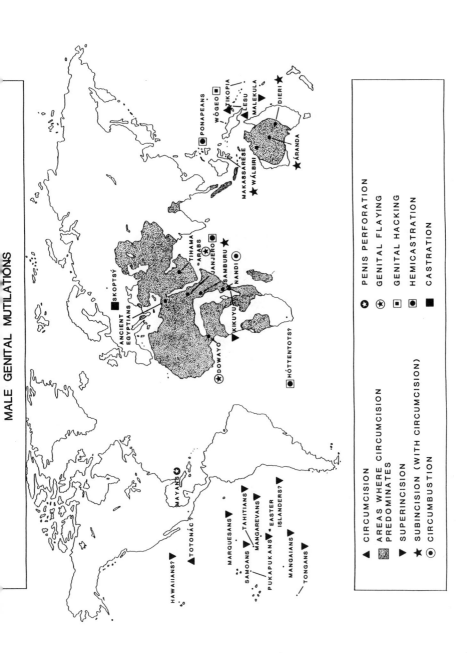

HAWAIIANS ▶

TOTONÁC ?

MAYANS ✪

MARQUESANS ▶
SAMOANS ▶ TAHITIANS ▶
PUKAPUKANS ▼ MANGAREVANS ▶ EASTER ISLANDERS? ▶
MANGAIANS ▶
TONGANS ▶

SKOPTSÝ ■
ANCIENT EGYPTIANS
DOWAYO ✪
KIKUYU ▶
HÓTTENTOTS? ◉

TIHAMA
"ARABS"
NANJERÓ ◉
SAMBURU ★
NANDI ◉

PONAPEANS ◉
WÓGEO ■
TIKOPIA
LESU ▶
MAKASSARÉSÉ
WÁLBIRI ▶
MALÉKULA ◉
MAKASSARÉSÉ ★
ÁRANDA ★
DIERI ★ ▶

◀ CIRCUMCISION

▦ AREAS WHERE CIRCUMCISION PREDOMINATES

▶ SUPERINCISION

★ SUBINCISION (WITH CIRCUMCISION)

◉ CIRCUMBUSTION

✪ PENIS PERFORATION

✪ GENITAL FLAYING

■ GENITAL HACKING

◉ HEMICASTRATION

■ CASTRATION

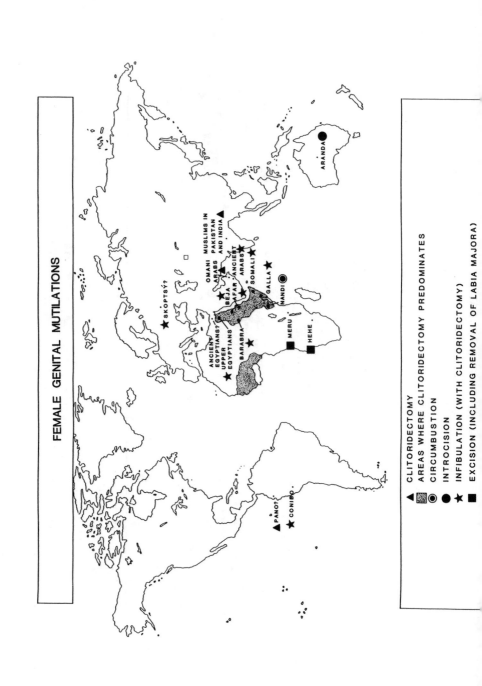

FEMALE GENITAL MUTILATIONS

SKÖPTSY?

OMANI MUSLIMS IN PAKISTAN AND INDIA
ARABS
BEJA
AFAR
ANCIENT EGYPTIANS?
UPPER EGYPTIANS
BARABRA
ANCIENT ARABS
SOMALI
GALLA
NANDI
MERU
HEHE
ARANDA

PANO?
CONIBO

▲ CLITORIDECTOMY
▒ AREAS WHERE CLITORIDECTOMY PREDOMINATES
◉ CIRCUMBUSTION
● INTROCISION
★ INFIBULATION (WITH CLITORIDECTOMY)
■ EXCISION (INCLUDING REMOVAL OF LABIA MAJORA)

NINE MARRIAGE AND INCEST

Since marriage of some sort is the setting for much
(probably most) sexual behavior throughout
the world, it is important to realize the great
variety of forms marriage has taken.

Among the Kwakiútl, a man could "marry" the arm or leg of the chief —
that is, if the son of the chief were not available.

Such marriages are marriages in name only from a western point of
view, but it is clear that several kinds of marriage may be recognized
within a single society. An extremely complex situation occurs among
the Dahomey of Benin in West Africa. They permit 13 different kinds
of marriage, each depending on a different economic arrangement. In
ancient Rome, at least two types of marriage were distinguished: free
marriage, in which the wife and her property did not come under the
power of her husband; and marriage with *manus* (literally "hand,"
referring to the hand of the husband), in which the woman's status was
changed so that she was legally the equivalent of her husband's child and
was adopted into his family.

But there is no need to go so far afield. In the contemporary western
world, there is traditional monogamous marriage defined either by a
religious or civil ceremony (or both), as well as cohabitation. Although
the living arrangements may be identical, money interests and the
legitimacy of children are different in the two situations. The much
publicized legal battle in 1979 between the American movie star Lee
Marvin and a woman he had lived with for several years but never
married, illustrates the difference well. In spite of the social
acceptability of their relationship (at least in the circles they moved in),
legally she was not entitled to alimony (the money settlement she did get
was facetiously termed "palimony"). A decade later, an almost identical
battle occurred involving another movie star, John Hurt. In some circles
even homosexual unions are sometimes referred to as marriages. This is
nearly everywhere not legally the case, though various proposals have
been made for the legal recognition of such unions, and in 1989,
Denmark became the first modern nation to recognize homosexual

"partnerships" with the same rights and obligations found in heterosexual marriage (except for adoption).

In some societies it is the custom to arrange marriages between living people and the dead. The best known example of this is contemporary American Mormons, who believe that being mated is a necessary condition for being saved and going to heaven, and that dead unbelievers can be saved by posthumous marriages with Mormons. Among traditional Chinese groups, if a couple betrothed as children both die, they are married anyway in a kind of heavenly marriage, in part to placate their ghosts.

All of these ritual joinings and others like them have been called pseudomarriages. But even if we do not consider them in defining marriage cross-culturally there are other problems. The definition given by a basic reference book *Notes and queries in anthropology* (1951), put out by the Royal Anthropological Institute, is useful in a rough and ready way, but even the following definition is too specific to apply in all societies:

> Marriage is a union between a man and a woman such that the children born to the women are recognized as legitimate offspring of both partners.

If we are concerned that marriage (and with it its minimal domestic realization — the nuclear family) should be a universal category, then this definition will not do.

The classic counterexample dealing with the first part of the definition ("a union between a man and a woman") is found among the Naayar of India. Before she begins to menstruate, a Naayar girl is supposed to go through a four-day ceremony that links her to a man who has been described as a ritual husband. A special pendant is tied around her neck indicating that, in a sense, she is married. But this does not mean that she is going to settle down and form a family with her "husband." On the contrary, it means that she is now free to have as many lovers or "visiting husbands" as she likes. These men come to her room in the great house where she lives with her mother's family. Her lovers do not live with her, they merely spend the night. Any children born after the marriage ceremony are legitimate, but if the woman has a baby before the marriage she is punished. In short, the ritual husband is totally peripheral to her family unit, though essential for legitimizing children.

An interesting relationship exists between the Naayar and the Nambuutiri Braahmans, who belong to a higher caste. Among the

Nambuutiri Braahmans, only the eldest son is allowed to marry and raise a family. His younger brothers instead arrange alliances with Naayar women. For the Braahmans such alliances do not count as legal marriages and the resulting children are not considered legitimate. For the Naayars, however, they are a source of prestige and the offspring are legitimate.

Because of the Naayar, Kathleen Gough has proposed a definition of marriage that is considerably more general than the one quoted earlier from *Notes and queries*. But her definition also emphasizes the notion of legitimacy, the second part of the Notes and queries definition. However, a rule of legitimacy is also not a cultural universal.

The Caribbean is a case in point. This is an area of the world where the rule of legitimacy is lacking. An unusually high percentage of children are here born to unmarried women: between 53 and 56 percent of the births are "illegitimate" in Guatemala, Jamaica and Trinidad; 67 percent in Martinique. Leyburn maintains that "there is less marriage in Haiti than anywhere else in the world." It is true that upper-class groups in these areas follow the western rule of legitimacy, but the other groups do not. There is no stigma in being illegitimate. The people who are not upper class and who do marry — they sometimes do this when their children are grown up — do not do so to legitimize their children, but to hold a large party *(fête)* thereby meeting their social obligations and expressing group solidarity. To hold such a *fête* even after one's children have grown up is prestigious among these groups. To get married in a church at any time without a *fête* is deviant and despised. Nevertheless, people may get married for different reasons; certain jobs such as school teacher, for example, require a parent to be married. Clearly there are many problems in getting a cross-cultural definition of marriage. I shall not belabor the point further but use the term "marry" in the following pages in an informal and practical way.

In western society, the only form of marriage legally recognized is that between one man and one woman at a time: monogamy. The great majority of people in the history of mankind have lived in monogamous marriages and the great majority of people in the world today are monogamous. The preferred form of marriage, however, in most societies is, and has been, a kind of plural marriage in which a man is married to several women at one time, technically known as polygyny. Nearly half (44 percent) of all the societies in Murdock's *Ethnographic* atlas — a compilation of information on 862 cultures throughout the world — regard having more than one wife at a time as the norm, and 39 percent

more permit it along with monogamy. Only 16 percent insist on monogamy. (The remainder have other arrangements.)

Furthermore, even though monogamy is the reality (but not the ideal) for most people, an enormous number of them have more than one spouse in a lifetime. Liberalization of divorce in the West has resulted in multiple marriages, often called serial monogamy. According to the *Guinness book of records* (1979), the greatest number of such serially monogamous marriages is 20, entered into by Mr Glynn de Moss Wolfe, an American. Serial monogamy is also reported for other monogamous groups such as the Hopi Indians and the Siiwans of Egypt.

Having more than one wife at a time is generally considered shocking and immoral in the West. In most parts of the world, however, it is a sign of being successful, rich, even powerful; such a man might well be considered a good match and accumulate still more wives. Usually there is a ranking system among the co-wives so that their status is reasonably defined. To offset favoritism, traditional polygamists normally institutionalize some form of rotation system so that a man must spend an equal amount of time with each wife. In spite of these safeguards and considerations, much ill will may exist between co-wives. In Hausa, the very term for co-wife is *kúishiyáa*, which means "partner in jealousy." Nevertheless, Christian missionaries who try to break up polygamous families have reported that the women object most to the imposition of monogamy.

All the men in a society cannot have many wives if only because the sex ratios are fairly equal: one does not find normal populations with two or three times as many women as men. The number of women available depends in part on the absolute number of wives permitted. In some the number is enormous — at least for kings and noblemen. King Solomon is described in the Bible as having 700 wives and 300 concubines. A chief of the Kuba and Kete groups in Zaïre, called Lukengu, had 800 wives according to the *Guinness book of records* (1964). But the all-time record seems to be the 3,000 wives of one of the Monomotapa kings in what is now Zimbabwe.

In some societies, such as that of the Tiwi of Australia or the Zande of central Africa, the older, richer men take up all the marriageable women of whatever age and younger men must delay marriage until their 30's and 40's or until they "inherit" their fathers' wives (all except their own biological mother). A kind of widow inheritance is known from the Bible: a widow was supposed to marry one of her dead husband's

brothers. This custom is found in a number of societies throughout the world.

For a woman to marry a number of men at the same time — a form of polygamy known as polyandry — is very rare: only four societies in the *Ethnographic atlas* permit polyandry. Societies permitting polygyny are roughly 100 times that number. This makes sense in light of an interpretation of marriage offered by Claude Lévi-Strauss, that it is the "gift" of women exchanged between men. He formulates the reality of the situation thus: "Men exchange women; women never exchange men." Marvin Harris adds that sex (through such marital gifts) is used in most societies as a reward for male bravery: "No battle-hardened headhunter or scalp-taker is going to settle down to connubial bliss in the company of four or five of his boon companions under the tutelage of a single woman...."

True polyandry involving a stable household where a woman's husbands all share the same residence is unusual and found mainly in the Himalayas. Such households almost always involve a number of brothers who share a wife. One of the major advantages of such a system is that it prevents the breaking up of family wealth or property.

All forms of polyandry are exceedingly rare at present and it seems likely that it was always so. Consequently nearly all anthropologists reject a suggestion by J F McLennan, a nineteenth-century ethnologist, that polyandry was the normal form of marriage at one stage in the development of human social organization.

In the African forms of polyandry (found in a limited number of groups in Nigeria), the husbands do not live together. They are not brothers and the wife circulates from one household to another. Furthermore, both polyandry and polygyny occur, so that some men have several wives living with them in the same household — unlike the women, who never have several husbands living with them.

Another variety of polyandry characterizes the preferred and most common form of marriage among the Pahaarii of northern India. Their custom requires a very high bride price, a gift given by the groom's family to the bride's family. Because of this great expense, brothers normally pool resources and acquire a wife in common. Later, when they can afford other wives, they will again acquire them in common. This is not really polyandry but what is called group marriage. The Pahaarii are apparently the only society in the world in which group marriage is the cultural norm.

An even more extreme form of group marriage, known as complex marriage, was practised for a short time by the Oneida community, a utopian Christian religious group founded by John Humphrey Noyes in Putnam, Vermont, in 1841. The group moved to Oneida, New York, in 1847. In this society every man was the husband of every woman and every woman the wife of every man. This aspect of the society evoked considerable hostility from the surrounding communities. In 1879, Noyes recommended that the complex marriage system be abandoned.

In almost all societies — whatever form of marriage is permitted — a marriage can be ended by divorce. The traditional western Christian view that marriage is indissoluble is practically unique, Hinduism being the only other important tradition to take the same position. Hindus have even frowned on the remarriage of widows, but not widowers. Until the practise was outlawed by the British in 1829, the prestigious way for a widow to mourn for her husband was to burn herself to death on his funeral pyre, a custom called *satii*. Some Hindu fundamentalists have called for the decriminalization of *satii*. The social position of widows can be awkward indeed. As a matter of fact, in some parts of India the expressions "widow" and "son of a widow" are serious insults.

In some groups, such as the ancient Scythians (as reported by Herodotus) or the Zande of modern times, some of the wives or concubines of a king were killed at his death and buried with him. This custom is rare cross-culturally. In 1971, a mass grave was found in Gomolava in Vojvodina, Yugoslavia, dating about 1800 BC. In it, the body of a man (presumably a chief) was surrounded by the bodies of 15 women who were believed to be his harem.

Incest

The Kubeo of South America reportedly require a boy to copulate with his mother to mark the beginning of his official sex life. This is the only instance in the world that I have heard of, of compulsory mother-son incest. Marriage between them is forbidden, however.

Among the Tutsi (or Watusi) of East Africa, a cure for the impotence that a bridegroom may experience on his wedding night requires that he copulate with his mother.

These are the only reasonably well-attested rules for all the cultures of the world promoting mother-son matings. A number of unreliable reports suggest that even mother-son marriages are or have been possible in some societies, but they are seldom taken seriously. They may in

some instances be true, however, e.g., among the Kóniag Éskimo and the ancient Persians.

A tabu on mother-son marriage is usually cited as a cultural universal. Moreover, any form of approved, institutionalized incest is decidedly rare, and more commonly incest tabus are extended beyond the nuclear family to larger kinship groups.

The great social and cultural importance of incest regulations has not escaped anthropologists and other social scientists. The pioneer thinkers Sigmund Freud, Lewis Henry Morgan and Claude Lévi-Strauss, approaching the subjects from totally different perspectives, suggest that human social organization as we know it today began with the conscious institution of incest tabus. In the Freudian model, one of the prices one has to pay for being civilized, one of the prime discontents of civilization, is the suppression of the satisfaction of incestuous urges. But Freud was partially wrong: this is not restricted to civilized man. Even the otherwise promiscuous chimpanzee would be given a good slap by his mother if he attempted to copulate with her. Mother-son matings have rarely, if ever, been reported by field observers of any of the primates. Nature has its discontents, too.

Any examples of institutionalized incest have occasioned great interest. The most common exceptions to universal tabus on incest involve brother-sister marriage practised by the royal families of ancient Egypt, Hawaii and the Inka (or Inca), among others. Kleopatra (actually Kleopatra VII) is the classic example: herself the descendant of several incestuous unions, she was simultaneously her husband's sister as well as his wife. Unfortunately for her young husband-brother, Kleopatra had him murdered when he was 15 in order to pursue some nonincestuous unions with Julius Caesar and Mark Antony: politics rather than a horror of incest seems to have been her primary motivation.

Half-sibling, occasionally also full-sibling, marriage was legal and fairly common in the ancient Near East and was found among the ancient Persians (at least among the upper classes) as well as the ancient Hebrews at one point — Abraham and Sarah were half-siblings, with the same father but different mothers. The ancient Greeks also permitted it, though Roman law forbade it altogether. The Lakher of southeast Asia permit the son and daughter of one mother but two different fathers to marry. Elsewhere, when half-sibling marriages are permitted, this would most likely be forbidden, but this was also the ancient Greek practise at least in Sparta, justified in part perhaps because they held to a spermatist view: in the *Oresteia*, Orestes is eventually freed from

further punishment for having killed his mother (who had earlier killed his father) because she was not considered a blood relative.

In Bali, both full- and half-sibling incest is forbidden with one interesting exception. It is assumed that twin brother and sister have already been intimate in the womb. With an appropriate ceremony of purification, they are allowed to marry each other when they grow up. The Aymará of South America also permit twins to marry. The Marshallese of the Pacific believe that twins have indeed committed incest in their mother's womb, but unlike the Balinese, feel they must therefore kill at least the boy.

The Lamet of southeast Asia permit brother-sister marriage if the couple has been brought up in different households: they are then not viewed as members of the same sociological family. Similarly, the Nuer of East Africa feel that incest has not occurred if the relationship is not known (unlike the ancient Greeks, as seen in *Oedipus rex*). Interestingly, the same argument applied in a recent legal proceeding in Sweden. A government official discovered by accident that a man and woman who were married were brother and sister, and therefore under Swedish law the marriage was null and void. When the couple was confronted with the matter, it turned out that they did not know they were related because they had been separated as children and had lost contact with one another. The couple decided to challenge the law. Their argument was that even though they are biologically brother and sister, sociologically they are not, and therefore they should not be forced to separate. The Swedish courts have let the marriage stand.

Father-daughter marriage is occasionally tolerated or institutionalized but doing so is very rare, much more so than brother-sister unions. (As a matter of fact, however, father-daughter incest is the most common form of incest in the modern western world.) The Persian emperor Artaxerxes was said by Plutarch to have married his own daughter, and the Egyptian pharaoh Amenhotep III is known to have married at least one daughter: his son Akhenaten several. Among the Romans, incest was totally forbidden, but a few royal instances that went unpunished existed; Caligula committed incest with his three sisters, and even married one, Drusilla. Another sister, Agrippina, was rumored to have had sex with her son also, the emperor Nero. This was not something traditionally permitted to the royal family by Roman custom.

More widespread and of great importance in anthropological theorizing are restrictions on cousin marriages. The majority of societies

in the world today prohibit marriage to any kind of cousin. In Murdock's *Ethnographic atlas*, about two-thirds forbid cousin marriage.

In the Judaeo-Christian tradition, considerable variation has occurred with regard to the question of cousin marriage. The Bible does not prohibit cousin marriage of any kind, and Jews have allowed it throughout their history. But under Pope Gregory "the Great" (in 590-604) marriage between third cousins was forbidden. A little more than a century later, Pope Gregory III (in 731) forbade marriage even between sixth cousins.

These fairly extreme rules were changed by Innocent III in the fourth Lateran Council in 1215, when marriage beyond third cousins was permitted. Modern Roman Catholic marriage laws date from the Council of Trent (1563): second cousin marriage is permitted, and sometimes even first cousin marriage (but special permission is required).

The living law can change. Two interesting examples are known from outside Christendom. The emperor Claudius petitioned the Roman senate to change the incest laws so that he might marry his niece, Agrippina, who has been mentioned before as being involved in other incestuous unions. The senate made the required change, but according to Suetonius, a contemporary of Claudius's, there was no great rush by uncles and nieces to get married.

The second historically attested change occurred because the prophet Muhammad received a special revelation permitting him to marry Zaynab, the wife of his adopted son, Zayd. Custom prohibited marriage between a man and his son's wife, and up until that point an adopted son counted as a blood son. From then on inheritance laws were to differentiate between adoptive and blood relatives.

To return to the question of cousin marriage. The marriage laws of the western world take into account only such distinctions as first and second cousin; but other societies observe different ones. For example, 20 percent of the *Ethnographic atlas* sample prohibit marriage between a man and his father's brother's daughter and his mother's sister's daughter but permit it between a man and his mother's brother's daughter. A few societies are even more selective and insist on only one kind of cousin as a possible spouse. Less than four percent (32 out of 862) of the *Ethnographic atlas* sample permit and encourage marriage between a man and his mother's brother's daughter. Less than one percent (4 out of this 862) require marriage between a man and his father's brother's daughter.

But the question remains: why should any rules about incest exist at all? This is a perennial topic among anthropologists and a variety of answers have been proposed. For the most part, anthropologists (but not sociobiologists) reject the idea that incestuous ratings have been tabued because the children of such matings may be deformed, insane, sterile or markedly unhealthy in other ways. Such results are not inevitable; primitive peoples have no knowledge of genetics and explain misfortunes in terms of witchcraft or similar supernatural events; and the marriage laws of a society may exclude some close relatives but permit others equally close (as we have just seen with cousins).

Theories more popular with anthropologists to account for incest rules have played up a number of different, quite diverse considerations. For example, incest rules force people to form ties with other families that are important socially, economically and politically (a view championed by Edward Burnett Tylor, the first professor of anthropology at Oxford and in the world, whose position can be summed up in his motto "marry out or be killed out"). Or, tolerating incest would create jealousy in the family and disastrous role confusion (associated with Bronislaw Malinowski; summed up in the words of an American song from the 1940's, "I'm my own grandpa"). Or, early childhood association kills off sexual interest (the "familiarity doesn't breed" theory, apparently first formulated by Havelock Ellis but generally associated with Edward Westermarck and directly at variance with Freudian notions). Or, modern incest tabus simply spell out what in prehistoric times was improbable for a number of factors including longevity, e.g., people then seldom lived beyond 30, making parent-child marriage unlikely (a theory proposed by Mariam K Slater, partially summed up by the sentiment "the old ways are best").

Traditional approaches to incest are at least equally varied in non-western societies. The !Kung of southern Africa give no explanation for such tabus at all. It is simply so horrible they refuse to theorize about it: "Only dogs do that — not men," they say. And, "it would be dangerous, like going up to a lion." The Yapese of Oceania also think incest is something animals do, not human beings. But they regard it as impractical rather than horrible, and betray no sense of deep revulsion. However, they believe that a woman who has committed incest can never bear children.

The Kágaba of South America think incest has no biological effects whatever, and will certainly not produce deformed or retarded children. The Comanche Indians seem to lack an idea of incest altogether: they

consider incest neither a crime nor a sin, but impossible. The Tallensi of West Africa condemn brother-sister incest intensely but find the idea of mother-son incest incredible and ridiculous because a grown man's mother is inevitably thought of as an unattractive old woman.

A cross-culturally common explanation for tabuing incest assumed that kinsmen share the same blood, and that mixing this blood together is harmful. Though scientifically untrue (blood is not even involved in fertilization), this belief is still held by many Westerners — including, to my surprise, many of my own students. In some societies, other shared substances are believed to render individuals inappropriate as mates, so that in addition to what we can call "blood" incest (the usual kind), at least two other kinds exist.

(1) Milk incest: people who have been breast-fed by the same woman may not marry. This tabu is found in the Koran and is absolutely binding on all Muslims. (Malayan Muslims get round the rule by a ritual pardoning.) Milk incest may have been an ancient Mediterranean custom and is still found among Eastern Orthodox Christians, and possibly also southern Italians and various Spanish groups. It may also have been more general in all of Christendom. We still find expressions like "milk brother" in French and German, although milk incest is not recognized among them at present.

Another kind of milk incest occurs among certain groups in the Transkei of South Africa: if a man drinks milk from the cattle of another family line, he may not marry a woman of that family.

(2) Name incest: a person may not marry someone who has the same personal name as one of his parents or siblings (a common surname is not in question here). This rule is found to my knowledge only among the Bushmen of southern Africa, Orthodox Jews, and possibly some Éskimo groups.

Other kinds of incest exist that are symbolic extensions of parent-child relations:

(3) Spiritual incest: among Roman Catholics and Eastern Orthodox Christians, godparents are thought of as spiritual parents. Consequently, it is tabu to marry one's godparent and in some groups even the children of godparents. In Latin America, the compadrazgo (godparenthood relationship) has been elaborated to an extent rare in Europe.

(4) Teacher-student incest: among the Balinese it is forbidden to marry the daughter of one's teacher; among Confucianists it is forbidden to marry his widow.

(5) Master-servant incest: among Albanians of Martanesh, a servant could be condemned to death for seducing the daughter of his master because in a sense his master was his "father" and he had committed incest.

(6) Midwife incest: among the Semáng of southwest Asia, a man may not marry the midwife who assisted at his birth, nor may his father marry her. The Zande of Central Africa have a similar rule, but it apparently does not apply to the man's father.

The extension of incest tabus in these ways readily fits in with Tylor's model that it is impractical to marry into groups one already has ties with. But even so, I do not think this proves that incest tabus necessarily began because people realized the practical consequences of setting them up.

Premarital virginity
According to Marco Polo, "no man [in Tibet] would ever on any account take a virgin to wife. For they say that a woman is worthless unless she has had the knowledge of men." He maintains that foreigners were besieged to sleep with unmarried girls and to give them some trinket as a sign that they had had a lover. Although this description may be inaccurate or exaggerated, reports from contemporary societies suggest it could be true. Clearly, premarital virginity is not a universal value.

On the other hand, in many other societies there is a mania for virgins, and premarital virginity is highly prized, but almost always in the female only. Many societies have devised various tests for determining whether a bride is a virgin at her first wedding. In a sample of 141 societies, Broude and Greene found that 36 required brides to be virgins, and meted out severe punishments for those who failed virginity tests. On the other hand, an almost equal number of societies, 34, were found to approve of girls having premarital sex. An additional 29 societies tolerated premarital sexual behavior in girls if they were discreet. Broude and Greene offer no information about attitudes toward premarital sex on the part of males. The general impression one gets from the ethnographic literature is that males are usually expected to have had some sexual experience before marriage.

In the western world, controversies exist as to the value of virginity. Of course, some positions are merely repetitions of the traditional Judaeo-Christian moral code. But there are various arguments that have a more general significance. Some theorists have argued that cultural evolution is largely an outcome of diverting sexual energy into socially

desirable goals. Havelock Ellis, for one, suggested that "it is impossible to say what finest elements in art, in morals, in civilization generally may not be rooted in an autocratic impulse ... arising from the impeded spontaneous sexual energy of the organism and extending from simple physical processes to the highest psychic manifestations."

The Freudian theory of sublimation, which is perhaps the most important nonreligious argument for sexual abstentions of any kind, first appeared in 1905 in *Three essays on the theory of sexuality.* Briefly, sublimation is the doctrine that psychosexual energy (libido) can be directed away from sexual gratification to nonsexual ends. Freud viewed the diversion and desexualization of such energy as one of the most important ways that civilization was achieved, the prime example mentioned as an instance of sublimation being artistic activity.

The authors of *Sexual behavior in the human male* considered the question in some detail. Kinsey, Pomeroy and Martin assumed that "if sublimation is a reality, it should be possible to find individuals whose erotic responses have been reduced or eliminated, without nervous disturbance, as a result of an expenditure of energy in utterly nonsexual activities."

Two groups were considered by them, together totaling over 4,200 males who had either unusually low rates of sexual activity or were consciously trying to sublimate. Kinsey and his co-workers were unable to find any clear-cut cases of successful sublimation.

There is another line of argument. Since sublimation has been regarded as one of the great civilizing factors, if the theory makes any sense there should be some sort of cross-cultural confirmation of this.

The most ambitious attempt to get cross-cultural support for such a theory — not couched entirely in Freudian terms, however — is that by J D Unwin in his book *Sex and culture* (1943). This is a serious contribution to the subject, and one of the first cross-cultural anthropological studies on a truly massive scale designed to test any hypothesis.

What Unwin specifically tries to establish is that the mental level of a culture is directly correlated with the number and severity of impediments that the society places in the way of sexual contacts.

An impartial examination of Unwin's data shows that a correlation of some sort exists between the classes of culture he sets up and the impediments to sexual contact. Unwin's study is based on an analysis of some 80 non-European societies, ranged on a cultural scale whereby the mental level of a society can be deduced.

Unwin believes that his data show that sexual restrictions produced a higher level of culture. He argues that a cultural advance must depend upon a factor that produces thought, reflection and social energy. The compulsory check of sexual impulses is that factor. He grants that continence may produce morbid symptoms in some individuals, but he insists that when sexual opportunity of a society is reduced almost to a minimum (particularly for women before marriage) the resulting social energy produces "great accomplishments in human endeavor" and "civilization." When the compulsory continence is of a less rigorous character, lesser energy is displayed, and lower level cultures result.

A later study by a professional anthropologist, G P Murdock, corroborates a good deal of what Unwin discovered. Murdock's study of 400 societies generally goes along with Unwin's finding that the stricter the rules for premarital sex behavior, the greater the degree of cultural complexity of a society. But Murdock gives a different explanation for this finding. For example, he says that in advanced societies practising intensive agriculture, a high level of self-discipline and industriousness is expected: the young must spend a considerable amount of time acquiring needed skills and discipline and cannot be allowed to indulge themselves in unrestricted sexual freedom. In simpler hunting and gathering societies, the same rules do not apply. The fewer the skills demanded, the fewer the sexual restrictions. But if this is so, how can we account for the spread of permissive standards in contemporary American society?

The answer Murdock suggests is not altogether compelling. He finds a relationship between permissiveness and the fact that a newly married couple establish their own place to live without reference to the families of either the families of either the bride or groom. In cultures where a bride must live with her husband's family, on the other hand, there is also a demand for virginity in the bride. When people know they can eventually escape from the control of their parents and kinsmen, they are more apt to establish permissive rules. This is precisely the case in contemporary America.

Murdock concludes his article with the observation that if a fully permissive code of premarital sexuality is achieved in the United States and elsewhere in the civilized world it would mean that there would be "a reversal of the long-term direction of cultural evolution, at least with respect to premarital sexual morality."

One of the problems in Unwin's and Murdock's discussions is that they talk about morality and codes of permissiveness as opposed to what

people really do. But the theory of sublimation deals not with moral codes but behavior. There is no necessary correlation between the two. Murdock suggests — quite accurately, it seems to me — that American society in the 1940's and before would have to be characterized as having restrictive premarital sex norms, in contrast to the 1960's, when there was a tendency toward permissiveness. Nevertheless, some scholars maintain that behavior has remained relatively constant, although a greater freedom to talk openly about sex may generate a belief to the contrary. John L Gagnon and William Simon, former senior research sociologists at the Kinsey Institute, writing in 1969, state that "the evidence is that very little has changed in American sexual patterns over the past four decades." Whatever the truth of this assertion, we must emphasis again that what people say sexual behavior should be need not necessarily have anything to do with what the people themselves actually do. The Kinsey report was not controversial for nothing.

How then can we explain Unwin's and Murdock's findings? Perhaps there are factors that neither has considered.

Consider simply the factor of age of marriage. It is one thing to tabu premarital promiscuity if the average age of marriage is 15, quite another if it is 25. Westerners tend to forget that biblical standards of premarital virginity presuppose early marriage: about 13 for girls (as practised among Orthodox Jews until quite recently). Christian tradition has the Virgin Mary becoming the Mother of God at 14 — and age was not the miraculous part of this event.

From a survey by Ludwik Krzywicki, it would seem that members of hunting and gathering societies tend to marry soon after puberty, at about 15. Note that it is these societies that are always listed as being among the most permissive, although the marriages are overwhelmingly monogamous. Moni Nag's cross-cultural survey of societies with relatively recent data tends to confirm a tendency toward early marriage for women (at 18 or younger) in most societies; of 48 societies in his sample, 37 had early marriage.

Why then strict rules about sex before marriage? Murdock's suggestion of the need for a greater concentration on acquisition of skills in more complex societies has a certain plausibility. Surely someone in constant pursuit of sex partners simply has not adequate time to learn many other things. This does not confirm the theory of sublimation, however, only the very obvious fact that one seldom can do two things at one time. It would be equally reprehensible, by the same token, for a youth to spend all his time reading and rereading *Bambi*.

What is more important with these tabus is their economic implications. They may simply boil down to attempts to ensure legitimate inheritance and succession. Because inheritable property and high social status are negligible in hunting and gathering groups, there would be little motivation at that level to develop elaborate rules for establishing such legitimacy, but there would be a great deal of interest at higher levels. Contemporary American society does not go against these economic interests: because of effective contraception, legitimate heirs can be guaranteed in spite of actual promiscuity.

The cultural differences in permissiveness and restrictiveness do not, as we have seen, provide a convincing case for sublimation. The question, however, is more profound than a cross-cultural test might suggest. What is needed is detailed information about the energy levels and cultural accomplishments of individuals. It is quite plausible to assume that high levels of cultural productivity could go along with comparably high levels of sexual performance, which the careers of artists such as Boccaccio and Fragonard might suggest. Certainly, the prodigious Bach, with his incredible musical output as well as 20 children, was not sublimating all the time. These are admittedly isolated examples. However, of the six most active males in the Kinsey sample — men with maximum orgasm frequencies during 30 continuous years, ranging from 10.6 to 33.1 weekly orgasms — two were physicians, one an educator, one a lawyer and one a scientific worker.

Punishments for sexual misbehavior
Societies vary to a certain extent with regard to which sexual behaviors are prohibited as well as in the severity of the punishments handed out. A striking example of this is rape. In western society at present even the most ardent liberalizers of the sex laws are opposed to rape and want it punished as a serious crime. The model penal code sponsored by the American Law Institute proposes that all sexual acts performed in private by consenting adults be decriminalized, but retains rape as an offense — not because of its sexual nature but because it involves violence and is nonconsensual. However, the Judaeo-Christian tradition nowhere singles out rape as a sin. It is forbidden in the Bible when committed against a betrothed or married woman. Even then the victim may have a hard time proving her case because if she was raped in a city she was expected to call for help and prevent it. This sort of reasoning was incorporated into the laws of Rome under the Christian emperor Constantine.

In two societies — the Marshallese and the Baiga — rape is reportedly
the preferred form of sexual activity and goes totally unpunished. A
number of societies similarly ignore rape altogether; these societies are
fairly numerous and include the Copper Éskimo, Kaska, Mundurucú,
Trumai, Návaho, Hadza, Lepcha, and Trobriand Islanders.

In most societies, however, rape (particularly of a married woman) is
one of the most serious sexual offenses. Death is regarded as the
appropriate penalty for rape among some societies, severe punishment
among others, and still others ridicule the rapist or impose a token
punishment. The spectrum is fairly wide.

Again, the same sort of variation is found with regard to male
homosexual acts. In some societies they are universal and compulsory,
as among the Étoro. Among the ancient Hebrews and Aztecs they were
punishable by death.

The most frequently tabued and most severely punished sexual acts
are incest, abduction and rape. The least frequently mentioned and most
lightly punished infractions include premarital promiscuity and
intercourse with the person one is betrothed to. Adultery (particularly by
a woman) is generally a serious offense but seldom considered as
serious as rape or incest. Punishment may typically include public
ridicule, disgrace and divorce. However, in some societies people guilty
of adultery may be killed along with their lovers. The Jívaro of South
America permit a betrayed husband to kill or mutilate the genitals of his
adulterous wife and to slash her lover's scàlp. A woman found guilty of
adultery among the Vietnamese might formerly be thrown to a specially
trained elephant, who in turn threw her into the air with his trunk and
when she had landed, trampled her to death.

The more people a sexual infraction involves, the more severely it
is punished. Solitary masturbation, for example, may be considered
reprehensible but is seldom punished in any way but through ridicule.
The suggestion in Jewish tradition that death is appropriate for
masturbation (being a total "waste of nature" and hence the most
reprehensible of sexual crimes) is decidedly at variance with cross-
cultural judgments. Generally, sexual acts involving a married person
are more serious than other acts, perhaps because marriage in most
societies is not only a union of two people but also of two kin groups.
Thus, adultery is more serious than premarital promiscuity; rape of a
married woman is more serious than rape of an unmarried girl.

The actual punishments used for a particular sexual offense may
vary considerably from society to society. The Ganda of East Africa, for

example, traditionally punished incest by drowning the offenders; the Vietnamese and Aztecs by strangulation. Among the Cayapa of Ecuador, anyone guilty of incest was formerly punished, say informants, by being suspended over a table covered with lighted candles and slowly roasted to death.

Rape occurs as a form of punishment in a number of societies for a woman's adultery. Among the Cheyenne, a man who discovered that his wife had committed adultery invited all the unmarried men in his military society (except his wife's relatives) to a feast on the prairie. This meant that the woman was to be raped by each of these men in turn. A woman who survived being raped by 30 to 40 men had the unending burden of the disgrace. Gang rape as a means of social control is reported from several other societies.

Mutilation of one sort or another is used by a number of groups as punishment for adultery. Fairly common throughout the world has been cutting off the nose of an adulterous wife. A Freudian explanation for this is tempting; since adultery in men is seldom punished and often expected, cutting off a woman's nose (a phallic symbol) can be seen as equivalent to castration. Nose-cutting was practised by Plains Indians such as the Comanche and Blackfoot. Similar punishment was meted out in England in the time of King Canute (or Knut), who ruled from 1016 to 1035: a woman caught in adultery was to have her nose cut off as well as both her ears. In twelfth-century Naples, adulterous women and procuresses had their noses slit (elsewhere in the Holy Roman Empire under Emperor Frederik Barbarossa, cutting off the nose was a punishment for whores). The cutting off of an adulteress's nose was recommended in ancient Mesopotamian legal codes; her lover could either be castrated or put to death. This same custom of nose amputation in ancient India prompted what may be the first known attempt at plastic surgery.

The Zande punished the wife's lover by very severe mutilations; the ears, upper lip, hands and penis — but not nose, interestingly — might all be cut off the man unlucky enough to be found out. If caught in the act both he and the woman could be killed. Among the Ashanti, adultery in a wife required compensation to the husband by the lover; but adultery involving the wife of a paramount chief required that she should undergo an excruciating, long-drawn-out surgical death.

Among some Zulu groups, adultery could be punished with death, but flogging the offenders with thorny bushes also occurred, and the adulterous wife was sometimes punished by having cacti thrust into her

vagina. The Igbo punished adultery by a chief's wife by forcing her to copulate publicly with her lover and hammering a stake some five feet long through his back until it came out through her body.

Burning an adulterous wife to death seems to have occurred at some time among the ancient Egyptians. Both the Hebrews and Aztecs killed such a woman by stoning. According to the Koran, a woman convicted of adultery or fornication should be killed by being locked inside a room until she dies (the severity of this sentence mitigated by the necessity of four witnesses to an adulterous act before a verdict is reached). In point of fact, stoning has been the traditional punishment in Muslim countries.

Among the ancient Romans, seducers of married women were occasionally castrated. Other more unusual punishments have also been recorded. According to Juvenal and Catullus, the lover of a married woman who was caught could get the hair on his buttocks burnt off with red-hot ashes, or the head of a certain fish covered with spines shoved up his anus. The Emperor Aurelian punished one of his soldiers for having seduced his innkeeper's wife with a punishment considered so terrible and unprecedented that the whole Roman army was said to be seized with fear: the guilty soldier was tied by his feet to the tops of two trees that had been bent over; suddenly, the trees were let go so that he was literally snapped apart.

Punishments for sexual crimes have grown increasingly less severe in the West. Nevertheless there are certain broad categories of acts that are universally tabu and generally punished with severe penalties: incest and acts involving violence and a lack of consent among the parties concerned.

TEN PROSTITUTION

**Prostitution is today regarded as,
at best, a necessary evil in most societies.
Yet it may have originated as a
sacred rite.**

The history of "the oldest profession" is not well documented. Marx and Engels argued that prostitution — along with adultery and cuckoldry — was invented when matriarchal societies were overthrown by patriarchy. There are problems with this view if only because a universal matriarchal stage is no longer generally believed to have existed.

In any event, prostitution is known to have been widespread and generally accepted in the ancient Near East. The Babylonian Code of Hammurabi from about 1700 BC contains a reference to "beer houses" kept by women. These beer houses may have been brothels; at any rate, they were not respectable. According to this code women dedicated to the worship of a god were to be killed if they even entered such a place for a drink. Otherwise there was legal indifference to prostitution.

The same attitude was true of the ancient Hebrews. For the most part, no moral judgment of any kind is passed on the secular prostitutes mentioned in the Old Testament. The story of the two harlots seeking a judgment from King Solomon concerning the custody of a child indicates, if nothing else, that they were allowed access to the king like other subjects. Nor do the clients of prostitutes come under censure in biblical stories. The Book of Judges (16:1) describes Samson's visit to the whore in Gaza without any reprimand even though Samson had the status of Nazirite: a man dedicated to God from the womb.

On the other hand, although tolerated, prostitution was not respectable. The Mosaïc code forbade priests from marrying harlots and the daughters of priests from becoming harlots (Leviticus 21:7-9) — the penalty for the latter was death by burning. But even with the coming of Christianity and its often antisexual biases, toleration of a sort persisted. St Augustine maintained: "Remove prostitutes from society and you will disrupt everything because of lust." Some 800 years later,

Thomas Aquinas quoted Augustine with approval in his *Summa theologica*. Another mediaeval source — occasionally attributed to Aquinas but almost certainly by someone else — invokes a more vivid image: "What the prostitute does in the world is...what the sewer does in the palace. 'Take away the sewer and the palace will be filled with a putrid stench'."

Usually people look for two things before they speak of prostitution. First, there must be a payment (normally immediate) of money or valuable materials in return for sexual services. Second, sexual services must be made available to individuals in a relatively indiscriminate way.

In some situations, even using both criteria, there are borderline areas. In pre-Islamic Arabia and today among some Muslims, particularly Shi'ites (who are found predominantly in Iran), there is a kind of temporary marriage, called *mut'a* in Arabic. Most but not all Muslim moralists have denounced it as simple prostitution. The "marriage" is contracted for a limited time, often only for a night, sometimes with a minimal "dowry" and no legal claims by the woman after the contract expires. But children of such unions are regarded as legitimate.

It might very well be that within a particular culture there is simply no notion of prostitution at all. This is true of the Trobriand Islanders. Among them, men constantly have to give small presents to the women they sleep with. Someone from another culture might, therefore (but unjustifiably), conclude that prostitution is universal among the Trobrianders. Certain early travelers seem to have made comparable judgments on cultures they did not understand well. There are, however, many borderline cases of prostitution, as in some forms of sex hospitality.

It has been said that prostitution was introduced to many parts of the world by European travelers, colonialists and military men or that it had been brought about by a breakdown of traditional morality which was due to the coming of the Europeans. The classic example of European influence is that of Polynesia. Tahiti is a case in point. In 1767, Captain Samuel Wallis witnessed women "prostituting" themselves to sailors for the price of an iron nail. The length of the nail was in proportion to the beauty and charm of the woman.

In the New World before the coming of European settlers, prostitution is sometimes said to have been practised among the high cultures of the Aztecs, Maya and Inka. Francisco Guerra says that male homosexual prostitution also occurred in some areas of Central America. Again we do not know what the natives thought.

In native North America the picture is even less clear, although some early accounts report the existence of prostitution. Captain John Smith in 1624, for example, wrote that among the Indians (coastal Algonkians) "they have harlots and honest women; the harlots never marry, or else are widows." Other early information about the North American situation from white commentators suggests extensive prostitution in the contacts between colonists and Indians, but not necessarily because of a native tradition of prostitution. Prostitution may, however, have existed among the Kwakiútl, Nootka, Bororo, and Araucanians.

In Black Africa, prostitution would seem for the most part to result from social upheavals that occurred after contacts with the Europeans. The Chaga of Tanzania have been cited as a classic example of a society with no tradition of prostitution that developed a complete European model of it, including the town brothel. Among certain Central and West African kingdoms, however, prostitution may be considerably older and, if not native, then perhaps derived from North African (Arabic) models. The Banyoro of Uganda were described by all early European travelers as having an organized corps of about 2,000 prostitutes under the control of the king. They were regarded as his servants but plied their trade quite openly in the market places of large towns.

Among the Hausa of West Africa (predominantly northern Nigeria and parts of Niger), prostitution is quite formalized. A head prostitute is officially recognized and installed in a public ceremony in which she receives a turban from the local chiefs as a symbol of her office. Hausa prostitutes not only form a deviant subgroup within the society because they are prostitutes, they are also the devotees of a pagan possession cult known as *bòorii*, even though they are nominally Muslim. In the Hausa kingdom of Abuja, they are joined in support of this cult by yet another group of powerful and relatively independent women: the women of the royal family.

North African prostitution represents a continuation of ancient Near Eastern patterns with local variations. The extent to which prostitution

was practised seems to have been extraordinarily high, if we are to believe the accounts of early commentators. An estimate of the number of prostitutes in Algiers in 1830 has been made at 3,000 out of a total population of about 30,000 — that is one out of every five women (presuming that there were about 15,000 women).

Before the French occupation, most Algerian prostitutes were under the control of *mezouars*, officials given the right by government to collect taxes from prostitutes. The *mezouars* were also empowered to force prostitutes to work and functioned virtually as pimps. One of the *mezouars'* duties was to hold a prostitutes' festival once every two years to which all the men of Algiers were invited.

In rural Algeria, prostitution was of a somewhat different type since the girls stopped once they had accumulated enough money to make up their dowry. Similar dowry prostitution has been reported from ancient Armenia, Cyprus and Etruscan Italy. A study by Florence Kalm of contemporary prostitution on Aruba, an island in the Caribbean, suggests the same sort of pattern.

In Muslim Egypt, prostitution was traditionally associated with entertainers, particularly dancers known as *ghawaazii*. They married mainly within their own distinctive ethnic group, which was possibly allied to the gipsies. Like the gipsies the men were often blacksmiths or tinkers. They acted as procurers for their wives and as their musical accompanists. Figures given by Lane suggest that one out of every 25 people in Egypt were *ghawaazii* in the 1830's. They enjoyed social acceptance if not respectability and some of them who accompanied pilgrims to Mekka were permitted to count their trip as a pilgrimage and take the much coveted title of *haajjaa*. In June of 1834, the Egyptian government outlawed female dancing in public and prostitution.

The latent disapproval of prostitution found in Islamic and Christian societies presents a marked contrast to the attitude found in ancient India. In the *Kaama suutra* an important section is devoted to what the successful prostitute must do. The author discusses, for example, 27 ways for her to obtain money from her customer or patron, including lying about such incidents as pretended theft or loss of her jewels, or pretending to be sick and making up items for doctor's expenses.

Another source for ancient Hindu attitudes to prostitution is a book on how to govern a kingdom: the *Artha-shaastra* by Kautilya, a kind of

Indian Machiavelli, living perhaps as early as 300 BC. The book was lost
for several centuries and only rediscovered in 1905. One chapter is
devoted to how prostitutes should be regulated. The king should employ
a superintendent of prostitutes. There should be at least one main court
prostitute receiving a yearly salary of 1,000 *panas* and a rival prostitute
getting half that salary. The daughters, sisters or even mothers of such
prostitutes must substitute for them if they go traveling or die. Some of
their nonsexual functions should include holding the royal umbrella and
fan, attending the king seated on his throne or in his chariot, and spying
on visiting foreigners.

In spite of the institutionalization of prostitution, it was not an
honorable profession. In line with Hindu doctrine of the transmigration
of souls, it was believed that a person was reborn as a whore because of
some transgression in a previous life. But following the teachings of the
Mahaabhaarata, however, someone who is a whore must be a good whore
in order to be reborn to a higher life.

Buddhism held the same view of prostitution and prostitutes, but
offered the option of achieving grace in one's present life by renunciation.
There are many instances of a prostitute achieving holiness through
becoming a nun in Buddhist literature. A famous example of this is the
story of Ambapaali, who gave the Buddha a mango grove. She became
a nun and achieved a state of grace. In spite of such stories, Buddhists
view prostitutes as threatening to the spiritual life.

The Muslim conquest of India did virtually nothing to change the
status of prostitutes. Although the Koran requires that prostitutes be
punished and forbids the faithful to marry them, nevertheless public
prostitution flourished under Muslim rulers and large red-light districts
were part of the more important towns.

Certain castes and tribes traditionally practised prostitution. Among
the Bediyas, for example, all the women became whores and the men had
to find wives from other groups. The Kolhatis, nomadic acrobats from
Bombay, permitted their women either to marry or to work as
prostitutes. The Harni and Mang Caruda criminal castes were also
associated with prostitution, and robbed their customers with regularity.

The Indian system of prostitution extended to Java, which has long
been influenced by India: in particular, the close association of
prostitute and dancer, the terms for both being synonymous. This

system did not spread to neighboring islands in what is now Indonesia. In nearby Sumatra, for example, prostitution seems to have developed in response to the European whaling enterprise.

Prostitution in China is traditionally said to have been initiated by a woman, Hung Yai, more than a millennium before the beginning of the Christian era; but the first reliable historical reference to it is much later, stemming from the Jou dynasty (650 BC), during which the minister Gwan Jung officially established red-light districts for merchants. Interestingly, this was also the dynasty during which China became one of the most technologically advanced countries in the world: large-scale irrigation, iron plows, writing — and chopsticks — were introduced. Brothels for the general public came much later during the Tang and Sung dynasties (AD 618-1279). Attempts to contain prostitution in specified wards of a town failed and the prostitutes infiltrated other areas, with the result that another kind of brothel developed — one that provided various kinds of entertainment as well as prostitution.

In China, the attitude toward prostitution has been ambivalent. Confucians, for example, found the practise evil. But prostitution flourished. According to Marco Polo, in the thirteenth century, there were more than 20,000 female prostitutes in the suburbs of Beijing (then Cambalac), the capital of Kublai Khan, but none in the city. Marco Polo suggests that most of these were for the benefit of foreigners, but this is doubtful.

Throughout Chinese history, prostitution has had certain special features. Distinctively Chinese, for example, were the "floating brothels" — boats docked in a riverine red-light district.

Not until the Communist takeover of China was the basic fabric of Chinese prostitution shaken. The official government claim is that prostitution has in large part been eliminated.

The descriptions of prostitution in Japan suggest that it was well integrated into, and institutionalized within, the Japanese social system. In the Shinto religion, there is even a recognized god of prostitution, Inari, who is also the god of rice, a fertility deity whose association with prostitutes resembles ancient Near East sacred prostitution practises.

There seems to have been much greater acceptance of prostitution in Japan than even in China. Although modern governments after World

War II have modified the traditional pattern and in many cases outlawed it, nevertheless the continuing social acceptance of prostitution is reflected in the demands for fringe benefits sometimes made by trade unions in Tokyo (at least as late as 1958) so that employees may be guaranteed an allowance to visit bars in order to consort with bar girls (the modern equivalent of the traditional whore).

The early history of prostitution in Japan is not clearly known. Englebert Kaempfer, writing in 1727, suggests that brothels both public and private were first established in the twelfth century under the Shogun Yoritoma to placate his soldiers for their participation in his long and strenuous military expeditions. But prostitution probably existed in Japan long before that. In 1617 one of the most famous red-light districts in the world was established: the Yoshiwara (literally "meadow of happiness") district of Tokyo. It took 10 years to build. Before that time, there was no fixed place set apart for brothels. By 1889 there were 156 brothels in the Yoshiwara with 3,000 prostitutes.

One of the main sources for Japanese prostitutes was destitute parents willing to sell their young daughters, usually between the ages of 10 and 20, to a bawd or proprietor of a "tea house" for a specific number of years. Girls were brought up to regard compliance in such matters as fulfilling the duty of obedience to parents. In any event, prostitutes were expected to be entertaining in a number of ways — not only sexually — and consequently had to start early and work through a period of instruction and apprenticeship.

There was a hierarchy within the ranks of prostitutes, the lowest being the pan-pan, street walkers who accepted customers of any social class; the highest were the tayu, whose clientele was restricted to the well-born. Occasionally, prostitutes were bought and subsequently married.

The eighteenth century saw the rise of the geisha. The term refers to anyone possessing a skill, and was first used of men skilled at riding, fencing or shooting who were attached to the courts of feudal lords. Female geisha were women who had skills in dancing and singing. They eventually became confused with prostitutes, who tried to imitate their accomplishments. In 1872, the government enacted legislation to make sure that only real geisha were employed at geisha houses. There has been a partial resurgence of the geisha as an institution since the 1930's.

Geisha were never common prostitutes if only because their sexual favors were not granted indiscriminately.

During World War II, the Japanese government sponsored an enormous network of brothels for its soldiers, staffed by women forcibly recruited from China and Korea, as well as from other areas such as the Philippines and Indonesia. Estimates of the number of women kidnaped to become prostitutes vary from 100,000 to 200,000, but precise figures are impossible to come by. The Japanese government officially denied any connection with these brothels until incriminating documents were discovered by a Japanese scholar, Yoshiaki Yoshimi, in 1992.

In the 1950's various aspects of prostitution (but not technically prostitution itself) were made illegal: soliciting, procuring, incitement to prostitution. Brothels have since been closed. What has happened is comparable to what has occurred in the West: the development of new forms of prostitution involving call girls and bar girls with few of the stabilizing elements associated with the traditional highly structured institution.

In the western world, prostitution has existed since antiquity on a large scale. There have been many attempts to regulate it by licensing, requiring special clothing or setting aside various wards for red-light districts. Since the nineteenth century attempts have been made at eradicating this phenomenon altogether. A number of factors have contributed to the recent development including the emancipation of women, the evolution of egalitarian romantic marriages, and the rise of humanitarian movements of various kinds.

The first known western regulations are to be found in Solon's establishment of state-run brothels in Athens in 594 BC. Prostitutes of one form or another had existed earlier than this in Greece but without legal definition. The prostitutes in such brothels were usually slaves, but there were also women who had been sold to the brothels by their fathers or brothers for having committed fornication.

In the hierarchy of prostitution that existed in ancient Greece, such prostitutes were at the bottom. They were badly paid civil servants who had few civil rights and had to wear distinctive clothing. Some of these restrictions were relaxed after Solon's time, but the social status of the common prostitute was never high. Above them in rank were the flute players, who were specialists in dancing, gymnastics and fellation. They

were mainly foreigners from Asia Minor (modern Turkey). The hetaerae were the most famous of the prostitutes. They were comparable to the Japanese geisha in that they were "companions to men" because of their intellectual and cultural training.

Roman society was quite different and did not continue the hetaera tradition. There were women who were similar in some ways but seem not to have had the accomplishments of the Greek courtesans.

The Romans were the first to register prostitutes in Europe. The overwhelming majority of whores, however, were unregistered. Registration had profound consequences for the social status of a woman. Once she was included on the roll and given a license, it was impossible for her to be removed from it. For the most part these women were slaves, although under the emperor Augustus, because his laws against fornication were so strict, some highborn women tried to register themselves as prostitutes to avoid severe punishments. Further legislation under Tiberius prevented them from doing so and under Caligula a tax on prostitutes was introduced.

The prostitutes' dress was regulated by law, although some are known to have flouted these and other rules quite openly. They were forbidden to wear the stola, the normal dress of freeborn women. They had to dye their hair yellow or red (some authorities also say blue) and were forbidden to wear purple clothes, jewelry and shoes. They normally wore sandals and clothes with a flowered pattern, but some wore transparent dresses. Brothels were common, and Roman moralists such as Cato who were otherwise incensed about the moral decay they saw around them, praised men who satisfied their lusts in brothels rather than with respectably married women. In competition with the brothels and sometimes synonymous with them were the public baths. Some baths were frequented only by prostitutes or loose women and their clients. Prostitutes plied their trade in many places, including the space provided by the arches forming the basements of theaters and circuses. The word *fornicate* is, in fact, derived from the Latin word for these arches — *fornices*.

The rise of Christianity in Europe saw the development of a great ambivalence toward prostitution. The Council of Elvira in 301 excommunicated all prostitutes. However, at other times even the Church saw fit to profit from them. It is said that in 1309, the Bishop

of Strasbourg kept a brothel. Pope Clement II required any person found guilty of prostitution to leave half her property to the Church. On the other hand, from time to time, pogroms of various kinds were launched against prostitutes. The emperor Charlemagne, for example, enacted laws with severe penalties including capital punishment. In the thirteenth century, they were expelled from France by Louis IX (St Louis). There was, however, no consistent policy except perhaps a general toleration of a necessary evil. In reality prostitution flourished in Europe. Some brothels are known to have been enormously elegant. Protestant countries tried to suppress prostitution but only drove it underground. The vast African slave trade in the New World led to widespread black prostitution organized by whites.

By the end of the seventeenth century, because of the epidemics of syphilis that swept through Europe in the preceding century, the regular medical inspection of prostitutes began. It became a feature of nineteenth-century state-regulated brothels in France and elsewhere.

In the nineteenth century, a movement for the eradication of prostitution developed. In 1869 in England, a campaign was started to launch an international movement to abolish state-regulated prostitution. By the 1940's the Soviet Communist government declared that it had eliminated brothels as well as prostitution. How real this elimination was, however, is not known.

In France, state regulation ended in 1946 due largely to the urging of a national heroine, Marthe Richard. This merely meant the closing of state-controlled brothels *(maisons de tolérance)* which — no matter how despicable they were made out to be — made life somewhat less oppressive for the prostitutes who were not rehabilitated under the new legislation. Marthe Richard eventually changed her mind about the desirability of the abolition.

What has happened is that brothels in all their variety are being closed although the reality of prostitution goes on. In the United States where prostitution is nearly everywhere illegal, attempts have been made by some militant prostitutes to have it decriminalized and a labor union for prostitutes recognized. Although there is a greater sense of sexual liberation than ever before in western culture, prostitution continues to survive.

Male prostitution
Male prostitution has existed from ancient times and is referred to in the
Bible (Deuteronomy 23:18-19; a male prostitute is there referred to as
a "dog"). Quite predictably, it often occurs in social situations in which
women are dramatically absent — among migrant laborers, for example,
working in mines or on plantations where the sex ratio may be one
woman to 100 men or more. Junod mentions that in Johannesburg in
1915, in the all-male compounds of the copper mines, young boys called
tinkhontshana worked as prostitutes and received about one dollar for a
night's work. The men in these compounds reportedly preferred the boys
to female prostitutes, who spread venereal diseases (whereas the
tinkhontshana were believed not to). Junod characterizes male
prostitution as a "regular institution" in the Johannesburg mining
community.
 Very little attention, however, has been paid to the subject. Possibly
this has to do with western ways of conceptualizing sexual careers. The
structural equivalent of female prostitution in the western scheme of
things is not male prostitution but male homosexuality: female
prostitution or male homosexuality constituting the traditionally most
despicable sexual statuses. Male prostitution and female homosexuality
are somehow more remote or unimportant or unexpected, as shown by
the use of the word "prostitute," which normally refers to women, and
"homosexual" to men.
 Male prostitution has almost invariably been homosexual, although
male prostitutes in the modern western world frequently conceptualize
themselves as heterosexual. Heterosexual male prostitution, where
women pay men for sexual services, exists but is relatively rare and
practically unstudied (rarer still is homosexual female prostitution). The
use of male prostitutes by women is virtually never (if ever) reported for
primitive societies.
 Homosexual male prostitution is reported from a great many
societies. It existed in ancient Greece but was discouraged. Solon, who
created state-run female brothels in the sixth century BC, feared male
prostitutes because he presumed that anyone who sold his body for
money would be ready to betray his country without even giving the
matter much thought. Thorkil Vanggaard argues that homosexual
relationships were so idealized by the ancient Greeks that male

prostitution was considered especially contemptible. Whatever the motivation, the men who had been prostitutes in their youth were not granted full civil rights as adults. This was possibly due not to some extraordinary romanticism about homosexuality but because male prostitutes were frequently prisoners of war who had been sold into slavery. The same seems to have been true for the Romans, who did not register male prostitutes.

Among the Greeks and Romans, male prostitution seems to have been essentially pederastic — that is, involving teenagers. But transvestites were sometimes involved and occasionally also eunuchs. Elsewhere in the world, particularly in the Near and Far East, transvestites are the more numerous.

One of the most extensive reports by a modern anthropologist on such prostitution is by Unni Wikan for certain towns in Oman. She says that male prostitutes have much lower rates than their female counterparts: 1 rial Omani (about £2 or $3.20), whereas a woman would charge 5 rial. Female prostitutes are not only expensive but also rare (they may, in fact, be mainly foreigners and their very existence is concealed).

Comparable transvestite male prostitutes called *washoga* have been reported for Mombasa and other East African coastal areas among Muslim groups.

Serena Nanda presents another important study of male prostitution, this time as found in India. In the groups she describes, the *hijraa*, the men are usually not only transvestite entertainers but actually transsexuals who often have had themselves castrated.

One of the earliest reliable accounts of Near Eastern transvestite prostitutes comes from G W Lane's *An account of the manners and customs of the modern Egyptians* (1833-35). He mentions two kinds, the *xawal* (which he writes as *khawal*) and the *gink*. Of the latter he says almost nothing except that the word itself "is Turkish, and has a vulgar signification which aptly expresses their character." They were male transvestite dancers of non-Egyptian background, mostly Jews, Armenians, Greeks and Turks. The *xawal* were also dancers and were considered less offensive in some respects than their female counterparts, the *ghawaazii*. The *xawal* often wore a veil but their other clothing was a mixture of male and female styles, although their mannerisms and

overall style were more feminine than masculine. They were native Egyptians. Henriques suggests that they may have had their heyday after 1834, when female dancers were declared illegal. The present status or even existence of the *xawal* is not clear.

In ancient China, transvestite male prostitutes had developed their own guilds or trade unions as early as the Southern Sung dynasty (in 1127-1279). This was a tremendous change from the previous Northern Sung dynasty (960-1127), when male prostitutes were threatened with heavy fines and 100 blows with bamboo rods.

In Japan, male prostitution was also largely transvestite. It became fairly common in the seventeenth century with the early development of the Kabuki theater, in which young men played the part of women. Some of the places where they could be hired were the grounds of religious shrines (which suggests a kind of sacred prostitution).

Male brothels have been reported from many countries over the centuries. In eighteenth-century England they were known as "molly houses." One in particular became famous because the proprietress, Margaret Clap (known as Mother Clap), was brought to trial in 1726 for running the place and sentenced to two years in prison. In nineteenth-century Victorian England, male brothels flourished. The best known of these, located on Cleveland Street in London, became embroiled in a tremendous scandal. The authorities pressed charges and the prosecutors pursued several high-ranking people including H.R.H. Albert Victor (Prince Eddie), the son of the Prince of Wales (later Edward VII), and Lord Somerset, a confidant of the Prince of Wales.

In the present century, although some brothels exist, most male prostitutes either work the streets or more frequently operate from specialized gay bars or other homosexual meeting places. Unlike female prostitutes, they function independently without pimps. A call boy system also can be found in large cities, although little is known of it. In various gay newspapers in the United States, but less often elsewhere, personal advertisements for models, escorts and masseurs are frequent: they are barely disguised code terms for prostitutes. Male prostitution is tolerated in many countries and even legal in a few, such as Germany.

A comparison of contemporary western and nonwestern forms of male prostitution reveals extraordinary differences. Nonwestern prostitution nearly always involves either young boys or transvestites. In the West,

transvestite prostitution has apparently become specialized for clients who may not even conceptualize themselves as homosexual and who prefer to think they are being serviced by real female whores. Among self-avowed homosexuals, transvestite prostitution is almost nonexistent if the advertisements in the gay underground newspapers are representative. Thus, of 360 advertisements in one issue of such a newspaper, not one suggested that the available prostitute was even remotely transvestite. On the contrary, adult supermasculinity was the most frequent drawing card.

What these advertisements indicate is a remarkable transformation in the nature of male homosexuality in the West during the past two centuries.

Sacred prostitution

Sacred (or temple) prostitution refers to a number of different customs in which sexual acts are performed as part of a religious rite or with persons who are regarded in some sense as sacred, or associated with a sacred place.

The most famous description of sacred prostitution is found in Herodotus, writing in the fifth century BC. In his account of the Babylonians, he describes two kinds of sacred prostitution and these have become the prototypes for related phenomena throughout the world. In one, a woman performs a single act of prostitution and never does so again. The other involves dedication to the services of a god or temple for a period of time, perhaps for life.

In describing the first kind, Herodotus says that every Babylonian woman must have sexual intercourse with a stranger in the temple of Mylitta (a variant of Ishtar or Astarte, a goddess Herodotus equates with Aphrodite) once in her life. As soon as she has taken her seat in the sacred enclosure, she may not return home until a stranger throws a silver coin into her lap and she goes off with him. Once the women have fulfilled their obligation they return home and never prostitute themselves again.

In Heliopolis (now Baalbek) in Lebanon, the function of such temple prostitution was primarily that of defloration: women could not marry before they had performed this ritual. Possibly also it was an attempt to secure a dowry. This custom survived in Heliopolis until the fourth

century AD, when it was prohibited by the emperor Constantine. He destroyed the temple of Astarte and erected a Christian church on its ruins.

The second kind of sacred prostitution can be found in Herodotus's description of the precinct of Baal in Babylon. It contains an enormous tower on which are built several other towers, one on top of the other. In the topmost tower there is a richly adorned temple literally taken to be a dwelling of the god. This chamber is occupied by a woman specially chosen by the god as his bride. Herodotus remarks in passing that he does not believe that part of the story but notes a resemblance to similar customs observed by the Egyptians.

Apparently the Babylonians also had long-term sacred prostitutes dedicated to the goddess Ishtar, who offered their services to worshipers during fertility ceremonies. The god Marduk was also attended by sacred prostitutes.

Sacred prostitution existed among the Hebrews for a considerable period of time, at least from the thirteenth century BC until the Babylonian Exile in 586 BC. It was, however, officially associated with polytheism and idolatry and was condemned as an abomination, although profane prostitution was tolerated.

Male prostitutes both sacred and secular also existed among the Hebrews. King Rehoboam, son of King Solomon, tolerated male sacred prostitutes, and as late as King Josiah (who died in 608 BC) they were reported to be living in the temple itself in Jerusalem (II Kings 23:7). Transvestite male prostitutes existed in ancient times in Canaanite temples and were described as devotees of Ishtar at Erech in Syria.

In both Christianity and Islam sacred prostitution was never officially countenanced. Curiously, several Christian female (but no male) saints had originally been whores — including SS Mary of Egypt, Pelagia, Theodotea, Afra of Augsburg (who had even set up a brothel before her conversion). In folk Christianity, Mary Magdalene has frequently been thought of as a fallen woman, although there is no biblical justification for this. In spite of official views, mediaeval French prostitutes, who were organized into trade guilds, adopted her as their patron saint.

Before Mohammed, sacred prostitution was known to have existed among the Arabs when on pilgrimages to the Kaaba. The name of one

such woman, who lived shortly before the Prophet, is known: Kharqaa of the Banuu 'Aamir tribe. She is said to have considered herself "one of the pilgrimage rites." Some of the women from her tribe used to perform the ritual of walking round the Kaaba naked, reciting obscene verses. Even after Islam, sacred prostitution probably survived in various areas.

The Near Eastern complex of sacred prostitution was found throughout western Asia and in ancient Greece. Sacred prostitutes were known at the temples of Artemis at Ephesus, Aphrodite at Corinth and Dionysis in Sparta.

A second important area of sacred prostitution is India, where the practise is essentially a southern, Dravidian, one. Both the Near Eastern and the Indian institutions were linked to a fertility cult of a great mother goddess, so they may belong to some single cultural unit.

The earliest references to Hindu temple prostitutes, the *devadaasii*, seem to be no earlier than the ninth or tenth centuries AD. But prostitutes associated with religious shrines probably go back much further and may have existed in the Harappaa culture (in what is now Pakistan), which is as early as 3000 BC!

In more recent times, the *devadaasii* constituted a caste of women who were in attendance on the god of the temple to which they were attached, and prostituted themselves to priests and public alike. A *devadaasii* was either the daughter of a *devadaasii* or was dedicated at the age of 12 by her mother as a special act of devotion. The girl was regarded as the wife of a god or of the representative of the god. In a Portuguese description from the sixteenth century, she was described as having to deflower herself ritually on a *lingga* (a sacred phallus). She sprinkled the blood from the broken hymen over the *lingga* and the stones on which it rested.

Large temples might have as many as 100 sacred prostitutes in attendance. But in the twentieth century, mainly because of attacks on the institution by Hindu reformers, they have fallen into disrepute and have begun to disappear.

The third area of sacred prostitution is West Africa, where it has been reported for the Ewe, Igbo, and a number of groups in Ghana. Any direct historical tie between West African practises and those of the Near

East is not obvious. Sacred prostitution existed, however, in northwest Africa at Carthage and there may be some sort of link.

The Ewe type of sacred prostitution (now defunct) has been described by A B Ellis, a nineteenth-century traveler. According to him, sacred prostitution occurred only in association with the worship of Dang-gbi, the python god. Such prostitutes were thought of as the wives of the god, as well as priestesses. These women underwent a three-year initiation. If any woman, free or slave, single or married, publicly simulated possession, she could immediately join the novices. Because she was inviolable in this state, becoming a sacred prostitute could be seen as a kind of asylum from a bad husband or master. During the three-year training period, the prospective brides of the god were allowed to prostitute themselves to anyone. But once they were finished with their training, they were theoretically supposed to submit only to actual worshipers (although this rule seems to have been largely disregarded). Any children they might bear were considered to be offspring of the god himself. The status of such women seems to have been high; because a god had driven them to it, they were not reproached for prostituting themselves.

Other West African groups had similar institutions, most probably derived from the same cultural source, whatever that might be. Priestesses among Twi-speaking groups, for example, could not marry because they belonged to the god they served, but sexual license was not tabu and Ellis reports "custom allows them to gratify their passion with any man who may chance to take their fancy."

There is a possibility that prostitution in general began as a sacred rite and only later became secularized. Today sacred prostitution has virtually disappeared.

ELEVEN CURRENT DEVELOPMENTS

Contraception and the women's movement are key developments in twentieth-century western sexuality. But the so-called sexual revolution has hardly touched western commitment to the family.

In 1948, the first of the Kinsey reports was published *(Sexual behavior in the human male)*.

In 1952, George Jorgensen gained international notoriety through a sex-change operation and became a household name as Christine Jorgensen.

In 1955, the American Law Institute recommended in its Model penal code that all laws concerning private sexual behavior between consenting adults be abolished. (A few states have since adopted the major provisions of this code, including New Jersey, Illinois, Colorado, Oregon and Hawaii — the earliest being Indiana in 1961. Wisconsin dropped laws against sodomy but retained a prison sentence for adultery; the same was true of Connecticut until 1991 when the law about adultery was repealed. As of 1991, only 21 states retain anti-sodomy laws.)

In 1956, "the pill" was developed by Gregory Pincus and his associates as the first effective oral contraceptive.

In 1957, the Wolfenden report was published urging that private homosexual acts between consenting adults no longer be considered crimes in Great Britain. (These recommendations were made law in 1967 in England by the Sexual Offenses Act.)

In 1960, the United States Supreme Court relaxed the traditional notion of obscenity and what was formally regarded as illegal pornography gained wide distribution.

In 1963, Betty Friedan published *The feminine mystique*. This is generally considered the beginning of the modern Women's Liberation movement.

In 1965, the United States Supreme Court legalized the sale and use of contraceptives in all of the United States.

In 1966, Masters and Johnson published the first of their books on sexual functioning *(Human sexual response)*. Their work prompted the spread of sex therapy centers.

In 1968, Pope Paul VI issued his encyclical *Humanae vitae* reaffirming traditional Catholic morality and condemning all forms of artificial birth control, including the pill.

In 1969, a police raid in the Stonewall Inn in New York sparked the Gay Liberation movement.

In 1969, Denmark dropped all laws against publication or sale of pornography — the first western country to do so. Reports of sex crimes in that country fell dramatically.

In 1973, the United States Supreme Court sharply curtailed government regulation of abortion in Roe v Wade.

In 1974, the American Psychiatric Association stopped labeling homosexuality as a mental illness.

In 1978, the first test-tube baby was born, in England.

In 1980, RU486, an abortion pill, was developed by Dr Étienne-Émile Baulieu. Despite threats against the manufacturers, the French drug firm Roussel Uclaf, the French government insisted on its production. (It has been commercially available only since 1988 in France. In 1991, Great Britain became the second country to authorize its use. It is also legal in China and Sweden.)

In 1981, AIDS was first diagnosed as a special disorder. For some, this signaled the end of the so-called "sexual revolution."

In 1982, the Equal Rights Amendment failed to be ratified in the United States. This was a significant blow to the modern feminist movement.

In 1986, the United States Supreme Court ruled in *Bowers v Hardwick* that there was no constitutional guarantee of a right to privacy for homosexuals engaged in "sodomy" (but no ruling was issued about heterosexuals performing comparable acts).

In 1987, the Anglican Church changed its policy on polygamy and at least in Tanzania permitted a man with more than one wife to be baptized along with his wives (with the proviso that he might not marry again after baptism).

Also in 1987, ACT UP (AIDS Coalition To Unleash Power) was formed by the writer Larry Kramer.

In 1988, the European Court of Human Rights ruled that the government of Ireland had to abolish its laws against homosexual acts. (In 1993, these laws were in fact removed from the books.)

In 1989, the American Episcopal Church consecrated the first female bishop, Barbara Harris, challenging a nearly 2000-year-old tradition of male hierarchical exclusivity in the church.

Also in 1989, the Danish government legalized homosexual domestic partnerships, which have all the rights and privileges of heterosexual marriage except joint adoption of children. Denmark is the first modern state to do so.

In 1990, Reform Jews decided not to exclude practising homosexuals as legitimate candidates for the rabbinate.

By 1990:

The world's population had gone beyond 5,333,000,000 (in 1970, the total was 3,721,000,000). By the year 2000 the total is predicted to be 6,291,000,000. At the end of the 21st Century the figure should stabilize at 11,300,000,000.

One out of every three couples in the world was using some sort of artificial contraception or had undergone sterilization.

An estimated 36,000,000 to 53,000,000 abortions were performed a year (nearly half illegally). This involved about one out of every four pregnancies in the world.

A world-wide cumulative total of over 300,000 cases of full-blown AIDS was reported to the World Health Organization. This was assumed to represent only a portion of the total number affected, generally estimated as between 700,000 and 1,000,000. Between 6,000,000 and 8,000,000 people were believed to be H.I.V.-positive. By the year 2000, the number of full-blown AIDS cases is predicted at between 5,000,000 to 6,000,000. The number of H.I.V.-positive people for the same year is predicted at between 15,000,000 and 20,000,000.

Legislation on various aspects of sexuality or related fields such as adultery, fornication, contraception, abortion, homosexual acts, and pornography were generally becoming more liberal throughout the West and other industrialized parts of the world. For example, abortion was legalized in Italy (1978), France (1979), Greece (1986), Argentina (1987), Rumania (1989), and Belgium (1990). In 1991, a ban on abortion in Poland urged by the Roman Catholic Church was rejected by the Polish

parliament in the first political setback for the Church since the fall of Communism in 1989. Also in 1991, Brazil outlawed the killing of adulterous wives, which had traditionally been seen as the right of cuckolded husbands. In several Muslim countries, however — notably Pakistan and Iran — there was by the end of the 1970's a return to traditional Islamic laws involving the death penalty for adultery, prostitution, and homosexual acts — as well as a return to the veil for women. And in the United States, various conservative trends won significant victories, as in the defeat of the Equal Rights Amendment and the Supreme Court ruling in 1989 *(Wade v Reproductive Health Services)*, considerably weakening the rights of women to an abortion.

Population and birth control
What has just been outlined are some of the more important aspects of the social setting for modern-day sexuality.

One of the major realities that have helped to shape a significant change in values has to do with the threat of overpopulation. It was Thomas Malthus (1766-1834) who first pointed out that human population always tends to outrun food supply. But in his 1798 work *An essay on the principle of population as it affects the future improvement of society*, the only solution offered was sexual abstinence. Various followers of Malthus felt that this was an unrealistic approach to so serious a problem. A worldwide effort to promote birth control was launched in 1900 with the foundation of the International Neo-Malthusian League. Its goals met with almost unrelieved opposition on the part of governments and Christian religious groups, until 1930 when the Lambeth Conference of the Anglican Communion cautiously accepted birth control. In 1958, another Lambeth Conference came out strongly for the morality of birth control because (it was argued) there could be nothing moral about allowing children to be born who were to die as a result of malnutrition, disease, and the other scourges of overpopulation. From that point on, liberal Protestant groups became vociferous not only for the toleration of birth control but also for the moral obligation of family planning.

Politically, since 1960 there had been a radical change in government policies throughout the world regarding birth control. In 1960, only India and Pakistan supported family planning programs, but

by the 1970's, over 60 other countries had launched their own family planning program.

A massive birth control policy has been adopted by the Chinese, whose population in 1990 was over 1,130,065,000. Their government is experimenting with a number of means to achieve zero population growth by the year 2000, including raising the legal age of marriage, encouraging married couples to have only one child and experimenting with a pill to be taken by men. However, the total population predicted for the year 2000 is now taken to be 1,291,587,000.

In the industrialized West, artificial contraception is practised by over 80 percent of the total population. The consequences for the role of women in such societies is obvious: they need not devote themselves all their lives to bearing and caring for children. It is in such an environment that women's liberation movements flourish and by their success contribute to the further acceptability of birth control. Contraception and the women's movement are probably the two most important developments in setting the sexual scene in the twentieth century.

Until the 1960's, the most common form of population control was abortion. Even now, one out of every four pregnancies results in an abortion. In France, Austria, Italy, Portugal, Uruguay and what was the former Soviet Union the percentage is even higher; and in Japan it is higher still.

The social reality behind the widespread use and acceptance of contraception and abortion has serious implications for much of traditional western, specifically Roman Catholic, morality. Not only Roman Catholics are affected, but also certain Protestant fundamentalists, Mormons, and Orthodox Jews. In many instances they oppose the same development but not for the same reasons. Roman Catholics, for example, have traditionally been opposed to birth control in terms of the doctrine of natural law, but Mormons have a different reason. They believe that the souls of all future people already exist and are simply waiting to be born. The practise of birth control deliberately keeps these souls without a body.

With regards to abortion, the official Roman Catholic position forbids it in all circumstances including threats to the mother's life. Orthodox Jews, on the other hand, permit it to save the mother. The Jewish position is rooted in the rule that amputation (except for health and the

special ritual of circumcision) is forbidden: because the foetus is considered as part of the mother, abortion falls under this prohibition. However, if the mother's health is jeopardized, the foetus is seen as an intruder much like a cancerous tumor and may be destroyed. The Catholic position rests on very different premises. Although the issue is couched in terms of the taking of life, moral obligations do not extend to all life: a Catholic has no moral obligation to animals, for example. Rather, moral rights exist only for beings with "rational souls." The mother and the embryo/foetus both are believed to have such souls: there can be no legitimate way of choosing between them. To kill an embryo deliberately to save a mother's life is therefore forbidden. For such a woman to die during childbirth would be regrettable but not an act of murder on the part of an attending physician. Interestingly, there is no official position on when the soul enters the body; traditionally, this was believed to occur not at conception but rather a month or so later. The total ban on abortion from conception on is to guard against any miscalculations about the entrance of the soul.

Another consideration, seldom mentioned publicly, however, has to do with the fate of the soul of the aborted foetus. Although abortion is often referred to as "slaughter of innocents," traditional Catholic teaching holds that the aborted, having inherited the sin of Adam and being unbaptized, cannot enter Paradise — in this, they share the fate of the miscarried.

Interestingly, when Christianity was first introduced to various groups, the idea that baptized children were cleansed of all sin was occasionally taken quite literally: mothers would murder their just-baptized infants, willingly giving up their own hope of heaven to guarantee their children's salvation.

Developments in the Roman Catholic Church are of particular interest, if only because of the great number of people who profess to being Catholic (over 18 per cent of the world's population, the single largest religious group in the world). The Church has officially tended to hold out against any change in its traditional teachings on sexuality, marriage, and abortion. But its traditional and well-publicized position on sexuality is at variance with social reality even in predominantly Catholic countries such as France and Italy.

It is in the area of birth control that its teachings have been most seriously threatened, at least in western Europe, the United States and

other developed nations — by the great majority of Catholics, both
nominal and churchgoing. In the 1950's, for example, some 80 percent
of Roman Catholic women in the United States conformed to the
Church's teaching that forbade all forms of contraception (outside of the
rhythm method). By 1975, 90 percent of Roman Catholic women
married for fewer than five years were using forbidden contraceptive
methods. And this only a few years after the proclamation by Pope Paul
VI, in his encyclical *Humanae vitae*, reaffirming the traditional tabus on
artificial contraception including the pill, sterilization and abortion.

 Although there has been tremendous pressure to change the official
stand on birth control, no pope in modern times has been willing to do
so. In the 1990's, Pope John Paul II continued actively to denounce all
forms of mechanical birth control. In 1992, Vatican pressure in large
part forced the dropping of the topic of birth control from the agenda of
the U.N. Conference on Environment and Development in Rio de Janeiro.

 The official teaching is ignored by increasing numbers of Catholics
— including priests. Although shortly after Paul VI's 1968 ruling some
people actually left the Church, nevertheless no substantial numbers of
people deserted. What has happened instead is that Catholics in
increasing numbers feel that the Church has no right to "meddle" in
their private lives.

 The birth control issue has all sorts of interesting repercussions for
Catholic morality in general. Since the traditional ban was based on the
idea of natural law, to permit mechanical birth control would mean that
the justification of sexual acts in terms of potential reproduction would
have to be given up. But this would destroy the traditional argument for
the bans on masturbation and homosexual acts — a radical change to say
the least.

 A number of significant statements assailing the traditional moral
code have been made by various Catholics, but they have not been
excommunicated for making them. The controversial Dutch catechism
of 1967 is a case in point.

 An even greater tolerance of traditionally forbidden sexual behavior
is shown in a publication called *Human sexuality: new directions in
American Catholic thought*. In large part, this is in agreement with and
seems to have been influenced by ideas developed among Quakers some
time earlier, as presented in 1963 in an official Friends' document,
Towards a Quaker view of sex. *Human sexuality* was produced by a

team headed by Father Anthony Kosnik and sponsored by the Catholic Theological Society of America. It appeared in 1977. Referring to sexuality as "God's ingenious gift," it departs from the traditional views by denying that some sexual acts are intrinsically immoral (e.g., masturbation, adultery, and homosexual acts) and suggests that sexual practises are moral if they are "self-liberating, other-enriching, honest, faithful, socially responsible, life-serving, and joyous."

In 1979, the Vatican condemned this book. No sanctions were leveled against the authors of the report. In 1986, however, Father Charles E Curren was forbidden to teach theology at the Catholic University of America in Washington DC for having published very similar views.

In 1990, over 4500 "concerned Catholics" took out more than a full page ad in the New York *Times* (February 28), calling on the Church to ordain women and married men to the priesthood and to engage in "extensive consultation with Catholic people in developing church teaching on human sexuality" — presumably along the lines of the Kosnik book. No official response greeted this ad. But a similar one a few years before, suggesting that Catholics had a moral choice with regards to abortion, generated grave official censure.

The "sexual revolution"
Throughout the West, the legal requirement that marriage was indissoluble was by the 1980's given up in virtually all countries, even in predominantly Catholic ones. Notable exceptions include Poland, Malta, and Ireland (which in 1986 reaffirmed the ban on divorce in a country-wide referendum). Furthermore, there is a trend toward living together without a marriage ritual to define the relationship. In the United States for example, in the period from 1970 to 1978, the number of unmarried couples living together went from 523,000 to 2,588,000.

Furthermore, in the U.S. at least, divorce rates have dramatically increased, from 393,000 in 1960 to 1,187,000 in 1991. And the percentage of people in the total U.S. population who had never married rose from the 1970's figure of 18.9 per cent for males and 13.7 per cent for females to an all-time high in 1991 of 26.1 for males and 19.3 for females.

The causes of these extraordinary changes in the basic structure of western society are complicated. One cause is the massive adoption of

effective contraception, which prevents modern marriage from being tied to the production of children. In particular the use of the pill as well as intra-uterine devices, which are all "intercourse independent," have made it possible for women to decide without the knowledge or even co-operation of men if and when they have children. The development of the abortion pill, RU486, and similar abortifacients will probably make women even more independent in controlling their reproductive capacities.

The breakdown of the traditional division of labor was also crucial. World War II and the inflationary spiral since have forced women more and more to compete with men for traditional male jobs. The rhetoric of Women's Liberation — that women should be free to seek out the same options as men — made sense when a tremendous number of middle class women had no other recourse.

Another reason for change was probably the development of a drug-oriented counterculture in the 1950's and 1960's — often associated with rock musicians and epitomized by the Woodstock concert (actually held in Bethel, New York) in 1969. In a sense the counterculture represented a development of earlier movements such as the bohemianism of the 1920's and existentialism following World War II. But it also had a rationale in terms of the grim reality of a persistent threat of the hydrogen bomb and, in the United States especially, the highly unpopular Vietnamese War. The counterculture had many facets: the hippie movement, the anti-Vietnamese War movement, the civil rights movement, and in particular the drug culture which saw large numbers of middle-class young people throughout the West flouting laws with the secure conviction that the laws were wrong. The 1960's saw an emergence of new life-styles among the young middle class that were tied in part to radical politics. In the 1970's, the radical politics diminished in importance and were separated from the life-styles. But the new life-styles tended to spread to the working class.

The counterculture not only accepted premarital sexuality but also public nudity, abortion, and homosexuality. A sort of "deviant chic" arose that included other social changes such as co-ed dormitories and "swinging." Wife-swapping among friends gave way to the more anonymous encounters in establishments such as Plato's Retreat, developed in the late 1970's, where heterosexual couples (not necessarily married) went to explore the sexual field. Here was the "sexual

revolution" at its most blatant. (Actually, the expression "sexual revolution" was applied earlier to the post World War I period. Sexologists have tended to see that "revolution" as involving a greater social change.) In January of 1980, a New York cable TV station (the infamous channel J) actually presented a copulation contest — a so-called "spermathon" — on the air from Plato's Retreat: a woman wanted to beat all existing records. The number of men she brought to ejaculation was 82, plus her husband (there was no known record, so she won by default — but the Roman empress Messalina may have given her a run for the money).

Another development that is quite extraordinary from a historical perspective is the Gay Liberation movement in the late 1960's and early 1970's in the United States. Although other societies have been tolerant of or even insistent on homosexual behavior and it had acquired a certain chic in the western counterculture, nevertheless this movement was the first in which sexual orientation became the basis for political organization.

The result of this politicization has been a change from what was even in the late 1960's a secret and, in some commentators' views, an impoverished subculture, to a fairly public "satellite culture," with spin-offs into the heterosexual world. What is certainly remarkable in most cities in the United States is the public display in newspaper stands of homosexual newspapers, gay student clubs at colleges and universities, and possibly even a gay church (or at least a church that permits gay groups to meet there) and a gay community center. There was literally nothing comparable in the 1950's. In France, where private homosexual acts between adults have not been crimes since the time of Napoleon, such a satellite culture does not exist or is only now beginning — probably as an American influence. Clearly legal toleration does not always produce social creativity.

Attempts at changing anti-homosexual laws are not something new. They were started in the 1860's in Germany by Karl Heinrich Ulrichs. The main strategy of the German movement was to modify the laws (notably paragraph 175 of the penal code) through petition and education. Magnus Hirschfeld and his Scientific-Humanitarian Committee actually compiled a petition of more than 6,000 names of prominent professionals to present to the government. The names included those of Albert Einstein, Thomas Mann, Herman Hesse, Karl

Jaspers, Arthur Schnitzler — leaders of the German-speaking intelligentsia. Several prominent foreigners also sent their unsolicited backing — including Leo Tolstoy and Émile Zola.

The movement collapsed several years later under the Nazis. Although the Nazis had been ideologically anti-homosexual from the start, the beginning of intense persecution began on June 30, 1934, "the night of the long knives." On that date Ernst Röhm, the leader of the Storm Troopers (SA), was assassinated along with dozens of SA officers. This assassination was clearly political since Röhm's homosexual interests had been common knowledge at least since 1925, when his association with a male prostitute became public. What happened was that Röhm eventually got into serious conflict with Heinrich Himmler, the head of the Blackshirts (SS) and the Gestapo.

A new and much more severe law was issued, Paragraph 175a. The new law added the following to the already existing offenses: kissing, embracing, having unacceptable fantasies, and being listed in the address book of a homosexual.

Homosexuals were imprisoned, tortured, castrated and killed under the Nazis. The exact number of those killed is not precisely known. Current estimates vary between 220,000 (a figure suggested by the Protestant church of Austria) and 500,000. These actions against homosexuals are rarely mentioned in commentaries on the holocaust and went virtually unnoticed until the appearance of the play Bent by Martin Sherman produced first in London, and then in New York, in 1979. In West German courts, it was ruled that homosexuals could not be granted any form of restitution (unlike Jews and political prisoners) because they were punished for criminal not political offenses.

The Gay Liberation movement in the United States is usually dated as beginning the Friday night of June 28, 1969, two days short of the thirty-fifth anniversary of "the night of the long knives." The triggering event was a police raid on a gay bar in New York, the Stonewall Inn. The extraordinary thing about the raid was that the clients fought back. The police were pelted with beer cans and bottles along with chants about gay power.

About a month later, the Gay Liberation Front (GLF) was formed. Demonstrations and marches became the order of the day. The '70's saw the rise of many gay groups and factions as well as increasing friction between homosexual men and lesbian feminists.

In England, a more staid approach had paid off in 1967 with the enactment into law of the recommendations of the Wolfenden Report. Denmark, West Germany, and Canada followed suit. But what happened in the United States was often not decriminalization of homosexual acts in spite of the wide variety of attacks on the legal system. Rather, *de facto* toleration of homosexuality and of a gay life-style spread — but without the guarantees of law. The United States Supreme Court has continued to uphold the legality of certain laws against homosexuals, although there is a widespread view that laws dealing with private sexual acts between consenting adults are religious and therefore unconstitutional.

In conscious imitation of the gay lib movement, a Masochist Liberation group was formed in 1971, called the Eulenspiegel Society. It soon changed from a group exclusively catering to masochists to one that included sadists as well, and of any *sexual minorities* (which is what the abbreviation SM means in Eulenspiegel Society publications). The group is predominantly heterosexual, but has functioned in several ways as part of the gay subculture. For example, an Eulenspiegel contingent regularly marches in gay parades in New York. The change from a predominantly masochist liberation society to a sadomasochistic social club came about partly through homosexual members, some of whom were able to play both masochistic and sadistic roles.

In spite of the fragmentation, and real lack of change of the anti-homosexual laws throughout much of the United States, in some areas homosexuals developed an impressive political clout. This is most obvious in San Francisco, where it has been estimated that 20 percent of the voters may be homosexual.

In a number of ways, gay rights have tended to increase. However, harassment of suspected homosexuals has apparently become more frequent in many countries since the outbreak of AIDS particularly, and increasingly more violent, at that. In Great Britain in 1988, a law was passed prohibiting local councils from promoting positive gay images in sex education courses or from sponsoring events supporting gay rights. But a sort of schizophrenia is apparent: in 1991 the actor Ian McKellen, himself a homosexual who had spent an enormous amount of money on AIDS-related concerns, was knighted, the first openly gay person ever to have been so. Another matter: attempts to legalize homosexual marriages have almost completely been unsuccessful. Although in the

early '70's the right to marry was sometimes held up as a goal of gay liberation, the decline in heterosexual marriages perhaps helped bring about a decline in the interest in homosexual marriage. Towards the end of the '80's, however, a drive towards a redefinition of the family and the acceptance of gay marriage returned to the political arena. It has, for example, been taken up by the Lambda Legal Defence and Education Fund, a U.S. gay lobbying group. Certain religious denominations have given their blessings to gay unions, such as the Quakers and Unitarians. A movement among Episcopalians in this direction has been launched, but with much resistance from the conservative mainstream. Apparently such blessings are granted in the liberal Roman Catholic churches of the Netherlands. As of March of 1991, the Star Tribune of Minneapolis, Minnesota, began publishing announcements of "domestic relationships" on the page traditionally reserved for wedding and engagement announcements.

The most dramatic change occurred with the legalization in October of 1989 of homosexual "marriages" (technically, domestic partnerships) by the Danish government. Similar laws providing for homosexual domestic partnerships were subsequently passed by Norway in 1993, and by Sweden in 1994.

Reaction to the movement by various religious groups has been very uneven. The Southern Baptists have consistently been opposed to extensions of gay rights. Other groups have recognized as legitimate the right of homosexuals for sympathetic treatment. The question of ordaining known homosexuals to the ministry has been particularly vexing. The ordination of a homosexual woman priest in New York in 1977 by Bishop Paul Moore Jr caused a furor in the ranks of Episcopalians. In 1979, The House of Bishops of the United States Episcopal Church decided that it was not appropriate to ordain a practising homosexual. But in the same year, the Church of England produced a report *recommending* that homosexuals should not be barred from the priesthood and even admitted that homosexual relationships could be justified, though the report rejected the institution of homosexual marriage.

An even more controversial case occurred in 1989 in New Jersey, when an openly gay male priest was ordained who did not hide the fact that he had a lover. A little more than a month later, in January of 1990, this priest, Fr J Robert Williams, was forced to resign as director

of a Hoboken ministry because he had publicly questioned the value of monogamy and of celibacy and even suggested that Mother Teresa, a Catholic nun and Nobel prize winner, would have been a better person if she had not been celibate. He has even asserted that Jesus was gay and had an affair with the man not for nothing called The Beloved Disciple. A year after this, the bishop who had consecrated Williams, John S Spong, created yet another controversy: a book of his was published in which he asserted that St Paul the Apostle was actually a homosexual filled with self-loathing. These are hardly the most orthodox sentiments in the world, and unlikely to silence the foes of ordaining homosexuals as priests.

In the same year, the Evangelical Lutheran Church in America suspended two congregations for ordaining as ministers a gay man and two lesbians. But Reform Jews decided to permit homosexuals to become rabbis. Such religious oscillations and battles will doubtless continue.

Technological changes
An entirely different aspect of changes involving sexuality in recent times had to do with technology in one way or another. For example, in 1978, the first publicized "test-tube" baby was born: Louise Brown. She was actually conceived in a petri dish (rather than a test-tube) from an egg cell removed from her mother, fertilized by a sperm from her father. This breakthrough in *in vitro* fertilizations, achieved in a British hospital under the direction of Dr Patrick C Steptoe and Dr Robert G Edwards, occasioned considerable controversy and brought forth ominous charges of Hitlerian or Frankensteinian possibilities. On the other hand, many childless couples immediately wanted to avail themselves of the possibilities.

Artificial insemination, which often involves the donation of sperm from a man other than a woman's husband, had been practised for some time before this. At least 100,000 individuals who are products of artificial insemination are said to exist in the United States at the time of writing. Sperm banks exist in many places throughout the western world and the practise of inseminating a woman whose husband is sterile with semen from an unknown donor is reasonably common (exact statistics are unavailable). The use of a "surrogate mother", on the other hand, to take the place of a sterile wife is rare. Such solutions are generally discouraged because of legal, social and psychological

complications — as are requests for the insemination of single and/or homosexual women, but they occur.

In 1986, the legal and emotional problems latent in the "surrogate motherhood" issue exploded in a public controversy centering on the kidnapping by Mary Beth Whitehead of the child she had been the surrogate mother for. She was brought to trial and although she did not win custody over the child, her action challenged the wisdom of continuing such surrogate practises.

In 1991, the Supreme Court of France outlawed surrogate motherhood. Nevertheless, the practise will probably continue in one variant or another. In 1987, a woman in South Africa functioned as the surrogate for her own daughter and carried her triplets to term. In 1991, an American woman was reported in a front page article in The New York *Times* (August 5) as bearing her own grandchildren, twins, for her daughter who lacked a uterus. Yet other legal complications have developed along with the perfection of techniques to freeze human embryos for maturation at a later date.

The extraordinary technological finesse involved in these matters is rivaled in the development of surgery associated with transsexual operations. In changing a male to a phenotypic female, the penis and testicles are amputated and an artificial vagina is constructed — sometimes from the tissue of the penis itself. In changing a female to a phenotypic male, a penis is sometimes constructed from skin flaps. Although natural erection is impossible, various devices that have been used in treating men who are impotent for physiological reasons have been applied. One of the most recent of these is a tiny hydraulic system that permits voluntary erections by pumping fluids from the abdomen into the belly.

In spite of the fact that transsexual operations are drastic and in a sense irreversible, by 1980 an estimated 3,000 to 6,000 people in the United States had undergone the procedure and sex-change operations had spread to medical centers around the country. Possibly the world-wide figures for 1992 may be as high as 60,000 but precise statistics are hard to come by.

Contemporary sex research
Since the publication of the Kinsey report, sex research has become a generally accepted academic enterprise. Even outside of academia, a

tremendous audience exists seeking out reliable information about sexuality and sex. But in spite of the general acceptability of the topic, many special-interest groups have helped in part to stifle government and private foundation support for sex-oriented research. For example, the Kinsey Institute had lost most of its funding by private and government agencies by 1977.

Several studies have been made since Kinsey's pioneering work. But the fact remains that with some rare exceptions such as the *Rapport Simon* (for France), we simply lack basic information about sexual behavior for the vast majority of cultures. It is unlikely that this situation will be dramatically changed within the next few years because of general opposition by governments to such projects. However, the threat of AIDS has prompted some action — though hardly in proportion to the severity of the situation. For example, the Norwegian State Institute for Public Health in 1987 conducted by mailed questionnaire a sex survey of 10,000 Norwegians, to help find out how to allocate money to fight AIDS. A similar study is under way in Great Britain — despite the disapproval of former prime minister Margaret Thatcher.

In the United States, with the highest incidence of AIDS in the western world, a depressingly different picture emerges. In 1987, the Federal Government expressed interest in a large-scale survey of sexual behavior, which would in effect update the Kinsey reports but be especially designed for use in AIDS research as well as the study of sexually transmitted diseases in general. Two studies were planned, one on adolescents' behavior, the other on adults' (which was called SHARP: Sexual Health and AIDS Risk Prevention). In 1989, the House Appropriations Committee eliminated $11 million for SHARP and effectively demolished any chance that it could be carried out — this largely as a response to very vocal outrage from conservative religious groups objecting to Government interviewing on sexual matters. In 1991 the Secretary of Health and Human Services blocked the study of adolescent behavior. Representative William E Dannemeyer, a Republican from California, was one of the influential members of the Congress opposed to it, on the grounds — remarkably enough — that it would constitute "wasteful government spending."

Ironically, on the other hand, in traditionally prudish China, without any tradition of scientific sexology, a massive report on Chinese sexual behavior has been compiled, published at the end of 1991. The

architect of this study (which involved interviews with 23,000 people) is a Shanghai sociologist, Liu Dalin.

Several years ago, when I was planning on doing such a study and wanted especially to contrast the behaviors of people living in groups that had very permissive norms with neighboring groups that were very puritanical, I faced similar opposition. Margaret Mead wrote to me that my project simply would not be tolerated by the government in question. If such studies were to be done, they might have to be done secretly under the protective shield of a totally innocent project — for some anthropologists and sexologists, such deception would be morally and ethically indefensible. Laud Humphreys' brilliant *Tearoom trade* (1970), a study of sexual behavior in public men's rooms, was condemned in many quarters for the deception that was necessarily involved at different stages of his project. Humphreys was fortunately able to deal with the ethical problems to his own satisfaction so that the work was not sabotaged.

There are, however, many studies short of full-length Kinsey-type projects that could be done. The work of the several anthropologists mentioned throughout this book is evidence of that. Even in the course of nonsexological studies, significant information could be gathered. For example, linguists would do well to study sexual terms as a semantic field. Physical anthropologists could finally get basic data about genital size to the relation to overall body size and structure. An exceedingly easy and basic task would be to collect photographs of people regarded as physically attractive and unattractive.

Paul Gebhard, writing up his own proposals for future research, has put forward suggestions that are relatively straightforward and of considerable theoretical interest. For example, he notes that our knowledge of fetishes would be deepened if we would isolate variables as much as possible, such as dimensions (e.g., must a boot be of a particular size to be a turn-on?). Gebhard proposes that fetish objects be varied by small degrees to determine precisely such information. Another of his proposals: since it is known to be the case that heterosexuals develop "deprivation homosexuality" when confined with members of the same sex for a long period of time — in prisons or on boats — it would be interesting to see if "deprivation heterosexuality" should appear if say a man, hitherto exclusively homosexual, were placed in a closed institution with only women.

It is unlikely that any of these studies will be made in the near future.

But some other studies are likely. For one thing, as more and more of the primitive world becomes literate and as more and more anthropologists study nonprimitives, new strategies in massive sex research open up. Informants could be urged to keep sex diaries. At a minimum, questionnaires could more readily be distributed and filled out. Furthermore, with the greater knowledge of both anthropology and sexology, members of cultures or subcultures could undertake their own studies. One that comes to mind is the subculture of the European aristocracy and in particular of royal families. At least some of the members of this subculture are known to have studied anthropology on the university level. And this subculture would be interesting because in societies where we have some information, there seems to be noticeable differences between the sexual lives of commoners and aristocrats. Apart from rumors and scandals we know little about sexual practises and norms in these circles. It has been asserted that in England, circumcision and "sodomy" are U (upper class, aristocratic) but birth control is non-U. These assertions warrant being checked and we probably need a U anthropologist-sexologist to do so.

Sex in the age of AIDS
The year 1981 saw the beginning of the "age of AIDS," and the end in many ways of the "sexual revolution."

In that year, AIDS was first medically recognized. How long it existed prior to that date is unknown. In 1990, tissue from a British sailor who died mysteriously in 1959 was discovered as containing the AIDS virus. Because tissue specimens are not usually stored as long as this (31 years), it is unlikely that earlier cases will be found. But the sailor in question may have been infected some 10 years before, bringing the spread of AIDS very close in time to World War II. It has reached pandemic proportions since the 1970's and promises to be with mankind for a long time, barring some extraordinary medical breakthrough.

Its spread — presumably from central Africa (according to most historical reconstructions) — has been dramatic, no doubt yet another consequence of the jet age.

The initial Western reaction to the discovery of AIDS was marked by indifference on the part of the population at large, who saw it as

associated with generally despised or at least ignored groups such as male homosexuals or drug addicts, and by disbelief on the part of many gay people, who thought at first it was part of some anti-gay propaganda. The world was soon to learn differently. Fear bordering on paranoia set in.

It was perhaps the much publicized death of the movie star Rock Hudson in 1985 that most startled the public: the message here was that even a handsome, multimillionaire celebrity could not escape the ravages of AIDS. The subsequent deaths of other well known persons such as Liberace, Halston, Roy Cohen and the deaths of haemophiliacs and children born of AIDS-infected mothers democratized the message for Westerners.

An initial floundering on strategies by gay groups and ignoring by public officials led to many developments. On the official side, the forced closing of anonymous sex clubs, such as gay baths and comparable heterosexual places — including the previously noted Plato's Retreat. On the part of the gay community, much soul searching and eventually some remarkably militant groups. In the United States, the Gay Men's Health Crisis (G.M.H.C.) was formed in 1982 by, among others, the writer Larry Kramer, seen by many as a prophet of doom. (He is the author of an early play about AIDS, *The normal heart*.) This was an organization to help people — primarily gay men, but all others as well — who were afflicted with AIDS. G.M.H.C. and various other groups drew up lists of sexual behaviors that were labeled with regard to whether they were relatively safe (such as mutual masturbation) or high risk (anal foration). Some groups encouraged the general use of condoms and suggested a less promiscuous life-style than had formerly been championed as somehow "politically correct" by certain gay libbers in the '70's and early '80's.

However, medical involvement by governments, or rather lack of it — in particular the conservative Reagan government — led to profound disillusionment with policy treatments and the handling of people infected with AIDS.

In 1987, Kramer started an activist group of people with AIDS and their advocates to challenge such policies and to force members of the medical profession to make available experimental drugs without waiting for confirmation of their effectiveness following usual scientific procedure. The organization was ACT UP (an acronym for "AIDS Coalition To Unleash Power"). The initial policy was to create incidents

of civil disobedience to effect changes in social policy and to denounce any medical research involving clinical trials depriving some people with AIDS of possibly effective drugs. Some members of the medical establishment as well as politicians who did not go along with the goals of ACT UP were publicly heckled. Religious groups opposed to teaching safer sex practises — such as the use of condoms — were subject to comparable demonstrations. In one instance, at St Patrick's Cathedral in New York City, one demonstration became infamous because of an act by a single individual of what could be considered by Catholics as a supreme blasphemy: desecrating the host by spitting it out during Communion.

Many of the tactics used by ACT UP (which has spread to several other countries such as Great Britain and Germany) are seen by some, including people who are openly gay and others who are concerned about the plight of people with AIDS, as counterproductive. But in a sense these tactics are probably at least therapeutic, in that they handle the rage brought about by the threats and ravages of the disease itself. To internalize such rage would probably lead to massive depression and despair. It is not clear whether the stated goals of the organization could be met more effectively by other tactics.

An activist group derived from ACT UP was founded in 1990: QUEER NATION. It was set up to protest homophobia in general and acts of violence against homosexuals in particular.

A somewhat related development, but one with all sorts of complicated motivations, has been called "outing": revealing in the media that a person is homosexual. A well-known instance of this policy was the report in 1990 in the gay magazine *Outweek* that the multimillionaire entrepreneur Malcolm Forbes was gay. He had married, sired several children, and was romantically linked with Elizabeth Taylor during his lifetime. He hobnobbed with the rich, famous, and in many instances the homophobic. The writer Michelangelo Signorile felt that the facts of Forbes's secret life should be made public for a variety of reasons: to confound the homophobes, to make the mentioning of homosexual behavior in gossip columns as commonplace as the mentioning of heterosexual liaisons, and also (it was said) to provide role models for young homosexuals who might otherwise have a low self-image.

Certainly revelations about the sex lives of famous people after their deaths had become commonplace by the 1990's — perhaps as a continuation of the verbal freedom associated with the sexual revolution. The late president John F Kennedy, for one, had become notorious for a wide range of heterosexual affairs, and highly explicit details became widely known, including the assertion that the actress Marilyn Monroe was photographed by Peter Lawford, the president's brother-in-law, while she was performing fellation on Kennedy in a large marble bathtub (this photograph, if it exists, has yet to appear).

Similarly, the movie star Joan Crawford was revealed as having posed for porno photographs — and rumor has it that before her breakthrough in Hollywood, also appeared in a porno film she spent much time and money after her success trying to destroy all records of. (Several decades later, when the rock star Madonna in the late 1980's was confronted with the release of a porno movie she had appeared in before her rise to fame, she reportedly reacted by saying "So what?")

Celebrities who had become known for leading secret homosexual lives included Errol Flynn, Tyrone Power, Rock Hudson, Greta Garbo, Leonard Bernstein, Cary Grant (who had sued another actor for alleging that he was homosexual — and won). So gossip of this sort was nothing new. But "outing" is supposed to have a kind of ideological justification. One reason given for it was the punishment of "closet" homosexuals guilty of overt anti-homosexual behavior. An early example of this occurred in 1976 when the French pornographer Roger Peyrefitte alleged that Pope Paul VI was homosexual. The Pope denounced this assertion as a "horrible and slanderous insinuation" (as reported in the New York *Times* 1976 April 5). This incident had few repercussions. But it occurred at a time before frequent scandals concerning homosexual impropriety among Roman Catholic priests were widely publicized, including that of Fr John Ritter in New York, who allegedly had sex with underage boys seeking his help in the Covenant House operation, an organization dedicated to helping troubled, homeless youths. An even more extensive homosexual scandal occurred in Newfoundland in the 1980's and somewhat before, involving at least five priests and some ten or more lay members of the Christian Brothers who ran an orphanage. Altar boys, orphans, and other youths were sexually assaulted — some as young as six. In the wake of this scandal, the Archbishop of Newfoundland resigned in July of 1990.

At the same time that AIDS profoundly shook the gay world and made homosexuality more of a public issue, the age of AIDS has had other, sometimes equally profound consequences. The most important of these is that AIDS has entered the heterosexual mainstream of western societies as well, although the rate of spread seems not to have assumed the gigantic proportions initially predicted — yet. Nevertheless, a great many heterosexuals seem to have altered their lifestyles out of fear of AIDS; for example, the red-light district of Hamburg has been hit with a serious recession since 1988. Such changes will probably be intensified in light of the announcement in 1991 on the front pages of newspapers all round the world that the enormously popular basketball player — and presumed heterosexual — Earvin "Magic" Johnson had contracted H.I.V.

A specific intensification of greater verbal freedom associated with the "sexual revolution" has been the result of the AIDS crisis itself. References to condoms, anal intercourse and the like (because of dissemination about safer sex techniques) are now commonplace in the media—including prime time television. Jokes about condoms are almost old hat. It would seem that verbal puritanism is dead in the mainstream culture — even if (dare one say, even when?) the AIDS epidemic will have been ended.

Another development largely associated with the age of AIDS seems to have a somewhat more precarious future: "fone sex." The "dial-a-porn" industry has proliferated considerably in the United States and the explicit sexual messages it provides is seen as a form of safer-sex option. In France, a comparable service is provided on the *réseau rose*, the "pink network" of the Minitel, a kind of national computer setup. Ads for such services are now routine in both explicitly sexual publications as well as other, considerably more conventional outlets like *The Village Voice* and on certain television channels, where they compete with ads for dating services and even unambiguous prostitution (offered by various enterprises with enticing names such as Seduction Escorts and Geisha-to-Go). However, anti-pornography organizations including the National Decency Forum have tried to limit access to these services drastically. Conservative courts may well be persuaded to do so.

Possibly also the explosion of the multi-million dollar business of sexually explicit videos is in part related to safer-sex life styles. However, some 200 or so "stag films" are known to have been produced

before 1910 so that the recent phenomenon is not something out of the blue. Even the high-tech world of computers has recently lost its virginity with the development of sexual computer games — sometimes referred to as "dildonics," perhaps the ultimate in safer-sex.

The very great freedom that exists nowadays in publishing and film (in comparison with former times) continues to be a successful holdover from the days of the sexual revolution. But it generates considerable controversy. When attacks are made on these freedoms by otherwise liberal people the situation gets complicated and sometimes very specific indeed. For example, certain women's groups have in a sense joined with religious fundamentalists in launching a crusade against pornography. As a matter of fact, in 1984 a woman in Minneapolis doused herself with gasoline and set fire to herself to protest pornography. It is not usually the traditional definition of pornography that is used here but something very much more specific: sadomasochistic pornography in which women are depicted as tortured and abused, even killed. Attempts to rescue pornography as a legal category after much legal obfuscation had led to curious results. A United States Supreme Court ruling that local judgments can be made as to what is objectionable in light of community standards about prurience brought an acquittal in at least one case of a man who had produced films showing sexual acts between two men and a dog. A jury in Manhattan ruled that these films starring a German shepherd were too disgusting and repulsive to appeal to the average person's sense of prurience (the guidepost of the law). The judge agreed, saying "If you're not aroused, it's not obscene." The film maker was let off.

The U.S. presidential committee on pornography set up in 1967 by Lyndon Johnson ultimately recommended that all existing pornography laws should be repealed. The committee based its recommendations in part on the results of the decriminalization of pornography in Denmark where no increases in sex crimes occurred — in fact, the incidence of certain offenses declined dramatically. The U.S. committee offered its conclusions in 1970. They were rejected by (then) President Richard Nixon as "morally bankrupt".

In 1985, under Ronald Reagan, another committee on pornography was set up, the so-called Meese Commission. Its recommendations were virtually the opposite of 1970 ones. This commission was headed by Henry Hudson, whose impartiality and even appropriateness were widely

questioned because he was known for actively curtailing sales of pornography in Arlington County, Virginia, where he was chief prosecutor. Other members had taken comparable anti-pornography stands. Fr Bruce Ritter was one of these: as we have seen, he was himself later embroiled in a sex scandal involving teenage boys. Most sexologists and other social scientists dismiss the Meese Report recommendations as politically rather than as scientifically motivated.

Anti-pornography groups, of course, have not given up. At the time of writing, the United States in racked with the issue of government funding for art construed by some as offensive, morally and in other ways. This came to a head because of a controversial exhibit of photographs made by the noted photographer Robert Mapplethorpe, who shortly before had died of AIDS. Critics of the show stressed the idea that the government as funder was acting as patron, and could stipulate the kind of art it would support. Defenders saw the issue as one of censorship sounding the death-knell of creative freedom, in addition to being an attack on the first amendment of the U.S. Constitution. Meanwhile, in those galleries where the Mapplethorpe show actually got to be shown, attendance was breaking all records. In an anti-obscenity trial held in Cincinnati, the museum displaying the Mapplethorpe work was acquitted.

Another strategy recently taken by anti-pornography groups is to promote laws permitting victims of sex crimes to sue producers and distributors of pornography. This is done in the belief that exposure to pornography triggers people to commit such crimes. This is precisely the line of reasoning that led the Supreme Court of Canada in February of 1992 to vote unanimously in favor of such a bill. The advocates of this strategy are convinced by the findings of a number of small scale studies that suggest a link between the two. They forget the massive social experiment in Denmark mentioned earlier. They also ignore a report issued by the Kinsey Institute in 1965, *Sex offenders*, which found that sex offenders and non-sex offenders could not be differentiated on the basis of interest in or possession of pornography materials. This study concluded that exposure to specialized pornography (e.g. sadistic pornography emphasizing violence) does not create a corresponding interest. On the contrary, people seek out pornography — if they do so at all — to satisfy a pre-existing interest.

What has developed is a legal quandry because of attempts to uphold traditional morality through the laws. It seems likely, however, that the laws will be changed if social trends in the western world continue.

These trends are, however, difficult to assess. The apparently greater tolerance of nudity and pornography described for the 1960's and 1970's in the United States, seems to have persisted. Other aspects are not so clear.

Studies of American behavior since Kinsey's work simply do not approach the massiveness of his sample (although they attempt to avoid the errors his sampling has been charged with), so the picture is even more sketchy than the one he presented. On the basis of these more recent studies, it seems reasonably clear that more college women engage in premarital intercourse than was true in Kinsey's study, and that young people are beginning their sexual careers even earlier despite the risk of AIDS.

Other differences between present trends and the patterns described by Kinsey include the following. Fewer men experience their first intercourse with a prostitute, 20 percent in Kinsey's findings. Present estimates range from 2 percent to 11 percent. This change would seem to follow from the greater availability of ordinary women. Fellation seems to be the sexual service most frequently requested from prostitutes; in Kinsey's findings it was intercourse. At the present time, oral-genital acts seem to be more commonly practised by the general public or are more readily admitted. They do not carry the very great stigma that was fairly general in Kinsey's day. If true, what may have happened is that "upper level" practises have spread to working-class people — perhaps through the influence of virtually omnipresent pornographic movies and videos: these serve not only to titillate but also to instruct. Pomeroy has suggested that homosexual experiences in the '70's were probably more common than in the 1940's. Other scholars see evidence that the percentage of exclusive homosexuals went down — this again before the AIDS crisis. After it, the picture has probably changed considerably in the other direction.

Even with regard to the incidence of sexual intercourse within marriage, there is disagreement, some experts providing figures that it has gone up whereas others argue that with the greater autonomy of women and the widespread ideology of feminism, mutual consent rather than mere acquiescence in wifely obligations would rule out greater

frequency. A fairly interesting change from a legal perspective is the widespread acceptance of the notion of marital rape — an idea totally foreign to traditional Christian western culture (though not to Jewish moral precepts). The incidence of adultery may also have gone up, in part because of the spread of a philosophy of "open marriage," which in some versions includes "swinging" and consensual adultery. All of these practises were known in the United States in Kinsey's time and before. What seems to be different is percentages. And these differences may not be great.

However, in 1994 *The social organization of sexuality; sexual practrices in the United States*, a study by Edward O Laumann et al., was published. It was hailed in some quarters as "definitive" and a comfort to conservatives because it suggested that Americans were more "moral" than the original Kinsey reports had found. For example, in the 1994 study, only 25% of the married men admitted committing adultery, and only 9% of the men said that they had ever had any homosexual experiences. Although this survey made use of a random sample, it had other reliability problems. For example, six percent of the 3,432 people surveyed were interviewed in the company of their spouse or other sex partner, and fifteen percent when others, including children, were present. Unsurprisingly, the authors found that the presence of a third party was associated with, for one thing, lower rates of reported multiple partners. Obviously the perfect survey of sexual behaviors is elusive.

From a cross-cultural perspective, none of these things verges on the extraordinary. Even the divorce rate, which has clearly gone up, is unexceptional cross-culturally. A study by G P Murdock of 40 societies led him to conclude that American society was nowhere near levels of family disorganization that would be truly disruptive socially. Furthermore, an emotional ideological commitment to family exists in spite of the increase in the number of unmarried adults in the society.

Human sexuality has a variety of cultural components superimposed on a biological structure. The basic biological adaptations and constraints do not change. No sexual revolution is going to permit human males to experience 100 orgasms a day no matter what ideology is involved. The relation of sexuality to culture is more complicated. Clearly the cultural aspects can change dramatically, but even the culture of sexuality is perhaps more stable than has been supposed.

Part Two

THE GEOGRAPHY OF
SEXUAL PRACTICES

Sexual customs and ideologies
differ enormously from culture to
culture throughout the world.
This diversity often challenges
sexuality, society,
and the individual.

TWELVE AFRICA

A footprint nearly four million years old from Africa
may provide a clue about the earliest sexual
preferences of humanity. Modern African sexuality
too may have lessons for the West.

Sex in its distinctively human forms must have started out in Africa. For
one thing, the earliest fossil evidence for humanlike forms is found there,
going back nearly four million years. More specifically, the earliest clear
indications that humanlike beings walked erect on two feet come from
Africa; this human peculiarity led to major changes in primate sexuality.

The most dramatic evidence for erect posture and walking on two
feet is surely human footprints 3,600,000 to 3,800,000 years old
discovered in 1979 by Mary Leakey in Laetolil, Tanzania. The prints,
preserved in volcanic ash, have even led Leakey to believe that they
indicate the first traces of a nuclear family. There are three sets of
prints, apparently of two adults walking side by side leading a child: if
these represent a man, a woman and their single offspring, we have at
once the modern western ideal and the dream of zero-population
proponents; we cannot know for sure.

But something else is suggested by these footprints; the distinctively
human big toe revealed by the prints is good evidence not only for
upright posture but probably also for preferential frontal entry
intercourse (and possibly a whole range of other distinctively human
sexual practises).

There are at present no unambiguous Paleolithic representations of
sexual intercourse, whether human or otherwise. In Africa, the earliest
so far is believed to be an engraving on sandstone found at Tel Issaghen
in Libya; it dates from 7000 BC (an even earlier representation comes
from the Near East). Although this engraving almost certainly shows
sexual intercourse, it is not clear what it means, because one of the
figures has a wand or implement of some sort in one hand. It is even
hard to see what coïtal position is shown.

In southern Africa, rock paintings are also to be found, but of a
considerably more recent date (as late as 1800). The people shown in

these drawings resemble modern-day Bushmen and Bantu-speaking peoples. Occasionally female figures seem to be shown with long labia, the so-called "Hóttentot apron." What is strange, however, is that male figures, usually shown naked and with erections, have some sort of decoration on their penes. Some have suggested that this is a kind of *ampalang* (penis bar), found nowadays among groups in Borneo and the Philippines. The odd thing is that nothing in present-day cultures in southern Africa — or anywhere else in Africa — helps explain the "crossed penis."

Hunters and gatherers
For about 99 percent of all of man's existence, hunting and gathering have been the predominant ways of getting food. The raising of crops and the herding of animals developed only about 10,000 years ago and brought about a dramatic change in human lifestyles, referred to as the Neolithic Revolution.

Today, very few peoples in Africa live as hunters and gatherers: fewer than 200,000 out of a total population for the continent of over 350,000,000. Even at the beginning of European exploration in the fifteenth century, most groups were already agricultural and a few were herders. But African hunters and gatherers probably represent an unbroken line from the earliest kind of economy.

Generally, African hunter-gathering groups appear to begin an active sexual life early in childhood. According to Marjorie Shostak, all the !Kung Bushman women she interviewed had experienced sexual intercourse as children. Even though adults say they do not approve of this and maintain that it should wait until the children get older, they do nothing to prevent such sexual experimentation unless it occurs near them.

The same general lack of concern about childhood sexuality has been reported for the neighboring Hóttentots, who are related to Bushmen hunters and gatherers linguistically, culturally and physically. But Hóttentots have taken up herding.

All hunting and gathering groups permit a man to have more than one wife. In actual fact, however, few have more than one at a time and the greatest number is seldom more than three or four. Although there are sporadic instances where a woman might have more than one husband, these are highly irregular.

Little is known about the sexual repertoire of hunters and gatherers, but for the !Kung we have more information than for most. Most

striking is the rear-entry coïtal position: both the man and woman lie on their sides, the man at the back. Richard B Lee maintains that this position is assumed at night, around communal fires under a shared blanket and is prompted by a desire to be inconspicuous. It may be that rear entry is the most common position, but it is not necessarily the preferred one. In sexual encounters during daytime away from camp, the most common is the missionary position. Frontal entry is a distinctively human copulating manner, so these Bushman data are important.

What seems to be the most reasonable explanation for the development of the Bushman position is not the continuation of a basic mammalian pattern, in spite of walking on two legs, but another human peculiarity that no baboon or chimpanzee can ever understand: a sense of modesty. Bushmen cannot escape into a hut or a room because they have none.

The ancient Egyptians
The earliest documented commentaries about the sex life of any group living on the African continent exists for the ancient Egyptians. This is no earlier than 5,000 years ago. Although they may have influenced other cultures in Africa, it is not clear that they did so directly. But the sexual life of the ancient Egyptians is interesting in its own right and will be considered here in some detail.

In the ancient world, the Egyptians enjoyed a reputation for being, in a word, sexy. Their erotic freedom and skill seem to have been as proverbial to their contemporaries as that of the French in modern times.

Kambyses, king of Persia, started a war with Egypt in the sixth century BC because the pharaoh would not let him marry one of his daughters. According to a Greek commentator, he had heard that "Egyptian women excel all others in passionate embraces." The Hebrew prophet Ezekiel spoke with disgust of the whoredom brought "from the land of Egypt." According to Suetonius, the Roman emperor Tiberius kept in his villa on Capri a sexual manual, possibly illustrated, by an Egyptian courtesan named Elephantis. Egyptian dancing girls were particularly popular in Rome because of their erotic dances and songs.

In light of such a reputation, it is perhaps surprising that little direct information has survived about ancient Egyptian sexual behavior. This has been compounded by the prudery of modern Egyptologists. Representations of the god Min, for example, have embarrassed many Egyptologists because he is usually represented with an erection (in

statues, he is shown masturbating himself with his left hand). One young museum curator told me of having found a box of over a dozen wooden phalli removed from statues of Min by previous curators and then merely hidden away. The great Egyptologist Flinders Petrie found publishing illustrations of the god so awkward that he placed the label of the illustration over the phallus to block it out.

In the absence of a codified law dealing with ancient Egyptian sex and marriage, it is not clear what their conceptions of incest might have been. Incest within the royal family was permitted: pharaohs sometimes married their sisters or half-sisters, possibly because succession to the throne went in the female line. Ramses II is believed to have married two of his sisters and two or possibly even three of his own daughters. An earlier king, Amenhotep III, seems to have married at least one daughter but no sister. What happened among commoners is not clear for most of Egyptian history but during the Graeco-Roman period, brother-sister marriages seem to have been fairly common, apparently most frequently among ethnic Greeks who did not want to intermarry with the native Egyptians. The problem is compounded because the words "brother" and "sister" are generally extended to sweethearts without apparently implying incestuous attachments.

The king married several wives and both he and the rich frequently had harems, but monogamy predominated among people at large.

There is some evidence that marriage was arranged by parents, perhaps even in childhood. Adultery was condemned, and an adulterous wife could be killed (death by burning is mentioned in at least two stories). Adulterous husbands were not similarly punished, but men were admonished against adultery and frequenting prostitutes. In the late period, the position of women seems to have improved, and divorce was substituted for death. Also, there was the development of a form of temporary marriage in addition to the traditional permanent kind. Marriage contracts often mention a period of five months. Love magic from this period reflects this contractual possibility. One inscription from the first century AD reads, "Make Niké, daughter of Apollomes, be stricken with love for Pantus, son of Tmesis, for five months."

Premarital chastity was not stressed, although a word for "virgin" (referring to a sexually mature female) existed. Lifelong celibacy seems to have been discouraged, but at least some priestesses were virgins. Sexual acts were apparently forbidden in temples. But the evidence is not altogether conclusive, and at least in Ptolemaic times sexual acts may have been performed as part of a religious role in the so-called "Bes

chambers" in Saqqara (Bes was a god of sexual love). According to some authorities the worship of the god of virility and generation, Min ("the bull who covers females"), was accompanied by orgies.

Prostitutes other than sacred prostitutes did exist and were quite common. Coïtal positions are shown in drawings made by the ancient Egyptians and described in their literature, usually religious, in which sexual acts of various gods are discussed in some detail. There seems to be only one clear illustration of the missionary position in all of Egyptian art: a petroglyph at Beni Hasan from the XIth dynasty. Nevertheless, it was probably the most common position used and thought of as normal. This is clear from a story about the goddess Isis, who has to copulate with her dead husband Osiris by sitting upon his prostrate body. In the story Isis says, "l have played the part of a man though I am a woman" — which makes sense only if the missionary position was taken for granted. In the Turin erotic papyrus a number of acrobatic and whimsical positions are illustrated: one scene shows the woman standing above the man, suggesting the woman-on-top position highly reminiscent of common representations of the earth god Geb, often shown with an erection, and the sky goddess Nut, who hovers above him.

Almost no information about homosexuality survives. In one version of the Book of the Dead, a man is advised to say "I have not copulated with a man." A more literal translation is "I (a male) have not copulated with a (male) copulator," the critical Egyptian word being nkk, in hieroglyphs ~~~⚑𝔾— note that the writing system was hardly prudish. Formerly, this was translated as "...with a boy." A curious story about King Pepi II can be read as ancient gossip about a trist he had with one of his generals — the secrecy suggests that for some reason it was shameful. But in a myth about the fight between the gods Horus and Seth, a general Middle Eastern view seems to be displayed: for a man not to play the "man's role" in a sexual encounter or for a man to be emasculated in certain ways is degrading. A text from the Middle Kingdom suggests that a dead man can render the gods powerless by foration ("Atum has no power over me, because I copulate between his buttocks"). With all this in mind, one is tempted to interpret the line from the Book of the dead on the order of "I have not raped an 'active' man". But scholars don't agree and there is much to be unsure about.

Masturbation and fellation are rarely if ever shown and yet both had religious significance. The world was believed to have been created through an act of divine masturbation by the god Atum, whose hand was his celestial spouse. The earth god Geb is sometimes depicted as

performing autofellation. Of the god Re, it was said that "he copulated with himself."

Nekrophilia was known and disapproved of at the time of Herodotus. He specifically says that the corpses of noble and beautiful women were protected from embalmers. It may have been different with the corpses of men because some sort of ritual pseudocopulation with the actual mummy was performed to restore the dead man's virility.

Herodotus also reported animal contacts. He was shocked by seeing a woman having public intercourse with a he-goat. This act may well have had religious significance, since the province in which the incident occurred held "all goats in veneration, but the male more than the female." There was a single, especially sacred he-goat before whom women traditionally exposed themselves in order to strengthen his generative power and possibly to guarantee their own fertility.

Egyptian erotica is scanty, mostly in the form of figurines. One common theme is musical: a man with a gigantic penis having intercourse with a woman playing a harp. (This presumably came about because of a play on the words for "harp" *bnt* and "to have an erection" *wbn*.)

Marriage in Africa as a whole
Returning to the "ethnographic present" (the time when westerners first came in contact with a group), I shall deal with Africa as a whole, emphasizing black Africa south of the Sahara.

The general ideal marriage pattern throughout all traditional African cultures is for a man to have more than one wife. In some groups, such as the hunting and gathering societies already mentioned, this is permitted but rarely achieved. In other societies, notably the Zande and the Nupe, a few men control great numbers of women, leaving many men without any legitimate mates.

The only African society — and one of the few societies anywhere in the world — in which it is regarded as natural for some men never to marry at all and to have little or no heterosexual life is that of the Dorobo of Kenya. An unusually great shortage of women may be the major cause of this.

The only traditional societies on the whole continent for whom the ideal is monogamy are the Ethiopian Christians, the Berbers of North Africa (even though they are Muslim), the Mbugwe (a Bantu-speaking group in mainland Tanzania) and the Nigerian Daka and Jibu.

For a woman to have more than one husband has been described as almost nonexistent throughout Africa. But there are instances where a woman may have several recognized mates.

What is clear is that in many societies — whatever the label given by the particular society itself to the arrangement — women are allowed to have many sexual partners. This fact is a serious problem for exponents of sociobiological theories of differing male and female reproductive strategies. And this does not even consider the illegitimate affairs of women. These may be extensive, even in societies that trace descent through males, which sociobiologists believe have a lower rate of female promiscuity than those that trace descent through females. An extraordinary counterexample is that of the patrilineal Muslim Nupe, where married women are so free with their sexual favors that it has been described as bordering on prostitution.

A husband may share his wife with other men, at least occasionally, for various reasons. In some instances he is supposed to make her sexually available to a close relative. Among the Mongo-Nkundu, for example, his brothers have the right of copulating with her; if she refuses, her husband may scold or even beat her.

Sex hospitality in which a wife is offered to a guest, is reported from a number of societies, mostly Bantu or East African. Among the Maasai, etiquette specifically requires that a man leave his own hut so that his wife can entertain their guest alone. A married woman may have sexual intercourse with any man belonging to her husband's age group.

Tabus
Sexual intercourse performed out of doors is condemned in a considerable number of societies, including the West African Dogon, Mossí, Edo, Edda, Ibibio, Twi and Tallensi, the Nilotic Lango and also some Bantu groups such as the Mongo-Nkundu, who think it is inappropriate even for illicit affairs. Among the Tallensi and the Lango, who came from otherwise very different cultural traditions, if it is discovered that copulation has occurred out of doors, the very spot must be covered and everyone who passes by must throw leaves, grass or branches on it. Bowdich, an authority on the Twi, says that formerly the custom was that if a couple were discovered copulating in the open, they became the slaves of the first person to discover them (they could, however, be bought back by their families). Among the Bini, a man guilty of copulating in the bush was charged with manslaughter and chained for up to three months.

This tabu is not held by all African groups, for example the Bushmen, who lack houses in the first place, and the Pigmies, who prefer sexual encounters in the forest. If we consider the practises and tabus of people from other areas of the world, this tabu on sex *outside* a house contrasts strikingly with the rules of New Guinea tribes where sex *inside* a house is forbidden.

A similar, fairly commonly reported tabu is on intercourse during daylight hours. The Zulu feel that this rule is merely part of common decency — otherwise people would be like dogs. The Bambara believe that doing so would produce albino offspring. The Kikuyu prohibit daytime copulation except in certain ritual situations; breaking this tabu would cause sickness among the people and their cattle. Others with the same tabu are the Mongo-Nkundu, Fang, Ganda and Maasai.

Tabus on sexual intercourse during pregnancy and nursing are common throughout the world and are not unusual (though by no means universal) in African societies. Among the Kikuyu and Maasai it is believed that sexual intercourse during pregnancy causes a miscarriage. The Kikuyu permit the practise of a restricted kind of intercourse, in which the husband may insert his penis up to a certain point (said to be about 2 inches/5 cm); full penetration would destroy the womb and the foetus. The limit for penetration is actually gauged on the penis itself because of a peculiarity of the Kikuyu circumcision operation; the foreskin is not totally removed but is arranged to hang at the appropriate distance below the glans in a kind of tassel called *ngwati* (the result is the closest thing to supercision in all of Africa). This practise is explained both in terms of its use for determining the proper depth of insertion in restricted intercourse, and also because in unrestricted intercourse it serves to increase sexual excitement — presumably like a french tickler. Peoples who lack such a tabu generally believe that more than one ejaculation is necessary to produce a child, or that in some other way copulation during pregnancy helps the foetus. The majority of Kgatla-Tswana believe that conception requires at least three or four nights of successive copulation: people who want to avoid pregnancy consequently take precautions on the third or fourth nights only — with sometimes unexpected results.

A tabu on sex during breastfeeding is not universal in Africa; it is absent, for example, among the Rundi. The duration of such tabus when found is quite variable: from four months to two years for the Yao, from six to eight months for the Twi, for three years for the Tallensi.

The usual justification for the tabu is that if the mother gets pregnant before a child is weaned, the child will suffer.

Tabus on copulation during menstruation are the rule; I know of no exception for the whole of Africa. To break the tabu leads to ritual contamination, and it may also be injurious to the man's health.

Another widely held rule requires abstinence from all sexual behavior before warfare. Similarly a tabu exists in many societies before and during a hunt or a fishing expedition. The Hóttentot observe such a tabu only before an elephant hunt. The Ila do so before fishing, but some believe it is good luck to have sex before hunting. The Zande believe that a wife's adultery during a husband's hunting trip may result in an accident to him.

The Mongo-Nkundu believe that adultery during the period of ritual seclusion on the part of a man will hurt his newly born child, but after that period it will not — provided the father does not take the child on his knees the very day he commits adultery. A wife can easily guess at her husband's infidelity through his refusal to take the child on his knee. The Nkundu use the expression *ba ngó b'âbé*, "a father's bad knees," when talking about this adultery.

Adultery during pregnancy by either husband or wife is considered exceedingly serious by many groups. The Bemba, for example, hold to the common Bantu belief that if a man commits adultery when his wife is pregnant, the baby will be born dead. The Ganda, Ngoni and Yao require even the husband to confess publicly during a difficult labor, but usually only the wife is forced to do so.

As a matter of fact, some groups define adultery more strictly than mere sexual intercourse. The Lozi, for example, count that a man has committed adultery with a married woman he is not related to if he walks along a path with her or gives her snuff or a drink of beer.

Stepping or jumping over people, or sitting in certain positions may be treated as the equivalent of sexual intercourse or at least as fraught with sexual overtones. For a man to sit on his daughter-in-law's mat is a sin of the first magnitude among the Tallensi. Among the Ganda, on certain ritual occasions a man and a woman must have sexual intercourse even if they are divorced or separated, and this may happen on the night of the wedding of their daughter. If the girl's parents do not actually copulate, the woman must jump over the man, which is taken as the symbolic equivalent of sexual intercourse. In the same vein, the Zulu forbid a person to step over someone else of the opposite sex.

The Zulu have a number of very specific prohibitions. For example, a woman should not have sexual intercourse with her husband after he has killed — or even touched — a python, hyaena or crocodile. A man involved in a lawsuit may lose it if he sleeps with his wife. Copulation should be avoided after a bad dream and during a storm (because thunder and lightning can interfere with sex).

Among the Twi, if a man or woman should be overheard bragging or even talking about a dream in which the dreamer has sex with another person, a charge of adultery may be brought against the dreamer by the husband or wife of the dream partner.

The sex life of royalty
One characteristic of several African kingdoms was brother-sister unions in the royal family. The practise of such first-degree royal marriages very likely spread from Egypt to various kingdoms in black Africa and in some instances were purely symbolic. In some Lunda kingdoms in Zaïre, the king at his enthronement goes through a ritual in which he lifts his sister's skirt and looks at her genitals. The Luba of Zaïre actually require incestuous consummation, but only once — as part, again, of the ritual of enthronement. In at least six eastern or central African kingdoms — Ankole, Buganda, Bunyoro, Zande, Shilluk and possibly also Rwanda and Burundi — the royal brother-sister unions were supposed to be sterile; from a practical point of view this means that abortion or secret adoption was probably practised. In the Fon kingdom of Benin, children produced by incestuous marriages could not be heirs to the throne.

Societies in which first-degree marriages were customary or permitted among royal (and sometimes noble, less frequently other) families with no restrictions on offspring include not only the ancient Egyptians but also the former Monomotapa Empire of Zimbabwe, and the Nyanga. Sociobiologists point out that in such a setting, brother-sister marriage could well hit a genetic jackpot if it produced a fit offspring with unimpeachably high status, carrying on the royal genes to an unprecedented extent.

In some societies there was another aspect to royal sexual life. If a king proved to be sterile or impotent, it was a matter of grave concern for the whole kingdom because he embodied the health of all the people. The ancient Hausa kept an official (the *ƙarya-gíiwáa* "breaker of elephants"), who was supposed to strangle an infirm king.

Sex rituals

There are a few instances in which sexual acts have to be performed for ritual purposes. For example, the Ila force boys during their initiation training to imitate sexual intercourse with one another after they have been given the traditional sex education, and they are also ordered to masturbate.

In at least three societies a woman must perform sexual intercourse ritually to remove her polluting status as a widow. The Twi of Ghana require that the widow (before she remarries) have sex with a stranger who does not know she is a widow. By doing so, she is cleansed of the spirit of her dead husband. The Thonga and neighboring Yao have similar customs, and believe that the widow actually transmits her contamination to the man she copulates with.

There is a variety of other forms of required, ritual sexual acts restricted to Bantu speaking groups.

With regard to ritual copulation, consider the custom of "ceremonial rape" formerly found among the Kikuyu, Rundi, and possibly also Chaga. Among the Kikuyu, boys who had been circumcised had to find a married woman who was a stranger to them and have sex with her. The rape became rape in name only because most of the boys simply masturbated in her presence, although some also ejaculated on her body. As soon as this ritual act was accomplished, each boy threw away a ceremonial bundle of sticks and the wooden plugs that had been stuck in his ear lobes as a sign that he was now a man. Until his ceremony was completed, no boy or man could lawfully copulate with or marry a Kikuyu woman.

Initiated girls had to undergo a similar experience, but precisely what is not clear.

Many African societies practise widow-inheritance: a man inherits all his dead father's wives except his own mother. No matter how unusual this may sound to Westerners, the custom makes sense if marriage is thought of as an alliance between families. Although the custom is fairly common, there is a detail in the transfer of wives that is quite remarkable and found to my knowledge only among Bantu groups — it is reported only from two (but probably has occurred in more): the Chaga and the Nyakyusa. In both these groups the heir must have intercourse with each one of the wives in a single night. Among the Chaga, this is done the day when the widows' heads are shaved as a sign of mourning. Only pregnant and nursing wives are excepted. If the man does not go through with this ceremony, it is taken as proof that he has

renounced his claim on his father's property. Among the Nyakyusa, a man must sleep with all the wives no matter how old or unattractive, or else the women's legs will swell and their minds and bodies grow weak.

Semen has a certain ritual importance among the Bantu — particularly the eastern Bantu — which is not reported from other groups in Africa. For example, the Bemba, Nyika and Yao perform semen testing. Among the Yao, the first intercourse after menstruation must take place on the veranda of a girl's home (one of the few instances in which out-of-door copulation is permitted in Africa) and her husband should withdraw before he ejaculates so that his semen falls upon a cloth. The cloth is then taken by the girl to some old women in the village who will evaluate its qualities.

The Bemba and Thonga require ritual sexual acts in founding a new village. The Bemba custom is for the village headman to "warm the bush" by copulating ritually with his wife before the huts of a new village are occupied. The Thonga have a more elaborate set-up. First, the headman and his principal wife must go through with the ritual copulation at the spot chosen for the new village. From that point on, all the people in the community must observe a tabu on sexual relations until all the huts have been built and the fence surrounding the whole village has been completed. Then, after a purification ceremony, each couple in the village copulates in a fixed order of precedence, one every night. The principal wife of every man is the last to do so.

The Zande share a custom found in several Bantu groups: a belief in the magical detection and punishment of adultery. The Zande version of this is for a man to smear a special poison on his own penis before having intercourse with his wife. The poison enters the woman but does not harm her since it affects only men (the husband has taken an antidote beforehand). Any man who copulates with her will be affected by the poison: his penis will rot and he will develop a skin disease that will eventually kill him.

The Ngoni and Zulu similarly use medicines to cause their wives' lovers to die. The Zulu also have an adultery punishment magic that causes the adulterous lover's muscles to shrivel up and become stiff, his veins to become full of blood clots, his testes to swell up and throb painfully. In addition to the pain, he becomes impotent.

A custom that may have been developed by Nilotic speaking groups (or by some Kushitic group) and then borrowed by the Bantu is a sexual act without actual penetration, such as copulating between the thighs or against the belly. Among a great many traditional Africans, young

unmarried people are permitted to do so quite freely. From a cross-cultural point of view, this practise of "external intercourse" (a kind of foration) is almost entirely restricted to black Africa.

I suspect that the institutionalization of such a practise probably started in a society that insisted on late marriage, as do the Maasai. Maasai society is broken up into a number of age grades so that males are classified as uncircumcised boys, circumcised boys, junior warriors, senior warriors and elders. Only senior warriors may marry, although juniors are expected to sleep around.

A right-left symbolism among Bantu and other African groups may point to wider cultural ties. For example, a common position for sexual intercourse involves both the man and woman lying on their sides, facing each other. The custom is that the man should lie on his right side, so that his left hand is free for sexual play. The woman lies on her left side. In many African languages the right hand is said to be the male hand, the left the female hand.

Homosexuality

The high incidence of AIDS in certain parts of Africa might make us wonder about the frequency of homosexual acts there — despite the usual assertion that African AIDS is transmitted almost exclusively through heterosexual contacts. But we have no systematic studies. As a matter of fact, references to homosexual behavior among African peoples are often confusing. Western travelers, themselves sometimes homosexual, who recount their own experiences have suggested a fairly high tolerance in some areas for homosexual acts. Perhaps the best known of such travelers is André Gide, the Nobel prizewinning novelist and self-proclaimed pederast. In his last book, *Ainsi soit-il (So be it)*, he describes how a young boy called Mala was given to him, along with another boy, by the Sultan of Rey Bouba in Cameroon in 1926. Gide's affair with him, hidden from public view only by a mosquito net when they were on safari, occasioned the lines, "Gentle Mala! it is your elfin laugh, it is your joy, that I should like to see again on my death bed."

Observers from other areas seldom leave such personal accounts and what they say may be contradictory. For example, Wandres and Fritsch writing about the Nama Hóttentot deny the occurrence of any kinds of homosexuality, but Falk maintains it is fairly common and regarded as a matter of custom. A special, intense, institutionalized friendship called *soregus* is often (according to Falk) a homosexual relationship, especially between boys, who are described as watching over each other jealously.

Because the strong feeling against homosexuality in the West may tip the scales against getting or giving adequate information about the subject, I shall assume that disagreement about its presence or absence should be resolved in terms of the positive description.

With regard to the Zulu, the only unambiguous reference to homosexual acts to be found in the records involves purification, when a warrior has contracted a ritual disease known as *izembe* after killing an enemy. The warrior cannot go to live in his own home until he has had sexual intercourse with any woman not of his own tribe, thus removing the *izembe* disease. But if the warrior cannot find an appropriate woman, he may substitute a boy. This indicates little except that ritual pederasty is at least known and sometimes tolerated.

Western notions of homosexuality often raise problems when used cross-culturally.

J H Driberg, for example, writes that the Lango of Uganda punish "sexual aberrations contrary to the order of nature" by death. In his own official government capacity he was occasionally called in to decide such cases, which usually involved involuntary nocturnal emissions by boys sleeping near each other in a communal hut. Now if these had been deliberate acts, the situation would have been very serious. In a footnote, however, Driberg mentions that a number of Lango men have opted to live as women, wear women's clothes, simulate menstruation — and marry other men. They are not killed but fill a culturally recognized role. Driberg notes that in the related Iteso and Karimoja tribes, "such people of hermaphroditic instincts are very numerous."

Clearly in the Lango instance we are dealing with one style of homosexuality not usually distinguished by Westerners. The laws relating to homosexual acts apply in the West whether the participants are transvestite or not. Without Driberg's footnote, a most misleading notion of Lango life would have developed: it is not homosexual acts in themselves that are crimes (since some are in fact institutionalized), but only such acts when they occur in specific contexts. The Nyakyusa reverse the Lango pattern: male adolescent homosexual acts are not punishable with death but are accepted as a natural part of development. Other kinds would be regarded as witchcraft and the perpetrators punished.

Incidentally, early Portugese travelers to the royal court of Luanda (in what is now Angola) also described male homosexual marriage where one of the partners was a transvestite. But comparable customs are rare on the continent, at least at present.

Among the Mbundu and the Fang, one or another kind of homosexuality is known but is condemned. The Fang are said to treat homosexuals with public contempt, and to believe that they are punished supernaturally with leprosy. But it is not clear whether the people reporting this found out about all the possible variants — which, as we have seen, makes a difference. In spite of the contempt the Fang are reported to show, they consider homosexual intercourse as one of the ways of acquiring wealth — not through prostitution but through the "medicine" (or spiritual power) that rich men have and which is believed to be transmitted by sexual contact. A similar belief is found in several West African societies.

Male homosexual techniques are rarely mentioned, although there seems to be a convention among ethnographers that anal foration is to be understood unless otherwise noted.

Information about female homosexuality is even more skimpy. Turnbull says lesbians are unknown among the Pigmies, but gives an expression for "lesbian" in their language *(dora bopa)*. Lesbianism is said to be completely unknown among the Bala and Kikuyu as well. Mongo-Nkundo girls and women engage in homosexual acts, and co-wives reportedly do so. The Kgatla-Tswana women may also do so when their husbands or lovers are away.

The Zande
In the western world, male homosexual acts have been far more intensely condemned than female ones. The situation is dramatically reversed among the Zande, whose sexual customs have been fairly well described by E E Evans-Pritchard, and whose treatment of homosexuality is closely interwoven with the rest of their sexual practises.

Zande practises include a marked difference between the sexual behavior of noblemen and commoners; institutionalized incestuous marriages between noblemen and their daughters and paternal half-sisters; betrothal and, in some legal sense, marriage of very young girls, often at birth or a few hours after; the keeping of large harems by royalty, the nobility and rich commoners; and a resultant scarcity of women for younger men, who had, therefore, to marry fairly late in life (well into their twenties and thirties). This large-scale monopoly of women by a few men encouraged the widespread practise of homosexual acts by both men and women. Such acts were institutionalized for men but condemned for women.

The wives in a harem might be sexually deprived, but because adultery was severely punished, young unmarried men were loath even to attempt it. Death for an adulterous wife and her lover was a possibility. The minimum punishment for the lover was a very stiff fine. Some irate husbands were not satisfied with this, but demanded that the offender be mutilated. Jan Czekanowski, in his expedition to Central Africa in 1907-1908, met a man who had been found guilty of adultery and had both his hands as well as his penis cut off. He was married and his wife was sufficiently fond of him to stay with him after his adultery was discovered and the mutilations inflicted. He satisfied her sexually by gantizing her with the stump of his arm.

Adultery clearly is a very serious offense. But unless a couple is caught in the act, the only proof is provided by the poison oracle. The poison used is a red powder made from a forest creeper mixed with water so that it forms a paste. Some small domestic fowl are forced to eat it. The fowl generally experience violent spasms and may even die. Their behavior forms the basis of the judgment.

Institutionalized male homosexual acts were associated with the military organization of the various Zande kingdoms. Before the coming of the Europeans, large numbers of adult men were organized into military units of either married men or bachelors. It was the custom for the men of the bachelor companies to take boy-wives, who could be as young as 12 or as old as 20. The relationship between the two was regarded as a legal union as long as it lasted. The older man had to pay a bride-price of five or more spears to the parents and performed services for them as he would if he had married a woman. If he proved to be a good son-in-law, he might later get one of their daughters as a wife to replace their son, who would in turn become a bachelor soldier and take a boy-wife. If another man had relations with the boy-wife, the husband could go to court with a charge of adultery.

The Zande thought the sole reason for such marriages was the shortage of women, not the lure of boys, but the custom was never spoken of as disgusting or abnormal. In post-European times it entirely disappeared, most probably because of a breakdown of the traditional punishment for adultery, and because it was easier for young men to marry women.

Lesbians are regarded as especially dangerous, being associated with the most feared of all evil creatures, the *adandara*, fantastic wild cats that live in the bush, and utter shrill cries in the night. It is unlucky even to hear their cries and Zande carry whistles round their necks to

help ward them off. The male cats copulate with women, who give birth to kittens and breast feed them as though they were human babies. It is fatal for a man to see one of these women suckling her kittens. It is said that the great king Bazinbi died precisely in this way. He opened the door of a hut belonging to one of his wives, Nanduru — who was also his daughter — and saw a cat run out of it. She was executed along with her two cat children.

In the past, if a prince discovered that any of his wives were involved in homosexual activities, he would not hesitate to execute them. At present, such women are merely expelled from princely households in disgrace.

However, it was precisely in large polygamous households that lesbianism was practised — in large part, because of sexual deprivation. Men may, in a sense, initiate such relationships. A prince might actually give a slave girl to one of his daughters (simultaneously his wife) and the two would be likely to have an affair.

Sexual techniques and statistics
Very little evidence of a statistical nature is found for any African group for any kind of sexual act. Among the Zande, Kgatla-Tswana and Nyika two or three coïtal acts are said to be normal every night for a married man, and one of these occurs early in the morning upon rising. Chaga men have been reported as copulating as often as 10 times in a night, and it is claimed that this is not unusual. Among the Kgatla-Tswana, the maximum reported for a man is six or seven times in succession, but this would occur only after a period of ritual abstinence or a long absence without sexual contacts. Thonga men may copulate with three or four of their wives in a single night. This is unusual: elsewhere a man rotates among his wives and copulates with only one of them a day or a week. The most complete data on coïtal frequencies come from the Bala: 10 men kept sex records for 20 days. The rate of intercourse varied from once a day to 1.9 times.

With regard to sex technique, the African position (side by side) and external intercourse have already been mentioned. The missionary position is reported from the Kanuri, Zande, Chaga and Nyika; rear entry from the Bushmen and Hóttentot. Other forms are rare or not reported.

Very little mention is made of any kind of oral sex in African societies. Kissing is specifically mentioned as either unknown or not practised in sex play among the Kikuyu, Rundi, Thonga, Mongo-Nkundo and Somali. Bala and Kgatla-Tswana men suck on the breasts of their

wives as foreplay, but the Nyika find this disgusting and would use it as grounds for divorce. The Fang consider fellation by a wife or her husband as grounds for divorce. The Ila regard all oral-genital contacts as crimes.

Information about anal foration is very scanty. It is reported from Arabicized groups, but little is known about it in heterosexual contexts. Foration is said cross-culturally to be the most common homosexual practise, but it is specifically denied for the Zande, for example. Among them, orgasm is achieved in homosexual contacts for the older partner by rubbing his penis between the boy's thighs (interfemoral foration) — the younger partner has to be satisfied as best he can with the friction of his penis on his husband's belly or groin.

Unique customs
Certain African sexual customs or beliefs are nonexistent or rare cross-culturally.

The Cewa (Chewa) believe that if a girl does not copulate before she starts to menstruate she will die. Cewa parents specifically encourage childhood copulation when children are playing house. If by misfortune a girl had not been deflowered by puberty, her hymen was forcibly ruptured in a prescribed way. This idea that death is the consequence of virginity is apparently unique in Africa. The neighboring Ngoni, for example, expect girls to be chaste (although Cewa views seem to be spreading).

Among the Ngoni, if a girl has no lover after puberty, her grandmother will call a young man to her house to copulate with the girl. This is done to see if everything is all right and more particularly, to find out if the girl is proficient. The boy is rewarded for his "investigation" by the grandmother.

The Ganda have a custom somewhat reminiscent of this. A bride's aunt (more specifically, her father's sister) is actually present in the bridal chamber during the first week or so of the honeymoon.

The Yao have special regulations about sex and salt. A boy may not eat food containing salt until he has had sexual intercourse. Furthermore, if a woman who has committed adultery puts salt into the food while cooking, it is believed that her husband will die if he eats it.

The Nyakyusa have a rule that a woman must avoid drinking for a day the milk of a cow that has copulated with a bull.

There are many other sex-related customs on the African continent, and elaborate sexual symbols that permeate the thinking of various

societies, such as the Bemba identification of sexuality and fire. An elaborate variation of views on sexuality also occurs, from the notion that sex is debilitating (as found among the Bushmen and the Kikuyu) to the ideal that sex should be performed as often as possible (Ila) and that its major purpose is pleasure (Ngoni and Kgatla-Tswana).

Recent developments

Many traditional African views are changing because of contact with the West and the breakdown of long-established cultures. We have little precise information about how this influences sexuality, although we can see implications of it in statements about what people look for in a partner. In several societies, lighter skin color has become more highly regarded. In at least one instance, the Fang, the ideal for breasts has changed because of European (movie) influence: girls no longer bind their breasts with strips of bark or cloth to make them fall and hang — the older ideal. Among Ngoni women, a man is considered attractive if he has a part in his hair (following European fashions).

There is only one study, for any African groups, that has attempted acquiring statistics about sexual behavior among modern-day, westernized Africans: Pierre Hanry's 1970 book on the sexual behavior of Guinean adolescents. There were 720 boys and girls (high-school students), who filled out questionnaires. The striking thing is that only one student in the whole sample belonged to a traditional African religion; the rest were atheists, Christians or (the great majority) Muslims. Even so, at least 84 percent of the girls had undergone clitoridectomy, and of the Christian group 9 percent had fathers who still had more than one wife (70 percent of the families in Guinea are polygamous).

From this study, two interesting patterns emerged, which differ from western, specifically European patterns. One is that boys were never sexually initiated by an "older woman." The female partners of teenage males were generally between 17 and 20.

The second difference is much more striking. Sex is seen simply as a need, not a symbol of being a man or an adult. Boys who had had sexual intercourse did not get any particular prestige from their fellow students because of their conquests. Hanry suggests that for a Guinean, the first sexual intercourse does not count as an initiation rite as it seems to for many Westerners. Consequently sexual behavior does not play the same role in the total personality of an individual. If true, this could have implications for psychology, psychiatry and social engineering.

THIRTEEN THE MIDDLE EAST
and neighboring societies
influenced by Islam

Middle Eastern sexuality is commemorated in art 10,000 years old. Contemporary Islamic societies celebrate sex as a foretaste of Paradise — at least for men.

The earliest evidence of sex techniques, sex tabus, sexual dysfunctions, marriage laws, prostitution, love magic and other aspects of human sexuality comes from the area around the Tigris and Euphrates rivers and extending west to the Nile river.

A limited amount of information on prehistoric sexual practises can be culled from ancient works of art. A small Natufian stone sculpture showing a couple copulating is the earliest known representation of a sexual act; it may date from as early as 8000 BC. The stone seals from Ur, made a few thousand years later, show a variety of coïtal positions. But our main source of knowledge about ancient sexual beliefs and practises is written records. This is, after all, where writing began.

The society in which the written word evolved was that of the Sumerians in about 3000 BC. The symbols used for male and female in their writing system were stylized representations of the sex organs. Juxtaposing these representations created a new symbol designed to mean a married person.

Not much is known of Sumerian sexual customs, but it seems that ritual sexual intercourse was practised by a priest and priestess in the New Year to ensure fertility for the coming year. The goddess Inanna personified sexual love. In later times and among succeeding cultures in the area she was known as Astarte or Ishtar, the patron of prostitutes. Some hold her to be the precursor of the biblical Esther; there is no evidence that Esther was a historical person. In fact, her other name, Hadassah, meaning bride, is known to have been used of Inanna-Ishtar as well. If true, then in a sense the cult of Inanna still lives!

The Assyrians and Babylonians carried on much of the Sumerian way of life and probably perpetuated many of their sexual customs. Ritual sex acts, for example, are known to have been practised. Certain

acts — including premature ejaculation — were taken as omens, and nocturnal emissions counted as a sign of good luck.

There seems to have been more than one kind of temple prostitution: either priestesses were sexually available to devotees or to the priests of the temple, or ordinary women were called upon to perform an act of ritual intercourse once (or at least once) in their lives — perhaps as a form of dowry prostitution. Male temple prostitution, transvestism and the making of eunuchs were also a traditional part of these early religious customs.

Precisely how much sexuality and what kinds of sexual acts entered into Sumerian, Assyrian and Babylonian religious observances is unclear. Clearly some did, including heterosexual vaginal and anal intercourse. But it has been suggested that some more elaborated sexual and specifically phallic cults were known in this area.

There are even some tantalizing references in Hebrew writings to what may have been masturbatory rites, as in the biblical tabu: "And thou shalt not let any of thy seed pass through the fire to Molech" (Leviticus 18:21).

The oasis of Siiwa

In the oasis of Siiwa in Egypt there were believed to be ancient phallic cults dedicated to the god Amun, which required nocturnal orgies of ritual masturbation, foration (sodomy) and promiscuous copulation. This particular detail is based on certain statements about modern Siiwans together with a few ancient sources.

The people who lived in the oasis of Siiwa in the Libyan desert are an important group because it is possible that they have maintained earlier Near Eastern customs intact. They are still considered so notoriously "loose" in their sexual behavior that some of the Egyptian officials stationed there refuse to give out their real address and tell friends they are posted several hundred miles away at Marsaa Matruuh, a port on the Mediterranean coast.

By AD 1100 the Siiwans had converted to Islam. Apparently the Siiwans are now fairly good Muslims in everything but sex, and the fact that they eat dog meat (which they consider a cure for syphilis).

The Islamic laws about sex are flagrantly disregarded. This disregard is found primarily in three areas: the widespread practise of prostitution, indulged in even by respectable married women; the prostitution or lending out of adolescent boys to older men by their parents — usually their mothers (formerly there was also institutionalized

homosexual marriage); and public orgies allegedly held in honor of certain local saints.

A girl marries for the first time at such an early age that she is probably a virgin. After that she may live quite a promiscuous life. Although a married woman must observe a certain decorum — for example, she must turn her face to the wall or cover her eyes with her veil when a man passes her on the street — it is said she would prostitute herself for less than five dollars. Husbands sometimes condone this behavior; a few even share their wives' earnings.

Although Siiwans are allowed to have four wives at a time, for a man to have more than one wife is rare. Divorce, however, is exceedingly common — more so than elsewhere in Egypt.

Belgrave met a man at a wedding who was at least 85, looked about 90, and was said to be 102 years old. It turned out that he was the bridegroom and that this was his thirty-sixth wedding. The bride was 14. The groom died eight months later, "a victim of connubiality." Serial monogamy is by no means rare and it is quite usual to find women in their forties who have been married 10 times or more. The novelist Robin Maugham, who visited Siiwa in 1947, mentions a girl of 25 who had been divorced 19 times.

The practise of pederasty — including pederastic marriages and pederastic prostitution — has been reported from a number of sources. Some of the descriptions were reported by travelers who were not professional anthropologists and might therefore have inflated the facts. But even so we may assume homosexual behavior was and is very common and accepted socially.

According to Robin Maugham, the passion of men for boys is greater than for women and fatal triangles are almost invariably homosexual: "They will kill each other for a boy. Never for a woman."

Boy marriage was practised until at least 1926, when a high Egyptian official escorting an English tourist was scandalized to find that an elaborate wedding celebration was in honor of a man and a boy. An imaam (a Muslim holy man) was sent to help the Siiwans mend their ways, but according to Robin Maugham, two years later this same imaam married a boy.

The boys are between the ages of 12 and 18 (they start to marry heterosexually at about 17). The dominant sexual practise seems to be anal foration (sodomy). In many instances it is the boy who is the active partner, which goes against the practise in other societies where pederasty is institutionalized.

Boys are rented out for the night for 5 or 10 piasters (less than 35
cents or 20p). Prominent men lend their sons to each other, and these
love affairs are common knowledge among all local Siiwans.

The last distinctively Siiwan aspect of sexuality that is strikingly at
variance with Islamic rules is the public orgy at functions at least
partially as a religious rite. These orgies are said to involve both
heterosexual and homosexual acts. Their history is not clear, but they
may go back to rituals performed at the oracular temple. The historian
Quintus Curtius Rufus says in his life of Alexander the Great that a
statue of the god Amun was carried in procession by 80 priests "behind
which followed a train of matrons and virgins singing uncouth hymns
after the manner of the country."

Remnants of the sex cults persisted for a long time in various
cultures. Among the Israelites, for example, sacred prostitutes probably
existed as late as 608 BC, and in pre-Muslim communities much later.
The ancient Near East tolerated or even enjoined a variety of sexual
practises.

Out of this setting arose several important religious traditions, which
have survived to this day. One of these, Zoroastrianism, developed
among the Persians about 600 BC. Without going into the details of the
religion — which posits a battle between the forces of light and darkness
— we can characterize the sexual code associated with it as apparently
something new: a restricted sexual life was regarded as one aspect of the
good life and a necessity for salvation. Marriage was for reproduction
only, sexual acts that did not lead to procreation were condemned and
homosexual acts were considered more serious than homicide. Nocturnal
emissions were also regarded as offenses (not good luck, as earlier).

Some Zoroastrians had many wives and even practised wife-sharing,
but generally polygamy was condemned, as were adultery and the
frequenting of prostitutes. But prostitutes had a kind of patron: Jeh, the
demonness of menstruation and the primal whore.

An extraordinary social feature associated with Zoroastrianism is
marriage with close relatives. The Parsis (modern Zoroastrians) take this
to mean marriage between first cousins, but scholars tend to accept the
interpretation that such marriages were between brother and sister,
father and daughter and even mother and son. The Greek writer Philo
maintained that the children of a mother-son marriage were considered
particularly well born. A number of other authors (including Strabo and
Plutarch) wrote that the Persians married their mothers, daughters and

sisters. The custom continued as late as the Sassanian dynasty but was extinct by the fifteenth century AD.

Certain elements of Zoroastrianism may have influenced the Judaeo-Christiano-Islamic continuum that eventually came to dominate the Middle East.

Sexual customs

In some instances, the Hebrew tradition is known to have turned away from an earlier pattern reminiscent of either ancient sex-cult religions or of Zoroastrianism. Of these elements we can include half-brother/half-sister marriage. Evidence suggests that marriage between paternal half-siblings was legal in ancient Israel at least until the tenth century BC.

This type of marriage seems to have been a general Near Eastern custom, found among the ancient Egyptians and Phoenicians as well as the Persians. Among pre-Islamic Arabs, it was legal for a man to marry his half-sister, and even his daughter or daughter-in-law. The Bible itself does not explicitly forbid father-daughter marriage though it does forbid mother-son marriage.

Quite possibly the ancient Hebrews practised another custom they later dropped — sex hospitality. The story of Lot before the fall of Sodom offering the men of the town his virgin daughters (Genesis 19:8) is paralleled in the tale of the town of Gibeah (Judges 19:21), where a virtually identical incident takes place. Raphael Patai has suggested that only a tradition of sex hospitality could make sense of two such incidents. (However, some scholars believe that the story of Sodom was actually copied from that in Judges.) The custom has been widely reported in the Middle East, from the Berbers in northwest Africa to the people of Baluchistan.

Both of these customs have been condemned in general by the Orthodox Judaïc and Islamic teachings.

The only vestige of ancient Near Eastern sex cults that has arguably survived in the later monotheistic religions is the *metsitsah*. This is part of the Jewish circumcision ritual which refers to the sucking of a drop of blood from the penis of a newly circumcised infant. The usual explanation for it is hygiene. The Talmud, for example, says: "If a surgeon does not suck the wound caused by circumcision, it is dangerous and he is dismissed" (Gemara 133d). The custom, however, may date from the Middle Ages and not be truly ancient.

If we look at the history of traditional Jews and Muslims, as well as of the Samaritans (who broke off from the Jews about the fourth century

BC and who preserve many ancient customs long since abandoned by the Jews), several themes can be seen to pervade their approaches to sexuality. On the whole, I shall not discuss Christian groups here because they depart most from these shared themes and I will deal with them in a later chapter. Furthermore, I am not now talking about highly urbanized, westernized, secularized groups such as the élite of Cairo, Tehran, Istanbul or Tel-Aviv.

One of the general themes of Middle Eastern morality is modesty. This includes a prohibition on the public display of affection between men and women, even when married. On the other hand, it does not prohibit men from holding hands in public — actually quite a common sight, without homosexual overtones. Covering the body is another aspect of modesty. Some Muslim commentators insist that even in a medical examination, neither a man nor a woman should look directly at the genitals of a patient but must use a mirror, except in cases of absolute necessity. According to the Talmud, a female nurse may tend a man even if she might have to see his genitals, but a male nurse may not tend a woman in the same circumstances. In everyday life, Muslim women must cover their whole bodies and often even their faces in public. Although hiding the face was never adopted by Samaritans or Jews, there is nevertheless great concern about covering the head and hiding the hair — which among some European Jews evolved into the custom of married women wearing wigs (often shaving off their own hair as well). Nudity in all groups is suspect and public nudity almost always forbidden, although there have been exceptions. For example, the Haqqa, a radically deviant Islamic sect in Kurdistan, is said to have required that men and women (along with dogs!) bathe together naked in the basin of a mosque.

Another characteristic of Samaritans, Jews and Muslims is the general opposition to celibacy: it has been tolerated by only a very few groups, such as the Jewish Essenes and some of the Sufi sects of Islam (particularly the Bektaashiiyah of Turkey). On the other hand, sects that have played up sexual license are also few and far between; they include the Jewish Shabbetaians, who believed in the "sacredness of sin" and thought sexual excesses would hasten the coming of the Messiah.

All the groups (including Koptic and Ethiopian Christians) practise male circumcision. Some Muslims, the Falashas (the black Jews of Ethiopia) and Ethiopian Christians practise various forms of female circumcision. A few Muslim groups also practise infibulation.

Sexual secretions are considered unclean among all the groups. A ritual washing is required after menstruation and nocturnal emissions. It is also required after sexual intercourse: in one part of the Muslim marriage rite the bridegroom is told to "marry the bride and make her wash."

The control by men of the sexuality of women is an overriding theme that shows up in various ways.

One of these ways is stress on the virginity of brides. Tokens of virginity are frequently required and some groups insist on public or near-public deflowering. In the Orthodox Jewish wedding ceremony a time is allotted for consummation, but it is not actually used for this purpose today — the bride and groom simply withdraw from their guests for a few minutes. Although the consequences of the test for virginity can be a calamity for the bride — death in some instances — the whole consummation business can be traumatic for the bridegroom as well: impotence is always disturbing but here becomes a public disgrace. Among the Fellahin of Egypt a religious man is called in to read to an impotent groom or to write out a charm that the unfortunate man must wear under his clothes.

Stressing the fidelity of wives is another important way of realizing the theme of male control of female sexuality in the Middle East. In all groups, adultery committed by a woman is a grave offense. Although the Koran says that the punishment for adultery, by a woman or a man, is public flogging of up to 100 strokes, in practise it is the woman who suffers most. In Saudi Arabia she is liable to be buried up to her waist in a pit and then stoned to death. Among Afghans both may be bound in sacks and carried out into a field to be stoned to death by outraged neighbors. Men, however, are allowed several wives and concubines.

Prostitution is native to the Middle East and of long standing. Although it is not forbidden, it is considered shameful. Muslim prostitutes sometimes wear conspicuous crosses and pretend to be Christian so that they will not be punished for fornication or adultery under Muslim law.

The Middle Eastern treatment of women can be related to a topic played up by sociobiologists: the concern for ensuring physical paternity. Bukhaarii, writing in the ninth century, mentions various kinds of marriages practised in pre-Islamic Arabia in which women were able to have several husbands; at least concern for physical paternity seemed not to play a role in them and a social father was designated either arbitrarily by the mother or by some specialist who was called in to

decide which man the child most resembled. But this is very foreign to the mainstream of Near Eastern and modern Middle Eastern society: practically all the societies in the Middle East, whether Muslim or not, trace descent through men.

Male dominance in the Middle East has become associated with the public separation of men and women (purdah), symbolized in the custom of veiling. The rationale for this separation is the belief that women are a threat to men through their disruptive sexuality. The custom varies considerably throughout the Muslim world, however. Tuareg women go unveiled but the men are veiled. Sometimes it is a matter of social standing, as among the Kanuri and Hausa of West Africa, where only upper-class women observe purdah. Elsewhere, it may be part of urban as opposed to rural custom. The Dard of Afghanistan do not practise the usual seclusion of women, but in more remote areas, where Islam has not penetrated so deeply, a different kind of seclusion is the rule: the sexes are kept strictly apart from May until September. Reports seem to suggest that sexual intercourse is forbidden at this time even between husband and wife. Any detected attempt to break this tabu is punished with a fine.

It seems clear that the practise of monogamy among European Jews (which has become part of Israeli law) was influenced by the large Christian society in which these Jews found themselves. The Torah specifies no limitation on the number of wives a man may have, and the Talmud admits the legitimacy of four wives at one time — the orthodox Muslim practise. Furthermore, Jews living in Muslim countries sometimes have more than one wife. On the other hand, Muslim modernists have argued that it cannot be truly lawful for a man to have more than one wife because even though the Koran seems to permit as many as four wives at a time, it specifically states that all of them must be treated equally. And in another passage it declares that "...you will not be able to be equitable among your wives, no matter how much you desire it" (Suura Al-Nisaa' 4:129).

It is not so easy to trace the general development of all such customs. Consider, for example, the rules concerning incest.

Milk incest

The Koran forbids marriage not only between blood relatives but also "milk relatives": a man and his wetnurse, or a man and woman who have been breast-fed by the same woman. In some interpretations this tabu

is extended to mean that a man may not marry the wetnurse who breast-fed his present wife.

Among the Dard of Afghanistan, milk regulations have proliferated. If a man drinks milk with a woman it means that she has become a milk relative and that they cannot marry. In some instances milk adoption is practised: a man places his lips upon a woman's breast in the presence of the ruler or vizier, and from that time on the woman is regarded as the man's foster-mother. Such adoption takes place when a woman dreams she has adopted the man, or when the man dreams he has been adopted by the woman. A jealous husband may also force adoption on his wife of any man suspected of being her lover.

The distribution of these milk incest rules throughout the world is not clear at present. Among the non-Muslim Mende of West Africa, a man may not marry any woman who has suckled him. This may be Muslim influence, however, since a number of Mende are now Muslim or have come into contact with Muslims. The prohibition on marriage between two people who have been breast-fed by the same woman is found also in some Christian groups, notably the Kopts of Egypt and Ethiopia, and Eastern Orthodox groups. A Muslim influence cannot be ruled out for at least some of these groups. What seems most likely is that it is an ancient Near Eastern trait. It is true that Samaritans and Jews do not recognize the tabu — but I suggest that they have lost the custom. Raphael Patai is probably right when he suggests that a milk-incest tabu existed among the ancient Hebrews, though there is no biblical reference to it.

Temporary marriage

A temporary marriage *(mut‘a)* involves a contract for a specific time — sometimes only a night, three days, or some other very short period of time. The contract may even specify the kinds of sexual acts that may be performed. Although there is some Koranic justification of this custom, today most Muslims reject it as a kind of prostitution, but it is recognized by Shi'as (who live predominantly in Iran and parts of Iraq). Temporary marriage has never been recognized for married women whose husbands are away.

Although most scholars do not agree, some have suggested that temporary marriage is recognized in the Torah and that the Hebrew term *shipxaah* refers to a temporary wife.

To my knowledge the Amhara of Ethiopia, a Christian group, is the only other society since ancient Egypt to institutionalize temporary

marriage. It is highly improbable that the Ethiopian Christian and the (Iranian) Muslim customs are unrelated: both probably represent a continuation of pre-Muslim Semitic customs. Bukhaarii mentions that temporary marriage was known in pre-Islamic Arabia.

So far I have discussed what has or has not been permitted by moral codes. When the evidence for actual behavior is examined it becomes clear that people often disregard and depart from these regulations.

Orthodox Jews and religious Muslims believe that the only truly legitimate sexual acts are between married couples; but a questionnaire answered by 269 rural Moroccan youths in 1969 showed that 14 percent practised masturbation or had contacts with animals; 20 percent practised homosexual acts; and 34 percent went to a brothel as often as they could afford.

A Muslim is encouraged to combat all desire for illicit intercourse, and one of the ways is to have sex with his wife as often as necessary. Similarly, Jews believe that to prevent sexual fantasies from distracting him, a young religious scholar should marry early. In Islam, the need to protect a man from adultery is so great that even if his wife is menstruating (a time of pollution during which intercourse is discouraged) a man may nevertheless approach her. Al-Ghazaalii, an important Muslim divine of the early Middle Ages, maintains that the menstruating wife can be asked to cover her body between the naval and the knee with a cloth and to masturbate her husband with her hands. Jews forbid contact altogether during the menstrual period.

Samaritans, Jews and Muslims are all opposed to celibacy — the former two on the grounds of the biblical commandment "be fruitful and multiply," the latter partly because the prophet Mohammed was married and partly because of a fear that a sexually frustrated person is dangerous to the community. There are religious legal requirements for the frequency of sexual relations. When a man has more than one wife, he is supposed to distribute his favors equally among his wives. According to the Talmud, each wife should have sexual intercourse with her husband at least once a month.

Jewish tradition even developed minimal frequency obligations associated with occupation. The Talmud (Ketubbot 5:6) lists the following frequencies: gentlemen of leisure, every night; sailors, once in six months; laborers working in their home town, twice a week, but once a week if they are working elsewhere; donkey drivers, once a week, but camel drivers, once a month; scholars, once a week, customarily on Friday night (unlike Samaritans, who forbid sex on the Sabbath).

But again, these are the religious requirements; we have no definite information about actual frequencies.

The stereotype of Middle Eastern sexuality is one of extreme licentiousness, but this is probably a consequence of being written up by monogamous and sexually repressed Westerners, who seldom provide any statistics. Harrison, for example, says that Arabs show an unusually high level of sexuality and that their emotional lives evolve around gratifying their sexual appetites.

Coïtal frequency.
Philby (1951) has reported stories told in the presence of the King of Saudi Arabia in the 1930's. A man called Sayyid Hamza was said to cap all the stories that had been told one evening by claiming that he regularly copulated at least once a night and not infrequently in the morning as well. At that time he had three wives (none of whom had ever met either of the others) and probable access to several slave girls in his three households. This hardly approaches satyriasis.

It is somewhat astonishing in the light of relatively detailed discussion of such matters in Jewish and Islamic treatises on religion, that there is such scarcity of information about sex techniques. The Human Relations Area Files produce almost no evidence for the whole of the Middle East. The Kanuri are said to find any intercourse position where the woman is above the man undesirable for social reasons. By the same logic — that social inferiors should not be physically higher than their superiors — they object to western-style buildings with many stories, unless an emir is in possession of the top floor while the lower floors house people of successively lower social positions.

Intercourse between the thighs (interfemoral foration) is reported for the Tuareg, apparently as a contraceptive technique. The Rif believe that if a man copulates in the direction of Mekka, any child that is produced will be blessed and have a face "shining like the sun and moon." (Al-Ghazaalii says however, that one should not copulate facing Mekka, out of respect.)

There are, it is true, several handbooks of eroticism, the most famous being *The perfumed garden*, written in the sixteenth century by Shaykh al-Nafzaawii of Tunisia, but in spite of this we have little information as to what is actually done.

Samaritans, Jews and Muslims in particular tend to have a certain latitude about sex techniques. For example, although masturbation is discouraged by all of them, some Muslims feel it is permitted in times

of sexual deprivation. It is never so regarded by Orthodox Jews, however, some of whom think it is the worst of all sexual offenses. For most Muslim married couples, various forms of fellation and foration are permitted — provided that the wife agrees. However, anal penetration is forbidden in Islam. A similar attitude is acceptable to those Jews who follow the views of Maimonides (1135-1204) on the subject — views probably influenced by Islamic thought (he did not sanction ejaculation outside the vagina, however). Other Jews (a minority at present within the Orthodox tradition) believe that only vaginal intercourse is acceptable.

Ritual abstinence
Samaritans tabu sex on every Friday night and Saturday of the year and also on seven other holidays. Jews do not require Sabbath abstinence and tabu sex on only two days of the year: Yom Kippur (the Day of Atonement) and Tisha-be-Av (the commemoration of the destruction of the Temple). Muslims forbid sexual intercourse during the daylight hours of the whole month of Ramadaan and also during the whole time of the pilgrimage to Mekka. For ritual and legal purposes, sexual intercourse has been strictly defined by Muslims and Jews: the glans of the penis must penetrate the vaginal opening. Among Muslims, to determine whether the fast has been broken, it is necessary to know how far the penis has entered: if it goes in only as far as the "circumcision ring" (the point at which the foreskin has been cut off), the fast has been broken even if ejaculation does not occur; if it goes in less deeply (and no ejaculation occurs) or if the man cannot determine for sure how deeply his penis has entered, the fast has not been broken.

During the American conflict with Iran after the overthrow of the Shah in 1978, a book purporting to be extracts from the writings of Ayatollah Khomeini was published. It caused some amusement and virtual disbelief because it dealt with such matters as what to do with a "sodomized" camel, that is, a camel anally penetrated by a man. Although only part of the book can be attributed to the Ayatollah, *The little green book* does, in fact, present traditional ritualistically correct views on this matter and similar issues. Westerners, however, should not find the work so bizarre, since the law relating to sodomized camels follows the biblical ruling but is actually less strict. According to both Jewish and Muslim regulations, sodomized animals must be killed and cannot be eaten, but the biblical ruling also states that "whosoever lieth with a beast shall surely be put to death" (Exodus 22:19).

Earlier Near Eastern laws were not so strict or so apparently consistent about sexual contacts with animals as the Torah or Muslim codes. In the Hittite code (probably from the thirteenth century BC) a man must be killed if he sins sexually with a cow, sheep, pig or dog. There is no punishment if he sins with a horse or a mule, though he may not appear in the king's presence and is not allowed to become a priest. In the Talmud, the nonoccurrence of bestiality seems to be proclaimed in the assertion that "a Jew is not to be suspected of pederasty or bestiality" (Qiddushin 82a); on the other hand, a widow is forbidden to keep a pet dog on the principle that "Caesar's wife must be above suspicion."

Among the Muslim Rwala, sexual contact with animals is said never to occur because it is punishable by death, but in fact the threat of a death penalty has never eradicated forbidden sexual acts from any society. Rif boys are known to forate ("sodomize") she-asses in the belief that it will enlarge their penes (some also dip their penes into a heap of fresh donkey dung for the same purpose).

In spite of the Muslim rule against all sex with animals, an interesting distinction has been reported from Turkey, where some people regard it as sinful only when it involves animals that are eaten, such as cattle or sheep (a rule reminiscent of the Hittite code). Like the Rif, Turks believe that sex with donkeys makes the penis grow large.

Homosexuality
Zoroastrians, Samaritans, Jews and Muslims specifically condemn homosexual acts. With regard to Islam, it should be noted that no specific punishment for homosexual acts is contained in the Koran. Some commentators have therefore assumed that homosexuality is only a minor infraction. What seems to be the case is that there is a very complicated interplay of Islamic views and folk notions, which blend but sometimes also contrast with actual practise.

One of the problems is that Middle East folk notions about homosexuality distinguish sharply between active and passive roles. For a male to play the active, inserting role with another male is generally not thought of as homosexuality at all, yet it is shameful for a male to play the passive role as a vagina substitute. Throughout the Middle East, words for a passive homosexual are serious insults. Studies of psychological problems among males in Turkey and Algeria disclosed a great fear of retreating into passive homosexuality. The process of becoming an adult male is seen as putting aside the boy's female passive

role — whether sexual or social. In Turkey, teenage boys engage in verbal duels to trick opponents into acknowledging that they play a passive homosexual role.

With this background in mind, one should not be totally surprised with a report from 1985 — whether true or not — that a male Iranian student wearing western style clothes was raped by a group of young men dedicated to the Ayatollah Khomeini because he did not display politically correct enthusiasm during a demonstration. The Ayatollah himself would probably have condemned the form of the punishment. But some Muslim jurists of the Maalikii school of law apparently argue that the Koran authorizes such treatment of non-Muslims. However, as we have seen, Islam generally forbids all anal foration (intercourse) even between husband and wife.

There is very little evidence with regard to actual practise, in spite of literary references to Arab homosexual proclivities or the accounts of travelers from Richard Burton to André Gide, who described the accessibility of North African boys as astonishing. But when he writes of naked boys among the sand dunes, he is really depicting a kind of outdoor brothel. Pederastic prostitution has probably been cultivated in that area for centuries, mainly for European tourists; it cannot really count as evidence for the toleration of homosexual acts.

A certain amount of tolerated, perhaps even institutionalized homosexuality involving transvestism and prostitution can be found in many Muslim areas, including Oman and other countries on the east coast of Africa. Such transvestites are socially recognized and regularly entertain at weddings and on other social occasions.

The Mossí of Upper Volta used to observe a rule of not having sex with their wives on Fridays (the Muslim holy day), but the chiefs got round the prohibition by sleeping with their boy pages, who were dressed like women. These pages were between the ages of seven and 15 (or 10 and 20 according to another account).

Reports on homosexual activity elsewhere are often contradictory. For example Lhote, writing in 1944 about the Iklan Tuareg of the Sahara, says they practise pederasty "and other vices"; Blanguemon (1955) insists that among the Tuareg, both male and female homosexuality is unknown. Concerning the Rif of Morocco, Coon (1931) discusses markets where boys who had been kidnapped were sold either to become apprentice musicians or sex slaves used for foration, but Blanco Izaga (1975) says that homosexuality is nonexistent among the Rif.

Other comments found in the Human Relations Area Files are fairly brief. Of the Dard, it is said that Muslim influence stopped the tradition of men and women dancing together and introduced dancing boys, which, according to a commentator writing in the 1890's, brought "a worse evil." Information about female homosexuality is even less extensive. Lesbian activity is assumed to exist in the harem and, according to Oskar Baumann, among the heavily Arabicized peoples of East Africa involves use of ebony dildoes.

The most vivid description comes from Kuwait, where Dickson (1951) says that a sex-starved Arab woman will take a black woman as her lover. The black woman inevitably takes the male role and gets the Arab girl completely under her power. Whereas the Arab develops "a depraved and absorbing affection for the negress, [the negress] becomes an overbearing, jealous tyrant." This is not the level of description expected of a Kinsey-trained investigator — which Dickson decidedly is not.

Distinctive customs

The Islamic religion is so widespread that many local customs have been maintained that are sometimes at variance with orthodox teaching or not associated with Arab culture. For example, in a number of groups a man will sometimes keep more than four wives. Among the Kazakh of Central Asia, it seems that a man can have as many wives as he wants, given certain conditions. Sex hospitality, though originally found throughout the Middle East, is against Islamic precepts. Nevertheless, it is still found, or was until fairly recently, in a number of areas. Among the Dard and Burusho, in Hunza and in Hazara, a man is expected to place his wife at the disposal of a male guest. In Nager, a man considers himself honored if his wife attracts the attention of the thum (the local ruler). In the Caucasus, a kind of sex hospitality exists among the Akhvakh (Daghestanians): a guest might do anything he wants with a young girl, provided her hymen remains intact. (The same rule also applies to an unmarried girl's lovers.) In some groups, sex hospitality involved only slave girls.

The orthodox Islamic tabus concerning menstruating women occasionally seem to be ignored. Although Caucasian groups observe these tabus and even require that menstruating women go to live in special menstrual huts, the Burusho add a decidedly un-Islamic touch: at the end of her menstrual seclusion the woman, instead of performing the required ritual washing in water, washes in cow's urine (urine is by

definition impure and polluting in Islam and so is totally inappropriate). A Zoroastrian origin for this custom has been suggested.

The Caucasus has a number of distinctive customs. Among the Abkhazians, Cherkess and Ossetes, for example, a girl must wear a chastity corset, which is not to be removed by anyone except her husband on their wedding night.

An extraordinary report by Interiano maintains that at the funeral of a prominent person in the Caucasus, a girl of about 13 is placed on the skin of an ox that has just been killed. A robust young man must attempt to deflower her publicly. After several failures, the young man promises to marry her (or makes some other promises) and the girl usually consents to the deflowering.

Another peculiarity restricted to the Caucasus is the custom — still practised — of marrying a little boy to an adult woman. The boy's father is allowed to have intercourse with his son's wife until his son comes of age. Any children produced by the father belong to his son (or sometimes belong to both of them): the father is simply "raising seed" for his son, or helping to build up his son's house, just like the seed raiser found in many societies who helps impotent and elderly men. Seed raising is not permitted by Islam but is known to occur in Islamic groups, for example among Libyan Beduins. It is related to the custom of ghost marriage: the wife of a man who dies leaving no children will sleep with or marry another man, but the first child of this second union counts as the child of the dead man (a custom is sanctioned in the Bible).

An exceedingly rare if not unique custom is reported for the Burusho. The bridegroom's mother shares the bridal couple's bed, and actually sleeps between them until they feel ready to consummate the marriage. Apparently she is there to guide them through the difficulties of marital and sexual adjustment. It is possible that she may create more difficulties than she solves.

Whereas the Christian West tends to see civilization as a struggle against sexuality, the Middle East leans to the view that civilization is the product of satisfied sexuality. Muslims in particular believe that sexual delights on earth are a foretaste of the pleasures of Paradise. In this vein — at least for men — the Koran promises "...those who served Allah with sincerity
... For them awaits a bountiful repast...
Beside them large-eyed women, modest, chaste
Like pearls inset in jewelry." (Suura Al-Rahmaan 55:47,57,59.)

Figure 78 Japanese women considered attractive by traditional standards.

Figure 79 A Yóruba woman from Nigeria considered physically attractive by local standards.

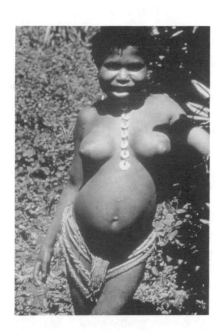

Figure 80 A Kapauku woman from New Guinea considered extrèmely attractive by local standards.

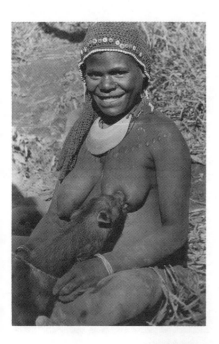

Figure 81 Huli woman from the New Guinea Highlands suckling a pig—a fairly common custom throughout the area, where pigs are highly regarded and women's breasts are not considered particularly erotic.

Figure 82 "Here she comes..." Finalists in the first beauty contest in the 20th century: the 1903 contest to select "The Most Perfectly Developed Woman in the World", sponsored by Bernarr Macfadden in association with his magazine *Physical culture*. Emma Newkirk (top, right) won but unlike her male counterpart did not make the front cover of the magazine.

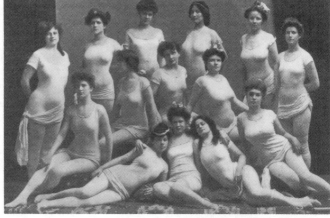

Figure 83 The recent fashion of female bodybuilding has challenged traditional notions of the ideal body for women. Anne Bolin, pictured here, an anthropologist studying the subculture of female bodybuilders through participant observation, has herself become a champion.

Figure 84 (right) The first physique contest winner in the 20th century, Albert Treloar, judged "The Most Perfectly Developed Man in the World" in a contest held at the original Madison Square Garden in New York the last week of December 1903, sponsored by Bernarr Macfadden.

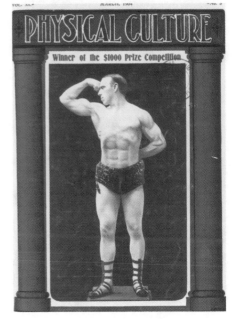

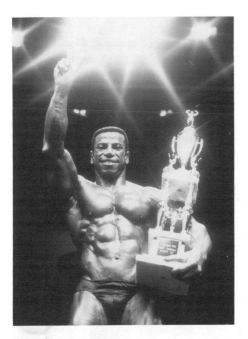

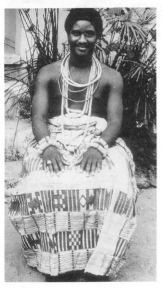

Figure 85 (left) In 1982, some 80 years after the first modern physique contest, Chris Dickerson won the title of Mr Olympia, having previously won numerous others (including Mr America and Mr Universe). The contests have become more numerous, the posing trunks much skimpier, over time.

Figure 86 (left) A Benin (West Africa) man considered physically attractive by local standards. The fact that he is also a prince doesn't hurt.

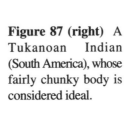

Figure 87 (right) A Tukanoan Indian (South America), whose fairly chunky body is considered ideal.

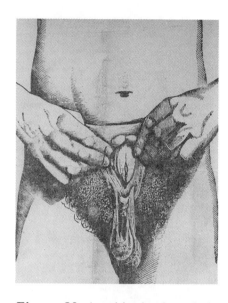

Figure 88 Farinelli (1705-1783)—real name, Carlo Broschi—perhaps the most famous castrato; said to have had great influence on Philip V of Spain.

Figure 89 A subincised penis in a 19th-century drawing.

Figure 90 Infant circumcision is traditional in the Kingdom of Benin, Nigeria.

Figure 91 Chinese eunuch.

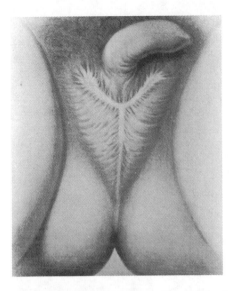

Figure 92 The "minor holy seal" of the Skoptsý (a 19th-century Russian religious group): surgical removal of the testicles.

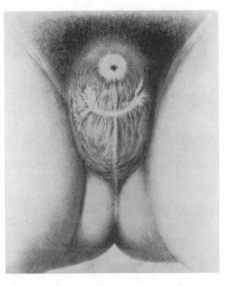

Figure 93 The "major holy seal" of the Skoptsý: removal of the testicles and the penis.

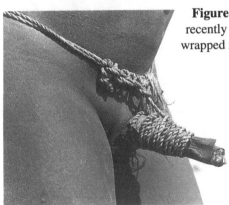

Figure 94 Close-up of West African boy recently circumcised, whose penis has been wrapped in a leaf held in place with string.

Figure 95 Circumcision as performed in ancient Egypt, about 2300 BC. The relief suggests that boys were circumcised in groups, as in many modern-day African societies. However, it is not clear how widespread the custom was.

Figure 96 A Skoptsý woman, 20 years old, with nipples surgically removed.

Figure 97 Founder of the modern nudist movement, Richard Ungewitter, c 1905.

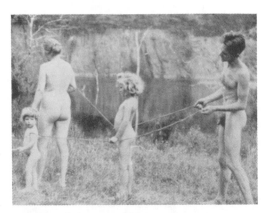

Figure 98 A European nudist family pre-World War II

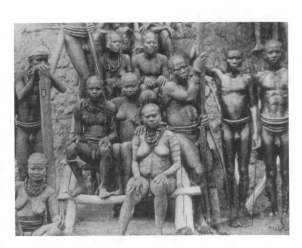

Figure 99 The Andamanese decorated their bodies with necklaces, body-paint and the like but otherwise went naked.

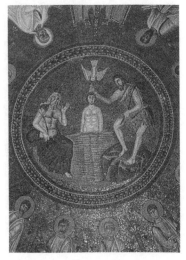

Figure 100 Jesus being baptized in the nude. A 6th-century mosaïc from the Arian baptistry in Ravenna, Italy. (A comparable mosaïc from nearly a century earlier is in the Orthodox baptistry.)

Figure 101 A lady of fashion at the French court at the end of the 16th century.

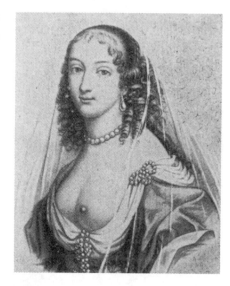

Figure 102 Good Catholic women from northwest Papua New Guinea, where the Church has decided that young women must go with tops but older women need not. Young men have developed a sexual interest in breasts which their fathers and grandfathers lacked.

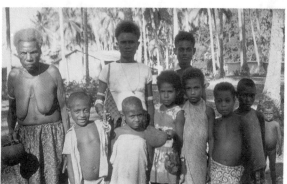

Figure 103 (below) New Guinea highlander decked out in ceremonial dress, with nose decoration, facial paint, feathers—and a modern badge.

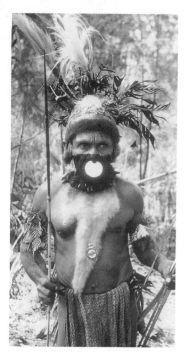

Figure 104 (left) A transvestite saint: Joan of Arc. The national heroine of France was condemned by an English-dominated church court in 1431 for heresy and transvestism and burnt at the stake.

Figure 105 Traditional Muslim women go veiled when they are not at home.

Figure 106 Muslim women in Zanzibar tend not to wear veils but cover themselves when they go out of doors with a *buibui*, basically a large shawl (like the *chador* in Iran).

Figure 107 (left) Sign forbidding immodest dress in a Roman Catholic church in Dubrovnik. Shorts and short sleeves are considered inappropriate even for visiting when a service is not being held.

Figure 108 Firedancer from Chambri, New Guinea, wearing ritual penis covering and body paint.

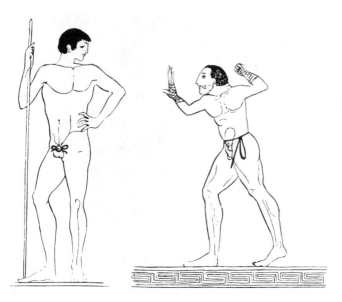

Figure 109
Ancient Greek athletes displaying foreskin tying using a leather thong or *kunodésma*, literally "dog leash".

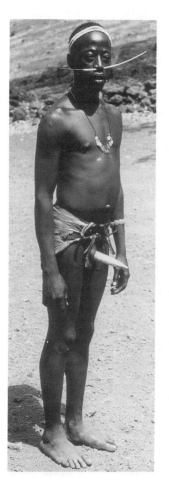

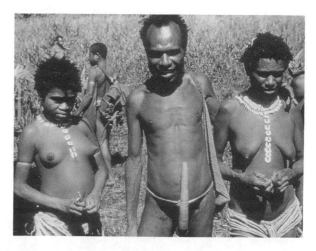

Figure 110 (above) Man wearing penis sheath flanked by his two wives—all in the traditional dress of the Kapauku of Irian Jaya, New Guinea. The man, by the way, is considered handsome by other Kapauku.

Figure 111 A Basari (West African) youth wearing a penis sheath, with a porcupine quill stuck through his nose. Penis sheaths of various kinds were formerly quite widespread in Africa and were occasionally worn by the ancient Libyans and Egyptians.

Figure 112 Virginity of the bride (but not of the groom) is important in many societies. A Chinese woodcut illustrates the display of the bloodstained bedsheet.

Figure 113 Part of the marriage ceremony in Benin, Nigeria: the eldest male member of the groom's family receives the bride (seated on his lap) on behalf of his family.

Figure 114 Polygamous marriage ceremony among Mormons in the 19th century. The Mormon Church no longer officially advocates polygamy (technically, polygyny) in any practical sense, but sees it as a spiritual ideal.

Figure 115
Samaritan wedding ceremony in Naablus (Shkhem), West Bank. The high priest is reading aloud the marriage contract (*ketuba*).

Figure 116 The Samaritan bridegroom, in dark suit and fez, at the reading of the marriage contract. The bride was not present.

Figure 117 Blessing of the marriage bed by a bishop, a mediaeval Christian custom.

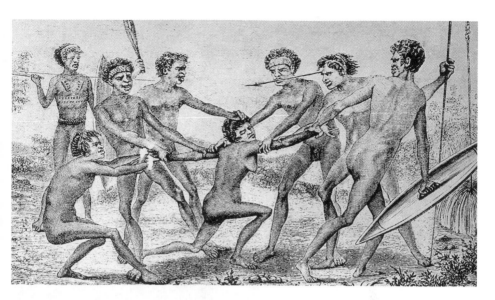

Figure 118 Bride capture was thought by some 19th-century anthropologists, notably J F McLennan (1827-1881) to have been a stage in the development of human social organization. Although some groups (such as the Tikopia) practise real kidnappings of this sort occasionally, the theory has been abandoned by sober anthropologists.

Figure 119 A 19th-century community of Shakers, separated according to sex, marching or dancing in concentric circles; some believe this behavior was an attempt to release sexual energies in a society that otherwise insisted on total chastity.

Figure 120 Edward Burnett Tylor (1832-1917), the first professional anthropologist, usually credited with formulating the alliance (or co-operation) theory to explain incest tabus, though Lord Bolingbroke (1678-1751) should probably be given the credit, or possibly even Lucretius (98-55 BC).

Figure 121 Edward (or Edvard) Westermarck (1862-1939), a Finnish historian of marriage, usually credited with formulating the early childhood aversion theory for incest tabus, but he seems to have got it originally from Havelock Ellis, who was struck by the fact that he was not sexually attracted to his own sisters.

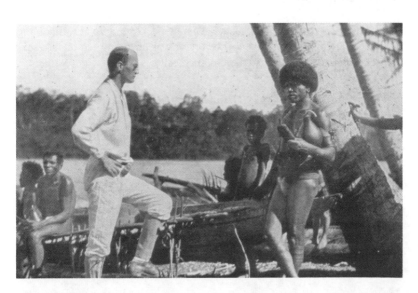

Figure 122 Bronislaw Malinowski (1884-1942) (left, in western clothes), famous for his fieldwork among the Trobriand Islanders. He believed that incest tabus were established to prevent psychological and social disruption within the nuclear family, a position proposed earlier by Lord Bolingbroke.

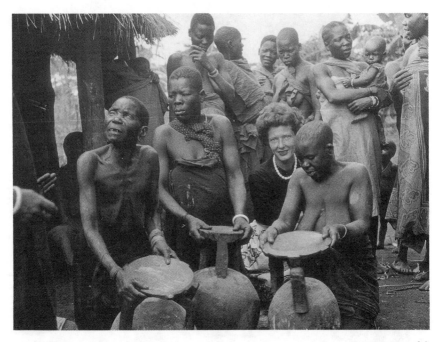

Figure 123 Mariam K Slater (center, right, wearing a black dress and faux pearls) among some Nyika women of Tanzania, asserts that most theories dealing with incest tabus do not explain their origin but rather why they continue once started. She suggests that in earlier times the possibility of incestuous marriage was virtually nil.

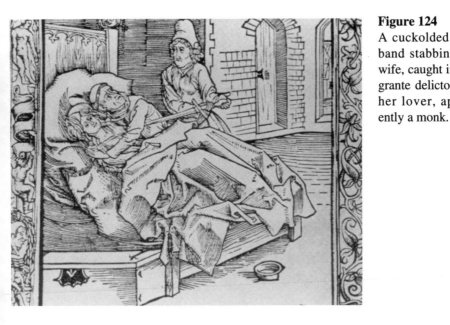

Figure 124
A cuckolded husband stabbing his wife, caught in flagrante delicto with her lover, apparently a monk.

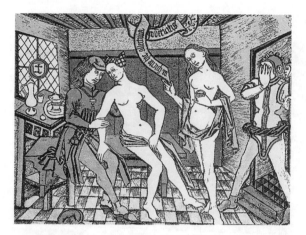

Figure 125 15th-century broth

Figure 126 Call Off Your C
Tired Ethics (COYOTE). T
emblem of a labor union f
prostitutes.

Figure 127 Early 20th-century Algerian prostitutes.

Figure 128 Hindu temple
dancer or bayadère (presum-
ably also a *devadaasii*).

Figure 129 Prostitutes in ancient Roman society were licensed and had to wear distinctive clothing. Here, one of the brothels (*lupānar*) of Pompeii.

Figure 130 Prostitutes in northern Nigeria sometimes became quite rich and decorated their houses with elaborate outer-wall painting, a style that eventually became fashionable among respectable people as well.

Figure 131 There really are lights in the windows. Scene from Amsterdam's enormous red-light district.

Figure 132 Christine Jorgensen former American soldier who underwent a sex-change operation Denmark in the early 1950's.

Figure 133 (below) The Eulenspiegel Society contingent in a Gay Pride parade.

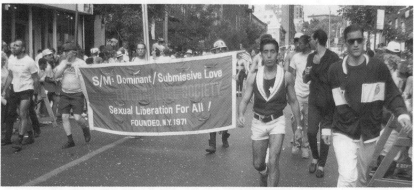

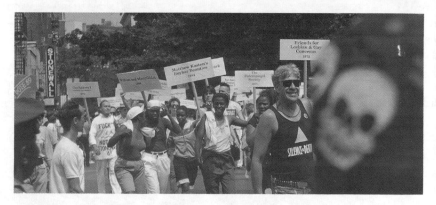

Figure 134 Part of a Gay Pride march commemorating the 20th anniversary of the Stonewall riots. The original Stonewall Inn sign can be seen on the left (it has since been taken down)

Figure 135 At an anti-abortion rally in Washington, DC.

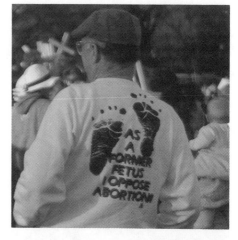

Figure 136 (below) Denmark became the first industrialized country to legalize gay marriages." Pictured here are some of the couples who participated in the first weddings, 1989 October 1.

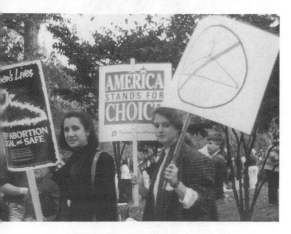

Figure 138 RU486, an abortion pill developed in 1980 in France, was permitted to be distributed in Great Britain in 1991 but as of 1992 was still forbidden in the U.S.A.

Figure 137 Women demonstrating at a pro-choice rally in Washington, D.C. The coat-hangers on the signs refer to a method of abortion, often lethal to a woman, common in the U.S. before the 1973 Supreme Court ruling.

Figure 139 Dr Marie C Stopes (1880-1958), one of the leaders of the birth-control movement in Great Britain. In 1921, she founded the first instructional clinic for contraception in the U.K. and had a profound influence on the Church of England, which by 1958 spoke of the moral obligation of family planning.

Figure 140 Margaret Sanger (188 1966), the leader of the birth contr movement in America. She opened t] first U.S. birth control clinic, in Brookly and became the first president of t] International Planned Parenthoe Federation in 1953.

Figure 141 Buttons associated with the Gay Liberation movement. The Greek letter lambda was chosen by early "gay libbers" because they believed it was a chemical symbol indicating a catalytic agent, hence an activist who would promote social change. Specifically lesbian movements also sported buttons.

Figure 142 Erotic art, particularly anything even remotely homoërotic, has become an intensely political issue in the U.S.A. since the late 1980's. Here, a photographic study by Joe Ziolkowski called "Precarious."

Figure 143 Shop specializing in erotic clothing, paraphernalia for leather fetishists and sadomasochists, as well as various other sex toys." Several other similar shops exist in New York as well as several other major cities in the U.S.A.

Figure 144 "Fone sex" ads for a variety of interests cover two full pages in a New York newspaper that is not otherwise geared to the sexually explicit.

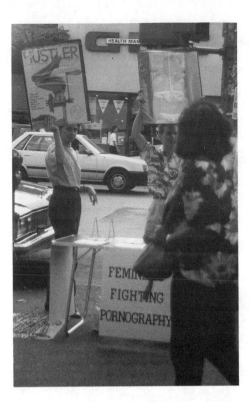

Figure 145 (left) Feminists against pornography presenting their case on a street corner in Manhattan.

Figure 146 (above) Poster for the opening of The International Museum of Erotic Art in San Francisco, 1973. The phallic rocket design was taken from a painting by German artist Alfred Beloch

Figure 147 Posters claiming U.S. government involvement in the creation and spread of AIDS were plastered on buildings and mailboxes all over New York City in the 1980's until the author was arrested.

THE TRUTH The U.S. gov't is waging economic war, military war (remember Philadelphia fire-bombing) and biological war –AIDS– against their own people! U.S. gov't created AIDS to intimidate, conservatize and regiment the masses!

AIDS IS GERM WARFARE BY THE U.S. GOV'T AGAINST GAYS & BLACKS!

AIDS is Not Spread by Sexual Intercourse Except Under Certain Conditions

Scientific evidence, including: 1. Irrefutable evidence that *AIDS Lentiviruses*, "LAV/HTLV-3" & "LAV-2", are genetically-engineered, man-made organisms (see below) 2. Deliberate U.S. government suppression of the most effective chemotherapies & immuno-augmentation methods which have been proven to keep people with AIDS alive 3. Blocking

Figure 149 (left) Lollipops in the form of sex organs, totally secular in purpose and more a joke than erotic.

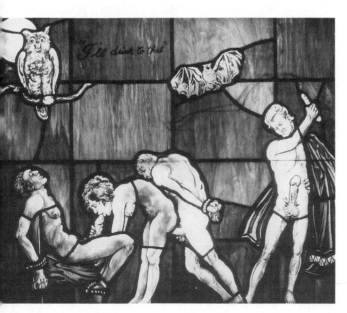

Figure 150 Even stain glass windows have been used to represent sexual scenes. This one may have been made about 1900 in Germany.

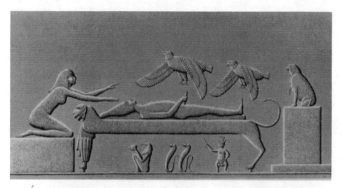

Figure 151 "I ha[ve]
played the part of a m[an]
though I am a woma[n]
The ancient Egypti[an]
goddess Isis in the fo[rm]
of a bird about to copul[ate]
with her dead but ith[yphallic]
phallic husband Osiris[.]

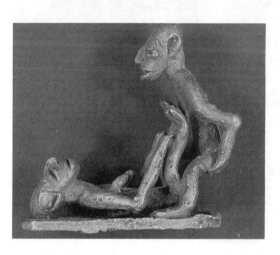

Figure 152 Erotic art for tourists. Today, repli-
cas of African gold weights play up non-traditional
themes and are manufactured for sale at airports.

Figure 153 Symbolic representati[on]
of a circumcised penis used for r[it]-
ual purposes. Burkina-Faso.

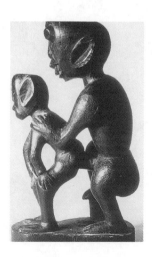

Figure 154 Stylized scene
of rear-entry intercourse or
foration.

Basically just head, legs and penis: an
nropomorphic goblet from Central Africa (Zaïre)
d in weddings.

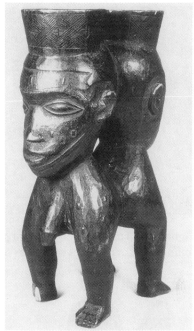

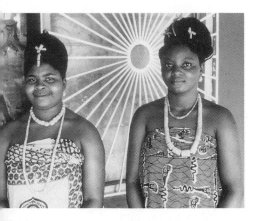

ure 156 Co-wives of a Benin nobleman.

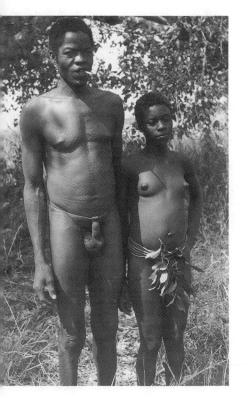

Figure 157 Lobi man
and wife from Burkina-
Faso in traditional dress,
which was uncommon
enough when the photo
was taken (1965) and
now has almost entirely
disappeared. Western
influence is nonetheless
visible even here (the
cigarette). Note the
elaborate scarification.
Foreskin tying has been
found not only in Africa
but also in South
America and Oceania.

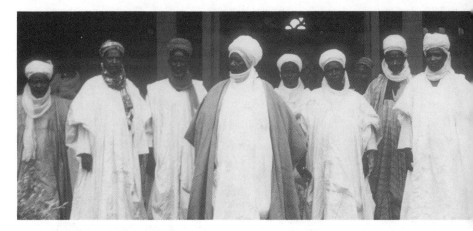

Figure 158 Traditional clothing for Muslim men in West Africa: the Sultan of Sokkoto an some of his court. Males as well as females should be modest.

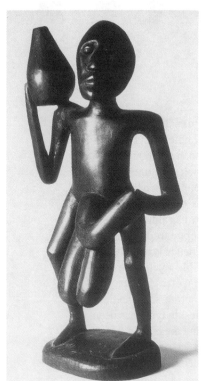

Figure 159 The left hand is, in many African and other cultures, the appropriate one for touching sex organs, as in this Makonde wooden figure.

Figure 160 The ancient Egyptian fertility go Min, shown in characteristic pose: ithyphall with right arm lifted. In statues, he is shown clutc ing his penis with his left hand, presumab masturbating.

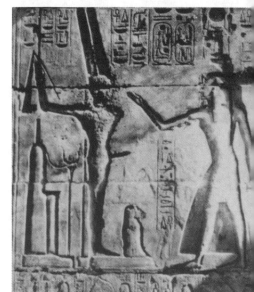

jure 161 Earliest known depiction of intercourse from Africa. A sandstone engraving from
l Issaghen, 8th millenium BC.

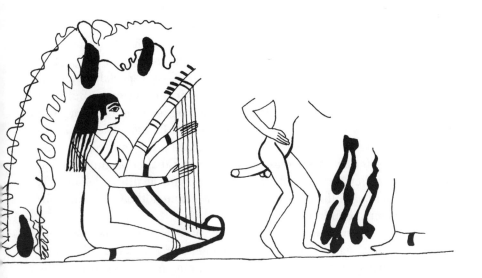

gure 162 Perhaps the earliest depiction of a sadomasochistic scene if, as has been sug-
sted, the male figure originally held a whip with several lashes. A leather hanging found
Deir el-Bahri, Upper Egypt, c 1500 BC.

FOURTEEN INDIA AND SOUTHERN ASIA

Sexuality has been regarded as divine in the high cultures of India and southeastern Asia. Yet nowhere has chastity been more honored than in India. Today, the paradox continues.

In one Hindu tradition, sexuality began when the god Shiva fell in love with the female aspect of himself. To celebrate his discovery, he composed 10,000 books on the subject. Shiva's servant Nandin reduced these to 1,000. Later scholars continued the condensation until we get to the distillation by Vaatsyaayana, which is the *Kaama suutra.*

At one point, a scholar called Baabhravya is described as editing this divine manuscript into a manageable sex encyclopaedia. He delegated the various chapters to a number of scholars, the most notable of whom was Dattaka, entrusted with the section on prostitutes. It is said that Dattaka lived among the prostitutes of Paataliputra and they commissioned him to write a textbook for novice whores.

The *Kaama suutra* is supposed be a distillation of Baabhravya's compilation. It has, in any event, the cool, unromantic air of an academic treatise reminiscent of an encyclopaedia.

It is not surprising that in an area where such erotic manuals developed, in part sanctioned by religion, sects arose that taught that sexual intercourse (and sometimes even adultery — or especially adultery) is an act of the utmost piety leading to a mystical experience. But what may be surprising is the fact that this is also the area where celibacy was first considered a virtue — a doctrine refined by Buddhists and Jains in the fifth century BC. Furthermore, Hindus place great value on chastity — in men — for two basic reasons: the fear of ritual contamination and the certainty that semen is the basis of strength, health and long life. Letting semen leave the body is always detrimental, although justified for the production of children.

Notions of ritual pollution and purity permeate everyday behavior in many south Asian countries. For example, many orthodox Hindus do not touch their mouth to a cup they are drinking from but will pour the water into the mouth so that the lips will not be defiled by contact with the drinker's own saliva.

The semen ejaculated in sexual intercourse pollutes both the man and the woman — but the woman more. The man's contamination is merely external: he can wash his genitals with water. But the woman cannot: her contamination is internal. This difference in pollution justifies a social practise: men may have sexual relations with women from a lower caste, but for a woman to have sex with a lower caste man is a crime since she cannot remove the added contamination. Thus a woman of higher caste would be expelled from her own caste for such an act.

Semen power
The second reason justifying abstinence is the superpower believed to be found in retained semen. It is widely believed that semen is stored in a special organ in the head. The person who does not lose his semen will become a superman. For this reason, medicines to prevent nocturnal emissions are common, and masturbation is frowned on — not so much as a sin but because it will sap the body of strength. This belief that semen is vital in maintaining and regaining bodily strength and prolonging life is an essentially Hindu doctrine but is also found among the Muslims of India and neighboring areas, as well as Buddhists (at least of Sri Lanka).

The practise of celibacy (*brahmacaarya* — here as elsewhere in Indian words, *c* is pronounced like the *ch* in *church*) is really abstinence to develop "semen power," a term actually used by Indian social scientists. Ascetics are believed to develop great powers both physical and psychic. These ideas have wide currency even among western educated peoples. A notable example is Mahatma Gandhi, who is said to have gone to extraordinary extremes to develop semen power. In later years, he would share his bed chastely with young girls. He did so with his 19-year-old grandniece because he believed that by in this way he could gain control over political events, including the riots brought on by the partition of Bengal. It is known too that Gandhi became very much upset because he spilt his semen in a train compartment when the train stopped at a railway station.

This great concern about semen among Hindus is reflected in the fact that some men do not use soap while bathing because it would rob the skin of oil necessary for the production of semen. Instead, oil is used. It is rubbed all over the body in the belief that it will eventually seep down to the sexual glands and nourish the semen.

In part, these notions about semen power come from the idea that semen is somehow a distillation of blood. The Sinhalese and other

groups throughout the area believe that one drop of semen is produced
from 80 drops of blood. This is, of course, not true: semen is not
derived from blood at all. But similar ideas have been held even by
western scientists in the nineteenth century.

Among some sects of Hindus, Jains and Buddhists, sexual intercourse
may be considered a significant spiritual rite, which permits in some
sense a mystical union with a god. But often the male worshiper is
cautioned not to ejaculate. Instead, he should draw the semen up the
spinal column by a technique of "nonspilling" (Sanskrit *askanda*),
represented in Hindu and Jain art by the *nicha medhra* "down penis"
(shown for example on the famous statue of the Jain saint Baahubali, the
Gommateshvara, at Sravana-Belgola in the Kamataka province in India).
In short, the worshiper is exhorted to develop what in the West would
be regarded as a sexual dysfunction: ejaculatory incompetence (or, more
euphemistically, retarded ejaculation). In part, the importance of
preserving or developing semen power explains this.

The Hindu, Buddhist and Jain traditions are exceedingly complicated
and constitute enormously varied approaches to sexuality. Certain
archeological finds in Harappaa, in Pakistan, a third millennium BC
civilization, suggest an early and probably pre-Hindu origin of present-
day Hindu phallic worship. At Harappaa were found various objects
resembling the modern *lingga* (or *linggam*) which modern Hindus revere
as a symbol of the god Shiva.

Phallic worship may not have been approved in early Hinduism but
was possibly borrowed from the non-Hindu native peoples by the Aryan
invaders. *Linggas* of various sizes are used in Hindu worship, and some
function specifically as dildoes. The real penis itself is sometimes the
object of veneration. In some contexts, the penis of a particular guru or
saintly ascetic may be touched or even kissed by his followers, especially
by women who want children.

Phallic worship is found in some Buddhist groups as well, as is
attested by the veneration of *lingga* in Sri Lanka. The *lingga* as a
religious motif has been reinterpreted by Nepalese Buddhists as the lotus
in which a certain Buddha (Aadi-Buddha) revealed himself. The mystical
phrase of *om mani padme hum* ("hail the jewel in the lotus") is probably
a reference to the divine copulation of the soul with the godhead. A
specific phallic cult is reported from Thailand, where the phallus is
worshiped and known under the name *phra sephaling*.

By about 2000 BC the historical form of Hinduism known as Vedism
developed, associated with the scriptures known as the *Rig veda*. At that

time monogamy seems to have been the only recognized form of marriage, although a younger brother may have had rights of access to his elder brother's wife and some scholars suggest that brothers might even have been able to marry the same woman. Moreover, women seem very much to have been in charge of their own sexuality: they were allowed to carry on love affairs before marriage, could choose their own husband, and were not forced to marry. By 1000 BC, the time of the scriptures known as the *Atharvaveda*, men were allowed several wives, and widow immolation was practised, although widows had the option to remarry.

From the *Mahaabhaarata*, one of the major Indian epics equivalent in some ways to the *Odyssey* and the *Iliad*, a number of other points can be inferred. It may have been compiled about 400 BC or as late as in 200, but basically refers to events that occurred around 1000 BC. Part of the epic deals with the life of five heroes, the Paandava brothers, who jointly married the same woman, Draupadii. This would seem to indicate that women were generally allowed to marry many men, although it may have counted as something special. Such a custom certainly did not exist in the later Hindu system. Furthermore, premarital sex is reported for women. Sex hospitality (with the host's wife) is also mentioned. A K Sur, maintaining that sex hospitality is nowhere practised in India today (not quite accurate), mentions two references to it in the *Mahaabhaarata*, including an incident involving the mother of one of the more important figures, Shvetaketu.

By 500 BC, two "purifications" of Hinduism developed, Buddhism and Jainism. Both kept such fundamental Hindu doctrines as reincarnation. But originally both religions emphasized an austere life-style and apparently encouraged celibacy. They were the first large-scale cultural movements that played up celibacy as a virtue. Quite possibly, this (in addition to a general tendency toward vegetarianism) was a response to food shortages and population pressures. In later times both relaxed their sexual rules, for lay people at any rate, and even monks and nuns were associated with rumors — and facts — of quite liberal sex behavior. When asked why the Buddhist nuns in the Lepcha area did not shave their heads, one woman laughed and laughed and eventually gave the reason: "Once a woman's head is shaved, it is no longer possible to sleep with a man." Nuns in other parts of the Buddhist world have sometimes even been characterized as plying prostitution.

Buddhist monks have often fared no better, although some areas are reputedly stricter than others. Their social reputations are similar to that

of Christian monks during the Middle Ages. Abel Rémusat, writing in 1875, maintained that in thirteenth century Cambodia (Kampuchea), Buddhist priests were obliged to deflower young girls before they married. In Bhutan, new monks and nuns are recruited either from the sons of a family who cannot share the same wife (traditionally only three brothers were allowed to share a wife) or from the illegitimate children of monks and nuns.

Incest and ritual laws
Buddhism has been fairly tolerant of a variety of sexual customs and has accommodated a number of marriage poems. It has also sanctioned royal incest, found among the Burmese, Cambodians and Thai. Among the Burmese, the king could marry his (presumably paternal) half-sister, although this was forbidden to all other people in the country, including royal princes.

Among the Cambodians, the king was placed above ordinary laws and could also marry his paternal half-sisters (and possibly also his maternal half-sisters, although this is not entirely clear). Other members of the royal family could do the same. The only marriage between siblings that was absolutely forbidden was with full sisters. On accession, a new king inherited the entire harem of his predecessor.

The Thai do not seem to have any clearly stated laws forbidding incest at all for any class of people, but only in the royal family was uncle-niece marriage practised, as well as marriage between paternal half-siblings. At the beginning of the twentieth century, King Paramindr Maha Culalongkorn married two of his half-sisters (his father had had 35 wives and sired at least 84 children).

By AD 100 the Hindu *Code of Manu* appeared, the first systematization of ritual laws. Some of these laws include the following punishments for sexual crimes: "A man who has committed a bestial crime, or a crime with a female, or has intercourse in water, or with a menstruating woman, shall subsist on cow urine, cow dung, milk, sour milk, clarified butter and a decoction of kusa grass, and fast for one day and one night." "He who has had sexual intercourse with sisters by the same mother, with the wives of a friend, or of a son, with unmarried girls, and with females of the lowest caste shall perform the penance prescribed for the violation of a guru's bed."

Now adultery with the wife of one's spiritual teacher, or guru, turns out to merit uniquely dreadful punishments. One punishment requires the evildoer to sit down on an iron plate that is glowing hot and cut off

his own penis. Another is similar: he is to clasp a metal statue of a woman that has been heated until it is red hot so that he dies in simulated lovemaking. Yet a third punishment: the culprit must cut off his own penis and testicles and walk holding them in his hands until he literally drops dead. The least gory of the options is that he give up his life on behalf of a Braahman.

In the same vein, Confucianism specifically forbids a student to marry the widow of his professor. Pierre de Gentile-Duquesne, writing in 1925, asserted the same rule existed among Buddhist Vietnamese.

Other legal codes spelling out Hindu sexual behavior were drawn up later. For example, fellation, according to the law commentator Mahaanir-vaangat, is to be punished with death. Other authorities talk of forbidden forms of sexual intercourse as the moral equivalent of murdering a Braahman, an exceedingly heinous crime.

There is so much variety within Hinduism, however, that no one code reflects some universally approved standard. Sexual acts such as fellation, that were condemned in the legal writings, actually appear in sculptures on the outside and inside of various Hindu temples. The most famous of these erotic sculptures are found in the surviving temples of Khajuraaho (built in 950 to 1050), and in particular the Sun temple of Konaarak from the thirteenth century. The tradition of erotic temple sculpture survives in Nepal, and there couples in various coïtal positions are regularly used as ornaments for carved gable brackets. In India the tradition has ended. Indeed, for many Indians the preservation of such sexual scenes in a sacred spot has been an embarrassment, perhaps as a legacy of Muslim rule and later of Victorian English domination.

It should be noted that some of the sexual scenes represented in Indian temples (though not in Nepalese ones) seem dictated by aesthetic considerations rather than the actual sexual behavior of the people. For example, couples are most frequently shown standing, even when copulating. Such a posture is presumably rarely practised by ordinary people (although standing positions are recognized in erotic handbooks).

The religious aspects of sexuality can be found in a number of areas, including the belief that intercourse with temple prostitutes is an act of devotion. At least one modern scholar, Michael Edwardes, has pointed out the economics involved in such devotional acts as well, and has suggested that erotic sculpture found on temples was done not exclusively out of piety but in a word, to entice to a business proposition. The Raajaraajeshvara temple in Thanjaavuur (Tanjore) employed some 400

sacred prostitutes *(devadaasis)* in the eleventh century and their earnings probably constituted an important source of income.

Temple priests themselves are involved in sexual acts with the laity because of the belief that they can cure barrenness in women. Some temples — Triupati in the Karnataka, for example — have priests particularly renowned for this. Childless women copulate with the priests believing them in some sense to be gods.

Yet another element is an approach that cuts the through theology and across religious boundaries: Tantrism. One of the doctrines of the Tantrik approach is that every act of sexual intercourse is a repetition of the primal sexual act, and is a mystical way of transcending material barriers of all kinds, including one's own sex. In one of the Tantras (Tantrik scriptures) called the *Niruttara-tantra,* even adultery is regarded as a necessary religious act: the worshiper will not gain merit in this life unless he unites sexually with a married woman. A doctrine of primal androgyny also pervades the Tantrik approach: a male seeks out a female, and the female a male, because they do not know that the opposite sex is lodged within their own being. To realize this fully is important for the future life. In some ways this doctrine resembles that attributed to Aristophanes in Plato's *Symposium,* where the first beings were imagined to be doublesexed and then split apart, but are forever seeking to reunite with their other selves.

The south Asian religious traditions are extremely varied in their approaches to sex and in some instances seem to reverse western morality and belief altogether. In particular, virginity for women is not approved and girls traditionally in Hindu society were to be married as early as possible, since each menstrual flow was thought of as an act of murder.

The traditions considered are associated with high cultures that have themselves evolved in historic times. Throughout the area there are various groups who have not capitulated to these high cultures, and at least some of them may have continued sexual practises and ideologies even more ancient.

Hunting and gathering societies

A few hunting and gathering cultures continue to exist, such as the Cencu (Chenchu), Andamanese, Vedda and Semáng, but descriptions of them are sadly lacking in information about sex.

Some authorities have said that both the Andamanese and Semáng employ no marriage ceremony. But a Semáng couple will eat together as a kind of ritual. When this act has taken place it is forbidden for them

to consummate their marriage on the same day. According to one informant it is always forbidden to have sex in the camp, and couples must go off to the jungle to copulate. Related groups such as the Negritoes of Grik do not observe this prohibition. All the Semáng prohibit sexual intercourse during the daytime, which is regarded as a great sin that has to be expiated with blood sacrifice.

As for the Andamanese, there is a kind of minimum marriage ritual: the husband takes "possession" of his wife in the presence of the rest of the group, but this is unlikely to mean public copulation.

As to tabus on sexual intercourse, the information available is minimal. The Andamanese forbid sex during menstruation. The Semáng regard obscene talk as on a level with adultery: both may be punished by death caused by lightning or by falling trees, brought down in a storm or by a flood. The expiation for these offenses is a blood sacrifice.

According to early accounts, Vedda men were allowed to marry their younger sisters, but this is apparently untrue. There is an aphrodisiac made from a ground-up orchid, the very name of which suggests disapproval of brother-sister incest: *nagamarrualla* "you who killed a sister." This name derives from a story told about a girl who tasted this aphrodisiac by accident and became sexually attracted to her brother, who killed her when she made amorous advances toward him.

Various assertions have been made about the Andamanese that are fairly idiosyncratic. Some British colonists believed that they practised rear-entry intercourse, a belief based on the assumption that women refuse to remove or even lift their pubic apron. While it is true that the women are very modest and will not renew these leaf aprons even in the presence of another woman, the assertion about rear entry appears to be false. A custom that is fairly rare cross-culturally had to do with the apron worn during a girl's first menstruation. Menstrual blood is exceptionally (from a world-wide perspective) thought of as an especially good thing, and the aprons of the first menstrual periods are worn later on by relatives of the girls because they are thought to ensure good health. Only a few other societies in the world have similar customs.

Menstruation is believed by the Andamanese to be the result of previous sexual contacts. The same belief has been attributed to the Lepcha of Sikkim; possibly early marriage and sexual intercourse were quite general throughout the whole of this area. Sexual intercourse during menstruation is forbidden by the Andamanese: if the tabu is not observed the girl's arms or legs will swell.

The most striking thing about Andamanese sexual behavior is the claim, by Cipriani Lidio, that homosexuality is rife among the men. He maintains that all the Andamanese have homosexual tendencies, and believes this is biologically rather than psychologically motivated.

This view is made less plausible with the sentence that follows his exposition, seemingly supplying some sort of causal factor: "... kissing is unknown; sexual excitement is aroused instead by nose-rubbing."

To my knowledge, no other theory relating to nose-rubbing, homosexuality and absence of kissing has ever been proposed.

Sex without feelings?

The societies that have been considered can perhaps be seen as representing ancient patterns, in a journalistic sense "living anachronisms." Living virtually side by side with these groups are others that exhibit the kind of sexuality described in such futuristic scenarios as, for instance, Aldous Huxley's *Brave new world*, where sexual fidelity is a sin, jealousy is a joke, and children are considered disturbed if they do not take part in school-run sex play.

No society on earth has all the characteristics of Huxley's vision, but two societies from this part of the world, the Múria of Madhya Pradesh, in India, and the Lepcha of Sikkim, have played up sex without emotional entanglements and fidelity.

The Múria are a subdivision of the Gond in central India. Like many neighboring groups they have what are known as dormitories or communal houses. But the Múria maintain a co-ed youth dormitory system in which premarital sex is actively encouraged.

There are two kinds of dormitories, or *ghotul*. One kind is called the *jodidaar*, or "yoking" *ghotul*, in which every boy and girl is paired off and required to be sexually faithful to each other. This may be the earlier of the two kinds. In the second, called the *mundi-badalna ghotul*, any lasting connection between a boy and girl is strictly forbidden. If a boy is discovered as having slept with the same girl for more than three days in a row, he is punished.

Not only is fidelity not rewarded, extraordinary improprieties can occur even from the Múria point of view. The basic problem comes from the lack of privacy.

For most of the year in the smaller *ghotuls*, boys and girls must sleep together in a small, smoky room. And this means that relatives may often perform sexually in front of each other — at least in each other's presence if the dark can count as a way of maintaining privacy. It is not

merely embarrassing but morally wrong for a boy to copulate in his sister's presence, and the other way round. Although this is avoided as much as possible, it nevertheless occurs. What is surprising is that incest apparently does not occur by accident in such situations.

In the *mundi-badalna ghotul*, lovers try to preserve decorum by waiting until the others are asleep, but often the place is so crowded that it is hard not to wake the others up. Although the Múria are acquainted with several positions for intercourse, the normal position practised in the *ghotul* appears to be merely a variant of the missionary position.

Few rules exist in the *ghotul* with regard to sexual behavior. In most *ghotuls*, no permission is needed from *ghotul* leaders to start a love affair or to engage in sexual intercourse at a particular time. No ceremony of sexual initiation is performed, and no formal act of defloration is practised. Boys wait until a girl starts menstruating before they approach her sexually and during her menstrual periods she is avoided as dangerous. With regard to sexual acts, there seem to be few restrictions, but rear-entry intercourse is generally regarded as improper. Homosexual acts are said not to occur in the *ghotul* and the Múria seem to lack homosexual interests. In the stricter *ghotuls*, the frequency of intercourse is regulated, so that a couple is not allowed to copulate more than two or three times a week.

In Binjhli, a couple is allowed to sleep together only on Fridays, but they may copulate every day outside the *ghotul*, and three times on Fridays. In most *ghotuls* copulation is allowed every day. Sometimes when a pregnancy occurs the rules become stricter, and *ghotul* leaders demand that couples ask and receive permission for intercourse.

In part, fears about pregnancy and illegitimacy are alleviated by a belief that having sex within the *ghotul* lessens the likelihood of conception. Perhaps this reflects an earlier view that sexual intercourse should not be performed in a house at all but in the jungle. The Múria do not believe this at present (if they ever did), but their close Gond cousins, the Hill Máriaa, traditionally consider it indecent to have intercourse in a house. They feel that a man and his wife should go into the jungle to make love. This view is dying out even among the Hill Máriaa themselves. This rule of outdoor copulation is strikingly at variance with the widespread African tabu. A number of other south Asian societies share the Máriaa notion, such as the Kadar of Cochin and the Semáng, as well as various New Guinea societies. The Santal of India copulate indoors as a rule, but sex in the jungle is a popular theme in folk songs.

That the Múria at one time observed the custom of outdoor copulation is suggested by a certain saying relating to impotence. It is taken as a matter of course that a woman will want to divorce an impotent husband, and this is tersely expressed in the phrase: "As soon as the penis weakens, the vagina runs to the forest."

The institution of the dormitory, particularly the men's house, is found in a number of other south Asian societies such as the Naaga, Mikir, Munda and Juaang. In New Guinea it is usually forbidden to bring women into the men's houses, but elsewhere similar dormitories seem to be associated with some degree of sexual license. Among the Kachin of Burma (Myanmar), the co-ed youth dormitory (called *blaw*) fits this pattern, as it does among the neighboring Brec. But another neighboring group, the Sgaw Karen, have only bachelor dormitories — the girls staying with their mothers. These dormitories follow the New Guinea pattern and are not associated with sexual freedom.

The Múria justification for the *ghotul* system is simply that sex is something good. One Múria stated it succinctly: "the penis and vagina are in a joking relationship to each other."

But there is further incentive to Múria sexual behavior, similar to but very different from Hindu beliefs. Both orthodox Hindus and the Múria believe that celibacy creates and stores up power. Whereas the Hindus see this as a virtue, the Múria fear it. Too much power may be built up; when released, it may turn out to be too powerful.

The Lepcha

The Lepcha, according to Geoffrey Gorer, seem to be almost cut off from passion. Sexual gratification is compared to food and drink; it does not matter who you get it from just as long as you get it. And once the day's work is done, the only things left to do are drinking and sex.

This down-playing of personal involvement also leads to a down-playing of physical attractiveness. There are features considered beautiful about individuals. Both women and men are considered good-looking if they have long hair, a straight nose, flat face and a straight body (ugly features include eyes too big or too small, pop eyes, dimples, buttocks that stick out and — on women — big breasts). But these criteria are said to play no role in deciding on a temporary partner. Gorer found that most of the men with young and pretty wives would also sleep on occasion with promiscuous, haggard old women. The invitations of these women were never, as far as Gorer could make out, refused. (It should be noted, however, that youth is not a criterion of attractiveness among

the Lepcha; many young men — in spite of the predictions of
sociobiologists — find older women more attractive, and no one found it
strange that a man would go to bed with a woman twice his age.)

There is little romance among the Lepcha. Courtship barely exists.
Techniques of seduction are minimal. Lovers neither kiss nor embrace
and the only kind of foreplay is for the man to fondle the woman's
breasts, but this occurs immediately before intercourse. Occasionally a
man may fondle a woman's breasts in public as a direct invitation to sex.
This is considered more funny than shameful. John Morris tells about
a boy who actually did so. The woman's reaction was simply to aim her
breast at him and squirt milk all over the boy.

Nakedness is not considered exciting or enticing. One or two men
admitted that looking at a woman's naked thighs turned them on, but
the great majority are not sexually stimulated by anything but
immediate anticipation of sex.

The Lepcha think it absurd to pay for sex. Native prostitution does
not exist, but some Tibetan prostitutes live in the neighborhood and of
the two Lepcha men who made use of these services, at least one
preferred them to Lepcha women. The Tibetan whores were at least
lively: Lepcha women reportedly lie completely motionless and relaxed
during coïtus. This would suggest that they do not experience orgasms,
but the Lepcha believe, however, that men and women enjoy sex equally
and there are some who say that women enjoy it more.

Marriage patterns of the area in general
The marriage patterns of the area tend toward de facto monogamy, even
in those groups where the religion is not theoretically opposed to a man's
having many wives, as among Hindus and Muslims. The Hindu Marriage
Act of 1951, undoubtedly influenced by British law, prohibited
polygamy among Hindus and also child marriage: girls had to be at least
15 (later, the age was raised to 16). In Pakistan and Bangladesh, Muslim
men seldom have more than one wife and the governments have fostered
the idea that Islam forbids polygamy in normal circumstances. Among
Muslim Maláys and neighboring Muslim groups, such as the Minangkabáu
of Sumatra, monogamy is preferred.

The *Ethnographic* atlas lists two societies for this general area that
permit a woman several husbands: the Sherpa and Toda, but a number
of others are known, including the Sabubn Semáng, Lanoh, Gandyan
Sinhalese, Pahaarii, Lepcha and Bhot (Bhutiya). Most groups permit only
brothers to share the same wife. Among the Sherpa, normally only two

brothers may marry the same woman; in the other groups more than two
may do so. In Bhutan, formerly the custom was for not more than three
brothers to share a wife, but in the 1960's, having more than one
husband was banned altogether.

A fairly unusual marriage custom sometimes referred to by the
Russian term *snoxácestvo* is reported from several south Indian groups in
Kérala. There, a small boy may be married to a mature woman, and the
bride's father-in-law functions as a "seed raiser," having regular sexual
relations with his daughter-in-law. Any children produced in this way
belong to the son. Among one of these groups, the Reddi, the boy-
husband may never actually consummate the marriage, even when he
grows up, but instead have an affair with the wife of some boy kinsman
of his own.

Among the Toda in the southern part of India, a woman may not
only have several husbands (usually brothers) but she may also have
several officially recognized lovers, just as a man may have several
concubines.

The great majority of societies in this area mentioned permit
premarital sex without any restrictions. Only nine insist on virginity of
the bride at marriage. Some Hindus believe that intercourse with a
bride whose hymen is unbroken is dangerous for the groom.
Consequently, some mothers practise "deep cleansing" on their very
young daughters which tears the girls' hymen.

Erotic handbooks and art
Erotic manuals are part of the cultural heritage of south Asia.
Sometimes the sexual techniques indicated in them are creative and
highly gymnastic, with little likelihood of being performed by any
significant number of people.

The *Kaama suutra* is, of course, the starting point of this handbook
tradition. Many derivatives and offshoots appeared in subsequent
centuries. An important work from the twelfth century is now widely
known as the *Koka shastra*, by Kokkoka. It differs in part from the
Kaama suutra because it reflects the stricter social norms of mediaeval
as opposed to ancient India. Whereas the *Kaama suutra* distinguishes a
code for marriage and a code for sex outside marriage, and is geared for
the Don Juan working within the second, the *Koka shastra* is geared for
the husband. Its purpose is to preserve marriage by reducing sexual
boredom: "The husband, by varying the enjoyment of his wife, may live

with her as with thirty-two different women, ever varying the enjoyment of her and rendering satiety impossible."

The *Anangga rangga*, a similar work, became important because its author, Kalyaanamalla, was employed by a Muslim nobleman. Through this connection the information in the book spread throughout the Islamic world, and the book itself was translated into Arabic and other languages spoken in countries under Muslim control.

In addition to this written tradition there is also that of the sculptured figures performing sexual acts on the walls of temples. The two traditions coincide, so that an enormously rich repertoire of sexual acts has been known for some time.

Sexual behavior and statistics

It should come as no particular surprise, however, that in spite of this potential variety the information we have about actual sexual activity suggests a very limited repertoire on the part of ordinary people. Part of the reason for this is that, unlike the women of the handbooks or the divine maidens of the temple sculptures, real women throughout the area are traditionally passive. Múria women, however, are described as aggressors and unique in India because they actually undo their own pubic cloth before coïtus. Otherwise, although women may be highly interested in sex and find sexual pleasure an absolute necessity in marriage, they are very unlikely even to move about much while copulating.

Kissing in the western sense is denied for the Andamanese, Santal, Thai and Vietnamese. Nose sniffing or rubbing is said to be practised instead. Kissing, however, is the rule in most of the area, even though for Hindus contact with saliva renders the act ritually contaminating.

With regard to coïtal positions, the little information available can be summarized as follows. Neither the Santal nor the Balinese use the missionary position; and the Balinese consider it impractical and clumsy. Both use a variant of the Oceanic position. The only description of Balinese coïtus says that the man kneels, the woman reclines. Santal copulation has been described more vividly: the man takes the lead by suggesting intercourse and he removes the woman's clothing. The man penetrates the woman immediately. The woman lies on her back with her thighs raised. The man squats on his toes between her thighs. Her legs are sometimes entwined on his back, and his hands might be on her shoulders or breasts. She raises her thighs even higher during the act

and shakes her hips when experiencing orgasm.

According to Prince Peter of Greece — himself an anthropologist — some of his Toda and Thandan (Kérala) informants said that other groups performed intercourse with the woman on top. There is no direct confirmation of this, however, and it was specifically denied by the Toda and Thandan themselves. The Thandan accused members of higher castes of doing so, but felt it undesirable because it "was not favorable to the procreation of warriors."

The most varied copulatory repertoire comes from the Múria. In a *ghotul*, they usually copulate using some form of the missionary position. But elsewhere more choices are possible, including the Oceanic position; both sitting and facing each other; and a variant of the missionary position in which the woman either raises or extends her legs. One of the aggressive traits attributed to Múria girls is that sometimes a girl will actually catch hold of a boy's penis, play with it, and put it between her thighs. This is not done as a substitute for real intercourse, but simply to entice the boy into real honest-to-goodness copulation.

Cunnilingus and fellation are shown on temple sculptures. The *Kaama suutra* devotes a whole chapter to fellation, called *auparishtaka* or *maukhyaa*. Vaatsyaayana says that in his time fellation was prevalent among the people of the eastern provinces of India. Richard Burton, in a footnote to his translation of the *Kaama suutra*, notes that an ancient Indian medical text, the *Shushrutaa* (perhaps 2,000 years old), describes as a cause of a particular disease the biting of the penis — not recommended in the sex manuals but suggestive of the likelihood that mouth-penis contacts were actually practised.

Information about frequency of sexual intercourse is available for only two societies in the area other than the Múria. Some Santals are said to copulate in the early part of their marriage as often as five times a day every day. After children appear on the scene, copulation goes down to a maximum of once or twice a day, with days missed.

The other society we have information about is that of the Lepcha. Gorer has suggested that because the Lepcha seem to be emotionally uninvolved with sex they can be quite prodigious in their potency. Men boast that when first married they copulated five or six times and even sometimes eight or nine times in a single night. But Gorer's 1938 assertions (and comparable statements made by John Morris) were seriously questioned by Mathias Hermanns in 1954. Hermanns says in effect that Gorer's whole picture of Lepcha sexuality involves unwarranted generalizations from a few oversexed men. (It should perhaps be noted that Hermanns is a Catholic priest.)

Sex tabus and rituals
Tabus on sexual intercourse are generally similar to those found elsewhere. A unique tabu is found among some Hindu groups who forbid copulation during certain phases of the moon: for example, the first night of the new moon and the night of the full moon. These days (as well as the fourteenth night and eighth night of each half of the month) are considered especially unlucky: evil spirits are about, particularly near trees and pools of water, as well as in graveyards and deserted houses. All these places are considered especially dangerous for sexual intercourse.

Sexual intercourse is forbidden to Hindus during a woman's menstrual period. Women take a ritual bath at the end of four days and are then sexually available. The Naayar specifically believe that a man who copulates with a menstruating woman is likely to become impotent. To my knowledge there is no group in south Asia that does not tabu intercourse during menstruation.

Although sexual acts are performed in many parts of the area as an aspect of religious devotion, ritual intercourse in the sense we have seen it for many African societies is rarely mentioned. The Lepcha practise a ritual intercourse that is very similar to some of the African customs. Three, seven or twenty-one days after the birth of a baby the father must copulate with his wife in a special way: rear entry, with the couple lying on their sides. The movements are to be slow and gentle; the purpose is that lubrication from the ejaculated semen should get rid of the pains of childbirth.

Homosexuality
Homosexual activity is said to be unknown to the Múria, even in prisons. It is also denied for the Santal and there is no clear evidence that Toda practise it. Homosexuality is a "meaningless concept" for the Lepcha, according to Gorer, although he does note that boys attempt a certain amount of mutual masturbation. Morris corroborates Gorer to a certain extent by saying that homosexuality is practically unknown. Morris adds that homosexuality is considered disgusting. Furthermore, although no specific word exists corresponding to "homosexual," the idea can be expressed with the astonishing phrase, "one who has eaten uncastrated pig." For a Lepcha man to eat such a pig would induce homosexuality.

From this end of the spectrum we can go to the other: Andamanese men, as we have seen, are described as being almost universally homosexual.

Generally in Hindu Indian culture, homosexual acts are usually considered defiling, but male transvestite sacred prostitutes have been reported from certain temples in the Bombay area. These men tend to be associated with the worship of particular goddesses, such as Ambabai and Yallamma, and are forbidden to marry. As early as 1792 to 1823 Dubois writes about men found in larger towns who wear their hair like women, pluck out their beards and affect the mannerisms of female prostitutes. Transvestite and castrated transsexual prostitutes called *hijraa* still exist (and have been discussed more fully in Chapter Six).

Pederasty was outlawed in an act passed in 1871, in which possession of boys for sexual purposes was condemned. All homosexual acts are now illegal in both India and Pakistan. These laws seem to be the result of British influence. But transvestism is not, as far as I know, similarly outlawed and sex with a *hijraa* is apparently not prosecuted.

Burmese and Karen homosexuality would seem to center on transvestism and effeminacy — the general pathic type. Harry Marshall, writing in 1922, said that he had known of some instances among the Karen where two men lived together as husband and wife, but adds that transvestite homosexuals seem to be less common among them than among the Burmese. Among the Burmese such men are called *mein ma sha* "womenhalf." Among other things, they wear face powder and jewelry like women. Although tolerated, they are said to be scorned. Rare in villages, they have tended to congregate in Rangoon, where they form a subculture. Folk belief explains their existence as punishment for having committed sexual sins in a previous life. The Burmese believe that there is a similar kind of person who had committed even more serious sexual sins. Such a person is said to undergo a complete physical sex transformation from month to month, so that he is alternately a man, then a woman, then a man again, and so on — a built-in switchable transsexual.

Homosexual guidebooks describe Malaysia as having fairly bisexual traditions and Thailand is highly recommended for its beautiful and accommodating young men. But a closer reading of the text suggests that these guides are dealing with prostitution geared to foreigners.

The general characteristics of male homosexuality in south Asia (female homosexuality is almost never mentioned in the literature) is that it usually involves transvestism to some degree, or less commonly pederasty, or a combination of the two. It is rarely described as being seriously condemned, although it may be regarded as undesirable. True homosexual marriages are not reported from any group in the area.

Paraphilias and other sexual interests
Native handbooks on sex technique suggest considerable interest in various degrees of sadomasochism. It is possible, according to the suggestion of Dr Alex Comfort, that the longest word ever created to describe a sexual talent may have reference to sadomasochism. This is the Sanskrit *premanibandhanaikanipunaa*, used to describe women of Andhra in the *Koka shastra*. Dr Comfort suggests it might conceivably be translated as "skilled in sexual bondage." But bondage is not known as an erotic theme in this area, as it is in Japan or the West.

The *Kaama suutra* has separate chapters on scratching, biting and hitting. It specifically says that the women of both Balhika and Malwa "are gained over by striking." In the Burton-Arbuthnot translation, a section is devoted to south Indian customs of "striking with instruments," but according to Alex Comfort the "instruments" refer not to real tools but to positions of the hand known technically as *mudras*. But even so, the consequences of their use can be lethal, as stories about ardent southern Indians attest. For example, the king of Cola embraced the fragile courtesan Citrasenaa so violently that he crushed her; in his passion he was unable to control himself and hit her on her chest with the "wedge" and killed her.

Information about animal contacts and masturbation is also rare. The Múria consider bestiality ludicrous, not repulsive, and label it a "crime of civilization." The Santal find animal contacts abhorrent, requiring a ceremonial purification.

Perhaps the most extensive information about masturbation is from the Télugu. Both boys and girls start masturbating at about six. The practise is condemned by adults. Lepcha boys practise a certain amount of mutual masturbation, but this ceases at adolescence.

This chapter started out with a paradox, by referring to the area as the homeland of chastity as a virtue even though sexuality itself was seen as divine. We may close by pointing out that at the present time India has been the country in the forefront of advocating population control — in a sense a continuation of the ancient virtue of chastity. Furthermore, even though the great masses of people in south Asia may be totally ignorant of the *Kaama suutra* and the erotic tradition of their own high culture, this tradition has spread to the West where it flourishes on many levels. The paradox continues.

FIFTEEN THE FAR EAST

The Far East has a very ancient and sophisticated tradition of erotic culture. But the modern threat of overpopulation is perhaps the most potent factor affecting sexual customs and ideologies.

Two distinctive themes in Far Eastern cultures seem also to be sexual "firsts" in the world: (1) the cultivation of sex handbooks; (2) concern about loss of semen and the development of techniques for delaying or preventing ejaculation.

At least eight Chinese sex manuals are known from the early Han dynasty (206 BC to AD 220). But they have not survived intact. It is possible that Indian manuals of even greater antiquity existed, but apart from a mythologized history of the *Kaama suutra* we have no knowledge of them. The Chinese books — known generally as *Fáng-zhōng* (Inside the bedchamber) or *Fáng-zhōng-shū (Art of the bedchamber)* — were closely associated with the second Far Eastern theme, which was stressed in Daoist (Taoist) philosophy: the need for the conservation of semen, especially during sexual intercourse. Like their south Asian neighbors, the Chinese believed in a version of semen power. Their version was couched in rarefied philosophical notions.

Yin and yang
The Chinese view builds on the doctrine of the opposition of cosmic forces: yin and yang. This opposition was accepted in several schools of thought. The opposition yin/yang permeates the universe and is realized in a number of ways: dark/bright, female/male, heart/stomach, outer body/inner body, moon/sun, earth/heaven. At birth, the body is filled with both principles. But yin tends to increase at the expense of yang. Death is caused by a serious imbalance between them. In both sexes, long life is achievable by retaining as much yang as possible.

In specifically sexual terms, yang can be identified with semen or seminal essence *(jīng)*. In sexual intercourse, if a man ejaculates, he would of course lose his *jīng,* thereby diminishing his yang. If he could prevent ejaculation, he would not only build up *jīng* but retain yang. The best thing for a man would be not to ejaculate but to enable the

woman to reach orgasm and give off her yin essence, which would strengthen the man. Conversely, the best thing for a woman would be not to reach orgasm (and so lose her yin essence) but to gain the man's yang. Abstinence is no good because it does nothing to increase yang and so leads to death.

Traditional Chinese stories about the success of Daoist sex control stress the great age attained by practitioners. The mythical Yellow Emperor, Huang-di, became immortal by having had Daoistically correct sex relations with 1,200 women. A woman, the Queen Mother of the West, was said to have duplicated the immortality of the Yellow Emperor by having gained the yin essence of more than 1,000 women in homosexual unions, and by taking the semen of numberless men who did not know the arts of the bedchamber, and therefore were not able to prevent the loss of their yang.

Early Daoism encouraged wife exchange and created liturgies of sexual rites organized down to the minutest detail. The Daoist Canon of the Ming includes the only record of these pre-Buddhist rituals, which took place in a special closed cell. After several mental exercises and prayers, couples would stand up face to face and intertwine fingers. At a certain point the officiating Dao master ordered the couples to undress and undo their hair after which the couples performed a great many complicated movements, involving genital touching. But penetration with ejaculation was legitimately not practised at all in this setting.

A number of heterodox schools of Daoism existed that took even more literally the need to conserve seminal essences. One practise of the School of the Master of the Three Peaks was to get young men and women together and gather up their sexual secretions, which were to be swallowed by the faithful.

Confucian and Buddhist approaches to sex
These Daoist practises came under attack from Confucian and Buddhist groups. Eventually the Daoists themselves chose reforms, and some sought to join together Confucian and Daoist principles into a single system. The ancient sex feasts, however, ended after the fifth and sixth centuries and more and more Daoists saw sexual control in figurative rather than in real terms. Daoism virtually retreated to monasteries organized along Buddhist principles. But Daoist teachings on sex have lingered, although virtually ignored by all except a few of the scholarly elite.

Much more important in shaping the practical approach to sex in the high cultures of the Far East was Confucianism. It was not only dominant in Chinese life for over 2,000 years, becoming the state orthodoxy as early as the emperor Wu (140-87 BC) in the Han dynasty, but it also spread to Korea, Vietnam and Japan.

Although much of Daoist thought was eventually incorporated into Confucianism, many Confucianists were opposed to Daoist sexual ideas. Confucianists generally held that love was a sentiment unworthy of a perfect gentleman, and that no decent man would show public affection for his wife. As for women, it was held by some at least that for a woman to make herself sexually attractive, even to her own husband, was a crime of the worst order. Sex itself was all right, but love and tenderness were suspect and physical displays of them were forbidden.

These are not just philosophical precepts observed largely in the breach, but they have had a deep-rooted standing in traditional Chinese society. Francis L K Hsu reports that in 1943 a young man, returning to his native Chinese village from westernized Hong Kong with his bride, was punished for walking hand in hand with his wife by furious villagers, who drenched them with human excrement. The same scene might possibly be played out again today.

Furthermore, with the tremendous emphasis on an orderly family life associated with Confucianist teachings, a strict segregation of the sexes was demanded throughout Chinese history. This was to ensure that women would enter marriage as virgins and remain faithful to their husbands. Sex segregation even came to include a tabu on hanging a husband's and a wife's clothing on the same clothes rack.

Such segregation of the sexes and concomitant prudishness increased during the period of the Mongol invasions and the establishment of the Yuan dynasty (1279-1368). Thus, the making of an erotic book was deemed to deserve 1,000 demerits. Nevertheless, one of the characteristics of the area is the development of erotic literature and art.

Buddhism first entered China about 2,000 years ago and did not originally require sex segregation, but in its Chinese form it blended with Confucianist customs and the social position of women was not high. Women, however, could enter Buddhist nunneries, permitting them a degree of independence not usual for respectable women elsewhere in China. Perhaps because of this departure from the general Chinese pattern of female subservience, nuns were often disapproved of and distrusted. It was common to accuse them of lesbian activities.

Chinese Buddhism codified a hierarchy of punishments for sexual sins in various hells in the hereafter. The worst sexual sin was raping a Buddhist saint.

Buddhism as well as Confucianism spread to Japan, where they contended with native Japanese religious beliefs ancestral to modern-day Shintoism. But Japanese society made profound compromises, so that we find most of the country following both Buddhist and Shinto practises. For example, nearly everyone gets married according to Shinto rituals and customs, but at funerals Buddhist ceremony wins out. Perhaps the predominance of Shinto marriage has something to do with the more obvious concern of Shintoism with fertility.

The native religions of the high cultures of the Far East are generally quite sex positive. Sex in itself is seen as good. There is nothing like the Christian idea of original sin.

Hunters and herders
There are hunters in the Far East, but only in extremely out-of-the-way areas — notably in parts of Siberia. Their lifestyle may represent a peculiar adaptation to a fairly harsh environment rather than a continuation of earlier customs possibly ancestral to those found in China, Japan or Korea.

The few hunters that exist are referred to by anthropologists as Paleosiberians and include the Ainu of northern Japan, and the Koryak, Kamchadál, Gilyak (or Nivkh), Chukchi and Yúkaghir of eastern Siberia. Some groups include both hunters and herders, such as the Chukchi and Koryak. Explicit information about these groups is practically nonexistent. Nicholas Seeland, writing in 1822, writes that Gilyak men and women seldom kiss, but they eat each other's lice, and "wash each other's faces with saliva."

One oddity is surely unique: the maritime Koryak custom whereby men "marry" stones instead of women. It is true that in many societies pseudo-marriages are contracted with trees (or belts, swords, rugs, etc.), but there is no evidence of any sexual interest in the tree. But the Koryak situation is somewhat different. The Koryak "husband" will put clothes on his stone, put it in his bed, and sometimes caress it as though it were a person. The Russian traveler Stepan Krasheninnikov in the middle of the 18th century was given two such stones by a man called Okerach; one of these stones Okerach referred to as his wife, and the other as his son.

Among the Chukchi, as many as 10 couples may participate in a kind of group marriage, and the men are called *newtumgit* "partners in wives." They share sexual rights to all the women. A special ritual is performed in making couples members of the group: as in an ordinary Chukchi marriage, this involves anointing each other with blood.

All the Paleosiberian groups permit a man more than one wife and so do most of the other peripheral groups.

Sex hospitality is widely practised. The Koryak are particularly incensed about having their hospitality refused. A man would be mortally offended if a guest turned down his wife or daughter and might even kill for such an insult.

Premarital virginity in girls is seldom valued. The Gilyak, in point of fact, value the pregnant bride, who has proved her fertility. Information about the Ainu is conflicting: one source denies it for girls, another affirms it; in the *Ethnographic atlas*, however, they are listed as permitting premarital sex quite freely, as are also the Chukchi and Yakút. But the Yakút have at least some interest in a girl's virginity; girls are required to wear what has been called a "chastity girdle." It is actually a kind of leather trousers tied securely round the girl with many leather straps. The girdle is supposed to be worn constantly — presumably until marriage. Possibly the use of such an article is related to similar chastity devices found in the Caucasus; but it is unique in the Far East.

Marriage and adultery

Kamchadál marriage ceremonies seem to consist of a sort of ritual copulation: all that must be done for the marriage to be legal is that the groom touch the girl's naked vulva with his hands (in one account he actually has to stick his fingers into her vulva). This is not as simple as it may sound because even though parents may give a man permission to marry their daughter, he must "capture" her — which often turns out to be more than a mere formality. All the women of the village protect the girl from him and she is specially dressed in several layers of clothing. The groom must find her when she is alone or else fight off other women at the same time that he tries to tear off the girl's clothes. If the girl wants him there are few problems. But one case has been reported of a man who tried to touch his promised wife's genitals for 10 years and was much the worse for wear, since she fought him off vigorously and left his head and body covered with bruises.

Many of these groups are much concerned about a wife's adultery, even though sexual arrangements seem fairly loose in general. During a difficult labor, the custom of the Samoyéd is for both the woman and her husband to confess sexual acts. In the man's case, this confession may uniquely include all the times he has had sex with female dogs and reindeer.

Although some Koryak practise sex hospitality, the nomadic Koryak do not, and a man will sometimes even kill his wife if she is suspected of adultery. To avoid any such lethal suspicions, women go to pains to look unattractive. Whereas sedentary Koryak women decorate their faces and wear fine clothing, their nomadic sisters never wash their faces or hands, and do not even comb their hair. They wear dirty, ragged, torn clothes when they go out (hidden underneath is their good clothing).

Sex-change shaamans
One last trait that is found in these Siberian cultures but absent in the high cultures of the Far East is the presence of transvestite medicine-men (or shaamans). Writers often refer to some of them as sex-change or transformed shaamans, but they do not really undergo any kind of transsexual operation. They are often thought of by natives as a third sex. Some may in fact be hermaphrodites.

Some of these transvestite shaamans marry other men, who are not themselves transvestites. Such homosexual marriages are reportedly as durable as any other. The shaaman plays the passive role, but he may also have mistresses in secret and father children by them.

Transvestite, "sex-change" female shaamans are also known among the Chukchi.

Among other Siberian peoples, homosexual marriage is not reported, but their shaamans are nevertheless associated with various degrees of transvestism.

Marriage patterns in general
Most of the societies in the Far East permit a man to have more than one wife. The high cultures of traditional China also permitted concubinage. Monogamy is found only among the Japanese, Koreans, Okinawans, Shantang and Ket.

Only one large group in the area permits a woman to have more than one husband: the Tibetans. Until the Chinese Communist takeover in 1959, the custom of having more than one husband was more prevalent here than in any other country in the world, and existed in a number of

varieties. The most common is for brothers to share one wife. It is seen as a way of keeping land within a family and not breaking it up into portions that would ultimately force males to leave home en masse.

The problems derived from having one woman shared by several men have been discussed by commentators. According to Prince Peter, in one marriage where five brothers were married to two women, the four older brothers became impotent because they were put off by the need to share wives. The younger brother was not, however, and he boasted that he was the one who had sired all the children of the family.

A very practical problem is that of privacy. Unlike most societies where men have many wives and the wives normally have their hut or at least a separate room, the co-husbands in a Tibetan family usually do not have separate accommodation.

Another aspect of Tibetan sexual life is the extraordinary number of men and women who have become monks and nuns and are theoretically supposed to live chaste lives. The estimate is that one-quarter of the entire population were members of monastic orders at the time of the Chinese annexation of the country.

Buddhism began as a monk-oriented religion. But the appeal of monasticism in Tibet probably comes not only from piety but out of economic necessity. Monks and nuns have had a very mixed reputation not only in Tibet but throughout the Far East. It is said that a Buddhist monk first brought a rubber dildoe from India via Tibet in the seventeenth century, which eventually was acquired by the Chinese Empress Wu-Ze-tien (1685-1704). Even earlier, in the thirteenth century, Tibetan monks were said to have introduced to Mongol emperors a kind of genital device referred to as a "goat's eyelid" or "happy ring." The device made use of goat's eyelashes, which were tied round the penis and served to stimulate the woman during coïtus.

Tibetan monks have developed a very lively reputation for homosexuality. Homosexual acts are theoretically condemned, even in — if not especially in — monasteries, but jokes about master-novice affairs are common. According to tradition, homosexuality in Japan started with the monk Kuukai (Kobo Daishi) after his return from China about AD 806. He is also credited with the invention of kana, one of the Japanese forms of writing.

In addition to this side of the monk's reputation there is also a heterosexual one. References to women who had straying lovers almost inevitably invoke images of the promiscuous monk; such a woman would be referred to as a *la-dud* "dragger away of a lama [monk]."

Tibetan Buddhism shows a variety of influences, including Tantrism, which began in India and spread to China. In China it declined, but revived under the Mongols (1280-1367) in a basically Tibetan form. The decline of the Mongols brought a similar decline in Tantrism.

Tibetan Tantrism sees sexual ecstasy as a metaphor for religious transcendence. Sexual union with another person is a way of lighting the spark of an individual's Buddha nature. Such a union is usually but not always thought of in literal physical terms. In intercourse of a transcendent sort, a male will realize his femaleness, a female her maleness. In an inauthentic sexual experience, this realization does not occur but merely the temporary quenching of a biological hunger. In Tantrik terms, "Buddhahood abides in the female organ": that is, in a male's experience of his own female nature (and vice versa).

Religious art in the Tantrik tradition often depicts sexual acts in many positions, but in Tibetan tradition these portrayals seem more symbolic than realistic.

In spite of the considerable interest that Tantrism and Tantrik approaches to sex have generated in the West, ordinary Tibetan sexuality seems to be little affected by it. With regard to the variety of positions for intercourse that Tantrik doctrine encourages, the everyday Tibetan seems to want none of it. Informants are reported to state with some feeling that the only appropriate position is with the man on top.

Erotic handbooks and art
The very first sex manual books from China have virtually disappeared, but the Japanese carried on the tradition and their versions have survived. *Ishinhoo* or *Ishimpoo (The essence of the medical prescription)*, by Tamba Yasuyori (912-995), a Chinese doctor living in Japan, lists about 30 coïtal positions. At least one, labeled the "dog of early autumn," seems to be utterly impossible: the lovers have to copulate back to back. Other positions were frequently named after animals, suggesting their movements, such as flying or swimming or running.

Because of Confucian prudery, however, the ancient tradition of erotic handbooks was not kept up to the same extent as in India.

A characteristic of both China and Japan is the development of an elaborate tradition of erotic art, even though this was against Confucian principles as well. This art was secular, unlike the temple erotica of India, and in the form of "pillow books" was in part used for the sex education of a newly married bride and groom. That these books were a source of titillation and not merely instruction seems clear.

According to Chinese tradition, erotic art was invented by Xiao-jing (Hsiao-ching) in the second century BC. He is credited with painting erotic murals on the walls of private houses. Certain themes of a fairly unusual sort appear in Far Eastern erotic art. One picture shows a woman hanging from a bamboo tree and sitting upon the erection of a naked reclining man; the woman apparently moves up and down with the swaying branch. Other pictures show the woman lifted above the ground and held by female attendants.

Sex in some sort of seated position is fairly common in Chinese erotica. According to Wu-shan Sheng, the earliest known Chinese erotic painting shows a naked man seated with his legs outstretched and his female partner sitting on top of his penis while she is embracing him. Copulation while seated on a swing is a fairly frequent theme.

Threesomes are common in these pictures. It is interesting to note that in the *Ishimpoo* coïtal positions, there are three that require a third person. Chinese erotica — quite unlike comparable Japanese material — has the peculiarity of showing women (otherwise frequently naked) with some sort of socks or slippers over their tiny deformed feet. This of course played up the national fetish for bound feet that was never borrowed by the Japanese or Mongolians or Tibetans.

The women of Yangzhou (Yangchow) were particularly famous for the beauty of their bound feet. The Chinese custom of foot binding was started at least as early as the seventh century AD and spread from aristocratic families quite far down in the social hierarchy. Even prostitutes who had not had their feet bound were at a disadvantage.

Japanese erotica emphasizes other physical details, more specifically pubic hair on both sexes and gigantic penes on men. The only other Far Eastern group that has been reported as having comparable interest is the Chukchi, where abundant pubic hair is regarded as a mark of beauty in a woman.

The other physical characteristic stressed in Japanese erotica, gigantic male genitals, is reflected not only in the actual sizes shown in the pictures but also in the content of scenes, which frequently depict penis contests of one sort or another.

Further peculiarities of Japanese erotica include very great interest in sexual gymnastics (almost but not quite as extreme as in Hindu representations) and human-animal contacts, often with very unlikely animals such as octopuses.

Sexual behavior, statistics, tabus and rituals

The actual sexual repertoire of Far Easterners seems to have little to do with either the handbook recommendations or the pictorial representations. But in some sense the high cultures of China, Japan and Korea were at least familiar with the possibility of several positions for intercourse, as well as cunnilingus, fellation, soixante-neuf and other sexual acts.

Except among Muslims, very long tabus on sexual intercourse between husband and wife after the birth of the child are not found. Generally speaking, long tabus (of at least one year and sometimes longer) are absent throughout Asia and are found mostly in the disease-ridden tropics of Africa, New Guinea and South America, or in hunting and gathering societies (although not among Siberian sea-mammal hunters). Some anthropologists have seen such a tabu as a very significant birth control method to ensure individual and group survival in hard situations.

More frequently mentioned are tabus on sex during menstruation, found among the Chinese, Manchurians, Japanese, Chukchi and Gilyak. Sources for Okinawans both affirm and deny such a tabu. The Chukchi (and Asiatic Éskimo) believe that menstruating women are so dangerous that even their breath is contaminating and may cause a man to drown at sea. The Gilyak have similar fears (apparently not found in the high cultures): a female shaaman can kill her shaaman competitor by rubbing menstrual blood on her eyes.

The exceptional nature of Ainu beliefs can well be appreciated because of the striking contrast to Chukchi and Gilyak views. Among the Ainu, menstrual blood is good luck. There is no mention of a tabu on sexual intercourse during a woman's period. Furthermore, menstrual blood is believed to be a very powerful medicine to relieve pains, bring success in the hunt and ensure wealth. If someone sees a drop of menstrual blood on the floor, he should dip a finger in the blood and smear the chest with it.

Sex tabus in association with death are reported from a few groups. The Gilyak are said to tabu intercourse after the death of a man. The Miao require the husband of a dead woman and her children to observe sexual abstinence for a year after her death; but if a man dies, the widow has to observe only a week's abstinence. Koreans, following Confucian rules, are supposed to abstain from sexual intercourse for three years after the death of a relative.

Among the Taiwan Hokkien, when people become grandparents they
are supposed to give up sex entirely. Other societies sometimes feel that
sex for the old is inappropriate, as traditionally in the West — hence such
expressions as "dirty old man." But the Hokkien specifically relate a
tabu on sex to a change in social status.

Traditional Chinese have very elaborate sexual tabus, in association
with the birthdays of gods or days on which the gods are believed to be
more active than otherwise. The list of tabu days varies. One Daoist
book gives 24 as the maximum number of tabu days, the minimum being
21. Nearly all Chinese who were interviewed about the matter (by
Francis Hsu) agreed that it was absolutely necessary to observe sexual
abstinence during any epidemic or when prayer meetings were being
held.

Insistence on virginity for unmarried women is found only among
the Chinese, Japanese, Minchia and Koryak. The Koreans, Okinawans
and Gilyak also prohibit premarital sex, but the rules are not strongly
enforced. Most of the other groups permit premarital sexual freedom.
The only group in the whole area (as listed in the *Ethnographic Atlas*)
tracing descent through women is the Ainu, but it does not seem to be
any more free in the sexual relations of its women than the other groups.

There is almost no information about ritual occasions that require
sexual acts to be performed. It must be said, however, that the rules for
copulation that were imposed on the Chinese emperor, with regard to his
various grades of wives and concubines, approach ritual. Each one of
these women had specific calendar days allowed to her for intercourse.
The lower ranking women would have sex with the emperor more
frequently than those of higher rank. The queen was to have intercourse
with him only once a month at the time he was regarded as most potent
(he was required also not to have squandered that potency by having had
intercourse to orgasm with other women).

Other sexual interests

The nineteenth-century traveler Richard Burton described the Chinese
as *omnifutuentes* ("all copulating"), that is, willing to copulate with
anything, including not only little boys but ducks, goats and any other
animals available. However, very few paraphilias have been recorded for
the area, although Japanese erotic pictures suggest at least the presence
of voyeurism and interest in erotic bondage (other forms of
sadomasochism are not common), and the traditional Chinese passion for
bound feet is well known.

Specific information about foreplay is also not usual. Okinawan men are said to enjoy caressing breasts, but there is a generational difference with regard to kissing: older people do not like kissing, but some younger couples include it in their foreplay. Kissing is specifically denied for the Ainu and Miao. Kissing of a sexual nature is reported for Manchurians, Tibetans, Chinese and Japanese. But except for Tibetans, kissing is avoided in public. Georges Valensin (1977) considers the Communist Chinese rule of "oral chastity" (at least in public) as a continuation of an earlier tradition.

Arnold Landor, writing in 1893, says that kissing was apparently unknown to the Ainu — at least to a woman who was virtually throwing herself at him — but biting was not: "Loving and biting went together with her. She could not do the one without doing the other ... when she had worked herself up into a passion she put her arms round my neck and bit my cheeks."

Nose rubbing is mentioned only for the Formosans. In traditional Chinese society, masturbation leading to ejaculation was discouraged for males because it would deprive them of yang without any yin compensation. Nocturnal emissions were similarly a matter of concern; they were thought to be caused by evil fox spirits, who changed into beautiful women to rob men of their vital fluids. After the Communist takeover male masturbation continued to be discouraged: Mao Zedong (Mao Tse-tung) publicly condemned masturbation and suggested vigorous exercise as a preventive measure.

Foreplay really does not seem to have played a great part in actual Far Eastern sexual behavior. Valensin believes that traditionally Chinese sex play was minimal. Descriptions of marital sexuality in several Far Eastern societies (at least on the peasant level) seems to point to a general poverty of affection and sensual enjoyment. Cornelius Osgood, writing in 1951, surmised that marital sex among Koreans is not even adequate "relative to any standard except that of conceiving children." Descriptions of Japanese marital sexuality are more or less the same.

Homosexuality and paraphilias
Homosexual acts and paraphilias are for the most part ignored in anthropological accounts for the area. A few anecdotal accounts of historical interest are sometimes cited. For example, the last Han emperor, Ai-di (6 BC-AD 2) was involved with a boy, Dung Xien (Tung Hsian), and the story goes that once, when the two were in bed, the boy fell asleep on the emperor's sleeve. Rather than disturb the boy, Ai-di

cut off the sleeve with his sword. The expression *dànxiù*, "cut sleeve," is used for "homosexuality" in recollection of that occurrence.

Throughout Chinese history, pederasty was associated not only with the court but also with actors. Female roles were traditionally played by effeminate young men, so possibly pathicism or transvestite pederasty was involved.

In any event, exclusive homosexual interests are rarely discussed in the Chinese literature. Instead we find bisexuality within the Confucian tradition of the obligation of producing children — with the exception of Buddhist monks and nuns (and possibly, also of actors).

Valensin maintains that under the present Communist regime there is almost a total absence of homosexual acts — as well as of prostitution and of extramarital heterosexual acts in general. But evidence one way or the other is lacking. However, when individuals are discovered to be homosexual, they are regularly given electrical shocks as aversion treatment. One could have imagined that given the great concern for population control, the Chinese government would instead tolerate if not promote homosexual acts and other nonreproductive sexual behavior, such as masturbation. But as we have seen, such is not the case.

Although historically a good deal of toleration has existed on practical and personal levels, legally the situation has been different. Some believe that Chinese legal disapproval of homosexual acts goes back to Genghis Khan's code of law called the Great Yassa (from about 1219), where the death penalty is mandated for both adultery and "sodomy". However, the word "sodomy", as used in V A Ryazanosky's account of the Great Yassa, refers unambiguously to human-animal contacts, not to homosexual acts at all. This example should suffice to show that the term "sodomy" must be abandoned (as has been suggested earlier).

Among contemporary Japanese, according to John Beatty, the concepts of "homosexuality", "masculinity" and "virility" are perceived in a manner profoundly different from usual American or British attitudes. If a man visits a married couple, a normal Japanese sleeping arrangement would have the host sleeping in the same room as his guest, and his wife in another room or sent off to her mother. The western pattern of married couples sleeping in the same room would not occur to the Japanese, whose solution is perfectly in accord with their notions of "masculinity", defined in terms of social relations with other men. Japanese are concerned that exclusive homosexuals will have no children to care for them. But homosexual acts in a bisexual lifestyle are socially irrelevant.

The Japanese
Data based on Kinsey-type interviews exist for the urban Japanese, the only non-western culture about which this can be said. The data deal, however, almost exclusively with the sexual behavior of students after World War II.

An attempt to do an investigation into sexual behavior as early as 1922 was made by Senji Yamamoto, a zoölogist, in association with Tokutaro Yasuda, a medical student. Yamamoto, however, was assassinated in 1929 by ultra-rightists opposed both to his socialist politics and to his sexological studies.

Since World War II, Shin'ichi Asayama did a number of surveys on the sexual development of university and high-school students. In 1949 only three percent of the males (21 out of 693) and four percent of the females (12 of 283) admitted to having had any homosexual contacts such as kissing, petting and mutual masturbation (oral and anal contacts are not mentioned at all). By 1974, the figures were about seven percent of males (184 out of 2,674) and four percent of females (84 of 2,101). These percentages are much lower than comparable Kinsey figures for the United States but approach the incidence of exclusive American homosexuals. Very striking differences in heterosexual behavior can also be found. For example, in the 1974 survey, only 15.1 percent of Japanese males admitted to having had sexual intercourse (and this spans an age group of 16 to 21), whereas in the Kinsey sample, 85 percent of males who did not go beyond eighth grade in elementary school and 42 percent of males who went on to college experienced premarital intercourse by the time they were 20 years of age.

The Japanese studies show an increasing similarity over the years between the sexual behavior and sexual desires of Japanese men and women, with women more and more approaching the male levels. With regard to extramarital intercourse, it is believed that all Japanese married men before World War II had some sort of sexual contact outside of marriage and this was sanctioned by the prevailing mores. Since the war, in spite of profound social changes, the majority of married men (60 percent in a survey of Tokyo; 75 percent in the Kansai area) have had extramarital intercourse; rich men show much higher figures (90 percent). For women, the figure was about five percent between the ages of 30 and 40. American women show a range five times greater than that. As for husbands, Japanese men exceed Americans by 20 percent.

Unique customs

Certain customs that have been reported from this area are unique, or
nearly so, even cross-culturally. Korean women traditionally wear a
small rod-like silver pin, which is stuck in the bun of hair at the back
of the head. Its use is primarily decorative, but it can also, as was stated
in all seriousness, be used by the woman to jab her husband's testicles
during intercourse and prod him on when his passion lags.

In Mongolia and among the Monguor, certain pseudo-marriages occur
where the daughter is offered to a guest. If she should get pregnant she
gets married to a belt, which must be left behind by the guest. The belt
is simply symbolic of the man, who may never return. Similarly in
Mongolia, if a girl gets pregnant outside of a situation of sex hospitality,
she is formally married to a prayer rug.

Finally, an unverified custom is the ceremony reportedly initiated
by the Tang Dynasty empress Wu Hou (AD 625-705). She is said to
have required that all government officials and visiting dignitaries
should, by royal decree, perform cunnilingus on her in public. I have
been unable to corroborate this account but it is included in *Simon's
book of world sexual records* (1975) as "world record No. 348:
cunnilingus — only royal example."

The future of sexual customs and ideology in the Far East promises
to be complicated and invariably interesting. The overriding reality is
the huge population in the main centers: China and Japan. Policies of
massive contraception and abortion have been adapted to counteract the
disastrous consequences of sexual activity. The present Communist
government in China has been fostering an antisexual ethic that goes
beyond Confucian prudery. A country which once produced philosophers
who maintained that "the more women a man has intercourse with, the
greater will be the benefit he derives from the art," now has generated
slogans like: "Making love is a mental illness that squanders time and
energy." It remains to be seen how the people themselves will deal with
the situation.

SIXTEEN OCEANIA

The South Seas have stirred the sexual imagination of the West ever since the earliest reports of a paradise of the flesh inhabited by beautiful people uncontaminated by civilization.

This fantasy distorts the real world in several ways. But it is true that many of the sexual customs found in the Pacific differed considerably from Judaeo-Christian morality.

The general tolerance of premarital promiscuity is a case in point. But it is one thing to tolerate promiscuity, another to practise it. You cannot do so unless you find willing partners. A very important restraint on sexual life on small islands is found in incest tabus. For example, on Raroia, an atoll in Tuamotu, there were only 109 people in all in 1951.

The incest rules on Raroia prohibited any unions at all — whether marriages or love affairs — for seven of the nine women of marriageable age. In the neighboring atoll of Tepuka in the 1930's, some young people were so related to all otherwise potential partners that they had to journey to other islands or wait for the arrival of visitors.

Early explorers were amazed and usually delighted by native women who, according to some reports, would swim out to the boats naked and climb aboard in the same condition. Further study suggests that this sort of uninhibited sexuality was part of a conscious strategy to keep foreigners peaceful. Only women who had a reputation for looseness were allowed to participate in this form of sexual diplomacy; high-ranking women were kept well out of sight. The *ariori* society of Tahiti was made up of men and women who traveled about the Society Islands as singers, dancers, athletes and sexual exhibitionists. They were permitted promiscuous relationships wherever they went. Early travelers did not realize that they represented a religious organization and that much of their sexual behavior had a religious justification: after all, the society had been founded by a god of fertility.

Greater knowledge of Pacific cultures has considerably modified the simple-minded notion of sexual paradise. In the first place, there is too much variation to set up a single pattern for this gigantic geographical area. In the second, certain ritual considerations must surely put a

damper on the joys of sex in many cultures. In some parts of New
Guinea, for example, beliefs about pollution from menstrual blood may
do just that. All sorts of dreaded diseases and disorders are said to come
from contact with a menstruating woman. Premarital sex is said to be
rare because the men are simply too frightened. Before his wedding, a
man is given magic charms that will help to protect him from menstrual
contamination. But he still has a problem about *where* he will copulate.
Because of extensive tabus, couples are left with few options and usually
have sex in the bush, often even in mud.

Australian hunters and gatherers
The aboriginal Australians were once taken to be the most primitive
peoples on earth. Hence, they were thought to be living examples of
what the earliest human beings were like.

But it is clear that the aborigines had developed their own regional
differences not shared by other hunting and gathering groups such as the
Bushmen in Africa. So we cannot legitimately assume that their sexual
and marital customs are truly representative of the earliest human
culture.

Spencer and Gillen (nineteenth-century anthropologists) asserted that
the Áranda and presumably Australian aborigines in general did not
understand that men were necessary for the procreation of children.
Malinowski claimed the same thing for the Trobriand Islanders of Papua
New Guinea, and a few other Pacific cultures have also been
characterized in this way. This assertion at first went along with the
idea of a kind of super-primitiveness. But later evidence suggests that
the anthropologists did not get the story quite straight. Lloyd Warner
reported that he originally got the same story from the Murngin, another
Australian aboriginal group. But when Warner finally changed the
wording of his question and asked what semen did when it entered the
womb of a woman, several old men expressed contempt for his ignorance
and replied: "That's what makes babies."

Of the Tasmanians — now totally extinct, the last one having died
in 1876 — we know next to nothing except that they practised
rear-entry intercourse (although even this is uncertain), that kissing in
the European sense and even embracing was possibly unknown to them,
and that men had the habit of holding on to their foreskin with the left
hand — which also means that they were not circumcised.

A great deal more is known about several Australian groups. The
Áranda have a ritual dance called the *wuljankura*, the purpose of which

is said by Strehlow to arouse the sexual interest of women for strange men. At the end of the dance, a woman tells her husband which man she is attracted to, and the husband arranges a rendezvous between them.

Among the Murngin, special ceremony involving a ritual exchange of wives is performed called the *gunabibi*. Not to participate causes sickness — both in oneself and in one's potential partner. The ritual intercourse is thought to be purifying and it is said that "it makes everyone's body good until the next dry season."

Before the *gunabibi*, a girl participating in it must be ritually deflowered. In many Australian groups — Spencer and Gillen say this is true of all the desert tribes — defloration is done by the girl's husband, after she has begun to menstruate, by inserting his index finger into her vagina. But defloration can also be done as a part of the *gunabibi* ritual with a special boomerang.

In Australia, such acts of defloration generally go together with two other customs: subincision (a slitting of the penis) and introcision (an operation to enlarge the vaginal opening to make — it is said — childbirth easier). The Matúntara require that the girl's husband must have intercourse with her immediately after introcision while the vagina is still bleeding, because the wound will heal more quickly that way. The ritual exchange of wives in the *gunabibi* serves as a kind of grand finale to the entire ceremony. A person may copulate more than once during the ceremony, either with the same or with a different partner. A woman is said to be especially proud of the number of men she copulates with.

The other main variant involves mass simultaneous copulation. After the ceremonial dancing is finished, all the women lie down on the ground in two rows depending on their kinship group. They assume the position for sexual intercourse. The men dance into place in front of their female partners and are so positioned that they have their back to one another so that husbands cannot see what their wives are doing. The men then copulate with their partners. When they are finished the men get up and go to the side.

Rear-entry intercourse is sometimes reported as the usual nonritual form used by married people at night in a camp. They do so out of modesty, so that no one else will know what is going on between them.

The Áranda also practise side-by-side copulation. Intercourse with the woman on top also occurs, although some male informants vehemently deny it, insisting that "the penis might break."

Quite generally, then, Australian aborigines seem to regard sex not only as pleasurable but also as sacred, conveying health and vigor. The Áranda, and presumably other groups, believe in a spirit of sex, called Knaninja, who is worshiped with special ceremonies.

Homosexual relations are also recognized. Among the Áranda, homosexual acts are said to play a "conspicuous part" in the life of a young girl. Male homosexuality activity has also been reported from other Australian groups. Arnold Pilling maintains that among the Tiwi, teenage boys take a regular lover of about the same age from the group of males who are their potential brothers-in-law. Carl Strehlow, writing in 1913, says that pederasty was institutionalized among the Námbutji. Various authors talk of boy-wives, as though a homosexual marriage were implied.

Among the Námbutji, every young man becomes the boy-wife of the man who has performed circumcision and subincision on him during initiation. They live together for a while and the boy plays the passive role. Eventually when the boy is considered fully adult he will marry his "husband's daughter."

Mervyn Meggitt, from his work among the Wálbiri, believes that these descriptions are highly unrealistic. He thinks that although homosexual acts during puberty rites occur widely and are expected, they are not approved of.

Marriage rules throughout Oceania

All Australian groups permit a man to have more than one wife. In this respect, they resemble the majority of peoples in the Pacific. Although a classic description of Marquesans says that they permitted a woman more than one husband, more recent work suggests that this was not so. The Lesu and Trukese, however, are Oceanic examples of societies that permit women to have more than one husband. Few women, however, avail themselves of the possibility.

Another group where women have been described as having multiple husbands is the Marshallese. Closer examination of the description shows that the natives themselves do not regard the unions as marriages. A striking aspect of the sexual situation, however, is the fact that the chief's wife among the Marshall Islanders had the power to force every one of her male subjects to have intercourse with her. This was awkward for the men because the chief in turn had the right to kill any man — and his family — who committed adultery with his wife. Even though she undertook her intrigues with great secrecy, handsome young men

tried to avoid possible calamity by staying out of her sight. It is reported that, formerly, such men would even disfigure themselves to avoid attention.

In a few groups, all the women are married to a very few, usually fairly old, men. A case in point is the Tiwi, a northwest Australian group. In one study, all the men under 28 had no wives and few men under 40 had any either — when they had, the women tended to be very unattractive or old widows. But the sexual reality was that all the women had young lovers. This seems to be true no matter how fond they were of their own husbands.

The Tikopia

With regard to modes of marriage, the Tikopia (a Polynesian group) are of special interest because of their tradition of marriage by capture. Early anthropologists sometimes speculated that bride capture had been a characteristic of primitive society in general and that various mock abductions found as part of the ritual of marriage in a number of societies represent survivals of an earlier reality. Theorists nowadays reject this reconstruction.

Tikopia represents a society in which bride capture (fairly common until the 1920's) actually formed an integrated structural part of the culture. Of course, marriage sometimes took place between sweethearts, and elopement of varying degrees of secrecy constituted the most frequent prelude to marriage. But capture occurred in a significant number of instances, although it was characteristic mainly of the families of chiefs. The capture itself was real and sometimes involved true violence. Nevertheless, it was surrounded by various considerations of etiquette. It was not good form, for example, to abduct a girl when she was working in the fields or walking along a path. The correct thing was to take her from her father's house. If an improper way was followed, sometimes the struggles over the girl became so severe that deaths occurred — virtually never the case when decorous abduction took place.

The morning after the kidnaping, the woman was taken to her future husband's house and a ritual feast was held constituting the formal proclamation of the marriage. It was also the prelude to the public sexual consummation of the union, which occurred that night. This public consummation was really ritual rape, with the bride held down. The remarkable thing from native accounts is that once she had been penetrated, she gave up resistance immediately and accepted her status as wife from that moment on.

Sexual outlets outside of marriage

For many Oceanic cultures, one often has the feeling that marriage is not the preferred outlet. Even incest seems to have its charms — especially with forbidden relatives not in the immediate family.

In some societies among the families of chiefs, father-daughter incest was permitted. On Truk, at least one chief was known to have married his own daughter. Among the Marshallese, a chief deflowered his own daughter. On Hawaii and Rarotonga brother-sister marriage was permitted in the royal family.

One source of legitimate sexual outlet outside of marriage was sex hospitality, probably common throughout Polynesia, but specifically reported from the Samoans, Marquesans and Maori. The Maori did not use the custom to any great extent, however, because women frequently accompanied men on their travels. Nevertheless, it *was* a possibility, as even an Anglican bishop was to learn. The bishop's companion cried out in horror when the suggestion was made. "What? A wife for the bishop!" The chief who made the offer reconsidered and grudgingly obliged: "Oh well, give him two!"

Oceania is the area par excellence where public copulation, erotic festivals, ceremonial orgies and sex expeditions have been reported. For the most part they have disappeared with European colonization and Christian missionaries. The Kwoma, for example, have two ceremonies involving sexual license — something like the Australian *gunabibi.* Similar erotic festivals have been reported from the Orokaiva, Trobrianders, Yapese and Normanby Islanders.

Naked dances occurred formerly on Easter Island and the Marquesas. According to Ralph Linton, at the close of feasts, Marquesans would hold public group-copulation displays. The women taking part would take pride in the number of men they serviced. Linton recalls one nice old woman who boasted about having made the entire crew of a whaling boat happy.

Both the Trukese and Trobrianders had the custom of sex expeditions. A group of young men (also young women among the Trobrianders) would get together to seek out sex partners. Trukese sex parties who met with refusal would sprinkle "magic oil" on uncooperative women to make their hair fall out and ulcers and boils appear on their bodies.

The Pukapukans have developed a sex institution to rival any American swingers' club. They set aside places called ati where men and women go to form sex parties. They chant and dance and have sex

under the watchful eye of a general organizer and guard, who keeps out
jilted lovers and irate husbands.

Clearly, over much of Oceania a pro-sex attitude prevails. Concern
for sex technique and even aspirations to sex virtuosity exist. Sex
education is known in some instances to involve a practical as well as a
theoretical side. Among the Mangaians a boy is sexually trained by an
older experienced woman some two weeks after he has had his penis
superincised. The old custom was for this instruction to take place on
the beach where the water comes up to the sand.

In Polynesian societies, there is little concern for virginity except for
the daughters of chiefs. Such girls may have to prove their virginity in
a public defloration. On Tonga, a girl of high rank slept with her legs
tied together so that her virginity might not be lost to some night-
crawler. General insistence on a girl's virginity in marriage is found
among only a few peoples.

Mead and Samoa

Margaret Mead's famous account of the sexual life of girls in Samoa
(primarily in her classic book from 1928, *Coming of Age in Samoa*, but
also from later writings) painted a picture of a society free from the
sexual "hang-ups" of Western society. The message she gave proved
immensely popular to and something of a relief for Western readers, who
themselves were going through what some historians believe was the one
true sexual revolution in the 20th century, associated with the moral
crises created by World War I. She described premarital sex among the
Samoans as casual and care-free. Frigidity was supposed to be absent,
even the idea of rape was "completely foreign to the Samoan mind."
True, certain women were designated as ceremonial virgins *(tāupous)*
who had to be ritually deflowered. But Mead insisted that this was a
technicality in most instances: to ensure the necessary proof of virginity
the blood of a chicken or a pig was smeared on a mat in a deception even
the officials involved in the ceremony went along with.

In 1983, in a book entitled *Margaret Mead and Samoa: the making
and unmaking of an anthropological myth*, Derek Freeman provided
evidence to undermine this picture based on his own fieldwork of several
years. (Mead's stay was nine months). For example, he maintained that
rape was a major element in male sexuality in Samoa and that a cult of
female virginity was intense (in his words, "probably carried to a greater
extreme than in any other culture known to anthropology").

His book became an instant scandal. Several anthropologists rushed to Mead's defense, others were skeptical, still others accepted Freeman's critique that an anthropologist in her twenties on her first fieldtrip was simply duped by teenage informants. The controversy continues but it would be a foolhardy anthropologist who nowadays took Mead's account as gospel without any further discussion.

Sexual practises and statistics
If we look at Oceania as a whole, we can see considerable diversity in spite of the general, pro-sex orientation. In some instances the variation reflects obvious social factors, but in many cases no clear-cut reason is readily apparent. The Wógeo, for example, think masturbation is all right for children (because they are just "trying out their organs") but bad for adults. The Trukese believe children will get sick from masturbation, but not adults; in fact there is said to be a god of masturbation, Olefat, who taught it to the Trukese.

So, similarly, knowledge about sexual anatomy also varies widely. The Trobrianders are described by Malinowski as having only a rudimentary knowledge; they lack words for such parts of the female anatomy as mons veneris, labia minora and majora, and hymen. A Mangaian youth in Marshall's account, on the other hand, has a sexual vocabulary rivaling that of a western doctor. Certain Mangaian words have no common or even scientific English counterpart, for example *tipipaa* "ridge of the glans of the penis."

A majority of the societies we have such information about use the missionary position as the main or very frequent position. The Oceanic position is a close second.

The Trukese and Yapese practise a variation of this that is apparently unique. The Trukese themselves seem to be aware of this uniqueness since they call their coïtal technique *wechewechen chuuk* "Trukese striking." The man sits on the ground with his legs wide open and stretched out in front of him. The woman faces him, kneeling. The man places the head of his penis just inside the opening of her vagina. He does not really insert it but moves his penis up and down with his hand in order to stimulate her clitoris. As the couple approach climax, the man draws the woman towards him and finally completes the insertion of his penis. Before climax, as the partners become more and more excited, the woman may poke a finger into the man's ear.

A Yapese variant, called *gichigich*, is said not to be used by a man with his wife because she would insist on it all the time and this would

wear him out, making it impossible for him to work like other men. Nor
could the woman work as she should. Consequently, as soon as a couple
marries — even though they may have practised *gichigich* before as
lovers — the man substitutes the standard marital form: none other than
the missionary position.

The description of the Yapese *gichigich* is one of the most graphic
in the anthropological literature, written up by Fr Salesius in a report
from about 1906. The man just barely inserts his penis between the
woman's outer sexual lips as she sits on his lap. The head of the penis
is moved up, down and sideways for a period of time, which can be quite
long. The rate of this movement varies, and can become quite intricately
contrapuntal. All this is said to make the woman frenzied, weak and
helpless. She experiences one orgasm after another and involuntarily
urinates a little after each orgasm (the sensation for the man is that he is
on fire).

Co-incidence, I think, accounts for the fact that the Yapese with this
rather strenuous frenetic sexual technique have one of the lowest rates
of frequency for intercourse found in the world. A number of other
coïtal positions are reported from Oceania as a whole. Having the woman
on top as a common option seems to be more frequently admitted here
than elsewhere. Possibly this is related to a greater concern for the
sexuality of women. A sitting position (with the woman astride the man's
lap) somewhat like the Yapese custom but without the *gichigich* addition,
is mentioned for the Wógeo and Marquesans. A side-by-side facing
position (without any symbolism attached to which side the male or
female lies on, as in Africa) has been reported as very common among
the Marquesans, Mangaians, Tikopia and Alorese.

Although some societies have a fairly limited traditional sexual
repertoire, others have a quite large one. The Trobrianders, for example,
recognize only two acceptable, "natural" coïtal positions: the Oceanic and
side-by-side facing. The Mangaians include in their repertoire all the
basic coïtal positions and several other techniques.

Interestingly, what may have been the traditional coïtal position, the
Oceanic, is becoming rarer today, although it is admitted that "older
people believe that this is best." The most common coïtal position at
present is the missionary position, probably as a result of western
influence.

The use of foreplay even in societies with great emphasis on
technique is often minimal. What is desirable in much of Polynesia is
delayed ejaculation so that the man can bring his partner to orgasm. The

adept lover will not only be concerned about satisfying his partner but he will want to have multiple orgasm himself in any one session. Unlike the Yapese, who consider a tight, nearly impenetrable vagina a sexual ideal, Mangaians want a well-lubricated path: saliva or a concoction from the hibiscus or even soap may be used.

Oral sex has been characterized as well established in parts of Oceania, but specific information turns out to be really quite scanty. Marquesans and Mangaians seem to be completely permissive about cunnilingus and fellation. The Woleaians also practise both. Coïtus interruptus is reported from the Maori, Marquesans, Tikopia and Yapese. The Tikopia clearly do it for birth control.

With regard to frequencies of sexual acts, we have virtually only cultural expectations (or fantasies) and an occasional anecdote to go by. One Marquesan man claimed to have set an island record and possibly a world record by copulating 31 times in a single night. He later became "alcoholic, psychotic and impotent." Frequencies for Marquesan adolescents are sometimes said to be more than 10 times in a single night, whereas older married couples may copulate from five times a night to two or three times a week.

The Yapese, at the other extreme, apparently copulate about once or twice a month. Alorese informants said the custom was to have sex every night, but Cora DuBois, the anthropologist studying them, thinks every other night is more likely.

A study approaching the Kinsey method, that by Donald Marshall for the Mangaians, suggests that for males nightly orgasm varies considerably for different groups, the average being three for 18-year-olds, seven nights a week (perhaps somewhat less frequently); two for 28-year-olds, five to six nights a week; one for 38-year-olds, three to four times a week; and one for 48-year-olds, two to three times a week (perhaps somewhat more frequently). Marshall concludes that Mangaians copulate more frequently than Europeans and Americans but probably pay a price in a higher rate of impotence and sterility in later life. Considerably more information is needed, however, before such a correlation can be accepted.

Sex tabus

Sexual frequencies are in part modified by various tabus. The kinds of tabus found in the area are fairly usual, involving such occurrences as menstruation, pregnancy, ceremonies and warfare. A tabu on sexual intercourse during menstruation is specifically mentioned for the Áranda,

Kwoma, Lesu, Toraja, Trukese, Wógeo and Yapese; for only one group, the Tongans, is it specifically denied. The Lesu insist that only the mother observe the tabu during pregnancy. Interestingly, they extend the tabus to the time pigs are giving birth — apparently a man must observe continence for his piglets but not for his own offspring.

Tabus for a period after the birth of a child are mentioned only occasionally; and the length of time varies considerably, from two to five months among the Apayo to five to six years among the Yapese and the Dani. The Yapese spacing of children indicates that this tabu is almost always observed in the breach.

Heider says that Dani spacing of children fits the tabu and that he believes their testimony about having no other outlets. He concludes that they have a low level of sexuality that simply does not tie in with Freudian or other universalist notions of human sexuality. His assertion is so at variance with human behavior elsewhere that he must expect skepticism.

Tabus in association with going to war are fairly common. The Trobrianders believe that if a man should break this tabu a spear would pierce his penis and testicles. The Yapese have what seems to be a unique tabu: never go into the water the same day that you have sexual intercourse (elsewhere on the islands in Oceania, bathing in the sea after intercourse is almost de rigueur).

These tabus no doubt affect sexual behavior to a certain extent but occasionally one finds counter-tabu techniques to offset the harm that breaking them may cause. The Buka, for example, have "medicines" to neutralize the tabu before fishing.

In the same vein, rules against adultery are often simply ignored. A Wógeo man admitted adultery was wrong but when asked what he would do about his unfaithful wife said: "I can't keep my fingers in her vagina from sunrise till dark and on till sunrise again so I keep quiet."

Among the Lesu, actually committing adultery is the "correct" thing to do (even though forbidden).

Nevertheless, in many societies the breaking of tabus and the committing of adultery in particular is believed to cause sickness or other disorders — particularly in a child of the wrongdoer.

In a few instances, confessions of sexual misconduct are required — but this custom is not reported as widely here as for African or Siberian groups. The Pukapukans and Wógeo require detailed confessions of adulterous acts by a woman who has a delayed delivery. The Trukese extend the need for a parent's confession beyond delivery to cure a

child's sickness. The Tongans do not limit confessions to mothers in labor. They believe that any member of a family can get sick because another member has broken a sexual rule. A man might get sick because his son committed adultery — and it is the son who would have to confess.

Homosexuality

According to Malinowski, the Trobrianders admit that homosexuality, though contemptible, was formerly practised — but only by mentally deficient people. Male homosexuality is denied for Easter islanders, but female homosexuality occurs and is both tolerated and accepted.

Adolescent homosexual acts are said to be nearly universal for Makassarese boys and Lau girls before marriage. In Samoa such acts are regarded simply as play and not given much thought.

The general pattern of adult male homosexual acts has a striking distribution according to "culture area" in Oceania: pederasty (possibly even paedophilia) in Australia and Melanesia (where it is often ritualized as well as institutionalized); but pathicism (which involves transvestism) in Polynesia, Indonesia and the Philippines.

The Polynesians share a number of traits both because of a common ancestry as well as trade connections. From a sexual point of view a number of traits are sufficiently common to be significant: the practise of superincision in males and an intense interest in genital cleanliness; a preference for broadhipped, fairly stocky women with light skin coloring who have mastered a considerable amount of sexual technique; the practise of night-crawling by young men, whether considered admirable or not; premarital sexual freedom except for high-born girls; and, formerly, public copulation as part of religious ceremonies.

To this add the component of institutionalized transvestites, *mahu*, who frequently enter into homosexual relations with nontransvestite men. This pattern is found among the Marquesans, Tongans, Tahitians, Samoans and Hawaiians.

The Tahitian setup displays some extraordinary details ranging from the belief that swallowing semen ensures strength and health, to the rule that a village must always have a *mahu*, but only one at a time. Curiously enough, the rule reflects reality with few exceptions. When asked whether there could be more than one *mahu*, natives replied "No, only one... When one dies, another replaces him. God arranges it like that. It isn't in the nature of things, two *mahus* in one place."

Robert Levy suggests that this custom helps stabilize the society at large by presenting a highly circumscribed but clearly negative image of ideal personality. This explanation is similar to one given by George Devereux in explaining the institutionalized homosexuality among the Mohave Indians as a way of localizing what he takes to be a disorder in a small and manageable area of society. But since the number of these individuals — whether institutionalized or not — is probably not particularly large to begin with, such argument falls short of being compelling.

The Melanesian and New Guinea pattern of pederasty involves quite a different setup. This pattern is usually associated with a puberty cult, more like what is found in Australia (and may be historically related to it). The ritualized homosexual relationships associated with these cults have become the focus of intense speculation in recent years, raising as they do profound issues concerning psychosexual development and other basic questions in anthropological psychology. One of the foremost researchers in this area is Gilbert Herdt, in part because of his own fieldwork among the Sámbia of New Guinea who have such a pederastic cult, but also because of his theoretical work on the subject.

Some 30 to 50 groups within this general area are known to have had some variant of these pederastic rituals. Because Western government officials and missionaries have tried to wipe them out altogether, the evidence for their existence is, in many cases, poor. A fairly typical picture emerges when evidence has survived: participation in homosexual acts is a necessary part of the coming of age training for boys and is obligatory. Usually the reason given for such acts is the belief that boys do not produce their own semen and must get it from older men by playing a passive insertee role. So, instead of robbing a male of his manhood (which would be the traditional western view), this role is here seen as bestowing manhood.

Characteristically, such societies show extreme social differences between men and women, with the women in a markedly inferior status. Commonly but not invariably, circumcision or other genital mutilation is not performed, the blood of men and women is not especially ritually differentiated (though milk and semen are), and marriage often involves men exchanging sisters with no special marriage payment. Other societies in the area lacking ritual homosexual acts do not share these features; for example, menstrual blood may be considered extremely dangerous or a "bride price" may be required to legitimize a marriage.

It is sometimes suggested that such homosexual rituals function as a kind of birth control. But more plausibly they seem to provide a sexual outlet for males in an area with an unbalanced sex ratio (too many males) and the practise by older men of having many wives — very much like the situation among the Zande in Africa, who formerly had institutionalized pederastic marriages.

A major question involves the relationship of these rituals to the development of sexual orientation or at least to the nature of erotic arousal. On the one hand, Herdt suggests that among the Sámbia only about 5 per cent of the male population become exclusively homosexual — virtually the same percentage Kinsey found for the United States where all homosexual acts were tabu. On the other hand, to discount homosexual arousal altogether in these institutionalized semen transfers seems unrealistic: slavish performance of a ritual does not produce erection and ejaculation unless an erotic component exists as well.

Sometimes extensive tabus on heterosexual coïtus exist but none on homosexual contacts. This is true of the Étoro (Étolo) who tabu heterosexual contacts for between 205 and 260 days a year (an earlier account suggested as many as 295 days). Although hard and fast statistics are lacking about the degree to which these tabus are observed, the seasonal clustering of births, suggests general compliance with the rules.

None of these tabus holds for homosexual acts among the Étoro. In fact they are positively encouraged because semen is seen as a life force, of which men have only a finite amount. Boys are believed to have no semen at all at birth. It is through oral insemination by older men that they acquire the necessary semen to become men and to provide life for their offspring. Consequently, boys between the ages of 10 and the mid-twenties are continually inseminated by older men. Among the neighboring Marínd-aním the cultural preference for homosexuality has allegedly helped produce so low a birth rate that to sustain the tribe, large numbers of children must be kidnaped from other groups and raised to become Marínd-aním.

Among the Malekula, the institution of pederasty is closely associated with a kind of circumcision (probably a variant of superincision). Both circumcision and ritualized pederasty are symbolic expressions of the holiness of men (as compared with women). John Layard suggests that just as in some societies tracing descent through women the female line of descent is conceived of as "an umbilical cord joining all generations to

the first ancestress, so here the continuous penis unites all those belonging to the male line of descent."

In all these pederastic societies, the sexual role played depends on age. The initiation of sexual behavior with a partner starts as passive homosexual and then shifts to active.

The origins of such ritual homosexual acts remain obscure. For a variety of reasons, largely linguistic, Herdt has suggested that they may be variants of an ancient ritual complex that spread throughout parts of Melanesia perhaps as long ago as 10,000 years. It might be noted that Papuan languages (spoken by most of the groups in question) are now believed to be related to the language spoken by the Andamanese living on islands in the Indian Ocean. It is probably only co-incidence but homosexuality has been stated to be rife among Andaman men.

On the island of Java, which is outside the Melanesian area, a kind of age-graded homosexuality occurs — but not of a ritual sort. There, boys are sometimes kept by rich men or shared by groups of less well-off men. Known as *gimbalan*, these boys seem to live an exclusively homosexual life until they become adults, when most of them become exclusive heterosexuals and get married.

In another Melanesian society, fictitiously called East Bay, neither transvestism nor ritualized pederasty exists, but almost every male has extensive homosexual contacts during his lifetime. Furthermore, there are no fears of ritual contamination through contacts with women or very strict tabus about associating with women. Although a few men may be exclusively heterosexual, and no men are reportedly exclusively homosexual, the great majority are openly bisexual.

Tobias Schneebaum has described another similar society, the Asmat of Irian Jaya (on the island of New Guinea). If his interpretation is accurate, this group would be the only one reported in Melanesia and practically all of the world outside of the West where male adultophilia (sexual attraction to adults who are not transvestites) is common and traditional. In the cosmopolitan town of Papeete on Tahiti, an apparently nontraditional form exists where *mahu* play no part. The men involved are called *raerae*.

The Big Nambas of Malekula apparently have a kind of cult lesbianism, but it is virtually undescribed. This is the only reliable report of such ritual lesbianism corresponding to the male cults described. This may be simply because of anthropologists' ignorance of the subject rather than a clear-cut absence of the practise.

Paraphilias and other sexual interests

Information about paraphilias and miscellaneous other sexual interests is few and far between. The paraphilia level for Oceania — in spite of fairly extensive reporting of sexual behavior in general — seems to be fairly low.

The only two Oceanic societies for which there is any evidence at all of nekrophilia are the Pukapukans and Káinantu. Although reports on the Pukapukans deny the existence of paraphilias in general, reference to nekrophilia occurs. At the outset it must be said that sexual contacts with corpses are strictly forbidden; it is tabu for a relative or friend even to take a last look at the deceased's body. Nevertheless, there is a cultural twist that makes sex with a corpse excusable and that is the belief that the grief of a cousin will be naturally so intense that the tabus will be broken — not only by looking at the corpse, but even embracing it and sometimes having intercourse with it. Sex in this setting even has a special word: *wakaavanga*. Reactions to such behavior reveal no horror; other mourners find it unseemly and extreme but almost expected. (The practise has disappeared in modern times.)

Animal contacts are reported from a few peoples: Buka, Trukese, Marquesans and Toraja. Such contacts are denied, condemned, or apparently unknown among the Wógeo and Trobrianders.

The Marquesans — both men and women — make use of animal contacts as an "emergency practise." Women sometimes induce dogs to perform cunnilingus on them. Men commonly copulate with chickens. Larger animals such as dogs and horses are also sometimes used, for foration (sodomy).

Although there seems to be no reality in the belief, a few societies think of eels as particularly lecherous as well as phallic. Marquesans have legends in which sexual relations occur between women and eels, and the Maori have a myth of a phallic eel tickling a woman with its tail as she bathes.

Reports about rape span a remarkable spectrum. The Yapese have no concept of rape at all and reportedly find the idea that a woman would have to be physically overwhelmed to submit to sex amusing. Among the Trukese, rape is unknown, whereas on Tonga it is reported to be the most frequent criminal offense.

Rape is here distinguished from night-crawling, which is a common Polynesian practise also found in the Philippines. It is generally accompanied by the idea that a man can copulate with a sleeping woman without waking her.

The Trukese

The Trukese are especially famous in anthropological literature for their sadomasochistic practises (which a western SM adept might not find particularly impressive, however). Women often like to leave a minor mutilation on their partner's body. Today, this mutilation is usually a series of cigarette burns arranged in two parallel rows down the upper arm on both sides; four six or eight bums in each row are normal. In the past, powder from dead breadfruit stumps was ignited on the man's skin, but it left a less neat scar. Women are not mutilated except for a scratch on the cheek from the man's thumbnail (men used to grow long thumbnails specifically for this purpose).

The Trukese have a variety of sexual preferences. Men appreciate women who urinate when they climax, and women also like it when a man urinates inside them after orgasm (this is reminiscent of the Yapese). What is valued in a woman is prominent labia minora and a prominent clitoris; girls often pull at their labia minora whenever they bathe — and they do so at their mother's request. Formerly small tinkling objects were inserted into the pierced labia minora and they sounded as the woman walked. These objects were matters of honor. If women got into a fight, one of them might get completely undressed and dare her opponent to compete in a kind of "vulva contest." They did so even in the presence of men.

The Trukese look with tolerance and good-natured amusement on the sexual activities of the old. Older women often entice dogs to lick their vaginas by putting fresh coconut meat in them; older men often perform cunnilingus on pre-adolescent girls. Both practises are viewed with acceptance and humor.

Unique customs

Among the Tikopia it is tabu for a man to touch his own genitals or the genitals of his female partner. During intercourse the woman may have to guide his penis into her vagina herself. Among the Wógeo, it is tabu for a man to touch a woman's genitals.

Ponape is, as far as I know, the only Micronesian island to have hit *Playboy* magazine (1976 December). The *Playboy* article referred to the sexual use of a certain large stinging ant native to the island. The ant is placed on the clitoris because its sting produces a brief but acute tinglingly erotic sensation.

The most extraordinary example of erotic ingeniousness developed by the Ponapeans involves the placing of a small fish into the woman's

vagina, which is gradually licked out by a man before they attempt intercourse. A fuller account is simply not available. And we may be dealing with folklore rather than actual practise.

Of the many interesting aspects of Marquesan sexual culture, two are perhaps most unusual. One of these is a husband's obligation to have sex with his wife almost immediately after she has given birth: as soon as she has expelled the afterbirth and has bathed in a stream. According to one informant, the husband should copulate with her in the stream itself. Doing so is believed to stop the flow of blood.

Another unusual feature involved the etiquette surrounding a chief: it was considered good form to talk about his genitals and this was done constantly. They were given names indicating their vigor and size.

The Western impact
The West had profound significance for Oceania: a mixed blessing at best and often painful to the natives of the area.

In many instances, traditional sexual morality was undermined. The result was the very opposite of what Christian missionaries and white colonialists were officially sponsoring. Sexual license often increased rather than decreased. This is said to be true in relation to the Murngin *gunabibi*, described earlier. The missionaries attempted to abolish the ceremony altogether, which encouraged the Murngin to play up the sexual aspects of the *gunabibi* even more, so that the sacred character of the whole proceeding was lost.

An even more striking account of missionary influence comes from Tonga, reported by Basil Home Thomson in 1894. The missionaries apparently succeeded in breaking down the traditional social structure and morality but were unable to build up a Christian counterpart.

Reactions to the whites set in throughout the Pacific and anticolonial movements proliferated. These were aimed at getting rid of whites but keeping their possessions. Although political, these movements often had religious overtones and are generally referred to as "cargo cults." In some instances, the sexual mores of a group were deliberately violated in the practise of the cult, or else some new notion about sexual style was taken up. The Tuka movement of Fiji in the 1880's is an example. It was founded by a prophet called Ndugumoi, who surrounded himself with a special group of female attendants. It was rumored that he had sex with these women but promised that they would remain perpetual virgins nonetheless as long as they drank a special holy water.

Another cult, which was quite radical in breaking old tabus, was the Naked Cult on the island of Espiritu Santo of Vanuatu (the New Hebrides). European contact had created virtual anarchy. The cult employed drastic measures to restore some semblance of order, including an overhaul of laws on marriage and sex. For example, marriage within a clan was now permitted although formerly regarded as incestuous. The cult got its name because of a ban on clothing and body ornaments. Christian missionaries convinced the European administration to take action against the cult, which was eventually driven underground.

The western and Christian influence on these movements was sometimes quite obvious even though they were anti-western and anti-Christian. For the Mambu Movement of the Madang district of Papua New Guinea, which occurred in 1937 to 1938, part of the initiation involved a "baptism" of the sex organs: women had their grass skirts cut away, and men their pubic coverings. Their genitals were then washed or sprinkled with holy water. After that, the initiates had to wear European-style clothes.

The initial western fantasy of Oceania as a sexual paradise lingers in Hollywood movies and elsewhere. But despite considerably more freedom than in the West, sex was never devoid of problems even here and could occasion considerable anxiety. The western presence did not alleviate these problems and sometimes added to them. Even language shows this: the Marshallese word for "venereal disease" is *merika* (from *America*).

SEVENTEEN THE AMERICAS

**They were not supposed to exist at all. St Augustine
had argued learnedly that people on the other side of
the earth were an impossibility. And there was
certainly no biblical reference to them.**

Almost without exception anthropologists are now agreed that the
aboriginal American peoples came from Asia across the Bering Straits at
least 25,000 years ago — possibly even 50,000 years ago. All these
Siberian immigrants had to pass through Alaska and must have had
skills and technology similar to those of more recent Alaskan peoples
merely to survive. Possibly they also had similar social and sexual
customs.

A base line for comparison with other New World cultures may
perhaps be built up from descriptions of Athapaskan Indian groups as
well as those of the Éskimo and their close kinsmen, the Aleút. The
Éskimo are probably the most recent immigrants and are unusual in
several ways, so that by including them we are probably making our base
broader or at least more generous than it really was.

The Éskimo and others

Marriage options seem to have been quite fluid among the Éskimo and
especially the Aleút. The Aleút had neither marriage or divorce
ceremonies, they permitted a man to have many wives and a woman to
have more than one husband, and also allowed group marriages. A wife
could be sold, loaned or exchanged. A man could legitimately have sex
with his wives, his brothers' wives, his wives' sisters, as well as
concubines. The only tabus involved parents and children, and brothers
and sisters related through their mother.

The various Éskimo groups had almost equally fluid arrangements.
It is generally said that men could have many wives and women many
husbands, but having more than one husband was normal only among the
Netsilik Éskimo.

People with the same name could not marry (some Éskimo groups did
not distinguish between men's and women's names) nor could people in
some groups who shared the same "amulet" (or magic charm). Mother-son

marriage has been reported from the Kóniag Éskimo (although a later source says mating between known relatives was discouraged by them). The Ingalik, a neighboring Athapaskan group, may formerly have permitted brother-sister marriage. The Hare, another Athapaskan group, seem to have tolerated brother-sister incest but forbade brother-sister marriage.

The great flexibility of these basic marriage rules makes it unlikely that any form of marriage would have to have been reinvented in the New World.

Sex hospitality and wife exchange are reported from both the Éskimo and Aleút. In anticipation of a catastrophe, Éskimo men would exchange wives, presumably because doing so changed the individuals' identity and therefore confused evil spirits. The Éskimo also practised "seed-raising," the use of vicarious husbands if a man was impotent or sterile. This suggests (but does not prove) that Indians entered the New World knowing about the relationship between sex and procreation. If this is true and an assertion that the Pomo of California at one time denied this relationship is also true, then a curious loss of knowledge must have occurred.

Institutionalized homosexual relationships occurred among the Kóniag Éskimo and among the Aleút, and involved some degree of transvestism.

These facts suggest that customs involving transvestism and homosexuality could have been part of the original New World immigrant pattern. However, neighboring Athapaskan groups show very little of either.

The Old and New Worlds
These northern cultures showed much tolerance and fluidity but they clearly lacked certain customs also found in Asia, Africa and Europe. The presence of such customs elsewhere in the New World means that they must have been invented independently of the Old World, where they also existed, for example:

A very high status given to virgins is found especially among the Plains Indians and among the Inka (Inca) of Perú, where women who broke their vow of chastity were burned alive.

In the Old World, Europe developed chastity belts, and the Caucasus developed chastity corsets. Among some Plains Indians and others, as part of their interest in female virginity a rope was bound around the loins of women as a symbolic "chastity belt."

At least at some levels the Aztec priesthood were required to be chaste. Apparently, certain classes of priests had to have their sex organs totally cut off.

No contemporary American Indian group practises male genital mutilations. But Palerm states that boys were aboriginally circumcised among the Totonác of Mexico. Voget notes that circumcision has been reported for the prehistoric Mochica. Early explorers among the Maya of Mexico sometimes said they practised circumcision, but a more detailed account by Diego de Landa, written about 1566, shows that this was not the case. Rather, the penis was cut in a variety of ways to draw blood for use in religious ceremonies. Landa also describes a ritual involving "penis perforation," in which a number of men had holes punched through their penes on the sides and then a long thread was passed through the hole. The same thread was passed through all the penes of all the men, binding them together. Blood from the wounds was smeared on idols. Landa adds: "and it is a horrible thing to see how inclined they were to this practise."

Only two societies are reported as practising any female mutilations: the Pano of Ecuador, who are reported as having developed clitoridectomy, and the Conibo of Perú, who seem to have developed a kind of infibulation.

Several Old World societies, including cultures in China and India (as well as the contemporary West), have been concerned about size of penis, and developed a number of techniques to enlarge it. This is seldom reported from anywhere in North or South America, but the Tupinambá of Brazil shared this concern. A report from the sixteenth century by Soares de Souza says that men let poisonous animals bite their penes, which caused the men to suffer for six months, during which time their members become so monstrously big that women could hardly stand them.

Australian aborigines, Hindu groups from India and some Indonesian groups deflower girls when infants by inserting a finger into the vagina. Finger defloration in the New World is reported from a few South American groups such as the Yãnomamö, Bororo and Tukano, as well as the Totonác of Mexico. Among the Totonác, the deflowering is done by a priest 28 or 29 days after birth: he inserts his fingers into the vagina to destroy the hymen and orders the girl's mother to repeat the defloration six years later. To my knowledge, no aboriginal groups north of Mexico appear to have a comparable custom.

The belief that menstruation is caused by intercourse is found in a number of New World groups: Tepoztecans, Apinayé, Timbira, Bororo. There are no reports of this belief north of Mexico.

Sheath covers for the penis are worn by certain South American groups such as the Kashuiana, Parantintin, Tupinambá and Tupi.

The practise of various kinds of foreskin tying has much the same distribution as that of penis sheaths, but was sometimes found in North America as well. The northernmost group that practised it was the Mandan, who lived along the Missouri River. They tied the foreskin with deer sinew during certain rituals. Návaho men did so before going into a sweat-house, otherwise (they believed) they would go blind.

The penis bar of the Araucanian Indians is like the penis bar of Borneo. The *guesquel* used among certain Patagonian tribes was made of hairs from a mule's mane and was comparable to the "happy ring" used in China made from a goat's eyelashes. The *guesquel* may not be aboriginally American since mules were introduced into the New World after Columbus. Possibly the llama or some other animal source was used more anciently.

Because agriculture developed independently in the New World, sex rules associated with it must have done so, too, even when virtually identical with Old World customs. Among the Maya Kekchi, Mam and various other groups, married couples had to abstain from sex before the planting of maize. But some Indian groups required that sexual acts take place before the planting.

Public copulation is reported from contemporary Aymará during carnival. Since this is hardly a Catholic custom, it probably represents a vestige of pre-Christian rituals. Among the Inka, who lived in the same general vicinity of the Peruvian highlands, massive public copulation sometimes took place. The historian Pachacuti states that the Inka ruler Huascar ordered 100 male dancers to copulate in public with special women.

Cieza de León, 1551, suggests that ritual homosexual acts took place on feast days between (transvestite?) priests and noblemen in certain areas of the Inka empire. Details are not clear. The Spanish invaders tried to stamp out all such practises, which they regarded as abominable. It is known that at least one Peruvian gold statue showing a homosexual act was destroyed by the Spanish.

There are Indians whose sensibilities approach those of the primmest Victorians. The Kuna of South America, for example, go out of their way to keep children totally ignorant of sexuality and refuse to permit

children to look at animals mating or giving birth. The Kuna are modest about exposing their genitals even in the presence of the same sex, and use euphemisms in talking about sex.

The notions that masturbation leads to insanity or blindness have been common in the west even in recent times. They are also found among the Náhane Indians of western Canada. Their belief may, however, represent a western influence.

A number of other apparent parallel developments could be cited. But I think the point has been made that many exist.

Sex in the high cultures of Mexico and Perú

Many of the sexual customs that developed independently in the New World are associated with the high cultures of Mexico and Perú. This is no surprise since this was the area where agriculture was developed independently and profound changes in society, such as the emergence of social classes, took place which paralleled developments in the Near East and elsewhere.

An extraordinary source of information is the erotic ceramics from Perú, associated with the Mochica culture from about 200 BC to AD 600. They are also found at about 850 BC in cultures of northern Perú known as Vicús and Salinar, and continued down to about in 1400 in the kingdom of Chimú. The tradition ended with the arrival of the Inka empire.

Precisely what the purpose of the ancient Peruvian pots was is not certain. Paul Gebhard has suggested that the sexual acts shown probably reflect actual sexual practises and tabus. At least they show that a particular sexual technique was fantasized about. There are some interesting gaps. Male, but never female, masturbation is shown. Fellation by a female is shown but never cunnilingus by a male. Male homosexual acts are depicted, but no instance of female homosexual acts is shown at all. Heterosexual intercourse in nine positions has been noted, including the missionary, Oceanic, woman-on-top and side-by-side rear-entry positions. Since in Mochica ceramics a woman is often represented having sex with a skeleton or corpse, these representations are hardly to be taken as clinically accurate. Rafael Larco Hoyle suggests that this motif indicates that the acts are disapproved and the pots are, in a sense, three-dimensional morality lessons.

From Spanish accounts, the Maya, Aztecs and Inka seemed to be quite intolerant about sexual deviations. Both the Inka and earlier Maya were monogamous, except that men in the highest social class may have

had many wives or concubines. The Aztecs allowed men to have many wives and also permitted the keeping of concubines. Spanish chroniclers denied that the Maya practised homosexual acts, although there may have been considerable local variation. The Aztecs and Inka were decidedly anti-homosexual and punished such acts severely, but in some areas of the Inka empire, notably in the district of Pueblo Viejo, they were apparently quite common. The Aztecs were very severe in their punishments of homosexual acts, transvestism, and father-daughter and brother-sister incest: death was by strangulation or stoning. Only in the Inka royal family was brother-sister marriage required.

The Aztecs also severely punished adultery and even fornication. If a man had a reputation as a womanizer he was strangled, shot with arrows or cast into a fire alive — if he survived the fire, he was beaten with maguey spines or with sharpened bone.

In at least one religious context, sexual license was permitted, but the result was death: the Aztecs practised human sacrifice as part of their religion. For 20 days before a victim was sacrificed he was given four beautiful, specially trained young women as a kind of earthly reward for his impending fate.

Marriage
The New World followed the basic trend in human marriage patterns in permitting a man to have more than one wife. The Kaingáng of Brazil are considered to be the only legitimate New World example of group marriage. The Aleút, with their extremely fluid arrangements, are possibly another. The Kaingáng are also unique for allowing father and son to share the same wife (this is very rare cross-culturally and is reported elsewhere only from a few areas in Tibet).

Permitting a woman to have more than one husband was sometimes allowed in societies that permitted a man more than one wife. In North America the groups that permitted multiple husbands include the Aleút, Bellacoola, Comanche, Tlingit, Éskimo, Pawnée and various subdivisions of the Klamath.

An example of brother-sister marriage comes from the Aymará of Bolivia and Perú, who, like the Balinese, permitted twins to marry. The Araucanians permitted father-daughter marriage, to my knowledge the only group in either North or South America that did so. Marriage between grandfather and granddaughter was possible among the Tlingit, though in the nature of things hardly likely.

In addition to marriage, several other options were frequently available by way of sex partners. Sex hospitality or wife lending is mentioned for a number of groups, but such customs seem to have been more common in North than in South America. Wives were exchanged in a number of social contexts. Among the Tarahumara, wives were exchanged as part of social drinking customs. Timbira men were expected to exchange wives after hunting special animals, such as the anteater, armadillo and peccary.

In a few societies a special class of promiscuous women was recognized who made themselves available without charging a fee. This was true among the Pápago and Pima, who called them by a name that meant "playful." The traditional Pápago myth of origin for such "wanton women" (as they are usually called in the American Indian literature) is that long ago a young man charmed them out by playing the flute and drove them mad. They always wore festive clothes. The relatives of such women did not punish them but allowed them simply to do what they wanted. The Ómaha, Osage and other Dhégiha groups also had such wanton women, as did the southeast Salish — but among them a promiscuous girl was sometimes killed by her father and left unburied.

Another approach to sex partners outside of marriage is night-crawling, found in both North and South American groups and similar to practises in Polynesia and elsewhere in the Pacific. A peculiarity of the North American version is that men sometimes crept into houses or slid their hands under tents merely to touch the genitals of a sleeping woman.

In spite of these possibilities for sex outside of marriage, many societies nevertheless held female chastity and fidelity in high repute — particularly the Plains Indians.

Sex beliefs, tabus and rituals
The belief that sexual misdeeds can harm others — usually the perpetrator's own children — is reported for a few groups. The obligation of confessing misdeeds to avoid causing this harm is reported from the Aleút, Ojibwa, Yurok, Timbira and Kágaba. The Crow once required a warrior to announce publicly before a war that he had slept with a married woman even in front of the woman's husband. The cuckolded husband could do nothing against the warrior, although he might leave his unfaithful wife.

Generally, people were quite free in their talk. For example, several groups gave sexual or other obscene names to places and people that

would be the height of bad taste in English. Hopi place names, for example, include: Horse-Kunt, Clitoris-Spring, Shit-Kiva. Examples of Crow nicknames are In-the-corner-of-his-balls and Shit-in-his-face.

Tabus in association with religious ceremonies and important or dangerous events appear to be the most common. The Mundurucú forbade a headhunter who had taken a head from having sex for a certain length of time, and both he and his wife were forbidden to look at someone who had had sex recently. The Zuni required warriors who had taken a scalp to abstain from intercourse for a year.

More commonly, it was the shaamans who had to abstain from sexual activity — among the Nambikwara, a shaaman (to ensure his powers) should not even see others engaged in intercourse. Sexual abstinence for several months was frequently the rule for people training to be shaamans.

Although no society in the New World formulated a doctrine quite like the "semen power" found in India and elsewhere, the Bellacoola of the northwest coast have a notion that is similar but unique: sxetsta "ceremonial chastity." What is peculiar about the Bellacoola version is that even though abstinence alone conveys power, abstinence coupled with intercourse (not necessarily with one's own wife) at ritually proper moments enormously increases that power. There is a special term for such intercourse: *xoldujut*. Even women (apparently lesbians) who live like men will hire men to sleep with them when they embark on a *sxetsta* cycle. Once the cycle begins, not to follow the rules leads to death.

In some societies, men were expected to go out on a vision quest to acquire supernatural power. Among the Crow and Klamath, sexual abstinence was seen as a necessary preparation for that quest.

A few groups forbid having sex outdoors (Tzeltál, Yúcatec Maya). The Hopi specifically forbade having intercourse in a cornfield because it would offend the Corn Maiden spirits who protect the maize crop. The opposite view was held by the Návaho and Mandan, who thought it a good thing to have sex in cornfields. A very few groups insisted that intercourse should be performed outdoors.

A tabu on intercourse during menstruation is reported from a few societies; probably many more have the same tabu. In some North American groups, breaking the tabu is believed to lead to immediate pregnancy. Some groups in both Americas say it causes sickness of one sort or another. Tabus during some part of pregnancy are recorded from even fewer societies. In a few Central and South American groups, it is

obligatory to copulate during pregnancy, sometimes right up to delivery, because semen is thought of as food for the foetus.

The most consistently reported tabus on sexual intercourse were those after birth. Long tabus of one year or more (up to three years) were found among Central and South American groups — often from tropical areas. Short tabus of a few days to a few months were found in North America, but not in South America except for nontropical groups.

The Jívaro forbid sex after planting narcotic plants (as well as while preparing poison for arrows). Few groups have extensive tabus in association with mourning, although formerly the Hare required a widow to abstain for one year, and the Tlingit for seven months.

The Hopi used a lot of simulated sex in their rituals. For example, at a shrine dedicated to a supernatural being called the Salt Woman, a man would insert his penis into a small black stone shaped like a vagina. He did this four times (a magic number).

The most dramatic instances of sex ceremonies in North America come from the Great Plains. The Mandan and Hidatsa believed that power could be passed from one man to another by having sexual intercourse with the wife of the man seeking power. This idea spread from the Mandan and Hidatsa to neighboring but unrelated groups such as the Arápaho, Gros Ventre and Blackfoot. The Cheyenne modified the notion that a woman could be the channel for the transfer of power and stopped short at real sexual intercourse: during the Sun Dance, the chief priest and the wife of the sponsor of the dance simply stayed under a bison robe for part of the ceremony.

In one Mandan ritual, the Buffalo Dance, the wife's intercourse was seen as a religious act of copulating with the bison, and thereby drawing power from the primal bison. The Buffalo Dance was performed to ensure abundant bison herds and prosperity to the Mandan.

The Gros Ventre changed this in their own ritual of power transfer by making it into a kind of sex test. This occurred in a ceremony known as the Crazy Dance, as well as in the Kit-Fox Dance. Again, it was the wife of a man who was the channel of the power transfer. The women assembled for the test were all naked and were handed over to ceremonial "grandfathers," who were also naked. A "grandfather" would lie on top of a woman, put his lips against hers, and pass a chewed-up sacred root or powdered "medicine" from his mouth to hers. But he was not to have sexual intercourse with her, nor was her husband to show any jealousy — that was the test.

Among South American Indians the Kágaba require ritual coïtus interruptus in some instances, religious offers of semen and sometimes of pubic hair and ritual copulation in association with mourning.

The Kubeo

Among the Kubeo (a subdivision of the Tukano), at the end of a boy's coming of age ritual he reportedly had to have sexual intercourse with his own mother in the presence of his father. That marked the official start of the boy's sex life. If this report is true, it is — to my knowledge — the only instance in the entire anthropological literature to record compulsory mother-son incest. Arthur Sorensen, who has done extensive field work in the area, doubts that it is true.

The Tukano in general apparently permitted public incestuous acts at a lunar eclipse and even on the occasion of a new moon. Non-incestuous public sexual acts are, if the reports are accurate, not considered shocking among the Tukano-Kubeo. The remarkable aspect of these rituals is the incest.

In spite of great sexual laxity among the Tukano-Kubeo, some things were forbidden. For example, real sexual intercourse between a brother and a sister was thought abominable, though external intercourse was tolerated. (Again, Sorensen doubts the accuracy of this assertion.)

A Kubeo girl was deflowered at the age of eight by an impotent old man with his fingers. He kept stretching at the vaginal opening until he could insert three fingers. When he could do that, he proclaimed "You are a woman." If this was not done before her first menstruation, it was believed that sex would always be painful and childbirth difficult. Although much of Tukano-Kubeo sexual life was performed in public this finger defloration was done in secret. The view was that a girl does not lose her virginity to the fingers of an old man, but through copulation with the moon.

Another interesting feature of the Tukano-Kubeo is that women were sexually aggressive (a trait commonly mentioned for Indians of the Amazon Basin). Rather than forgo sexual intercourse during nursing (which custom required), many women would rather not have children at all, and practised abortion or infanticide. The sexual passion of women was so great that many men sought relief by giving their wives anaphrodisiacs (medicines to cool ardor). Adultery in a woman was considered natural. In a man, it was a sign of hostility, not machismo. When adultery occurred, it was assumed that the woman seduced the man, not the other way around.

Other South American societies where women were said to be the aggressors include the Cayapa, Choroti, Kallinago and the perennially interesting Kágaba, where groups of women have been known to rape men on occasion. In North America, such levels of aggression were seldom reported but in some groups night-crawling took place not only by men but by women, too.

Sexual statistics and techniques
The Yurok believed a man who could copulate 10 times in a single night would become rich. This number was apparently considered so unlikely that something extraordinary would have to be associated with it. The Polynesian mentioned in the previous chapter who copulated 31 times in one night would surely have become the Yurok equivalent of a multimillionaire.

But we cannot really know anything definite because of a lack of reporting and the fact that many of the societies described no longer function in a traditional way.

Information about sexual technique is equally sporadic and unsatisfactory, but perhaps somewhat fuller. Few societies are reported as using more than one coïtal position.

Rear entry was reported from a number of South American societies: the Ona, Chiriguano, Nambikwara, Timbira, Apinayé, Sherente and Guayaki. From a world-wide perspective this is high.

The missionary position was reported as the most common position in North America for the Hopi, Návaho, Nahane, Crow and Penobscot (the last two according to Ford and Beach); and in South America, for the Araucanians, Carib, Kágaba, Kaingáng, Chamacoco, Kaskihá, Tapicapé, as well as the Rãmkokamekra (a subdivision of the Timbira), Barama, Colorado and Rucuyén (the last four also according to Ford and Beach).

The Cashinahua of southeastern Perú normally use variants of the Oceanic position but others are known, including rear entry. A standing position occurs when chance of discovery is great — even for married couples. The preferred form is, however, the missionary position — especially when performed in a forest stream or a shallow pool of water, which cuts insect attacks down to a minimum.

In addition to rear entry, the Nambikwara used a variant of the missionary position not recorded elsewhere as a standard form of intercourse. The woman lays on her back with the man on top facing her, his right leg between her legs and his left leg outside them.

A peculiarly South American penchant for copulating in a hammock has its risks. The Sirionó often joked about the awkwardness of the whole business. Sometimes — virtually at the moment of orgasm — a man's knees would slip through the holes of the hammock and he would get an unpleasant emotional jolt.

Fellation was used by the Ojibwa and Pomo in both heterosexual and homosexual encounters. The Nahane denied practising fellation and also rejected cunnilingus as poisonous. The Ojibwa thought that it was disgusting, the Hopi that it caused sickness, the Yurok that it would keep the salmon from running. Aboriginal Americans were not noticeably oral in their sexuality.

Foreplay is seldom reported, and kissing in the European sense seems not to have been aboriginal, although it is reported for the Hopi. No society is reported where men are interested in delaying ejaculation to help their partners achieve orgasm. In general, quick ejaculation seems to be the ideal.

Homosexuality and transvestism
Two patterns for homosexual relationships predominate in the Americas: pathicism, in which one of the partners is a transvestite (almost always referred to as a *berdache*), found primarily in North America; and adolescent experimentation or deprivation, in which young men who have little or no access to women have sex with each other — the most usual South American pattern. Information about female homosexuality is scanty.

Several societies are mentioned as having berdache, but whether they were homosexual or not is often not discussed. Walter L Williams's book on the berdache, *The spirit and the flesh*, reviews the whole subject and asserts that the way the berdache were (in many instances, still are) conceptualized is remote from western categories and might therefore be misunderstood. In the first place, he cautions that we cannot assume that they were completely absent from any American Indian culture, though they are not reported from most of eastern North America. Second, Indians themselves often play up the spiritual and religious aspects of the berdache role, while taking the androgynous sexuality of the berdache as a given. Interestingly, Williams points out that the early Gay Liberation movement in the United States was at least partly motivated by the knowledge that the berdache were almost universally treated with tolerance and in many cultures, great respect.

In one North American group, the Nahane, there were remarkably enough no male transvestites at all, only females. Cross-culturally, this is almost unique as far as I know (the closest parallel, which shows many striking similarities, is found among the Albanians of Europe). If a married couple felt they had too many daughters and wanted a son to hunt for them when they got old, they picked one of their daughters to live like a man. When the girl was about five, the dried ovaries of a bear were tied to her belt (the reason for which is not clear) and she was henceforth raised as a boy. Later on, such a girl would very likely have lesbian relations.

Several societies permitted homosexual marriage. Male homosexual marriages were reported from the Arápaho, Návaho, Klamath and Achómawi. The Achómawi and the Sawa'waktödö (a Northern Paiute group) recognized female homosexual marriages.

These customs are in marked contrast to American cultures from Mexico and farther south. Although homosexual behavior seems to be quite common in a great many societies there, transvestism is much less commonly reported. Among the Warao, the only male transvestite seen was said to be married to three men younger than himself. Another society, the Tupinambá, recognized pathic homosexual marriage as well, but only involving women.

The Yãnomamö, written up in famous studies by Napoleon Chagnon, are particularly interesting in terms of a causal model that links warfare and homosexuality to the widespread practise of killing off girl babies and of developing an extremely brutal version of male chauvinism. One view of this whole complex offered by Marvin Harris suggests that the Yãnomamö had experienced a population explosion possibly because of the acquisition of steel, axes and machetes, originally of white origin, and also because they had begun to grow bananas, and plantains introduced into South America (where they are not native) after Columbus. The growth in population led to a need to expand into other areas already settled by Indians, and also to cut down on the population. The consequence: warfare and female infanticide. But the killing of girls led to the need for even more warfare to raid neighboring groups for their women. Even so there was a tremendous sex imbalance, with the result that almost all bachelors had sex with each other.

Tobias Schneebaum discusses a Peruvian group, the Amarakaeri (Amarakaire) where the young men also seem to be universally involved in homosexual acts. According to Schneebaum, most tribes in that

general area show the same general homosexual pattern; if so, it may be independent of a population explosion model.

Many have been skeptical of Schneebaum's description, however. In a sense it receives support from observations by Arthur Sorensen of groups in northwest Amazonia, primarily the Kubeo mentioned earlier, but also other groups speaking fairly divergent languages. He noted frequent acts of fondling, sometimes even mutual masturbation between males, at least when women were believed not to be witnesses. This behavior is cross-culturally quite unusual since it involves sex not only between young bachelors but apparently any adult males of about the same age, none of whom are involved in cross-dressing (this is known technically as male homosexual adultophilia, or androphilia).

Information about female homosexuality in South America is scanty and minimal, as elsewhere. An almost lyrical note is recorded for the Araucanians. It is said that lesbian acts are common among young girls in the spring, but such activities are generally regarded as a sign that the girls are now ready to marry — boys.

Other forms of sexual behavior
Information about masturbation, sex with animals and paraphilias is uneven but suggests a wide variety of attitudes and behaviors throughout the Americas. Sex with animals is said to have been unknown among the Chiriguano, but common among the Crow, who apparently had no scruples in having sex with mares and wild animals that had just been killed in the hunt. Ojibwa women also made use of dogs, but Ojibwa men had a more varied cast: not only dog, but also moose, bear, beaver, caribou — and porcupine! Despite this apparent freedom, all forms of animal contacts are tabu among the Ojibwa. The Hopi regard sex with animals unemotionally, with neither guilt nor affection.

In South America, several groups have made use of the llama or related alpaca for sexual outlets. Under the Inka, laws were enacted against this and llama drivers were not permitted to make journeys unchaperoned but had to be accompanied by their wives. An interesting aspect of llamas/alpaca-human contacts is the theory that syphilis may thus have been transmitted to human beings.

Biting and scratching in a sexual encounter are sometimes reported, for example from the Mataco, Ojibwa and Nahane. Hints of sadomasochistic tendencies in a few particular people have been noted for the southeast Salish. Sirionó lovers seem not to have been particularly gentle: poking a finger in the eye counted as affection, and

couples emerged with scars after passionate encounters in which head, neck and chest had been bitten and scratched — the scars being something of an embarrassment in the case of an illicit interlude.

Rape has been reported primarily as gang rape, often as a form of punishment of a woman's adultery. This was true, for example, for the Cheyenne and some other Plains Indians. In South America, among the Bororo any girl not married by puberty was fair game for gang rapes. Gang rapes by women of a man are reported only for the Kágaba.

The Návaho believe that a woman is able to defend herself against rape. Her strategy: grab the man's penis and threaten to drag him home. He would, it is believed, almost certainly give in because of the pain and fear of scandal.

Some groups, such as the Tepoztecans and eastern Apache, discouraged childhood sexuality as much as possible, and punished masturbation quite severely. But in other societies, even adults openly played with the sex organs of children. Babies have their genitals stroked by their mothers among the Hopi, Návaho, Sirionó, Kaingáng and Kubeo. In a few instances, such contacts decidedly approach paedophilia. Among the Yãnomamö, for example, fathers would often put their mouth on the vulva of their little daughters and suck on it.

A more unambiguous case of cultural paedophilia comes from the Sirionó. Not only did a nursing mother fondle her infant son's penis until he got an erection, she then rubbed his erect penis over her vulva — which was not necessarily to soothe the child. Similarly, men have been observed getting partial erections (men wear no clothes at all among the Sirionó) when playing with the sex organs of infants. The Sirionó approach to adult-infant sexual relations was exceedingly casual and open — and probably quite shocking — to western sensibilities. In the light of psychoanalytic theories about the effects of childhood seduction, it is important to know what, if any, the effect of such treatment had on adult sexual adjustment. As far as the Sirionó go, sex did not seem to present an area with many adult problems. But this may just possibly be because they were so preoccupied with food and fearful of going hungry.

Among the Trumai, little boys would often initiate sex play with men (seldom did men start it) and sometimes even with their own fathers. The boys would pull at the man's penis.

The Kágaba

The only society in all of North and South America — indeed in the world — where adults generally admit that masturbation is their preferred form of sexual release is the Kágaba. Furthermore, only among Kágaba — again, from a worldwide perspective — are sexual contacts with animals said to play an important part in the sex life of almost everyone in the society. Children of about five or six are frequently subjected to sexual advances by adults, so there seems to have been an exceptionally high incidence of paedophilia. The Kágaba are one of two peoples in the world about whom it is reported that women commit rape (the other being the Trobriand Islanders of Papua New Guinea). And in the introductory chapter they were singled out as possibly the only society in the world where, in order to expiate for the sin of incest, incest has to be repeated.

Information on the Kágaba comes from a number of sources. There seems to be enough consistency in the accounts to take them seriously. The Kágaba are an agricultural people of northern Colombia. They developed an elaborate cosmic theory of sexuality, referred to in Chapter One, that ideally should have suppressed all masturbation and incest but which in fact was accompanied by a reality where both seemed to have occurred to a remarkably high degree — along with what might have been the highest rate of sexual dysfunction for men anywhere in the world.

Their general attitude to sex is that it is dangerous and bad. The Kágaba ideal is to abstain totally from sex and to become asexual. This is a view held most often by men. Women seem to be much more positive about sex but generally bemoan the fact that they are sexually unsatisfied. Perhaps the occasional instances of rape by women relate to this.

Men have an extraordinarily high rate of impotence, which several openly admit. These sexual dysfunctions may have come about because of bad diet, ritual fasts, alcoholism, the consumption of coca (thought by the men to lessen sexual interests) and religious beliefs. But there is an additional factor that they recall with dread: as soon as a boy was thought old enough to copulate, he was put in charge of an old woman with whom he had to have intercourse. The woman was a widow, usually between 50 and 60 — which in that society probably meant quite wizened and toothless. As in other ritual copulations, the sexual secretions were collected and offered up to the god of sexuality. Men remember this experience with horror. When they talked about their own impotence (which occurred just before ejaculation), men tended to

relate it to their first experience of copulation with the widow, and said
that they "remembered the old woman."

The Mehinakú

The Mehinakú, thanks to the full-scale treatment of the subject by
Thomas Gregor, are the best studied aboriginal group in either North or
South America with respect to their sexuality. Although seemingly
sexually permissive, the Mehinakú perceive sex as dangerous at the same
time that it is desirable. The title of Gregor's book conveys this
ambivalence well: *Anxious pleasures*.

The Mehinakú of central Brazil live in the Amazon and share many
features of other Amazonian groups already mentioned, such as the
Cashinahua. They are enthusiastically heterosexual, and sexual liaisons
are commonplace. Gregor found during his last visit that 37 adults were
involved in approximately 88 extramarital affairs. The average for men
was 4.4 (one man had as many as 10). The behavior of women was more
varied, but two reportedly had 11 or more lovers. An adulterous wife
is usually (if grudgingly) tolerated as an economic asset to her family
because of the presents she gets from lovers. However, men tend to say
that women are "stingy with their genitals." It is not clear if women
experience orgasm.

The Mehinakú tabu masturbation, homosexual acts, and sex with
animals (all of these behaviors reportedly are nonexistent or exceedingly
rare). They also tabu incest, sex with Indians of other tribes, and sex
with white people.

Romantic love is considered absurd, and public affection between
husband and wife borders on bad taste.

Sexual encounters tend not to include foreplay. The missionary
position is disliked, being considered unattractive and especially
vulnerable to insects. The most common position involves both partners
seated on the ground facing each other, the women's legs over and round
the man's thighs. However, other methods are used including a side-by-
side position in a hammock, which apparently requires great gymnastic
dexterity. Standing positions are also reported, either on dry land or
submerged partially in the water in bathing areas.

The only possible paraphilia reported may be a clothing fetish: the
G-string worn by women — universal though it is — would seem to be a
considerable turn-on.

Unique customs

Certain customs or beliefs associated with sex reported from the Americas are unique, or nearly so, even cross-culturally. Some of these have already been mentioned; others include the following.

The Kabedile Pomo did not practise vaginal intercourse on the wedding night because the bride was likely to be a virgin and vaginal penetration was believed to hurt too much. Instead, the bridegroom penetrated her anally (which does not sound like much of an improvement).

Nootka brides were sometimes very hesitant about consummating the marriage at all; some were known to delay for several months. If the groom found his wife totally unresponsive to his advances, he would cut off (or bite off) the end of her nose. The bride's family sided with the husband if they wanted the match to continue. This act of the husband's was said to be 100 percent effective.

Among the Pawnée, a woman could have sex with one man only, in any given menstrual period. This was to make sure that she would know who the father of any resulting child might be. As soon as she knew she was pregnant, she told the man, who was then obliged to be concerned with the child's welfare and had to supply it with fresh meat until it reached maturity. In other societies such rigor in establishing paternity was associated with marriage rules only. The Pawnée rule is apparently the only one to occur outside of the framework of marriage. It would be interesting to know how scrupulously it was observed.

Puna Indians of La Paz, an Aymará group, had a belief that clearly developed after contact with Europeans, but possibly reflected some older notion that had been transformed to fit a Christian setting. According to David Forbes (writing in 1870), the Puna believed that on Good Friday any crime could be committed without fear of punishment and sexual sins would not count as sins. It was said that on that day, fathers had been known to rape their own daughters in the presence of their mothers. The folk explanation for this extraordinary license was that on Good Friday, God is dead and for that reason could not remember anything the next day.

This chapter started out by citing speculations denying that the American Indians could exist. Not only do they exist: they provide incredibly rich data for anyone mapping the sexual variations of mankind.

EIGHTEEN EUROPE AND EUROPEAN OUTPOSTS

A contraceptive culture. A people addicted to masturbation and pornography. The only civilization to develop a *scientia sexualis* (science of sex) but lacking an *ars erotica* (art of love).

These labels, and many others like them, are attempts to characterize in part or in whole the vast culture complex developed by Europeans and their cultural kinsmen outside of Europe. Michel Foucault, the modern French philosopher, relates these attempts to what he thinks is really a European cultural rule: translate sex into talk. Although first crystalized in the seventeenth century, this "rule" goes back to the mediaeval penitentials and the church requirement of confessing all sexual sins. It stays with us in the form of seemingly interminable pornography and of psychoanalytic sessions — or the writings of certain anthropologists, alas!

Many aspects of western sexuality have been discussed throughout this book. This chapter will deal primarily with prehistoric and folk perspectives.

Some of the folk cultures have preserved customs that city people from industrialized centers would find remote and exotic. This is particularly true for certain areas in the Balkans where ancient kinship structures have survived into the twentieth century.

The Balkans
In rural Balkan communities there seems to be a very lively sense of the difference between "sacred" and "profane" women. Sacred women include one's mother, sister and wife. Sex with a wife is not regarded as fun (although it might be pleasurable): after all, a sacred woman cannot be expected to be a whore in bed. Sex as fun can be found only with profane women: gipsies, singing girls from cafés, widows who have become prostitutes, foreigners and particularly Skandinavian tourists.

There is the expectation that men are intensely interested in sex, but women are sometimes said to dislike intercourse. Among the Sarakatsani shepherds of Greece, women often deny that they find any physical pleasure in sex at all. During intercourse, a decent woman should not move and should not make noises. A Sarakatsani bride sometimes

threatens before her wedding to hide a knife under her clothes so that when the bridegroom comes to claim her virginity, she will be ready to castrate him.

Sexual intercourse is thought to have its dangers. Shepherds throughout the Balkans tend to avoid intercourse in certain critical situations. In Rumania, they avoid women altogether from the time they arrive at the spring pasture lands until July 20 (the Feast of St Eloi). The Sarakatsani feel that the shepherds who milk ewes should be unmarried. In any case, a man must wash his hands before milking if he has slept with his wife.

Similarly, Bulgarian peasants believe that soldiers in active service would be quite vulnerable if they engaged in intercourse. These notions are clearly associated with ideas of ritual pollution rather than anything else. The Sarakatsani regard male virginity much as Hindus do: as a source of power and invulnerability. A virgin soldier, for example, is thought to be invulnerable to bullets. Sex, sin and death are all related in the Sarakatsani world view; virginity and continence are life-giving and life-preserving.

Throughout the area, male dominance (at least publicly) is the order of the day. In Montenegro, Serbian women may not eat at the same table with men and are expected to kiss men's hands as a sign of greeting, to rise when they enter the room, and to step aside to let them pass on the road. Public affection between husband and wife is forbidden.

Eugene Hammel writes that among Serbians sexual intercourse may be fairly infrequent for a married couple. One time, when he was asking some working men about the monthly frequency of intercourse between husband and wife, he received the answer, "Better to ask about *yearly* frequency."

Sex hospitality used to be practised in what was formerly Yugoslavia and some historians think it was widespread. "Seed raising" was found in some areas; among Serbians a priest or monk could serve as the vicarious husband. There was also the custom of marrying young boys to much older girls (the boy's father very likely having sexual relations with his daughter-in-law), a practise known by the Russian term *snoxácestvo*.

Faithfulness in a wife is expected. There are cases reported where husbands have been away from home for five and six years on end and even so their wives are (believed to be) faithful. Nevertheless, some evidence suggests that at least among Serbs the brother of the woman's husband may take some sort of sexual liberties with her. One man who was teased about fondling his sister-in-law's breasts said: "She's mine down

to her belt; below that she's his." Another Serbian custom permits the best man (usually the groom's brother or another male relative) to sleep with the bride on the day of the wedding and for the first two or three days after she has gone to her new home. They are not to have sex but only to sleep together fully dressed.

Trial marriage is reported in some areas of the former Yugoslavia and also among Albanians where a couple could cohabit once they were betrothed but no marriage ceremony would take place until the birth of a son. The birth of a son was so stressed that even though a woman might have borne several daughters and in spite of church pressures, a marriage might never take place. A woman who never gave birth to a son would be regarded as worthless and treated like a widow (although she might stay in the family house).

Among the Dinaric Serbs, a sense of honor was so intense that a simple thing like a wedding party could end in a tragedy. Marriages traditionally take place only in certain months of the year, and a potential calamity could occur if two wedding parties were going in opposite directions and met each other on the same road. For one party to step aside and let the other pass would be an intolerable admission of inferiority, a serious blow to one's honor. Unfortunately, these wedding parties went about armed. Sometimes fights would break out so serious that the result was almost the complete annihilation of both parties.

The same kind of sense of honor obtained when a girl was kidnaped from a village, to be married by capture (this sort of thing still occurs occasionally but seems to be rigged with the girl's permission). In such an instance the honor of the girl's whole village was at stake, but it was an even greater question of honor for the kidnapers, who were prepared to die rather than give her up.

One of the customs reported from Albania is to my knowledge unique in Europe. A girl could escape from an arranged marriage in only one way: she must find 12 elders of her tribe and in their presence swear that she will remain a virgin for the rest of her life. Once she had done so, she was allowed to dress and behave as a man, carry arms, eat and smoke with men (otherwise forbidden), and work as a herdsman. If the woman eventually broke her vow, the honor of the 12 elders who vouched for her would be blackened and a blood-feud could ensue.

Although trial marriages are reported from some areas, ideally a bride should be a virgin. Proofs of the bride's virginity in the form of her bloodstained nightgown or sheet were publicly displayed after the wedding night. Among Greeks, the custom usually took the following form: the

bride's mother-in-law was the one to do the testing by sticking a finger into the girl's vagina. Without this proof, the bride's family was disgraced.

Among Catholic Albanians, the marriage bed was prepared at midnight on the wedding day by two female attendants who undressed the bride, put her into a long silk shirt and laid her forcibly on the bed. The groom was brought in by two male attendants. The wedding guests waited outside the bridal chamber and sang traditional marriage songs and shouted advice through the keyhole until the consummation had taken place and the bridal couple emerged completely re-dressed as befitted their new status. Only then were they left alone.

Among Slavic groups even outside the Balkans, a married couple had to be seen in the marriage bed together by a number of witnesses. In Pojko, Czechoslovakia, the bride and bridegroom had to lie down on a blanket spread out before the wedding guests. Another blanket was spread out over the couple; after a few minutes, the couple got up, clasped hands, and wine was poured over their hands. No copulation actually took place. Among Russian peasants, copulation on the wedding day has been described as so important that if for some reason the groom could not actually perform, he would have to call in a friend to take his place.

The Irish

At almost the opposite end of both the geographical boundaries of Europe as well as of the sexual spectrum are the Irish. According to a controversial study by John Messenger, who studied the rural Irish of Innis Beag (a fictitious name for a community in the most conservative part of the country), they may be among the most sexually naïve people in the world.

Sex is never discussed in the home and there is no formal sex education because "after marriage nature takes its course." Marriage is late. The average age for men is 36; for women, 25. A high percentage of the adults are single (29 percent). Premarital sex is said to be limited to masturbation. Marital sex is always in the missionary position with little foreplay. Women seem not to know about or experience orgasm. Nudity is intensely disapproved of: intercourse takes place between husband and wife with at least some clothes on.

According to Messenger, the Irish have produced a culture that has traditionally been fearful of overt sexuality. He cites sources to show that St Patrick himself was surprised to observe how Irish converts to Christianity flocked to monasteries and nunneries with a zeal unknown in other parts of Christendom.

Messenger's picture has been severely attacked by informal Irish critics. An earlier study of rural Irish society by Arensberg and Kimball, *The Irish countryman*, goes along with the strictness of sexual morality but adds that "the country-bred boy and girl grow up in an atmosphere of constant reference to sex and breeding." It must be added that other commentators on the Irish scene have reported that some married couples were childless because they did not know the basic facts of procreation.

The industrialized urban West
The West has indeed become a contraceptive culture tolerating more and more premarital sex for both men and women. The double standard has, in some areas, given way to one in which women have practically equal rights to sexual outlets.

This modern culture is virtually unique in the world's traditions in making sex almost totally profane: there are no fertility ceremonies or phallic cults, and even tabus on sexual intercourse (such as before an athletic event) are justified for health or hygiene rather than ritual pollution or sin.

Specific sexual interests that have developed in or are practically restricted to the area include the enormous interest in written and especially photographic pornography. The very category of pornography is probably missing in most societies. The "pillow books" of Japan — illustrated sex manuals given to married couples at their wedding — are not thought of as pornographic in traditional Japanese society but would probably be in a traditional European context.

Even drawings and sculptures that are specifically made to be sexually titillating are seldom if ever found in primitive societies, although outrageously "sexual," representations occur in fertility cults of some religions. At present, pornography of all kinds is a major multimillion dollar business in America and Europe, with millions of people actively involved — either in its production or in its enjoyment. One of the extraordinary signs of the increased respectability of pornography is the film *Caligula*, dealing with sexual depravity in the Roman Empire, showing not only copulation but also fellation and cunnilingus (both heterosexual and homosexual) as well as simulated gantizing. Its cast included very well-known and respected actors (Malcolm McDowell, Peter O'Toole, Helen Mirren and Sir John Gielgud).

Another development of cultural interest is male homosexual adultophilia (or androphilia) in which the partners are both adult and neither tries to change his sex role (say, by becoming a transvestite). This

is rarely reported outside the western world. For the most part, true homosexual adultophilia is essentially a northern European, especially English- and German-speaking phenomenon; elsewhere pederasty or pathicism (which involves transvestism or extreme effeminacy) is still a common and perhaps predominant form of homosexual interest. The modern lesbian pattern (where at least some women adopt male hairstyles and male clothing but not to the extent of trying to pass as men) seems to have emerged at more or less the same time, in the early eighteenth century.

A last striking aspect of western sexuality is the development of a number of paraphilias virtually absent from other cultural areas. Sadomasochism in particular seems to be a northern European phenomenon, associated primarily with Germanic-speaking groups. Fetishism is also more frequently reported from here than in other areas. Precisely why these distributions should be so, is not clear. A very general explanation is that western societies are perhaps more repressive of both sexuality and aggression in general than most other cultures and that these interests are realized in more indirect ways than elsewhere. Also, it may simply be a matter of reporting.

Sexual customs and religious boundaries
In general, features of sexuality and sexual customs seem to follow the division of Europe along historic religious boundaries. Thus, the extreme development of sadomasochism and other paraphilias as well as homosexual adultophilia come from historic Protestant territories. Protestant areas sometimes also developed various kinds of trial marriages or permitted some sort of premarital sexuality for both boys and girls, whereas the Roman Catholic areas were more usually involved with an honor and shame complex, where the bride's premarital virginity was highly stressed.

Such customs as "handfasting" in Scotland or "ring engagement" *(ringforlovelse)* in Skandinavia (which tacitly permits intercourse before the actual marriage ceremony) seldom have counterparts in southern Europe.

Eastern Europe, associated primarily with Eastern Orthodox Christianity, has been characterized by a more lively sense of ritual pollution and still observes tabus that were discouraged in western Europe at least as early as Pope Gregory in about 600. In Eastern Orthodoxy, for example, menstruating women are not allowed to take communion, nor may they kiss holy pictures. Women cannot even serve as cleaners behind the holy doors of the church (the ikonóstasis) for fear that menstrual blood might possibly contaminate the altar. There is some evidence that even

in Roman Catholic Poland, which borders on the strongholds of Orthodoxy, this notion of ritual uncleanliness survives. It is no wonder that with such beliefs, the Eastern Orthodox churches broke off talks with the Anglican Communion when American Episcopal churches ordained women as priests. It is interesting to note that Pope John Paul II, who has come out against women as priests, is Polish.

In Greek Orthodox households, holy pictures and crosses are not allowed in the bedrooms of married couples: copulating in their presence would be an act of sacrilege. (Peasants who live in one-room houses do not observe these niceties.) This is very different from Roman Catholic practise, where crucifixes are regularly found prominently displayed over the beds of married people. (In some parts of Spain — and possibly elsewhere — holy pictures are turned to face the wall during copulation.)

The Orthodox churches maintain a tabu on milk incest: a person may not marry the child of his wet-nurse. The feeling that this is incestuous is widely found among older people in the Soviet Union, even among atheists and Jews (elsewhere Jews do not observe such a rule). In other parts of Europe, for example Italy and Majorca, de facto milk incest seems to be observed not so much as a religious rule but simply as a folk custom.

Eastern Orthodox groups also require atonement for nocturnal emissions.

In many ways, then, the Eastern Orthodox groups preserve an ancient tradition that was given up several centuries ago in Catholic and Protestant Europe.

Ancient and prehistoric Europe

Prehistoric cave art gives a very flimsy picture of sexuality. What exists is subject to very differing interpretations. In any event it can be said that in the cave art of the Paleolithic (the Old Stone Age, lasting in Europe until about 10,000 BC) — stretching from France and Spain to Siberia — no representations of either human or even animal copulation exist. There is one dubious exception: an unfinished double sculpture from Laussel from about 23,000 years ago, accepted by a few archeologists as a genuine scene of human sexual intercourse (in a flattened-out, stylized Oceanic position). Others think that it shows a woman giving birth or some sort of hermaphrodite or possibly an unfinished representation of a woman.

Statues of women (Venus figurines) of very large proportions are fairly common, as are drawings that seem to be kusthic symbols (symbolic vulvas).

The Venus figurines have occasioned much speculation as to their function, origin, and so on. They are usually interpreted as fertility objects; some have seen them as associated with the worship of mother goddesses. On the other hand, Stanley Meltzer has maintained that they might merely be realistic representations of the woman of that era, who for reasons of diet tended to be fat. Mariam Slater believes that they are derived from naturally occurring stone shapes, made human-like with only a minimum amount of carving. A recent and most intriguing explanation has been offered by LeRoy D McDermott, who has provided tantalizing and very specific bits of evidence that they are the self-portraits of pregnant women. If this is so, then the earliest artists may well have been women — something that should confound male art historians who wonder why there have been no early women artists.

Very few unambiguous phallic symbols are found and representations of men (as opposed to women) are fairly rare. Elizabeth Fisher thinks that this probably means that people then did not connect fertility, their prime concern, with sexual intercourse. Phallic symbols, she believes, became important only after the male role in procreation was realized, which she assumes began with the Neolithic, the great cultural revolution that involved the cultivation of plants and domestication of animals. However, hunting and gathering societies are known to have a knowledge of the importance of sexual intercourse. Even Australian aborigines, who have been cut off from Neolithic insights — and have often been described as ignorant of paternity — have proved in at least some instances to have had a perfectly practical knowledge of the "facts of life" — as Lloyd Warner has shown for the Murngin.

Some scholars are willing to see phallic representations in Paleolithic art. A number of pierced staffs from France have been interpreted as phallic objects, possibly even used for ritual defloration. From La Madeleine, a "double phallic" staff has been found as well as a bone incised with a picture of a bear possibly licking the end of a penis.

It seems very unlikely, however that we shall ever be able to find out the symbolic value of cave art in any convincing detail because to do so would mean somehow getting into the minds of people long dead.

To return once again to phallic symbols. The ancient Romans used them in a variety of situations, often highly decorated, to ward off evil.

Statues and drawings of gods with erections also figured in Old Norse religions. The god Freyr was depicted with an enormous penis and it may be that he was worshiped with ritual copulation. The penes of stallions were used in magic. Such practises seem now to have almost entirely

disappeared from the European scene except among the Lapps of northern Skandinavia where reindeer penes as well as reindeer uteri are sacrificed to the family gods. The Lapps are not necessarily representative of an earlier form of European culture, however, but are more closely tied to Siberian cultures, discussed in the chapter on the Far East.

Phallic breads and cakes persisted in many parts of Christian Europe in spite of their pagan background. What is perhaps more striking are reports that certain saints believed to help in curing impotence and childlessness are really priapic holdovers from ancient fertility cults. Such saints included Paterne (or with the more obviously procreative name Paternel), who had a shrine in Bretagne, and Guignolet, who had shrines in several French towns at least until the French Revolution in 1789. Guignolet was depicted "indecently" according to hostile accounts — which presumably means that he was shown with an erection. This was true of statues in Montreuil and Brest. At Brest, women who hoped to be cured of infertility would take scrapings of the statue's penis, mix them with water and drink the concoction.

There was perhaps a kind of counter-Christian cultural base. Some representations often include crude and sometimes even skatological carvings on the outside of churches including the so-called shelah-na-gig figures of women exposing their vaginas. Horseshoes still hung over doors are supposedly a vestige of these figures once meant to frighten off the devil and other evil spirits. But more subtle touches are also found: unmistakable phallic carvings in otherwise innocent contexts, or the visual double entendres of scenes as sacred as the Flagellation.

The reverse may also be true, in the case of, say, much of Michelangelo's religious work, now taken to be entirely appropriate from a religious point of view but denounced when first exhibited. The nudity of Christ and the saints in his *Last judgment* was condemned as fit for a brothel and forced the overpainting of pubic coverings by another artist, Daniele da Volterra (called, contemptuously, *Il Braghettone* "the trouser maker.")

Even statues that did not show total nudity were described as "figures that undermine faith and devotion" carved by "that inventor of obscenities, Michelangelo Buonarroti." One of these is the *Pietà* now in St Peter's. Leo Steinberg in a fascinating analysis of the statue points out that it is almost identical in composition and treatment with pagan depictions of Venus lamenting the death of her lover Adonis.

More surprising is Steinberg's analysis of another *Pietà*, now in Florence, which originally made use of a pagan symbol of sexual union or

sexual aggression revived in the Renaissance: the slung-leg motif. Christ's left leg was originally slung over the Virgin's thigh, as indicated by a drawing from the original. Steinberg points out that this use of the slung-leg motif was "a direct sexual metaphor" employed "on a scale unprecedented in Christian devotional art." But Michelangelo himself smashed the statue and when it was restored, refused to have the left leg replaced. Could it be that even for him the sexual imagery in dealing with the Virgin as the Bride of Christ was too much?

Some art from important European masters was not veiled sexual symbolism but straightforwardly erotic, and almost always remained — until recently — private or secret. One of the most famous of these is the erotic frescoes painted by Raphael for Cardinal Bibbiena's bathroom in the Vatican. Several of these were subsequently whitewashed. The Vatican seldom allows even scholars to visit what remains.

Even more famous are the drawings by Giulio Romano, which appeared in a book of obscene sonnets by Pietro Aretino published in 1527. (These have already been discussed in Chapter Three.)

The study of pornography could be pursued in some detail with reference to a variety of cultural implications. But what must be conceded is that pornography has played an enormous role in the sexuality of the West.

Marriage
Marriage in Europe from ancient times has been overwhelmingly monogamous. The Greeks and Romans were solidly monogamous. Bigamy was declared a civil offense under the pagan emperor Diocletian. Christians, who had no biblical sanction for monogamy, departed from Jewish custom by following pagan monogamy. The Germanic tribes to the north of the classic Mediterranean area were also basically monogamous. With the coming of Christianity as the state religion throughout Europe, monogamy became official church policy, later adopted even by western Jews.

In the sixteenth century the Anabaptists preached and practised polygamy. But the most important break with established Christian tradition was that of the American Mormons in the nineteenth century, two divisions of whom encouraged the practise of taking many wives in what was called "celestial marriage." They believe that polygamy was divinely sanctioned. Their justification for it was not only taken from the example of Old Testament heroes but remarkably enough from the life of Jesus himself. Whereas all other Christian groups (to my knowledge)

maintain that Jesus did not marry and lived a chaste life — the very basis for the Catholic insistence on priestly celibacy — Mormons believe that Jesus did marry. The wedding at Cana is believed to be Jesus' own wedding. They also believe he had several wives. How else explain why he appeared to Mary, Martha and Mary Magdalene first after his resurrection rather than to his male disciples?

The practise of polygamy flourished for 50 years and then was given up in order for Mormon groups in Utah to become part of the United States. But sporadically polygamy still occurs.

The Mormons also have a dogma quite at variance with the rest of Christendom — that marriage continues after death, and so does sexuality and procreation. Sex goes on in all of eternity: those persons who can create enough descendants will become gods themselves.

The Mormons with their espousal of polygamy are perhaps the best known deviants from the western heterosexual monogamous ideal. But occasionally others have appeared on the scene. Epiphanius, a fifth-century cataloger of heresies, mentions a libertine sect where the communion banquet became an orgy and the rule was that semen was not to be ejaculated into a woman's body but caught in the hand, offered up to God and eaten. He mentions sects that played up masturbation and others such as the Levites who restricted themselves to homosexual relations, as the Albigensians of the later Middle Ages were sometimes alleged to do. Some of these heretical groups apparently believed that with Christ, sin could no longer exist; therefore, any behavior was acceptable. A number of such groups, usually called Adamites, have existed from time to time in Christianity.

A number of recent utopian communities have tried to change western sexual mores. In 1851, a community called Modern Times was founded on Long Island, New York, that was accused of promoting free love. It apparently did not disown monogamy but made wife-swapping perfectly legitimate. The community was shut down in 1857. The most revolutionary of all the utopian arrangements with regard to marriage was probably that of the Oneida Community in New York, with its "complex marriage": every man in the community being married to every woman simultaneously.

Russia after the Revolution
With the Russian Revolution another attack on monogamy was briefly launched. Marx and Engels took a position on sex relations that can be

summed up in the notion that sex was a private matter for the individual and not for the state.

The laws on marriage and sex were changed dramatically right after the Russian revolution. Laws against bigamy, as well as adultery, incest and homosexual acts were dropped. Abortion was available on request. The early Soviet Union supported the League for Sexual Freedom. But Lenin seems to have had misgivings.

Local developments were sometimes found, such as the "nationalization of the women act" passed by the City Soviet of Vladimir in 1918. According to this act, any unmarried women 18 years of age or older had to register at the Free Love Office of the Commissariat of Welfare. Men between the ages of 19 and 50 would be permitted to choose any woman they wanted as a wife — the woman's consent not being necessary. Children of such unions became the property of the state.

Under Stalin, in the 1930's, most of these rules were revoked. In 1934, homosexual acts were reinstated as serious crimes. During 1935 and 1936, a campaign began against promiscuity, bigamy and divorce.

Trotskyists, who have kept to the earlier position that sex is no matter for the state, accuse Stalin of trying to entice powerful conservative peasants to co-operate with his regime by making concessions to their moral code. Others have argued that society simply cannot tolerate sexual anarchy. No doubt other reasons existed as well, including psychological motivations on the part of the political leaders.

What was formerly the Soviet Union is sexually still one of the most repressive societies in the world. Pornography is not tolerated. Sex education for children is frowned on and interest in sexual matters receives a puritanical response. Divorce is possible and birth control available; but in Russia today western traditions find their most rigid fossilization. It remains to be seen how glasnost, perestroika, and recent political disaffiliation will affect sex in the various countries involved.

Sexual behavior
Actual sexual practises from folk societies in Europe and the rest of the West are seldom reported. We have information about the sexual behavior of certain groups, generally of the educated elite, but they may not be indicative of folk practises at all. As for earlier times, very little information exists on any level, the poet Ovid being an exception in his *Ars amatoria (Art of love)*. The lists of sexual sins in the Christian penitentials offer hints of a negative sort, and there are always scandals or rumors of scandals for illustrious families. In his celebrated *Decline*

and fall of the Roman Empire, Edward Gibbon genteelly alluded to such matters in a footnote: "...of the first fifteen emperors, Claudius was the only one whose taste in love was entirely correct."

The most extensive national study on sexual behavior outside of the Kinsey report comes from France, the *Rapport Simon*, based on work done in 1970 involving 2,625 interviews. Interviews were done partially face-to-face by 173 interviewers and partially in a written questionnaire. The oral part was largely geared to determine attitudes about such subjects as adultery, prostitution and birth control. The written part dealt with actual sexual behavior. The procedure was clearly very different from that of the Kinsey team. There was, for example, no attempt to establish an independent grid of events in the life of the person being interviewed so that an internal check could be made about dating first occurrence of masturbation, intercourse or other sexual acts. The statistical rigor of the procedure was offset by problems in getting answers.

According to the *Rapport Simon*, the coïtal position used overwhelmingly by the French was the missionary position. For the rest, 80 percent of the men and 75 percent of the women had experienced intercourse with the woman on top (more than half had done so frequently.) A number of other positions were reported, more often by men than women, but they were infrequent. Cunnilingus and fellation were reported as practised or experienced by 60 percent of the men and 55 per cent of the women. Here there was a significant difference according to generation, which suggests that there has been a major increase in oral-genital contacts since World War II — is this because of American influence? Abstinence during menstruation is the general rule, but intercourse at that time is somewhat more common among people younger than 30 and among non-churchgoers. Anal foration (intercourse) is fairly uncommon among heterosexuals, over 81 percent of the men and 86 percent of the women denying that they had ever experienced it.

These findings are interesting in light of certain stereotypes associated with different cultures. Fellation is sometimes referred to in English by expressions that suggest it is particularly associated with the French — an association that is unsupported by the facts. (In the personal advertisements of sex magazines, "French culture" is a code expression for oral sex, whereas "Greek culture" is used for anal contacts. Sadomasochism is referred to as "English culture.")

Homosexuality

Information about homosexuality and homosexual acts is not extensive, at least when it comes to peasant societies. For example, John Messenger writing about the rural Irish says he was unable to discover any information about overt homosexuality although it was his assumption that latent homosexuality was very common. Concerning the Sarakatsani, the only information in the Human Relations Area Files is a casual reference to the insulting term *pústis*, "passive homosexual." The use of this word, which comes from Turkish, suggests that among the Sarakatsani as elsewhere in Greece, the notion about homosexuality is the same as in the Middle East: the "insertee" (or vagina substitute) role is shameful.

In a sense, institutionalized homosexual relationships might possibly exist among various groups in the Balkans, such as the Dinaric Serbs. Among them, two men from different clans may enter into a special sworn "brotherhood" relationship. In Montenegro, this sometimes involves a church ceremony. Church officials occasionally come out against it because — as one priest, Pope Gjuro of Njegushi, is quoted as saying — it is "the marriage of two men and against all nature." Sworn sisterhood relationships also exist, although a homosexual connotation here is apparently not so clear.

John Boswell, the Yale historian, has argued that these ceremonies are actually homosexual marriages originally condoned by the Church — both Eastern Orthodox and Roman Catholic — and that in fact in some areas they still continue as such. Few scholars accept his position.

Another of Boswell's assertions, that in AD 342 "gay marriages" (his term) were outlawed in the Roman Empire although they "had hitherto been legal (at least de facto) and well-known" is difficult to understand. Why should it have been outlawed if Christians permitted it? Furthermore, there is no hard and fast evidence from the Greeks and the Romans that they conceptualized homosexual unions as marriages and there was no recognition of legal claims of any kind between homosexual couples because of their union. With regard to his assertion of early Christian acceptance of homosexuality, far and away the great majority of scholars take the view that ancient toleration of homosexual relations changed at some point after the establishment of Christianity to a pervasive homophobia that has persisted in western culture. Precisely why the change occurred is currently much debated.

It has sometimes been suggested that Boswell unjustifiably projects a modern notion of "gay culture" and "gay sensibility" into antiquity. This is an aspect of the social constructionist critique discussed below.

A related issue concerns transferring stereotypes from one culture to another with regard to jobs. In the English-speaking world, male hairdressers and ballet dancers are generally thought of as being homosexual. In Russia, although ballet dancers may be suspect, hairdressers are not: on the contrary, they have the reputation of being womanizers. In Denmark, hairdressers are thought of as homosexual, but not ballet dancers.

These findings show that such stereotypes vary tremendously even within the same culture — not to speak of cross-culturally. What is probable is that a tradition of stigmatizing a profession may deter heterosexuals who might be interested. Hence the tradition tends to be self-perpetuating.

Something that is much more perplexing is that certain professions that have no traditional stigma attached to them attract homosexuals, but closely related professions do not. Ned Rorem, the distinguished American composer, says in his *The final diary 1961-1972* that he suggested to Alfred Kinsey in the 1940's certain percentages of male homosexuals in the arts. Thus, in the 1940's, Rorem's observations led him to believe that 75 percent of serious western composers were homosexual, but in 1966, only 50 percent. He believes that no more than 10 percent of solo violinists are homosexual (because they are predominantly Jewish and "the solid Jewish family" produces heterosexuals), but 50 percent of pianists are and 95 percent of harpsichordists. In a personal communication, Rorem said that in the United States over 90 percent of organists are homosexual, but in Europe they number only one percent.

Alfred Kinsey had planned a thoroughgoing study of the sexuality of artists. His death unfortunately precluded writing it and the Kinsey Institute seems unlikely to finish the job.

Some evidence links male homosexuality with ritual specialists (priests, ministers and cult leaders) in the western world. This is reminiscent of shaamans who in some cultures are transvestite and enter into pathic marriages. Figures bandied about for Roman Catholic priests range from 30 to 80 per cent. Whatever the exact percentages, they would seem to be higher for this group than for the general population. Obviously no study is going to settle the question in religious professions because no such study will be tolerated. But there may have been early European precedents: the ancient Scythians, living in what is now southern Russia, were reported by Herodotus in the 5th century BC to have a group of effeminate (androgynous) priest-diviners, the *enáreës*.

The *Rapport Simon* gives a very low figure for the incidence of homosexual activity in France. The figure for people who have had any homosexual experience at all is about five percent, almost the percentage Kinsey gives for exclusive homosexuals in the United States (those who had had any homosexual experience numbered 37 percent). Possibly the low French figure is correct but it is more likely that it reflects the fact that written questionnaires were used that devoted many pages to heterosexual behavior and only near the end asked a few questions about other activity.

Although institutionalized male pederastic relationships were part of ancient Greek culture, nothing comparable has survived anywhere in Europe. (A suggestion that the earlier ancestral Indo-Europeans practised a similar kind of initiatory pederasty has not been widely accepted.)

Western concepts of sexual orientation
This change and various other apparent changes in western history have prompted some scholars to re-examine some basic issues, including the notion of sexual orientation itself.

Michel Foucault, the French philosopher mentioned earlier, is one of these scholars. In 1976 he proposed that the modern western notion of homosexuality — and by implication the whole concept of sexual orientation — did not exist prior to the 19th century. According to Foucault, previous European thinking as demonstrated in ancient civil or canonical codes, did not assume the existence of homosexual persons but was concerned only with homosexual acts. Foucault asserts that in 1870, in an epoch-making psychiatric paper, Karl Westphal created the medical category of homosexuality by the very act of characterizing it. As a result, whereas "the sodomite [the person who broke the moral or legal code] had been a temporary aberration; the homosexual was now a species." Foucault's position has largely been taken up by social constructionists, who deny that "homosexual" or "heterosexual" are cross-culturally valid categories. (Interestingly, social constructionists also look with favor on an earlier reconstruction by Mary McIntosh; she, however, dates the creation of the "modern homosexual" a century earlier.)

The issue is ultimately how natives of a particular time and culture conceptualize behaviors (the behaviors themselves are not usually a matter of controversy). But getting at such conceptualizations is fraught with difficulties — especially with peoples now dead. Even obvious gaps in vocabulary may not prove conclusive: in English no single word for a day of 24 hours exists to contrast with the day that is opposed to night — and

yet the concept exists in English-speaking culture. So similarly, if a particular language lacks special words to refer to homosexuality or heterosexuality, we cannot conclude that the notions are therefore alien to the speakers of that language.

Ancient Greek is a case in point. No special terms in that language existed that correspond directly to the notions in question (modern Greek has had to invent them: *omofilofilía* "homosexuality"; *eterofilofilía* "heterosexuality"). And as we have seen, the fact that pederasty was institutionalized means that Greek society was very different from the contemporary west. Does Foucault's analysis hold up?

If it does, we find some awkward details that make no sense. For example, consider the discussion about the power of love given in Plato's *Symposium*, one of the classics of western philosophy. In it, the character Aristophanes concocts a fantastic story to explain sexual attraction. Originally people were very different from what they are today: they had two faces, two sets of sex organs, four arms, four legs, and moved more or less by doing cartwheels. They were divided into three sexes, not two: (1) those who had both male and female sex organs — Aristophanes calls them hermaphrodites, (2) those who had two sets of female organs, and (3) those who had two sets of male organs.

Eventually these beings become very powerful and the gods feel threatened by them. Consequently, Zeus splits them in two and rearranges their body parts so that the "half" beings come to look like modern-day people. But they long to return to their earlier joined selves.

This story is utterly fantastic and of historic or literary interest only; incidentally, it may be related to the biblical account of the creation of Eve from Adam. But the crucial thing for us is that Aristophanes goes on to say that those men and women who are descended from the original hermaphrodites still seek out the opposite sex, whereas the women who are descended from the double female beings seek out other women, and — the most noble category of all, in his estimation — those men who are descended from the double male beings seek out other males.

What sense does this story make if at least some ancient Greeks did not take for granted the existence of sexual orientation? Indeed, others can also be cited as believing that at least some varieties of homosexuality are congenital, including Aristotle and Parmenides.

The citations social constructionists use in support of their case in this particular matter also pose problems. Consider the mediaeval dictum sometimes (but apparently falsely) attributed to Thomas Aquinas: "Remove prostitutes from the world, and you will fill it with sodomy." In one

reading, this could be taken to mean that acts are not related to a notion of orientation (if "sodomy" is to be understood as implying only a kind of homosexual behavior) — which would fit nicely with Foucault's contention. But this may not be the correct reading, as anyone who accepts the notion of orientation but also knows about the realities of prison life will have to concede.

The examples given do not necessarily demolish a strict social construction position. But they suggest that great care must be taken in trying to reconstruct the mental (eemic) categories of an earlier time.

Unique sexual customs

The Files reveal very few sexual customs for European groups, and few that can readily be considered unique cross-culturally. Nevertheless, there are some and I have come across other instances from informal sources that may be of interest.

Genital contests among males are sometimes reported, especially from teenagers. Usually the reports are simply of comparing size. A fairly unusual one comes from Norway, where males in the country occasionally take part in informal penis-weightlifting contests, in which pails with varying amounts of water are suspended from erections.

Although not a contest, Australian "hamboning" suggests a similar motivation, and sheer exhibitionism may be involved. What is involved is a kind of male strip-tease: exposing oneself in a party of men. The name perhaps comes from identifying the penis with the bone in a cut of pork. No doubt hamboning occurs occasionally in other societies as well, but I suspect it is not culturally recognized, as is the case in Australia.

The most exacting goals for male masturbation contests in come from United States private-school systems. The function of these games is not only sexual gratification but also the maintenance of a kind of age-based power hierarchy, since some of the participants are unable (because of age) to ejaculate at all.

Unique customs involving women are nearly always related to prostitutes or women in sex shows: women, for example, who can pick up coins in their vagina or who can twist their labia into a knot.

Sexual customs and ideology differ considerably throughout Europe and its outposts. It is not possible to assume a constancy merely because of the influence of Christianity. However, there are customs (such as hand tickling to initiate a sexual contact) that may be found over an enormous area and cut across national boundaries, the distribution of which we do not really know. There are sophisticated practitioners of contraception as

well as their rural relatives, like the Dukagini Albanians, who keep a pair of goats or sheep in their livingroom to guarantee fertility even when that room has to be shared with 20 people. There are urban people who are perfectly happy to stay single (if not chaste) all their lives, as opposed to the Sarakatsani who feel it is a disgrace to die unmarried and bury such a person in wedding clothes, the funeral in effect being a marriage to the earth.

This diversity is more and more being homogenized to a general international sexual culture, with less symbolism perhaps but a greater variety in technique.

Figure 163 A vendor of aphrodisiacs and penis-enlarging potions, in the open-air market Place Jema al-Fna of Marrakesh, Morocco.

Figure 164 Totally veiled woman from Iran at the beginning of the 20th century.

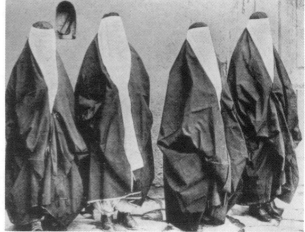

Figure 165 Roman memorabilia in Morocco: a phallic altar (?) in the ancient city of Volubilis. The Middle East is an area that has experienced many cultural traditions.

Figure 166 Earliest known representation of copulating couple. A stone sculpture, Natufian, dated c 8000 BC.

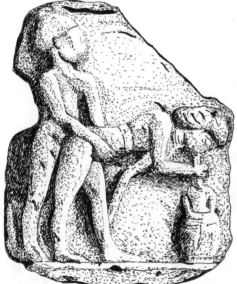

Figure 167 Ancient Mesopotamia. Ritual copulation while woman drinks through a tube. From Uruk, fifth millenium BC.

Figure 168 Mythical or ritual sexual scene from ancient Mesopotamia. An archaïc Sumerian cylinder seal impression.

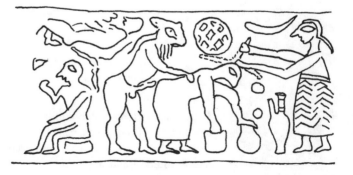

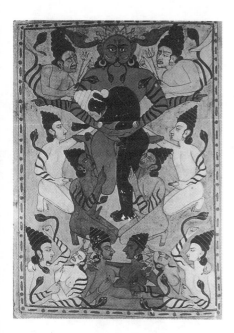

Figure 169 (above) Tantrik panting showing spiritual intercourse in a very graphic way.

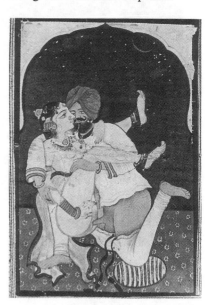

Figure 170 An 18th-century Mogul depiction of lovers under the stars. The Hindu tradition of erotic manuals spread through the Islamic world, but was given a different emphasis.

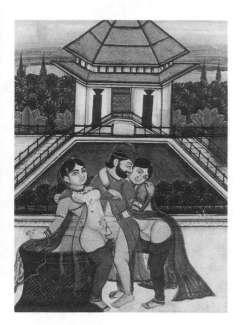

Figure 171 Indian threesome in standing position, much like earlier temple reliefs. Note depilated bodies, which reflect reality more often than the sexual technique shown.

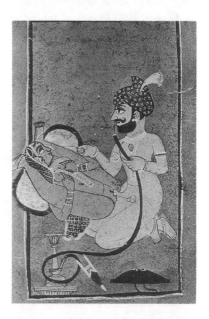

Figure 172 Indian erotic art is often playful as well as acrobatic. Here, the man cannot forgo his hookah (waterpipe) despite other enticements.

Figure 173 Japanese interest in bondage can be found in illustrations intended not only for foreign consumption.

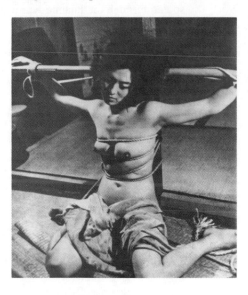

Figure 174 A modern Japanese marriag manual, graphically illustrated.

Figure 175 Japanese depictions of sex are often whimsical but nearly always emphasize pubic hair on both sexes.

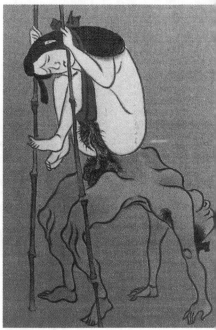

Figure 176 Exaggerated genitals are com mon in Japanese erotica. This is a scen from a painted scroll entitled *Island o Women*, telling of the fate of a group o shipwrecked fishermen.

Figure 177
Phallic objects
dot the Japanese
landscape as a
sign of religious
(Shinto) piety.
Here, a phallus
in a park.

Figure 178 (right) Korean transvestite
shaaman.

Figure 179 (above) Giant carved
wooden phallus (surrounded by
other phallic objects in a Shinto
shrine) used in an important festival
to ensure a good harvest and carried
in a public procession by priests to
other shrines.

Figure 180 Phallic object displayed
in a liquor shop window in Tokyo.

Figure 181 Stone naturally resembling a vulva in a Shinto shrine in Japan.

Figure 182 Kusthic representation in a Shinto shrine in Japan. The plaque was set up by four men to ensure happiness for their families and good luck for their company.

Figure 183 A fan, gigantic genitalia and copulating mice in the bottom right corner are crucial details in this elaborate Japanese woodblock print by Katsushika Hokusai.

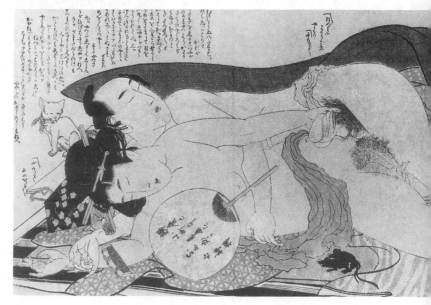

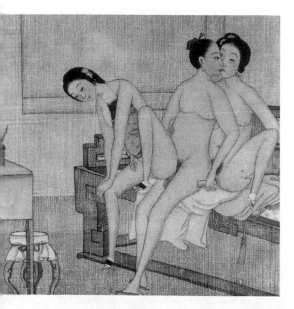

Figure 184 Distinctive Chinese erotic representation: one man and two women (whose bound feet are covered with tiny socks). Late Ming dynasty, c 1600 (?).

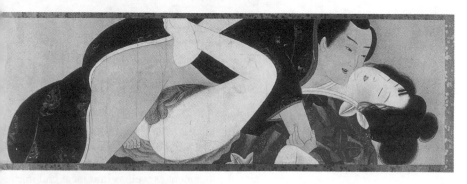

Figure 185 The missionary position: a Japanese version from the 17th century.

Figure 186 Koryak transvestite shaaman (not seen clearly on the photo are the distinctively long striped women's leg coverings).

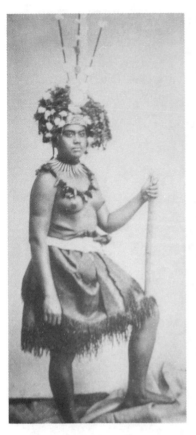

Figure 187 Samoan ceremonial virgin or *tāupou* i traditional dress. The institution of the *tāupou* has i recent times disappeared. Curiously enough, in h famous discussions of the *tāupou*, Margaret Mea used the erroneous spelling *taupo*, which is a totall different word meaning "to indulge in love affairs : night".

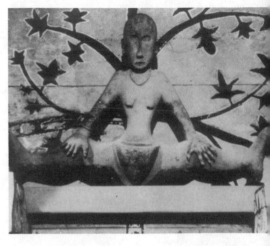

Figure 188 (above) Detail of a gable, men's clul house, Palau Islands. The motif of a woman wi vagina exposed and legs stretched far apart occu in many cultures round the world and suggests bo sexual enticement as well as imminent childbirth.

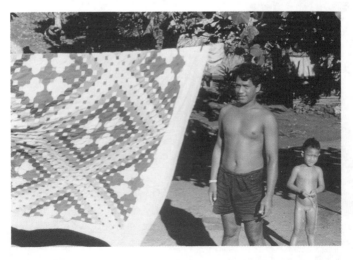

Figure 189 A Tahiti mahu showing a qui he has made. Quiltma ing is, aside from hi in his village of Pi exclusively woman work.

Figure 190 (right) Copulating ancestors from a Maori doorpost. The traditional Oceanic coïtal position is apparently on the decline.

Figure 191 (below) Drawings by a young Australian aborigine (of the Yolngu group) showing traditional sex positions.

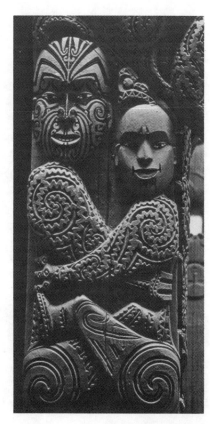

NHUGANMIRR
WALALGA
MIYALK
GA diRAAMU

NiYANiYA

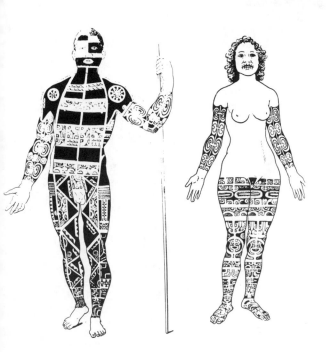

Figure 192
Traditional tatoo designs for men and women from the Marquesas.

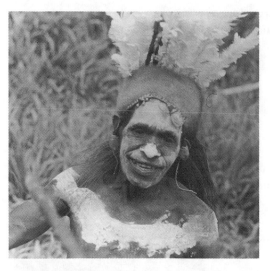

Figure 193 (left) In a basically nudi society, only the use of sex-specifi decorations approaches transvestism Here, an Asmat woman from Ne Guinea has put on body paint normall appropriate only for men. This occu when men are away, and women danc in the men's house.

Figure 195 (below) Close-up Asmat man who would, followin custom, go naked but not lack jew elry. His nose ornament is a she inserted through the septum. Boar tusks, quills and beetle antennae ar sometimes used for similar purpose in other societies.

Figure 194 (above) Transvestite fashion shows in urban Indonesia are quite popular among the general population and parents even bring their children along.

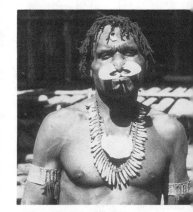

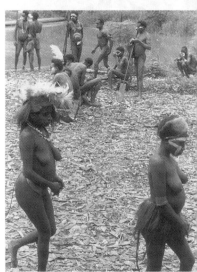

Figure 196 Asmat men traditionally went naked, and women topless.

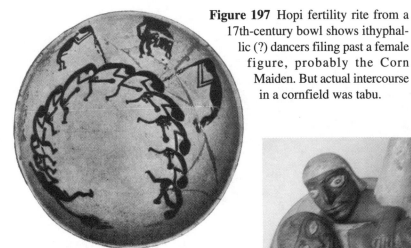

Figure 197 Hopi fertility rite from a 17th-century bowl shows ithyphallic (?) dancers filing past a female figure, probably the Corn Maiden. But actual intercourse in a cornfield was tabu.

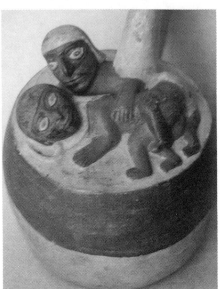

Figure 198 (right) Sexually explicit scenes have been found on some 200 or so pots from Perú and were made perhaps as early as 1000 years before Columbus. Here, a Mochica pot showing side-by-side copulation.

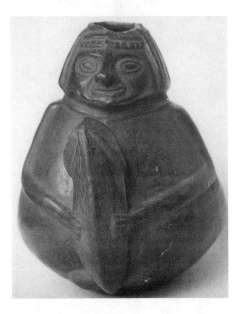

Figure 199 Masturbating skeletons or sex with a skeleton is a frequent theme in Mochica ware. Some have interpreted this as suggesting that pre-Columbian Peruvian pottery conveys a puritanical moral.

Figure 200 Peruvian pot in the shape of a man with a gigantic penis.

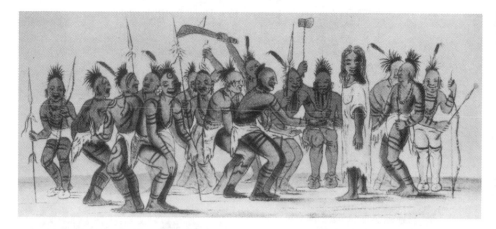

Figure 201 "Dance to the berdache," as shown in a sketch by the English painter George Catlin in the 1830's, while among the Sac and Fox Indians.

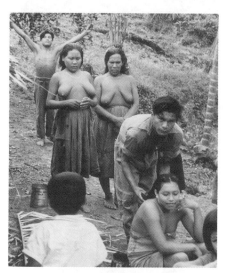

Figure 202 Adoption of western clothing and western notions of modesty does not happen overnight. The South American Indians pictured here would have been just as comfortable with almost total nudity, following their own traditions.

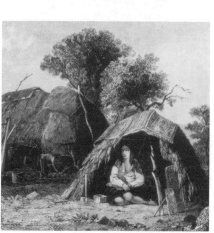

Figure 203 Ceramic vessel in Recuay style showing a man and woman copulating. The man wears an animal headdress and earspools; the woman, a cap.

Figure 204 In many North American Indian groups, women had to observe strict menstrual tabus. Here, a woman secluded in a menstrual hut.

Figure 205 Human sexual intercourse was possibly first depicted in a relief from Laussel, Dordogne, France, more than 20,000 years ago.

Figure 206 (below) Shelah-na-gig figure from the church of St Mary and St David, Kilpeck, England, 11th century.

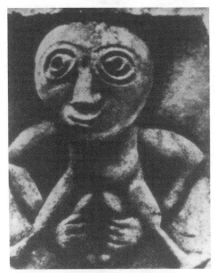

Figure 207 Winged phallus used as a chime. Drawing of an ancient Roman bronze figure.

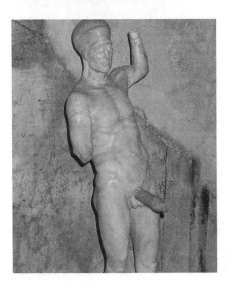

Figure 208 Ithyphallic Roman statue at the notorious House of the Vettii, Pompeii.

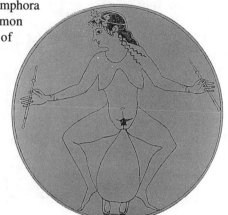

Figure 209 Woman using an amphora (large jar) as a dildoe. Uncommon ancient Greek representation of woman masturbating.

Figure 210 One of the tamer erotic scenes to be found on an ancient Greek vase: two couples reclining on cushions.

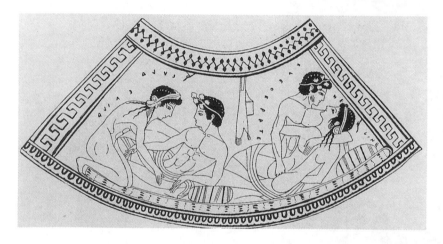

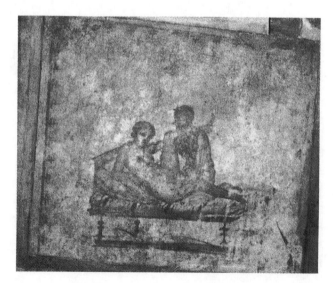

Figure 211 Ancient Roman copulation scene as wall decoration in a private Pompeiian house (in room at the side of the kitchen).

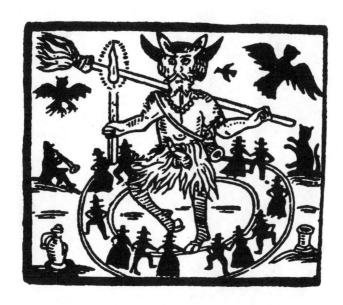

Figure 212 Robin Goodfellow: demonic and ithyphallic.

Figure 213 Secret meeting of a Christian nudist group, the Adamites, in a 17th-century Dutch representation. Obscure sects referred to as Adamites have existed at least as early as the 2nd century AD and have been revived several times since. One of the last was suppressed by force in 1849 in Bohemia.

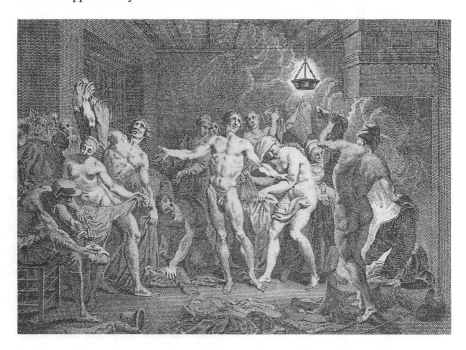

Figure 214 A detail from Michelangelo's *Last judgment*. A demon appears to be thrusting his hand up the anus of one of the damned in what may be the earliest representation of "gantizing." Michelangelo's religious work was sometimes described as "fit for a brothel."

Figure 215 Redrawing of possible gantizing scene in Michelangelo's *Last judgment* by an early 20th-century artist.

Figure 216 X-ray of a gantizing episode: if the long thin bone at the bottom center of the picture is followed upward, it will be seen to develop into the bones of fingers (the bar on the right is a ruler, the circle/angle higher up simply indicates the right side).

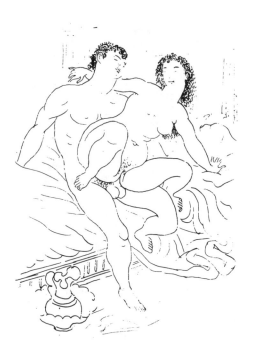

Figure 217 Experimentation has figured prominently in the sex lives of certain western social classes. Here, coïtus in a variant of a seated position, as shown in a modern French engraving.

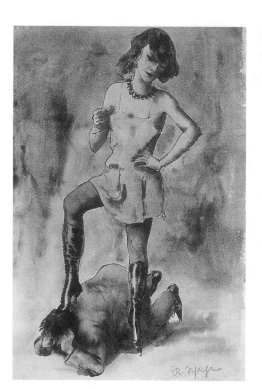

Figure 218 (above) In traditional western culture, intercourse with the woman on top has been seen as unnatural or pathological. These views did not prevent its occurrence.

Figure 219 The dominatrix, a popular theme in much heterosexual SM fanticizing.

Figure 220 Michel Foucault (1926-1984), French philosopher who has argued that modern western views on sex have suffered 19th-century "medicalization" of folk notions.

Figure 221 Edward Osborne Wilson, an American and the synthesizer of sociobiology; in social constructionist terms, the quintessential essentialist.

Figure 222 John Money, a New Zealander, arguably the world's leading expert on hermaphroditism, transsexualism and paraphilias.

Figure 223 Gilbert H Herdt, an American anthropologist who has combined anthropological fieldwork and a psychological perspective in studying ritualized homosexuality in Melanesia.

Figure 224 Human-animal contact. Iron Age cave painting, Val Camonica, Italy, 7th century BC.

Figure 225 Silver chastity belt from the beginning of the 16th century.

Figure 226 Child bride in India in an early 20th-century photograph taken before changes in the law in 1955 set the minimum marriage age for girls at 15.

Figure 227 Cisvestites displaying variants in leather styles. Note the chain worn by the bare-chested man on the left: it is attached to his pierced nipples.

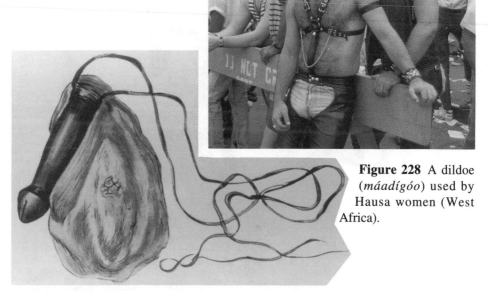

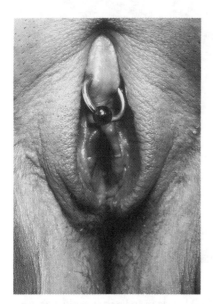

Figure 228 A dildoe (*máadígóo*) used by Hausa women (West Africa).

Figure 229 (below) Guesquel used by certain American Indians in Patagonia, much like a contemporary "french tickler".

Figure 230 Clitoris ring, often used by women who are into piercing or more general SM. Rings and other items are sometimes inserted into the labia, as well as other body parts common to both females and males such as nipples, navels, eyebrows, lips and even the tongue.

Figure 231 Ampalang inserted through the glans of a man, presumably a Dayak from Borneo.

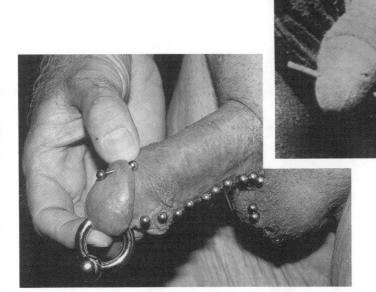

Figure 232 (above) Male piercing enthusiasts in the contemporary West make use of a number of penis inserts. Shown here are three: (1) a smaller variant of the ampalang called a dydoe stud, (2) a ring called a Prince Albert, and (3) small metal balls referred to as fraenum piercings.

Figure 233 (right) Rock painting from South Africa, presumably by ancestors of modern Bushmen, showing the mysterious "crossed penis," which suggests the use of ampalangs—known, however, from no groups in all of Africa.

Figure 234 Sappho (between 630 and 570 BC), Greek poet, born at Mytilene in Lesbos. She is generally but not universally believed to have been homosexual (hence the modern terms *lesbian*, and formerly also *sapphist*).

Figure 235 The frequency of enemas in Kuba art suggests that klismaphilia might be a common paraphilia in this Central African group.

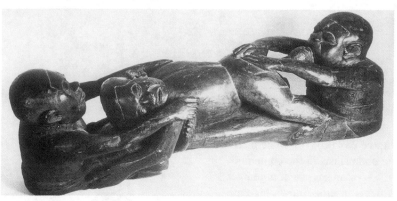

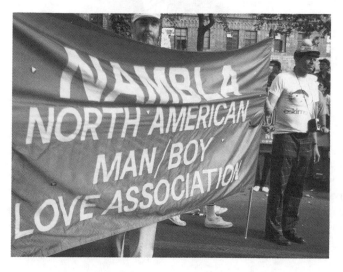

Figure 236
Paedophilia (sexual interest in prepubescent children) is more and more being lumped together with adolescentophilia (interest in teenagers), but the interests are quite distinct even though the legal status of child and teenager have been considerably blurred in modern western society. Here, the demonstration of a homosexual paedophile organization.

Figure 237 Decidedly phallic: a highly stylized Makonde woodcarving (Tanzania).

Figure 238 (below) Downtown sex-show area, Baltimore, Maryland, known as "The Block" and located across from the precinct police station.

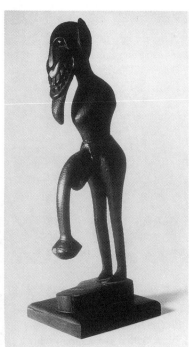

Figure 239 (above) SM torture chamber or "play-room." Most of the men are dressed—if dressed at all—in almost de rigueur leather outfits.

Figure 240 Leopold von Sacher-Masoch (1836-1895), an Austrian nobleman (*Ritter*) and novelist whose themes centered on men literally beaten by aristocratic women. His name was taken by Krafft-Ebing to denote masochism.

Figure 241 The man whose name was taken as appropriate for coining *sadism* has no portraits surviving from his lifetime. The Marquis de Sade (1740-1814)—actually *Comte* Donatien-Alphonse-François de Sade—in a lithograph made several years after his death.

Figure 242 The Chevalier d'Éon de Beaumont (1728-1810), right, a skilled swordsman who gave fencing exhibitions dressed in women's clothes, here shown in a match in 1787. Havelock Ellis coined the term eonism to refer to transvestism in the Chevalier's honor, but it is not clear whether de Beaumont was actually a transvestite, a showman, or a transvestite showman.

Figure 243 American transvestite at a gay rally, Greenwich Village, N.Y., 1991.

NINETEEN CROSS-CULTURAL SURVEY

**This chapter is arranged alphabetically.
It provides a summary of topics not dealt with
in a unified way elsewhere in this book,
but it is by no means exhaustive.**

Abstinence, celibacy and chastity

"What would you call a woman who has grown up without knowing a man?"

"Well, I should call her a fool."

This is a fragment of an actual conversation between an anthropologist and a member of the Ila of southeastern Africa. The anthropologist was trying to learn an Ila equivalent for "virgin" (which turned out not to exist).

The Ila reply was not unusual from a cross-cultural perspective. Similarly a word for "virgin" or "virginity" does not exist natively in several languages, including Ila of southeastern Africa, Tukano of South America and Pukapukan and Trukese of the Pacific.

Among most human societies, chastity (a life without sexual intercourse) is considered abnormal. Similarly, celibacy (not being married) is held to be tragic, dangerous, or the lot of the retarded or seriously deformed. On the other hand, abstinence (not having sexual intercourse on certain days or during certain periods) is almost universal.

Sexual abstinence, even chastity, is sometimes given specifically religious sanction. In the Muslim world, abstinence from sexual intercourse and even passionate kissing is obligatory for all believers during the daylight hours of the month of fasting, Ramadaan.

Priests and other religious specialists are sometimes required to live chaste lives. This was true of the vestal virgins in Rome and some of the Aztec priesthood. Even earlier, in Egypt, the chief priestess of the god Amun (the Divine Adoratrice) had to be celibate; male priests had to abstain from sexual acts at least when they were in service. Buddhism started out as a celibate order. Although celibacy for priests was encouraged rather early in the western Christian church, it did not become general until the tenth century.

Chastity is not prized among hunting and gathering groups, pastoralists or among people who practise rudimentary agriculture. As a culturally defined virtue it does not appear in human history until about the fifth century BC with the development of Buddhist and Jain monasticism in India — this at a time when India was experiencing problems with regard to food resources and overpopulation.

AIDS. Also called **H.I.V. infection** (formerly **GRID**).
AIDS is a disease damaging the body's immune system, which is sometimes (but not invariably) transmitted through sexual contact.

The name AIDS comes from the expression *A*cquired *I*mmune *D*eficiency (or *I*mmuno-*D*eficiency) *S*yndrome; this English acronym has spread to many other languages as well, such as Arabic, Chinese, German, Polish, Norwegian, Czech, Japanese. In other languages, a related acronym such as SIDA is more common; this is used in French, Spanish, Italian (Russian has its own variant).

The first reported cases of AIDS in the United States occurred in 1981. The origins of the disease are obscure but it is generally believed to have originated considerably earlier in central Africa — possibly as a mutation in a disease found in certain monkeys — and to have been transmitted to human beings through contact with monkey blood. In any event, half of all the world's cases of AIDS apparently exist in Africa; as of 1990 there were an estimated 375,000 cases (63,842 actually reported) of full-blown AIDS and an estimated 3,500,000 individuals who tested positive.

Other theories that have been proposed are often regarded as lunatic fringe and dismissed out of hand, such as the belief that it came from King Tut's tomb or the assertion (formerly found plastered all over New York City on the walls of public buildings and post boxes) that the C.I.A. had produced it through some sort of evil chemical engineering as the "final solution" for homosexuality and for drug addict problems. (The K.G.B. sponsored a similar theory of C.I.A. complicity. Another theory, not so often heard but less easy to dismiss, assumes it is caused by a smallpox vaccine gone bad through an unfortunate mutation.) Yet another relates AIDS to malaria experiments in which blood from monkeys and chimpanzees was actually injected into human beings to discover whether the malaria parasite could be transmitted from animals to people. Several studies of this sort were made from 1922 up until the 1950's.

Most researchers believe that the agent causing AIDS is one of the two or more H.I.V. retroviruses (H.I.V. stands for *H*uman *I*mmuno-Deficiency *V*irus). This was proposed in 1985 by Dr Luc Montagnier of the Pasteur Institute of Paris, as well as by Dr Robert Gallo of the National Cancer Institute in Bethesda, Maryland. There has been some controversy as to the priority of discovery. In 1988 both men co-signed a paper on the history of the discovery of the virus but in 1991, Gallo acknowledged that the virus he identified was one that had been sent to him by Montagnier. This probably means that Montagnier will be conceded to be the sole discoverer of the H.I.V. retrovirus. Working independently, Dr Shyh-Ching Lo of the Armed Forces Institute of Pathology in Maryland suggested that mycoplasma was important in AIDS, a position virtually ignored until 1990 when Dr Montagnier argued that both H.I.V. and mycoplasma work together in causing AIDS.

In any event, the H.I.V. virus is transmitted through the exchange of body fluids such as semen and blood primarily, but also vaginal secretions and milk. Although saliva, sweat, and tears also contain this virus, they are not known to have been directly associated with transmission, presumably because of low concentration levels of the virus in these substances. Transmission by insects, shared food or casual contact has never reliably been reported as producing AIDS.

Two patterns in the sexual transmission of AIDS have been reported. (1) In North America and Europe primarily through male homosexual and bisexual contacts, usually involving anal foration. Because of the high rate of incidence of AIDS among young homosexual men in the United States, the disease was originally called GRID: *G*ay *R*elated *I*mmune *D*eficiency. (2) In Africa and other Third World societies, through heterosexual intercourse — presumably aided by the existence of other diseases, often venereal, at time of infection. The reason for assuming this second pattern is the nearly equal rate of infection for both men and women, whereas in the first pattern something on the order of 19 men to every one woman is found. But little is really known about the actual sexual behavior in these second areas (nothing remotely like a Kinsey report exists for any of them). One explanation offered for the high incidence of the disease in women in Africa (at least) must almost certainly be ruled out: the practise of female genital mutilations. AIDS in fact seems to have developed in Central Africa where no genital mutilations at all are practised, either on women or men. However, as AIDS spreads to areas where mutilations occur, the pattern may change because in traditional societies girls and boys often undergo such

mutilations in groups, with the same unsterilized cutting tools used for all — very much like the sharing of hypodermic needles by drug addicts (another significant way AIDS is transmitted).

On the other hand, the assertion of a correlation between male circumcision and relative immunity to AIDS seems unwarranted. Using the same sorts of distributional arguments that prompted this assertion, one could even more convincingly maintain the opposite: in the United States, with an enormous incidence of AIDS, most of the infected men are circumcised, whereas in Russia with a very low incidence, circumcision is rare. Probably, circumcision is irrelevant as far as AIDS goes.

Amazon: see **Transvestism.**

Ambisexuality: see **Bisexuality.**

Anaphrodisiacs. Also called **Antiaphrodisiacs** or **Antaphrodisiacs.**
Anaphrodisiacs are drugs or substances used to diminish or eradicate sexual excitement.

Pliny the Elder says that the vestal virgins of Rome helped maintain their virginity (and their lives — the punishment for violating their vow of chastity was being buried alive) by the use of anaphrodisiac drinks. Buddhist monks in Cambodia allegedly make use of a substance known as *bhesajja*. The Kubeo of South America consider their women to be so passionate that a worn-out husband may resort to plying his wife with anaphrodisiacs.

The best known anaphrodisiac in western folklore is saltpeter, often rumored to be mixed in the food served to boys in boarding school and to men in prison. It is a diuretic lacking all anaphrodisiac properties.

Animal contacts. Often subsumed under the term **Bestiality.**
Sexual contacts between human beings and members of other species usually do not involve sexual attraction but rather lack of a suitable human partner or ritual requirements of one sort or another. Actual sexual attraction to animals is called zoöphilia.

Formerly, among the Ijo, animal contacts were part of the male coming of age ritual. Every boy had to copulate successfully with a specially selected sheep to the satisfaction of a circle of elders who witnessed his performance.

Among the Yóruba there was the custom (now long discontinued) that a young hunter had to copulate with the first antelope he ever killed — while it was still warm.

The only society where animal contacts are said to be an important part of most people's sexual experience is that of the Kágaba of South America. Such contacts seem also to be fairly common among the Hopi. Hopi boys are apparently sometimes directed to animal contacts so that they will leave girls alone.

A few societies are known in which human-animal contacts occur and are not condemned, but for the most part they are both condemned and occasionally severely punished. Hanging was the appropriate punishment among the Inka. In Genghis Khan's code of law for the Mongols from 1219, death was mandated.

The most common animals used in such contacts are domesticated mammals: dogs, cattle, sheep, goats, pigs, horses and burros.

Occasionally other animals such as snakes, turtles, eels, octopuses and frogs are mentioned or depicted in art, but they are for the most part either mythical or whimsical. The explorer Richard Burton did, however, describe some Middle Eastern natives copulating with female crocodiles. It was considered a magical act that would make the man rich and important. Burton said that a crocodile on her back was almost helpless, so the story might just be less apocryphal than it sounds.

The only data about the frequency of animal contacts are found in the Kinsey volumes for the United States. In Kinsey's overall sample, such contacts are rare. But they are fairly common among boys raised on farms: about 17 percent had at least one orgasm through animal contacts.

See also **Zoöphilia** and **Dildoe.**

Aphrodisiacs

Aphrodisiacs are drugs and other substances used to produce, heighten or sustain sexual excitement. Perhaps the earliest known was a drug made up of powdered dried crocodile penis recommended by the ancient Egyptians.

More common is the use of penis-like objects such as stag's horn (in Europe), birds' beaks such as the billknob of the king eider (by Éskimo groups in Greenland) and most notably the horn of the white rhino, especially highly prized in Southeast Asia and China.

The root of the mandrake (or mandragora) has been said to have all sorts of powers as well as aphrodisiac. In spite of its remarkable history,

and the fact that in appearance it resembles both the male and female genitals, the mandrake has no aphrodisiac effects at all.

Another category of aphrodisiac includes spices and spicy foods, presumably in the hope that the heat of the dish will inspire the heat of passion. A variety of wild ginger found on the Solomon Islands is believed locally to be quite effective. One aphrodisiac mentioned by the Romans involved rubbing the soles of the feet with pepper and the penis with the urine of a bull that had just copulated.

Spanish fly, a fine powder made from the dried bodies of cantharides (a beetle found in southern Europe), may actually produce prolonged erections; it can also produce an exciting sensation in the genitals of both sexes (and may even bring about premature menstruation in women). It is, however, exceedingly dangerous and deaths have been reported after its use. The Bush Negroes of the Guianas make use of mashed seeds of the mucca-mucca plant, which produces a similar kind of irritation. The seeds are actually inserted into the urethra and may cause urethritis.

Muriacithin, produced from a root grown in the tropical forests of Brazil, was used aboriginally as an aphrodisiac and may actually have some effect.

The most generally acknowledged likely candidate for a full-fledged aphrodisiac is yohimbine, derived from the bark of a tree native to Africa. Its aphrodisiac properties were discovered by natives in Cameroon.

From this same general area of Cameroon and Gabon came perhaps the most elaborate collection of aphrodisiacs as well as the greatest cultural appreciation of them. The Fang make use of about 100 different plants as aphrodisiacs and a large number of other items such as the bones of albinos, the teeth of chiefs, and even the sex organs of women who have been mothers-in-law. Parents who are afraid their sons are not sexually active enough give them aphrodisiacs to spur them on. Sometimes aphrodisiac or love medicine festivals are held to help renew the sexual life of the young people of a whole village.

The most recent candidate for a genuine aphrodisiac is an oat extract originally used in China as a food supplement for carp. This product is called exsativa, available under the trade name Oncor.

Taking all the evidence into account one cannot say there are any known genuine, safe aphrodisiacs. Helen Singer Kaplan in her book on sex therapy puts it this way: "No chemical substance has as yet been discovered which can rival the aphrodisiac power of being in love."

Astringents
Chemicals used to shrink the mucus membranes of the vaginal wall. In the western world, the use of alum has been reported from brothels where prostitutes must pretend to be virgins to satisfy the tastes of clients who are into deflowering.

The most detailed account of the use of astringents is given for the Marquesans of the Pacific. For them, the use of astringents is an important and probably ancient tradition. Treatment usually begins in infancy and continues until the onset of menstruation. In the opinion of Marquesan men this treatment renders Marquesan women greatly superior to European or even to Tahitian women.

Berdache: see Transvestism.

Bestiality. Rarely also called **Zoöerasty.**
Bestiality refers to any kind of sexual contacts with animals. The term is considered unfortunate by many sexologists who use a phrase such as *human-animal sexual contacts*, or the like, instead.

See **Animal contacts** and **Dildoe.**

Birth control and related topics
Societies throughout the world have developed a number of ways for regulating the size of their population. In some, the Lepcha and the Trobrianders, for example, no contraceptive methods are even attempted.

Coïtus interruptus is supposed to be the most widely used contraception method cross-culturally. On the small Pacific island of Tikopia, it was part of a conscious population control policy and was used by the married and the unmarried alike.

Attempts to remove the semen from the vagina are reported from a few societies. Kavirondo women stand up after coïtus and shake their bodies in a quick jerky rhythm. Zande women try to get rid of the semen by slapping their backs.

Hunting and gathering groups have no chemical or mechanical contraceptives that work. Other societies outside of the influence of modern western technology also tend to lack any truly useful contraceptives.

The Návaho believe that some drugs will render even men sterile, but for the most part all drugs are taken by women. Certain Indian tribes in Nevada make use of a plant *Lithospermum ruderale*, which has

been subject to scientific investigation and found to inhibit the functioning of rats' ovaries.

Contraceptive charms are not rare. A "snake girdle," made of beaded leather and worn over the navel, was used by certain Plains Indians. Ancient Roman charms included the liver of a cat placed in a tube and worn on the left foot, or a part of a lioness's womb kept in an ivory tube.

Considerably more effective than these devices is abortion, which is tolerated, even institutionalized in a great many societies, and practised in a great many others. Hunting and gathering groups reportedly know numerous plant and animal poisons that are effective in inducing miscarriages. Other means include tying of tight bands round the stomach, beating the stomach or inserting sharp sticks into the vagina.

Infanticide would seem to be of considerably greater effectiveness in primitive population control than the other techniques. Nevertheless, Moni Nag has concluded that infant mortality due to infanticide is far lower than mortality due to natural causes.

Bisexuality. Rarely also **Ambisexuality.**
Bisexuality is an expression that has been used in two basically different ways. In one sense, a bisexual individual is a hermaphrodite. This is the sense most commonly used by biologists. In another sense, a bisexual individual is anyone who is attracted and can respond sexually to members of both sexes. Although this sense is fairly common and is used by many psychologists and sexologists, anthropologists have for the most part ignored it.

William Davenport's study of East Bay (the fictitious name of a society in the Pacific) is an exception. He points out that in that society, and a great many others, homosexual acts are tolerated and sometimes encouraged — but within the context of a general bisexuality. In such societies, the exclusive homosexual might well be considered deviant. On the other hand, where ritual homosexual acts are considered necessary to insure the growth of children (as in New Guinea societies), the exclusive heterosexual would be deviant.

Masters and Johnson have proposed another term, which would be unambiguous: ambisexuality. This expression is not yet in common use.

Bride price, bride service, groom price, dowry
In nearly all societies in the world, marriage involves some sort of material consideration or economic transaction to make it legitimate.

The most common form of marriage payments is known variously as bride price, bride wealth, *lobola* or progeny price. Whatever the term used, the custom involves the presentation of substantial gifts by the bridegroom's family to the kinsmen of the bride. The gifts given are often of symbolic rather than true utilitarian value. Along the coast of Guinea and Liberia, special metal "hoes" were traditionally used for bride-price payments: they were neither real hoes nor general-purpose money. Other bride-price payments include dogs' teeth, feathers, shell decorations, ivory tusks and brass gongs. In many African societies cattle frequently constitute the traditional bride price.

For a considerable time European Christian marriage also involved bride price. In early English marriage, there was not only this form of marriage payment (called "the price of upfostering," interpreted as a return to the bride's father or guardian of the expenses of rearing her) but also another one, the "morning gift," the present the bridegroom had to give to his bride after the bridal night for permitting him to consummate the marriage.

Some societies permit a man to work for his bride's family instead of paying a bride price. This arrangement is referred to as bride service. In various societies throughout the world — particularly hunting and gathering societies where there is little real wealth — working for in-laws for several months or years is the only form of marriage payment. A disadvantage inherent in bride service is that it cannot be returned in case of divorce, whereas bride price can. The most famous instance of bride service is the biblical story of Jacob, who was to have worked for his prospective father-in-law Laban for seven years before he could marry Rachel, but wound up working 14 years because of Laban's trickery (Genesis 29).

Shirley Lindenbaum has suggested that ritualized homosexual acts in New Guinea and elsewhere in Melanesia might be thought of as a kind of bride service. In the first place, the individuals involved usually have ties through marriage. Second, providing semen is an important service because without it a boy cannot (according to traditional belief) grow and become a man. Furthermore, such rituals do not occur in neighboring groups where the people are rich enough to provide a bride price. Interestingly, however, among the Zande of the Sudan in Africa who formerly practised pederastic marriage, the man who was deemed a good husband to his boy-wife could expect to marry one of the boy's sisters or other female relatives later on. But the Zande required a bride price for boy-wives as well as for female ones.

Yet another alternative for bride price involves a payment in kind: a woman from the bridegroom's group is given in marriage to a male relative of the bride. Such a transaction is known as an exchange marriage. A particularly common form of this is sister exchange in which the groom exchanges his sister for his bride.

The reverse of bride price is groom price, which occurs in only one known society, the Nagovisi of Bougainville. According to Jill Nash, a marriage payment is made in that group by the bride's sister and mother to the groom's sister and mother.

The dowry is not to be confused with either groom price or bride price. A dowry is found only in patrilineal or patri-oriented societies. It can be thought of as a bride's inheritance from her family given to her before the death of her father, to be used by her husband.

The change in marriage payments in English society is interesting. As we have seen, in the earliest times, before the twelfth century, a form of bride price existed. By the twelfth century, the dowry had supplanted it. In the early eighteenth century, the dowry began to disappear in upper-class families, and the bride was simply allowed to inherit more or less equally with her brothers. The eighteenth century was also the period when romantic love started to become *the* justification for marriage, as well as the time when homosexual adultophilia made its first appearance in history as an important sociological phenomenon. Is there a relationship among these three developments?

Bundling, night-courting and related customs
Bundling is a custom in which two people of the opposite sex share the same bed while remaining fully clothed. Bundling has popularly been identified as a colonial American practise suitable in a country without hotels, where cold nights were unalleviated by central heating. The custom, however, is a continuation of what is sometimes referred to as night-courting, reported from various northern European areas such as England, Scotland and Skandinavia.

In the United States, bundling was abandoned by 1800, although sporadic instances of it occurred as late as 1845. It seems to have been most prevalent in Connecticut.

Comparable customs are sometimes reported from outside of Europe. The Kikuyu of Kenya have similar custom, called *nguiko* "fondling." In this society it is the girls who visit their boyfriends in a special hut where they eat and sleep together (without full intercourse).

The Blackfoot and Dakota Indians allowed a girl to sit with her suitor in the daytime under the same blanket in full view of her whole family.

Celibacy, Chastity: see **Abstinence, celibacy and chastity**

Chastity belts and other chastity garments
Chastity belts, devices attached to the bodies of women to prevent sexual intercourse, were in Europe usually made partly of metal. Some had barbed openings to permit urination but not copulation.

Making and using chastity belts in Europe began during the later Middle Ages. The common belief that the crusaders attached chastity belts to their wives as they went forth to fight for the Holy Land seems to be pure myth. The Crusades occurred from the 11th to 13th centuries. But one of the earliest representations of such a device is a drawing from 1405, representing a chastity belt known as the "Bellifortis." However, contact by the crusaders with infibulated women in the Middle East may have inspired the development of such devices.

Chastity belts are manufactured commercially today by at least one firm. Every once in a while, in letters to various newspaper columns, people admit to using them.

Among some Plains Indians such as the Cheyenne, an easily removable belt was worn by all girls until marriage and thereafter when their husbands were away. In the Caucasus, chastity corsets were used. All these traditions apparently developed independently.

Child marriage and infant betrothal
Among the Tiwi of Australia, the Yãnomamö of South America, and the Zande of Africa, men may promise the daughters of their female relatives to other young men even before the daughters are born. The reason is that marriage is thought of primarily in terms of alliances between groups and the romantic inclinations of the individuals involved are generally ignored.

There is no evidence in societies such as that of the Zande that men actually copulated with their infant brides (a girl could technically be married shortly after birth). But copulation apparently could occur when the girl was as young as eight.

Among the Kadar of Northern Nigeria, most marriages are arranged by a girl's father when she is between three and six years old. She may not go to live with her husband until ten years later and may actually

conceive another man's child during that time. The Kadar do not value premarital chastity. On the contrary, her pregnancy is taken as welcome proof of fertility.

In northern India, however, where traditionally infant betrothal or marriage before menstruation was the rule, great emphasis was placed on a girl's virginity. To ensure virginity, a girl was married off before puberty and sent to live in her husband's household.

Child marriage in India has been severely attacked by Christian missionaries and Indian reformers. The Hindu Marriage Act of 1955 set the minimum age for girls at 15; this was later raised to 16.

Cisvestism

This is a term coined by Magnus Hirshfeld that refers to dressing in clothes that would usually indicate an inappropriate age or social role but are otherwise appropriate.

Unlike transvestism, which occurs in the great majority of cultures and is often institutionalized, cisvestism seems to be restricted to highly advanced societies, particularly the West.

One variety of cisvestism is the wearing of diapers or other infantile clothes by adults in sexual scenes. Another, possibly more common, involves wearing uniforms. An accountant or business executive might, for example, choose to dress up as a construction worker, cowboy, policeman, sailor, marine or Nazi officer. Most of these are fairly common in the contemporary sadomasochistic world. In former decades, for women to dress up as a riding mistress had a certain vogue. The social inappropriateness of the styles is seen in the fact that many men who wear motorcyclist garb — almost totally a homosexual sadomasochistic style — do not own and cannot even ride a motorcycle.

The origin of the motorcyclist fashion is usually believed to be the Marlon Brando film *The wild ones* (released in 1953), which was about a motorcycle gang. An even earlier possible influence was Jean Cocteau's *Orphée*, made in 1949 but released in the United States in 1950. In the film two motorcyclists figure prominently.

Leather bars, now commonplace in large metropolitan centers in the United States, England and Germany, were unknown before the 1950's. Such bars are the meeting places for various kinds of cisvestites as well as male homosexual sadomasochists, leather fetishists, and men generally attracted by supermasculinity.

Condom

A condom is a sheath worn over the penis during intercourse. The earliest evidence of such a device comes from the sixteenth century. Its invention is debatably attributed to the Italian anatomist Gabriel Fallopius (1523—1562), known for his description of the fallopian tubes. He described (and claimed to have invented) a linen sheath to fit over the glans to prevent the spread of syphilis. Since then, the condom has developed to become the most widely used mechanical method of contraception.

The only nonwestern society that developed a condom-like contraceptive is that of the Dyuka Bush Negroes of Surinam, who were reported in the 1930's to be using a seed pod as a contraceptive device. The pod was about five inches long (c. 12 cm), with one end snipped off. The man inserted his penis into the pod when it was already in the woman's vagina.

Contraception: see **Birth control and related topics.**

Couvade. Sometimes but rarely also called **Men's childbed**
 (from the German *Männerkindbett*).
The couvade refers to a number of customs in which a man will copy his wife's behavior during pregnancy and labor or is treated as if he, not his wife, has given birth.

The term was first used by Edward B Tylor in 1865 but descriptions of couvade go back to antiquity. Herodotus (fifth century BC) may have referred to such customs when he describes some Scythian men as being afflicted by "female sickness" as a divine punishment because they or their ancestors had plundered a temple of Venus. Diodorus Siculus (first century AD) described a variety of the couvade found on the island of Corsica.

The couvade or couvade-like customs have been found on all continents but chiefly in South America, perhaps least commonly in Africa. Famous examples include the Basques in northern Spain (a somewhat disputed case, however), the Ainu of northern Japan, the Carib Indians of the West Indies and the Timbira of Brazil, who involve not only the woman's husband but also any men she might have had sex with during her pregnancy.

Dildoe. Also called **Olisbos** and **Godemiche.**
A dildoe is a device for vaginal or anal masturbation, usually in the
shape of a penis, occasionally of exaggerated size. Dildoes were known
in the ancient world, and were clearly familiar to the ancient
Babylonians, Greeks, Indians and Chinese. Dildoes have been produced
in a variety of sizes and from different materials. Chukchi women in
Siberia are said to use the calf muscle of a reindeer, Tikopian and Zande
women are both known to use bananas or appropriately shaped roots.

France was reputed the master of dildoe manufacture in the
eighteenth century. In the early twentieth century that distinction was
associated with Japan, and after World War II American soldiers bought
elaborately decorated Japanese dildoes back as souvenirs and started a
western popularization that has resulted in widely displayed sales of
"vibrators."

Rumors about a kind of "live dildoe" crop up from time to time,
almost exclusively about men in the United States: a small animal,
almost invariably specified as a gerbil, is forcibly inserted into the anus.
After much frenzied but ineffectual clawing to escape, the animal dies
of asphyxiation. Titillation apparently comes in part from the clawing
as well as merely having the animal inside the body. This act is referred
to as "getting a miki" — presumably in honor of Mickey Mouse.
Considerable folklore has developed round this behavior but no scientific
investigation of the matter has so far been undertaken.

Droit du seigneur. Also called **Jus** (or **ius) primae noctis.**
The droit du seigneur refers to the right of a feudal lord in Europe to
deflower or at least have sexual intercourse with any bride on his estate
on the first night of her marriage. Scholars disagree as to whether such
a right actually ever existed in Europe. Those who believe it did differ
among themselves as to the extent to which it was practised. One
conservative reconstruction limits it to some parts of Scotland in early
times. A more expansive view maintains that not only feudal lords but
even some monks held this right. Customs similar to the droit du
seigneur have been reported from a few nonwestern cultures: the Dard
of Asia, the Zande of Africa and the Tonga of the Pacific.

Some groups believe that the first act of sexual intercourse with a
virgin is dangerous. A shaaman has to do the deflowering among the
Kágaba of South America. Among the Seri of Mexico, a chief must do
it. If the droit du seigneur actually existed in Europe, it may have had
a similar justification.

Exhibitionism: see **Paraphilia.**

Fetishism and partialism
Both of these represent the most common of the paraphilias. They are almost entirely restricted to males and seem to be unknown in other animals.

Technically, fetishism refers to sexual interest in some inanimate object, generally some article of clothing; partialism refers to an intense interest in some particular part of the body, usually not the genitals — but genital partialisms can occur, for example the great concern among some male homosexuals in the size of a penis or whether or not it is circumcized.

At one time the term fetishism was regularly used for both notions and frequently still is. But if a distinction is made, we can generalize that fetishism seems to be absent or at least highly uncommon in primitive societies, whereas some partialisms occur at all levels of societal evolution. More specifically, the great interest in elongated labia among the Hóttentot and other groups is an example of a partialism. Intense sexual interest in feet or breasts is almost always restricted to highly developed civilizations. The former Chinese passion for bound feet is an example of this and could be considered a national partialism.

Fetishes have been classified as to whether they involve media or form. A media fetish is one where the material or substance rather than the form is a crucial aspect. Leather fetishism is a common example of this. It does not matter for the leather fetishist what article of clothing is made of leather: it is the material that counts. The same is true for the rubber fetishist. Form fetishism reverses this: lingerie or shoe fetishes are common examples.

Some form of fetishism frequently accompany sadomasochism, for example those involving high heeled shoes and boots. Fetish objects that are fluffy, furry and frilly, such as lingerie, are less often associated with sadomasochism in spite of Sacher-Masoch's famous fantasy of being beaten by a woman in a fur coat.

Some articles of clothing are seldom fetish objects. Hats are an example. Although underpants are quite popular among fetishists, brassieres seldom are, and a true stocking fetishist is rare.

Frigidity and other female sexual dysfunctions

The main types of sexual dysfunction found among women are frigidity or anorgasmia (inability to experience either orgasm or more generally any sexual pleasure), vaginismus (uncontrolled spasmodic contractions of the vagina) and dyspareunia (pain during coïtus). It seems clear from therapeutic work done in the United States that culture plays a significant role in bringing these about. For example, Masters and Johnson, as well as other sex therapists, such as Kaplan, agree that "religious orthodoxy" (by which they mean strict conservative Judaïsm and Christianity) is of major importance in almost every form of sexual dysfunction for women.

Sexual dysfunction in a nonwestern culture, the Ganda of Uganda, includes *ewuzza* (frigidity), *matabo* (a condition in which a woman could have sex only after an attempt was made to strangle her by the neck) and *olwazi* (a tight vagina, the traditional cure for which was to pour grain into the vagina itself and let a rooster peck the grain out). Among the Ganda, a woman's sexual satisfaction in marriage is regarded as vital.

Frigidity is often considered a serious disorder in western society at present. But Helen Singer Kaplan suggests that women who do not get orgasms but are not otherwise frigid are not dysfunctional at all. Their response may simply represent a normal variant of female sexuality.

Gadgets

Gadgets are a variety of devices used to produce, heighten or even prevent sexual response. Basically, three kinds of sex gadgets have been produced: genital substitutes used mostly in masturbation; genital modifiers used to facilitate or enhance pleasurable sensations during copulation; and devices like chastity belts to make intercourse difficult or impossible.

The best known genital substitute is the dildoe. Other substitutes include the *rin-no-tama*, a device generally believed to have been invented by the Japanese. It was known at least as early as the eighteenth century in France, where it was sometimes referred to as *pommes d'amour* "apples of love." The *rin-no-tama* consists of two small metal balls, which are inserted into the vaginal canal. The erotic effect of the *rin-no-tama* comes from the movements of the balls and their delicate vibrations when the pelvis changes position — no matter how slightly. This seems to have been developed from a Chinese gadget called a "Burmese bell".

Vaginal substitutes are less common. Among Hindus a device known as a *viyoni* has been employed by men in fertility rites. It was made in the shape of a woman out of wood and cloth, with a vagina *(yoni)*-like opening of fruit, vegetables and leaves. Modern western varieties include rubber models of a vagina or even a life-size rubber doll with varying degrees of anatomical detail, but always outfitted with a "vagina" (such a figure is sometimes referred to as a *dame de voyage*). Comparable rubber figures with male sex organs have also appeared on the scene, almost exclusively aimed at male homosexuals rather than heterosexual women.

The second kind of sex gadget includes all sorts of genital modifiers. With few exceptions, such modifiers are attached to the penis and are described as aids to inducing orgasms in women.

A french tickler (or simply tickler) is such a device. One of the earliest known examples, called the "happy ring" or "goat's eyelid", was reportedly introduced into China by Tibetan lamas in the thirteenth century. A similar device, the *guesquel*, was used by some American Indians in Patagonia.

In the contemporary West, comparable ticklers are usually made of rubber or plastic and in some instances are built into the design of a condom.

What are known as tickling stones or penis balls are reported from Southeast Asia. Little stones or sometimes pellets made of metal (occasionally even gold or silver) are inserted into cuts made into the skin of the penis. The motivation for doing so is that the resulting lumpy surface is reportedly arousing to women. It may be that the penis ball is the source for the Burmese bell and ultimately the *rin-no-tama* mentioned earlier.

See also **Dildoe** and **Genital jewelry**.

Gender
The term was originally used only in grammar to label various subdivisions in nouns or pronouns that often seem to reflect the sex of the being referred to: English *he* or *she*; or French *un élève* (masculine) "a boy pupil" versus *une élève* (feminine) "a girl pupil" — but curiously enough *le vagin* "the vagina" (masculine).

The term "gender" has fairly recently been taken up by sexologists, anthropologists and others to refer to temperamental or behavioral aspects generally described as masculine or feminine, as opposed to the possession of particular genitalia (maleness or femaleness). Edward Stein

has come up with the slogan "sex is between the legs and gender is between the ears."

More and more, however, "gender" is used as the equivalent of — possibly a euphemism for — "sex," and one frequently finds expressions such as "discrimination on the basis of *gender*" (almost certainly "sex" is meant here).

"Gender identity" refers to an individual's sense of being masculine or feminine, or conforming to the cultural norms of being male or female. "Gender roles" refer to behavior patterns expected of men and women — and even boys and girls — in a particular culture.

Genital jewelry

In the overwhelming majority of human societies, the genitals are hidden and unadorned. Very rarely in some societies what might be called genital jewelry is used.

Formerly on the island of Truk, some women would perforate their labia and insert objects that tinkled when they walked in a certain way. A number of sadomasochists in the western world have taken to piercing nipples, foreskins (or remnants of foreskins), labia and, more rarely, other parts of the sexual anatomy.

In the cross-cultural literature, the best known example is the penis bar or *ampalang (or palang)*. The *Kaama suutra* mentions a device that may be a penis bar under a more general label of *apadravya*. An unambiguous bar is reported as early as AD 1590 in the *Boxer Codex* in the Philippines. In that description the penis bar is mentioned primarily as a way of securing a ring to the penis — worn, it is said, in the same way that a ring is put on the finger. The custom has survived, and penis bars of one sort or another are still used in the Philippines and in Borneo.

The device is seldom thought of as an adornment but rather as a means of increasing the sexual pleasure of women. It is said that women readily become addicted to its presence, although it does not add much to the pleasure of the male.

In Europe and America various kinds of ring have been used around the male genitals, for the most part to help the wearer keep an erection but possibly also for decoration. Such penis rings may have been derived from the erotic devices developed by the Japanese, where so-called "pleasure rings" have long been in use. These proliferated in the West after World War II, probably because of extensive American contact with the Japanese.

Genital preservation

In several societies, genitals — almost always male genitals — have been preserved for one reason or another. In various East African societies, ancient Egypt and some Ethiopian groups such as the Sidamo, male genitals have been taken as war trophies, much like scalps among American Indians.

Among the ancient Egyptians, at least two pharaohs, Seti I and Ramses II, had their penis and testicles removed in the process of mummification. Their genitals were mummified separately and placed in a kind of penis coffin. On the other hand, the penis of Tutankhamun ("King Tut") was left attached to his body by ancient embalmers, only to be stolen by a modern souvenir hunter — a fate shared by Napoleon's.

In Imperial China, eunuchs preserved their amputated genitals in a container. The penis and testicles were put through a kind of pickling process right after they were severed from the man's body. The pickled genitals had to be presented as proof of his eunuchoid state as he proceeded up the civil service or palace servant hierarchy — staffed largely by eunuchs. These pickled genitals were traditionally buried with the man in expectation that he would become whole again in the next life.

Genital tatoos

Tatooing of the genitals as an established custom is generally restricted to various Oceanic cultures and seems to be predominantly a fashion for women. Occasionally it is reported from other parts of the world, e.g., the Mongo of Africa.

Genital tatooing seems to be done for aesthetic or erotic reasons as well as to mark the adult status of the person. On Nukuoro it has been reported that tatooing marked a girl as a woman. Children born to those who had not been tatooed were put to death.

Vulva tatooing on Easter Island had the unusual implication that the woman had been seen by a man while she was copulating with another man.

Penis tatooing is extremely rare cross-culturally. Successful Don Juans on Mangaia often get a vulva tatooed on their penis. At least one king of Tonga is known to have had the glans of his penis completely covered with tatoos to show his disregard for pain. Penis tatooing is an idiosyncracy occasionally found among western men, notably sailors and male prostitutes.

Gerontophilia: see Paraphilia.

Homophilia
A term that has had at least four meanings. (1) As an alternate for
homosexuality. In certain European languages such as Danish and
Norwegian (where it is written *homofili*), the term is more and more
becoming the usual expression for homosexuality. (2) As an equivalent
of *homoërotophilia*, the acceptance or tolerance of homosexuals. In this
sense *homophilia* is contrasted with *homophobia*. (3) As more
comprehensive than the term *homosexuality* by not being seemingly
restricted to sexual attraction but also encompassing feelings of love and
limerance (John Money has suggested this use). (4) As a mode of
homosexuality in which sexual attraction is directed at adults who are
not in any way involved in "gender-bending" (transvestism, or the
adoption of social roles appropriate for the opposite sex). Geoffrey Gorer
introduced the term in this meaning in 1961, and I have used it this
way in earlier publications. However, because of the very great variation
in its use, I abandon the term here and replace it with the expression
homosexual adultophilia.

See also **Homosexuality** and **Paraphilia.**

Homophobia. Also called **Homoërotophobia.**
An intense fear or hatred of homosexuals and behavior attributed to
homosexuals. Also fear of being homosexual oneself (sometimes
accompanied by what has been called homosexual panic, an acute anxiety
reaction).

Homophobia characterizes traditional Western culture but seems
otherwise to be cross-culturally unusual. Precisely what the factors that
could account for it are, are unknown. Some anthropologists, including
Dennis Werner, believe that attitudes about homosexual acts (and other
sexual acts that cannot lead to procreation) are ultimately a reflection of
population pressures. But attitudes about male sexuality should then be
fairly constant, since it is the behavior of females that is crucial.

Gregory Lehne suggests that homophobia derives from a perceived
threat to male bonding. The exclusion of known homosexuals from the
United States military seems to take this position. However, among the
ancient Spartans and mediaeval Japanese, the opposite belief was held.

Gordon Gallup suggests a motivation in terms of the sociobiological
model: exclusive homosexuality, he points out, is tantamount to
sterilization. To the extent that a population believes that sexual

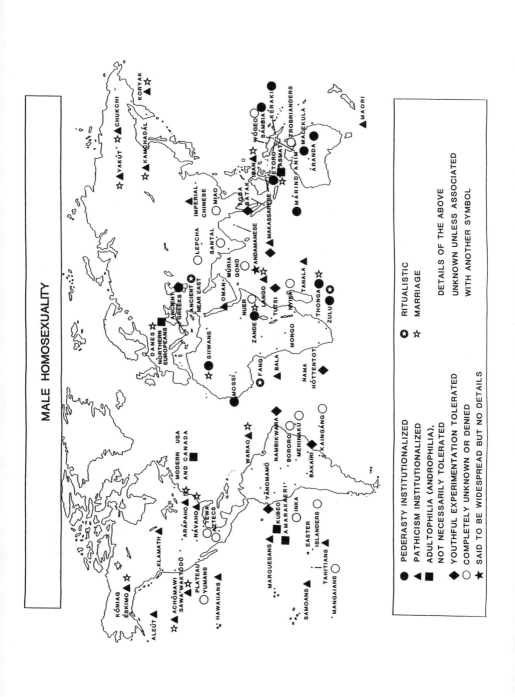

MALE HOMOSEXUALITY

KÓNIAG ▲
ALEÚT ·
ÉSKIMO ▲
☆ ACHÓMAWI ·
SAWA'WAKTÓDÖ ·
PLATEAU ☆
YUMANS ▲ ◯
KLAMATH ▲
☆ ARÁPAHO ▲
NÁVAHO ☆☆
TÉWA ☆
AZTECS ☆
MODERN USA
AND CANADA ■
☆ WARAO ▲
MARQUESANS ■
YÁNOMAMÖ ▲
KUBEO ■
AMARAKÁERI · ■
INKA ◯
BORORO ◯
MEHINÁKÚ ◯
NAMBIKWARA ◆
BAKAÍRI ◆
KAINGÁNG ◯
EASTER
ISLANDERS ◯
SAMOANS ·
TAHITIANS ◯
MANGAIANS ◯

DANES ☆
NORTHERN
EUROPEANS ■
ANCIENT
GREEKS ●
ANCIENT
NEAR EAST ★
SIIWANS ◯
MOSSÍ · ●
FANG ●
ZANDE ●
BALA ▲
MONGO
NAMA
HÖTTENTOT ◆
NUER ▲
OMAN· ▲
MÚRIA ·
GOND ◯
SANTAL
LEPCHA ◯
IMPERIAL
CHINESE ◯
MIAO ◯
ANDAMANESE ◆
LANGO ☆
TUTSI ▲
NYÍKA ◯
TANALA ◯
THONGA ☆
ZULU ★

YAKÚT ☆
☆ CHUKCHI ▲
KAMCHADÁL ▲
KORYAK ☆ ▲
WÓGEO ☆ ◯
SÁMBIA ●
TOBA
BATAK ▲
MAKASSARESE ▲
BANÁ ▲
KÉRAKI ●
ETORO ●
ASMAT ●
TROBRIANDERS ◯
MÁRIND-ANÍM ●
MALEKULA ●
ÁRANDA ▲
TASMA· ☆
MAORI ▲

● PEDERASTY INSTITUTIONALIZED

▲ PATHICISM INSTITUTIONALIZED

■ ADULTOPHILIA (ANDROPHILIA),
NOT NECESSARILY TOLERATED

◆ YOUTHFUL EXPERIMENTATION TOLERATED

◯ COMPLETELY UNKNOWN OR DENIED

★ SAID TO BE WIDESPREAD BUT NO DETAILS

✪ RITUALISTIC

☆ MARRIAGE

DETAILS OF THE ABOVE
UNKNOWN UNLESS ASSOCIATED
WITH ANOTHER SYMBOL

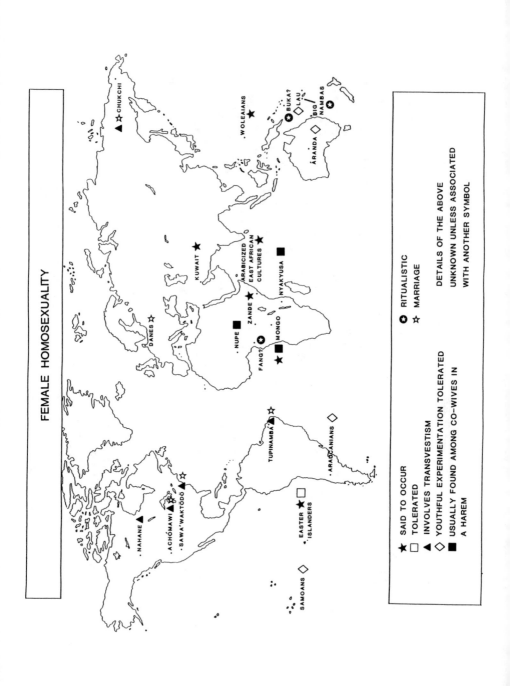

FEMALE HOMOSEXUALITY

★ SAID TO OCCUR
□ TOLERATED
▲ INVOLVES TRANSVESTISM
◇ YOUTHFUL EXPERIMENTATION TOLERATED
■ USUALLY FOUND AMONG CO-WIVES IN A HAREM

✪ RITUALISTIC
☆ MARRIAGE

DETAILS OF THE ABOVE
UNKNOWN UNLESS ASSOCIATED
WITH ANOTHER SYMBOL

CHUKCHI
WOLEAIANS
BUKA?
LAU
BIG NAMBAS
ÁRANDA
KUWAIT
ARABICIZED EAST AFRICAN CULTURES
NYAKYUSA
DANES
ZANDE
NUPE
MONGO
FANG?
TUPINAMBÁ
ARAUCANIANS
NAHANE
ACHÓMAWI
SAWA'WAKTÖDÖ
EASTER ISLANDERS
SAMOANS

orientation is acquired by seduction or role modeling, hostility will be shown to homosexuals — particularly those in charge of children such as teachers. Gallup himself rejects these ideas of causation and believes that at least for males the best way to guarantee heterosexuality is to provide more heterosexual opportunities, which might include legalized prostitution.

Other explanations have been offered, including some invoking capitalism, or urbanism vs. rural life — but no theory that is universally accepted.

A few writers have deplored the use of the term *homophobia* because — following its etymology strictly — it means literally "fear of same[ness]", which is judged to be too vague to be useful. However, the fact of the matter is that the word has entered the language. In a comparable way, words like *heterosexual* and *homosexual* jolt the purist because a Greek form (*hetero-*, *homo-*) has been grafted onto a Latin one (*-sexual*). Again, we must accept that these and similar items are now part of the language no matter how barbarous they strike the classical scholar.

Homosexuality. Also, but less frequently, called **Homophilia** or
 Homoëroticism or **Homosexualism;** formerly, **Sexual inversion**
 and **Uranism.**
Homosexuality refers in one sense to a sexual orientation to members of one's own sex. In another sense it includes the practise of any homosexual acts no matter how they are thought of by the people performing them or what their motivation is, for example lack of a partner of the opposite sex (as in prisons or aboard ships) or for ritual purposes (as in various puberty rites). The work of Kinsey and his associates in the United States has shown that the life histories of a great many people who consider themselves to be heterosexual include some homosexual experiences.

Of all aspects of human sexuality, western anthropologists have probably dealt least objectively with homosexuality. Even Malinowski's account of the Trobrianders turns out to be suspect.

A further problem is that female homosexuality (or lesbianism) is hardly ever mentioned — which of course does not mean that it does not exist. We just do not know in most cases.

Consequently, it is difficult to answer questions frequently asked of anthropologists such as, how common is homosexuality throughout the world and what are the attitudes about it?

In an earlier, classic cross-cultural study by Clellan S Ford and Frank A Beach (1951) 49 groups (64 percent of their sample) considered at least some homosexual acts "normal and socially acceptable for certain members of the community."

For the present book, I have made use of a much greater range of societies: 274 in the Human Relations Area File, plus eight others mentioned in the File sources but not given a separate treatment, as well as 12 others not in the Files at all.

Of the 294 societies considered in all, 142 had no information at all about male homosexuality, and a larger number (178) none about female homosexuality. I was able to find only 59 that made any clear-cut judgments on the topic of male homosexuality: 18 condemned (31 percent), 41 (69 percent) approved. These are virtually the same percentages as those given by Ford and Beach, though the later figures suggest a somewhat greater approval. I found 25 societies for which it was denied; societies that both condemned and denied totaled 36 — which swings the percentages in the other direction.

Ford and Beach sometimes list a society as disapproving if one kind of homosexual relationship is condemned though others seem not to be. A case in point is the Chiricahua. As Randolf Trumbach has pointed out, they apparently condemn homosexual acts between two men only if one of them is not a transvestite. The same thing is true of the Lango, listed by Ford and Beach as approving. The same label should apply to both.

If we combine Ford and Beach's sample with mine, then at least 63 societies in the world are tolerant of homosexual acts in some instances and for some purposes. This is a very rough estimate. But my guess is that given the general bias of western reporters, whether anthropologists or not, this figure is low.

Societies said to be lacking homosexuality altogether, or where homosexual acts are exceedingly rare, include the Kwoma, Lepcha, Wógeo, Nuer, Timbira, Lesu, Kikuyu, Ulithi, Truk, Pukapukans, Kaingáng and Sirionó. At the other extreme are societies in which there is virtually total participation (by males) in homosexual acts, within a larger bisexual context, for example, in societies with obligatory pederasty in puberty rituals. One of the important lessons from such societies is that although the first sexual experiences of boys are frequently if not always homosexual, the boys themselves do not grow up to be exclusively homosexual. Surely this fact alone undermines all theories that directly derive homosexuality from early adolescent sexual

experiences, especially seduction by older homosexuals. The majority of
reports from these societies also tends to rule out genetic explanations for
most homosexual behaviors.

Several different styles of homosexuality exist. Geoffrey Gorer
distinguished three: *pederasty*, which involves a considerable age
difference between the partners, with the younger partner in his teens
or very early twenties; *pathicism*, which involves a role change on the
part of the passive (pathic) partner, who is often a transvestite or in some
other way does not play a masculine role sexually or socially; *homophilia*,
in which both partners are adults and there is no interest in changing
sex roles. To these can be added two additional types: *adolescent
experimentation* and *deprivation homosexuality* (where suitable
heterosexual partners are lacking).

More recent writers have tended to substitute other expressions for
Gorer's terms. For example, for pederasty, at least three other
expressions are widely used instead: *intergenerational homosexuality*,
transgenerational homosexuality, *age-differentiated homosexuality*. These
three are misleading because they do not rule out paedophilia or
gerontophilia. Another term, *ephebophilia*, has been used to refer
specifically to an interest in males 17 to 19 years old, sometimes a little
older (which *pederasty* technically does not, though it commonly does).
It seems to me that of all the terms, the traditional one — *pederasty* — is
best, and it is retained here. But an even better term would be more
general, in line with *paedophilia* and *gerontophilia*, which can be used
both of homosexual and heterosexual interests, and does not specify the
sex of the sex object itself. I suggest a new term, *adolescentophilia*, to
parallel the other two terms for a paraphilia based on an age dimension.

Similar problems exist for *homophilia* (which has several other
meanings), also called *androphilia* when it applies to men. I suggest a
new expression: *homosexual adultophilia*.

The term *pathicism* has also had variants, including *gender-
differentiated homosexuality*, *transgenderal homosexuality* and
cross-gender homosexuality. I retain Gorer's term simply because it is
less clumsy.

These styles tend to cluster geographically. Adolescent
experimentation is the type most commonly reported from South
America; pathicism from Siberia, North America and Polynesia;
pederasty from New Guinea and Australia. It may be, however, that
once one kind was recognized by a field anthropologist, the other kinds
were not looked for and so not reported.

From the scanty information about female homosexuality cross-culturally, a pederastic (or adolescentophilic) mode seems to be lacking in most instances. In the United States, the modes are often class-bound: a pathic, role-differentiating mode found among working-class women, and an adultophilic mode in middle-class women.

Among homosexual men in the western world, the predominant homosexual style is mutual adultophilia — but this is quite exceptional from a cross-cultural point of view and seems to be a fairly recent phenomenon. Homosexual adultophilia is virtually unknown in primitive or peasant societies and very little evidence for it appears before the nineteenth century. However, it is found in various Amazonian groups in South America and possibly also among the Asmat of Irian Jaya on New Guinea.

Why male adultophilia as a relatively large-scale social phenomenon should have appeared within the past two centuries and not before remains unclear. Gorer thinks it has to do with the fact that modern families are small and isolated and that boys are not exposed to enough male models. I think this is unlikely. Also, it does not explain the common adultophilic style of lesbian relationships.

Until very recently in traditional societies, men were in dominant power positions in families, as fathers and as husbands. The pederastic and pathic styles simply reflect these traditional power relationships in a homosexual context. Even the adultophilic relations sometimes reported between kings and mature men preserve an unequal power relationship: king to subject. By the eighteenth century in England, there was a change in the structure of the upper-class family, which has spread through the social classes and to other countries so that it has become the general family structure in Europe and America. This new structure was the egalitarian family, where husbands and wives counted as equals. It developed as women became more independent financially; and as romantic love became a justification for marriage. This model of equality between spouses who are romantically attached to each other is precisely the adultophilic model — and it developed for homosexual men only after the heterosexual model changed.

Pathicism is institutionalized in a great many societies, but it normally involves no more than a handful of members in any given community. In societies where pederasty is institutionalized, all the males in the society may participate. Pederasty — as in ancient Greece and among the Zande — seems to appear particularly when the women are secluded and unavailable to young men. With both pederasty and

pathicism, homosexual marriages are occasionally socially recognized and include bride-price. In my own sample, 19 societies are said to permit such homosexual unions. To my knowledge, only Denmark recognizes homosexual adultophilic marriages — but the Asmat of Irian Jaya (New Guinea) may be another exceptional case. Western homosexuals sometimes celebrate their own informal and not legally binding marriage ceremonies. A recent study of such "marriages" shows that they tend to be less stable than simple cohabitation without a ritual.

Generally speaking, anal foration (anal intercourse) seems to be the most common male homosexual act in primitive societies. Also fairly frequent is interfemoral foration (rubbing the penis between the thighs of the passive partner).

Among homosexuals in the United States, fellation is the most common act: European homosexuals sometimes refer to fellation as the "American vice." A kind of psychoanalytic interpretation is tempting if only because American heterosexual men have developed an intense interest in female breasts. Now the penis may, psychoanalytically, symbolize a breast (compare the teats of a cow). Add the fact that many middle class American infants are orally deprived and you have the beginnings of a fairly tidy — if involved — theory.

One of the consequences of the various factors that characterize western homosexuality — exclusivity, adultophilia, together with the generally despised status of homosexuals necessitating a quasi-secret organization — is the development of a "gay" subculture, characterized by fashions in clothing and the development of ghetto-like communities.

Not all homosexuals are members of this subculture. In fact, it is sometimes useful to restrict the word *gay* to people in it, and not use the word as totally synonymous with homosexual. Some observers do not agree with this statement, however. For example, Esther Newton says "Gay life is rather like the early Christian church: it exists wherever and whenever gay people are gathered together."

Very little is known about female homosexuality cross-culturally. I found only 5 societies in the world that specifically approved of lesbianism for at least some people. But usually it is not discussed at all. It is reported most often in societies where men have many wives, especially when the co-wives live a secluded harem-type of life.

Impotence and other male sexual dysfunctions
The main types of sexual dysfunction found among men are various degrees of impotence (inability to achieve or sustain an erection),

premature ejaculation, retarded ejaculation (or ejaculatory incompetence) and several conditions that Masters and Johnson have called dyspareunia (pain during coïtus).

Sex therapists suggest that religious orthodoxy (strict conservative Judaïsm and Christianity) is of major importance in almost every form of sexual dysfunction among men, with the possible exception of premature ejaculation. Furthermore, the incidence of such dysfunctions seems to vary considerably in different cultures. Impotence is said to be relatively infrequent among, for example, the Mangaians of the Pacific and extremely common among the Kágaba of South America. However, in 1922, U.C.L.A. researchers reported that low nitric acid levels inhibited erections in rabbits; probably this is true for human beings as well.

Nonwestern cultures have produced a variety of folk explanations for impotence, including witchcraft. The Dogon, Hausa and Fang say that if milk from a woman's breast drips onto her baby son's penis while nursing, he may grow up impotent. The Wolof tabu sex on Wednesdays and believe that if a boy should be conceived on that day, his impotence will result from breaking the tabu. Both the Fang and the Bemba associate impotence with elephant tusks. For the Fang a man need only step over a tusk to become impotent. The Bemba say it will occur if he sees the nerve inside. None of these beliefs has any scientific validity.

Among the ancient Mesopotamians incantations existed to prevent impotence, as well as ointments for its cure. The potency incantations were recited by women to their lovers.

Impotence almost universally produces shame in the afflicted individual. In some cultures, it is considered symbolic of even wider social repercussions. For example, in a number of African societies where the king was regarded as a god or very closely linked to a god, the king's physical health and in particular his sexual potency were regarded as barometers of the health and vigor of the kingdom. Among the Shilluk, a king who became sick or senile or was unable to satisfy his wives sexually was strangled or walled up in a house and left to die.

Although a strict puritanical background is one of the scientifically accepted causes of impotence, Donald S Marshall in his discussion of impotence among the Mangaians suggests almost the opposite. He says the Mangaians suffer from impotence and sterility as a biological penalty they must pay for very frequent copulation — and very vigorous copulation at that.

The Mangaians themselves recognized several degrees of impotence, the most serious being *tiranaro* "lost (or hidden) penis," in which the penis withdraws into the body and will kill the afflicted person unless he abstains from sexual intercourse for some months and is treated with smoke therapy, which involves squatting over smoldering herbs, the smoke seeping through punctured coconut shells.

This condition — retracting of the penis into the body — is also believed to exist by some Chinese and other Southeast Asian groups. The condition is known as *koro* and is also said to be caused by sexual excess.

Jus primae noctis: see Droit du seigneur.

Kissing

Kissing as an erotic act is almost universal in the western, Arab and Hindu worlds. In a few societies, it is totally unknown, for example the Somali, Cewa, Lepcha, Sirionó and Sámbia. In other societies, kissing is regarded as disgusting. The Thonga of South Africa find all mouth-to-mouth contacts revolting because of the possibility of getting the other person's saliva into one's own mouth.

Although in the West kissing is considered so innocuous or commonplace that it is regularly performed in public, in other cultures such open expressions of affection are forbidden. As late as 1978, the Hindi motion picture *Satyam Shivam sundaram* (called *Love sublime* in English) occasioned a scandal in India and created a national debate over censorship because it depicts several (to Westerners rather chaste) kisses between a man and his wife.

According to the Persian erotic manual *The perfumed garden*, the only kiss that can appropriately accompany copulation is the one variously known in English as a deep kiss, soul kiss, tongue kiss or french kiss. One of the earliest representations of deep kissing is found on the erotic Mochica pottery in Perú, dated about 200 BC. Another kind of erotic kiss has been called the "smell kiss" or "olfactory kiss": the nose is placed near or against the partner's face and one inhales. The ancient Egyptians probably used this; their words for "kiss" and "smell" are the same.

Nose rubbing may be a variant of the smell kiss or simply an inaccurate label. But rubbing has been specifically reported for the Éskimo, Tamil, Ulithi and Trobrianders.

Lesbianism: see **Homosexuality.**

Limerance

A word coined by Dorothy Tennov in the 1970's to refer to the state of being of a person in love. Not all people can become limerant, in her findings, and the ones who do can be limerant with only one person at a time. Limerance presumably should occur to some degree in all populations of any cultural tradition but in fact has almost exclusively been reported from western cultures. Some evidence that a biological base for limerance exists: brain surgery for a pituitary tumor may ruin the possibility for limerance in those who have previously experienced it. Furthermore, love-sickness — the result of unrequited limerance — may be associated with a depletion in the brain of a particular chemical, phenylethylamine.

Although sex is seldom the main focus for limerance, the potential for sexual contact apparently has to exist. However, among bisexuals, limerance occurs consistently only with one sex (which could reflect either a homosexual or heterosexual interest, but never both).

See also **Romantic love.**

Love: see **Limerance** and **Romantic love.**

Lovemap

The term was coined about 1980 by John Money.

A lovemap comprises for a particular individual both the ideal lover and the ideal settings and actions for a sexual relationship. In general, therefore, the lovemap includes sexual orientation, paraphilias, and any other components (such as transvestism) that go to make up one's romantic and erotic fantasies. Once developed in mental imagery, it may subsequently be translated into action with one or more partners.

Love magic

The majority of societies in the world for which we have reasonably adequate information have developed love potions, or created magical spells to entice a particular person to become a lover, or a spouse to be faithful, or some related desire. Among the Trobrianders, virtually all success in love is believed to result from magic.

Love magic has a considerable antiquity. Possibly the oldest example known is a Sumerian charm, which dates from several thousand years before Christ. This charm requires mixing the milk and fat from special

cows into a green ritual bowl and then sprinkling the mixture on the breast of a young girl. As a result, the girl will not only be available but will even run after the one who has applied the charm.

Although love magic is very common there are a few exceptions. The Tewa of North America and the Sirionó and the Kaingáng, both of South America, are reported to have no love magic at all, and the Kaingáng assume that all people except little children are "spontaneously, vigorously and indiscriminately sexual, and act accordingly."

Ford and Beach suggest that the use of love magic is least developed or nonexistent among people who are direct about their sexual advances. They cite the Lepcha, who have a little love magic but rarely use it because requests for sexual favors are usually met.

Some cultures have a reputation for the efficacy of their love magic. In Europe, Gipsies traditionally have been the dispensers of the best magic. In aboriginal North America, the Cree Indians were among the most illustrious in this field.

One technique to make someone fall in love is either by gaining control over the person through something intimately connected with him, such as a lock of hair, nail clippings or a piece of cloth, or by bringing the person into contact with some intimate physical part, particularly some body excretion such as sweat, semen or menstrual blood. Both these ways are varieties of what is known as contagious magic.

Love magic with a modern touch comes from African-derived Latin American possession cults sometimes called Santería. Because of the migration of many Cubans and other peoples of the Caribbean to the United States, these cults are found in many cities such as New York and Miami. One of these recipes is peculiarly American: "Prepare a hamburger patty. Steep it in your own sweat. Serve to the person desired." (Semen or menstrual blood might be added.)

Various other kinds of love magic exist, sometimes less easy to categorize. They may even involve human corpses or parts of corpses. One ancient Irish love recipe begins by advising: "Find a corpse nine days old."

The Hausa of West Africa have a number of different kinds of love magic, not only to attract a partner but also to blind one's spouse to the fact one has a lover. In spite of the wide variety of Hausa love magic and belief in its efficacy, the practical nature of the Hausa appears in a proverb, which refers to a well-known love magic involving dried-up bats: "Forget the bat magic, the real charm for getting a woman is money."

Male pregnancy

The Ila of Zambia tabu male homosexual acts because they believe pregnancy would be the outcome.

John Money reports that among a number of black homosexuals in America, it is also believed that a man can get pregnant as a result of anal foration. If the semen comes in contact with a certain organ (invariably unspecified), the semen itself develops into a "blood baby." The "pregnant" man's belly begins to swell after about the third week. Labor pains accompany actual delivery of the blood baby, which comes out of the rectum along with some faeces.

This belief in blood babies may represent a continuation of African beliefs such as those found among the Ila. But such a belief has not, to my knowledge, been recorded for West African groups who were ancestral to most contemporary blacks in the United States. At least one American Indian group shares a similar notion, but they are even less likely to be the source: some Návaho state that a man will get pregnant if he copulates with the woman on top. Also, that male pregnancy can occur if a menstruating woman steps over a man.

The belief in the possibility that male pregnancy may result from anal insemination is also reported from New Guinea. Among the Kéraki, boys go through a period associated with their puberty rites in which they are regularly forated by older men; the belief is that otherwise they would not grow. It is further believed that the boys can become pregnant, and to prevent this, a lime-eating ceremony is performed. After the period of playing the passive, insertee role, boys graduate to playing the active role both homosexually and heterosexually.

Interestingly, modern technology now seems to have made male pregnancy possible. Any child born of a male "mother" would have to start out as a "test-tube baby," of course. But the embryo can now be implanted in the abdomen and eventually delivered by a kind of caesarian operation. Cecil Johnson and Roy Hertz successfully demonstrated this with baboons in an experiment in the 1960's. That many men will want to entertain such a possibility for themselves seems unlikely, however.

Masochism: see Sadomasochism.

Masturbation. Formerly, also called **Manustupration, Ipsation,** or **Onanism.**

Masturbation is considered as normal adolescent behavior in most cultures and is not taken seriously unless practised by adults, when it is almost universally frowned upon. Although male masturbation is condemned by the Kágaba of South America as an exceedingly serious offense, married men tend to concede that it is their preferred form of sexual activity — an admission unique in the world's cultures. In many nonwestern societies, the actual rate of masturbation is low — as it is known to be in working-class groups in the United States, as opposed to upper-level groups.

Masturbation with the aid of a device like a dildoe is widely reported cross-culturally for women. Anal and urethral masturbation, which also require the insertion of some foreign object, have not been discussed in primitive cultures; in the western world, an amazing number of items have been used — from hairpins to Coca-cola bottles.

Not much information about group masturbation (or circle jerk, as it is informally known in English) is available, even for western society. College fraternity initiations are frequently rumored to involve various relatively uncommon sexual acts like group masturbation, but no statistical information exists about these practises.

Masturbation contests have also been reported — among certain American Indian groups, in Polynesia and West Africa, as well as among Europeans and Americans.

Masturbation has sometimes held religious significance. The ancient Egyptians believed that the creation of the gods occurred through an act of masturbation by the primal god Atum, whose hand was his divine partner. The existence of such a myth suggests that possibly masturbation was used in some sort of Egyptian religious rite.

Nekrophilia

Sexual attraction to and sexual acts with dead bodies are both subsumed under the term nekrophilia, a kind of paraphilia.

According to his biographer Wardell Pomeroy, Kinsey — in spite of his massive survey of sexual behavior — never met anyone he could regard as a real nekrophile. Anthropologists have seldom mentioned the topic for any society, even as a personal quirk. But when nekrophilia has been reported, it has nearly always been confined to men.

The earliest reference to nekrophilia occurs in Herodotus's account of ancient Egyptian mummification. He noted that the bodies of

beautiful or illustrious women were not handed over to embalmers immediately after death because of fear that they might be defiled.

Embalmers and morticians have been occasionally thought of as pimps of the dead, even outside of Egypt. Patricia Bosworth's biography of the movie star Montgomery Clift asserts that he knew a plastic surgeon and illegal abortionist who in the early 1960's occasionally "supplied dead bodies to a notorious homosexual —funeral parlor' on Sixth Avenue. For fifty dollars one could go in and have sex with a corpse."

In at least one society, that of the Luo of East Africa, a kind of ritualized obligatory nekrophilia is said to be practised. The ghost of a young girl who died as a virgin is regarded as extremely dangerous: to pacify this ghost a stranger is called in to deflower her corpse. No comparable nekrophiliac act for males is performed; instead a woman would be "married" to a dead man who had no children in order to bear a child that could then count as his offspring.

The Bellacoola of British Columbia formerly considered it appropriate for a man to copulate with his wife's corpse as a sign of profound grief (this is now totally tabu). Similarly, among the Pukapukans of Polynesia — who forbid even looking at a dead body — it is considered understandable if not desirable, if a sorrowing cousin should be driven by despair to have intercourse with the dead person.

The most extensive anecdotal accounts of nekrophilia are found in reports by Ronald M Berndt for the Káinantu of New Guinea. Among these people nekrophilia is seen both as an aggressive act (it is usually performed on the bodies of enemy women killed in warfare) and as a source of pleasure.

Night-courting: see **Bundling, night-courting and related customs.**

Night-crawling. Also called **Sleep-crawling.**
Night-crawling is the practise whereby a young man steals into a room (or tent, etc.) to have intercourse with an unmarried girl without her prior consent, even though her whole family may be sleeping in the same room. In Polynesia and the Philippines, this practise may be accompanied by the fantasy that a man can copulate with a woman without waking her.

North American night-crawling lacks this peculiarity but has two others of its own: the night-crawler sometimes simply tries to touch the girl's genitals and does not attempt intercourse; and women are occasionally reported as the night-crawlers — at least among the

Comanche, Hopi and Návaho. The Lau of Fiji in the Pacific share the
latter practise.

According to Margaret Mead, on Samoa only young men who are
unpopular would resort to such a practise and they do so out of
desperation because no one would accept them otherwise. She calls the
practise "surreptitious rape." Once a boy is caught as a night-crawler, no
girl will every pay attention to him again and he can only marry when
older, when he may have a position and title to offer.

The practise seems to be considered in a different light on Mangaia,
where it is quite widespread and highly praised if successful.

For two such different reports of virtually an identical practise to
exist may reflect actual cultural differences. On the other hand, since
one account was written by a woman (Mead), the other by a man (Donald
Marshall), these differences perhaps reflect varying attitudes about rape
found in western culture among men and women.

Paedophilia: see **Paraphilia**, also **Homosexuality** and
 Child marriage and betrothal.

Paraphilia
Paraphilia refers to specialized sexual interests that are independent of
sexual orientation. The term was apparently first used by the Viennese
ethnologist Friedrich Salomon Krauss and adopted by Wilhelm Stekel as
early as 1924. It fell out of use until revived by John Money in the
1950's.

The term paraphilia was historically coined to replace another term,
perversion, which suggests either condemnation or perhaps a (faulty?)
diagnosis in terms of pathology. However, usage has tended to restrict
the term to interests that are generally considered pathological or socially
unacceptable. Money himself has pointed out that from a legal point of
view a paraphilia is simply another term for perversion or deviancy, and
that in everyday use, paraphilia refers to kinky or bizarre sex. The
American Psychiatric Association's *Diagnostic and statistical manual III
R (DSM III R)* treats paraphilias as disorders.

Clearly, some unambiguous paraphilias tend to be very infrequent
or even dangerous and criminal. As an example of the first type,
consider sexual arousal produced by the sensation of having insects or
snails running over one's sex organs. Only one person has ever been
reported as having such an interest (called *formicophilia*) — though others
exist. An example of a dangerous or criminal type of paraphilia is surely

the passion produced in so-called lust-murders (*erotophonophilia* or *homicidophilia*). Some others are at least considered strange by most people, such as arousal by wearing diapers (*diaperism* or *autonepiophilia*) or seeking out the agèd as sex partners (*gerontophilia*).

But I suggest that the notion of paraphilia makes most sense when it plays up specificity of sexual interest rather than lack of social acceptability, if only because such acceptibility varies from culture to culture. In this revised view, attraction to blonds to the exclusion of all other persons is a paraphilia. That such an interest is not generally regarded as bizarre, kinky, or criminal in the western world, is irrelevant: in a society where only an occasional foreigner might be blond, social judgments could be very different. Even more clear as an example of social rather than psychological judgment involves another interest I consider a paraphilia: attraction to persons only of another race. When miscegenation laws do not exist, such a paraphilia may be of no social consequence. But in a society with a very strict color bar — as in earlier forms of apartheid — acting out this paraphilia would bring criminal prosecution.

My expanded use of the term paraphilia is therefore not in accord with that of most other writers or even that found in earlier publications of my own.

It is mostly from large, complex societies that paraphilias of any kind have been reported. Another striking characteristic of paraphile practises is that they are overwhelmingly male interests.

Members of primitive societies seldom develop or practise an interest in paraphilias except partialism (intense sexual interest in some body part) and transvestism (which may be referred to as *transvestophilia*, to distinguish it from nonparaphile types of cross-dressing). Sexual contacts between adults and children or between fairly old men and girls who have not yet begun to menstruate are reported from some societies, where such practises may even be institutionalized. But true sexual preference for children (*paedophilia*) or for the elderly (*gerontophilia*) is rarely described.

By the way, traditional terminology for sexual interests in partners of specific ages is deficient. Words for homosexual age interests occur — but divided up between male and female interests. For example, male homosexual interest in adolescents is called *pederasty* (and for older boys, *ephebophilia*) and the corresponding female homosexual interest is occasionally referred to as *parthenophilia*, but there is no term for the interest in general, including the corresponding interests of

heterosexuals. Pederasty might do etymologically but is almost always taken as a male homosexual interest. I suggest a new term altogether: *adolescentophilia*. Similarly, no generally accepted word exists for attraction to adults who are not agèd, though there are terms for the homosexual interests: *androphilia* for males, *gynekophilia* for females. Again I suggest a new term: *adultophilia*. I can therefore abandon a term used in some of my earlier writings, *homophilia* (which was unfortunate because it has had several other, different meanings). What I previously called homophilia is now technically *homosexual adultophilia*. The terms for age paraphilias are finally independent of sex or sexual orientations: *paedophilia*, *adolescentophilia*, *adultophilia*, *gerontophilia*.

Other recognized forms of paraphilia include the following: Peeping-Tom behavior (*voyeurism* or *skoptophilia*); flashing (*exhibitionism*); being sexually aroused by reading erotic stories (*narratophilia*); by listening to stories of sexual encounters or hearing sounds produced during sexual acts, either live or recorded (*ecouteurism*); by making obscene telephone calls, often to strangers (*telephone skatalogia*); by setting fires or seeing fires (*pyromania*, *pyrolagnia*); by stealing (*kleptolagnia*); by raping (*raptophilia* or *biastophilia*) Many commentators have seen this last behavior, rape, as not being essentially sexual but rather an expression of male domination at its starkest and most alarming. Hence, women who are not necessarily sexually attractive may be raped, according to this analysis. John Money suggests that there must be an erotic component — otherwise the rapist could not achieve erection. He maintains that the crucial component is the terror conveyed by the victim; this is the paraphile trigger.

Money believes that most paraphilias — at least the traditionally defined ones — are the result of responses to stress at about the ages of 5 to 8 (after sexual orientation has developed), and are induced generally by biochemical malfunctions. People with paraphilias often lose them being treated with the drug Depo-Provera (the trade name of the hormone medroxyprogesterone acetate).

An interest in enemas (*klismaphilia*) occurs among some Westerners. It may also have occurred among the ancient Egyptians, who believed that the enema had been invented by the god Thoth. The Kuba of central Africa (Zaïre) are well known for a seeming preoccupation with enemas, which are often represented in art work. The Mayans of Mexico even included hallucinogens in their enemas. In none of these instances is it clear that klismaphilia was involved.

Biting and scratching, sometimes even mild burning, have been reported as part of the sexual behavior in many societies. But an intense interest in pain or humiliation, which accompanies sadomasochism in advanced societies, seems to be generally absent. Sexual behavior involving corpses (*nekrophilia*) is occasionally found in nonwestern as well as western cultures. There is no mention at all for primitive societies of a sexual interest in amputees (*akrotomophilia*) and in becoming an amputee oneself (*apotemnophilia*); or in filth (*mysophilia*) — in particular excrement (*koprophilia* or *koprolagnia* — even *koprophagy* "eating of excrement"). An intense interest in urine (*urolagnia*) has been reported for the Trukese: men like women who urinate when reaching a climax and women want men to urinate inside them after ejaculation. The same thing may be true in part for the Yapese, another Pacific culture.

Partialism: see **Fetishism and partialism.**

Pederasty: see **Homosexuality,** also **Paraphilia.**

Pedophilia: see **Paedophilia.**

Penis holding
The custom of holding another person's penis is occasionally reported from different parts of the world as a nonerotic ritual.

Among the ancient Hebrews, men swore an oath while holding the penis of the man the oath was made to, the biblical euphemism being "Put your hand under my thigh" (no direct expression for "penis" is found in the Bible).

Among the Wálbiri of Central Australia, a man accused of a serious offense may try to place his penis in the hand of a close male kinsman. If the kinsman permits this, he has symbolically sworn to plead for the accused and even fight for him. Similarly, when men from another tribe arrive for certain ceremonies, they usually offer their penes to their hosts (much as Westerners shake hands).

In certain rituals found among the Nuer of East Africa, women have to grab the penes of men and even tie a cord to the penes and pull on them.

According to John Disney, writing in 1729, a "phallic oath" was recognized at one point in Welsh law. A woman accusing a man of rape could convict him if she held in her right hand the relic of some saint,

and took hold of the accused man's penis with her left hand while swearing that he had violated her chastity with "that member."

I know of no customs where touching the vulva had a comparable significance, but among the Fang of West Africa, girls initiated into a secret women's ritual were required to touch the vulva of the presiding woman.

Phallicism (or Phallism) and kusthicism

These terms refer to the worship of sexuality and fertility, especially in the form of male and female sex organs. No traditional word exists to denote the feminine counterpart of phallicism. I have, therefore, coined the term *kusthicism* from the Greek word for vagina (*kústhos*); the corresponding adjective is *kusthic*. Examples of kusthic symbols include cowrie shells, triangles and, for the Freudian-oriented, any tunnel or room.

One of the noticeable cultural universals is that phallic representations are more frequent than kusthic ones. In some societies breast representations more commonly indicate aspects of femaleness rather than kusthic symbols, e.g., classical representations of the goddess Artemis with many breasts (though some scholars say these are not breasts at all but honeycombs — bees were sacred to Artemis — or stag teeth — stags were also associated with the goddess).

The two most famous examples of phallic cults are the Dionysiac rites of the ancient Greeks and the *lingga-yoni* worship of modern Hindus. For Hindus the *lingga* or *linggam* (phallus) is a representation of the god Shiva; the *yoni* (kusthos) which the *lingga* may be set in, is frequently taken as a representation of the goddess Shakti — the two together representing the sacredness of sexual intercourse, and the totality of existence.

In Japan, phallic cults as part of Shintoism have been quite widespread and phallic representations are found throughout the countryside. In 1972, the Japanese government tried to suppress phallic ceremonies, but ceremonies and the shrines still persist.

Some commentators have been prone to see phallic representations wherever stone columns exist or wherever anything remotely penile comes into view. Others have tried to interpret the Bible to show that the ancient Hebrew religion involved phallic cults. Most biblical scholars disagree. We can call them literalists: they tend to call a stone a stone. But which of these two camps is right is not immediately obvious.

Proofs of virginity
The virginity of a bride (but not of a groom) plays an important role in many societies of the world, and "proof" of this virginity is sometimes demanded.

The most widespread culturally accepted proof is a piece of cloth (less commonly some other material) that has been stained with the blood shed because the bride's hymen has been broken in the first intercourse she has with her husband. This is the usual test in the Old World.

In the Americas, the only society I know of where an intact hymen is taken as proof of virginity is the eastern Apache. Among the eastern Achómawi of California, if either girls or boys got tired during a ritual puberty dance it was taken as a sign that them were not virgins; spectators were on the lookout for this.

The "tokens of virginity" mentioned in the Bible most probably refer to bloodstained garments from the bride's first intercourse with her husband. The parents of the bride are advised to keep them if ever her husband should accuse her of not having been a virgin at her wedding. If her husband makes such an accusation falsely, he will be forced to pay a stiff fine of 100 shekels of silver to her father and will not be able to divorce her ever (which was otherwise not the case). If bloodstained garments cannot be produced, the bride is to be stoned to death (Deuteronomy 22:13-19).

Similar practises have been reported from Arab and Islamic societies, the Kopts in Egypt and various other Mediterranean groups, such as the Greeks and Sicilians. Moreover, comparable customs have been found in eastern Europe (among Russian and Estonian peasants), in many parts of Africa, the Far East, and a number of Oceanic societies. Eastern European immigrants to the United States have been known to send bloodstained sheets back to their families in "the old country" to legitimize their marriages traditionally.

For modern Egyptian peasants, the test does not come with the first marital intercourse, but before that: the bridegroom wraps a piece of cloth round his index finger, which he inserts into the bride's vagina. In some parts of Greece, it is the bride's mother-in-law who inserts her finger.

The tremendous interest that such rituals show in the state of the hymen is remarkable, since bleeding does not invariably accompany first intercourse. The hymen itself varies greatly with regard to size, thickness, flexibility and sturdiness. Cases have been reported of women

with repeated sexual experiences whose hymens are so elastic that they remain unbroken.

Pubic wigs

The only common form of public wig is the merkin, a covering for a bald female pudendum. The fashion is first mentioned in the seventeenth century and may be associated with the widespread custom of wearing wigs on the head. Both probably developed after waves of syphilis epidemics swept Europe, one consequence of which was extensive loss of body hair. The term merkin was first reported in 1728, but the object must be somewhat older.

Even in the twentieth century such wigs are occasionally found. During and after World War II, Neapolitan prostitutes sometimes wore blond merkins to suit the tastes of foreign soldiers.

Pubic wigs for men are not reported but occasionally other kinds of body wig are found in the western world.

Wigs of any sort are seldom regarded as erotic turn-ons in themselves. However, in one Ancient Egyptian story, a young man says to a woman: "Don your wig and let us go to bed!"

Public copulation

In most societies, sexual behavior takes place in private, or at least what passes for private by convention. The word might merely mean in the dark — while surrounded by dozens of other people, sleeping, or pretending to sleep, in the same room, as in some Polynesian or European peasant households.

A few instances of public copulation as a custom have been recorded, as in Captain Cook's account of such a scene on Tahiti, but the accounts are frequently inadequate.

Public ritual copulation has been reported from certain Polynesian groups such as the aboriginal Mangaians, where married couples had sexual intercourse in sacred closures before battles.

Public outdoor nonritual copulation has been reported from contemporary Aleúts, Tukano, Yapese and Formosan aborigines.

Rape

The usual definition is forced sexual contact with an unwilling partner, usually a woman. However, the notion of rape may be wider or narrower in a particular culture. So for example, sexual intercourse is regarded as rape in western society even when consented to, if it is performed

with a minor or someone mentally defective. This would not be so in at least some instances involving arranged marriages of prepubescent girls in many groups. On the other hand, even the possibility of rape within marriage is usually ruled out because the marriage contract confers virtually unlimited sexual access to spouses. The idea of "marital rape" is a recent one in the western world — or anywhere for that matter, except in rabbinic Jewish tradition — and is correlated with the increasing economic independence of women, bolstered by the consciousness raising of the women's movement.

Ceremonial rape occurs: some east African groups incorporate it into male coming-of-age rituals. Furthermore, rape may be a recognized form of punishment: many American Indian groups and various other societies across the world have punished women guilty of adultery with gang rape.

In most societies, rape (particularly of a married woman) is one of the most serious of sexual offenses. Death is regarded as the appropriate penalty among many groups including the Lamba, Rwala, Murngin, Cheyenne and Chiricahua. However, a number ignore rape altogether: the Copper Éskimo, Kaska, Mundurucú, Trumai, Návaho, Hadza, Lepcha and Trobrianders.

In at least two societies, male rape of women is reportedly the preferred form of sexual activity for men. These societies are the Marshallese of the Pacific and the Baiga of India. In some societies, the distinction between rape and nonrape is not always clear since women are expected at least to feign reluctance to male advances. The modern feminist dictum that when women say no, they mean no, was not always the case even in the western world. R A LeVine's study of sexual offenses among the Gusii of east Africa illustrates this clearly.

As a matter of fact, the Judaeo-Christian tradition never singled out rape as a special sin and was quite wary of a distinction between rape and seduction. In the Bible, if a woman alleges she was raped in a city, she is not to be believed presumably because she did not resist sufficiently, did not cry out and get help. Consequently, she is to be killed for having committed a sexual offense of her own. On the other hand, a woman raped in a country field where no one could come to her aid is held to be innocent (Deuteronomy 22:23-26). The Talmud tends not to distinguish between seduction and rape either, and is more concerned with violation of the woman's "purity." Similarly among the ancient Romans and traditional Muslims, among whom raped women have been abandoned by their husbands even in times of war.

Rarely is rape of men by women even discussed. Some have denied the very possibility (after all, erections require some degree of desire). In at least two societies anecdotal accounts of such rapes are found: the Trobrianders of the Pacific and the Kágaba of South America. Rape of women by women is almost never mentioned.

Rape of men by men, on the other hand, seems fairly frequent in prison populations or with war captives. Usually, dominance rather than homosexual passion is given as the reason for such incidents.

Susan Brownmiller, in her 1975 book *Against our will*, popularized the view that rape is essentially not sexual at all, even in male-female encounters. Rather, she asserts that it has been "From prehistoric times down to the present...a conscious process of intimidation by which *all* men keep *all* women in a state of fear." Although this view has entered mainstream thinking, it has its critics. Donald Symons, for one, points out that every interview with a rapist he has read, reveals mixed motives, but that sex is definitely an important one. John Money argues that rape involves a specific paraphilia, which he has labeled *raptophilia* or *biastophilia* (from the Greek *biastées* "rapist"): the terror of the victim is the sexual turn-on.

Some societies tend to accept rape as a male prerogative. A graphic example of this made international headlines in 1991. The incident involved a mass rape of female students at a co-educational college in rural Kenya, in which 71 girls were attacked and 19 died in the accompanying mêlée. Had girls not died, it is alleged that the situation would have been considered unremarkable and occasioned no discussion. As one of the administrators of the school (the deputy principal who happened to be a woman) explained: "The boys never meant any harm against the girls. They just wanted to rape."

See also **Night-crawling** and **Paraphilia**.

Romantic love

The notion of romantic love is rare in all cultures except that of Europe and America. The literary notion of romantic love is usually associated with the mediaeval constellation of knighthood, chivalry and feudalism. In theory, such romantic love was unrequited since it necessarily involved the near adoration of a sexually unattainable, virtuous married woman. The reality was no doubt sometimes different. Even the ideal changed, as the poetry of the troubadour shows.

The idealization of this strictly defined kind of romantic love began in eleventh-century France, but soon became part of general European

culture. Co-inciding with this development was the spread and intensification of the cult of the Virgin Mary, but a connection between the two phenomena can be disputed. Curiously enough, neither the cult of the Virgin nor romantic love actually elevated the status of women in the real world.

Romantic love can be less strictly defined as involving some degree of idealization, attraction and willing loyalty between lovers or spouses. Since even such a conception is lacking in some societies, at least as a basis for marriage, a basic question is why should romantic love develop in a society and what role does it play.

Two interesting correlations have been made between the degree of importance of romantic love and other aspects of society. It has been found that romantic love is unimportant in societies where husband and wife are held together because of their dependence upon each other for an adequate food supply. But in societies without such dependence, the motivation for staying in a stable marriage is less secure. Romantic love may function as a substitute for dependence based on food sharing. Secondly, when a mated couple live on their own away from the relatives of either husband or wife, romantic love tends to be unimportant cross-culturally. On the other hand, when the couple following cultural rules has to live near kinsmen of one or the other spouse, romantic love tends to be stressed. What may be going on is that such love helps protect the marriage from the pressures that relatives may impose on it: the couple in a sense can cut themselves off from the rest of the world.

The major exception to these generalizations is obviously western industrialized societies, where food dependence need not exist and married couples normally do not live near relatives. One suggestion to account for this glaring discrepancy is that these societies have developed a highly sophisticated technology of communication, which really does not shut off kin pressure. In a word, the telephone may make romantic love a necessity to help a marriage withstand the onslaught of in-laws.

Sadomasochism. Also called **Algolagnia.** And also referred to in terms of its components **Sadism** and **Masochism.**

The term *masochism* was coined by Richard von Krafft-Ebing, with reference to the Austrian novelist Leopold von Sacher-Masoch, whose most famous book *Venus in Pelz* (*Venus in furs,* 1870) has the hero tortured by an icy, domineering woman dressed in furs. The term *sadism* was coined with reference to Donatien Alphonse François, Comte de Sade

— usually called the Marquis de Sade. The term was popularized by Krafft-Ebing, but seems to have been in use before his time.

Sadomasochism is usually defined as a paraphilia or paraphilias involving a variety of sexual interests associated with the giving (sadism) or receiving (masochism) of pain and/or humiliation. In this sexual sense it is rare in primitive societies, or else it is restricted to such activities as biting and scratching.

However, even in the western world where it is most commonly reported, sadomasochism strains at the very notion of sexual to begin with. People who are "into" sadomasochism may intersperse torture or humiliation with straightforward sexual scenes but during the actual sadomasochistic part of the encounter, unambiguous sexual response seems to be rare indeed. Paul Gebhard has maintained that "one never hears of an agèd Polynesian having to be flogged to obtain an erection, and for all their torture and bloodshed there seem to have been no DeSades amongst the Plains Indians or Aztecs." The reality is, however, that even among western sadomasochists, clear-cut sexual response during such a scene seldom occurs. I have myself in previous publications simply assumed that when informants maintained their sadomasochistic experiences were sexual that it was so.

However, in a trial involving so-called sadomasochistic pornography (*U.S.A. v Toushin*), which took place in Nashville, Tennessee in 1989, the facts were hard to deny: various self-styled sadomasochists did not show any visible signs of sexual arousal at any time during the films. No erections were observed, not to speak of ejaculations by any of the male participants. Interviewing other self-defined male sadomasochists revealed that they had not experienced either orgasm or even erection but that such scenes became the basis for later masturbatorial fantasies. One informant who had been in the "scene" for 30 years and had witnessed thousands of sadomasochists in "orgies" maintained that 90 percent of the participants did not achieve erection. He estimated that only one out of a hundred ejaculated in such scenes. These statistics held for both sadists and masochists.

Perhaps what we are dealing with is somehow a problem of metaphor. In earlier religious times, sadomasochistic experiences were discussed as a variety of religious ecstasy. In a secular age, sex may be the closest thing to getting at the essence of sadomasochistic sensibility. What is required is massive rethinking of the whole notion of sex. It is worth realizing that these problems came up because of the pornography trial where the lawyers for the prosecution (the U.S. government) argued the

films were clearly sexual and without any redeeming value. On the contrary, they represent a challenge to received wisdom.

The western world has had a long tradition of flagellation and similar acts associated with Christian penance. The West today has seen the secularization of sadomasochism, once looked upon as an exemplary religious experience.

In the West, very few women are involved in a conscious sadomasochistic life style. Psychoanalysts generally believe that masochism is a component of femininity, but here we are speaking of a more specific and deliberate kind of sadomasochism. Masochistic heterosexual men usually must rely on the services of prostitutes who specialize in sadism.

Northern and eastern European societies have produced the greatest number of sadomasochists — this in spite of Japanese bondage pornography and the works of the Marquis de Sade as well as the confessions of Rousseau. The most frequent ethnic backgrounds of sadomasochists found in one study undertaken in New York were British, German and Dutch, and eastern European Jews. Latin Americans, Asians and to a lesser extent Mediterraneans and blacks were seldom involved in the sadomasochistic subculture.

Although the reasons why people become sadomasochists are obscure, it seems likely that a major component has to do with restrictions on expressions of aggressiveness. In societies where fairly high levels of overt aggression are tolerated, people tend not to become sadomasochists. Compare Italians with the English. Italian culture tends to tolerate an openness about anger that would shock the average Englishman, for whom practically every overt expression of aggression is accompanied by guilt. It is considered not only morally wrong but bad form.

If these characteristics are true — and they seem to be — one might think of sadomasochism as an expression of anger and aggression that cannot generally find other outlets. Since other northern European societies tend to play down overt aggression as well, it is likely that this cultural factor is important in the development of sadomasochism.

The most public and obvious sadomasochistic subculture in the western world is associated with homosexual men who meet in leather bars and motorcycle clubs. It might be useful to distinguish between sadomasochistic and SM (the in-group term) in the same way that homosexual and gay have occasionally been distinguished. The first term would refer, for example, to the practise of sadomasochistic acts whether

the person performing them labels them as sadomasochistic or not. The second would refer to the subculture.

See also **Paraphilia**.

Sex and sexuality

These topics present no clear-cut boundaries universally agreed on. Matters as diverse as genitalia and shoe fetishes, or reproduction and sadomasochism, have traditionally been considered as in some sense "sexual." This book was not designed to challenge this tradition (though a re-evaluation would be desirable). Hence, the terms *sex* and *sexuality* remain deliberately undefined here.

Sex careers

Sex careers refer to life styles based on sex roles that are recognized in a particular culture. Although the sex careers that are actually found cross-culturally are few in number, some societies provide fewer options than others. The sexual revolution in the modern western world is at least in part an attempt to expand on the traditional options in that world.

In many societies, there is only one tolerated sex career: heterosexual marriage. People who do not pursue such a career would be regarded as seriously deviant. This is true among Orthodox Jews. In other societies, an unmarried state is practically forced on at least some members of the society, as is true of the younger brothers in Tikopian households, who are not, however, expected to lead chaste lives. In some Christian groups — notably Eastern Orthodox and particularly Roman Catholic — a celibate life is a possible sex career and has traditionally been regarded as a somehow "higher" or "superior" career at that.

A number of other sex careers have been reported cross-culturally. In some instances they are assigned early in life without much choice on the part of the persons involved. It is sometimes alleged that the berdaches (institutionalized transvestites) in American Indian groups were occasionally chosen to adopt this career on the basis of some ritual decision rather than clear desire. This is a matter of debate, however. Eunuchs represent perhaps an even better example. The custom of castrating men was seldom a matter of personal preference (outside of China) and seems to have been generally restricted to slaves and war captives.

Other sexual careers that have been reported include: temple prostitute, spinster and the age-determined sex roles involved with ritualized pederastic acts in Melanesia.

At present in the western world, the sex career opportunities have increased — at least in some groups. For example, more and more men and women are living together and are active sexually without getting married — without the social repercussions that would have been likely at the turn of the century.

Sex shows

In 1964-65, a man's buttocks were glimpsed for a moment on the London and Broadway stage in Peter Weiss's play *The persecution and assassination of Marat as performed by the inmates of the asylum of Charenton under the direction of the Marquis de Sade*. This daring display has since been followed by various other "respectable" productions, including the rock-opera *Hair,* and in 1968-69 a more elaborate production played almost totally in the nude, and dealing with subjects such as wife swapping, group masturbation and rape: *Oh! Calcutta!* These productions in the 1960's were dramatic changes in recent western theatrical tradition. But, in a few nonwestern societies sex shows are known to have been performed for audiences.

The most famous example of institutionalized sex shows outside the high cultures of the East and West was associated with the *ariori* society in Tahiti. Owing to the strenuous efforts of Christian missionaries and other Westerners, the society was abandoned shortly after French colonization.

In India at various times (but apparently no longer) groups of traveling entertainers would sometimes perform public sex acts of incredible gymnastic virtuosity. It should be noted that such virtuosity is required for many of the coïtal positions advocated in the *Kaama suutra* and other sex manuals.

In the West, sex performances have historically been associated with various royal courts. Erotic displays are said to have been sponsored by the Roman emperors Tiberius and Caligula.

A particularly American variety of sex show is the striptease, which has been said to have developed in frontier towns in the West. In a classic striptease, however, no actual sex acts are performed.

The ascendancy of Christianity as the official religion of the Roman Empire gave even non-erotic theater an ambiguous and often condemned

status. Nevertheless, specifically erotic private theaters have existed in Christian countries from time to time.

In the nineteenth century, sex shows became increasingly democratized and were included in brothel entertainments, which might include scenes of copulation, lesbian acts and animal contacts — some places becoming known for shows in which women have sex with dogs or horses. At present, topless and bottomless bars continue to exist in the United States, and sex shows are publicly advertised in many larger western cities such as Amsterdam and New York.

Sexual orientation. Sometimes called **Sexual preference.**
The pattern of sexual interest of an individual with regards to other human beings. Three types are usually distinguished: heterosexuality, homosexuality and bisexuality. Kinsey, however, pointed out that reality does not comfortably fit into such a neat classification and established a 7-point heterosexual-homosexual rating scale, where 0 represents exclusive heterosexuality and 6, exclusive homosexuality.

In point of fact, Kinsey did not speak of the sexual orientation of individuals, but spoke rather of their total sexual life histories, which combined both overt sexual experience and psychosexual reactions. His scale combines both dimensions, though it emphasizes actual behavior. However, if the notion of sexual orientation is to make sense, we must probably define it solely in terms of fantasy life — what Kinsey called psychosexual reactions. People with an exclusively homosexual fantasy life might possibly never act it out but engage only in heterosexual acts because of social pressures (as has likely been the case among some traditional Jewish or Christian groups). By the same token, people with an exclusively heterosexual fantasy life might not be able to act on it because they are in prison, a concentration camp, or other same-sex situations such as the navy or a mining camp. To argue that an otherwise heterosexual man had changed his orientation because of having sex with other men in a prison would seem to be foolish (although one could reasonably suggest that an erotic component cannot be entirely absent).

It seems best, therefore, to divide the Kinsey scale in two, each representing one of the following components: (1) a psychosexual or "orientation" scale, and (2) an experience scale. The same numbering conventions could apply, and in discussing a particular individual, the orientation feature would be given first. An "0-1" would therefore be a person of exclusive heterosexual orientation who has had only incidental

homosexual contacts; whereas a "5-4" would be a person who is almost wholly homosexual in orientation but has experienced somewhat more homosexual than heterosexual experience.

Why precisely there should be any variation at all in orientation has been the subject of much discussion, and considerable social and political stakes are involved.

Social constructionists generally hold that orientation categories are not valid cross-culturally or trans-historically.

The 19th century explorer Sir Richard Burton proposed a geographical and climatic theory. He posited an area he called the Sotadic Zone (named for an ancient Greek, Sotades, known for his licentious poetry) where homosexuality was rampant and accepted. The Zone included the Middle East and parts of the Mediterranean world. To the north and south of this area, homosexuality was rare and despised. No reputable scholar today accepts Burton's view.

Some theorists have held that variation in sexual interests among human beings is essentially a "mammalian heritage" (a position taken by Kinsey and also offered by Clellan S Ford and Frank A Beach in their influential book *Patterns of sexual behavior*). Others relate such variation to pathology (as did psychoanalyst Irving Bieber with regard to homosexuality, which he saw as the result of particular family patterns involving — for males — absent or weak fathers and domineering mothers). The Gay Liberation movement has tended to champion variation in orientation as involving socially equivalent options, whereas the Roman Catholic Church — which usually states that homosexual acts are sinful but not homosexuals who practise abstinence — has referred to homosexuality in recent pronouncements as a serious intrinsic disorder.

Most theorists start with a presumption of heterosexuality: only interests that deviate from this must be explained. Freud was perhaps an exception. In an interesting footnote to his *Three essays on a theory of sexuality*, he assumed that bisexuality is the natural order of things and that exclusive heterosexuality is as much a problem needing explanation as exclusive homosexuality. However, in later writings he seems to assume that only a heterosexual adjustment marks off the truly healthy and mature individual.

In this footnote, Freud suggested too that sexual orientation was probably the result of a number of factors ranging from constitutional predisposition (biology) to accidental events in an individual's life. Other theorists have tended to place themselves more at the poles of the nature-nurture continuum.

Many, including most recently Gunter Dörner, have argued for hormonal explanations. However, their findings of hormonal imbalances have tended not to be replicated.

Frank J Kallmann in his study of identical twins found that in the 40 sets where one of the twins was homosexual, the other invariably was as well. Consequently, Kallmann suggested not a hormonal but a genetic basis for homosexuality. A later twin study by Michael Bailey and Richard Pillard, published at the end of 1991, supports his remarkable findings. But neither study ruled out nonbiological factors by dealing only with twins reared apart. As a matter of fact, Richard Green, in his work with effeminate boys (as written up in the book The "sissy boy syndrome" and the development of homosexuality) came across a single set of twins that challenged even his own theory that there is a biological (though not necessarily genetic) basis for effeminacy, which is in turn merely the antecedent of adult homosexuality. One of the twins was effeminate during childhood, the other quite masculine. By the end of the study nearly 15 years later, the effeminate one had sired a child, and the masculine one had taken on a male lover.

F L Whitam has argued for a biological base for male homosexuality because of certain alleged cross-cultural universals, such as the general correlation of effeminacy with homosexuality, and special professional interests in art and ritual. He believes that about five percent of all human populations become homosexual. However, he makes these generalizations using only four different societies, all of which are westernized to a considerable extent. And in the absence of Kinsey reports for these societies his five percent seems to come out of thin air (however, this is near to what Kinsey discovered in the United States for exclusive homosexuals; a similar percent has been suggested by Gilbert Herdt for the Sámbia in New Guinea).

Alan P Bell, Martin S Weinberg and Sue Kiefer Hammersmith in their book Sexual preference conclude that the only explanation for sexual orientation that is consistent with their own findings is probably a biological one, though they do not specify precisely what it is. They believe they have eliminated all the other possible explanations (e.g. domineering mothers, absent fathers) that have previously been given as not supported by their data. Of course, psychoanalytically-minded critics, among others, have pointed out the problems with their relatively short interviews. Interestingly, even though their book is an official publication of the Kinsey Institute, it does not meet the requirements Kinsey himself specified for any biological theory of sexual orientation:

the authors did not locate their subjects on the heterosexual-homosexual scale; they did not secure complete sexual histories of every individual in their subjects' families for at least two successive generations, etc.

The same criticism applies to causal interpretations of the findings of Simon LeVay, who in 1991 reported that the brains of at least some homosexual and heterosexual men differed with regard to the size of the hypothalamus. Moreover, his sample was small: 19 presumably gay men, 16 presumably heterosexual men, and 6 presumably heterosexual women (lesbian brains seem to have been unavailable). If there were indeed a causal connection between hypothalamus size and sexual orientation, would bisexuals have yet another size? Many similar questions would have to be resolved before a hypothalamus model could be taken seriously.

Perhaps the best known advocates of the position that sexual orientation is learned (and at least not entirely biological) are William H Masters and Virginia E Johnson. They argue that early sexual experiences with one sex, if rewarding and pleasurable, may lead to one orientation, particularly if experiences with the other sex are unpleasant or even frightening. They cite the finding that some heterosexual women who have been raped turn to lesbianism after this traumatic experience.

In the same vein but coming from a sociobiological framework, Gordon G Gallup and S D Suarez have argued that the sexual strategies of men and women are so antagonistic to each other that this may lead to homosexuality. Males become homosexual largely out of frustration because of inadequate heterosexual opportunities; females, on the other hand, become homosexual because they become disenchanted with lying, scheming and rapacious men. Citing a variety of studies, Gallup and Suarez point out that lesbians in American society have generally (about 85%) had heterosexual intercourse before defining themselves as homosexual, whereas relatively few (20%) of the males have done so.

C Tripp has argued that males who are precocious masturbators tend to become homosexual because they are still immersed in all-boy play groups. Other theories that play up crucial timing in maturational development have been suggested. However, the evidence from several New Guinea societies makes these positions less attractive. Here, all boys are obligated to participate in homosexual acts exclusively — sometimes for several years — before they are allowed any heterosexual experience. Nevertheless, they do not usually develop a homosexual orientation. The percentage who do (as mentioned earlier) seems to be more or less the

same as in the United States, where homosexual acts have traditionally been tabu and severely punished.

The controversies about sexual orientation are sure to persist.

Sexually transmitted diseases: see **Venereal diseases and diseases of the sex organs;** also, **AIDS.**

Sleep-crawling: see **Night-crawling.**

Transsexualism
A condition in which individuals are uncomfortable with their anatomic sex and feel trapped within an inappropriate body. Individuals who are extreme in this belief may undergo sex-change surgery accompanied by hormonal treatments to acquire secondary sex characteristics such as breasts, body hair, or the like. Actually a continuum of interests exists. Mere identification with the opposite sex, sometimes involving transvestism, but no desire for surgical change, is labeled *transgenderism*. Mimicry of behaviors and gestures of the opposite sex is called *transgestism* (effeminacy would be an example of this). Some individuals want only a partial sex change, as with males who seek to enlarge their breasts with silicone or other treatment but have no desire to lose their penis (a variety of *gynekomastia*). Sex shows in cities such as New York, New Orleans, and San Francisco sometimes feature such men (they occasionally appear on late-night television shows on cable stations). Although certain varieties of transsexualism seem to occur outside of the western world (as among the *hijraa* of India), postoperative transsexuals are a modern phenomenon associated with high-tech surgery.

Transvestism. Formerly also called **Eonism.**
The term transvestism was coined by Magnus Hirschfeld to cover a variety of phenomena perhaps better called *cross-dressing*.

In the contemporary western world, cross-dressing involves a whole complex of different behaviors, which range from temporary theatrical roles to lifelong fetishistic obsessions. When wearing clothing appropriate to the opposite sex is sexually arousing, it is sometimes referred to as *transvestophilia*. Generally, people within western culture assume that transvestism is a homosexual matter. Although some forms of transvestism are, the great majority of transvestites in the West turn out to be heterosexual men.

Very few women are involved in transvestism. One psychiatrist, Robert Stoller, denies that female transvestites even exist. But he defines transvestism very strictly as having "erotic value" for the wearer (i.e., as transvestophilia) and he believes that women who dress up as men do not feel erotic about doing so. He calls such women "female transsexuals."

Transsexuals believe that they are one sex but trapped in the body of the other, unless surgery mercifully removes the impediment. This desire to escape from one's genitals is not true of transvestites. Very frequently, transvestites will do something to give away their biological identity. It is interesting that a transvestite is usually despised or subject to ridicule and contempt in western society, but transsexuals — at least those who have actually undergone surgery — seem to be granted greater tolerance.

Heterosexual and homosexual transvestism are associated with totally different life-styles. Male homosexual transvestism often approaches a satire that makes fun of women and indulges in an obvious, camp misogyny. The heterosexual transvestite, on the other hand, tends to wear drab, old-fashioned clothes. Occasionally, he may even dress up like a pregnant woman. The heterosexual transvestite usually dresses up only in private; the homosexual seldom does so and is sometimes drawn toward female impersonation as a career.

In nonwestern societies, transvestism is frequently institutionalized. Among the Návaho (who lump both transvestites and hermaphrodites together under the same term, nadlε), a family that had a nadlε among its members was traditionally considered to be very fortunate. Because Návaho mythology describes them as having been given charge of all wealth in the beginning of time, families into which they are born are believed to be assured of wealth.

Not all societies that have institutionalized transvestism have been so kind as the Návaho, but it must be added that it is sometimes difficult to find out what the traditional attitudes were because of the intense hostility to the phenomenon by Westerners.

Although, in the western world, transvestism is predominantly heterosexual, outside the West it seems generally to be associated with homosexuality. In several of these nonwestern societies transvestites have frequently been allowed to marry nontransvestite persons of the same sex. Nevertheless, there are a few examples recorded in the anthropological literature of transvestites who apparently were not homosexual.

The term *berdache* is generally used of institutionalized transvestites (or hermaphrodites), particularly those found among North American Indian and Siberian groups. In accounts of Polynesia, the native term *mahu* (or some variant) is used. Some writers restrict these terms to male transvestites and use the word *amazon* in referring to female transvestites, who in some societies have actually served as soldiers, e.g. as special guards in the west African kingdom of Dahomey or as partizans in Albania sworn to life-long virginity.

In Tahiti, *mahu* are kept by the principal chiefs and function as servants in the chief's households. (The custom of dressing the male servants of a chief as women also occurs among the Mossí of West Africa, but transvestism there is otherwise not reported.)

There was once a wide distribution of institutionalized male transvestism throughout the Pacific, Asia and Africa. In general, in societies that have institutionalized pederasty, there is little evidence of transvestism as well. Perhaps the most famous examples of institutionalized transvestism come from the Plains Indians of North America.

Among the Sioux, the *berdaches* were merely tolerated, but among the Cheyenne as among the Návaho and apparently most North American Indian groups, they were treated with esteem; the Pima and the Apache are exceptions. They were considered powerful and important to bring along on war parties (all scalps collected were placed in their custody). They were believed to have the most powerful love magic as well as to be skilled doctors.

Becoming a *berdache* sometimes is said to have been compulsory. If true, this would be a strong case for a social constructionist type of interpretation of sexuality. Among the Dakota and the Ómaha, for example, young men had to become *berdaches* if they had had a certain kind of dream or vision. An essentialist interpretation would have to assume the dreamer had an inclination to transvestism before dreaming that dream. Other groups where the *berdache* role may have been imposed include the Luiseño and the Kóniag Éskimo.

Perhaps because of the notoriety of the Plains Indian *berdaches*, a very common theory accounting for why transvestism came to be institutionalized has been developed. The sex roles of the Plains Indians seem to have been extremely differentiated, and in particular being a man in the traditional sense was so demanding and difficult that some men would probably either be unwilling or even unable to make it as a man. Institutionalized transvestism, then, has been interpreted (by, for

example, Ruth Benedict in her influential book *Patterns of culture*) as cultural recognition of the hardship of meeting intolerable sex stereotypes set up by the culture. When we realize that the Mandan Indians required men to validate their social positions sometimes by grueling self-torture (such as being suspended by thongs inserted under chest muscles) this explanation appears to be quite attractive.

However, more recent studies seem to show that institutionalized transvestism does not generally occur in societies that emphasize sex differences. On the contrary, it tends to appear in societies that verge toward a unisex style.

Transvestites are frequently — particularly in their North American and Siberian settings — thought to have supernatural powers of various sorts and become healers and ritual specialists, more technically shaamans. Transvestite shaamans are also found in folk societies in Korea, Vietnam, Celebes (Indonesia) and Kalimantan (on Borneo). Among the Zulu of South Africa, divination (fortune-telling) can be done only by transvestites. The fact that in some societies transvestites are despised and considered disgusting but in others are highly esteemed tends to support a theory by Mary Douglas that things that do not fit into native categories or are somehow outside of what is felt to be "natural" (such as twins, or men dressing up as women) are perceived in different cultures in terms of the extremes of contamination versus supernatural power.

Vaginal teeth and similar folkloristic themes

A great number of cultures throughout the world have folklore about a woman whose vagina has teeth and who kills the men she has intercourse with. The best known examples of such *vagina dentata* myths come from American Indian groups north of Mexico. The same motif is also found in South America, India, Siberia, Greenland among the Éskimo, and in the Pacific on the Marquesas and Tuamoto.

Folklore about men that includes motifs of the penis that can cut down trees (found among the Klíkitat American Indians), the extendable penis that can perform long-distance sexual intercourse, and, from India, *penis dentatus* (the penis with teeth), not to mention the penis that eats and drinks.

Venereal diseases and diseases of the sex organs

The expression "venereal disease" was first used by Jacques de Bethercourt in 1527, and is today a legal term referring only to gonorrhoea, syphilis and chancroid. Several other diseases, however, can

be spread during sexual intercourse and other sexual acts. The expression *sexually transmitted disease (STD)* is more comprehensive and more frequently used at present.

In some societies, various diseases have been thought to be venereal that actually are not. Among the Apache Indians, for example, tuberculosis was at one time thought to be venereal and shameful, which made the treatment of it very difficult.

Gonorrhoea has definitely been known from ancient times. The term was apparently invented by Galen in the second century AD. But it was very likely known long before that. For the most part, however, among the Greeks and the Romans there is no mention of venereal diseases at all. In the Middle Ages, various references are clearly made to gonorrhoea. In 1161 a law was enacted in London prohibiting brothel keepers from hiring women suffering from "burning," probably a term derived from an old French expression for gonorrhoea.

The history of syphilis is a matter of great debate. No genuine instances of syphilis in Europe are known to have existed before the winter of 1494-1495, when French soldiers in Naples reported tumors on their genitals. One very widely held theory is that syphilis did not exist in Europe, Asia or Africa until Columbus and his men brought it with them after the discovery of America in March 1493. Several lines of evidence support an American origin for syphilis — a position known as the Columbian theory. Ancient syphilitic bones have been reported, perhaps incorrectly, from the Americas.

European and Asian commentators from Columbus's time said that it was a disease that was not known before. In China, no early references to syphilis occur. The first reference is not found earlier than the Ming Dynasty — at a time that agrees with the Columbian theory. Li Shi-chen, writing in that dynasty, specifically denies that syphilis had occurred in ancient times. No ancient European descriptions of syphilis are know to exist. But according to Ferdinand Columbus (Christopher's son), a friar Ramón, who had accompanied Columbus, observed syphilis among the Árawak Indians and even found that there was mention of it in Indian folklore.

Even names for the disease suggest that it was unknown to Europeans and brought in by travelers. The first clinical description of it, by a Portuguese physician, Ruy Diaz de Isla, in 1497, says that Columbus's men referred to it as "Indian measles." Terms used in other languages spell out the spread of the disease and support the Columbian theory. Syphilis was spread to the Orient by the crews of Vasco da Gama and

other Portuguese navigators: in both Chinese and Japanese it was formerly called "the Portuguese disease." The Turks called it "the Christian disease." And so on. In the languages of American Indians, on the other hand, there are no words for the sickness implying a foreign origin. The Aymará word, for example, is *cchaca-usu* (literally "bone disease").

According to another theory (sometimes referred to as the unitarian theory), for which there is some evidence, the development of syphilis in Europe was basically an alteration in some already existing disease, such as yaws. This does not rule out yet another possibility: Europe was hit almost at the same time by two waves of disease, one from Africa, the other from America.

Evidence at present supports the New World theory of origin. But whatever the facts, it has long been accepted uncritically in western folklore — as is obvious in these lines by Richard Wilbur for the original book of *Candide* (music by Leonard Bernstein), meant to be sung by a character who had contracted the disease:

> Columbus and his men they say
> Conveyed the virus hither
> Whereby my features rot away
> And vital powers wither...

The history of the other diseases mentioned earlier is even less clear. Chancroid was confused with syphilis and leprosy, and then only with syphilis until 1889, when the distinction was firmly established.

Folk treatment and beliefs about venereal diseases vary considerably. The Mangaians believe that not ejaculating into the vagina of a girl with gonorrhoea is a sufficient prophylactic, so coïtus interruptus is frequently practised. On the other hand it is believed that copulating with a menstruating woman causes venereal disease in a man. In Europe at various times it was believed that copulating with a virgin was a cure for syphilis. This belief is apparently still held by rural Serbians and Jamaicans. What may be an ancient remedy against syphilis among the Aymará of South America is mercury mixed with animal fat. In some Cuban cultures, syphilis is held to be a scourge visited upon a person by the god of syphilis, Shango. Its cure involves exorcising his spirit.

A number of nonvenereal diseases specifically involve the sex organs. Women sometimes develop inflammations of the vagina and vulva. These sometimes occur as the result of intercourse in very young girls who do not produce sufficient vaginal lubrication — as well as among rape

victims. In men, inflammation of the glans and infection of the foreskin are comparable disorders.

Venereal diseases have represented one of the major calamities of mankind. Unfortunately, as Havelock Ellis pointed out, western civilization and syphilization have gone round the world almost inseparably. In some societies the effect of conversion to Christianity has been to break down the traditional sexual code without successful replacement by the Christian code, so that syphilis and other venereal diseases have spread excessively. It has been asserted that at the turn of the century in some parts of Uganda as many as 90 percent of the people suffered from syphilis and half or more of the cases of infant mortality were caused by it.

More recently, venereal diseases have been brought under more effective control, although outbreaks occur at various intervals and new strains generally resistant to established medical treatment appear on the scene. One aftermath of the Vietnamese war was that the American soldiers brought back with them particularly virulent strains of venereal diseases.

For a discussion of AIDS, see that subheading in this chapter.

Virginity: see Proofs of virginity.

Voyeurism: see Paraphilia.

Zoöphilia

Zoöphilia refers to sexual attraction to animals. It should be differentiated from bestiality, which is a more general term for human-animal sexual contacts whatever the motivation. (The term *bestiality* is more and more being abandoned by sexologists in favor of expressions like *sexual contact with animals*.) The only instance of true zoöphilia I have come across in the anthropological literature is from the Nama Hóttentot. Leonhard Schultze, writing in 1907, says that Nama Hóttentot men found the sight of animals' sex organs sexually arousing. The sex of the animals is curiously enough never mentioned. One man went up to an elephant that had been killed in the hunt and was so aroused by looking at its genitals from the rear that he developed "an uncontrollable erection which made him walk lame."

John Money and Ratnin Dewaraja have documented a variety of zoöphilia involving insects (such as ants or cockroaches), snails, frogs or other small animals: sexual arousal comes from having these creatures

creep, crawl, or nibble on the person's body — particularly on the sex organs. Money and Dewaraja label this *formicophilia* (from the Latin *formica* "ant"). Only one individual has so far been formally reported as having this interest, although anecdotal accounts of other cases are sometimes heard.

See also **Animal contacts** and **Dildoe**.

NOTES

Unless otherwise noted, references to particular cultures throughout this book are taken from the Human Relations Area files (HRAF), which has systematized information on over 300 cultures from all over the world.An invaluable research aid, it was founded in the 1930's at Yale University.

CHAPTER 1.
The interested reader is advised to consult the classic work by Ford and Beach (1951) and a later follow-up with a somewhat limited scale:Frayser (1985).More general studies are found in Beach (1978); and Byrne and Kelley (1986).Particular societies are described in Marshall and Suggs (1971).Popular surveys include Davies (1984), despite the somewhat misleading title, and Eskapa (1987), despite the sensational title.A survey of anthropological work on sex up to the middle of the 1980's is given in Davis and Whitten (1987).A combination of anthropological and psychoanalytic approaches is given in Endleman (1989).

CHAPTER 2.
For a general review of the western religious and legal background, see Bullough (1976).A controversial view on Western attitudes on homosexuality is given in Boswell (1980).Epstein (1948) presents a summary of Jewish approaches; Patai (1960) is an unorthodox reconstruction of biblical practises.For a discussion of the *metsitsah* see Kinsey et al (1949); Weiss (1962); Gregersen (n.d.). Folklore is reviewed in Ellis (1951) and Simons (1973) and perpetuated or even created in Reuben (1969).

CHAPTER 3.
General sources include Pomeroy in Ellis and Abarbanel (1967); Brecher (1970) — quote from p 50; Gebhard (1970) — quote from p xi; Bullough (1976); Robinson (1976); Haeberle (1983).
 On Herodotus: Murdock (1980).
 On Hindu sexology: Thomas (1960); Comfort (1964).
 On Giulio Romano: Lawner (1988).
 On Tissot and fears about masturbation: Money (1985); see also Tissot himself (1758) and (1760).
 On Havelock Ellis: Grosskurth (1980).
 On Hirschfeld and developments in Germany: Wolff (1986); Lauritsen and Thorstad (1974); Steakley (1975).
 On Kinsey *et al.*: Pomeroy (1972) — quote about Margaret Mead, p 362; Christenson (1971); for detailed exposition of their sex history interviews, see Pomeroy, Flax and Wheeler (1982).
 On Masters and Johnson: Greer— quote from p 44.
 On social constructionism: Foucault (1976-1984); Caplan (1987); Vance (1989); Stein (1990).
 On anthropology and sexology: Davis and Whitten (1987); Tuzin (1988).

CHAPTER 4.
General sources include Wilson (1975); Williams (1975); Kolata (1977); Daly and Wilson (1978); Symons (1979).
 On sociobiology (in addition to the general sources):Sahlins (1976); Divale and Harris (1976); Draper and Harpending (1988).
 On paternity certainty: Barash (1979); Gregor (1985).
 On breasts and other anatomical features: Morris (1967); Immerman (1986); Tanner (1987); Harris (1988).
 On female orgasm: Sherfy (1972); Haraway (1989) — summarizes views of Chevalier-Skolnikoff and Hrdy, among others.
 On pair bonding and social organization: Slater (1978) and (1990); Cucchiari (1981); Fisher (1983); Tanner (1987); Tooby and DeVore (1987); Haraway (1989) — quote about Tooby and DeVore from p 327, also summarizes views of Lovejoy and Zihlman.

CHAPTER 5.
General sources include Ford and Beach (1951); Gebhard in Marshall and Suggs (1971);
Vaatsyaayana's and Nafzaawii's books are listed as Burton (1962) and Burton (1964), respectively.
The quotation from the *Kaama suutra* is from Burton (1962) p 114-115.Yasodhara's assertion is
mentioned in Thomas (1960) p 87.
 References for cultures or information not included in HRAF include the following: Marshall on
Mangaians, Merriam on Basongye, Schneider on Turu — all in Marshall and Suggs (1971); Gregor
(1985) on Mehinakú; Stern (1979) on Russians; Suggs (1966) on Marquesans.

CHAPTER 6.
General works in this area include Montagu (1969); Nag (1962); and Parkes (1966) and (1976) — the
testimony of the *tenduur* cook is from (1976) p 60.References concerning variation in sex organs
includes Simons (1975) and Dr Jacobus as quoted in Edwardes and Masters (1963), an otherwise
bizarre study in many ways.
 The Abkhasians are described in Benet (1974); the Yurok, in Kroeber (1925); workload and
birthrate, in Nurge (1970).
 The *Anangga rangga* correlations of physical type and sexuality are found in Arbuthnot and
Burton (1964) p 16.Sheldon's scheme is presented in two volumes: (1940) and (1942) — the case
study of Boris is from (1942) p 121 ff.
 On genetics, hermaphroditism and transsexualism: Money in Beach (1976) — the quote is from
p 65; Money (1952); Money, Hampson and Hampson (1955); Green (1987), Bolin (1988).Herdt
(1990) summarizes the literature on 5-alpha reductase hermaphroditism and discusses details of the
Sámbia situation.
 The Pokot are discussed in Edgerton (1964); the Gilyak, by Sternberg, translated and edited by
Chard (1961); Indian *hijraa*, in Nanda (1990); the Omani *xaniith*, in Wikan (1977) and (1978).
 Morris (1974) is an interesting if not particularly probing autobiography of a transsexual.
 A case for the superiority of women over men is given in Montagu (1953).

CHAPTER 7.
General sources include Symons (1968); Ford and Beach (1951); and Guthrie (1976).The quotes
from Darwin are from (1981) — citation from Hearne p 885, quote on beards from p 907.Quotes
from Nagiib Mahfuuz (Naguib Mahfouz) are from pp 78 and 34.
 Peruvian brothel description is from Primov & Kieffer (1977); of the Sirionó, Holmberg (1969).
 On body odor/pheromones: Suggs (1966); on Marquesans; Opler (1961a) on Apache; Doty, Ford
& Preti (1975) on vaginal odors; Kroeber (1948) on cleanliness — quote from p 601.
 On hair: Verinis and Roll (1970).
 On women: Marshall in Marshall & Suggs (1971) concerning Mangaians; Gorer (1964) and
Whiting and Child (1953) concerning breasts; Schapera (1966) on Tswana — quote from p 188.
 On men: Hooten (1937) — quote from p 263; ideal Englishman having paunch reported in the
New York *Times* 1978 December 17, p 47; Brues (1960) on broad shoulders.
 On beauty contests: Athenaeus (1937).
 On genital mutilations: Bryk (1934); Huelsman (1976); Bettelheim (1954); Dareer (1982); Cawte,
Djagamara and Barrett (1966); Singer and Desole (1967); Cawte (1968).An African view on the
uncircumcised is quoted from Turnbull (1962) p 82.The reference to modern penis-enlargement
surgery is from the New York *Times* 1991 September 24 p C10.The quote from Herodotus on
circumcision is from his *Histories*, Book II:37 (translation mine).

CHAPTER 8.
General sources include Stephens (1969) and (1972); Broude and Greene (1976); Rudofsky (1971);
Ellis (1942) — report by Tocantins given in 1.1:12, citation from Lombrose and Carrara quoted in
1.1:16, quote on Naaga in 1.1:14.
 On nudity: Polhemus (1978) — quote about Mau Mau initiation from p. 212; DeMartino
(1969) — A Ellis's comment on nudism quoted from p 4; Masani (1934) on the Sinhastra festival;
Whiting (1941) on Kwoma rules of modesty; von Fürer-Haimendorf (1969) on the Naaga.
 On clothing and sexuality: Harris (1973); Schneider (1978); Ellis (1942) on green and red ties,
p 1.4:299; Bullough (1976) — quote on red ties from p 611.

On the veil: Jeremias (1931); Murphy (1964); Pepys quote from Rudofsky (1971), p 31.
On penis sheaths: Ucko (1969); Morris (1969); Yato (1968) p 149.

CHAPTER 9.
General works include Broude & Greene (1976); Harris (1977) — quote, p 63; Murdock (1967).
On marriage: Gough in Bohannan & Middleton (1968); Slater (1977) — Leyburn quote, p 16.
On incest: Aberle et al., (1963); Slater (1959); Fox (1980); Bullough (1976) — reference to Zaynab pp 208-209.
On premarital virginity, sublimation: Ellis (1923) — quote, p 104; Freud (1905); Unwin (1943); Murdock (1964); Gagnon & Smith (1969); Krzywicki as summarized in Slater (1959); Nag (1962).
On punishments: Brown (1952); Igbo rules described by Meek (1934) and Hives (1932) as reprinted in Dundes (1968).

CHAPTER 10.
General works include the important multivolulme study by Henriques (1962-1968); as well as Bullough (1964); and Bullough & Bullough (1978); also Guerra (1971) on native American customs; Lane (1963) on Egypt; Kalm (1985) on Aruba; DeBecker (1934) on Japan.The Japanese war brothel network is reported in the New York *Times* 1992 July 7 p 8. Of interest still is Dufour (1851-61).
Quotation from Augustine: *De ordine*, Book 2, chapter 12.Dictum linking prostitutes and sewers from *De regimine principum*, some chapters of which are universally acknowledged to be by St Thomas Aquinas.But the dictum itself is from Book 4, chapter 14 — a section almost certainly not by him but rather by Tolomeo di Lucca.The whole section deserves to be quoted in full:"Unde Augustinus dicit, quod hoc facit meretrix in mundo, quod sentina in mari, vel cloaca in palatio: Tolle cloacam, et replebis foetore palatium'; et similiter de sentina:'Tolle meretrices de mundo, et replebis ipsum sodomia'."(Translation of the relevant sections, mine.)
On male prostitution:Wikan (1977); Nanda (1990).The ads referred to were from *The Advocate*, 1978 July 12.
On sacred prostitution: A B Ellis (1890); Dennett (1906).

CHAPTER 11.
Much of the information cited here is culled from newspapers, reports from the World Health Organization or other sources subject to constant revision.Only a few such are listed here.
On contemporary sexuality in the west, particularly with reference to the "sexual revolution ": Sorokin (1956); Simon (1972); Colton (1972), Winick and Kinsie (1973); Hunt (1974); Hite (1976); Klassen, *et al.* (1989) — but their data were collected in 1970; Reinisch (1990) on sexual "literacy"; Murdock (1950) on levels of divorce.For "spermathon", see Friedman (1986).
Catholic teachings on sex: Hardon (1975); Sommer (1970).Controversial approaches: Kosnik *et al.* (1977); McNeil (1976).Gay movement and scene: Lauritsen & Thorstad (1974); Steakley (1975); Humphreys (1970) and (1972); Teal (1971).Bishop Spong on St Paul in Spong (1991).The Rev. Mr Williams's own side of the story is given in Williams (1992).
Sex reassignment and other technical developments: Green & Money (1969); Bolin (1988); Furlow (1976), Money (1969); Bolin (1988); Furlow (1976) — on devices to deal with impotence.
Sex research: Gebhard (1968); the quote from William E Dannemayer reported in the New York *Times* 1991 July 21 p 19.

CHAPTER 12.
General sources include Murdock (1959) and (1967); Rachewiltz (1964); and Hanry (1970).
Important works on ancient Egyptian sexuality are Omlin (1973); and Mannniche (1977) and (1987).For incest, see Middleton (1962); Hopkins (1980); and Shaw (1992).
References for topics or cultures not included in HRAF, as well as specific works mentioned, include the following.Marshall & Suggs (1971) on Bala and Turu; Driberg (1923) on Lango — quote, p 210; Schapera (1930) on Hóttentot — includes references to Wandres, Fritsch and Falk; Schapera (1966) on Kgatla-Tswana; Slater (1976) on Nyika; Hollis (1971) on Nandi; Talbot (1926) on southern Nigerian groups; Rattray (1927) on Twi — includes reference to Bowdich; Evans-Pritchard (1970) and (1973) on Zande; Stannus (1922) on Yao — reference to salt customs p 386; Nadel (1942) on Nupe; Turnbull (1965) on Mbuti Pigmies; Shostak (1981) on !Kung Bushmen; Barley (1983) on Dowayo.

A survey of dynastic incest is given in van den Berghe & Mesher (1980).Needham (1973) discusses left-right symbolism.Czekanowski (1927) details punishments for seducing married women among the Zande.

The citation from André Gide is from *Ainsi soit-il, ou les jeux sont fait* (1952), Paris: Bibliothèque de la Pléiade, p 123 (translation mine).

CHAPTER 13.

General sources include Patai (1960); Bullough (1976); Murdock (1967); Neufeld (1944) and (1951); Reynolds (1914); Grayson and Reynolds (1973).

On Siiwans: Belgrave (1923) — the quotation is from p 150; Cline (1936); and Maugham (1948) — quotation from p 80.The quotation from Quintus Curtius is given in Belgrave p 86.

On Samaritans: Montgomery (1968); Jacob (1908).

On Jews: Epstein (1942) and (1948); Lamm (1980); Weiss (1962).

On Muslims: Bouhdiba (1985); Mernissi (1975) — the results of the Moroccan questionnaire are given on p. 53; Klausner in Ellis and Abarbanel (1967); Harrison (1924); Philby (1951); Dickson (1951) — quotation from p 204; Lhote (1944); Blanguemon (1955); Coon (1931); Blanco Izaga (1975); Greenberg (1988) — reference to Iranian "punishment" from p 181.

CHAPTER 14.

General sources include Bullough (1976) — the quotes from the Code of Manu are from p 247 (slightly paraphrased); Maloney (1974); Sur (1973); Jha (1979) — discusses "semen power" in some detail; Meyer (1930); and Thomas (1960).

References for topics or cultures not included in HRAF as well as specific works mentioned include the following: Comfort (1965) on erotic manuals; Edwardes (1969) on the economics of temple prostitution; Cipriani (1966) on Andamanese — quote from p 493; Gorer (1932); Morris (1938) — quote about nuns from p 269; and Hermanns (1954) on the Lepcha; Marshall (1922) on Karen; Elwin (1947) on Múria Gond; Peter (1963) on Thandan views about coïtal positions — quote from p 229; Gentile-Duquesne (1925) on Vietnamese incest rules.

CHAPTER 15.

General sources include Bullough (1976); Murdock (1967); Valensin (1977); Hsu (1948) and (1951); Asayama (1974) and (1976); Beatty (1979); and Beurdeley *et al.* (1969).

References for topics or cultures not included in HRAF, as well as specific works mentioned, include the following: Seeland (1922) on Gilyak — quote from p 30; Krasheninnikov (1764) on Kamchadál; Landor (1893) on Ainu — quote from p 141; Osgood (1951) on Koreans; Ryazanovski (also written Riasanovsky) (1929) and (1937) p 147 on the Great Yassa — see Greenberg (1988) for a misunderstanding of the use of "sodomy"; Watanabe and Iwata (1989) on Japanese samurai.

CHAPTER 16.

General sources include Marshall & Suggs (1971); Suggs (1966); and Vayda (1961).Topics or cultures not included in HRAF, as well as specific works mentioned, include the following.

On Australian aborigines: Spencer & Gillen (1927); Strehlow (1913); Róheim (1933) and (1974) — quote on penis breaking from p 235; Warner (1937) — quote on consequences of the gunabibi ritual from p 307, quote on the function of semen from p 24; Money, Cawte, Bianchi and Nurcombe (1970).

For the rest of Oceania: Malinowski (1932) on Trobrianders; Hogbin (1945) on Wógeo — quote about wife's adultery from p 344; Best (1924) on Maori — quote on sex hospitality for bishop from p 469; Firth (1936) on Tikopia; Linton (1939) and Suggs (1966) on Marquesans; Marshall in Marshall and Suggs (1971) on Mangaians; Heider (1976) and (1977) on Dani; Salesius (1906) on Yapese.

On homosexuality and ritualized pederasty in particular: Herdt (1981) on Sámbia and (1984) on Melanesia on general; Layard (1942) on Malekula — quote from p 489; Kelly (1976) and (1977) on Étoro; Davenport (1965) on East Bay; Schneebaum (1988) on Asmat; Pilling (n.d.) on Tiwi; Levy (1971) on Tahitians.

On Western impact: Thomson (1894); and Worsley (1957).

CHAPTER 17.

General sources are few but include Ellis and Abarbanel (1967) — articles on American Indians and Latin America; Bullough (1976).References for topics or cultures not included in HRAF, as well as specific works mentioned, include the following.

On genital mutilations: Murdock (1967) — reference to Palerm on Totonác on p 40; Voget in Ellis and Abarbanel (1967) p 108; Landa on Maya in Tozzer (1941) — quote from p 114; Montagu (1969) on female mutilations.

On high cultures: Cieza de León as cited in Bullough (1976) pp 39-40; Kauffman-Doig (1979) — reference to Pachacuti's statement about public copulation p 89.On erotic pottery: Gebhard in Bowie and Christenson (1970); Larco Hoyle (1965).

On Kágaba: Bolinder (1925); Preuss (1926); Reichel-Dolmatoff (1949-1950) and (1951).

On Kubeo (Tukano): Silva (1962); Goldman (1963); Sorensen (1984).

On other cultures: Kensinger (1988) on Cashinahua; Gregor (1985) on Mehinakú; Bailey on Návaho (1950); Osgood (1958) on Ingalik.

On transvestism and homosexuality: Williams (1986); Requena (1945); Schneebaum (1969) with specific reference to Amarakaeri (Amarakaire), which he calls by the fictitious name Akarama; Chagnon (1967) and Harris (1966) on Yãnomamö.

On sex ceremonies, etc.: Kehoe (1970); Forbes (1870) on Good Friday and incest beliefs among the Aymará Puna.

CHAPTER 18.

General sources include Taylor (1954); Ellis and Abarbanel (1967); Bullough (1976); D'Emilio and Freedman (1988); Mosse (1985); Foucault (1976-1984) — (English translation of volume 1 (1978); Simon (1972).References for topics or cultures not included in HRAF, as well as specific works mentioned, include the following.

On Serbians: Hammel (1967) — quote about yearly frequency from p 58; Krause writing in 1995, as cited in Hammel (1968) — "down to belt" quote from p 33.On Irish: Messenger (1969) and in Marshall and Suggs (1971) — quote from p 15; Arensberg and Kimball (1940) — quote from p 204.

On Venus figurines: Meltzer (1974); Slater (1974); McDermott (1982).

On Christian phallic cults: Dufour (1851-1861) vol. 3 p 126 ff.

On ancient behavior: Gibbon (1932) — quote from vol. 1, p 68 fn 49.

On erotica: Steinberg in Bowie and Christenson (1970) — quote from p 252; Webb (1975).

On homosexuality: Dover (1978); Boswell (1980) — quote from p 123; Tomasic (1948) on Serbian "marriages" — quote from p 79.On the conceptualization of sexual orientation: Westphal (1869) [Foucault gives the date as 1870]; Foucault (1978) — quote from p 18; McIntosh, Boswell, Dynes and Stein: all in Stein (1990).See also: Murray (1984).The dictum linking prostitution and sodomy is found in De regimine principum (see similar note for chapter 10).

CHAPTER 19.

To keep the number of references to a minimum, basic sources are not mentioned: Ellis and Abarbanel (1967); Ford & Beach (1951); Marshall & Suggs (1971); Bullough (1976); these include also general reference works: the Encyclopædia britannica (15th edition), The Hastings encyclopædia of religion and ethics, Encyclopaedia judaica, The encyclopaedia of Islam.Also information that can easily be checked in the Human Relations Area Files is generally not given a specific reference.

Abstinence... quote about Ila from Smith and Dale (1968) vol. 2, p 39; see also Harris (1977) for explanation of Hindu vegetarianism.

AIDS Grmek (1989); Perrow and Guillén (1990); Shilts (1987); Fumento (1990); Bongaarts, Reining, Way and Conant (1989); for report on Montagnier-Gallo controversy see New York Times 1991 June 31 p A12.

Aphrodisiacs quote from Kaplan (1974) p. 94; Money, Leal and Gonzalez-Heydrich (1988).

Astringents Suggs (1966).

Birth control... Nag (1962); Ewers (1970); Devereux (1955).

Bisexuality Davenport (1965); Geller (1990); McWhirter, Sanders and Reinisch (1990).

Bride price... Harris (1977); Radcliffe-Brown and Forde (1950); Lindenbaum in Herdt (1984); Nash (1978).

Bundling... Visted and Stigum (1971) vol. 1, p 401; Kenyatta (1965) p 153.

Chastity belts... Dingwall (1931).
Child marriage... Maloney (1974); Nag (1962).
Cisvestism Hirschfeld (1930).
Condom Ucko (1970).
Couvade Dawson (1929).
Drout du seigneur Westermarck (1968).
Fetishism... Money (1986); Gebhard (1969); Gregersen (1969).
Frigidity... Masters and Johnson (1970) and (1979); Kaplan (1974); Kisekka (1974).
Gadgets Hirschfeld (1930); Brown, Edwards and Moore (1988).
Gender Stein (1990).
Genital jewelry Hirschfeld (1930); Brown, Edwards and Moore (1988); Gladwin and Sarason (1953);
 Rawson (1973) p 272; Simons (1975) p 115.
Genital preservation Murdock (1968) p 189; Leca (1971) p 66; Forbes (1992) on Tut.
Genital tatoos Suggs (1966); Lessa (1966); Ploss, Bartels and Bartels (1927).
Homophobia Werner (1975) and (1979); Lehne (1976); Gallup (1983).
Homosexuality Dynes, Johansson, Percy and Donaldson (1990); Gorer (1966); Greenberg (1988);
 Gallup and Suarez (1983); Newton (1972) — quote from p 21 fn; Stein (1990); Blackwood
 (1986); Trumbach (1977); Tripp (1975); Sonenschein (1968); Churchill (1967); Karsch-
 Haack (1911); McWhirter, Sanders and Reinisch (1990).
Impotence... Masters and Johnson (1970); Kiev (1972); Money (1987).
Kissing Opler (1969b).
Limerance Tennov (1979).
Lovemap Money (1986).
Love magic González-Wippler (1973) pp 152-153; Leach (1949) pp 647-648.
Male pregnancy Smith and Dale (1968) vol. 2, p 74; Money and Hosta (1968); Meigs (1976); Barsky
 (1986); Munroe (1971).
Masturbation Suggs (1966) pp 48, 82, *et passim.*
Nekrophilia Berndt (1962); Bosworth (1978) — quote from p 399.
Night-crawling Mead (1928) p 76.
Paraphilia Money (1986).
Penis holding Patai (1960) p 142; Meggitt (1965) pp 133, 262; Scott (n.d.) p 147.
Phallicism... Leach (1949), article on phallism; Scott (n.d,); Edwardes (1967) pp 6-7; Davey (n.d.).
Proofs of virginity Ellis (1942) vol. 2, part 1, p 203; Patai (1960) pp 60-63; Montagu (1969) pp 103-
 108.
Pubic wigs Cox (1966).
Rape Brown (1952); Broude & Greene (1976); Symons (1979); Money (1986); Brownmiller (1975)
 — quote from p 15; quote on mass rape from the New York *Times*, 1991 July 29 p 7.
Romantic love Rosenblatt (1966) and (1967); Coppinger and Rosenblatt (1968).
Sadomasochism Gebhard (1969); Gregersen (1969), (1972) and (1987); Spengler (1977) and (1979);
 Gorer (1955); Money (1986).
Sex careers Mead (1961).
Sex shows Pauvert (1962).
Sexual orientation Bell, Weinberg and Hammersmith (1981); Masters and Johnson (1979); Dörner
 (1976); Kallmann (1952); Green (1987); Whitam (1983); Gallup and Suarez (1983);
 McWhirter, Sanders and Reinisch (1990).
Transsexualism Benjamin (1966); Bolin (1988); Nanda (1990); Wikan (1977).
Transvestism Ackroyd (1979); Suggs (1966) pp 121-122 *et passim*; Munroe, Whiting and Hally
 (1969); Williams (1986).
Vaginal teeth... Thompson (1955-1958) [the motif-number for the *vagina dentata* theme is F547.1.1]
 and (1968); Leach (1949).
Venereal diseases... Morton (1972); Baker and Armelagos (1988).
Zoöphilia Schultze (1907); Money and Dewaraja (1986).

BIBLIOGRAPHY

Books and articles found in the Human Relations Area Files are not included here unless specifically cited.This is done out of sheer practicality; otherwise 1000 items or more could easily have been added.

Aberle, David F, Urie Bronfenbrenner, Eckhard H Hess, Daniel R Miller, David M Schneider, and James N Spuhler
1963 "The incest taboo and the mating patterns of animals." *American Anthropologist* 65: 253-265.

Ackroyd, Peter
1979 *Dressing up; transvestism and drag: the history of an obsession.* New York: Simon and Schuster.

Allen, Paula Gunn
1981 "Lesbians in American Indian cultures." *Conditions* 7: 67-87.

Arbuthnot, F F, and Richard F Burton
1964 *Ananga ranga (stage of the bodiless one): the Hindu art of love.* New York: Medical Press of New York.

Arensburg, Conrad M, and Solon T Kimball
1940 *Family and community in Ireland.* Cambridge: Harvard University Press.

Asayama, Shin'ichi
1974 *Adolescent sex development and adult sex behavior in Japan.* Tokyo: The Japanese Association for Sex Education.
1976 "Sexual behavior in Japanese students: comparisons for 1974, 1960, and 1952." *Archives for sexual behavior* 5.5: 371-390.

Athenaeus
1937 *The deipnosophists* (trans. by Charles B Gulick: The Loeb Classical Library). Cambridge, Massachusetts: Harvard University Press.

Bailey, F L
1950 *Some sex beliefs and practices in a Navaho community; with comparative material from other Navaho areas.* Cambridge, Massachusetts: The Museum.

Baker, Brenda J, and George J Armelagos
1988 "The origin and antiquity of syphilis: paleopathological diagnosis and interpretation." *Current anthropology* 29.5: 703-737.

Barash, David P
1979 *The whisperings within.* New York: Harper & Row.

Barkow, Jerome H
1978 "Culture and sociobiology." *American anthropologist* 80.1: 5-20.

Barley, Nigel
1983 *The innocent anthropologist: notes from a mud hut.* Harmondsworth: Penguin.

Barsky, Lesley
1986 "Holy hormones...male pregnancy?" *Chatelaine* 59.8: 62-63, 122-124.

Beach, Frank, ed.
1976 *Human sexuality in four perspectives.* Baltimore: Johns Hopkins University Press.

Beatty, John
1979 "Sex, role, and sex role."In: Judith Orasanu, Mariam K Slater, and Leonore Loeb Adler,
 eds., *Language, sex and gender: does 'la différence' make a difference?* Annals of the
 New York Academy of Sciences, vol. 37.

Belgrave, C Dalrymple
1923 *Siwa, the oasis of Jupiter Ammon.* London: John Lane The Bodley Head.

Bell, Alan P, Martin S Weinberg and Sue Kiefer Hammersmith
1981 *Sexual preference: its development in men and women.* Bloomington: Indiana University
 Press.

Benedict, Ruth
1935 *Patterns of culture.* New York: Houghton Mifflin.
1939 "Sex in primitive society." *American journal of orthopsychiatry* 9: 570-574.

Benet, Sula
1974 *Abkhasians: the long-living* [sic] *people of the Caucasus.* New York: Holt, Rinehart and
 Winston.

Benjamin, Harry
1966 *The transsexual phenomenon.* New York: The Julian Press.

Berckmann, Noël
1967 *Kâma ciampa.* Paris: Le Trèfle d'Or.

Berndt, Ronald M
1951 *Kunapipi.* Melbourne: F W Cheshire.
1962 *Excess and restraint: social control among a New Guinea mountain people.* Chicago:
 University of Chicago Press.
Best, Elsdon
1924 *The Maori.* Memoirs of the Polynesian Society, vol. 5.

Bettelheim, Bruno
1954 *Symbolic wounds* (revised ed.). New York: Collier Books

Beurdeley, Michel, Kristofer Schipper, Chang Fu-Jui, and Jacques Pimpaneau
1969 *Chinese erotic art.* Rutland VT: Charles E Tuttle.

Bick, Mario
[n.d.]. "What's on, what's coming off? Notes on a theory of adornment."(Unpublished paper.)

Blackwood, Evelyn
1984 "Sexuality and gender in certain native American tribes: the case of cross-gender
 females." *Genders* 10.1: 27-42.

Blackwood, Evelyn, ed.
1986 *Anthropology and homosexual behavior.* New York: Haworth Press.

Blanco Izaga, Emilio
1975 (A selection of his material, published and unpublished, on the Rifians.) HRAFlex Books.
 New Haven: HRAF.

Blanguernon, Claude
1955 *Le Hoggar.* Paris: B Arthaud.

Bloch, Iwan
1907 *Das Sexualleben unserer Zeit in seinen Beziehungen zur modernen Kultur.* Berlin: Louis
 Marcus.
1933 *Anthropological studies in the strange sexual practices of all races in all ages.* New York:
 Anthropological Press.

Bohannan, P and J Middleton, eds.
1968 *Marriage, family, and residence.* Garden City, New York: Natural History Press.

Bolin, Anne
1988 *In search of Eve: transsexual rites of passage.* South Hadley, Massachusetts: Bergin &
 Garvey.

Bolinder, Gustaf
1925 *Die Indianer der tropischen Schneegebirge: Forschungen im nördlichsten Südamerika.*
 Stuttgart: Strecker und Schröder.

Bolton, Ralph
1971 "Tawanku: intercouple bonds in a Qolla village." Paper presented at the annual meeting
 of the American Anthropological Association, New York. [Printed in 1973 in *Anthropos*
 68: 145-155.]

Bonaparte, Marie
1948 "Notes sur l'excision." *Revue française de psychanalyse* 12: 213-231.

Bongaarts, John, Prisilla Reining, Peter Way and Francis Conant
1989 "The relationship between male circumcision and HIV infection in African populations."
 Current Science 3: 373-377.

Boswell, John
1980 *Christianity, social tolerance and homosexuality: gay people in Western Europe from the
 beginning of the Christian era to the fourteenth century.* Chicago: University of Chicago
 Press.

Bosworth, Patricia
1978 *Montgomery Clift: a biography.* New York: Harcourt Brace Jovanovich.

Bowie, Theodore, and Cornelia V Christenson, eds.
1970 *Studies in erotic art.* New York: Basic Books.

Bouhdiba, Abdelwahab
1985 *Sexuality in Islam.* London: Routledge & Kegan Paul.

Brecher, Edward M
1970 *The sex researchers.* London: Andre Deutsch.

Broude, Gwen J
1975 "Norms of premarital sexual behavior: a cross- cultural study." *Ethos* 3: 381-402.

Broude, G J and S J Greene
1976 "Cross-cultural codes on twenty sexual attitudes and practices." *Ethnology* 15: 409-429.

Brown, Donald E, James W Edwards, and Ruth P Moore
1988 "The penis inserts of Southeast Asia: an annotated bibliography with an overview and
 comparative perspectives." *Occasional Paper No. 15*, Center for South and Southeast
 Asia Studies, University of California at Berkeley.

Brown, J S
1952 "A comparative study on deviations from sex mores." *American sociological review*
 17:135-146.

Brownmiller, Susan
1975 *Against our will: men, women and rape.* New York: Simon and Schuster.

Brues, Alice
1960 "The spearman and the archer: an essay on selections in body build." *American anthropologist* 61: 457-469.

Brupbacher, Paulette
1949 "Sex penal laws in Soviet Union" [sic]. *The international journal of sexology* 2: 246-248.

Bryk, Felix
1934 *Circumcision in man and woman: its history, psychology and ethnology.* New York: American Ethnological Press.

Bullough, Vern L
1964 *The history of prostitution.* New Hyde Park, NY: University Books.
1976 *Sexual variance in society and history.* New York: John Wiley and Sons.

Bullough, Vern L, and Bonnie L Bullough
1978 *Prostitution: an illustrated social history.* New York: Crown.

Burton, Richard F, trans.
1962 *The Kama Sutra of Vatsyayana.* New York: E P Dutton.
1964 *The perfumed garden of the Shaykh Nefzawi.* New York: G P Putnam's Sons.

Byrne, Donn, and Kathryn Kelley, eds.
1986 *Alternative approaches to the study of sexual behavior.* Hillsdale, NJ: Lawrence Erlbaum.

Calder-Marshall, Arthur
1959 *The sage of sex: a life of Havelock Ellis.* New York: Putnam.

Camphausen, Rufus C
1991 *The encyclopedia of erotic wisdom.* Rochester VT: Inner Traditions International.

Caplan, Pat, ed.
1987 *The cultural construction of sexuality.* London: Tavistock.

Carrier, Joseph M
1980 "Homosexual behavior in cross-cultural perspective." In: J Marmor, ed., *Homosexual behavior: a modern reappraisal.* Basic Books: New York.

Cawte, J E
1968 "Further comment on the Australian subincision ceremony." *American anthropologist* 70:961-964.

Cawte, J E, N Djagamara, and M J Barrett
1966 "The meaning of subincision of the urethra to aboriginal Australians." *British journal of medical psychology* 39:245-253.

Chagnon, Napoleon A
1967 "Yanomamö warfare, social organization and marriage alliances." Doctoral dissertation submitted to the University of Michigan in 1966. University Microfilms Publications, No. 67-8226. Ann Arbor: University Microfilms.

Chard, Chester S, ed.
1961 "Sternberg's materials on the sexual life of the Gilyak." *Anthropological papers of the University of Alaska* 10(1):13-23.

Charrière, G
1970 *La signification des représentations érotiques dans les arts sauvages et préhistoriques.*
 Paris: G-P Maisonneuve et Larose.
Christensen, Harold T
1977 "Mormon sexuality in cross-cultural perspective." *Dialogue: a journal of Mormon thought*
 10(2):62-75.

Christensen, H T and C F Gregg
1970 "Changing sex norms in America and Scandinavia." *Journal of marriage and family*
 33:616-627.

Christenson, Cornelia
1971 *Kinsey: a biography.* Ann Arbor: Books on Demand UMI.

Churchill, Wainright
1967 *Homosexual behavior among males: a cross-cultural and cross-species investigation.* New
 York: Hawthorn Books.

Cipriani, Lidio
1966 *The Andaman Islanders.* New York: Frederick A Praeger.

Cline, Walter
1936 "Notes on the people of Siwah and El Garah in the Libyan desert." *General series in
 anthropology* 4. Menasha, Wisconsin.

Colton, Helen
1972 *Sex after the sexual revolution.* New York: Associated Press.

Comfort, Alex
1964 *The Koka shastra, being the Ratirahasya of Kokkoka and other medieval Indian writings
 on love.* New York: Stein and Day.

Coon, Carleton Stevens
1931 *Tribes of the Rif* (Harvard African studies 9). Cambridge: Peabody Museum.

Cooper, Wendy
1971 *Hair: sex society symbolism.* New York: Stein and Day.

Copley, Anthony
1989 *Sexual moralities in modern France, 1780-1980: new ideas on the family, divorce and
 homosexuality.* New York: Routledge, Chapman and Hall.

Coppinger, Robert M, and Paul C Rosenblatt
1968 "Romantic love and the subsistence dependence of spouses." *Southwestern journal of
 anthropology* 24: 310-319.

Cox, J Stevens
1966 *An illustrated dictionary of hairdressing and wig making.* London: Hairdressers
 Technical Council.

Cucchiari, Salvatore
1981 "The gender revolution and the transition from bisexual horde to patrilocal band: the
 origins of gender hierarchy." In: Ortner, Sherry B, and Harriet Whitehead, eds., *Sexual
 meanings: the cultural construction of gender and sexuality.* Cambridge: Cambridge
 University Press.

Czekanowski, Jan
1927 *Forschungen im Nil-Kongo-Zwischengebiet,* vol. 5. Leipzig: Klinkhardt.

Dallet, Charle
1874 *Histoire de l'église de Corée.* Paris: Victor Palmé.

Daly, Martin, and Margo Wilson
1978 *Sex evolution, and behavior: adaptations for reproduction.* NorthScituate, Massachusetts: Duxbury Press.

Dareer, Asma El
1982 *Woman, why do you weep?* London: Zed.

Davenport, William H
1965 "Sexual patterns and their regulation in a society of the southwest Pacific." In: F A Beach, ed., *Sex and Behavior.* New York: John Wiley.
1977 "Sex in cross-cultural perspective."In: Frank A Beach, ed., *Human sexuality in four perspectives.* Baltimore: Johns Hopkins University Press.

Davey, William Robert Parkhouse
[n.d.] *Semitic phallicism; preceded by a sketch of non-Semitic phallicism.* (Unpublished Ph.D. dissertation, Harvard University).

Davies, Nigel
1984 *The rampant god: Eros throughout the world.* New York: William Morrow.

Davis, D L and R G Whitten
1987 "The cross-cultural study of human sexuality." *Annual review of anthropology* 16:69-98.

Dawkins, Richard
1976 *The selfish gene.* London: Oxford University Press.

Dawson, Warren R
1929 *The custom of the couvade.* Manchester: University of Manchester Press.

deBecker, Joseph Ernest
1934 *The sexual life of Japan; being an exhaustive study of the nightless city or, the "History of the Yoshiwara Yukwaku."* New York: American Anthropological Society.

D'Emilio, John, and Estelle Freedman
1988 *Intimate matters: a history of sexuality in America.* New York: Harper & Row.

deLaszlo, H, and P S Henshaw
1954 "Plant materials used by primitive groups to affect fertility." *Science* 119:626-631.

DeMartino, Manfred F
1969 *The new female sexuality.* New York: The Julian Press.

Dennett, R E
1906 *At the back of the black man's mind; or, Notes on the kingly office in West Africa.* London: Macmillan.

Désy, Pierrette
1978 "L'homme-femme (les berdaches en Amérique du Nord)." *Libre* 783: 57-102.

Devereux, George
1937 "Institutionalized homosexuality of the Mohave Indians." *Human biology* 9: 498-527.
1955 *A study of abortion in primitive societies.* New York: The Julian Press.

Dickson, H R P
1951 *The Arab of the desert; a glimpse into Badawin life in Kuwait and Sau'di [sic] Arabia.* London: George Allen and Unwin.

Dingwall, John
1931 *The girdle of chastity*. New York: Macawley.

Divale, William, and Marvin Harris
1976 "Population, warfare, and the male supremacist complex." *American anthropologist* 78:521-538.

Dörner, Gunter
1976 *Hormones and brain differentiation*. Amsterdam: Elsevier.

Doty, Richard L, Mary Ford, and George Preti
1975 "Changes in the intensity and pleasantness of human vaginal odors during the menstrual cycle." *Science* 190:1316-1318.

Douglas, Mary
1966 *Purity and danger: an analysis of concepts of pollution and taboo*. New York: Frederick A Praeger.

Dover, K J
1978 *Greek homosexuality*. Cambridge, MA: Harvard University Press.

Draper, Patricia, and Henry Harpendinger
1988 "A sociobiological perspective on the development of human reproductive strategies." In: Kevin B MacDonald, ed., *Sociobiological perspectives on human development*. New York: Springer Verlag.

Driberg, J H
1923 *The Lango, a Nilotic tribe of Uganda*. London: T Fisher Unwin.

Duberman, Martin, Martha Vicinus and George Chauncey, Jr.
1989 *Hidden from history: reclaiming the gay and lesbian past*. New York: Meridian.

Dufour, Pierre (pseudonym of Paul Lacroix)
1851-1861 *Histoire de la prostitution: chez tous les peuples du monde depuis l'antiquité la plus reculée jusqu'à nos jours*. Paris: Seré.

Dundes, Alan, ed.
1968 *Every man his way*. Englewood Cliffs, New Jersey: Prentice Hall.

Dworkin, Andrea
1976 *Our blood: prophecies and discourses on sexual politics*. New York: Harper & Row.
1981 *Pornography: men possessing women*. New York: Putnam.

Dynes, Wayne R
1981 "Christianity and the politics of sex." In: *Homosexuality, intolerance, and Christianity: a critical examination of John Boswell's work* (Gai Saber Monograph No. 1). New York, pp 8-15.

Dynes, Wayne R, Warren Johansson, William A Percy and Stephen Donaldson, eds.
1990 *Encyclopedia of homosexuality*. New York: Garland.

Edgerton, Robert B
1964 "Pokot intersexuality: an East African example of sexual incongruity." *American anthropologist* 66:1288-1299.

Edwardes, Allen
1967 *Erotica judaica: a sexual history of the Jews*. New York: The Julian Press.

Edwardes, Allen, and R E L Masters
1963 *The cradle of erotica*. New York: The Julian Press.

Edwardes, Michael
1969 *Indian temples and palaces.* Feltham, New York: Hamlyn.

Elkin, A P
1956 *The Australian aborigines: how to understand them.* Sydney: Angus and Robertson.

Ellis, Albert
1951 *The folklore of sex.* New York: Charles Boni.

Ellis, Albert, and Albert Abarbanel
1967 *The encyclopedia of sexual behavior.* New York: Hawthorn Books.

Ellis, Alfred Burdon
1890 *The Ewe-speaking peoples of the Slave Coast of West Africa, their religion, manners, customs, laws, languages, and &c.* London: Chapman and Hall.

Ellis, Havelock
1923 *The dance of life.* New York: Grosset and Dunlap.
1942 *Studies in the psychology of sex* (2 vols). (Originally published 1905.)New York: Random House.

Elwin, Verrier
1947 *The Muria and their ghotul.* Bombay: Geoffrey Cumberlege, Oxford University Press.

Endleman, Robert
1989 *Love and sex in twelve cultures.* New York: Psyche Press.

Epstein, Louis M
1942 *Marriage laws in the Bible and the Talmud.* Cambridge, Massachusetts: Harvard University Press.
1948 *Sex laws and customs in Judaism.* New York: Bloch.

Eskapa, Roy
1987 *Bizarre sex.* London: Grafton Books.

Evans-Pritchard, E E
1970 "Sexual inversion among the Azande." *American anthropologist* 72.6:1428-1433.
1973 "Some notes on Zande sex habits." *American anthropologist* 75.1:171-175.

Ewers, John C
1970 "Contraceptive charms among the Plains Indians." *Plains anthropologist* 15.49:216-218.

Farkas, L G
1971 "Basic morphological data of external genitals in 177 healthy central European men. *American journal of physical anthropology* 34:325-328.

Feuerstein, G, and Sal-Marzooq
1978 "The Omani xanith." *Man NS* 13: 665-667.

Firth, Raymond
1936 *We the Tikopia.* London: George Allen and Unwin.

Fischer, J L
1964 "Semi-castration on Ponape." Paper presented at the VIIth International Congress of Anthropological and Ethnological Sciences, Moscow.

Fisher, Helen E
1983 *The sex contract: the evolution of human behavior.* New York: Quill.

Flugel, J C
1966　　*The psychology of clothes.* London: Hogarth Press.

Forbes, David
1870　　"On the Aymara Indians of Boliva and Peru." *The journal of the Ethnological Society of London NS* 2:193-305.

Forbes, Dennis C
1992　　"Abusing Pharaoh." *K.M.T.* 3.1: 58-67.

Ford, Clellan S
1964　　*Field guide to the study of human reproduction.* New Haven: HRAF Press.

Ford, Clellan S, and Frank A Beach
1951　　*Patterns of sexual behavior.* New York: Harper & Brothers and Paul B Hoever.

Foucault, Michel
1976-1984*Histoire de la sexualité* (3 vols). Paris: Gallimard. (English translation of vol 1 by Robert Hurley; NewYork: Pantheon [1978], *The history of sexuality,* vol. 1: *An introduction.*)

Fox, Robin
1980　　*The red lamp of incest: what the taboo can tell us about who we are and how we got that way.* New York: Dutton.

Frayser, Suzanne G
1985　　*Varieties of sexual experience: an anthropological perspective on human sexuality.* New Haven: HRAF Press.

Freeman, Derek
1983　　*Margaret Mead and Samoa: the making and unmaking of an anthropological myth.* Cambridge, Massachusetts: Harvard University Press.

Freud, Sigmund
1905　　*Drei Abhandlungen zur Sexualtheorie* (1962 English trans: *Three essays on the theory of sexuality*). Leipzig: F Deuticke.

Friedl, Ernestine
1975　　*Women and men: an anthropologist's view.* New York: Holt, Rinehart and Winston.

Friedman, Josh Alan
1986　　*Tales of Times Square.* New York: Delacorte.

Fumento, Michael
1990　　*The myth of heterosexual AIDS.* New York: Basic Books.

Furlow, W L
1976　　"Surgical management of impotence using the inflatable penile prosthesis." *Mayo Clinic proceedings* 51:325-328.

Gagnon, John L, and William Smith
1969　　"Prospects for change in American sexual patterns." In: *VD — challenge to man: a report on VD research priorities.* American Social Health Association (January) p 17.

Gallup, Gordon G, Jr.
1986　　"Unique features of human sexuality in the context of evolution." In: Donn Byrne and Kathryn Kelley, *Alternative approaches to the study of sexual behavior.* Hillsdale, NJ: Lawrence Erlbaum.

Gallup, Gordon G, Jr, and S D Suarez
1983 "Homosexuality as a by-product of selection for optimal heterosexual strategies. *Perspectives in biology and medicine* 26: 315-322.

Gebhard, Paul H
1968 "Human sex behavior research." In: M Diamond, *et al.*, *Reproduction and sexual behavior.* Bloomington: IndianaUniversity Press.
1969 "Fetishism and sadomasochism." *Science and psychoanalysis* 15:71-80.
1970 "Preface."In: Ailon Shiloh, ed., *Studies in human sexual behavior: The American scene.* Springfield, IL: Charles C Thomas.

Gebhard, Paul H, John H Gagnon, Wardell B Pomeroy and Cornelia V Christenson
1965 *Sex offenders: an analysis of types.* London: Heinemann.

Geller, Thomas, ed.
1990 *Bisexuality: a reader and source book.* Hadley, Massachusetts: Times Change Press.

Gentile-Duquesne, Pierre de
1925 *La situation juridique de la femme annamite.* Paris: Jouve et Compagnie.

Gibbon, Edward
1932? *The decline and fall of the Roman Empire,* 3 vols. (Originally 1776-1788 6 vols.)New York: Modern Library.

Gladwin, Thomas, and Seymour B Sarason
1953 *Truk: man in paradise.* New York: Wenner-Gren Foundation for Anthropological Research.
González-Wippler
1973 *Santería: African magic in Latin America* .New York: The Julian Press.

Gorer, Geoffrey
1934 *The Marquis de Sade.* New York: Liverright.
1938 *Himalayan village: an account of the Lepcha of Sikkim.* London: Michael Joseph.
1955 *Exploring English character.* New York: Criterion Books.
1964 *The American people: a study in national character* (revised ed.). New York: W W Norton.
1966 *The danger of equality.* London: Cresset Press.

Gough, Kathleen E
1968 "The Nayars and the definition of marriage."In: P Bohannan and J Middleton, eds., *Marriage, family, and residence.* Garden City, NY: Natural History Press.

Grayson, A K, and D B Reynolds, eds.
1973 *Papyrus and tablet.* Englewood Cliffs, NJ: Prentice-Hall.

Green, Richard
1987 *The "sissy boy syndrome" and the development of homosexuality.* New Haven: Yale University Press.

Green, Richard, and John Money, eds.
1969 *Transsexualism and sex reassignment.* Baltimore: Johns Hopkins University Press.

Greenberg, David F
1988 *The construction of homosexuality.* Chicago: University of Chicago Press.

Greer, Germaine
1971 *The female eunuch.* New York: McGraw-Hill.

Gregersen, Edgar A
1969 "The sadomasochistic scene." Paper presented at the annual meeting of the American Anthropological Association, New Orleans.
1971 "Sexual sublimation and cultural evolution." Paper presented at the annual meeting of the Southwestern Anthropological Association, Tucson.
1972 "Sadomasochism U.S.A." Paper presented at the annual meeting of the American Anthropological Association, San Francisco.
1974 "Masochist liberation." Paper presented at the annual meeting of the American Anthropological Association, Mexico City.
1987 "More deviant than thou." Paper presented at the annual meeting of the American Anthropological Association, Chicago.
1988 "The ultimate last tabu: sex with children." Paper presented at the annual meeting of the American Anthropological Association, Phoenix.
[n.d.] "Sex and circumcision: an alleged sex ritual in the Judaeo-Christian tradition. (Unpublished paper).

Gregor, Thomas
1985 *Anxious pleasures: the sexual lives of an Amazonian people.* Chicago: University of Chicago Press.

Grmek, Mirko D
1989 *Histoire du SIDA* (Eng. trans.: 1990, *History of AIDS: emergence and origin of a modern pandemic*). Princeton, NJ: Princeton University Press.

Grosskurth, Phyllis
1980 *Havelock Ellis: a biography.* London: Allen Lane.

Guerra, Francisco
1971 *The pre-Columbian mind.* London: Seminar Press.

Guiness Book of World Records (see: McWhirter).

Guthrie, Dale
1976 *Body hot spots: the anatomy of human social organs and behavior.* New York: Van Nostrand Reinhold.

Haeberle, Erwin J
1983 *The birth of sexology: a brief history of documents.* (A publication of the 6th World Congress of Sexology, sponsored by the World Association for Sexology). Berlin: Senate for Science and Research.

Hammel, Eugene A
1967 "The Jewish mother in Serbia or Les structures alimentaires de la parenté." In: William G Lockwood, ed., *Essays in Balkan ethnology.* Berkeley: Kroeber Anthropological Society Special Publication No. 1.
1968 *Alternative social stuctures and ritual relations in the Balkans.* Englewood Cliffs, NJ: Prentice-Hall.

Hanry, Pierre
1970 *Érotisme africain; le comportement sexual des adolescents guinéens.* Paris: Payot.

Haraway, Donna
1989 *Primate visions: gender, race, and nature in the world of modern science.* New York: Routledge.

Hardon, John A
1975 *The Catholic catechism, a contemporary catechism of the teachings of the Catholic Church.* Garden City, NY: Doubleday.

Harris, Marvin
1973 "The human strategy: What goes up, may stay up." *Natural history* 82.1.18 ff.
1977 *Cannibals and kings: the origins of cultures.* New York: Random House.
1989 *Our kind: who we are, where we came from, where we are going.* New York: Harper
 & Row.

Harrison, Paul W
1924 *The Arab at home.* New York: Thomas Y Crowell.

Heider, Karl G
1976 "Dani sexuality: a low energy system." *Man NS* 11.2:188-201.
1977 "Dani sexuality." *Man NS* 12.1:167-168.Henriques, Fernando
1962-1968 *Prostitution and society: a survey* (3 vols). London: MacGibbon and Kee.

Herdt, Gilbert H
1981 *Guardians of the flutes: idioms of masculinity.* New York: McGraw-Hill.
1984 *Ritualized homosexuality in Melanesia* (edited by Herdt). Berkeley: University of
 California Press.
1990 "Mistaken gender: 5-alpha reductase hermaphroditism and biological reductionism in
 sexual identity reconsidered." *American Anthropologist* 92.2:433-446.

Hermanns, Mathias
1954 *The Indo-Tibetans.* Bombay: K L Fernandes.

Hirschfeld, Magnus
1926-1930 *Geschlechtskunde auf Grund dreißig-jähriger Forschung und Erfahrung bearbeitet.*
 Stuttgart: J Püttmann.

Hite, Shere
1976 *The Hite report.* New York: Macmillan.

Hogbin, H Ian
1945 "Marriage in Wogeo, New Guinea." *Oceania* 15:324-352.
1970 *The island of menstruating men: religion in Wogeo, New Guinea.* Scranton: Chandler.

Hooten, Earnest A
1937 *Apes, men and morons.* New York: G P Putnam's Sons.

Hopkins, Keith
1980 "Brother-sister marriage in Roman Egypt." *Comparative studies in society and history*
 22:303-354.

Hsu, Francis L K
1948 *Under the ancestors' shadow.* New York: Columbia University Press.

Huelsman, Ben R
1976 "An anthropolgical view of clitoral and other female genital mutilations." In: Thomas P
 Lowry and Thea Snyder Lowry, eds., *The clitoris.*St Louis, Missouri: Warren H Green.

Humphreys, Laud
1970 *Tearoom trade; impersonal sex in public places.*New York: Aldine.
1972 *Out of the closets: the sociology of homosexual liberation.* Englewood Cliffs, NJ:
 Prentice-Hall.

Hunt, M
1974 *Sexual behavior in the 1970s.* Chicago: Playboy Press.

Immerman, Ronald S
1986 "Sexually transmitted disease and human evolution: survival of the ugliest?" *Human ethology newsletter* 4.11:6-7.

Jacob, Son of Aaron, High Priest of the Samaritans at Shechem
1908 "Circumcision among the Samaritans." *Bibliotheca sacra* 65:694-710.

Jeremias, Alfred
1931 *Der Schleier von Sumer bis heute.* Leipzig: J C Hinrichs'che Buchhandlung.

Jha, Akhileshwar
1979 *Sexual designs in Indian culture.* Atlantic Highlands, NJ: Humanities.

Kaama suutra: see Burton (1962).

Kallmann, Franz J
1952 "Comparative twin study on the genetic aspects of male homosexuality. *Journal of nervous and mental diseases* 115:283-298.

Kalm, Florence
1985 "The two faces of Antillean prostitution." *Archives of sexual behavior* 14.3:203-217.

Kaplan, Helen Singer
1974 *The new sex therapy: active treatment of sexual dysfunctions.* New York: Brunner/Mazel.

Karsch-Haack, Ferdinand
1911 *Das gleichgeschlechtliche Leben der Naturvölker.* München: Reinhart.

Katchadourian, Herant A, and Donald T Lunde
1975 *Fundamentals of human sexuality.* New York: Holt, Rinehart and Winston.

Kauffmann-Doig, Federico
1979 *Sexual behavior in Ancient Peru.* Lima: Kompaktos, SCRL.

Kehoe, Alice B
1970 "The function of ceremonial sexual intercourse among the northern Plains Indians." *Plains anthropologist* 15.48:99-103.

Kelley, R C
1976 "Witchcraft and sexual relations: an exploration in the social and semantic implications in the structure of belief." In: P Brown and G Buchbinder, eds., *Man and woman in the New Guinea Highlands.* American anthropologist special publication no. 8.
1977 *Etoro social structure: a study in structural contradiction.* Ann Arbor: University of Michigan Press.

Kennedy, John G
1970 "Circumcision and excision in Egyptian Nubia." *Man NS* 5.2: 175-191.

Kensinger, Kenneth M
1988 "Why bother?: Cashinakua views of sexuality." Paper presented at the annual meeting of the American Anthropological Association, Phoenix.

Kenyatta, Jomo
1965 *Facing Mt. Kenya.* (Originally 1938.) New York: Vintage.

Kiev, Ari
1972 *Transcultural psychiatry.* New York: The Free Press.

Kinsey, Alfred C, Wardell B Pomeroy, and Clyde E Martin
1948 *Sexual behavior in the human male.* Philadelphia: W B Saunders.

Kinsey, Alfred C, Wardell B Pomeroy, Clyde E Martin, and Paul H Gebhard
1949 "Concepts of normality and abnormality in sexual behavior."In: P H Hoch and J Zubin,
 eds., *Psychosexual development in health and disease.* New York: Grune and Stratton.
1953 *Sexual behavior in the human female.* Philadelphia: W B Saunders.

Kinzey, Warren G, ed.
1987 *The evolution of human behavior: primate models.* Albany: State University of New York
 Press.

Kisekka, Mere Nakateregga
1974 *Heterosexual relationship in Uganda.* Ann Arbor, MI: University Microfilms.(Thesis,
 University of Missouri).

Klassen, Albert D, Colin J Williams, and Eugene E Levitt
1989 *Sex and morality in the United States: an empirical enquiry under the auspices of the
 Kinsey Institute.* Middletown, CT: Wesleyan University Press.

Kolata, Gina Bari
1977 "Sexual dimorphism and mating systems: how did they evolve? *Science* 195:382-383.

Kosnik, Anthony, William Carroll, Agnes Cunningham, Ronald Modras, and James Schulte
1977 *Human sexuality: new directions in American Catholic thought.* New York: Paulist Press.

Krafft-Ebing, Richard von
1886 *Psychopathia sexualis: eine klinisch-forensische Studie.* Stuttgart: F Enke.

Krasheninnikov, Stepan
1764 *The history of Kamtschaka, and the Kurilski Islands with the countries adjacent.*
 Gloscester: R Raike's.

Kroeber, Alfred L
1925 *Handbook of the Indians of California.* Bureau of American Ethnology Bulletin 78.
 Washington: Government Printing Office.
1948 *Anthropology.* New York: Harcourt, Brace.

Lamm, Maurice
1980 *The Jewish way in love and marriage.* San Francisco: Harper and Row.

Landor, Arnold H Savage
1893 *Alone with the hairy Ainu: 3,800 miles on a pack saddle in Yezo and a cruise to the
 Kurile Islands.* London: John Murray.

Lane, E W
1963 *Manners and customs of the modern Egyptians.* (Originally 1860.)London: Dent
 (Everyman's Library).

Larco Hoyle, Rafael
1965 *Checan: essay on erotic elements in Peruvian art.* Geneva: Nagel.

Laumann, Edward O, John H Gagnon, Robert T Michael, and Stuart Michaels
1994 *The social organization of sexuality: sexual practices in the United States.* Chicago:
 University of Chicago Press.

Lauritsen, John, and David Thorstad
1974 *The early homosexual rights movement (1864-1935).* New York: Times Change Press.

Lawner, Lynne, ed.
1988 *I modi: the sixteen pleasures — an erotic album of the Italian Renaissance.* Evanston, IL: Northwestern University Press.

Layard, John
1942 *Stone men of Malekula.* London: Chatto and Windus.

LeBlanc, Steven A, and Ethne Barnes
1974 "On the adaptive significance of the female breast." *The American naturalist* 108:577-578.

Leca, Ange-Pierre
1971 *Les momies.* Paris: Hachette.

Lehne, Gregory K
1976 "Homophobia among men." In: Deborah David and Robert Brannon, eds., *The forty-nine percent majority: the male sex role.* Redding, MA: Addison-Wesley.

Lessa, William A
1966 *Ulithi: a Micronesian design for living.* New York: Holt, Rinehart and Winston.

LeVine, R A
1977 "Gusii sex offenses: a study in social control."In: D Chappell, R Geis and G Geis, eds., *Forcible rape: the crime, the victim, and the offender.* [Originally 1959.]New York: Columbia University Press.

Levy, Robert I
1971 "The community function of Tahitian male transvestism: a hypothesis." *Anthropological Quarterly* 44:12-21.

Lhote, Henri
1944 *Les Touaregs du Hoggar.* Paris: Payot.

Lieberman, Leonard
1989 "A discipline divided: acceptance of human sociobiological concepts in anthropology." *Current anthropology* 30.5:676-682.

Lovejoy, C Owen
1981 "The origin of man." *Science* 211:341-350.

Maccoby, E E, and C N Jacklin
1974 *The psychology of sex differences.* Stanford: Stanford University Press.

Malinowski, Bronislaw
1932 *The sexual life of savages in northwestern Melanesia.* London: George Routledge and Sons.

Maloney, Clarence
1974 *Peoples of South Asia.* New York: Holt, Rinehart and Winston.

Manniche, Lise
1977 "Some aspects of ancient Egyptian sexual life." *Acta orientalia* 38:11-23.
1987 *Sexual life in ancient Egypt.* London: KPI.

Mantegazza, Paolo
1935 *Gli amori degli uomini* (trans. by Samuel Putnam as *The sexual relations of mankind*). New York: Eugenics Publishing Company.

Marshall, Donald S, and Robert C Suggs, eds.
1971 *Human sexual behavior: variations in the ethnographic spectrum.* New York: Basic Books.

Marshall, Harry Ignatius
1922 *The Karen people of Burma: a study in anthropology and ethnology.* The Ohio State University bulletin 26.13.

Marshall, Lorna
1959 "Marriage among the !Kung Bushmen." *Africa* 29:335-364.

Masani, RP
1934 "The Sin Hast Fair and the cult of nudity." *The Journal of the Anthropological Society of Bombay* 15:215-250.

Masters, William H, and Virginia E Johnson
1966 *Human sexual response.* Boston: Little, Brown.
1970 *Human sexual inadequacy.* Boston: Little, Brown.
1979 *Homosexuality in perspective.* Boston: Little, Brown.

Maugham, Robin
1948 *Journey to Siwa.* New York: Harcourt Brace.

McDermott, LeRoy D
1988 "Autogenous visual information in Upper Paleolithic representations of the human figure." Paper delivered at the 12th International Congress of Anthropological and Ethnological Sciences, Zagreb.

McNeill, J J
1976 *The church and the homosexual.* Kansas City: Sheed Andrews and McMeel.

McWhirter, David P, Stephanie A Sanders, June Machover Reinisch, eds.
1990 *Homosexuality/heterosexuality: concepts of sexual orientation.* New York: Oxford University Press.

Mead, Margaret
1928 *Coming of age in Samoa.* New York: William Morrow.
1935 *Sex and temperament in three primitive societies.* New York: Morrow.
1961 "Cultural determinants of sexual behavior."In: William C Young, ed., *Sex and internal secretion.* Baltimore: Williams & Williams.

Meggitt, Mervyn J
1965 *Desert people: a study of the Walbiri aborigines of Central Australia.* Chicago: University of Chicago Press.

Meigs, Anna S
1976 "Male pregnancy and the reduction of sexual opposition in a New Guinea highlands society." *Ethnology* 15:393-408.

Meltzer, Stanley
1974 "Were women of the European Upper Paleolithic Junoesque?Implications of the venus figurines."Paper presented at the meeting of the American Anthropological Association, Mexico City.

Mernissi, Fatima
1975 *Beyond the veil: male-female dynamics in a modern Muslim society.* New York: John Wiley and Sons.

Messenger, John C
1969 *Inis Beag: isle of Ireland.* New York: Holt and Winston.

Meyer, Johann Jakob
1930 *Sexual life in ancient India.* London: George Routledge and Sons.

Middleton, Russel
1962 "Brother-sister and father-daughter marriage in ancient Egypt." *American Sociological Review* 27.5:603-611.

Minturn, Leigh
1965 "A cross-cultural linguistic analysis of Freudian symbols." *Ethnology* 4:336-342.

Minturn, Leigh, Martin Grosse, and Santoah Haider
1969 "Cultural patterning of sexual beliefs and behavior." *Ethnology* 8:301-318.

Money, John
1952 *Hermaphroditism: an inquiry into the nature of a human paradox.* Ann Arbor, MI: University microfilms 1967.(Dissertation, Harvard University.)
1966 "The strange case of the pregnant hermaphrodite." *Sexology*, August 7-9.
1985 *The destroying angel: sex, fitness and food in the legacy of degeneracy theory, graham crackers, Kellogg's corn flakes and American health history.* Buffalo: Prometheus Books.
1986 *Lovemaps: clinical concepts of sexual/erotic health and pathology, paraphilia, and gender transposition in childhood, adolescence, and maturity.* Buffalo: Prometheus Books.

Money, John, and Charles Annecillo
1987 "Body-image pathology: koro, the shrinking-penis syndrome in transcultural sexology." *Sexual and marital therapy* 2.1:91-100.

Money, John, and Robert Athanasiou
[n.d.] Review of Reuben, *Everything you always wanted to know about sex (but were afraid to ask).* (Unpublished manuscript.)
1973 "Pornography: review and bibliographic annotations. *American journal of obstetrics and gynecology* 1151.1:130-146 (Jan 1).

Money, John, J G Hampson, and J L Hampson
1955 "An examination of some basic sexual concepts: the evidence of human hermaphroditism." *Bulletin of Johns Hopkins Hospital* 97:301-319.

Money, John, and Geoffrey Hosta
1968 "Negro folklore of male pregnancy." *The journal of sex research* 4:34-50.

Money, John, J E Cawte, G N Bianchi, and B Nurcombe
1970 "Sex training and traditions in Arnhem Land." *British journal of medical psychology* 43:383-399.

Money, John, and Ratnin Dewaraja
1986 "Transcultural sexology: formicophilia, a newly named paraphilia in a young Buddhist male." *Journal of sex and marital therapy* 12.2:139-145.

Money, John, Jeffrey Leal and Joseph Gonzalez-Heydrich
1988 "Aphrodisiology: history, folklore, efficacy." In: John Money and Herman Musaph, eds., *Handbook of Sexology*, vol. 6. New York: Elsevier.

Money, John, and Herman Musaph, eds.
1977 *Handbook of Sexology*, 5 vols. New York: Elsevier.

Montagu, Ashley
1953 *The natural superiority of women.* New York: Macmillan.
1969 *Sex, man, and society.* New York: G P Putnam's Sons.
1974 *Coming into being among the Australian aborigines: a study of the procreative beliefs of the native tribes of Australia.* (2nd ed.) London: Routledge and Kegan Paul.

Montgomery, James Alan
1968 *The Samaritans, the earliest Jewish sect: their history, theology and literature.*
 (Originally 1907.) New York: Ktav Publishing House.

Morris, Desmond
1967 *Primate ethology.* London: Weidenfeld and Nicholson.
1969 *The naked ape: a zoologist's study of the human animal.* New York: McGraw-Hill.

Morris, Jan
1974 *Conundrum.* New York: Harcourt Brace Jovanovich.

Morris, John
1938 *Living with Lepchas: a book about the Sikkim Himalayas* .London: William Heinemann.

Morton, R S
1972 *Venereal diseases.* Harmondsworth: Penguin Books.

Mosse, George L
1985 *Nationalism and sexuality: middle-class morality and sexual norms in modern Europe.*
 New York: H Fertig.

Muncy, Raymond Lee
1973 *Sex and marriage in utopian communities; 19th century America.* Bloomington: Indiana
 University Press.

Munroe, R L
1971 "Male pregnancy symptoms and cross-sex identity in three societies." *Journal of social
 psychology* 84:11-25.

Monroe, Robert L, John W M Whiting, and David J Hally
1969 "Institutionalized male transvestism and sex distinctions." *American anthropologist*
 71.1:87-90.

Murdock, George Peter
1949 "The social regulation of sexual behavior." In: Paul H Hock and Joseph Zubin, eds.,
 Psychosexual development in health and disease, pp 256-266 .New York: Grune and
 Stratton.
1950 "Family stability in non-European cultures." *Annals of the American Academy of
 Political and Social Science* 272:195-201.(Reprinted in: Morton H Fried, ed. [1968],
 Readings in anthropology [2nd ed.]. New York: Thomas Y. Crowell.)
1959 *Africa: its peoples and their culture history.* New York: McGraw-Hill.
1964 "Cultural correlates of the regulation of premarital sex behavior."In: Robert A Manners,
 ed., *Process and pattern in culture: essays in honor of Julian H. Steward.* Chicago:
 Aldine.
1967 *Ethnographic atlas.* Pittsburgh: University of Pittsburgh Press.
1980 *Theories of illness: a world survey.* Pittsburgh: Univeristy of Pittsburgh Press.

Murphy, Robert
1964 "Social distance and the veil." *American anthropologist* 66:1257-1274.

Murray, Stephen O
1984 "Homosexual categorization in cross-cultural perspective."In: Stephen O Murray, ed.,
 Social theory, homosexual realities. New York: Gay Academic Union.

Nadel, Siegfried
1942 *A black Byzantium; the kingdom of the Nupe in Nigeria.* London: Oxford University
 Press.

Nag, Moni
1962 *Factors affecting human fertility in nonindustrial societies: a cross-cultural study.* New Haven: Department of Anthropology, Yale University (YUPA 66).

Nanda, Serena
1990 *Neither man nor woman: the hijras of India.* Belmont, CA: Wadsworth.

Nash, Jill
1978 "A note on groomprice." *American anthropologist* 80.1:106-109.

Neufeld, E
1944 *Ancient Hebrew marriage laws; with special reference to general Semitic laws and customs.* London: Longmans, Green.
1951 *The Hittite laws.* London: Luzac.

Newton, Esther
1972 *Mother camp: female impersonators in America* .Englewood Cliffs, NJ: Prentice-Hall.

Nurge, Ethel
1970 "Birthrate and work load." *American anthropologist* 72:1434-1439.

Omlin, Joseph A
1973 *Der Papyrus 55001 und seine satirisch-erotischen Zeichnungen und Inschriften.* Torino: Edizioni d'Arte Fratelli Pozzo (Catalogo del Museo Egizio di Torino vol. 13).

Opler, Morris K
1969a *Apache odyssey: a journey between two worlds.* New York: Holt, Rinehart and Winston.
1969b "Cross-cultural aspects of kissing." *Medical aspects of human sexuality* 3:11-21.

Ortner, Sherry
1974 "Is female to male as nature is to culture?In: Michelle Rosaldo and Louise Lamphere, eds., *Woman, culture and society.* Stanford, CA: Stanford University Press.

Ortner, Sherry B and Harriet Whitehead, eds.
1981 *Sexual meanings.* Cambridge: Cambridge University Press.

Osgood, Cornelius
1951 *The Koreans and their culture.* New York: Ronald Press.
1958 *Ingalik social culture.* New Haven: Yale University Press (YUPA 53).

Paige, Karen Ericksen
1980 "Female genital mutilations: world patterns and the case of Egypt." Paper presented at the annual meeting of the American Anthropological Association, Washington, D.C.

Parkes, Alan S
1966 *Sex, science and society.* Newcastle upon Tyne: Oriel.
1976 *Patterns of sexuality and reproduction.* London: Oxford University Press.

Patai, Raphael
1960 *Family, love and the Bible.* London: MacGibbon & Kee.Pauvert, Jean-Jacques, ed.
1962 *Dictionnaire de sexologie.* Paris: Société des Éditions.

Peter, Prince of Greece and Denmark
1963 *A study of polyandry.* The Hague: Mouton.

Philby, H St J B
1951 *Arabian highlands.* Ithaca, NY: Cornell University Press.

Perrow, Charles and Mauro F Guillén
1990 *The AIDS disaster: the failure of organizations in New York and the nation.* New Haven:
 Yale University Press.

Ploss, Herman Heinrich, Max Bartels, and Paul Bartels
1927 *Das Weib in der Natur und Völkerkunde.* Berlin: Neufeld & Henius.

Polhemus, Ted, ed.
1978 *The body reader: social aspects of the human body.* New York: Pantheon Books.

Pomeroy, Wardell B
1972 *Dr Kinsey and the Institute for Sex Research.* New York: Harper & Row.

Pomeroy, Wardell B, Carol C Flax and Connie Christine Wheeler
1982 *Taking a sex history: interviewing and recording.* New York: The Free Press.

Preuss, Konrad Theodor
1926 *Forschungsreise zu den Kágaba.* St Gabriel-Mödling bei Wien: Adminstration des
 "Anthropos."

Raboch, Jan
[n.d.] "Sexology medical service teaching and research in Czechoslovakia." (Unpublished
 paper.)

Rachewiltz, Boris de
1964 *Black eros: sexual customs of Africa from pre-history in* [sic] *the present day.* London:
 Allen & Unwin.

Radcliffe-Brown, AR, and Daryll Forde, eds.
1950 *African system of kinship and marriage.* London: Oxford University Press.

Rawson, Philip
1973 *Primitive erotic art.* New York: G P Putnam.

Reichel-Dolmatoff, Gerardo
1949-1950 *Los Kogi.Una tribu de la Sierra Nevada de Santa Marta, Colombia,* vol. 1. Revista del
 Instituto Etnológico Nacional vol 4, no 1-2. Bogotá [HRAF translation].
1951 *Los Kogi.Una tribu de la Sierra Nevada de Santa Marta, Colombia,* vol. 2.Bogotá:
 Editorial Iqueima [HRAF translation].

Reinisch, June M, with Ruth Beasley
1990 *The Kinsey Institute new report on sex: what you must know to be sexually literate.* New
 York: St Martin's.

Requena, Antonio
1945 "Noticias y consideraciones sobre las anormalidades sexuales de los aborígenes americanos:
 sodomía." *Acta Venezolana* 1:3-32.

Reuben, David R
1969 *Everything you always wanted to know about sex (but were afraid to ask).* New York:
 David McKay.

Reynolds, James Bronson
1914 "Sex morals and the law in ancient Egypt and Babylon." *Journal of the American
 Institute of Criminal Law and Criminology* 5.1:20-31, May.

Robinson, Paul
1976 *The modernization of sex: Havelock Ellis, Alfred Kinsey, William Masters and Virginia
 Johnson.* New York: Harper & Row.

Róheim, Géza
1933 "Women and their life in Central Australia." *Journal of the Royal Anthropological Institute of Great Britain and Ireland* 63:207-265.
1974 *Children of the desert: the western tribes of Central Australia.* New York: Basic Books.

Romer, Alfred Sherwood
1962 *The vertebrate body.* Philadelphia: W B Saunders.

Rosenblatt, Paul C
1966 "A cross-cultural study of child rearing and romantic love." *Journal of personality and social psychology* 4:336-338.
1967 "Marital residence and the functions of romantic love." *Ethnology* 6:471-480.

Royal Anthropological Institute of Great Britain and Ireland
1951 *Notes and queries on anthropology* (6th ed.). London: Routledge and Kegan Paul.

Rudofsky, Bernard
1971 *The unfashionable human body.*Garden City, NY: Doubleday.

Ryazanovski, Valentin Aleksandrovich [Riasanovsky]
1929 *Customary law of the Mongol tribes.* Harbin, China: "Artistic printinghouse."
1937 *Fundamental principles of Mongol law.*Tientsin: (Telberg's International Bookstores).

Sahlins, Marshall
1976 *The use and abuse of biology: an anthropological critique of sociobiology.*Ann Arbor: University of Michigan Press.

Salesius, Fr.
1906 *Die Karolinen-Insel Jap.* [HRAF trans.] Berlin: Wilhelm Susserot.

Schapera, Isaac
1966 *Married life in an African tribe.*(Originally 1940.) Evanston: Northwestern University Press.

Schneebaum, Tobias
1969 *Keep the river on your right.* New York: Grove.
1988 *Where the spirits dwell; an odyssey in the New Guinea jungle.*New York: Grove.

Schneider, Jane
1978 "Peacocks and penguins: the political economy of European cloth and colors." *American ethnologist* 5:413-447.

Schultze, Leonhard
1907 *Aus Namaland und Kalahari.*Jena: Gustav Fischer.

Seeland, Nicolas
1882 "Die Ghiliaken: eine ethnographische Shizze." *Russiche Revue* (St Petersburg) 21: 97-130, 222-254.
Shaw, Brent D
1992 "Explaining incest: brother-sister marriage in Graeco-Roman Egypt." *Man* 27.2: 267-299.

Sheldon, W H
1940 *The varieties of human physique: an introduction to constitutional psychology.* New York: Harper and Brothers.
1942 *The varieties of temperament: a psychology of constitutional differences.*New York: Harper and Brothers.

Shepherd, Gill
1978a "Transsexualism in Oman?" *Man NS* 13:133-134.
1978b "The Omani *xanith*." Man NS 13:663-671.

Sherfey, Mary Jane
1972 *The nature and evolution of female sexuality.* New York: Random House.

Shiloh, Ailon, ed.
1970 *Studies in human sexual behavior: The American scene.* Springfield, IL: Charles C.
 Thomas.

Shilts, Randy M
1987 *And the band played on: politics, people, and the AIDS epidemic.* New York: St Martin's.

Shostak, Marjorie
1981 *Nisa: the life and words of a !Kung woman.* Cambridge, MA: Harvard University Press.

Signorini, Italo
1971 "Agɔnwole agyalɛ: il matrimonio tra individui dello stesso sesso degli Nzewa del
 Ghana sud-occidentale." *Rassegna italiana di sociologica* 12.3:529-545.
1973 "Agɔnwole agyalɛ: the marriage between two persons of the same sex among the Nzema
 of southwestern Ghana." *Journal de la Société des Africanistes* 43.2:221-234

Simon, Pierre
1972 *Rapport Simon sur le comportement sexuel des Français* (édition abrégée). Paris: Pierre
 Charron René Julliard.

Simons, G L
1973 *Sex and superstition.* New York: Barnes and Noble.
1975 *Book of world sexual records.* New York: Pyramid Books.

Singer, Philip, and Daniel E Desole
1967 "The Australian subincision ceremony reconsidered: vaginal envy or kangaroo bifid penis
 envy." *American anthropologist* 69:355-358.

Slater, Mariam K
1959 "Ecological factors in the origin of incest." *American anthropologist* 61:1042-1059.
1964 "Some anthropological contributions to our knowledge of sexual behavior." Paper
 presented at the New York Society for Ethical Culture.The Institute for Ethical Studies
 conference on sex (October 31).
1974 "Paleolithic Venuses and the ecofacts of life." Paper presented at the annual meeting of
 the American Anthropological Association, Mexico City.
1976 *African odyssey: an anthropological adventure.* Garden City, NY: Doubleday Anchor.
1977 *The Caribbean family: legitimacy in Martinique.* New York: St Martin's Press.
1978 "A woman for all seasons: some evolutionary aspects of sexual reproduction."Paper
 presented at the annual meeting of the American Anthropological Association, Los
 Angeles, CA. (An expanded version was given in 1990 at the New York Academy of
 Sciences.)

Smith, Edwin W, and Andrew Murray Dale
1968 *The Ila-speaking peoples of Northern Rhodesia,* 2 vols.(Originally published 1920.)New
 Hyde Park, NY: University Books.

Sommer, Joseph
1970 *Catholic thought on contraception through the centuries.* Liguori, MO: Liguorian
 Pamphlets and Books.

Sonenschein, David
1968 "The ethnography of male homosexual relationships." *The journal of sex research* 4.2:69-
 83.

Sorensen, Arthur P, Jr
1984 "Linguistic exogamy and personal choice in the northwest Amazon." In: Kenneth M
 Kensinger, ed., *Marriage practices in lowland South America* (Illinois studies in
 anthropology no 14).Urbana: University of Illinois Press.

Sorokin, Pitirim A
1956 *The American sex revolution.* Boston: P Sargent.

Spencer, W Baldwin, and Francis James Gillen
1927 *The Arunta: a study of stone age people.* London: Macmillan.

Spengler, Andreas
1977 "Manifest sadomasochism of males: results of an empirical study." *Archives of sexual
 behavior* 6.6:441-456.
1979 *Sadomasochisten und ihre Subkulturen.* Frankfurt am Main: Campus Verlag.

Spong, John Shelby
1991 *Rescuing the Bible from fundamentalism: a bishop rethinks the meaning of scripture.* New
 York: Harper.

Steakley, James D
1975 *The homosexual emancipation movement in Germany.* New York: Arno.

Stein, Edward D, ed.
1990 *Forms of desire: sexual orientation and the social constructionist controversy.* New York:
 Garland.

Steinberg, Leo
1970 "The metaphors of love and birth in Michelangelo's *Pietà's.*" In: Theodore Bowie and
 Cornelia V Christenson, eds., *Studies in erotic art.* New York: Basic Books.

Stephens, William N
1969 *A cross-cultural study of modesty and obscenity.* Halifax: Dalhousie University Press.
1972 "A cross-cultural study of modesty." *Behavior Science Notes* 7:1-28.

Stern, Mikhail (with August Stern)
1979 *Sex in the USSR.* New York: Times Books.

Strehlow, Carl
1913 "Das soziale Leben der Aranda und Loritja." *Veröffentlichungen aus dem städtischen
 Völker-Museum* 1.4.1:1-103.

Suggs, Robert C
1966 *Marquesan sexual behavior.* New York: Harcourt, Brace and World.

Sur, A K
1973 *Sex and marriage in India: an ethno-historical survey.*Bombay: Allied Publishers.

Symons, Donald
1979 *The evolution of human sexuality.* New York: Oxford University Press.

Takahashi, Mutsuro
1968 "The Japanese loincloth." In: Tamotsu Yato, *Naked festival.* New York:
 Walker/Weatherhill.

Tannahill, Reay
1980 *Sex in history.* New York: Stein and Day.

Tanner, Nancy Makepeace
1987 "The chimpanzee model revisited and the gathering hypothesis." In: Kinzey, ed. (1987),
 q.v.

Taylor, G Rattray
1954 *Sex in history: the story of society's changing attitudes to sex throughout the ages.* New
 York: Vanguard.

Teal, Donn
1971 *The gay militants.* New York: Stein and Day.

Tennov, Dorothy
1979 *Love and limerance: the experience of being in love.* New York: Stein and Day.

Thomas, P
1960 *Kama kalpa, or the Hindu ritual of love.* Bombay: D B Taraporevala Sons.

Thompson, Stith
1955-1958 *Motif-index of folk literature: a classification of narrative elements in folktales,
 ballads, myths, fables, medieval romances.*
1968 *Tales of the North American Indians.* (Originally 1929.) Bloomington: Indiana
 University Press.

Thomson, Basil Home
1894 *The diversions of a prime minister.* Edinburgh: William Blackwood and Sons.

Tiger, Lionel
1969 *Men in groups.* New York: Random House.

Tissot, Simon André (also known as Samuel Auguste André David Tissot)
1758 "Tentamen de morbis ex manustupratione." (In the 1758 ed. of his *Dissertatio de
 febribus biliosis.*) Lausannæ: M-M Bousquet.
1760 *L'onanisme, dissertation sur les maladies produites par la masturbation.* [Trans. of 1758
 work.] Lausanne: F Grasset.

Tomasic, Dinko
1948 *Personality and culture in Eastern European politics.* New York: George W Stewart.

Tooby, John, and Irven DeVore
1987 "The reconstruction of hominid behavioral evolution through strategic modeling."In:
 Kinzey, ed. (1987), q.v.

Tozzer, Alfred M
1941 *Landa's Relación de las cosas de Yucatán: a translation.* Papers of the Peabody
 Museum of American Archaeology and Ethnology, vol 18, Harvard University.

Tripp, C A
1975 *The homosexual matrix.* New York: McGraw-Hill.

Trumbach, Randolf
1977 "London's sodomites: homosexual behavior and western culture in the 18th century."
 Journal of social history 11:1-33.

Turnbull, Colin M
1962 *The lonely African.* Garden City, NY: Doubleday Anchor.
1965 "The Mbuti Pygmies: an ethnographic survey." American Museum of Natural History,
 Anthropological Papers 50.

Tuzin, Donald
1988 "Intercourse, discourse and the excluded middle: sex and the anthropologist." Paper presented at the annual meeting of the American Anthropological Association, Phoenix, Arizona.

Tylor, Edward Burnett
1889 "On a method of investigating the development of institutions; applied to laws of marriage and descent." Journal of the Royal Anthropological Institute 18:245-269.

Ucko, Peter J
1970 "Penis sheaths: a comparative study." Proceedings of the Royal Anthropological Institute 1969, pp 24-67.

Ucko, Peter J, and Andrée Rosenfeld
1967 Paleolithic cave art. London: Weidenfeld and Nicholson.

Ullerstam, Lars
1966 Erotic minorities. New York: Grove.

Unwin, J D
1934 Sex and culture. London: Oxford University Press.

Valensin, Georges
1977 La vie sexuelle en Chine communiste. Paris: Jean-Claude Lattès.

van den Berghe, Pierre L, and Gene M Mesher
1980 "Royal incest and inclusive fitness." American ethnologist 7.2:300-317.

Vance, Carole S
1989 "Social construction theory: problems in the history of sexuality." In: Anja van Kooten Niekerk and Theo van der Meer, eds., "Homosexuality," which homosexuality? Amsterdam: An Dekker/ Schorer.

Vayda, A P
1961 "Love in Polynesia atolls." Man 61:204-205.

Verinis, J S and S Roll
1970 "Primary and secondary male characteristics: the hairiness and large penis stereotypes." Psychological reports 26:123-126.

Visted, Kristofer, and Hilmar Stigum
1971 Vår gamle bondekultur. Oslo: J W Cappelens Forlag.

von Fürer Haimendorf, Christoph
1969 The Konyak Nagas. New York: Holt, Rinehart and Winston.

Warner, W Lloyd
1937 A black civilization: a social study of an Australian tribe. New York: Harper and Brothers.

Watanabe, Tsuneo, and Jun'ichi Iwata
1989 The love of the samurai: a thousand years of Japanese homosexuality (trans. by D R Roberts). Boston: Alyson.

Weatherford, Jack McIver
1986 Porn row. New York: Arbor House.

Webb, Peter
1975 The erotic arts. Boston: New York Graphic Society.

Weiss, Charles
1962 "A worldwide survey of the current practice of milah (ritual circumcision)." *Jewish social studies* 24.1:30-39.

Werner, Dennis
1975 *On the societal acceptance or rejection of male homosexuality.* (Unpublished MA thesis, Hunter College of the City University of New York.)
1979 "A cross-cultural perspective on theory and research on male homosexuality." *Journal of homosexuality* 4:345-362.

Westermarck, Edward
1968 *A short history of marriage.* (Originally 1926.) New York: Humanities Press.

Westphal, Karl
1869 "Die konträre Sexualempfindung: Symptom eines neuropathologischen (psychopathischen) Zustandes." *Archiv für Psychiatrie und Nervenkrankheiten* 2:73-108.

Whitam, F L
1983 "Culturally invariable properties of male homosexuality: tentative conclusions from cross-cultural research." *Archives of sexual behavior* 12:207-226.

Whiting, John W M
1941 *Becoming a Kwoma: teaching and learning in a New Guinea tribe.* New Haven: Yale University Press.

Whiting, John W M, and Irvin L Child
1953 *Child training and personality.* New Haven: Yale University Press.

Whiting, J C Kluckhohn, and A Anthony
1958 "The function of male initiation ceremonies at puberty." In: E Maccoby, T M Newcomb, and E L Hartley, eds., *Readings in social psychology.* New York: Holt.

Wikan, Unni
1977 "Man becomes woman: transsexualism in Oman as a key to gender roles." *Man NS* 12:304-319.
1978 "The Omani *xanith*." *Man NS* 13:667-671.

Williams, Robert
1992 *Just as I am: a practical guide to being out, proud, and Christian.* New York: Crown.

Williams, Walter L
1986 *The spirit and the flesh: sexual diversity in American Indian culture.* Boston: Beacon.

Williams, George C
1975 *Sex and evolution.* Princeton: Princeton University Press.

Wilson, Edward O
1975 *Sociobiology: the new synthesis.* Cambridge, MA: Harvard University Press.

Winick, C, and P M Kinsie
1973 "Prostitution." *Sexual behavior* 3:33-43.

Wolf, Arthur
1966 "Childhood association, sexual attraction, and the incest taboo: a Chinese case." *American anthropologist* 68:883.
1968 "Adopt a daughter-in-law, marry a sister: a Chinese solution to the problem of the incest taboo." *American anthropologist* 70:864-874.

Wolff, Charlotte
1986 *Magnus Hirschfeld: a portrait of a pioneer in sexology.* London: Quartet.

Wong, Amos
1949 "Pathological beauty." *The international journal of sexology* 2:173-174.

Worsley, Peter
1957 *The trumpet shall sound: a study of "cargo" cults in Melanesia.* London: MacGibbon and Kee.

Young, Frank W
1965 *Initiation ceremonies: a cross-cultural study of status dramatization.* Indianapolis: Bobbs-Merrill.

Zuckermann, Solly
1932 *The social life of monkeys and apes.* London: Routledge and Kegan Paul.

AUTHOR'S ACKNOWLEDGMENTS

I am happy to acknowledge at least some of the many people
and institutions that have helped me in preparing this book.

Of institutions, the two most important are the Institute for Sex Research,
now the Alfred C Kinsey Institute, at the University of Indiana, in
Bloomington (Paul Gebhard, the director, John Huntington, assistant to the
director, and all the staff were extremely helpful, but particular thanks go to
Joan Brewer); and the Human Relations Area Files housed in the library of the
Graduate Center of the City University of New York (many thanks to Jane
Moore, the chief librarian, for many favors). These institutions proved to be
absolutely indispensable. Other important institutions: the New York Public
Library, reference branch; Butler Library, Columbia University; Columbia-
Presbyterian medical library; the New York Academy of Medicine; Bobst
Library, New York University; Wilbour Library, Brooklyn Museum (with
special thanks to Diana Guzman); the Fashion Institute of Technology; the
General Theological Seminary, the Jewish Theological Seminary, and the
Union Theological Seminary (all in New York); the Library of Congress; the
British Museum; the Museum of Mankind (London); the Bioliothèque
Nationale; the Musée de l'Homme (special thanks to Geneviève Domergue); the
Louvre (especially Jean Louis de Cenival); Völkerkunde Museum, Berlin;
Ägyptisches Museum, Berlin (special thanks to Karl Theodor Zauzich); Museo
Missionario-etnologico, Vatican City (special thanks to Fr Jozef Penkowski).

Mariam K. Slater, Harvey Zuckerman, John Beatty, Frank Spencer, Alex
Orenstein, Roger C Owen, Ronald Waterbury, and Chad Hardin read sections
of the manuscript and suggested revisions (some of which have been used) and
often helped in other ways. Thomas M Stutzbach cataloged a number of
materials for me, which proved to be invaluable in the final production of the
book.

The following people helped in various and sundry ways: Edmund White (who
suggested the book in the first place;), Robin Maugham, Raymond Firth,
Geoffrey E Gorer, George D Spindler, Gilbert H Herdt, Shirley Lindenbaum,
Richard B Lee, Marjorie Shostak, John M Campbell, Moni Nag, Stanley M
Garn, Raphael Patai, John Money, Vern L Bullough, Deborah Gewertz, Natasha
Sadomskaya, Jonathan Katz, Arnie Kantrowitz, Philippe Derchain, Robert A
Day, Junichi Takahashi, Mervyn J Meggitt, Robert M Glasse, Bernadette
Bucher, David D Schieber, Alan R Schulman, Pei-Yi Wu, Bernard S Solomon,
John M O'Brien, Per Schelde Jacobsen, Lynn Ceci, Gloria Levitas, James A

Moore, Amal Rassam, D Michael Steffy, Don Haarman, Robert Paynter, Jane Schneider, Edward C Hansen, Paul E Mahler, Randolph Trumbach, Paul Rubel, Abraham Rosman, Anne Chapman, Flora Kaplan, James deWoody, Walter Duncan, Carole Vance, William M Davis, David and Barbara Ames, Gillian and David Gillison, Virginia Guilford, Kenneth E Engel, Christine Mossaides, Evelyn Masana, Debbie J. Green, Arlene Zigmann, and Gus Rigas. My editors, Rachel Grenfell and James Hughes, were most diligent in cutting the manuscript down to manageable size while still accommodating many of my idiosyncracies. Rozelle Bentheim also proved to be most conscientious during the time she worked on the book.

I am indebted to Lisa Rosenblum and members of "the group" for helping me through some very trying times associated with the book.

I am also indebted to the various kinds of aid provided at Queens College and particularly the anthropology department and interlibrary loan service. Above all, I owe special gratitude to Dotty Belferman, who cheerfully and with incredible care produced a typed, proof-read manuscript from my handwriting.

For the present version, many of the previously-mentioned people were generous with their aid in one way or another. But special thanks to John Beatty for photographing at my request several items used in the illustrations.

The following people helped in a variety of ways: Robert Theodore "Ted" McIlvenna (who permitted extensive reproductions from his enormous collection of erotica), Julliane Imperato-McGinley, Gregory K Lehne, Melvin Ember, Walter L Williams, Tobias Schneebaum, Robert Carneiro, Stanley A Freed, John Hyslop, Craig Morris, Arthur Bankoff, David B Eyde, Patricia Bridges, Robert M Finks, Bernard B Gilligan, Fr John Adams SJ, David G Man, Roger G Rose, Robert I Levy, Arthur P Sorensen, Midge Keater, Benyamim Tsedaka, Joel Alter, Paul O'Rourke, Warren Johannson and Wayne Dynes, whose encyclopaedic knowledge was tapped on numerous occasions.

For help with technical problems in production, thanks to: Leonard J Cinquemani, Yan M Juras, Harry Wert, Arlen E Rauschkolb and Steven M Yoman. Helene Cinquemani prepared the original bibliography and Sandra Kotler worked on the revised, up-to-date bibliography. For photographic work I am indebted to Katherine McGlynn, Andrea C Davis and most of all Nancy Bareis. Maureen O'Doughterty proved to be invaluable in getting the manuscript on disc, and Donna Jordan was indefatigible in correcting errors, formating the manuscript and getting the whole thing into reasonable shape.

ILLUSTRATION ACKNOWLEDGEMENTS AND SOURCES

Figure 1 The Fall. Europe, 16th C woodcut (from Moll, 1911, *Handbuch der Sexualwissenschaften*, Leipzig: F C W Vogel).

Figure 2 Trobriand youths. Papua New Guinea, 1974 (Edgar Gregersen).

Figure 3 Painting for Madame de Pompadour's boudoir. France, 18th C (from Fuchs, 1910).

Figure 4 Coïtus with woman on top. House of the Vettii, Pompeii, Italy, 79 AD (Edgar Gregersen).

Figure 5 Kissing. Makonde, Tanzania, 20th C (Gregory Lehne Collection).

Figure 6 Spermatist scene. Tomb of Ramses IX (corridor C, right wall), Valley of the Kings, Egypt, XX Dynasty c 1112 BC (from Description de l'Égypte, 1809-1830).

Figure 7 Rear-entry copulation scene on pot. Perú, Mochica culture, 200 BC - AD 600 (photo by John Beatty, by courtesy of the American Museum of Natural History B9298).

Figure 8 Sex on a swing. Chinese, c 1650 (by courtesy of Archives of Erotology, Exodus Trust, San Francisco, California).

Figure 9 Amorous couple with female Peeping Tom. Woodblock print, early Ukiyo-e school, by Hishikawa Moronobu, Japan, 17th C (by courtesy of Archives of Erotology, Exodus Trust, San Francisco, California).

Figure 10 Aristotle and Phyllis. Woodcut, Hans Baldung Grien, Germany, 16th C (from Witkowski 1908).

Figure 11 Bertrand Russell versus Aristotle. New York, 1989 (Edgar Gregersen).

Figure 12 AIDS button. U.S.A., 1980's (Author's Collection).

Figure 13 Adam and Eve copulating. 13th C capital decoration from Pairon, Charroux (France) (from Witkowski 1908).

Figure 14 Burning of monks. Woodcut, Germany, 16th C (Author's Collection).

Figure 15 Punishments for fornication. After a fresco by Giotto in the church of Madonna dell'Arena, Padua, Italy, 14th C (from Witkowski 1908).

Figure 16 Punishments for sexual violations. Europe, Renaissance (?) (from Hirschfeld 1930).

Figure 17 Illustration from pamphlet, *The silent friend*. England, 19th C.

Figure 18 Fresco in entrance to House of the Vettii, Pompeii, Italy, 79 AD (Edgar Gregersen).

Figure 19 Anti-masturbatory devices. England, 19th C (Author's Collection).

Figure 20 Antonie van Leeuwenhoek (from Hirschfeld, 1930).

Figure 21 Drawing of human sperm by Antonie van Leeuwenhoek. Holland, 1703 (from Hirschfeld, 1930).

Figure 22 Discovery of sperm. (From Hirschfeld, 1930)

Figure 23 Indian pencil-and-ink drawing. Late 18th/early 19th C (by courtesy of Archives of Erotology, Exodus Trust, San Francisco, California).

Figure 24 Bloch. (From Hirschfeld, 1930.)

Figure 25 Krafft-Ebing. (From Hirschfeld, 1930.)

Figure 26 Forel. (From Hirschfeld, 1930.)

Figure 27 Baer. (From Hirschfeld, 1930.)

Figure 28 Mantegazza. (From Hirschfeld, 1930.)

Figure 29 Magnus Hirschfeld. (From Hirschfeld, 1930.)

Figure 30 Alfred C Kinsey. U.S.A., 20th C (Dr C A Tripp).

Figure 31 Kinsey team. U.S.A., 20th C (photo by Dellenbock, by courtesy of Paul H Gebhard).

Figure 32 William Masters and Virginia Johnson. U.S.A., 1968 (photo by Bob Levin, by courtesy of Masters & Johnson Institute).

Figure 33 International Congress for Sexual Reform. Germany, 1921 (from Hirschfeld, 1930).

Figure 34 "Secret collection" from the Naples Museum. 1991 (Edgar Gregersen).

Figure 35 Margaret Mead. U.S.A., 10th C (Margaret C Tellalian Kyrkostas Collection).

Figure 36 Havelock Ellis. England, 20th C (Library of Congress).

Figure 37 Human and chimpanzee penes. (Tom Doran).

Figure 38 Chastity belt scene. Europe, 1706 (from Hirschfeld, 1930).

Figure 39 Human foetus. Woodcut, Jakob Rueff, Germany, 16th C (Author's Collection).

Figure 40 Gantizing scene. Woodblock, Japan, 17th C (Author's Collection).

Figure 41 Coïtus with woman on top. Painted album by Uemura Shooen, Japan (by courtesy of Archives of Erotology, Exodus Trust, San Francisco, California).

All the maps in the book have been especially created by the author.

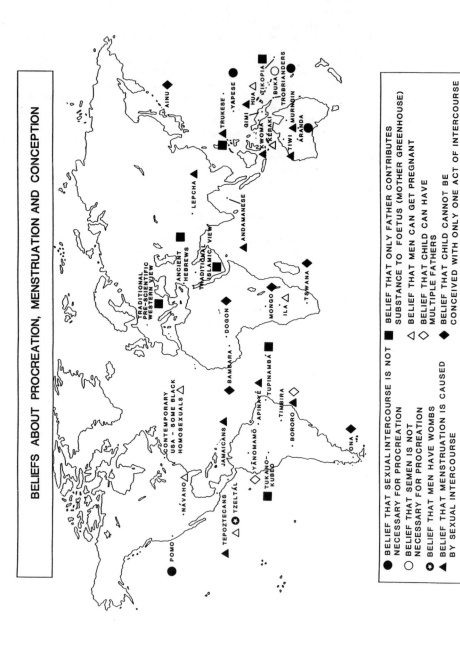

BELIEFS ABOUT PROCREATION, MENSTRUATION AND CONCEPTION

● BELIEF THAT SEXUAL INTERCOURSE IS NOT NECESSARY FOR PROCREATION
○ BELIEF THAT SEMEN IS NOT NECESSARY FOR PROCREATION
✪ BELIEF THAT MEN HAVE WOMBS
▲ BELIEF THAT MENSTRUATION IS CAUSED BY SEXUAL INTERCOURSE
■ BELIEF THAT ONLY FATHER CONTRIBUTES SUBSTANCE TO FOETUS (MOTHER GREENHOUSE)
△ BELIEF THAT MEN CAN GET PREGNANT
◇ BELIEF THAT CHILD CAN HAVE MULTIPLE FATHERS
◆ BELIEF THAT CHILD CANNOT BE CONCEIVED WITH ONLY ONE ACT OF INTERCOURSE

ONE RECONSTRUCTION OF THE SPREAD OF SYPHILIS

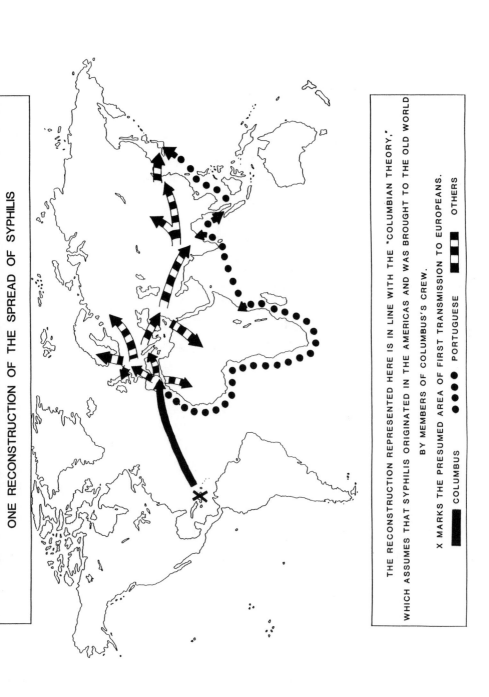

THE RECONSTRUCTION REPRESENTED HERE IS IN LINE WITH THE "COLUMBIAN THEORY," WHICH ASSUMES THAT SYPHILIS ORIGINATED IN THE AMERICAS AND WAS BROUGHT TO THE OLD WORLD BY MEMBERS OF COLUMBUS'S CREW.

X MARKS THE PRESUMED AREA OF FIRST TRANSMISSION TO EUROPEANS.

COLUMBUS PORTUGUESE OTHERS

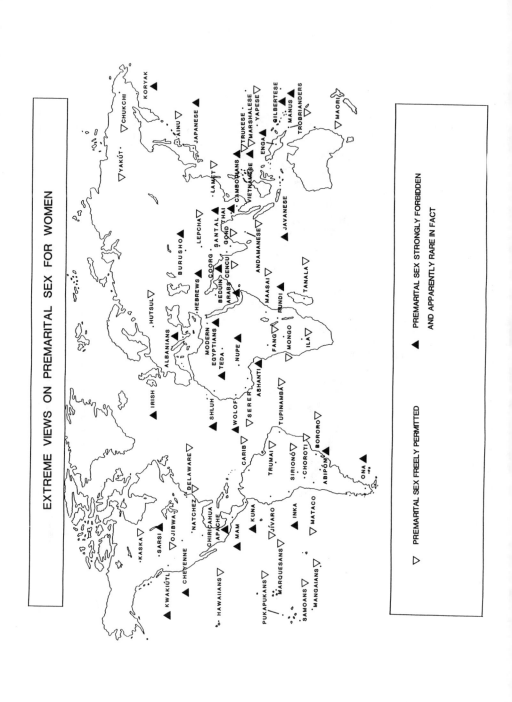

EXTREME VIEWS ON PREMARITAL SEX FOR WOMEN

▽ PREMARITAL SEX FREELY PERMITTED

▲ PREMARITAL SEX STRONGLY FORBIDDEN AND APPARENTLY RARE IN FACT

KORYAK
CHUKCHI
YAKÚT
AINU
JAPANESE
TRUKESE
MARSHALESE
YAPESE
GILBERTESE
MANUS
TROBRIANDERS
MAORI
ENGA
LAMET
CAMBODIANS
VIETNAMESE
JAVANESE
GOND THAI
SANTAL
LEPCHA
CENCU
ANDAMANESE
COORG
BEDUIN
ARABS
TANALA
HEBREWS
BURUSHO
MAASAI
HUTSUL
RUNDI
MONGO
ILA
ALBANIANS
MODERN EGYPTIANS
TEDA
FANG
NUPE
IRISH
SHLUH
WOLOF
ASHANTI
SERER
BORORO
TUPINAMBÁ
ABIPÓN
ONA
DELAWARE
CARIB
TRUMAI
SIRIONÓ
CHOROTI
NATCHEZ
CHIRICAHUA
APACHE
MAM
KUNA
JÍVARO
INKA
MATACO
KASKA
SARSI
OJIBWA
CHEYENNE
KWAKIÚTL
HAWAIIANS
PUKAPUKANS
MARQUESANS
SAMOANS
MANGAIANS

COÏTAL POSITIONS

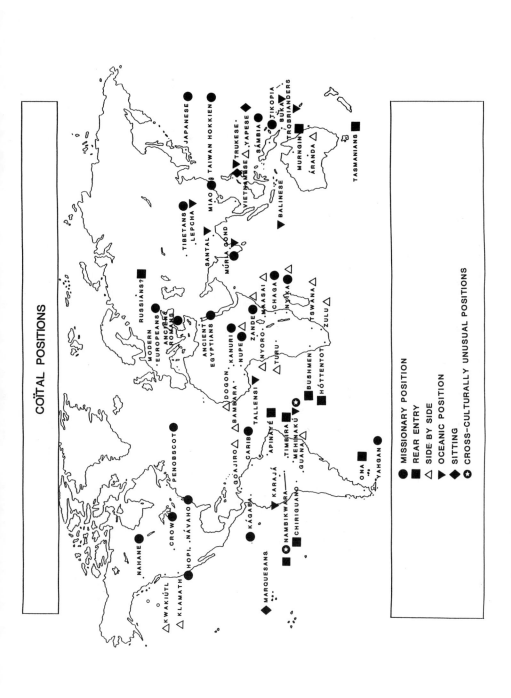

● MISSIONARY POSITION
■ REAR ENTRY
△ SIDE BY SIDE
▼ OCEANIC POSITION
◆ SITTING
☆ CROSS-CULTURALLY UNUSUAL POSITIONS

KWAKIÚTL △
KLAMATH △
HOPI, NÁVAHO
CROW ●
PENOBSCOT ●
NAHANE ●

MARQUESANS ◆
KÁGABA .
KARAJÁ .
CHIRIGUANO ■
☆ NAMBIKWARA ◆
GOAJIRO △
CARIB ■
APINAYÉ .
TIMBÍRA ■
GUANÁ △
☆ MEHINAKÚ ☆
TALLENSI ▼
BAMBARA △
DOGON △
KANURI ●
NUPE △
ZANDE △
☆ NYORO ○
TURU △
MASAI ●
CHAGA ●
NYAKA △
TSWANA △
ZULU △
HÓTTENTOT ■
BUSHMEN ■
ONA ■
YAHGAN ●

ANCIENT EGYPTIANS ●
ANC. GREEKS ■
ROMANS ●
MODERN EUROPEANS ■
RUSSIANS? ■
TIBETANS .
LEPCHA ▼
SANTAL ▼
MÚRIA GOND ●
MIAO ●
TAIWAN HOKKIEN ●
JAPANESE ●
VIETNAMESE △
TRUKESE ·
YAPESE ▼
SÁMBIA ●
TIKOPIA ●
BÚKA ◆
TROBRIANDERS
MURNGIN ■
ÁRANDA △
BALINESE ▼
TASMANIANS ■

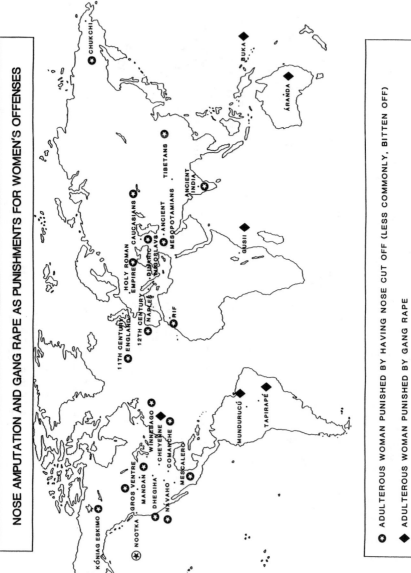

NOSE AMPUTATION AND GANG RAPE AS PUNISHMENTS FOR WOMEN'S OFFENSES

⊛ ADULTEROUS WOMAN PUNISHED BY HAVING NOSE CUT OFF (LESS COMMONLY, BITTEN OFF)

◆ ADULTEROUS WOMAN PUNISHED BY GANG RAPE

⊛ BRIDE WHO REFUSES TO CONSUMMATE MARRIAGE PUNISHED BY HAVING NOSE CUT OR BITTEN OFF

CHUKCHI

BUKA

ARANDA

TIBETANS

ANCIENT
INDIA

GUSII

CAUCASIANS

HOLY ROMAN
EMPIRE

DINARIC
YUGOSLAVS

ANCIENT
MESOPOTAMIANS

11TH CENTURY
ENGLAND

12TH CENTURY
NAPLES

RIF

MUNDURUCÚ

TAPIRAPÉ

KÓNIAG ESKIMO

NOOTKA

GROS VENTRE

MANDAN

DHEGIHA

N'YAHO

WINNEBAGO

CHEYENNE

COMANCHE

MESCALERO

ONE RECONSTRUCTION OF THE SPREAD OF AIDS

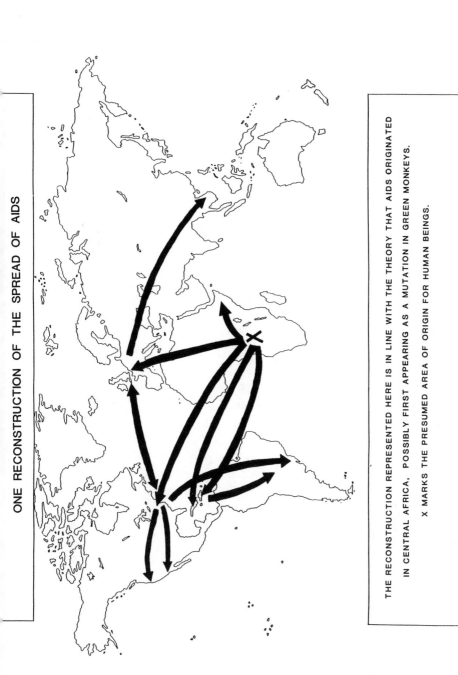

THE RECONSTRUCTION REPRESENTED HERE IS IN LINE WITH THE THEORY THAT AIDS ORIGINATED IN CENTRAL AFRICA, POSSIBLY FIRST APPEARING AS A MUTATION IN GREEN MONKEYS.
X MARKS THE PRESUMED AREA OF ORIGIN FOR HUMAN BEINGS.

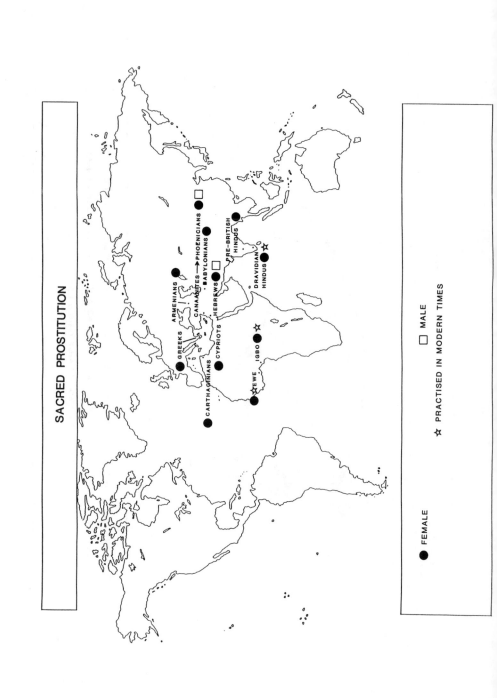

SACRED PROSTITUTION

GREEKS
ARMENIANS
CANAANITES → PHOENICIANS
BABYLONIANS
PRE-BRITISH HINDUS
HEBREWS
DRAVIDIAN HINDUS
CYPRIOTS
CARTHAGINIANS
EWE
IGBO

● FEMALE □ MALE

☆ PRACTISED IN MODERN TIMES

UNCOMMON MARRIAGE TYPES

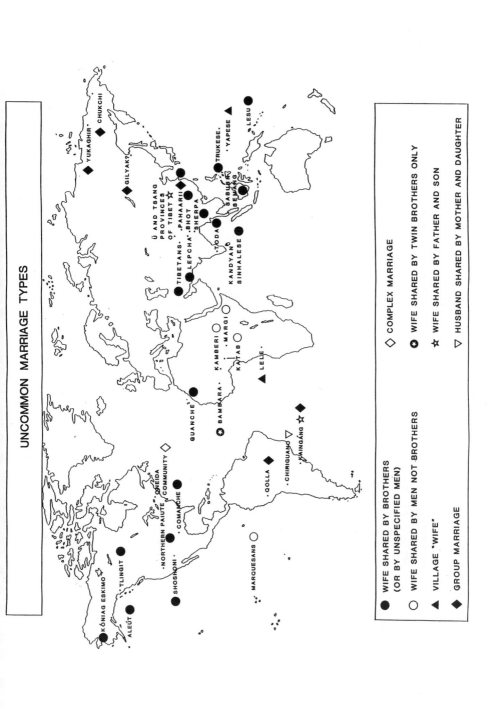

● WIFE SHARED BY BROTHERS (OR BY UNSPECIFIED MEN)

○ WIFE SHARED BY MEN NOT BROTHERS

▲ VILLAGE "WIFE"

◆ GROUP MARRIAGE

◇ COMPLEX MARRIAGE

✪ WIFE SHARED BY TWIN BROTHERS ONLY

☆ WIFE SHARED BY FATHER AND SON

▽ HUSBAND SHARED BY MOTHER AND DAUGHTER

CHUKCHI
YUKAGHIR
GILYAK?
Ü AND TSANG PROVINCES OF TIBET
TIBETANS
LEPCHA
PAHARII
BHOT
SHERPA
SABUR
SEMANG
TRUKESE
YAPESE
LESU
TODA
KANDYAN
SINHALESE
KAMBERI
MARGI
KATAB
LELE
BAMBARA
GUANCHE
CHIRIGUANO
KAINGÁNG
QOLLA
COMANCHE
ONEIDA COMMUNITY
NORTHERN PAIUTE
SHOSHONI
TLINGIT
KÓNIAG ESKIMO
ALEÚT
MARQUESANS

SEX AND MARRIAGE BETWEEN CLOSE KINSMEN

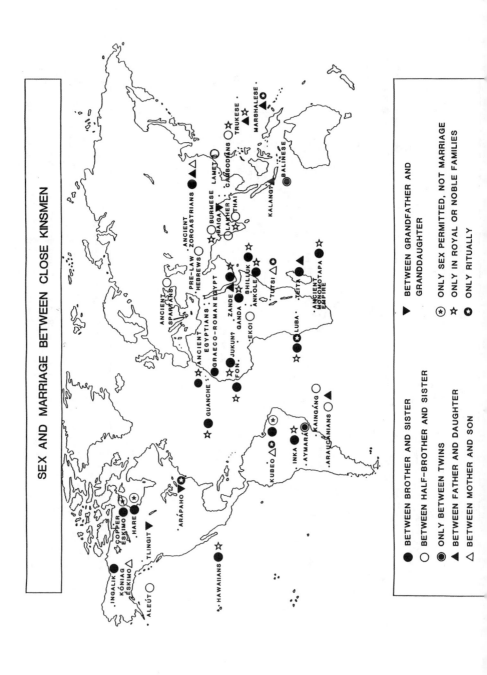

- ● BETWEEN BROTHER AND SISTER
- ○ BETWEEN HALF-BROTHER AND SISTER
- ◉ ONLY BETWEEN TWINS
- ▲ BETWEEN FATHER AND DAUGHTER
- △ BETWEEN MOTHER AND SON
- ▼ BETWEEN GRANDFATHER AND GRANDDAUGHTER
- ⊛ ONLY SEX PERMITTED, NOT MARRIAGE
- ☆ ONLY IN ROYAL OR NOBLE FAMILIES
- ✪ ONLY RITUALLY

PARAPHILIAS REPORTED

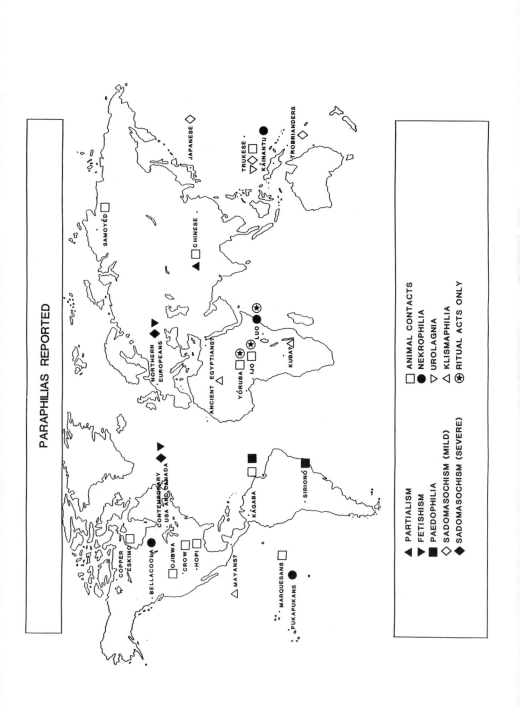

INDEX

INDEX

E

ear piercing 103
Easter Islanders (Rapa Nui, Oceania) 100, 274
Eastern Orthodox Church 9, 11, 13, 143, 222, 305-6
ecouterism 353
Edda (Africa) 201
Edo (W Africa) 201
Edwards, Robert G 182
eemics 35, 84, 317
Egypt, ancient 197-200, 222, 319
 circumcision 106-7, 111
 genital preservation 337
 homosexuality 199
 incest 139-40, 198, 204
 masturbation 349
 nekrophilia 349-50
 nudity 121-2
 prostitution 166, 199
 pubic hair 97
 punishment for adultery 198
 Muslim 155, 163, 220, 356
 see also Siiwans
Elizabeth I, Queen of England 17
Ellis, A B 168
Ellis, Albert 118
Ellis, Havelock 23, 30, 36, 119, 121, 123, 127, 142, 145, 375
emboîtement 27
emics *see* eemics
enáreës 314
encasement 27
Engels, Friedrich 152, 310
England 3, 11, 14, 17-18, 23, 73, 130, 150, 161, 164, 169, 170, 180-1, 186, 328, 330, 342
"English culture" 312
ephebophilia 341, 352
Epiphanes 310
Episcopal Church 11, 171, 181; *see also* Anglican Church, Church of England
episiotomy 110
erection 71, 77, 119, 130-1, 183, 197, 199-200, 256, 276, 296, 308, 336, 343, 353, 361, 375
erotic style 124
eroticism 224
erotophonophilia 352
Éskimo 73, 76, 127, 139, 143, 149, 257, 282-3, 287, 323, 345, 358, 372; *see also* Copper Éskimo, Kóniag Éskimo, Netsilik Éskimo

Essenes 13, 219
essentialism 34-6
Esther 214
estrus *see* oestrus
Ethiopia 97, 108-10, 219, 222
Ethnographic atlas 135, 137, 141, 241, 252, 258
etics 35, 85
Étoro (Étolo) (New Guinea) 149, 276
Etruscans 122, 155
Eulenburg, Albert 29
Eulenspiegel Society 180
eunuchs 86, 109-10, 163, 215, 337, 363
Europe 8-22, 300-18, 321, 328-9, 332, 356
 birth control 172-5
 clothing 125-7, 131
 coïtal positions 64-5, 312
 concepts of sexual orientation 315-17
 erotic art 306-9
 homosexuality 313-17, 342-3
 marriage 12, 143, 309-11
 paraphilias 352-4
 peak periods for births 56, 75
 prostitution 153, 160-65
 romantic love 359-60
European Court of Human Rights 171
Everything you wanted to know about sex (but were afraid to ask) 19
Evolution of modesty, The 119
Ewe (W Africa) 167-8
exhibitionism 353
exsativa 324

F

facial scars 103
Falashas (Ethiopia) 110, 219
Fallopius, Gabriel 27, 331
Fang (W Africa) 92, 202, 209, 212-13, 324, 344, 355
fathers of sexology 28; *see also* Aristotle, Bloch, Krafft-Ebing
fat 346, 374
fatness 78, 91, 93-4, 99-100, 103, 307
Faure, François Félix 48
Fellahin 220
fellation (fellatio) 9-10, 12, 49, 69-70, 159, 189, 193, 199, 212, 225, 235, 244, 257, 272, 286, 293, 304, 312, 343
Female eunuch, The 33
feminism 34, 60, 129, 169-70, 179, 193, 358; *see also* Women's Liberation movement
fertilization 27, 40, 45-50, 56, 81, 88, 143

ABOUT THE AUTHOR

Edgar Gregersen is a professor of anthropology at Queens College and the Graduate Center of the City University of New York. Born in 1937, he received a B.A. from Queens College, then obtained a Ph.D. at Yale University in 1962. He is a Fellow of the Royal Anthropological Institute and of the American Anthropological Association, and has carried out fieldwork in Kenya, Tanzania, Nigeria, Papua New Guinea and other countries.

The world of human sexuality is the distillation of over six years of work involving worldwide, multidisciplinary research. Professor Gregersen's other books include *Language in Africa* and *Prefix and pronoun in Bantu.* At present, he is finishing up two books dealing with insults.

Photo: Catherine S Brooker

LOVEMAPS
by John Money, Ph.D.

According to Dr. Money, lovemap pathology has its genesis early in life, but manifests itself in full after puberty. The author gives us a close examination of paraphilia, a lovemap that in response to the neglect, suppression, or traumatization of its normophilic formation has developed with distortions, and is legally referred to as perversion.

Lovemaps delineates new principles regarding the development of human sexuality and eroticism in health and in pathology, from fetal life through childhood to adolescence and adulthood. Technical and uncommon terms used in this book are defined in a glossary, making *Lovemaps* an interesting and useful resource to the professional as well as the non-specialist.

Available in Hard Cover for $29.95
ISBN 0-8290-1589-2

ORDER FORM Please photocopy or clip.

Name_____

Address_____

City_____State_____Zip_____Country_____

Payment Method ☐ Check ☐ Money Order ☐ MasterCard ☐ Visa

Credit Card #_____Exp. Date___/___

Signature_____

U.S., Canada, Mexico shipping & handling, add $4.00 per order. Overseas (via airmail) please add $10. Individuals must include check, money order or credit card information. Payment in U.S. funds only! Purchase orders are accepted from libraries and institutions. New York residents please add sales tax. Please allow 4-6 weeks for delivery.

QTY	TITLE	PRICE	TOTAL

Send to: **Irvington Publishers, Inc.** Tax and/or S/H
Lower Mill Road, North Stratford 03590
· (603) 922-5105 · Fax (603) 669-7945 TOTAL